Volume II

# The Orchid Pavilion Gathering

*Chinese Painting from the University of Michigan Museum of Art*

Marshall P.S. Wu

*To my dear wife, Judy T. Wu*

This catalogue was issued in conjunction with the exhibition *The Orchid Pavilion Gathering: Chinese Painting from the University of Michigan Museum of Art*, January 23–March 26, 2000

This catalogue and exhibition were made possible by Ford Motor Company. Additional support came from the University of Michigan Center for Chinese Studies and from Mr. and Mrs. William E. Steen.

ISBN: 1-930561-00-8 (Volume 2)

Library of Congress Card Number: 99-67186

Designed by Savitski Design, Ann Arbor, Michigan

Typeset by Impressions Book and Journal Services, Inc., Madison, Wisconsin

Printed by University Lithoprinters, Inc., Ann Arbor, Michigan

# Contents

# Notes to Introductory Essay

iv

1 For examples of Chinese pottery of the Neolithic period, see *The Chinese Exhibition: A Pictorial Record of the Exhibition of Archaeological Finds of the People's Republic of China* (Kansas City: The Nelson Gallery-Atkins Museum, 1975), color plates nos. 29, 36, and 37.

2 For examples of early Chinese bronze vessels with pictorial decoration, see Wen C. Fong, ed., *The Great Bronze Age of China* (New York: Metropolitan Museum of Art, 1980), pp. 138–165.

3 Although examples of paintings on silk found in tombs of the late Chou period are rare, there are two well-known works. The first, known as *Kuifeng renwu tu* (*K'uei-feng jen-wu t'u*) 夔鳳人物圖 (Female Figure with Dragon and Phoenix) was found in 1949 inside a Ch'u 楚 state (740–330 B.C.) tomb at Ch'en-chia ta-shan 陳家大山 (The Big Mountain of the Ch'en Family), Hunan 湖南. It now belongs to Hunansheng Wenwu Guanlichu (Hunan-sheng Wen-wu Kuan-li Ch'u) 湖南省文物管理處 (The Hunan Provincial Cultural Relics Bureau). Measuring 23 × 20 cm (9⅛ × 7 15/16 in.), it shows a woman dressed in a formal robe standing under a flying phoenix. A dragon is placed on the upper-left corner. The second work was also found in a Ch'u state tomb at Zidanku (Tzu-tan k'u) 子彈庫 (the Bullet Armory), Ch'ang-sha 長沙, Hunan in 1973. It is currently at the Hunan Provincial Museum. Entitled *Daifu yulong tu* (*Tai-fu yü-lung t'u*) 大夫御龍圖 (Scholar Mastering a Dragon) and measuring 37.5 × 28 cm (14 13/16 × 11 in.), it depicts a distinguish scholar facing left and holding a sword. A U-shaped dragon with a long body is placed beneath him. To indicate water, a large fish is found on the lower left corner. On the top of the composition, there is a black canopy. Both of these two works display advanced skill in human figure depiction.

4 For early examples of painted animals, see *Painted Shells with Hunting Scenes* at the Cleveland Museum of Art, reproduced in Sherman E. Lee, *A History of Far Eastern Art* (New York: Harry N. Abrams, Inc., 1964), color plate 6, p. 70. There are also numerous examples of animals found on stone relief, painted and carved tiles of the Han dynasty. See ibid., figs. 56, 58, 60, 62, and 63, pp. 59–63. For a detailed discussion of Han dynasty paintings, see Jan Fontein and Wu Tung, *Han and T'ang Murals Discovered in Tombs in the People's Republic of China* (Boston: Museum of Fine Arts Boston, 1976).

5 Hsieh Ho's 謝赫 (active 479–502) *Liu-fa* 六法 or *The Six Canons of Painting* is considered the first and most important treatise on Chinese painting. The principles outlined by Hsieh have been revered throughout history. They include: 1) *Ch'i-yün sheng-tung* 氣韻生動 (animation through spirit consonance); 2) *Ku-fa yung-pi* 骨法用筆 (using a flexible brush to produce forceful strokes); 3) *Ying-wu hsiang-hsing* 應物象形 (fidelity to the object in portraying forms); 4) *Sui-lei fu-ts'ai* 隨類敷彩 (conformity to type in applying colors); 5) *Ching-ying wei-chih* 經營位置 (proper planning in the placing of elements); and 6) *Ch'uan-i mo-hsieh* 傳移摹寫 (transmission of the experience of the past in making copies). For a discussion of these six canons, see James Cahill, "The Six Laws and How to Read Them," in *Ars Orientalis* 4 (Ann Arbor: The Department of the History of Art, University of Michigan, 1966), pp. 372–81.

6 See Jan Fontein and Wu Tung, *Han and T'ang Murals Discovered in Tombs in the People's Republic of China* (Boston: Museum of Fine Arts Boston, 1976), pp. 99–123.

7 See Pei Xiaoyuan (P'ei Hsiao-yüan) 裴孝源 (active first half of 7th century), *Zhenguan gongsi huashi* (*Chen-kuan kung-ssu hua-shih*) 貞觀公私畫史 (A Record of Paintings in Official and Private Collections during the Chen-kuan period [627–49]), preface dated 639, *juan* (*chüan*) 卷 (chapter) 1, reprinted in Yu Anlan 于安瀾, comp., *Huapin congshu* (*Hua-p'in ts'ung-shu*) 畫品叢書 (Compendium of Painting Commentaries) (Shanghai: Shanghai Renmin Meishu Chubanshe, 1982). In P'ei's book, which deals with early paintings, all paintings on silk were referred to as *chüan* 卷 or "handscroll."

8 There are several early handscrolls with figures and animals arranged in this manner. One is *Li-tai ti-wang t'u chüan* 歷代帝王圖卷 (The Thirteen Emperors Handscroll), attributed to Yen Li-pen 閻立本 (d. A.D. 673), currently at the Museum of Fine Arts, Boston. A section of this handscroll is reproduced in *Selected Masterpieces of Asian Art: Museum of Fine Arts, Boston* (Boston: Museum of Fine Arts, 1992), no. 133, p. 147. The other work is Han Huang's 韓滉 (723–89) *Wuniu tu* (*Wu-niu t'u*) 五牛圖 (Five Oxen), at the Palace Museum, Beijing. It is reproduced in *Gugong bowuyuan canghua ji* (*Ku-kung po-wu-yüan ts'ang-hua chi*) 故宮博物院藏畫集 (Paintings in the Collection of the Palace Museum), vol. 1 (Beijing: Renmin Meishu Chubanshe, 1986), pp. 46–51. Neither handscrolls have a background showing integrated space.

9 Although there is no painting that can be considered a genuine work by Li Ch'eng, there is an example entitled *Ch'ing-luan hsiao-ssu* 晴巒蕭寺 (Solitary Temple amid Clearing Peaks) done in his style at the Nelson-Atkins Museum, Kansas City. It is reproduced in Wai-kam Ho 何惠鑑 et al., *Eight Dynasties of Chinese Paintings: The Collections of the Nelson Gallery-Atkins Museum, Kansas City and the Cleveland Museum of Art* (Cleveland: Cleveland Museum of Art, 1980), no. 10, p. 14. For examples of the other three painters, *Hsi-shan hsing-lü* 谿山行旅 (Travelers amid Streams and Mountains) by Fan K'uan, *Tsao-ch'un t'u* 早春圖 (Early Spring) by Kuo Hsi; and *Wan-huo sung-feng* 萬壑松風 (Wind in the Pines Amid Ten Thousand Valleys), see Wen C. Fong and James C.Y. Watt, *Possessing the Past: Treasures from the National Palace Museum, Taipei* (New York: Metropolitan Museum of Art and Taipei: National Palace Museum, 1996), pls. 59, 60, and 61.

10 For a discussion of the intimate composition of Southern Sung album leaves, see Richard Edwards, *Li Ti*, Freer Gallery of Art Occasional Papers, 3 (Washington D.C.: Smithsonian Institution, 1967).

11 From this time on, painting activities centered around a few cities located on the south bank of the Yangtze River, such as Hangchou, Suchou, Nanking, and Shanghai. While the famous landscape painters of the Northern Sung dynasty were from

the north, most of the distinguished painters of the succeeding dynasties were from the south. Many of the later artists who were from the north spent most of their careers in the south.

12 During the Yüan dynasty, the term for literati painter was *li-chia* 隸家 or "amateurs." For the professional artists, the term was *hang-chia* 行家, literally meaning "experts." For a discussion of this two groups of painters in the 14th century, see Sherman E. Lee and Wai-kam Ho, *Chinese Art Under the Mongols: The Yüan Dynasty (1279–1368)* (Cleveland: Cleveland Museum of Art, 1968), pp. 28–29. The literati and professional are also known as the Southern and Northern schools. For a discussion of this subject, see James Cahill, "Tung Ch'i-ch'ang's Southern and Northern Schools in the History and Theory of Painting: A Reconsideration," in *Sudden and Gradual: Approaches to Enlightenment in Chinese Thought*, edited by Peter N. Gregory. Honolulu: University of Hawaii Press, 1987, pp. 429–46.

13 For a discussion of the Yüan literati artists and their works, see Maxwell K. Hearn, "The Artist as Hero," in Wen C. Fong and James C. Y. Watt, *Possessing the Past: Treasures from the National Palace Museum, Taipei* (New York: Metropolitan Museum of Art and Taipei: National Palace Museum, 1996), pp. 299–323.

14 For the names of the Eight Eccentrics of Yangchou, see note 21 of entry 36 on Huang Shen (1687–1770?), vol. II, p. 116. Works of four artists from this group, Huang Shen 黃慎 (1687–1766), Li Shan 李鱓 (1686–after 1760), Chin Nung 金農 (1687–1764), and Cheng Hsieh 鄭燮 (1693–1765) are included in this catalogue.

15 For more information on the Jen artists, see entries 49, 50, 51, and 52.

16 While there is only one way to handle a Chinese brush in painting, there are several different ways to handle a brush in calligraphy. For more information on this subject, see Tseng Yu-ho (Betty) Ecke 曾幼荷, *Chinese Calligraphy* (Philadelphia: Philadelphia Museum of Art, 1971), figs. 3–7.

17 While firm enough to control the brush, the grip should also be nimble and flexible. When executing a bending stroke with an angle, the fingers should turn the handle slightly at the corner in order to produce a continuous, swift, and smooth line. For more information on how to execute a cursive stroke, see ibid., figs. 9a–9c.

18 For an example of the adventurous *p'ien-feng* strokes executed by a Che painter, see entry 5 on Wu Wei 吳偉 (1459–1508), p. 28 and p. 33.

19 For more information on the production of Chinese pigments, see Yü Shao-sung 余紹宋 (1882–1949), "Yen-liao chih-fa chi yung-fa 顏料製法及用法" (How Pigments Are Manufactured and Used), in Yü's *Hua-fa yao-lu erh-pien* 畫法要錄二編 (Volume Two of A Compilation of Painting Methods), preface 1926 (Taipei: Chung-hua Press, 1967), p. 1–30. Among the numerous sources on this subject, Yü's writing is the more credible.

20 Hemp paper was made from bits of old cloth and hemp sacks. It was also known as *pu-chih* 布紙 or "cloth paper." This kind of paper was already popular in the

sixth century during the Six Dynasties period (220–589). In "I-wen chih 藝文誌 "(Documentation of Arts), chapter 1 of *Hsin-T'ang shu* 新唐書 (The New Book of T'ang [Dynasty]), it states: "The Chi-hsien (collecting the talented) Colleges' were established outside the Kuang-shun (favorable light) Gate of the Ta-ming (great brightness) Palace, as well as outside of the Ming-fu (illuminating happiness) Gate at the East Capital. [These schools] were attended by students from all over the country. Later, the National Educational Bureau issued them each month five thousand sheets of 'hemp paper' made in Szechwan." (大明宮光順門外, 東都明福門外, 皆創 集賢書院' 學士通籍出入. 既而, 太府月給蜀郡麻紙五千番.) See *Hanyu dacidian* (*Han-yü ta-tz'u-tien*) 漢語大詞典 (Chinese Terminology Dictionary), vol. 12 (Shanghai: Hanyu Dacidian Press, 1988), p. 1275, s.v. "*mazhi* (*ma-chih*) 麻紙' (hemp paper). The fact that T'ang painters often used this kind of paper can be verified by the many recorded T'ang paintings found in early sources. For example, Han Huang's *Five Oxen*, which is mentioned in note 13, is listed in Wang K'o-yü's 汪砢玉 (1587–after 1643) *Shan-hu wang hua-lu* 珊瑚網畫錄 (Nets for Harvesting Corals, a record of painting), preface 1643, *juan* (*chüan*) 卷 (chapter) 1, reprint in *Zhongguo shuhua quanshu* (*Chung-kuo shu-hua ch'üan-shu*) 中國書畫全書 (The Complete Collection of books on Chinese Painting and Calligraphy), vol. 5 (Shanghai: Shanghai Shuhua Chubanshe, 1992), p. 1006. Wang's book says, "*Niu t'u huang-ma-chih shang* 牛圖黃麻紙上") (The [five] oxen are painted on "yellow hemp paper.") On page 1005 of the same book, a horse painting by the famous T'ang painter Han Kan 韓幹 (active c. 742–56) is listed as, "*Yu T'ang Han Kan yung huang-ma chih, hua 'Yin-ma-t'u' chen-chi* 右唐韓幹用黃麻紙畫 '飲馬圖真跡'" (On the right is a genuine painting by Han Kan, executed on yellow hemp paper, showing a horse drinking. The famous horse painting, *Chao-yeh pai* 照夜白 (Night-shining White), attributed to Han Kan, is also listed in Zhang Chou's (Chang Ch'ou) 張丑 (1577–1643) *Zhenji rilu* (*Chen-chi jih-lu*) 真蹟日錄 (Daily Record of Genuine Works Seen by the Author), first edition c. 1620, vol. 3, reprinted in *Chung-kuo shu-hua ch'üan-shu* 中國書畫全書 (The Complete Collection of books on Chinese Painting and Calligraphy), vol. 4, p. 431, as "*Han Kan 'Chao-yeh pai t'u,' pai-ma chih, chen-chi* 韓幹 '照夜白圖' 白麻紙, 真跡" (Han Kan's *Night-shining White*, on white hemp paper, a genuine work). From these passages we can also conclude that hemp paper was available in two colors, yellow and white.

21 The painting, entitled *Pine and Hibiscus*, by the Ming dynasty painter Shen Chou 沈周 (1427–1509) in entry no. 4, is executed on *lo-wen* paper. For more information, see p. 23–24.

22 According to the brief definition of Hsüan paper found on page 50 in S. Howard Hansford's *A Glossary of Chinese Art and Archaeology* (London: The China Society, 1961), "[*Hsüan chih* is] a fine white bamboo-pulp laid paper, especially suitable for writing and painting. The name is derived from Hsüan-cheng (now called Ning-kuo)

in southern An-hui." Hsüan paper became popular around the seventeenth century. Although its production has been continued until today, the qualities and substances of paper made during different periods of time are not necessarily the same. In general, early Hsüan paper is finer and denser than that manufactured later.

23 Both the Persians and the Indians practiced seal engraving earlier than the Chinese. For examples of white steatite stamp seals from Mohenjo-daro, India, dated 2,500–1,500 B.C., see Sherman E. Lee, *A History of Far Eastern Art* (New York: Harry N. Abrams, Inc., 1964), figs. 6 and 7, p. 22.

24 During the Han dynasty, seals were pressed into wads of clay for sealing documents. For an example of a clay seal impression, see Jason C. Kuo (郭繼生), *Word As Image: The Art of Chinese Seal Engraving* (New York: China House Gallery, China Institute in America, 1992), pl. 20, p. 29.

25 See seal C on p. 263; and seal F on p. 37.

26 For an example of a small seal bearing only a few characters that is being placed at the beginning of a passage of text, see seal P on p. 21.

27 For an example of "a riding the edges seal," see seal I on p. 19.

28 Based on the *Zhongguo shuhuajia yinjian kuanshi* (*Chung-kuo shu-hua-chia yin-chien k'uan-shih*) 中國書畫家印鑑款識 (Signatures and Seals of Chinese Painters and Calligraphers), vol. 1 (Shanghai: Wenwu Chubenshe, 1987), pp. 242–56, Emperor Ch'ien-lung had as least 172 seals prepared for his collection. The largest one measures 12.8 × 12.5 cm (5 × 4 15/16 in.). One of the old paintings bearing numerous collectors' seals is Chao Meng-fu's 趙孟頫 (1254–1322) *Ch'iao Hua ch'iu-se* 鵲華秋色 (Autumn Colors on the Ch'iao and Hua Mountains), currently at the National Palace Museum, Taipei. This work, measuring only 28.4 × 93.2 cm (11¼ × 36¾ in.), bears a total of 62 collectors' seals. It is reproduced in Wen C. Fong and James C.Y. Watt, *Possessing the Past: Treasures from the National Palace Museum, Taipei* (New York: Metropolitan Museum of Art and Taipei: National Palace Museum, 1996), pl. 140, pp. 374–75.

29 The term *shuang-p'in* 雙拼, sometimes also referred to as *shuang-fu* 雙幅, or "twin pieces [of silk]," occurs frequently in old painting catalogues. For example, in Wu Ch'i-chen's 吳其貞 (1605–after 1677) *Shu-hua-chi* 書畫記 (A Record of Paintings and Calligraphy), c. 1677, facsimile reprint (Taipei: Wen-shih-che Press, 1971), p. 77, Kuo Hsi's work is listed as *Kuo Ho-yang 'Ch'iao-sung shan-shui t'u' shuang-p'in chüan ta-hua i-fu* 郭河陽 '喬松山水圖' 雙拼絹大畫一幅 (A large two pieces of silk painting by Kuo Ho-yang [Kuo Hsi] depicting 'Tall Pine Trees and Landscape'). On page 33 of Ku Fu's 顧復 (active second half of 17th century) *P'ing-sheng chung-kuan* 平生壯觀 (The Great Paintings and Calligraphic Works Viewed in Ku Fu's Life), preface 1692, facsimile reprint, vol. 2 (Taipei: Han-hua Wen-hua Shi-yeh Co. Ltd., 1971), Fan K'uan's famous *Travelers amid Streams and Mountains* is listed as *Hsi-shan hsing-lü t'u shuang-p'in chüan ta-*

*chou* 谿山行旅圖雙拼絹大軸 (The large hanging scroll *Travelers amid Streams and Mountains* has two pieces of silk [joined together]). As a matter of fact, the works by the four Sung painters mentioned in note 14, are all on two pieces of silk.

30 As Jen I's given name Run means "plenty" or "to enrich," it seems his *tzu* equates this idea with the abundant life of an aristocrat.

31 When Jen I adopted the *hao* of Hsiao-lou around 1868, he was in his late twenties. His intention was obvious. As this *hao* and Fei Tan-hsü's *hao* are pronounced identically, he apparently thought some might purchase a work of his, mistaking it for a work by the better known Fei. Seven years later in Shanghai, Fei's son, Fei I-keng 費以耕 (active mid-19th century) demanded that Jen I cease using this *hao*.

32 The twelve heavenly stems are 1) *chia* 甲; 2) *i* 乙; 3) *ping* 丙; 4) *ting* 丁; 5) *wu* 戊; 6) *chi* 己; 7) *k'eng* 庚; 8) *hsin* 辛; 9) *jen* 壬; 10) *k'uei* 癸. The twelve earthly branches or zodiac animals are 1) *tzu* 子 (rat); 2) *ch'ou* 丑 (ox); 3) *yin* 寅 (tiger); 4) *mao* 卯 (hare); 5) *ch'en* 辰 (dragon); 6) *ssu* 巳 (snake); 7) *wu* 午 (horse) ; 8) *wei* 未 (sheep) ; 9) *shen* 申 (monkey); 10) *yu* 酉 (rooster); 11) *hsü* 戌 (dog); 12) *hei* 亥 (boar).

33 For the title *Ta-chien p'u* found in early sources, see entry on Li Tsung-ch'eng 李宗成 (active 1068–77) in Guo Ruoxu's (Kuo Jo-hsü) 郭若虛 (fl. 1070–75) *Tuhua jianwen zhi* (*T'u-hua chien-wen chih*) 圖畫見聞誌 (A Record of Experiences in Painting), completed c. 1075, *juan* (*chüan*) 卷 (chapter) 4, reprinted in Yu Anlan 于安瀾, comp., *Hua-shih ts'ung-shu* 畫史叢書 (Compendium of Painting History), vol. 1 (Shanghai: Renmin Meishu Chubanshe, 1962) , p. 54. It says: "In the east hall at the State Affair Bureau, there was a screen, entitled *Ta-chien p'u*, which was painted by Tsung-ch'eng." (樞府東廳 有大 戭撲屏風乃宗成所畫。)

34 For a reproduction of Shen Chou's short handscroll in the Kunizo Agata Collection, see Suzuki, Kei 鈴木敬 comp., *Comprehensive Illustrated Catalog of Chinese Paintings*, vol. 4 (Tokyo: University of Tokyo Press, 1982), JP 8–043, p. 218.

35 The Agata Shen Chou in Japan, which depicts orchids and hibiscus, is entitled *Ch'un-ts'ao ch'iu-hua t'u-chüan* 春草秋花 圖卷 (The Spring Grass and Autumn Blossom Handscroll). The artist executed this work for one of his in-laws in 1481, about eight years earlier than he completed the Michigan *Pine and Hibiscus*. Unfortunately, the recipient's identification is not clear, as Shen had several in-laws. This work was included in Pien Yüng-yü's 卞永譽 (1645–1712) *Shih-ku t'ang shu-hua hui-k'ao* 式古堂書畫彙考 (A Corpus of Studies on Painting and Calligraphy at Pien's Conforming-antiquity Studio), preface 1682, *chüan* 卷 (chapter) 25, painting section, facsimile reprint, vol. 4 (Taipei: Cheng-chung Press, 1958), pp. 423–24. This work also bears several collecting seals of the prominent Korean collector, An Ch'i 安歧 (1683–?), although it is not found in An's catalogue, *Mo-yüan hui-kuan* 墨緣彙觀 ("Ink-remains, Examined and Classified," catalogue of calligraphy and painting in the author's collection). This painting was in the imperial collection during the Ch'ing dynasty, as it bears Emperor Ch'ien-lung's seals and is included in *Shih-ch'ü pao-chi san pien* 石渠寶笈三編 (The Third Sequel to Precious Books in a Box at a Rocky Stream [catalogue of painting and calligraphy in the imperial collection]), *chüan* 卷 (chapter) 7, facsimile reprint (Taipei: National Palace Museum, 1969), p. 3319.

36 In 1968, the National Palace Museum in Taipei held its first international symposium on Chinese ceramics. As junior staff, I was assigned to be in charge of the foreign participants' accommodation. Among the many experts, Soame Jenyns (1904–76), the Curator of Asian Arts at the British Museum, with his dignified three-piece suits and grey felt spats on his shoes, was extraordinary. Due to his mannered indifference, he rarely conversed with anybody, and many considered him inaccessible. The morning after the symposium was over, I picked him up at the hotel and drove him to the airport. Unexpectedly, he was quite amiable and we chatted like old friends. This event greatly enhanced my impression of this old dignified scholar. Shortly before he disappeared into the checkpoint for immigration, he took my right hand, put his left hand on my shoulder, and looked into my eyes. He wore a solemn expression and announced. "Marshall, you are young and at the beginning of your work in museums. In the future, you are bound to publish on Chinese painting. When you do, make it very clear which painting is authentic and which is not." This is an experience which I have kept with me. It is my hope that if he were alive today, he would be proud of this catalogue and its contents.

## 1. Anonymous

*Southern Sung dynasty (1127–1279)*

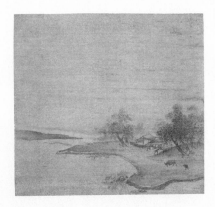

### Landscape with Returning Herder and Buffalo

*Yü-hou kuei-mu t'u*
*(Returning Herder and Buffalo after Rain)*

雨後歸牧圖

1  Li T'ang, a great master of the Sung dynasty (960–1279), was a court painter who first served in the Imperial Painting Academy under Emperor Hui-tsung (r. 1101–25) and then went to the south and continued his service in Hangchou under Hui-tsung's son, Emperor Kao-tsung 高宗 (1127–62). As he carried the northern influences to the south, Li played a vital role in the development of landscape painting during the Sung periods. Although this label attributes the Michigan album leaf, *Landscape with Returning Herder and Buffalo*, to Li T'ang, it is apparently a later work executed in the artist's style. For a discussion of Li T'ang and his representative landscape painting entitled *Wan-ho sung-feng* 萬壑松風 (Wind in the Pines amid the Ten Thousand Valleys) at the National Palace Museum, Taipei, see Wen C. Fong and James C. Y. Watt, *Possessing the Past: Treasures from the National Palace Museum, Taipei* (New York: Metropolitan Museum of Art, and Taipei: National Palace Museum, 1996), pl. 61, pp. 134–37.

2  Higashiyama (meaning "east mountain") is the studio name of the Japanese shogun, Ashikaga Yoshimasa 足利義政 (1435–90), the eighth shogun in the Ashikaga clan. He reigned from 1443 to 1474 and derived the "East Mountain" appellation from his palace located on a hill east of Kyoto. It was built around 1478 and is known today as the Ginkaku-ji 銀閣寺 (silver pavilion). Yoshimasa lived there for ten years, surrounded by talented bonzes, poets, actors, and painters. Under his patronage, painting and sculpture in Japan were greatly

promoted. Works produced during this time usually incorporated Zen references or affectations. See E. Papinot, *Historical and Geographical Dictionary of Japan* (Rutland, Vermont: Charles E. Tuttle Company, 1988), pp. 32–33. See also Morohashi Tetsuji 諸橋轍次, *Dai kanwa jiten* 大漢和詞典 (The Great Chinese-Japanese Dictionary), vol. 6 (Tokyo: Daishukan, 1976), p. 185 (or new page no. 5897), entry no. 331, s.v. "*Higashiyama jidai* 東山時代" (The East Mountain Period).

3  Shoseki 松石 (pine and rock) was the *go* (*hao* in Chinese) of Koyo 高陽 (1717–80), a well-known Japanese Nanga painter. The son of an antique dealer who specialized in Chinese art objects, Koyo learned painting in his teens and later painted landscapes in the style of the Southern Sung (1127–1279) period. For his brief biography, see Laurance P. Roberts, *A Dictionary of Japanese Artists* (Tokyo and New York: Weatherhill, 1976), p. 93.

4  See the section entitled *Yü-ti ch'ing-yu* 漁笛清幽 (Clear and Elegant Sound of the Fishermen's Flutes), found in the famous handscroll *Shan-shui shih-erh-ching* 山水十二景 (Twelve Views of a Landscape) by the well-known painter, Hsia Kuei 夏圭 (active c. 1180–1224). Hsia Kuei's *Clear and Elegant Sound of the Fishermen's Flutes* is reproduced in Ho Wai-kam 何惠鑑 et al., *Eight Dynasties of Chinese Paintings: The Collections of the Nelson Gallery-Atkins Museum, Kansas City, and the Cleveland Museum of Art* (Cleveland: Cleveland Museum of Art, 1980), fig. 58, p. 74.

5  *Tou* 斗 is a square container used as a volume measure for grain. The term *tou-fang* referred to square pictures that were approximately the size of the square mouth of this grain container. Examples of the use of small picture scrolls to decorate furniture can be found in Ku Hung-chung's 顧閎中 (active 10th century) famous handscroll *Han Hsi-tsai yeh-yen t'u* 韓熙載夜宴圖 (The Evening Feast of Han Hsi-tsai [902–970]) at the Palace Museum in Beijing. It is reproduced in Palace Museum Editorial Committee, *Zhongguo lidai huihua* (*Chung-kuo li-tai hui-hua*) 中國歷代繪畫 (Paintings of the Past Dynasties) in the series of *Gugong bowuyuan canghuaji* (*Kukung po-wu-yüan ts'ang-hua chi*) 故宮博物院藏畫集 (Paintings in the Collection of the Palace Museum), vol. 1 (Beijing: Renmin Meishu Chubanshe), pp. 86, 89, and 90.

6  During the twelfth to thirteenth centuries, the teaching of *The Ten Oxen* doctrine in *Ch'an* Buddhism became widespread and focused on the ten steps of the relationship between the wild, unruly bull and the naive herd boy. The animal represents the

undisciplined mind, while the herder personifies a seeker of enlightenment. Each step reflects the increasing gain of control over the mind. Paintings depicting the ox and herd boy during the thirteenth century and later in China and Japan were generally related to this *Ch'an* tradition. Thirteenth-century sculptures depicting this motif are found at the famous Buddhist grotto in Ta-tsu 大足, Szechwan. See Liu Changjiu 劉長久, ed., *Dazu shike yanjiu* 大足石刻研究 (Collected Works of Research on Dazu Stone Carvings) (Szechwan: Social Science Academy Press, 1985), pp. 62, 72, and 499–500. At Ta-tsu, where *The Ten Buffalo* sculpture is located, a long text by a certain Yang Cigong 楊次公 of the Northern Sung period is incised on the cliff. It is possible that all the thirteenth-century paintings and carvings using the ten-oxen (bull or buffalo) motif were based on Yang's writing. For a discussion of this subject matter in English, see Myokyo-ni (Irmgard Schloegl), *Gentling the Bull: The Ten Bull Pictures, A Spiritual Journey* (London: The Zen Center, 1988).

7  See note 2.

8  See note 3.

9  See note 3.

## 2. Anonymous
*Southern Sung dynasty (1127–1279)*

2

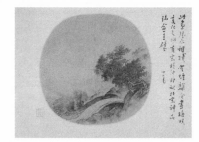

### Mountain Freshet—Wind and Rain
*Shan-hsi feng-yü*
*(Mountain Freshet, Wind and Rain)*
山溪風雨

1 Chiang Ku-sun 蔣穀蓀 (1901–73), a native of Wu-hsing 吳興 in Chekiang province, was a well-known painter and collector in Taipei during the late 60s to early 70s. He inherited major works belonging to his father, the Shanghai collector Chiang Ju-tsao 蔣汝藻 (1877–1954), also known by the name of Chiang Meng-p'ing 蔣孟蘋. For a brief biography of the father, see Editorial Committee of Zhongwai Mingren Yanjiu Zhongxin (Chung-wai Ming-jen Yen-chiu Chung-hsin) 中外名人研究中心 (Research Center of Famous Chinese and Foreigners), *Zhonghua wenhua mingrenlu* (*Chung-hua wen-hua ming-jen-lu*) 中華文化名人錄 (A Biographical Dictionary of Famous Individuals in the Cultural Circle) (Beijing: Zhongguo Qingnian Chubanshe, 1993), p. 1124. It seems that for several generations, the Chiang family collected rare books, paintings, and calligraphic works. Chiang Meng-p'ing once owned the famous *Sui-yang wu-lao t'u* 唯陽五老圖 (The Five Elders of Sui-yang) handscroll. See Ch'en Ting-shan 陳定山 (1896–1989), *Ch'un-shen chiu-wen* 春申舊聞 (Old Stories in Shanghai), vol. 1 (Taipei: Ch'en-kuang Monthly Magazine, 1964), p. 56. Two of the five figures from this scroll now belong to the Freer Gallery. Two more reside at the Yale University Art Gallery. The last one is at the Metropolitan Museum, New York. The Met also owns the original colophon. See James Cahill, ed., *An Index of Early Chinese Painters and Paintings* (Berkeley: University of California Press, 1980), p. 222. Through Chiang Meng-p'ing's associations with famous painters and collectors in Shanghai, the family also managed to accumulate an even more extensive collection of Chinese paintings by contemporary artists. Chiang's second son, P. S. Chiang, who migrated to Seattle, Washington, after World War II, also inherited a portion of the collection. The University of Michigan

Museum of Art owns a number of works from the two sons' collections. For more information on this family, see note 4 in entry 19 on Tseng Ching.

2 Sung Chung-mu was the *tzu* of Sung Lo 宋犖 (1634–1713), a high official under Emperor K'ang-hsi 康熙 (r. 1662–1723) of the Ch'ing Dynasty (1644–1911). Sung was a well-known connoisseur and collector of Chinese painting. For Sung Lo's brief biography, see Arthur W. Hummel, ed., *Eminent Chinese of the Ch'ing Period (1644–1912)*, vol. 2 (Washington, D. C.: United States Government Printing Office, 1943–44), pp. 689–90.

3 P'u Ju 溥儒 (1896–1963) was a leading twentieth-century painter and calligrapher who was a member of the Manchu imperial family. For more information on his life and work, see entry 59. Pu's attribution of this album leaf to the Northern Sung, as opposed to the Southern Sung, is not an oversight. There is a tradition in Chinese connoisseurship of using "Northern Sung dynasty" as an adjective to indicate the finest quality, rather than the actual date of the object's creation.

4 Hsin-yü 心畬, meaning "a mind which is like a newly cultivated barren field" was the *tzu* of P'u Ju.

5 Since this album leaf bears the collecting seal of Sung Lo, one can assume that it was part of his collection. Sung was known for his expertise in Chinese painting. Many works that belonged to him later entered the imperial collection of the Manchu court. Some are extant and can be viewed at the National Palace Museum, Taipei, home of the imperial collection. In general, paintings bearing his seals are of the finest quality, and it is likely this fan painting originally belonged to a set of album leaves grouped together by Sung Lo.

6 There are numerous fan paintings of the Southern Sung period extant today. In ancient China, these fans were referred to as *wan-shan* 紈扇 (round fan), and were usually made of fine silk. Most were originally decorated with paintings of superb quality. Some even bore the calligraphy of an emperor. This seems to suggest that they were produced by court painters for court use. The custom of using such decorated fans in the palace possibly began around the early twelfth century under the reign of Emperor Hui-tsung. For a painting depicting this type of fan, see *Court Ladies Preparing Newly Woven Silk*, attributed to Emperor Hui-tsung and reproduced in *Selected Masterpieces of Asian Art: Museum of Fine Arts, Boston* (Boston: Museum of Fine Arts, 1992), no. 136, p. 150. In this famous handscroll, one of the

maids by a hearth is waving a round fan. Although many of these fan paintings today do not bear a signature, the style and brushwork reveal their illustrious artistic sources. As a matter of fact, many fans were originally signed near the edge, and the signatures were cropped during subsequent remountings.

7 Painters who first served at Emperor Hui-tsung's academy in the north, then later joined his son's academy in the south include: Li T'ang 李唐 (c. 1070s–1150s), Li Ti 李迪 (active c. 1113–after 1197), Li An-chung 李安忠 (active c. 1110–50), Su Han-ch'en 蘇漢臣 (active c. 1120–60), and Yang Shih-hsien 楊世賢 (active c. 1120–50). These court painters are recorded in Xia Wenyan (Hsia Wen-yen) 夏文彥 (active mid-14th century), ed., *Tuhui baojian* (*T'u-hui pao-chien*) 圖繪寶鑑 (Precious Mirror of Painting), preface dated 1365, *juan* (*chüan*) 卷 (chapter) 4, reprinted in Yu Anlan 于安瀾, comp., *Huashi congshu* (*Hua-shih ts'ung-shu*) 畫史叢書 (Compendium of Painting History), vol. 3 (Shanghai: Renmin Meishu Chubanshe, 1962), p. 101.

8 The historical record of the Southern Sung period indicates that the imperial palace was set on hillside terraces. The exact location may still be identified today in the southern suburbs of Hangchou. The site is nestled between the Feng-huang 鳳凰 (Phoenix) Mountain on the west and the present day Zhongshan 中山 South Road on the east. See Wang Shilun 王士倫, "NanSong gugong yizhi kao" (Nan-Sung ku-kung i-chih k'ao) 南宋故宮遺址考 (An Investigation of the Site of Southern Sung Palaces) in Zhou Xun 周勛, ed., *NanSong Jingcheng Hangzhou* (Nan-Sung ching-ch'eng Hang-chou) 南宋京城杭州 (Hangchou: The Capital of Southern Sung) (Hangzhou: Zhengxie Hangzhoushi Weiyuanhui Bangongshi, 1985), pp. 16–35. This may explain the popularity of palaces in a mountain setting featured in Southern Sung paintings. For an example, see *The Han Palace* by an anonymous painter (formerly attributed to Chao Po-ch'ü 趙伯駒 [c. 1120–c. 1162]), reproduced in Wen C. Fong and James C. Y. Watt, *Possessing the Past: Treasures from the National Palace Museum, Taipei* (New York: Metropolitan Museum of Art, and Taipei: National Palace Museum, 1996), pl. 83, p. 179.

9 An example with similar subject matter to the Michigan album leaf is attributed to Li Ti. Entitled *Birds in a Tree above a Cataract*, it belongs to the Cleveland Museum of Art (formerly in the Perry Collection). Whereas the anonymous painter of the Michigan work executed precise lines to depict the action of water on

rocks, Li Ti used washes and blank space, with an occasional line to bring the waves into clear focus. See Wai-kam Ho 何惠鑑 et al., eds., *Eight Dynasties of Chinese Paintings: The Collections of the Nelson Gallery-Atkins Museum, Kansas City, and the Cleveland Museum of Art* (Cleveland: Cleveland Museum of Art, 1980), pl. 34, p. 52. Another round fan album leaf at the Osaka Municipal Museum depicts the same type of freshet, with two deer standing on a rock facing the surging water. Such an arrangement sharply diverts the viewer's attention from the water to the animals. See Suzuki Kei 鈴木敬, comp., *Comprehensive Illustrated Catalog of Chinese Paintings*, vol. 3 (Tokyo: University of Tokyo Press, 1982), no. JM3-200-7, p. 169. A later round fan depicting a similar scene in the Museum of Fine Art, Boston, is published in Germaine L. Fuller, *Eight Hundred Years of Chinese Painting and Calligraphy: Album Leaves from the Collection of the Museum of Fine Arts, Boston* (Waterville, Maine: Colby College Museum of Art, 1979), no. 19, p. 65.

10   The seventeenth-century painting connoisseur Wu Ch'i-chen 吳其貞 (active 1635–77) more than once used this term in his *Shu-hua-chi* 書畫記 (A Record of Paintings and Calligraphy), facsimile reprint of a seventeenth-century copy (Taipei: Wen-shih-che Press, 1971). For example, on page 2 of Wu's book, he lists: "Hsü Hsi 'Fen-hung lien-hua t'u' chüan-hua ching-mien i-chang." 徐熙粉紅蓮花圖絹畫鏡面一張 (The Silk Painting "Pink Lotus Blossom" by Hsü Hsi [d. before 975] on a Silk Mirror Cover). On page 43 he lists: "Liu Tsai 'Yu-yü t'u' chüan-hua ching-mien i-chang" 劉寀游魚圖絹畫鏡面一張 (Liu Tsai's [active c. 1068–85] "Swimming Fish" on a Silk Mirror Cover).

11   P'u Ju's copy of the Michigan work is reproduced in *P'u Hsin-yü shu-hua wen-wu t'u-lu* 溥心畬書畫文物圖錄 (A Catalogue of P'u Ju's Paintings and Related Materials) (Taipei: National Palace Museum, 1993), pl. 22, p. 327. The date 1963 is found on only one of the twenty-three album leaves in P'u Ju's set of copies. As 1963 was the year he passed away, it is unlikely that he completed all twenty-three in that year. More likely, P'u Ju completed the others throughout his later years and saved them as a personal reference. Since twenty-three is an uneven number, he probably intended to execute more in order to complete the set. In P'u Ju's set, there is another leaf that was modeled after an old album leaf by an anonymous painter, entitled *The Bore in Hangchou*, reproduced in the same book, pl. 4, p. 324. The old album leaf was also purchased by Professor Edwards at the same time he purchased the Michigan leaf. Since both leaves bear colophons by P'u Ju and were copied by him, the two presumably belonged to the same set. Edwards's leaf is reproduced in *Comprehensive Illustrated Catalog of Chinese Paintings*, vol. 1 (Tokyo: University of Tokyo Press, 1982), no. A6-007, p. 47. Unfortunately, there is little available information as to the sources of the other old album leaves that P'u Ju copied for his set.

12   See entry 26 on Sun I for more information on *The Cinnabar Peak*.

## 3. Anonymous
*(Formerly attributed to Chao Po-chü 趙伯駒, active second half of 12th century)*
*Ming dynasty (1368–1644)*

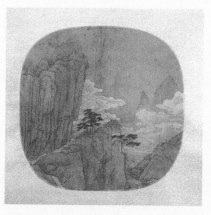

## Blue Mountains and White Clouds
*Ch'ing-shan pai-yün*
*(Blue Mountains and White Clouds)*
青山白雲

1   Weng Lo (1790–1849) was a well-known and accomplished flower-and-bird painter in Suchou. He was famous for his depictions of turtles.

2   This tiny signature of Chao Po-chü on the Michigan fan album leaf is evidently interpolated. The calligraphic quality of this signature is quite poor; the brushstrokes are weak and exhibit signs of hesitation. Chao Po-chü (Chao is the family name and Po-chü the given name, meaning "a distinguished colt") was a famous painter in the green and blue tradition, active during the early Southern Sung dynasty (1127–1279). Different sources assign widely varying dates to this seventh-generation descendant of the first emperor of the Sung dynasty. In the past, publications of the National Palace Museum in Taipei stated that Chao's dates were 1120–82 and that he was the son of Chao Ling-jang 趙令穰 (active 1070–1100), although no specific sources are provided as the basis for this information. Chao Ling-jang, the famous landscape painter of the Northern Sung, was known particularly for illustrating misty village scenes. See National Palace Museum, *Descriptive and Illustrated Catalogue of the Paintings in the National Palace Museum* (Taipei: National Palace Museum, 1968) no. 21, p. 9. If these dates are correct, Chao Po-chü would have been six years old when he went to the south after the Tartars sacked the Northern Sung capital in 1124. This Palace Museum dating of Chao's life conflicts with assertions by Laurence C. Sickman and Alexander C. Soper, *The Art and Architecture of China* (Baltimore: Penguin Books, 1971), p. 246. They state that Chao Po-chü and Chiang Ts'an 江參 (active first half of 11th century) both worked in the Imperial Art

Anonymous
**Blue Mountains and White Clouds**
*continued*

4  Academy under Emperor Hui-tsung 徽宗 (r. 1101–25) during the end of the Northern Sung dynasty. Thus, Chao would have been much older when he went to the south in 1126. Unfortunately, no records can be found to verify these dates. A more reliable source indicates that around 1126 or later, Chao Po-chü went to the south from the Northern Sung capital, Kai-feng 開封 and joined the government-in-exile in Hangchou. It states he could paint both landscapes and flowers and that he was especially known for his screen paintings. This source also indicates that Emperor Kao-tsung 高宗 (1107–87; r. 1127–63), the first emperor of the Southern Sung dynasty, greatly favored his work and once commissioned him to paint the screens inside of the Chi-ying 集英 (gathering the talented) Palace. See Deng Chun (Teng Ch'un) 鄧椿 (active 12th century), *Huaji* (*Hua-chi*) 畫繼 (Treatise on Painters and Paintings of the Period between 1070–1160), preface dated 1167, *juan* (*chüan*) 卷 (chapter) 2, reprinted in Yu Anlan 于安瀾, comp., *Huashi congshu* (*Hua-shih tsung-shu*) 畫史叢書 (Compendium of Painting History), vol. 3 (Shanghai: Renmin Meishu Chubanshe, 1962), p. 8. A more reasonable supposition would be to use the dates of Chao Po-chü's younger brother, Chao Po-su 趙伯驌 (1124–82) who was also a famous painter, to determine the artist's age. See Yu Jianhua 于劍華 et al., *Zhongguo meishujia renming cidian* (*Chung-kuo mei-shu-chia jen-ming tz'u-tien*) 中國美術家人名詞典 (A Biographical Dictionary of Chinese Artists) (Shanghai: Renmin Meishu Chubanshe, 1981), p. 1276, s.v. "Chao Po-su 趙伯驌." If his younger brother was born in 1124, Chao Po-chü was probably born one to ten years earlier. Thus, it would be safe to say that he flourished during the mid-1150s when, in his thirties to early forties, he served as *Che-tung-lu ch'ien-hsia* 浙東路鈐轄, or "The Seal Controller of the Infantry and Cavalry of the Eastern Region of Chekiang," the highest position he ever held. Chao Po-chü's given name may also divulge some information on this issue. For Chinese families, it is customary to follow a fixed pattern when naming descendants. Usually the names of each generation are preselected by an ancestor. Children of the same generation may either share one similar character in their given names or all use characters bearing the same radical. Examining the history of the Sung imperial family, one finds that after the death of the first emperor, T'ai-tsu 太祖 (r. 960–975), his eldest prince did not inherit the throne. It was the emperor's younger brother, T'ai-tsung 太宗 (r. 976–997), who became the

second Sung emperor. While T'ai-tsu's descendants all had given names with two characters, T'ai-tsung's offspring all had single names. For example, in the fourth generation, Emperor Che-tsung's 哲宗 (r. 1086–1100) name was Hsü 煦 and his successor Hui-tsung's name was Chi 佶. Hui-tsung's son, Kao-tsung, was named Kou 構. On the other hand, painter Chao Ling-jang, who had names with two characters, belonged to the sixth generation of T'ai-tsu, the first Sung emperor. So did the two Chao brothers, Po-chü and Po-su, who were of the seventh generation of this lineage. It is quite likely that these two brothers were Chao Ling-jang's nephews. Kao-tsung, the first Southern Sung emperor and the sixth generation of the second Sung emperor, had no son. In 1132, he adopted a nephew, a boy from the seventh generation of the first Sung emperor, as his heir apparent. The young lads of this generation were all supposed to have the middle name of "Po," as in the brothers Po-chü and Po-su. Most of these imperial boys were born between 1120 and 1130. According to a contemporary of Chao Po-su, in 1132 Emperor Kao-tsung ordered a member of the imperial family, Chao Ling-chih 趙令時 (1051–after 1132), who was a cousin of the painter Chao Ling-jang, to find an heir. Ling-chih selected ten boys, seven years or younger, from the "po" generation. From this group of ten, two were chosen, one chubby, the other lean. The emperor preferred the plump one and was to send the svelte one away. Just before the boy departed, the emperor told the two boys to stand side by side and took one last, more careful look. At that time, a cat happened to pass in front of them. The fat child abruptly kicked the animal, and his reckless, cruel behavior shaped his destiny. The emperor changed his mind and chose the skinny one, who became the next Southern Sung emperor, Hsiao-tsung 孝宗 (1127–94). The chubby boy grew up to be a minor provincial administrator and died in this position. It is unclear whether Chao Po-chü and his brother Chao Po-su were among the ten. This episode is found in Wang Mingqing's (Wang Ming-ch'ing) 王明清 (1127–after 1197), *Houlu yuhua* (*Hou-lu yü-hua*) 後錄餘話 (A Second Record and Additional Words), preface dated 1194, *juan* (*chüan*) 卷 (chapter) 1, found in Wang's *Huichenlu* (*Hui-ch'en-lu*) 揮塵錄 (A Record of the Author's Notes While Gesturing with a Fly-whisk), preface dated 1166, reprint (Shanghai: Zhonghua Bookstore, 1964), pp. 270–71. From this story, it seems that the approximate dates of Chao Po-chü, who was the same generation as the ten candidates, can be established. Chao was most

likely born shortly before the fall of the Northern Sung dynasty and grew up during Emperor Kao-tsung's reign in the second half of the twelfth century, at the time when Kao-tsung finally settled in Hang-chou and started his imperial painting academy. It was also during this time that the decorated round silk fan became a prominent format in Chinese painting.

3  This collecting seal belonged to the imperial painting and calligraphy collection of the Southern Sung dynasty (1127–1279). An authentic example of this seal is published in Joint Board of Directors of the National Palace Museum and National Central Museum, comps., *Signatures and Seals on Painting and Calligraphy: The Signatures and Seals of Artists, Connoisseurs, and Collectors on Painting and Calligraphy since the Tsin Dynasty*, vol. 1 (Kowloon: Cafa Co., 1964), p. 107. However, when the seal on the Michigan painting is compared to the one in the book, although the legends are same, the carvings of the two do not match. Thus, the seal on the Michigan painting is apparently a fake.

4  *Yün-chen chai*, or "The Collecting Truth Studio," was the name of K'o Chiu-ssu's 柯九思 (1290–1343) studio during the Yüan dynasty (1280–1368). K'o Chiu-ssu was a famous bamboo painter and a connoisseur who served at the Yüan court and was in charge of the imperial collection. An authentic example of this seal is also published in *Signatures and Seals on Painting and Calligraphy*, vol. 1, p. 238. For a brief biography of K'o Chiu-ssu, see "Painters of the Yüan Dynasty," in Osvald Sirén, *Chinese Painting: Leading Masters and Principles*, vol. 6 (New York and London: Ronald Press, 1956), p. 118. None of K'o Chiu-ssu's seals on the Michigan painting are authentic.

5  This is also supposed to be K'o Chiu-ssu's collecting seal. A genuine example is reproduced in *Signatures and Seals on Painting and Calligraphy*, vol. 1, p. 650.

6  Ch'en Ting (active 17th century) was a connoisseur-collector and major art dealer. An example of this seal is reproduced in *Signatures and Seals on Painting and Calligraphy*, vol. 3, p. 172. The one found on the Michigan fan is, unfortunately, not genuine. According to Wang Shih-min 王時敏 (1592–1680), a well-known painter and collector, Ch'en Ting, acted as an agent for several powerful collectors, including Keng Chao-chung 耿昭忠 (1640–86), who was the imperial son-in-law in Peking, and Chi Chen-i 季振宜 (1630–?), whose *tzu* was Ts'ang-wei 滄葦, in the Yangtze River region. See Victoria Contag and Wang Chi-

ch'ien, *Seals of Chinese Painters and Collectors of the Ming and Ch'ing Periods* (Taipei: Shang-wu Press, 1965), p. 603, s.v. "Ch'en Ting." See also Chiang Ch'un 江春, "Wang Shih-min yü Wang Hui teh kuan-hsi" 王時敏與王翬的關系 (The Relationship between Wang Shih-min and Wang Hui) in *I-lin ts'ung-lu* 藝林叢錄 (A Series of Articles on the Arts), vol. 2 (Hong Kong: Shang-wu Press, 1961), p. 312. Records suggest that Ch'en Ting was a greedy, cruel, and evil antique dealer. One story claims that at the end of the Ming dynasty, around 1645, Ma Shih-ying 馬士英 (1591–1647), a notorious official then serving at the Ming court in Nanking, borrowed money from Ch'en Ting by pawning a famous Chü-jan 巨然 (mid-11th–mid-12th century) painting, entitled *Hsiao I chuan Lan-t'ing* 蕭翼賺蘭亭 (Hsiao I Extorting Wang Hsi-chih's Calligraphic Work *Lan-t'ing Prose*). When Ma later redeemed this painting, Ch'en Ting, knowing that he could not keep the work for himself, abraded the facial features of the figures in the painting before returning it to Ma. The story is recorded in Ku Fu 顧復 (active second half of 17th century), *P'ing-sheng chung-kuan* 平生壯觀 (The Great Paintings and Calligraphic Works Viewed in Ku Fu's Life), preface dated 1692, reprint, vol. 2, *chuan* 卷 7 (Taipei: Han-hua Wen-hua Shi-yeh Co., 1971), pp. 16–17. Today, this particular painting by Chü-jan belongs to the National Palace Museum, Taipei. It is reproduced in *Ku-kung shu-hua t'u-lu* 故宮書畫圖錄 (An Illustrated Catalogue of Calligraphy and Painting at the Palace Museum), vol. 1 (Taipei: National Palace Museum, 1993), p. 103. This story could be true since Ch'en Ting's collecting seal is found on this work.

7   This seal belongs to an American collector, C. D. Carter, who donated this album leaf to the University of Michigan Museum of Art in 1970, along with seven other paintings. It is rather unusual for a Westerner to stamp his seal on a Chinese scroll. Nevertheless, in comparison to Chinese collectors, Mr. Carter was humble and modest. He stamped his seal on the protective flap exterior to the scroll instead of on the painting surface itself as was the custom of Chinese collectors.

8   Although the seal is rather blurred, it could have belonged to Shen Feng 沈鳳 (1685–1755), who was a literati-painter of the mid-Ch'ing period. See Shanghai Museum, *Zhongguo shuhuajia yinjian kuanshi* (*Chung-kuo shu-hua-chia yin-chien k'uan-shih*) 中國書畫家印鑒款識 (Signatures and Seals of Chinese Painters and Calligraphers), vol. 1 (Shanghai: Wenwu Chubanshe, 1987), no. 93, p. 534.

9   Since the Shang dynasty, mountains were worshipped as deities, and ritual bronze vessels were buried at the foot of mountains as sacrificial offerings. For information of this practice, see Virginia C. Kane, "The Independent Bronze Industries in the South of China Contemporary with the Shang and Western Chou Dynasties," in *Archives of Asian Art*, no. 28 (New York: Asia Society, 1974–75), pp. 77–107. Emperors of the succeeding dynasties also sanctified mountains and often buried jade tablets with incised eulogies at mountains. For examples of these jade tablets, see the bound jade tablets, dated 725, for the mountain sacrifices of T'ang Emperor Hsüan-tsung 玄宗 (r. 712–756) now at the National Palace Museum, Taipei. The tablets are reproduced in Wen C. Fong and James C. Y. Watt, *Possessing the Past: Treasures from the National Palace Museum, Taipei* (New York: Metropolitan Museum of Art, and Taipei: National Palace Museum, 1996), pl. 52, p. 102. See also the discussion of this ceremony in the same source, pp. 99–105. Still another source is found in "Mountain Worship in Early China," in Kiyohiko Munakata's *Sacred Mountains in Chinese Art* (Urbana-Champaign: University of Illinois, 1991), pp. 3–12.

10  The five sacred mountains in China are: 1) *The Sacred East*, Mount T'ai 泰山 in Shantung province; 2) *The Sacred West*, Mount Hua 華山 in Shensi province; 3) *The Sacred North*, Mount Heng 恒山 in Shansi province; 4) *The Sacred South*, Mount Heng 衡山 in Hunan province; and 5) *The Sacred Middle*, Mount Sung 嵩山 in Honan. See *Tz'u-hai* 辭海 (Sea of Terminology: Chinese Language Dictionary), vol. 1 (Taipei: Chung-hua Press, 1974), p. 148 , s.v. "*Wu-yüeh* 五嶽." For a discussion of the sacred mountains in China, see "The Geography and Topography of the Sacred Mountains," in *Sacred Mountains in Chinese Art*, pp. 51–61.

11  For more information on the relationship between mountains and immortals, see "Mountains and Daoist Images of the Immortals' Realm," in *Sacred Mountains in Chinese Art*, pp. 111–61.

12  For more information on the use of mountains in Chinese painting, see "Sacred Mountains in Early Chinese Art," in *Sacred Mountains in Chinese Art*, pp. 1–48.

13  The term "greeting-guest pine," is derived from one of the "ten famous pine trees" of Mount Huang 黃山 over the entrance of the Wen-shu 文殊 (Manjusri Bodhisattva) cave. Located on the south face of the mountain, the tree is said to be more than a thousand years old. Growing on the

rocky cliff, its dense needles and drooping branches above the cave are akin to the extended hand of a welcoming host. See *Hanyu dacidian* 漢語大詞典 (Chinese Terminology Dictionary), vol. 10 (Shanghai: Hanyu Dacidian Press, 1988), p. 747, s.v. "*yingkesong* (*ying-k'o sung*) 迎客松."

14  For paintings executed in the blue-green style of the T'ang dynasty, see *Chiang-fan lou-ko* 江帆樓閣 (Riverside Pavilions), attributed to Li Ssu-hsün 李思訓 (651–716), at the National Palace Museum, Taipei. It is reproduced in *Ku-kung shu-hua t'u-lu* 故宮書畫圖錄 (An Illustrated Catalogue of Calligraphy and Painting at the Palace Museum), vol. 1, p. 9. See also *Ming-huang hsing-Shu t'u* 明皇幸蜀圖 (Emperor Ming-huang's [r. 712–755] Journey to Shu [Szechwan]) by an anonymous painter of the T'ang dynasty, reproduced in ibid., pp. 39–40. Murals of the T'ang dynasty, with heavy red, green, and blues, can be witnessed in the many wall paintings excavated from tombs of that period. See Zhang Hongxiu 張鴻修, ed., *Tangmu bihua jijin* (*T'ang-mu pi-hua chi-chin*) 唐墓壁畫集錦 (Highlights of the T'ang Dynasty Tomb Frescoes) (Xian: Shaanxi Renmin Meishu Chubanshe, 1991).

15  For examples of the blue-green style paintings of the Sung period, see the long handscroll, *Qianli jiangshan tujuan* (*Ch'ien-li chiang-shan t'u-chüan*) 千里江山圖卷 (The Thousand Mile River and Mountain Handscroll) by Wang Ximeng (Wang Hsi-meng) 王希孟 (active 12th century), reproduced in Palace Museum Editorial Committee, *Gugong bowuyuan canghuaji (Ku-kung po-wu-yüan ts'ang-hua chi)* 故宮博物院藏畫集 (Paintings in the Collection of the Palace Museum) in the series *Zhongguo lidai hui-hua (Chung-kuo li-tai hui-hua)* 中國歷代繪畫 (Paintings of the Past Dynasties), vol. 2 (Beijing: Renmin Meishu Chubanshe), pp. 94–130. See also *Jiangshan qiuse (Jiang-shan ch'iu-se)* 江山秋色 (The Autumn Colors on the River and Mountain), attributed to Chao Boju (Chao Po-chü), reproduced in Gugong Bowuyuan Zijincheng Chubanshe, ed., *Gugong bowuyuan cangbaolu (Ku-kung po-wu-yüan ts'ang-pao-lu)* 故宮博物院藏寶錄 (A Catalog of the Treasures at the Palace Museum) (Shanghai: Wenyi Chubanshe, 1986), p. 33 and entry for this work on pp. 129–30. Both of these two handscrolls belong to the Palace Museum, Beijing.

16  For examples of paintings in the blue-green style of the Yüan dynasty, see Chao Meng-fu's *Yu-yü ch'iu-ho* 幼輿丘壑 (The Mind Landscape of Hsieh Yu-yü), reproduced in Wen C. Fong et al., *Images of the Mind: Selections from the Edward L. Elliott Family and John B. Elliott Collections of Chi-*

Anonymous
**Blue Mountains and White Clouds**
*continued*

6   nese Calligraphy and Painting at the Art
    Museum, Princeton University (Princeton:
    Art Museum, Princeton University, 1984),
    no. 6, pp. 280–83. For examples of paint-
    ings in the blue-green style of the Ming
    dynasty, see Shih Jui's 石銳 (c. 1426–70)
    *Landscape with Buildings and Figures*, at
    the Kyoto National Museum. This work is
    reproduced in James Cahill's *Parting at the
    Shore: Chinese Painting of the Early and
    Middle Ming Dynasty, 1368–1580* (New
    York and Tokyo: Weatherhill, 1978), color
    pl. 1 on p. 9 and discussion of this work on
    pp. 26–27. See also Shen Chou's 沈周
    (1427–1509) *Lin Tai Wen-chin Hsieh An
    Tung-shan t'u* 臨戴文進謝安東山圖 (A Copy
    of Tai Chin's [1388–1462] Hsieh An
    [320–385] at East Mountain), dated 1480,
    belonging to Mr. and Mrs. Wan-go H. C.
    Weng, reproduced in Richard M. Barnhart,
    *Painters of the Great Ming: The Imperial
    Court and the Zhe School* (Dallas: Dallas
    Museum of Art, 1993), cat. no. 8. Both
    works are in the blue-green style and
    depict imaginary mystic mountain
    retreats.

17  While one layer of wash with strong color
    might produce the necessary shade of
    color, the use of a single thick and opaque
    wash would not be very subtle. Thus in
    order to achieve the desired color more
    elegantly, one would size the surface and
    use many applications of light, colorful
    washes.

18  The scientific names and definitions for
    the minerals used in Chinese paintings
    include: 1) lapis lazuli: a semiprecious
    stone usually of a rich azure blue color
    that is essentially a lazurite but contains
    hauynite, sodalite, and other minerals;
    occuring usually in small rounded masses
    frequently showing spangles of iron
    pirites; probably the sapphire of the
    ancients; 2) lazurite: mineral, $(Na,Ca)_8$
    $(Al,Si)_{12}O_{24}(S,SO_4)$, occurring as the chief
    constituent of lapis lazuli, isomorphous
    with sodalite, and composed of a sodium
    silicate containing sulfur; 3) azurite: min-
    eral, $Cu_3(OH)_2(CO_3)_2$, consisting of blue
    basic carbonate of copper occurs in mono-
    clinic crystals; 4) malachite: mineral,
    $Cu_2CO_3(OH)_2$, consisting of a green basic
    carbonate of copper and used to make
    ornamental objects; pigment made of
    ground malachite; malachite green: a
    triphenylmethane basic dye prepared from
    benzaldehyde and dimethylaniline and
    used chiefly in making organic pigments;
    5) ochre: earthy, usually red or yellow, and
    often impure iron ore that is extensively
    used as a pigment; 6) cinnabar: mineral,
    HgS, consisting of mercuric sulfide, occurs
    in brilliant red crystals or in red or brown-
    ish masses and is the only important ore
    of mercury.

19  Examining Chinese paintings carefully,
    one finds that before Tung Ch'i-ch'ang's
    period, mineral pigments were used not
    only for decorating blue-and-green paint-
    ings but also for landscapes with only light
    color washes. The two major colors were
    red and blue—thus the term, *tan-ch'ing* 丹
    青 (red and blue), which became the gen-
    eral term for "painting." Traditionally, the
    red color could be either ochre or cinnabar,
    while the blue was lapis lazuli, azurite, or
    malachite. It seems that applying veg-
    etable dyes on landscapes became popular
    during the late seventeenth century and
    was especially popular among the Four
    Wangs. Although the reason for this shift
    is unclear, it is an undeniable fact. Possi-
    bly, Tung and his followers thought the
    mineral pigments were too decorative,
    suitable only for professional artisans.

20  The pigment *hua-ch'ing* is derived from
    the plant called indigo, a popular blue
    color used in many cultures. *T'eng-huang*
    is made from a complex practice using rat-
    tan. The rattan is chopped up and boiled in
    water. The resultant liquid is siphoned
    into bamboo tubes and left to evaporate.
    The bamboo is then split open and the yel-
    low deposits, which are quite poisonous,
    collected for use as yellow pigment.

21  See note 2.

22  In Osvald Sirén's *Chinese Painting: Lead-
    ing Masters and Principles*, vol. 2 (New
    York and London: Ronald Press, 1956), p.
    42, twenty-one paintings are listed as Chao
    Po-chü's work. Yet none of these paintings
    has been satisfactorily proven to be
    authentic.

23  One other possibility is that a knowledge-
    able collector discerned the implausibility
    of the signature and attempted to remove it.

24  See note 3.

25  The legend of Ch'en Ting's seal on the
    Michigan fan does not comply with that
    published in any of the seal books.

26  For more on Chao Meng-fu's paintings in
    the blue-green style, see the entry for *River
    Village—Fisherman's Joy* in Wai-kam Ho
    何惠鑑 et al., *Eight Dynasties of Chinese
    Paintings: The Collections of the Nelson
    Gallery-Atkins Museum, Kansas City, and
    the Cleveland Museum of Art* (Cleveland:
    Cleveland Museum of Art, 1980), cat. no.
    80, pp. 90–91. See also Richard Vinograd,
    "Some Landscapes Related to the Blue and
    Green Manner from the Early Yüan
    Period," *Artibus Asiae* 41 (New York:
    Columbia University, 1979 ), pp. 2–3, and
    his "River Village—The Pleasures of Fish-
    ing and Chao Meng-fu's Li-Kuo Style Land-
    scapes," *Artibus Asiae* 40 (1978): 2–3.
    Another article dealing with Chao Meng-

fu's blue-and-green style is Sherman Lee's
"River Village—Fisherman's Joy," *Bulletin
of the Cleveland Museum of Art* 41
(Cleveland: Cleveland Museum of Art,
October 1979), pp. 271–88.

## 4. Shen Chou 沈周
*(1427–1509)*
*Ming dynasty (1368–1644)*

### Pine and Hibiscus
*Sung-hsia fu-jung*
*(Hibiscus under Pine Tree)*
松下芙蓉

1 This label, which was inscribed by Weng T'ung-ho 翁同龢 (1830–1904), indicates that Weng was the owner of this scroll during the late nineteenth century. Weng's brief biography can be found in Arthur W. Hummel, ed., *Eminent Chinese of the Ch'ing Period (1644–1912)*, vol. 2 (Washington, D.C.: United States Government Printing Office, 1943–44), pp. 860–61. From Ch'ang-shu 常熟, in Kiangsu 江蘇 province, he was the youngest son of a prominent and educated landlord. A famous scholar, Weng was chosen to tutor Emperor Kuang-hsü 光緒 (r. 1875–1908) and held other high government posts. He was a well-known calligrapher and collector who accumulated a large painting and calligraphy collection, part of which was inherited by his grandson, Wan-go H. C. Weng 翁萬戈. On the eve of the Communist takeover in 1949, Wan-go shipped his inherited painting collection to the United States. Many paintings in American museums today come from his collection. The University of Michigan Museum of Art acquired two works from him. In addition to Shen Chou's painting, the Museum bought a handscroll by Wang Hui 王翬 (1632–1717) (entry 30). A portion of Wan-go's collection is listed in Suzuki Kei, comp., *Comprehensive Illustrated Catalog of Chinese Paintings*, vol. 1 (Tokyo: University of Tokyo Press, 1982), pp. 63–89. Currently retired, Wan-go H. C. Weng is a well-known photographer and scholar who served as the Director of the China Institute in New York for many years.

2 This label, inscribed by Chang Jo-ai in the eighteenth century, was perhaps the label on the scroll during the eighteenth and nineteenth centuries. The present label on the protective brocade flap was added later, when the scroll was remounted sometime at the end of the nineteenth century, possibly by its owner Weng T'ung-ho. Since Chang was a respected scholar-calligrapher, Weng mounted Chang's label at the beginning of the painting in order to preserve the calligraphic work, as it lends additional value and clarifies the provenance.

3 Chang Jo-ai 張若靄 (1713–46) was a scholar-official from a distinguished family. He was also known as a calligrapher and painter at the court. For more information on Chang Jo-ai, see *Eminent Chinese of the Ch'ing Period (1644–1912)*, vol. 1, pp. 54–56, under the entry for his father, Chang T'ing-yü 張廷玉 (1672–1755).

4 Among these four dates, the first date is found at the end of T'ang Hsia-min's colophon. T'ang was the original owner of this scroll.

5 The second date is given by the artist, the master of the Wu school of Suchou. It is inscribed at the end of the painting section.

6 The third date, inscribed at the end of Yao Shou's colophon, indicates that T'ang regularly solicited well-known poets to contribute poems for more than ten years.

7 The last date, found at the end of Weng T'ung-ho's colophon, testifies the year in which Weng purchased this work in Peking during the end of nineteenth century.

8 Ch'ang-chou 長州 was Shen Chou's hometown, located northeast of Suchou. It is a district in Wu-hsien 吳縣, or "Wu County."

9 Wo-an 臥庵 is the *hao* of Chu Chih-ch'ih 朱之赤 (active mid-17th century), a well-known collector during the late Ming and early Ch'ing periods. A portion of his collection is recorded in his *Chu Wo-an ts'ang shu-hua mu* 朱臥庵藏書畫目 (A Catalogue of Painting and Calligraphy in Chu Chih-ch'ih's Collection) and is reprinted in Teng Shih 鄧實 (1865?–1948?) and Huang Pin-hung 黃賓虹 (1865–1955), comps., *Mei-shu ts'ung-shu* 美術叢書 (Anthology of Writings on Fine Art) (Shanghai: n.p., 1912–36), *chi* 集 (part) 2, *chi* 輯 (division) 6, reprint, vol. 8 (Taipei: I-wen Press, 1962), pp. 65–126. In Chu's catalogue (p. 65), a painting by Shen Chou entitled "Hibiscus" is listed. As no further information is recorded about the painting, it is unclear whether this is the painting in the Michigan collection. The seal, "*Ch'ien-chiu-li jen* 千秋里人," which is positioned on the Michigan painting directly above Chu Chih-ch'ih's collecting seal, could also belong to him, although it is not commonly found on other paintings in his collection.

10 Yün-chen ko 緼真閣 (the Collecting Truth Studio) is the name of Chang Jo-ai's studio.

11 T'ang Hsia-min 湯夏民 was a scholar of the mid-Ming dynasty who attempted to pursue an official career by passing the civil service examinations. Failing the exam, however, he remained obscure all his life. From what is known about the several people who contributed to this scroll, we may surmise that he was active during the second half of the fifteenth century.

12 This Chinese sentence was incorrectly inscribed "暇則兒令輩 . . ." It should read "暇則令兒輩 . . . " or "In my leisure time, I let my sons and nephews . . . ."

13 Liu Hou 留侯, or Duke Liu, in this verse refers to Chang Liang 張良 (?–189) of the Han dynasty (206 B.C.–A.D. 220). Chang helped Emperor Liu Pang 劉邦 (r. 206–194 B.C.) to unify the country and found the Han dynasty. He was promoted to duke of the Liu state. Sensing the emperor's distrust, Chang Liang resigned and became a recluse. He claimed that he would rather give up all the fame and possessions of this mundane world in order to roam with the immortal Ch'ih-sung Tzu 赤松子. "Liu Hou" has thus become a term in Chinese literature associated with the idea of a meritorious statesman. Chang Liang's story is recorded in the chapter entitled "Liu-hou shih-chia 留侯世家" (Genealogy of the Duke of Liu) in *Shih-chi* 史記 (The Historical Records). See Ssu-ma Ch'ien 司馬遷 (145–86 B.C.), *Shiji (Shih-chi)* 史記, reprint with punctuation by Li Quanhua 李全華, *juan (chüan)* 卷 (chapter) 55, *Shijia (Shih-chia)* 世家 (genealogy) 25, (Zhangsha: Yuelu Shushe, 1990), pp. 453–460. Ch'ih-sung Tzu (literally meaning "a person living by red pine), sometimes also known as Ch'ih-sung, is the name of a well-known immortal in early Chinese mythology. His name appears in many books. See E. T. C. Werner, *A Dictionary of Chinese Mythology*, reprint (Taipei: Wen-hsing Press, 1961), p. 184, s.v. "Huang Ch'u-p'ing 黃 (皇) 初平" and also in *Hanyu dacidian* 漢語大詞典 (Chinese Terminology Dictionary), vol. 1 (Shanghai: Hanyu Dacidian Press, 1988), p. 1162, s.v. "Ch'ih-sung Tzu 赤松子."

14 Chang Hua 張華 (232–300) of the Tsin 晉 dynasty (265–420) was a famous politician. Well educated and excelling in administration, he held important official positions and had a very successful career. Nevertheless, he was destitute at the time of his murder by a member of the imperial family. Here the author of this poem tries to

Shen Chou
Pine and Hibiscus
*continued*

8 comfort his friend, T'ang Hsia-min, by pointing out that even if one is prosperous when young, one's life may still end in tragedy. Chang Hua's biographical information can be found in *Tsin-shu* 晉書 (The Book of Tsin), *chüan* 卷 36. See Morohashi Tetsuji 諸橋轍次, *Dai Kanwa Jiten* 大漢和詞典 (The Great Chinese-Japanese Dictionary), vol. 4 (Tokyo: Daishukan, 1976), p. 719, s.v. "Chang Hua 張華."

15 *Chu-sheng* 諸生 was an old term used for a student who attended the government established schools. Among the scholars who contributed poems, P'u Ying-hsiang was probably the youngest. He must have been an active figure in literary and art circles, as his colophon also appears on a handscroll, *Huahui quanshitu* (*Hua-hui chüan-shih-t'u*) 花卉泉石圖 (Flowers and Rocks by a Spring), by two well-known painters, Hsü Lin 徐霖 (1462–1538) and Tu Chin 杜堇 (active second half of 15th century). This work is now at the Palace Museum, Beijing. See Palace Museum Editorial Committee, *Zhongguo lidai huihua* (*Chung-kuo li-tai hui-hua*) 中國歷代繪畫 (Paintings of the Past Dynasties) in the series *Gugong bowuyuan canghuaji* (*Ku-kung po-wu-yüan ts'ang-hua chi*) 故宮博物院藏畫集 (Paintings in the Collection of the Palace Museum), vol. 5 (Beijing: Renmin Meishu Chubanshe, 1986), p. 123.

16 *Ya-hua-chih* 研花紙 (paper with pressed pattern) was a kind of paper popular among painters and calligraphers during the Ming dynasty. It was made by sizing the paper with a thin layer of gesso, with decorative designs then pressed or stamped onto the surface. The powder creates a smooth white surface that allows for swift, more spontaneous calligraphic brushstrokes. In order to produce different patterns, such as waves, flowers, or wood grain, onto the gesso, designs were sometimes carved on the roller or woodblock.

17 This is the collecting seal of Chang Jo-ai 張若靄 (1713–46). A seal stamped on the joined edges of two pieces of paper is called a *ch'i-feng* 騎縫 seal (a seal riding on the jointed edges of two pieces of paper). Such seals not only verify ownership but also indicate that the painting was remounted while in that collector's possession.

18 Ch'en Hu-ch'iung 陳湖璚 was better known as Ch'en Ch'iung 陳璚, a famous poet who obtained his *chin-shih* degree in 1478 and later served as the Deputy Censor-in-Chief in Nanking. This inference is based upon the *tzu* and *hao* provided on the Michigan colophon. As the two Ch'ens bear the same family name, Ch'en 陳, *tzu*, Yü-ju 玉汝 (the Jade Ju River), *hao*, Ch'eng-

chai 成齋 (the Study of Completion), and are from the same city, Suchou, and period, the second half of the fifteenth century, they must surely be the same person. A handscroll at the National Palace Museum, Taipei, entitled *Tiao-yüeh t'ing* 釣月亭 (Fishing the Moonlight Pavilion), bears a colophon by Ch'en Ch'iung. Comparing this colophon with the one in the Michigan scroll, not only are the calligraphic styles similar, but they both have a seal "*Yü-ju* 玉汝" under the calligraphers' signatures. Despite the fact that these two seals are carved in different manners, they do indicate that Ch'en Hu-ch'iung and Ch'en Ch'iung had the same *tzu*. Ch'en Ch'iung, was the grandfather of the famous Wu painter Ch'en Ch'un 陳淳 (1483–1544). For the life of Ch'en Shun, see L. Carrington Goodrich and Fang Chaoying, eds. *Dictionary of Ming Biography, 1368–1644*, vol. 1 (New York and London: Columbia University Press, 1976), p. 179. In this source, it is clearly indicated that Ch'en Ch'iung's *hao* was Cheng-chai, which appears also on the Michigan scroll. For a reproduction of Ch'en Ch'iung's colophon on the handscroll *Fishing the Moonlight Pavilion* at the National Palace Museum, see Fu Shen, "Shen Chou's Bamboo Dwelling and the Handscroll Painting Pavilion for Fishing the Moonlight," (Shen Chou Yu-chu Chü yü Tiao-yüeh T'ing 沈周有竹居與釣月亭) in *Proceedings of the International Colloquium on Chinese Art History, 1991: Painting and Calligraphy*, part 1 (Taipei: National Palace Museum, 1991), p. 369. As the Michigan scroll was executed between 1477 and 1489, and the National Palace Museum scroll was executed around 1500, it is quite possible that Ch'en's given name was originally "Hu-ch'iung," and he later went by simply "Ch'iung." For a discussion of Ch'en Ch'iung and his family, see Letha E. McIntire, "The Landscape Paintings of the Ming Artist: Ch'en Tao-fu," Ph.D. dissertation (Lawrence: University of Kansas, 1981), pp. 32–41.

19 The phrase "a pine tree growing from a person's belly," recorded in a footnote in "Sun Hao (r. 264–277) chuan" 孫皓傳 (Emperor Sun Hao's biography) in *Wu-chih* 吳誌 (Annals of the Wu State), is derived from the story of Ting Ku 丁固 of the Three Kingdom period (222–65). When Ting Ku was prime minister, he dreamed that a pine tree was growing from his stomach. He then told people that since the character for "pine" (松) could be divided into three parts, *shih* 十 (ten), *pa* 八 (eight), and *kung* 公 (duke), the emperor would promote him to the position of a duke after eighteen years. It turned out

that after eighteen years, Ting's prediction came to be. Since then, pine has been used symbolically in Chinese literature to represent the emperor. See *Dai kanwa jiten* 大漢和詞典 (The Great Chinese-Japanese Dictionary), vol. 3, p. 2637, s.v. "mengsong (meng-sung) 夢松" (dream of the pine tree).

20 The tenth character, *t'ien* 天 (meaning "sky" or "heaven") in the parenthesis, is a mistake. The author of this poem, Ch'en Hu-ch'iung, added two dots on its side to indicate that this character should be ignored.

21 The name of Sun Lin 孫霖 is recorded in Zhu Baojiong 朱保炯 and Xie Peilin 謝沛霖, *MingQing jinshi timingbeilu suoyin* (*Ming-Ch'ing chin-shih t'i-ming pei-lu so-yin*) 明清進士題名碑錄索引 (An Index of the Stele Bearing the Names of the Holders of the *chin-shih* Degree during the Ming and Ch'ing Dynasties) (Shanghai: Guji Chubanshe, 1980), vol. 3, p. 2473. Sun was the fifty-fifth candidate of the second class of the national examination in the seventeenth year (1481) of the Ch'eng-hua reign (1465–87). A total of 298 scholars passed that test. According to the record, he was from the Ch'ang-chou 長州 district, which is part of Suchou, and he had a *chün-chi* 軍籍, or "military classification." This classification was part of a system in ancient China of registering individuals based on their general family occupation or profession.

22 Lady Ch'ang-o 嫦娥 in Chinese mythology is associated with unattainable goals. A beautiful lady in ancient Chinese legends, she stole the potion of immortality from her husband, Hou I 后羿, and fled to the moon to live in a beautiful palace. In this chilly environment, she became the lonely goddess accompanied only by a white hare and a cassia tree. See E. T. C. Werner, *A Dictionary of Chinese Mythology*, reprint (Taipei: Wen-hsing Press, 1961), p. 43.

23 *P'ing-an tzu* 平安字 (peaceful characters) is a poetic term for a letter addressed to a family member reporting that everything is going well. According to T'ang Hsia-min's colophon, after his eighth failure, he was ashamed and fled home in humiliation to escape ridicule. Thus, this line implies that although T'ang did not pass the examination, at least he could report to his family that he was well in his seclusion.

24 *San-ching* 三徑 or 三逕 (three narrow passages) indicates the retreat of a recluse. The term was derived from the story of a certain Chiang Hsiang 蔣翔 of the Tsin dynasty who lived like a hermit. In order to discourage visitors, Chiang blocked the gate of his home with bramble bushes, leaving only three narrow paths. Consequently, his retreat was known as "the three passages."

See *Hanyu dacidian* 漢語大詞典 (Chinese Terminology Dictionary), vol. 1, p. 223, s.v. "*sanjing* (*san-ching*) 三徑."

25 *Shuo* 説, although commonly meaning "to speak," is sometimes pronounced *yüeh*, meaning "to take pleasure in" or "delight."

26 In this line, Yao Shou uses the term *kao-shih* 高士, or "a lofty scholar," to represent a sympathetic friend. This term is derived from a passage in Mocius's 墨子 work, *Chien-ai* 兼愛 (Fraternity). Mocius's full name was Mo Ti 墨翟, and he was a great philosopher of the Warring States period (481–221 B.C.). He preached love without distinction and asserted: "Those who resolve to become well-known lofty scholars, should [first] be considerate of their friends." (吾聞為高士於天下者, 比為其友之身.) Thus, Yao Shou uses this term to indicate T'ang Hsia-min's enthusiasm in searching for sympathetic scholars.

27 Pei-ch'uang 北窗 (northern window) was evidently T'ang Hsia-min's *tzu*.

28 *Li* is a Chinese measure of length that is roughly equal to 360 paces, or about 1,890 feet. Ping-wang 平望 is a small town south of the city of Suchou. See *Zhongguo Diming Cidian* 中國地名詞典 (A Dictionary of Names of Places in China) (Shanghai: Shanghai Cishu Chubanshe, 1990), p. 239.

29 In ancient China, alchemists claimed that, in order to produce a pill or elixir of immortality, it was necessary to refine the elements nine times with fire. In this line, the poet figuratively uses "hibiscus" as the element, due to the fact that it blooms in the fall and withstands the cold, thus symbolizing perseverance. The author symbolically uses the nine purifications of the hibiscus to allude to T'ang's multiple examinations. Thus with great stamina, T'ang would eventually be able to achieve his goal.

30 Taoist alchemists were famous for using all types of ingredients to produce an elixir of immortality. Once swallowed, a person would achieve longevity and be able to ascend to heaven carried by pheasants or cranes. See *Hanyu dacidian* 漢語大詞典 (Chinese Terminology Dictionary), vol. 12, p. 1182, s.v. "*luan-ho* 鸞鶴" (pheasant and crane). Thus the line, "carried to heaven by pheasants or cranes" indicates a person's success.

31 The "five-needle pine" is a tree that bears pine nuts. In Taoism, immortality has always been the primary goal. Taoists, seeking to become immortals, would practice a fast of eating only pine nuts for sustenance. The practice bears some analogy with the striving of scholars toward gov-

ernmental positions. In Tu Chin's poem, the author uses immortality to represent "a successful official career." By pointing out that those who attained immortality may not have all gone through the necessary fasts, Tu suggests that these scholars might not have studied diligently enough to merit their success nor have they gained their positions legitimately.

32 In the Warring States period (481–221 B.C.), the Wu 吳 state occupied the Suchou area and the Yüeh 越 state occupied the Hangchou area. The two were neighboring states and had been fighting continuously for many years. Later writers often invoked the memory of the two states to represent a long-standing feud. In this poem, a beauty from the Wu state became old and lost her beauty while residing in enemy land; consequently, it is analogous to the frustrated condition of a scholar who has failed many times at the civil service examinations.

33 *Chü-shuang* 拒霜 literally means "to resist the frost" and refers to hibiscus.

34 Tu Chin 杜堇 was from Tan-tu 丹徒 (present-day Chen-chiang 鎮江) in Kiangsu province but lived in Peking for many years. He excelled in figure painting and was also an accomplished scholar. For his work, see *Ku-kung shu-hua t'u-lu* 故宮書畫圖錄 (Pictorial Catalogue of Painting and Calligraphy at the Palace Museum), vol. 6 (Taipei: National Palace Museum, 1989), p. 293.

35 Customarily, scholars who failed the civil service examinations would end up teaching unruly young children, a disappointment for a person who prepared so diligently for a government career.

36 In this poem, Ch'en Yü encourages T'ang Hsia-min to keep trying and not to be reduced to the behavior of a quitter. "To return home and solitarily pet the pine trees" is a phrase derived from T'ao Ch'ien's 陶潛 (365–427) famous poem entitled *Kuei-ch'ü-lai hsi tz'u* 歸去來兮辭, or "Let Me Return Home." When T'ao, the great poet and recluse of the Tsin dynasty renounced his official position and returned to his farm, he composed this poem, which includes the line: "Before entering, I [stopped] in the shade under the thick, luxuriant foliage. Patting the lone pine tree, I lingered and pondered." To T'ang, this verse signifies a person giving up. For T'ao Ch'ien's poem, see Gong Bin 龔斌, *Tao Yuanming ji jiaojian* (*T'ao Yüan-ming chi chiao-chien*) 陶淵明集校箋 (T'ao Yüan-ming's Anthology with Collation by Gong Bin) (Shanghai: Shanghai Guji Chubanshe, 1996), vol. 5, pp. 390–401.

37 "The immortal cassia tree" is supposed to have grown on the moon. For more on this story, see Lady Ch'ang-o in note 22.

38 The Chinese character *tung* 東, which means "east," may sometimes be translated as "springtime." Therefore, "*tung-hua* 東花" literally indicates spring flowers such as the peony and peach blossom. See *Hanyu dacidian* 漢語大詞典 (Chinese Terminology Dictionary), vol. 4, p. 822, definition no. 5, s.v. "*dong* (*tung*) 東."

39 The small character "*pu* 不," which has been inscribed by the author of this poem at the end of this line, indicates that the first character of this line, "*wei* 未," is miswritten. In the past, if a character had been written incorrectly, the writer would apply a dot beside it instead of covering it with ink. The correct character was then added at the end of the paragraph in a smaller size. In this case, an unusual oval-shaped seal bearing the character "*fei* 非" (error or wrong) has also been stamped on the incorrect character "*wei* 未" to indicate the error.

40 In this line, there is a space between the second and the third characters. In order to show respect, it is customary for the Chinese to leave a blank space before writing characters that refer to the emperor, parents, elder relatives, or the name of an honored person. In this case, the third character is *chün* 君, "your majesty" or "the emperor." Therefore, an extra space has been placed before this character.

41 The correct form of the character for *hao* "灝," in the name of Liang Hao 梁灝, should be "顥." Liang Hao was a famous scholar-official of the Northern Sung dynasty (960–1126). It was said that he attained his *chin-shih* degree in the Yung-hsi 雍熙 period (984–87) at the age of eighty-two. Although the age was later revised, writers in the past often invoked him to represent those who passed the examination at an advanced age. See Tsang Li-ho 臧勵龢 et al., *Chung-kuo jen-ming ta-tz'u-tien* 中國人名大詞典 (Encyclopedia of Chinese Biographies) (Shanghai: Commercial Press, 1924), p. 1003, s.v. "Liang Hao 梁顥."

42 For the significance of "dreams of pine trees," see note 19.

43 "The late red blossoms by the autumn river" signifies the hibiscus, which in turn alludes to a person's late success.

44 "To bestow an official title upon a pine tree" is derived from a story recorded in "Ch'in-shih-huang pen-chi 秦始皇本紀" (The Chronicle of Emperor Ch'in Shih-huang) in Ssu-ma Ch'ien 司馬遷 (145–86 B.C.), *Shih-chi* 史記 (The Historical

10    Records), *chüan* 卷 (chapter) 6, pp. 52–76. According to this source, when Emperor Ch'in Shih-huang (r. 246–210 B.C.) made an imperial tour to the T'ai Mountain 泰山 in the east, he took shelter from the rain under a large pine tree. To reward the tree, he bestowed upon that pine the official title Wu-tai-fu 五大夫 (the Fifth Great Officer of the State). See also *Hanyu dacidian* 漢語大詞典 (Chinese Terminology Dictionary), vol. 2, p. 1261, s.v. "feng-ch'an shu 封禪樹" (a titled tree) and vol. 1, p. 344, s.v. "wu-tai-fu 五大夫."

45    In the caste system of ancient China, *yü* 輿 represented the people of the sixth level while *t'ai* 台 referred to the lowest, or the tenth, level. Together, *yü-tai* was often used to indicate people who held humble jobs. See *Hanyu dacidian* 漢語大詞典 (Chinese Terminology Dictionary), vol. 9, p. 1181, s.v. "yutai (yü-t'ai) 輿台."

46    For the meaning of "honored tree," see note 44.

47    "Red apricot blossoms" refers to the blossoms awarded to the champion of the national examination by the emperor. Customarily, the emperor would issue these blossoms to the winner so that he might wear them on his hat when returning to his hometown for a type of victory parade.

48    In Chinese mythology, the *peng* 鵬 bird is a fabulous eagle of enormous size. It is believed that it could fly 10,000 miles with ease and speed; consequently, *peng* was used as a metaphor referring to those who attained success early in life.

49    *Ku-jih* 穀日, or "grain day" simply means a lucky day. In Weng's poem, as he mentions his visit to a temple market in the next line, it seems to specifically indicate New Year's Day. Traditionally in Peking, people strolled to the bazaar held near temples during the New Year holiday.

50    Since the late seventeenth century, Hai-wang (King of the Ocean) village has been used as the more elegant name of the antique district in Peking. Today, the popular name of this area is "Liu-li Ch'ang 琉璃廠" (glass-ware workshop).

51    The "old man of the mountain" evidently refers to Shen Chou, painter of this scroll.

52    In his old age, Weng T'ung-ho adopted this name for his studio as it possesses a rich implication of longevity. The "purple fungus" indicates a fungus with purplish wooden stalk that will last for a long time. Thus it symbolizes long life and prosperity. The "white tortoise," on the other hand, refers to a kind of tortoise that camouflages itself by growing white moss on

its back. It was believed that this animal lived for several hundred years, and that the moss on its back was its white beard. Therefore the tortoise commonly represents longevity, even though it is also used derogatively, as a cuckold.

53    "Field of stone," refers to undesirable farm land filled with rocks. Picking this name illustrated Shen Chou's humility and humor.

54    The source of the sobriquet "White Stone Old Man" is found in a colophon written by Li Tung-yang 李東陽 (1447–1516) which accompanies a painting by Shen Chou. This colophon is reprinted in the chapter "Shih-t'ien hsien-sheng shih-lüeh" 石田先生事略 (A Brief Biography of Shen Chou), *chüan* 卷 (chapter) 10, p. 13, in Shen Chou's *Shih-t'ien hsien-sheng chi* 石田先生集 (Shen Chou's Anthology), reprint, vol. 2 (Taipei: National Central Library, 1968), new page no. 887. However, this source has two errors that need to be amended. First, the date in Li's colophon is wrong. Li stated that in the fourth moon, summer of the *chia-hsü* 甲戌 year (1514), he visited Shen Chou and was told by his host that when he reached the age of sixty, he would adopt the *hao*, "White Stone Old Man." (予於歲甲戌夏四月, 訪石田先生. 先生謂余曰: 吾年六十, 則更號 "白石翁" 矣!). Since Shen Chou died in 1509, Li's date is apparently inaccurate. It is quite possible that Li really meant the *chia-ch'en* 甲辰 year (1484), when Shen Chou was fifty-eight years old. Secondly, many scholars did not comprehend this information and mistakenly designated 1484 as the year Shen Chou began to use this *hao*. See Chiang Chao-shen 江兆申 (1925–96), *Wen Cheng-ming hua hsi-nien* 文徵明畫系年 (Wen Cheng-ming's Paintings at the National Palace Museum in Chronological Order), the chronology and commentary volume (Tokyo: Orijin Bookstore おりじん 書房, 1976), entry on 1484, p. 54. Shen Chou probably began using this sobriquet in 1486 at the age of sixty.

55    See Richard Edwards, *The World around the Chinese Artist: Aspects of Realism in Chinese Painting* (Ann Arbor: College of Literature, Science, and the Arts, University of Michigan, 1987), p. 74.

56    It is unclear when Shen Chou purchased this property. Although one record indicates that he owned the Bamboo Dwelling around 1471, it is possible he constructed the building several years earlier. See "Shih-t'ien hsien-sheng shih-lüeh" 石田先生事略 (A Brief Biography of Shen Chou), *chüan* 卷 (chapter) 10, p. 5b, in Shen Chou's *Shih-t'ien hsien-sheng chi* 石田先生集 (Shen Chou's Anthology), vol. 2, new

page no. 872. For a discussion of Shen Chou's painting related to his villa and its history, see Fu Shen, "Shen Chou's Bamboo Dwelling and the Handscroll Painting Pavilion for Fishing the Moonlight," in *Proceedings of the International Colloquium on Chinese Art History*, 1991: Painting and Calligraphy, part 1, pp. 377–99.

57    See Shen Chou's grave epitaph composed by his close friend, Wang Ao 王鏊 (1450–1524), which is reprinted at the beginning of Shen Chou's *Shih-t'ien hsien-sheng chi* 石田先生集 (Shen Chou's Anthology), vol. 1, new page no. 17. Wang says in the epitaph that neither Shen Chou's father nor his uncle would pursue a career in the civil service; instead, they would concentrate on literature and art. (父孟淵, 考恒吉, 皆不仕, 而以文雅稱.)

58    Among the several biographies of Shen Chou, the most credible and well-written is by his student, the great Wu master Wen Cheng-ming 文徵明 (1470–1559). Wen's "Shen hsien-sheng hsing-chuang" 沈先生行狀 (A Document of Mister Shen Chou's Life) is found in Wen's *Fu-t'ien chi* 甫田集 (Wen Cheng-ming's Anthology), *chüan* 卷 (chapter) 25, reprint (Taipei: National Central Library, 1968), pp. 10–13 (new page nos. 584–89). This account is also found at the beginning of Shen Chou's *Shih-t'ien hsien-sheng chi* 石田先生集 (Shen Chou's Anthology), vol. 1, new page nos. 22–27. Although this biography is cited widely, its entire text has not been translated into English. Therefore, a translation follows, with the Chinese text transcribed:

**A Document of Mister Shen's Life.**

The name of [Shen Chou's] great-great-grandfather was Shen Mou-ch'ing.

[Shen Chou's] great-grandfather's name was Shen Liang-chen, and his grandfather's name, Shen Meng-yüan.

[Shen Chou's] father's name was Shen Heng-chi, his mother, né Chang.

The Shens were from the Hsiang-cheng village, Ch'ang-chou county in the Suchou prefecture. Shen Chou passed away at the age of eighty-two.

While his given name was Chou, his family name was Shen. His *hao* was Shih-t'ien. Thus, people often called him "Mr. Shih-t'ien." For centuries, the Shens lived at the Hsiang-cheng village in Ch'ang-chou county. His grandfather, Shen Meng-yüan, was a well-educated scholar, who had two sons. The elder one's name was Chen-chi and the younger one, Heng-chi; both were known for their brightness and refine-

ment. Heng-chi's *hao* was Tung-chai (Confederate Studio) and he had three sons. Shen Chou was the eldest one from the legal wife. Even since childhood, Shen Chou possessed an elegant demeanor and lofty personality, as well as surpassing intelligence and great wisdom. His first teacher, Mr. Ch'en Meng-hsien, was the son of Ch'en Ssu-ch'u, the former imperial editor. The Ch'ens all excelled in literature and they rarely spoke of other people's achievements. Yet when Mr. Ch'en found his student, Shen Chou, could compose articles better than his own, he withdrew from his teaching position. At age fifteen, Shen Chou acted on behalf of his father and assumed the responsibility of paying taxes to the central government. As a representative of his native village, he went to Nanking and had an audience with the Vice-minister of the Department of Revenue and Population, Mr. Ts'ui, who was in charge of the levy. Shen Chou, aware that Mr. Ts'ui was fond of poetry, composed one hundred poems and presented them to him. Although Ts'ui was amazed by the achievement of this young poet, he also doubted that these poems were really written by Shen. Thus, Ts'ui called the young lad to his study and demanded that young Shen compose a poem on the subject of the Phoenix Terrace, a famous local scenic spot. With little hesitation, Shen picked up the brush and in no time finished a graceful poem, full of exquisite language. The vice-minister was greatly pleased, and he compared Shen Chou's skill to that of the talented Wang Po (648–675) [a legendary writer in Chinese history]. To reward Shen, Ts'ui remitted his taxes.

After growing up, Shen studied even harder. He first finished the *Five Canons of Confucius* and then concentrated on history and literature. His study even included Buddhist and Taoist scriptures and writings on mythology and folklore. Equipped with such extensive knowledge, he began his venture into poetry. He first followed the examples of the poets of the T'ang dynasty (618–905), especially those by the poet Po Chü-i (772–846), and next he emulated poet Su Shih (1036–1101) of the Sung dynasty (960–1279). After that he started to compose poems using Lu Yu's (1125–1210) work as his model. Whatever he wrote was refined and elegant. This was because his writings were sensible and rational and were usually based on real objects he saw or actual events he encountered. The contents of his poems were rich and full of

diversity, never confined to any one type of subject or style. Besides poetry, he also excelled in painting. His works could be compared with those by early masters, and wherever he went, a large multitude of guests visited him. In front of these people, Shen would paint in a relaxed manner, and he usually inscribed his works with his own writings. Within only a short period of time, he could finish a poem or passage of more than a hundred characters, which were all wonderfully lively. Both his painting and poetry were superb. He never turned down requests from the working class. When palanquin-carriers or donkey-drivers came to ask for his paintings, he would not disappoint them. Thus, silk and paper of varying lengths piled up in his studio, waiting for him to complete. His fame reached as far as the capital, as well as the remote Fukien, Chekiang, and Szechwan provinces.

During the Ching-t'ai period (1450–56), the local governor, Mr. Wang Kung-hu, attempted to recommend Shen Chou to serve at the imperial court. After receiving an official letter from the governor, Shen sought help by divining with stalks of plants. The divining solution was, "Concealing oneself would be most fortunate," a sentence found in the *Book of Changes*. Shen delightedly claimed, "Isn't it the right thing to conceal myself?" and decided to stay away from any government positions. However, many high officials became good friends of Shen Chou. The closest among them was Prime Minister Wang Ao. Every time Mr. Wang was in the Suchou area, he would visit Shen and linger there for days. Once the two discussed composing remonstrations submitted to emperors. Shen said to Wang, "Although memorandums and remonstrations were not the forte of commoners who had not occupied official positions, according to the *Book of Rites*, it seemed rational that, no matter the subject matter, the remonstrations should be composed with great care in order not to infuriate the emperor." Mr. Wang then asked Shen, "Given your understanding of the present ruler, what was the most appropriate tone for composing a memorandum. Should the message be frank and direct or should it be mild, tactful, and implicit?" Shen replied, "The current emperor was perceptive and reasonable, and the high officials, such as Mr. Wang, were virtuous and able and won the trust of the ruler. Memorandums should be direct, perhaps even a bit humorous." In order

to display his writing style, the prime minister leisurely took out a memorandum and handed it to Shen Chou. He claimed, "This was the manner in which I usually compose." After Shen read it, he said, "The content of this memorandum is pertinent to the fact, while the candid tone is neither acerbic nor sarcastic. Not only is the message clear; the remonstrative purpose was also fulfilled." Wang considered Shen's remark appropriate—an understanding comment of a true friend.

During Shen's time, scholars, who befriended high officials, were fond of discussing current events. Shen Chou acted differently. He told his friends, "While administrators appreciate the knowledge of scholars, and scholars should treat officials with respect, it is still difficult for the two to fully understand each other's position and standpoint. Isn't it Confucius's teaching that a gentleman's thoughts should be limited to where he stands and one must be honest and put forth an effort to [cultivate a friendship without interfering in the friend's business?]" Nevertheless, whenever Shen Chou heard of the actions or accomplishments of the government, he would express his sincere feeling on the matter. Thus, we know he was not someone who was indifferent to worldly affairs.

About one *li* (360 paces or about 1890 feet) from Shen Chou's home was his villa, which was called "The Bamboo Dwelling." He spent much time there, planting flowers, studying, and painting. On many occasions, he would prepare wine and food and invite his close friends to join him, usually showing them his old books, antiques, calligraphy, and paintings. The discussion of these objects brought him great pleasure. During his old age, he became even more famous, and thus there were more visitors. Despite his advanced age, his mind and memory did not decline, and he never tired of social activities. His talented and artistic demeanor outshone that of his peers. During the past century, there was no one from the southeastern region who could surpass his outstanding artistic knowledge and awareness. However, Mr. Shen was a humble person. Although he was truly talented, he never showed off his intelligence. He got along well with people, and due to his integrity, people would not take advantage of him. He was always eager to assist younger people. No matter how unimportant they were, when Shen discovered their merits, he

Shen Chou
Pine and Hibiscus
*continued*

12  would do his best to promote them. He was especially sympathetic to people's need and suffering and always responded to people's pleas. His relatives and neighbors respected him and relied on his assistance. He was a good son; he attended his father, who was fond of entertaining, with great love and care. When the father drank with his friends, he often got drunk. Although Shen Chou did not particularly enjoy drinking, to please his father, he would usually gulp down many cups with the guests. After his father passed away, he stopped drinking.

Shen Chou's mother lived for almost one hundred years. When she finally died, Shen was in his eighties. Even at that age, his relationship with his mother was as close as when he was a young child. Shen's younger brother, Shen Chao, had consumptive disease [tuberculosis] and was not allowed to have a normal relationship with his wife. Shen Chou moved his brother to his own bedroom and took care of him until he died a year later. Shen also treated his brother's orphans like his own sons. His youngest brother, Shen Pin, was young and immature. In order to set up an estate for the brother, Shen gave him half of his own belongings. The husband of Shen's younger sister died at an early age. He looked after her all the rest of her life. It seemed that he was born with a tremendous sense of filial and fraternal piety.

Shen Chou's wife was from the Ch'en family, and she gave birth to one son, whose name was Shen Yün-hung. The son was an established scholar who served as the Instructor of Philosophy and Geomancers in Kun-shan county. Shen Chou's concubine also gave him one son, Shen Fu, who was a student at the local government-supported school. The eldest of Shen's three daughters married Hsü Chen, a student in Kun-shan county. The second daughter married Hsü Hsiang, and the youngest married Shih Yung-ling, a senior student from Wu-kiang county. Shen Chou had a grandson named Shen Lü, as well as two granddaughters. He had one great-grandson and two great-granddaughters. Shen's poems were collected in an anthology entitled *A Draft of Shih-t'ien's Poetry*, which is divided into volumes. His other writings include: *Shen Chou's Essays; A Discussion on the History of Poetry; A Memoir; The News Heard from My Guests;* and *Precious Prescriptions*. Each has been edited into several volumes.

On the second day, the eighth moon, in the fourth year (1509) of the Cheng-teh reign (1506–21), Shen Chou became sick and died in his sleep at the age of eighty-two. At that time, his son, Yün-hung, had passed away several years earlier. Thus, Shen's grandson, Shen Lü, assisted by his uncle, Shen Fu, the son of Shen Chou's concubine, buried him at a cemetery in a county east of his home. The funeral was held three years later in the seventh year of the Cheng-teh reign (1512), on the twentieth day, the twelfth moon. In order to inform people about Mr. Shen's life, the members of the Shen family sought a famous person of high moral integrity to compose his biography. When I was selected, I was humbled by the honor, as I was only a mere student of Mr. Shen! However, I was under his instruction for many years and am familiar with the details of his life. So I have a responsibility to perform this job. My modest writing is presented to you as the above.

(沈先生行狀

高祖懋卿

曾祖良琛

祖孟淵

父恒吉母張氏

本籍蘇州府, 長州縣, 相城里. 沈周年八十有三狀:

先生諱周, 姓沈氏, 別號石田. 人稱石田先生. 世居長州之相城里. 自孟淵先生以儒碩肇家, 生二子, 曰: 貞吉 曰: 恒吉.才美雅飾, 並有聲稱. 恒吉號同齋 生三子. 先生嫡長也. 生而娟秀玉立, 聰明絕人 少學於陳孟賢先生. 孟賢 故檢討嗣初先生子也. 諸陳皆以文學高自標, 不輕許可人. 而先生所作, 輒出其上. 孟賢遂遜去. 年十五, 貸其父為賦長, 聽宣南京. 時地官侍郎崔公, 雅尚文學 先生為百韻詩上之. 崔得詩, 驚異疑非己出. 面試鳳凰臺歌. 先生援筆立就, 詞采爛發 崔乃大加激賞, 曰: "王子安才也!" 即日檄下有司, 蠲其役. 先生既長, 益務學 自經而下, 若諸史子集 若釋老; 若捭官小説; 莫不貫總淹浹. 其所得, 悉以資於詩. 其詩, 初學唐人, 雅意白傅 既而師眉山, 為長句. 已又為放翁近律. 所擬, 莫不合作然. 其緣情隨事, 因物賦形. 開闔變化, 縱橫百出. 不拘乎一體之長. 稍緻其餘, 以游繪事. 亦皆妙詣 追蹤古人. 所至, 賓客牆進. 先生對客揮灑不休 所作, 多自題其上. 頃刻數百言, 莫不妙麗可誦. 下至輿皁賤夫 有求輒應 長縑斷素, 流布克斥 內自京師, 遠而閩, 浙, 川, 廣, 莫不知有沈周先生也! 先是景泰間, 郡守汪公漰, 欲以賢良舉之 以書敦遣先生. 茣易, 得遯之九五. 曰: "嘉遯貞吉." 喜曰: "吾其遯哉?" 卒不應. 然一時, 監司以下, 皆接以殊禮. 尤為太保三原王公所知. 公按吳, 必求與語語. 連日夜不

休 一日, 論諫 先生曰: "對章伏諫, 非鄙下人所知. 然竊聞之禮 上諷諫, 而下直諫 豈亦貴沃君心, 而忌觸諱諫耶?" 公遽曰: "當今之時, 將為直諫乎? 抑亦諷乎?" 先生曰: "今主聖, 臣賢如明公, 又遭時依賴, 諷諫, 直諫 蓋無施不可." 公許出一章, 示之曰: "此吾所以事君者, 試閱之." 先生讀畢, 曰: "指事切, 而不汎演 言婉, 而不激. 是諷諫, 直諫 兩得其義矣!" 公以為知言. 同時, 文學之士, 為上官所禮者, 往往陳説時弊 先生不然. 曰: "彼以南面臨我, 我北面事之. 安能盡其情哉? 君子思, 不出其位. 吾盡吾事而已!" 然先生每聞時政得失, 輒憂喜形於色 人以是, 知先生非終於忘世者. 先生去所居里餘, 為別業. 曰: 有竹居. 耕讀其間, 佳時勝日, 必具酒肴, 合近局, 從容談笑 出所蓄古圖書器物, 相與撫玩品題, 以為樂. 晚歲, 名益盛. 客至亦益多. 戶履常滿. 先生既老, 而聰明不衰. 酬倡終日, 不稍厭怠. 風流文物, 照映一時. 百年來, 東南文物之盛, 蓋莫有過之者. 先生為人, 修謹謙下. 雖內蘊精明, 而不少外暴. 與人處, 曾無乖忤. 而中賣介辨不可犯. 然喜獎掖後進. 寸才片善, 苟有以當其意, 必為延譽於人, 不藏也. 尤不忍疾苦 緩急有求, 無不應之. 里黨戚屬. 咸仰成焉. 平居事其父同齋, 無不所至. 同齋高朗喜客, 飲酒必醉. 先生不能飲, 每為強酌 以樂客. 同齋沒, 乃絕. 母張夫人, 年幾百齡. 卒時 先生八十矣, 猶孺慕不已. 弟召, 病瘵 不內處. 先生與俱臥起者, 歲餘. 及卒, 撫其孤如子. 庶弟鬮, 稚未練事 為植產, 使均於己. 一妹, 早寡, 養之終其身. 其天性孝友如此. 先生娶於陳, 生子雲鴻 文學稱家. 嘗為昆山縣陰陽訓術. 側出子, 復, 郡學生. 女三 長適昆山縣學生許貞. 次適徐襄. 又次適太學生, 吳江史永齡. 孫男一人, 履, 女二人. 曾孫男一人, 女二人. 先生所著詩文, 曰: "石田稿" 總若干卷. 他雜著, 曰: "石田文鈔, 石田詠史, 補忘錄, 客座新聞 續千金方," 總若干卷. 正德四年己已, 先生年八十有三. 八月二日, 以疾卒於正寢 於是, 雲鴻先卒數年矣. 復, 乃相其孫, 履, 治喪 以七年壬申, 十二月二十日, 葬先生於所居之東, 某鄉, 某原. 屬將求銘當世有道, 以信於後. 俾某有述, 某辱再世之游耳! 受囑知先生為詳, 遂不克讓 用論次如右. 謹狀.)

59  Shen Chou's collection was listed by his student, Wen Cheng-ming. Wen's list was originally found in a colophon he inscribed on a calligraphic work. For Wen's list of Shen Chou's collection, see "Shih-t'ien hsien-sheng shih-lüeh" 石田先生事略 (A Brief Biography of Shen Chou), *chüan* 卷 (chapter) 10, pp. 27–28, in Shen Chou's *Shih-t'ien hsien-sheng chi* 石田先生集 (Shen Chou's Anthology), vol. 2, new page nos. 915–17. As for his reputation, two episodes record Shen Chou's magnanimity and tolerance. The first one states that once Shen Chou's name was improperly included in a list of commoners and he was drafted to paint a wall decoration at the compound of the newly appointed

magistrate alongside mere artisans. Shen Chou, instead of complaining or drawing attention to his elevated status, simply obeyed the order. The magistrate, whose name was Ts'ao 曹, later went to the capital and gained an audience with several high officials who were all Shen Chou's close friends. They inquired of the magistrate whether he brought greetings or a message from Shen Chou, which caused the magistrate to realize his folly. Upon the magistrate's return to Suchou, he went to the painter's house and apologized. Shen Chou welcomed his guest, accepted the apology, and ignored the past injustice. In order to avoid taking advantage of his newly established friendship, Shen Chou paid a courtesy call to the local magistrate by leaving his name card with the butler, without disturbing the host. See Chang Shih-ch'e's 張時徹 (active 16th century) "Shih-t'ien hsien-sheng chuan" 石田先生傳 (Biography of Shen Chou) reprinted in the chapter, "Shih-t'ien hsien-sheng shih-lüeh" 石田先生事略 (A Brief Biography of Shen Chou), chüan 卷 (chapter) 10, pp. 8–9, in Shen Chou's Shih-t'ien hsien-sheng chi 石田先生集 (Shen Chou's Anthology), vol. 2, new page nos. 878–79. The second anecdote is also found in the same source. It states that Shen Chou was always helpful when his neighbors were in need. Once a neighbor lost an article and mistakenly identified a similar one that belonged to Shen Chou as his. Shen Chou, without arguing, simply gave it to his neighbor. Days later, this person found the original article and returned the one he took from Shen, who simply smiled and accepted it. Another time, Shen bought a set of expensive old books and displayed them in his study. One visitor saw the books and recognized them as books stolen from his own collection. This guest pointed out that there should be a mark he made on a certain page. When the page was checked, the mark was indeed there. Shen Chou immediately packed the books and returned them to his guest. He absorbed the loss without disclosing the name of the person from whom he bought the stolen books.

60  From Shen Chou's poems, especially those he inscribed on his paintings, one can assert that he traveled extensively. For a discussion of Shen Chou's trips and his art, see Richard Edwards, *The World around the Chinese Artist: Aspects of Realism in Chinese Painting*, pp. 82–95. In addition to depicting scenic spots in his landscape paintings, he also used interesting objects with historical significance as motifs. For example, when he traveled to the neighboring Ch'ang-shu county, he was impressed by a group of old juniper trees, which were supposed to have been planted during the sixth century. Consequently, he executed his famous handscroll entitled *Sangui tu* (*San-kuei t'u*) 三檜圖 (Three Juniper Trees), currently at the Nanking Museum. Dated 1484, this work is the result of a trip with his friend Wu K'uan 吳寬 (1435–1504). Two of these trees are published in James Cahill, *Parting at the Shore: Chinese Painting of the Early and Middle Ming Dynasty, 1368–1580* (New York and Tokyo: Weatherhill, 1978), pls. 42–43, p. 76.

61  Shen Chou's best work in this style is his well-known large hanging scroll, *Lu-shan kao* 廬山高 (Lofty Mount Lu), executed when he was forty years old. This painting, now at the National Palace Museum in Taipei, is reproduced in *Ku-kung shu-hua t'u-lu* 故宮書畫圖錄 (Illustrated Catalogue of Calligraphy and Painting at the Palace Museum), vol. 6, p. 192.

62  For examples of Shen Chou's work depicting indigenous animals and plants such as buffaloes, chickens, donkeys, crabs, and shrimp, as well as hollyhock, magnolia, plums, and cabbages, see his *Hsieh-sheng ts'e* 寫生冊 (An Album of Plants, Animals, and Insects) at the National Palace Museum, Taipei, reproduced in *Three Hundred Masterpieces of Chinese Painting in the Palace Museum*, vol. 5 (Taichung: National Palace Museum and the National Central Museum, 1959), pl. 221 and *Woyou tuce* (*Wo-yu t'u-ts'e*) 臥遊圖冊 (A Set of Album Leaves Depicting the Landscapes Imagined While Reclining) at the Palace Museum, Beijing, reproduced in Palace Museum, comp., *The Wumen Paintings of the Ming Dynasty* (Hong Kong: Commercial Press, 1990), pl. 9, pp. 33–35.

63  The Chinese painting technique *mo-ku* 沒骨, or "boneless wash," stresses the use of multiple layers of color or ink washes, as in watercolors. Hsü Ch'ung-ssu 徐崇嗣 (active 960–1000) of the Northern Sung dynasty (960–1126) is considered the inventor of this technique. See Tung Yu 董逌 (active first quarter of 12th century), *Kuang-ch'uan hua-pa* 廣川畫跋 (Painting Colophons of Tung Yu), chüan 卷 (chapter) 3, s.v. "Shu mo-ku-hua t'u" 書沒骨花圖, in *Ts'ui-lang-kan ts'ung-shu* 翠琅玕叢書 edition, reprinted in Liu Haisu 劉海粟, ed., *Huapin congshu* (*Hua-p'in ts'ung-shu*) 畫品叢書 (A Collection of Books on Painting) (Shanghai: Renmin Meishu Chubanshe, 1982), p. 269. In his book, Tung Yu cited a statement of Shen Kua 沈括 (1030–94): "Hsü Chung-tz'u, son of Hsü Hsi 徐熙 (active mid-10th century), often created paintings with novel approaches. When painting flowers, he did not use ink lines. Instead, he applied several layers of colorful washes. People of his time called the painting 'boneless flowers.' Hsü Chung-tz'u used this technique to overcome the popularity of [court painter] Huang Chü-ts'ai 黃居寀 (933–?) and his father (Huang Chüan 黃荃, 903–?)." According to Tung Yu, the peony was also called the "boneless flower" during the T'ang dynasty. Thus, it is possible that this term originated from peony paintings with softly washed flowers.

64  The "line watermarks" are from the bamboo blinds used for lifting the pulp in papermaking.

65  When rolled, the edges of delicate paper are susceptible to tearing. When an area on the edge is damaged, it affects all layers and leaves equidistant U-shaped torn edges. Thus the equidistant repaired areas suggest the painting was damaged when rolled up and was repaired when the painting was mounted into a scroll.

66  See note 19.

67  Like Shen Chou, Weng T'ung-ho was from a prominent family near Suchou in Ch'ang-shu 常熟. For four generations, the boys of the Weng family were successful at the national examinations. Weng T'ung-ho and his uncle not only passed the examinations but were also holders of the champion with the highest honors. He obtained this level of excellence when he was a mere twenty-seven years old. What an ironic difference there is between the hopeless struggle of T'ang Hsia-min and the fabulous achievement of Weng! Weng tells us that he obtained this scroll in the first part of his first poem, and the rest of the verses are full of nostalgic expression about his hometown. It seems that, riding on the crest of success, he already had become aware of the precarious and treacherous life at the court. Six years after he bought this Shen Chou scroll, in 1898, he was punished by the empress dowager Tz'u-hsi 慈禧 (1835–1908) and sent back to his hometown. He was confined to his home under the surveillance of local officials, and all of his governmental posts were rescinded. He considered himself lucky that the capricious empress spared his life. For Weng's biography, see *Eminent Chinese of the Ch'ing Period (1644–1912)*, vol. 2 (Washington, D.C.: United States Government Printing Office, 1943–44), pp. 860–61.

68  As the poems appear not to be ordered chronologically, T'ang must have left most of them as they were written on the paper. Since "presumptuousness" does not conform to the teachings of Confucius, a poet of the fifteenth century would probably

Shen Chou

Pine and Hibiscus

*continued*

14

have inscribed his poem at the end of the paper, even if he were the first to be solicited. Thus the poems are probably not arranged in chronological order.

69  For other works of the Ming period brushed on *ya-hua* paper, see the *Snow Landscape* handscroll, attributed to Wang Wei 王維 (701–61), at the Honolulu Academy of Arts in Hawaii. It is reproduced in Gustuf Ecke's *Chinese Painting in Hawaii*, vol. 2 (Honolulu: Honolulu Academy of Arts, 1965), no. 41.

70  In order to make the surface even fancier, the powder was often applied first to a wooden board with incised designs and then calendered onto the surface of the paper. Placing ink calligraphy on a piece of powdered paper produces a contrast between the whiteness of the powder and the blackness of the ink, creating a distinctive and therefore impressive effect. The disadvantage of the medium is that, eventually, the powder bearing the ink strokes flakes off, resulting in a speckled image.

71  P'u Ying-hsiang, whose poem is next to T'ang's on the *ya-hua* paper, was a mere *kung-sheng* (tribute student), the lowest in status of all the contributors. T'ang would not have been so foolish as to include P'u's work on the fancy paper and then subsequently invite the contributions of more illustrious individuals on lesser quality paper. The small size of the characters of P'u's poem also does not conform to the larger characters that appear in the other poems. The small size suggests that P'u's poem was squeezed into the cramped space remaining after T'ang had inscribed his colophon on the *ya-hua* paper and after he had collected the other poems.

72  T'ang Hsia-min's *hao* was Pei-ch'uang 北窗 (northern window), found in Yao Shou's comments to his own poem. There are two seals that could have provided crucial information about T'ang Hsia-min. One is stamped at the beginning of his poem, and the other is found under his signature. Unfortunately, both seals are illegible due to the disintegration of the *ya-hua* paper on which T'ang's poem is inscribed.

73  The Chinese civil service examination system was divided into several levels. A boy in his teens would attend a test for admittance into the government school. He was called a *kung-sheng* 貢生 (a student who is subsidized by the government). Later, if he passed the local test, he became the holder of the *hsiu-ts'ai* 秀才 (a cultivated talent) degree, which qualified him to take the next test at the city where the provincial government was located. If

successful, he would attain the *chü-jen* 舉人 (a commendable gentleman) degree. This qualified him to go to the capital and take the national test. Those who passed would be invited to the palace to participate in a test in front of the emperor and might thus obtain the *chin-shih* 進士 (an advanced scholar) degree, roughly equivalent to doctoral degree. The individual with the highest score at the national test was called a *chuang-yüan* 狀元 (a man of the highest caliber). All of the tests took place in the fall at three-year intervals.

74  Yao Shou first inscribed that T'ang's brother was younger. He then corrected this mistake by writing "elder brother" in smaller script next to the error.

75  Four of Yao Shou's seals indicate the status of his granted degree. See Shanghai Museum of Art, *Zhongguo shuhuajia yinjian kuanshi* (*Chung-kuo shu-hua-chia yin-chien k'uan-shih*) 中國書畫家印鑒款識 (Signatures and Seals of Chinese Painters and Calligraphers) (Shanghai: Shanghai Museum of Art, 1992), pp. 697–700. One seal bearing this information includes these words: "*Tz'u chia-shen chin-shih ti* 賜甲申進士第" (granted a *chih-shih* degree in 1464).

76  Numerous cities and counties in Chinese history were named Yung-ning. It is not clear which one was the district Yao Shou served as prefect. See *Zhongguo Diming Cidian* 中國地名詞典 (A Dictionary of Names of Places in China), p. 301, s.v. "Yongning (Yung-ning) 永寧."

77  Tu Chin's biography can be found in Xu Qin (Hsü Ch'in) 徐沁 (active first half of 17th century), *Minghualu* (*Ming-hua lu*) 明畫錄 (Painters of the Ming Dynasty), *juan* (*chüan*) 卷 (chapter) 1, reprinted in Yu Anlan 于安瀾, comp., *Huashi congshu* (*Hua-shih ts'ung-shu*) 畫史叢書 (Compendium of Painting History), vol. 5 (Shanghai: Renmin Meishu Chubanshe, 1962), p. 15.

78  For Sun Lin's life, see note 21.

79  See note 18.

80  One of the poets was Chou Chao 周詔, who contributed the eighth colophon. This name is recorded in *Chung-kuo jen-ming ta-tz'u-tien* 中國人名大詞典 (Encyclopedia of Chinese Biographies) (Shanghai: Commercial Press, 1924), p. 539. According to this dictionary, an individual named Chou Chao was from Szechwan 四川 and served as prefect in Heng-chou 衡州 (present-day Heng-yang 衡陽 in Hunan 湖南 province) during the Chia-ching 嘉靖 period (1522–66). If the Chou Chao of the Michigan scroll was in his thirties when

he inscribed a companion verse for T'ang Hsia-min around 1477, by 1522, the first year of Chia-ching, he would have been in his mid-seventies. Therefore, the Chou Chao listed in the *Chung-kuo jen-ming ta-tz'u-tien* dictionary must have been another person bearing the same name.

81  The novel, *Ju-lin wai-shih* 儒林外史 (A Fictional History of Confucian Scholars), by Wu Ching-tzu 吳敬梓 (1701–54) is a sarcastic work lampooning Chinese scholars. One episode in the book describes Fan Chin as a poor and aged scholar who was informed that he passed the local civil service test. His great joy was so overwhelming that he suddenly became hysterical. His father-in-law, a butcher, resorted to slapping him on the face in order to call him back to his senses.

82  Two obvious examples of these unsuccessful scholars, both from Suchou, include the painter T'ang Yin 唐寅 (1470–1524) and the artist-scholar Wang Ch'ung 王寵 (1494–1533). T'ang miserably failed the national examination in 1499. Despite his failure he achieved national fame. For more information on T'ang, see *Dictionary of Ming Biography, 1368–1644*, vol. 2, pp. 1256–59. Wang Ch'ung experienced eight failures in the national examination, from 1510 to 1531. His teacher, Wen Chengming, stated that each of Wang's failures made him more famous and attracted more young men to study under him. Many of his students, through his instruction, successfully passed the examination and attained high official positions. See Wang's epitaph "Wan Lü-chi mu-chih-ming" 王履吉墓誌銘 (Epitaph of Wang Ch'ung), composed by Wen Cheng-ming, found in Wen's *Fu-t'ien chi* 甫田集 (Wen Cheng-ming's Anthology), *chüan* 卷 (chapter) 31, p. 1b (new page no. 768). Wen Cheng-ming himself failed ten times, from 1495–1522, to pass the provincial test. For more information on this matter, see Marc F. Wilson and Wong Kwan S. 黃光實, *Friends of Wen Cheng-ming: A View from the Crawford Collection* (New York: China House Gallery, 1974), pp. 24–25.

83  Another well-known case during T'ang Hsia-min's period was Hua Ch'eng 華珵 (1438–1514), a member of the prominent Hua family in Wu-hsi 無錫. See *Dictionary of Ming Biography, 1368–1644*, vol. 1, p. 648.

## 5. Wu Wei 吳偉
*(1459–1508)*
*Ming dynasty (1368–1644)*

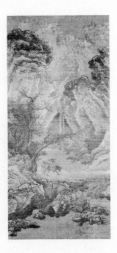

### Travelers on a Mountain Pass
*Kuan-shan hsing-lü*
*(Travelers on a Mountain Pass)*
關山行旅

1  This old label, as it was of little signifi-
cance, was removed when the work was
remounted in 1993.

2  Yang An-tao's name is recorded in a work
by Xia Wenyan (Hsia Wen-yen) 夏文彥
(active mid-14th century), *Tuhui baojian*
*(T'u-hui pao-chien)* 圖繪寶鑑 (Precious Mir-
ror of Painting), preface dated 1365, *juan*
*(chüan)* 卷 (chapter) 3, reprinted in Yu
Anlan 于安瀾, comp., *Huashi congshu*
*(Hua-shih ts'ung-shu)* 畫史叢書 (Com-
pendium of Painting History), vol. 3
(Shanghai: Renmin Meishu Chubanshe,
1962), p. 88. Since the painters in this book
are chronologically arranged and Yang An-
tao's name is found at the end of the
Northern Sung section, it is safe to say
that this painter was active around the
early twelfth century, during Emperor Hui-
tsung's 徽宗 reign (1101–26). A follower of
the great master Fan K'uan 范寬 (active
990–1030), he is known for his excessive
use of dark ink. However, Yang An-tao has
no relationship with this painting, which
stylistically belongs to the fifteenth cen-
tury, to the middle Ming dynasty. In order
to deliberately create an aged effect, the
person who added the spurious signature
most likely added the blurry seal under-
neath it.

3  This *p'ao-ch'uan* collecting seal, which is
not found on any other old painting, has
not been connected to any known collec-
tor. Since it is placed directly under the
blurry seal, beneath the spurious signature
of Yang An-tao, it was probably added by
the same forger.

4  The *tzu* of the collector Pi Yüan 畢沅
(1730–97) was Hsiang-heng 纕蘅 (a fragrant
plant on a sash) and his *hao* was Ch'iü-fan
秋颿 (an autumn sail). He was a native of
Chen-yang 鎮洋 a small town within the
present-day city of Tai-ts'ang 太倉, in the
northwest area of Shanghai. In ancient
times, it was located east of the town of
Lou-t'ang 婁塘. Thus, Pi Yüan's hometown
was often referred to as Lou-tung 婁東,
meaning the east side of Lou-t'ang. Pi
Yüan and his younger brother, Pi Lung 畢
瀧 (active c. second half of 18th century),
were well-known connoisseurs and active
collectors of the Ch'ien-lung 乾隆 period
(1736–1936). For a brief biography of Pi
Yüan, see Arthur W. Hummel, ed., *Emi-
nent Chinese of the Ch'ing Period*
*(1644–1912)*, vol. 2 (Washington, D.C.:
United States Government Printing Office,
1943–44), pp. 622–25. Pi Yüan's seal on the
Michigan scroll, *Lo-tung Pi Yüan chien-
ts'ang*, is published in Shanghai Museum,
*Zhongguo shuhuajia yinjian kuanshi*
*(Chung-kuo shu-hua-chia yin-chien k'uan-
shih)* 中國書畫家印鑑款識 (Signatures and
Seals of Chinese Painters and Calligra-
phers), vol. 2 (Shanghai: Wenwu Chuban-
she, 1987), no. 14, p. 892.

5  The *tzu* of the collector Ch'en Ch'ung-pen
陳崇本 (active end of 18th century) was Po-
kung (伯恭); he was from Shang-ch'iu 商丘
in Honan province. He earned his *chin-
shih* degree in 1775 during the Ch'ien-lung
reign. A minor painter and calligrapher, he
was a close friend of the famous calligra-
pher Weng Fang-kang 翁方綱 (1733–1818).
See Yu Jianhua 于劍華 et al., *Zhongguo
meishujia renming cidian (Chung-kuo
mei-shu-chia jen-ming tz'u-tien)* 中國美術
家人名詞典 (A Biographical Dictionary of
Chinese Artists) (Shanghai: Renmin
Meishu Chubanshe, 1981), p. 1018.

6  Pi Yüan's collecting seal, *Ch'iü-fan shu-
hua tu-chang*, is reproduced in *Chung-kuo
shu-hua-chia yin-chien k'uan-shih* 中國書
畫家印鑑款識 (Signatures and Seals of Chi-
nese Painters and Calligraphers), vol. 2, no.
10, p. 892. Two seals of Pi Yüan, bearing
the same characters, are found in this
book. The smaller one appears on Wu
Wei's painting at the University of Michi-
gan.

7  The primary information about Wu Wei is
found in Zhou Hui (Chou Hui) 周暉 (active
early 17th century), *Jinling suoshi (Chin-
ling so-shih)* 金陵瑣事 (Trivial Notes of
Nanking), preface dated 1610, *juan (chüan)*
卷 (chapter) 3, facsimile reprint (Beijing:
Wenxue Guoji Kanxingshe, 1955), pp.
133b–137a, and in Zhu Mouyin (Chu Mou-
yin) 朱謀垔 (active early 17th century),
*Huashi huiyao (Hua-shih hui-yao)* 畫史會

要 (An Assemblage of Distinguished Fig-
ures in Painting History), 1st edition dated
1631, *juan (chüan)* 卷 (chapter) 4,
reprinted in Lu Fusheng 盧輔聖, et al.,
comps., *Zhongguo shuhua quanshu
(Chung-kuo shu-hua chüan-shu)* 中國書畫
全書 (The Complete Collection of Books
on Chinese Painting and Calligraphy), vol.
4 (Shanghai: Shanghai Shuhua Chubanshe,
1992), p. 565.

8  The name of the duke Wu Wei met in
Nanking was Chu I 朱儀 (1427–96). His
daughter married the famous scholar-offi-
cial Li Tung-yang 李東陽 (1447–1516).
Chu I inherited the title from his ancestor
Chu Neng 朱能 (1370–1406), who was a
trusted general of Chu Yüan-chang 朱元章
(1328–98), the founder of the Ming
dynasty. For more on the relationship
between Chu I and Li Tung-yang, see
L. Carrington Goodrich and Fang Chao-
ying, eds., *Dictionary of Ming Biography,
1368–1644*, vol. 1 (New York and London:
Columbia University Press, 1976), p. 879.
See also Jiao Hong (Chiao Hung) 焦竑
(1541–1620), comp., *Guochao xianzhenglu
(Kuo-chao hsien-cheng-lu)* 國朝獻徵錄
(Biographies of Famous Individuals of the
Ming Dynasty), *juan (chüan)* 卷 (chapter)
5, reprint (Shanghai: Shanghai Shudian,
1987), pp. 51–55 (also listed as pp. 162–64).
Wu Wei's life and artistic career are
recorded in Ku Ch'i-yüan's 顧起元 *Kezuo
zhuiyu (K'o-tso chui-yü)* 客座贅語 (Notes
on Miscellaneous Subjects from the Con-
versations of My Guests), postscript dated
1618, *juan (chüan)* 卷 (chapter) 7, reprint
(Beijing: Zhonghua Shuju Chubanshe,
1991), pp. 174–75.

9  Among the people Wu Wei met in
Nanking through the recommendation of
Duke Chu of Cheng-kuo was T'ai-fu Li-pu
Wang-kung 太傅吏部王公, or "The Grand
Guardian of the Heir Apparent and the
Minister of Personnel, Mr. Wang." This
Mr. Wang was evidently Wang Shu 王恕
(1416–1508), who was made Minister of
War in Nanking in 1478 in addition to
serving as a member of the triumvirate. In
1487, he was appointed Minister of Per-
sonnel in Peking. See *Dictionary of Ming
Biography, 1368–1644*, vol. 2, pp. 1416–19.
Another high official Wu Wei met was
T'ai-pao P'ing-chiang po Ch'en kung, 太保
平江伯陳公, or "The Senior Guardian of
the Heir Apparent, Earl of P'ing-chiang."
This official's name was Ch'en Jui 陳鋭
(1439–1502), a general who inherited his
title from his grandfather Ch'en Hsüan 陳
瑄 (1365–1433). See *Kuo-chao hsien-
cheng-lu* 國朝獻徵錄 (Biographies of
Famous Individuals of the Ming Dynasty),
*juan (chüan)* 卷 (chapter) 9, pp. 27–28 (or
pp. 295–96). The third official with whom

16 Wu Wei became acquainted was T'ai-pao Hsin-ning po T'an kung 太保新寧伯談公, or "The Earl of Hsin-ning, whose name was T'an." This person's background is obscure.

10 In Peking, Wu Wei met Tai-shih Ying-kuo-Chang kung 太師英國張公, or "The Grand Preceptor, Duke Chang of Ying-kuo." This official is most likely Chang Mao 張懋 (1441–1515), who at the age of eight succeeded his father, Duke Chang Fu 張輔 (1375–1499). Chang Fu earned the dukedom by serving as an imperial advisor and a senior general in the Annam campaigns. See *Dictionary of Ming Biography, 1368–1644*, vol. 1, p. 67. The second official in Peking was Tai-fu Pao-kuo-kung Chu 太傅保國朱公, or "The Grand Guardian of the Heir Apparent, Duke Chu of Pao-kuo." This referred to Chu Yung 朱永 (1429–96), who headed the Peking training corps and assumed the title in 1479 after he successfully attacked the Jurchen land in Manchuria. See *Dictionary of Ming Biography, 1368–1644*, vol. 1, p. 536. The last official was Fu-ma tu-wei Chou-kung 駙馬都尉周公, or "The Imperial Son-in-law and Colonel whose name was Chou." This must have been Chou Teh-chang 周德章 (active 16th century), who married Emperor Cheng-hua's sister, Ch'ung-ch'ing kung-chu 重慶公主, or Princess Ch'ung-ch'ing. See *Kuo-ch'ao hsien-cheng-lu* 國朝獻徵錄 (Biographies of Famous Individuals of the Ming Dynasty), *chüan* 卷 (chapter) 4, p. 15 (or p. 132).

11 Emperor Hsien-tsung's name was Chu Chien-shen 朱見深. His biography is found in *Dictionary of Ming Biography, 1368–1644*, vol. 1, pp. 298–304.

12 The Imperial Embroidered Uniform Guard was formally established in 1382 under the first emperor of the Ming dynasty, Chu Yüan-chang, though this unit had been in existence as early as the 1360s. It acted as the emperor's secret agent service and had absolute authority over officials and commoners. Wu Wei's assignment to this unit did not mean that the emperor wanted to use him as a spy; instead, such an appointment demonstrated the emperor's trust in and favor toward a person close to him. See *Hanyu dacidian* (*Han-yü ta-tz'u-tien*) 漢語大詞典 (Chinese Terminology Dictionary), vol. 11 (Shanghai: Hanyu Dacidian Press, 1988), pp. 1332–33, s.v. "*Jinyiwei* (*chin-i-wei*) 錦衣衛." The most detailed information on this government department and its questionable practices is found in Shen Teh-ch'ien's 沈德符 (1578–1642) *Wan-li yeh-huo-pien* 萬曆野獲編 (A Collection of Notes from Unofficial Sources), preface dated 1606, *juan* (*chüan*)

卷 (chapter) 21, reprint, vol. 2 (Beijing: Zhonghua Shuju, 1959), pp. 532–33.

13 The Jen-chih 仁智 Palace of the Ming dynasty was a large hall located outside of the Pao-ning 寶寧 Gate of the imperial city in Peking. Its name was derived from the saying *Chih-che le-shui, jen-che le-shan* 智者樂水, 仁者樂山, or "the wise find pleasure in rivers and the good find pleasure in mountains," a statement by Confucius found in his *Lun-yu* 論語 (Analects). The statement represents the outlook favoring nature in quiet retirement. See *Han-yü ta-tz'u-tien* 漢語大詞典 (Chinese Terminology Dictionary), vol. 1, p. 1099, s.v. "*Renzhiju* (*Jen-chih chü*) 仁智居" and "*Renzhidian* (*Jen-chih tien*) 仁智殿." The Jen-chih Palace was used specifically for storage of the imperial coffins before the formal interment. A possible reason for choosing this palace for a court painter may be that the hall was empty most of the time, providing ample space in which Wu Wei could freely execute large paintings. Other sources testify that this palace was also used as a meeting place. See Sun Ch'eng-tze 孫承澤 (1592–1676), *Ch'un-ming meng-yü-lu* 春明夢餘錄 (A Record of Dreams in Spring Time), *chüan* 卷 (chapter) 11 (Hong Kong: Lung-men Bookstore, 1965), p. 1. For the best source of information on the various palaces inside the Forbidden City where artists worked during the Ming dynasty, see *Wan-li yeh-huo-pien* 萬曆野獲編 (A Collection of Notes from Unofficial Sources), *chüan* 卷 (chapter) 9, vol. 1, pp. 249–50.

14 On Wu Wei's handscroll *Liu-min t'u* 流民圖 (The Homeless People), at the British Museum, Wu Wei inscribed: "*Chih Wen-hua-tien chin-i Wu Wei* 值文華殿錦衣吳偉" (Wu Wei, an Imperial Embroidered Uniform Guard on duty at the Wen-hua Palace). The Wen-hua Palace is located at the southeast corner in the Outer Court of the Forbidden City. It is close to the famous Wen-yüan ko 文淵閣 (Literary Profundity) Palace where the Imperial Encyclopedia was stored during the Ch'ien-lung period (1736–96). For Wu Wei's handscroll, *The Homeless People*, see Suzuki Kei 鈴木敬, comp., *Comprehensive Illustrated Catalog of Chinese Paintings*, vol. 2 (Tokyo: University of Tokyo Press, 1982), no. E15-246, p. 206. This work, although less well known than the famous painting of the same title by his contemporary, Chou Ch'en 周臣 (c. 1450–c. 1535), provides a vivid record of the deplorable conditions of the poor during the fifteenth century. It is interesting to note that, based on the signature, Wu executed this painting for the emperor. While Wu intended the painting as a serious portrait of the unfortunate, the

emperor, in all probability, was impressed only by the lightheartedness of the depiction.

15 The *ch'uan-feng* was a method, adopted by the Ming emperors, of appointing a person to a government position without going through the qualifying examinations conducted by the Ministry of Personnel. At first, this practice was limited to service personnel such as physicians, artists, carpenters, jewelers, astrologers, and clergy. After 1475 this type of appointment not only became more frequent but also served as a thoroughfare to a government position through bribes of influential eunuchs or court ladies. See *Dictionary of Ming Biography, 1368–1644*, vol. 1, p. 301.

16 Emperor Hsien-tsung's father was captured in 1449 by the Oirat, a northern nomad tribe, when Hsien-tsung was only twenty months old. He was raised by his foster grandmother, a powerless empress. When his uncle assumed the throne, his position as heir apparent became even more precarious, and three years later he was replaced by his uncle's own son. The new heir apparent died in 1453, and the position of heir was left open for more than three years. There was speculation and intrigue at the court as to the future of this young prince. Treated as a potential pretender, he had a troubled and turbulent childhood. He acquired the habit of stuttering, probably as a consequence of this trauma. After he grew up and became the emperor, he was manipulated by court ladies and trusted eunuchs more than generals and high officials. The most notorious eunuch in this circle was Wang Chih 汪直 (active 1476–81), who controlled the imperial secret service and falsely persecuted many upright officials. A member of the Yao 猺, an aboriginal minority in the southwest region, he was the most powerful person at court during the Ch'eng-hua period. See *Dictionary of Ming Biography, 1368–1644*, vol. 1, pp. 298–304, for biographical material on Emperor Hsien-tsung, and vol. 2, pp. 1357–58, for Wang Chih's life story.

17 The Ch'in-huai 秦淮 River flows from the southeast side of the city of Nanking and proceeds into the Yangtze River along the west side of the city. Since ancient times, the banks have been crowded with courtesans, singing girls, wine shops, and restaurants, with gaily painted pleasure boats inundating the water. The river area became the most famous entertainment quarter in all of China. The poet Tu Mu 杜牧 (803–52) of the T'ang dynasty (618–905) composed a well-known poem, *P'o Ch'in-huai* 泊秦淮 (Anchored at the Ch'in-huai River), which reads: "Under the hazy

moonlight, the chilly water was enveloped in permeating mists. My boat was anchored at dusk near the wine shops at the Ch'in-huai River. The courtesans, unaware of the grief of the people of a conquered nation, sang across the water the decadent song of *Flowers at the Rear Quarter* [the anus]." (煙籠寒水月籠沙. 夜泊秦淮近酒家. 商女不知亡國恨. 隔江猶唱後庭花.) Despite such an unfavorable description, the entertainment quarter at Ch'in-huai during the Ming period also harbored eminent writers and artists. Many of the famed courtesans stationed there were also talented painters. Among them were Ma Shou-chen 馬守真 (1548–1604) and Hsüeh Su-su 薛素素 (late 16th–mid-17th century). For their works, see Marsha Weidner et al., *Views from the Jade Terrace: Chinese Women Artists, 1300–1912* (Indianapolis: Indianapolis Museum of Art, 1988).

18  Emperor Hsiao-tsung's name was Chu Yu-t'ang 朱祐樘 (1470–1505). See *Dictionary of Ming Biography, 1368–1644*, vol. 1, pp. 375–81.

19  Emperor Hsiao-tsung's sentimental attachment to Wu Wei was understandable. The emperor was the son of a slave girl at the palace. The girl's whole family was killed by the Ming army because they were members of an insurgent aboriginal group. She was brought to the palace as a prisoner-of-war at a young age, and her family name has never been positively identified. Once she was found to be pregnant by the emperor, a displaced empress hid her for many years to evade the wrath of a fanatically jealous court lady who did not want to share the emperor's favor. The slave girl died under suspicious circumstances when her son was only five years old. Raised as an orphan in a treacherous environment, the prince conducted himself with restraint, practicing Confucian ethics and principles. He had a warm and harmonious relationship with his officials. In all likelihood, he would have appreciated Wu Wei's honest, candid, and forthright character, as well as his brilliant artistic talent.

20  This painting by Wu Wei is reproduced in Mu Yiqin 穆益勤, *Mingdai gongting yu Zhepai huihua xuanji (Ming-tai kung-t'ing yü Che-p'ai hui-hua hsüan-chi)* 明代宮廷與浙派繪畫選集 (A Selection of Ming Dynasty Court Paintings and Che School Paintings) (Beijing: Palace Museum, 1983), no. 68. Executed only five years before he passed away, this significant work represents Wu Wei's last period of productivity. Moreover, the men in the picture may be portraits of real people. For example, the first figure on the left side, handsome and

wearing a different kind of cap from the other men in the painting, is probably T'ang Yin, who at that time had already earned a *chü-jen* degree. The man sitting between the two women is probably Chu Yün-ming 祝允明 (1460–1526), one of the most celebrated calligraphers in Suchou. He was known for his heavy beard, which is conspicuous in the painting.

21  This handscroll, currently at the Guangdong Provincial Museum, is entitled *Fang Li Gonglin xibingtujuan (Fang Li Kung-lin hsi-ping t'u-chüan)* 仿李公麟洗兵圖卷 (After Li Gonglin's Handscroll of Military Victory). This vibrant short handscroll depicts celestial generals holding their weapons amid clouds and thunderbolts. Shen Chou admired this work and put two of his seals on it. Unfortunately, the first half of the handscroll was separated and has been missing since the end of World War II. The second half is reproduced in Yang Han 楊涵, chief ed., *Zhongguo meishu quanji (Chung-kuo mei-shu chüan-chi)* 中國美術全集 (The Great Treasury of Chinese Fine Arts), vol. 6 (Shanghai: Renmin Meishu Chubanshe, 1989), no. 125, pp. 144–47. The recipient of Wu Wei's scroll, Huang Lin, possessed an excellent collection that included a famous handscroll, dated 1360, by Tsou Fu-lei 鄒復雷 of the Yüan dynasty (1280–1368) entitled *Ch'un-hsiao-hsi* 春消息 (A Breath of Spring), now at the Freer Gallery of Art, Washington, D.C. It is reproduced in *Masterpieces of Chinese and Japanese Art: Freer Gallery of Art Handbook* (Washington, D.C.: Freer Gallery of Art, 1976), p. 52. Huang Lin's collecting seals are reproduced in *Chung-kuo shu-hua-chia yin-chien k'uan-shih* 中國書畫家印鑒款識 (Signatures and Seals of Chinese Painters and Calligraphers), vol. 2, p. 1142.

22  See *Chung-kuo mei-shu chüan-chi* 中國美術全集 (The Great Treasury of Chinese Fine Arts), vol. 6, no. 126, p. 148. This elegant handscroll, executed in the *pai-miao* 白描 (ink line drawing) technique, depicts a literary gathering held in Nanking in 1505 for an official named Lung Chih-jen 龍致仁, who was leaving the city to take a government job in Chekiang. According to a colophon at the end of this scroll, twenty-two people attended the farewell party. Other colophons came from many famous scholars in Nanking. Apparently Wu Wei was well accepted by and associated with the literati of the city.

23  This handscroll, *Changjiang wanli tujuan (Ch'ang-chiang wan-li t'u-chüan)* 長江萬里圖卷 (The Ten Thousand Miles of the Yangtze River) is reproduced in Palace

Museum Editorial Committee, *Zhongguo lidai huihua (Chung-kuo li-tai hui-hua)* 中國歷代繪畫 (Paintings of the Past Dynasties) in the series *Gugong bowuyuan canghuaji (Ku-kung po-wu-yüan ts'ang-hua chi)* 故宮博物院藏畫集 (Paintings in the Collection of the Palace Museum), vol. 5 (Beijing: Renmin Meishu Chubanshe), pp. 140–47.

24  Emperor Wu-tsung's name was Chu Hou-chao 朱厚照. His biography can be found in *Dictionary of Ming Biography, 1368–1644*, vol. 1, pp. 307–15.

25  See "I-miao chi" 藝妙記 (A Record of Ingenious Art), *chüan* 卷 (chapter) 20, pp. 3–5, in Ho Ch'iao-yüan's 何喬遠 (active first half of 17th century), comp., *Ming-shan ts'ang* 名山藏 (Treasures in a Famous Mountain), reprint, vol. 19 (Taipei: Ch'eng-wen Press, 1971), pp. 5870–72.

26  See *Chin-ling suo-shih* 金陵瑣事 (Trivial Notes of Nanking), *chüan* 卷 (chapter) 2, pp. 103 a & b. There is a fan painting by Li Chu reproduced in *Ming-tai kung-t'ing yü Che-p'ai hui-hua hsüan-chi* 明代宮廷與浙派繪畫選集 (A Selection of Ming Dynasty Court Paintings and Che School Paintings), cat. no. 89.

27  Wu Wei's painting, *The Immortal of the Northern Sea*, bearing Shen Chou's calligraphy and depicting an enlightened Taoist riding on a gigantic turtle, is published in Wen C. Fong and James C. Y. Watt, *Possessing the Past: Treasures from the National Palace Museum, Taipei* (New York: Metropolitan Museum of Art, and Taipei: National Palace Museum, 1996), pl. 181, p. 365.

28  A prominent example of Wu Wei's figure painting is his *Lady Carrying a Lute* at the Indianapolis Museum of Art. See Richard M. Barnhart, *Painters of the Great Ming: The Imperial Court and the Zhe School* (Dallas: Dallas Museum of Art, 1993), cat. no. 64, p. 228. Other masterpieces include the above-mentioned *Ko-wu-t'u* 歌舞圖 (A Picture of Singing and Dancing) and his handscroll, *Wulingchun (Wu Ling-ch'un)* 武陵春 at the Palace Museum, Beijing, reproduced in *Ming-tai kung-t'ing yü Che-p'ai hui-hua hsüan-chi* 明代宮廷與浙派繪畫選集 (A Selection of Ming Dynasty Court Paintings and Che School Paintings), cat. no. 71. Wu Ling-ch'un was a courtesan whose real name was Ch'i Hui-chen 齊慧真.

29  Given that the painting style of the Che school evolved from the imperial academic court paintings of the Sung dynasty, this convention is probably based on ideals established in the Sung court. It is well known that Emperor Hui-tsung demanded

**Wu Wei**
**Travelers on a Mountain Pass**
*continued*

**6. Anonymous**
*Ming dynasty (1368–1644)*

18 certain rationales or rules for paintings. For example, spring flowers should not be present in autumn scenery, the peacock had to begin his walk with the left foot, and so on. Thus the presence of snow was likely suggested by the standard convention of the absence of the soles of the shoes.

30 This scroll was first identified by Dr. Richard M. Barnhart in 1985 and was later included in his exhibition and published in his catalogue, *Painters of the Great Ming: The Imperial Court and the Zhe School*, cat. no. 66, p. 233.

31 The use of a stepladder in painting is more common for wall paintings, especially for painting religious murals. This is because religious paintings usually have drafts that are traced onto the wall. Artists climb up the stepladder or raised planks and work slowly by following the guidelines. For Wu Wei, who had to move around, evaluate his composition, and wield his brush, a stepladder would have been impractical.

32 Sung dynasty landscape scrolls are, generally speaking, the largest hanging scrolls.

33 See *Painters of the Great Ming: The Imperial Court and the Zhe School*, cat. no. 66, p. 233.

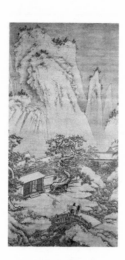

**Traveling at Dawn in the Mountains after Snow**
*Hsüeh-chi hsiao-hsing*
*(Traveling at Dawn after Snow)*
雪霽曉行

1 This imperial seal is supposed to have belonged to the Emperor Hsüan-teh (r. 1426–35) of the Ming dynasty. His name was Chu Chan-chi 朱瞻基 (1399–1435), the fifth ruler of the Chu imperial family. For his brief biography, see L. Carrington Goodrich and Fang Chaoying, eds., *Dictionary of Ming Biography, 1368–1644*, vol. 1 (New York and London: Columbia University Press, 1976), pp. 279–89. A strong and conscientious administrator, the emperor was also a talented poet and painter. It was under his patronage that the imperial bronzes and ceramics produced during his reign become renowned. However, the seal that appears on this scroll is apparently forged, as it is not recorded nor found on other paintings.

2 Although there are several figures in Chinese history who adopted this name, it is unclear who exactly the owner of this seal was. See Chen Naiqian (Ch'en Nai-ch'ien) 陳乃乾, *Shiming biehao suoyin* (*Shih-ming pieh-hao so-yin*) 室名別號索引 (An Index of Sobriquets) (Beijing: Zhonghua Shuju, 1982), p. 52.

3 Chang Wen-t'ao (1764–1814) was an official and minor artist of the Ch'ing dynasty. For more information on Chang, see Arthur W. Hummel, ed., *Eminent Chinese of the Ch'ing Period (1644–1912)*, vol. 1 (Washington, D.C.: United States Government Printing Office, 1943–44), pp. 59–60.

4 It is unclear who exactly was the owner of this seal.

5 As the second character of this seal is indiscernible, the owner is difficult to establish.

6 The owner of this seal is unidentified. Possibly it belonged to Chang Wen-t'ao.

7 For a discussion of the Chinese literati painters under the Mongols, see Sherman E. Lee and Wai-kam Ho, *Chinese Art under the Mongols: The Yüan Dynasty (1279–1368)* (Cleveland: Cleveland Museum of Art, 1968), pp. 79–112; see also Chang Kuang-pin 張光賓, *Yüan ssu-ta-chia* 元四大家 (Four Great Masters of the Yüan Dynasty) (Taipei: National Palace Museum, 1975); and Wen C. Fong et al., *Images of the Mind: Selections from the Edward L. Elliott Family and John B. Elliott Collections of Chinese Calligraphy and Painting at the Art Museum, Princeton University* (Princeton: Art Museum, Princeton University, 1984), pp. 105–29.

8 The first emperor of the Ming dynasty, Chu Yüan-chang 朱元璋 (r. 1368–98), emerged from humble origins. Having never received a formal education, he introduced a strict practical government. During his reign, Nanking was chosen as the capital. He was succeeded by his grandson, Emperor Hui-ti 惠帝 (r. 1399–1402). In 1403, however, the fourth son of the Ming founder, Chu Ti 朱棣 (1360–1424), usurped the throne; he was also the uncle of the young emperor. He moved the capital to Peking in 1409. For a record of this historical event, see *Dictionary of Ming Biography, 1368–1644*, vol. 1, pp. 355–65, s.v. "Chu Ti."

9 Protesting Mongol rule by withdrawing from society was more prevalent in the south because people in the north had lived under occupation for several hundred years, from the tenth to the thirteenth century, under the Liao 遼 and Chin 金 Tartars. Consequently, almost all of the Yüan masters were from the south. These southern masters had a tremendous influence on the Wu school painters in Suchou, who not only inherited the Yüan masters' artistic style and technique but also embraced their philosophy and ethics. During the sixteenth century, the Wu school, initiated by Shen Chou 沈周 (1427–1509), under the auspices of Wen Cheng-ming 文徵明 (1470–1559) became the most respected painting school and style.

10 See Shen Hao 沈顥 (1586–after 1661), *Huachen* (*Hua-ch'en*) 畫塵 (Dusts of Painting), reprinted in *Zhongguo shuhua quanshu* 中國書畫全書 (The Complete Collection of Books on Chinese Painting and Calligraphy), vol. 4, p. 814. Shen states

that painters such as Chao Kan 趙幹 (active c. second half of 10th century), Chao Po-chü 趙伯駒 (active 12th century), Chao Po-su 趙伯驌 (1124–82), Ma Yüan 馬遠 (active c. 1160–after 1225), Hsia Kuei 夏圭 (active c. 1200–c. 1240), and others such as Tai Chin 戴進, Wu Wei 吳偉 (1459–1508), and Chang Lu 張路 (c. 1490–c. 1563) are "nothing but a wild fox mischievously imitating the meditation of Chan Buddhist monks [displaying the presence of form with no sincere substance]. Their legacy is as worthless as a fox-monk who hands down his dusty mantle and alms bowl to his followers." (若趙幹, 伯駒, 伯驌, 馬遠, 夏圭, 以至戴文進, 吳小仙, 張平山輩, 日就狐禪, 衣鉢塵土.) It was not until the twentieth century that this label was recognized as arbitrary and that Tai Chin and his accomplishments were finally recognized. See Mary Ann Rogers, "Visions of Grandeur: The Life and Art of Dai Jin," in *Painters of the Great Ming: The Imperial Court and the Zhe School*, pp. 127–94. See also *Ming-hua-lu* 明畫錄 (Painters of the Ming Dynasty), *chüan* 卷 (chapter) 3, pp. 32–33. This author commented on the work by Chiang Sung 蔣嵩 (active 16th century), a follower of Tai Chin, by saying: "[Chiang Sung] was fond of utilizing dark-scorched ink and dry-brush work, which greatly pleased the eyes of his contemporaries. His use of the brush was rough and undisciplined and strayed from proper standards. Along with Cheng Tien-hsien (?), Chang Fu-yang (Chang Fu 張復, 1403–90), Chung Ch'in-li (Chung Li 鍾禮, active late 15th century), and Chang Ping-shan (Chang Lu), he persisted in the wild and outrageous expression of the heterodox [Che] school." (蔣嵩, 字三松. 江寧人. 山水派宗吳偉. 喜用焦墨枯筆. 最入時人之眼. 然行筆粗莽, 多越矩度. 時與鄭顛仙, 張復陽, 鍾欽禮, 張平山, 徒逞狂態目為邪學.) The comments on Che painters by still another Ming scholar, Ho Liang-chün 何良俊 (1506–73), are even more harsh. Ho's remarks are found in his *Ssu-yu-chai ts'ung-shuo* 四友齋叢説 (The Collected Notes at Ho's Studio of Four Friends), preface dated 1569, *chüan* 卷 (chapter) 29, reprinted in *Yuan Ming shiliao piji congkan* (*Yüan-Ming shih-liao pi-chi ts'ung-k'an*) 元明史料筆記叢刊 (A Series of Literary Sketches on Historical Materials of the Yüan and Ming Dynasties) (Beijing: Zhonghua Press, 1959), p. 269. It reads: "[As to the paintings by] Chiang San-sung (Chiang Sung) and Wang Meng-wen (Wang Chih 汪質) in Nanking, Kuo Ch'ing-kuang (Kuo Hsü 郭詡, 1456–after 1529) in Kiangsi and Chang P'ing-shan (Chang Lu) from the north, I would not even use them as dust rags for fear of disgracing my furniture!" (如南京之

蔣三松, 汪孟文. 江西之郭清狂. 北方之張平山. 此等雖用以揩抹, 猶懼辱吾之几揚也!) Although Tung Ch'i-ch'ang respected Tai Chin's accomplishment, his attitude toward the Che school was brusque. Yet he remarked, rather sadly, that with each passing day the Che school was being wiped out and that this school should never have accepted those painters who were sugary smooth, crookedly heretical, and tastelessly vulgar. (苦浙派日就漸滅, 不當以甜邪俗賴者, 係之彼中也.) See Tung's "Huayuan" 畫源 (The Derivation of Painting) in his *Hua-ch'an-shih sui-pi* 畫禪室隨筆 (Informal Notes at the Painting-Ch'an Studio), p. 46.

11 Many painting catalogues of this period included work by women painters and famous prostitutes while totally ignoring skilled works by capable Che school artists. For example, T'ao Yüan-tsao 陶元藻 (1716–1801), *Yuehua jianwen* (*Yüeh-hua chien-wen*) 越畫見聞 (Information about Painters of the Yüeh or Chekiang Region), preface dated 1795, reprinted in Yu Anlan 于安瀾, comp., *Huashi congshu* (*Hua-shih ts'ung-shu*) 畫史叢書 (Compendium of Painting History), vol. 6 (Shanghai: Renmin Meishu Chubanshe, 1962), includes two female painters of the Ming dynasty while totally ignoring Tai Chin 戴進 (1388–1462), the founder of the Che school. Works by courtesans such as Hsüeh Su-su 薛素素 (late 16th–mid-17th century) and Ma Shou-chen 馬守真 (1548–1604) appear in Pien Yüng-yü 卞永譽 (1645–1712), *Shih-ku t'ang shu-hua hui-k'ao* 式古堂書畫彙考 (A Corpus of Studies on Painting and Calligraphy at Pien Yüng-yü's Shih-ku-t'ang Studio), preface dated 1682, facsimile reprint of the original K'ang-hsi edition, 4 vols. (Taipei: Cheng-chung Press, 1958); and also in Sun Ch'eng-tse 孫承澤 (1592–1676), *Ken-tzu hsiao-hsia chi* 庚子銷夏記 (A Record of Calligraphy and Painting Compiled in the Summer of 1660), preface dated 1755 and 1761 (N.p, n.d.), in which no works by Che school professional painters were included.

12 Suzuki Kei 鈴木敬, former professor at Tokyo University, is a pioneer in this realm of study. In 1968, he published *Mindai Kaigashi no kenkyu: Seppa* 明代繪畫史の研究: 浙派 (A Study of the Painting History of the Ming Dynasty: The Che School) (Tokyo: n.p., 1968). Later, Shimada Hidemasa 島田英誠 completed a thorough study of one particular Ming-era Che painter in his article "Sho So no san-suigawa tsuite 蔣嵩の山水畫について" (On the Landscape Paintings by Chiang Sung), in the journal *Toyo Bunka Kenkyujo kiyo* 東洋文化所記要 (Memoirs of the Institute

of Oriental Culture), vol. 78 (Tokyo: Institute of Oriental Culture, Tokyo University, March 1979), pp. 1–53. By the early 1980s, Chen Fang-mei 陳芳妹, of the National Palace Museum, Taipei, had completed her M.A. thesis on Tai Chin. Her work was later published as a book, *Tai Chin yen-chiu* 戴進研究 (Research on Tai Chin) (Taipei: National Palace Museum, 1981). In China, Mu Yiqin 穆益勤 published *Mingdai gongting yu Zhepai huihua xuanji* (*Ming-tai kung-t'ing yü Che-p'ai hui-hua hsüan-chi*) 明代宮廷與浙派繪畫選集 (A Selection of Ming Dynasty Court Paintings and Che School Paintings) (Beijing: Palace Museum, 1983); two years later he compiled the *Mingdai yuanti zhepai shiliao* (*Ming-tai yüan-t'i Che-p'ai shih-liao*) 明代院體浙派史料 (Historical Material of the Imperial Court Style and the Che School of the Ming Dynasty) (Shanghai: Renmin Chubanshe, 1985). The latter includes useful information found in old Chinese books. One Western scholar who contributed greatly to this subject is Richard M. Barnhart. In 1993, he published the catalogue and organized the exhibition *Painters of the Great Ming: The Imperial Court and the Zhe School* (Dallas: Dallas Museum of Art, 1993). This valuable catalogue contains a study of Tai Chin by Mary Ann Rogers, pp. 127–94. For more publications on Tai Chin, see note 1 of Rogers's article.

13 Ma Pen 馬賁 (active c. 1086–1125) was the great-grandfather of Ma Yüan 馬遠 (active c. 1160–after 1225). He was from Ho-chung 河中, present-day Yung-chi 永濟, in Shansi 山西 province. He was adept at painting scenes positioned near to the viewer, as well as wild geese, monkeys, horses, buffalo, goats, and deer, all in large numbers. The Ma family was well known for their depictions of Buddhist figures. See Deng Chun (Teng Ch'un) 鄧椿 (active second half of 12th century), *Huaji* (*Hua-chi*) 畫繼 (Addendum to the History of Painting), preface dated 1167, *juan* (*chüan*) 卷 (chapter) 7, reprinted in *Hua-shih ts'ung-shu* 畫史叢書 (Compendium of Painting History), vol. 1, pp. 57–58; and in Yu Jianhua 于劍華 et al., *Zhongguo Meishujia Renming Cidian* (*Chung-kuo mei-shu chia jen-ming tz'u-tien*) 中國美術家人名辭典 (A Biographical Dictionary of Chinese Artists) (Shanghai: Renmin Meishu Chubanshe, 1981), p. 773.

14 This type of winter scene is called *wei-lu* 圍爐, or "sitting around a fireplace." It depicts a common winter activity in China—seeking out a warm and comfortable environment on a cold and snowy day. For a clearer depiction of a *wei-lu* scene, see a painting by Liu Jun (Liu Chün) 劉俊,

Anonymous
**Traveling at Dawn in the Mountains after Snow**
*continued*

20    *Xueye fang Pu* (*Hsüeh-yeh fang P'u*) 雪夜訪普 (Emperor Tai-tsung Calling on Chao P'u on a Snowy Night), published in Richard M. Barnhart, *Painters of the Great Ming: The Imperial Court and the Zhe School*, fig. 55, p. 115.

15   See Richard M. Barnhart, "Rediscovering an Old Theme in Ming Painting," *Orientations* 26.8 (Hong Kong: Orientations Magazine, September 1995), pp. 53–54.

16   For a discussion of Tai Chin and his works, see "Visions of Grandeur: The Life and Art of Dai Jin," by Mary Ann Rogers, in Richard M. Barnhart's *Painters of the Great Ming: The Imperial Court and the Zhe School*, pp. 127–94.

17   Tai Chin's father, Tai Ching-hsiang 戴景祥, was twice mentioned as a painter by the writer Lang Ying 郎瑛 (1487–after 1566). According to Lang, on the night Tai Chin was born, his father, who was "adept in handling the five colors" (in other words, a painter), dreamed that a dead friend came to visit him. This friend happened to be a Buddhist figure painter. The father believed that Tai Chin later became a painter because he was the reincarnation of this painter-friend. See Lang Ying, *Qixiu leigao* (*Ch'i-hsü lei-kao*) 七修類稿 (Notes on Seven Categories of Miscellaneous Topics), 1st edition c. second quarter of 16th century, reprinted in 1775, modern version, *juan* (*chüan*) 卷 (chapter) 45, category *Shiwu* (*Shih-wu*) 事物 (Things in General) (Shanghai: Zhonghua Press, 1959 and 1961), p. 661. Lang Ying also stated that during the end of the Yung-lo 永樂 reign (1403–24), the young Tai Chin went to the capital with his father. Although he was already a good painter, he did not receive the recognition he deserved because he was eclipsed by his father's fame as an artist. See Lang Ying, *Qixiu xugao* 七修續稿 (Sequel of Notes on Seven Categories of Miscellaneous Topics), 1st edition sometime after 1566, reprint, *juan* (*chüan*) 卷 (chapter) 6, category *Shiwu* (*Shih-wu*) 事物 (Things in General) (Shanghai: Zhonghua Press, 1961), pp. 838–40. Coming from an antique dealer's family in Hangchou (which happened also to be Tai Chin's hometown), Lang Ying had the cultural background and the right geographical location to know Tai Chin's life better than the other writers of his period. He used the eulogy on Tai Chin's tombstone, composed by an imperial doctor, He Jung (Ho Jung) 賀榮 (active mid-15th century), as his primary source. Tai Chin's biography in Lang Ying's *Qixiu xugao* 七修續稿 is considered the most informative and complete.

18   See "Tai Wen-chin chuan" 戴文進傳 (Biography of Tai Chin), in Chang Ch'ao 張潮 (active 17th century), *Yü Chu hsin-chih* 虞初新誌 (Yü Ch'u's Newly Collected Notes), preface dated 1683, collated by Shen Tzu-ying 沈子英 (Shanghai: Liang-hsi Press, 1924), pp. 150–51. The book states that when Tai Chin was young, he was a metalsmith, possibly a jewelry designer. He could forge gold or silver into realistic figures, animals, and flowers. These exquisite articles were often sold at a price twice as high as those for objects made by other artisans. Tai Chin was proud of this achievement. He was appalled one day when he saw his work being smelted by an artisan to produce new objects. Returning home, he quit his old profession and started to study painting. Since Chang Ch'ao's book contains collected stories and notes from numerous sources, this information must be considered somewhat dubious.

19   Tai Chin went to the capital three times for the purpose of seeking a position at the court. All of his attempts were unsuccessful. The first trip was taken with his father during the end of the Yung-lo 永樂 (1403–24) period, when Tai Chin was in his late twenties or early thirties. He did not succeed because he was overshadowed by his father's fame. See note 10. Tai Chin went to Peking again during the Hsüan-teh 宣德 reign (1426–36), on the recommendation of a certain eunuch, Fu 福太監, who served as the Defense Commissioner of Tai Chin's hometown in Hangchou. Although the exact reason Tai Chin was rejected by the emperor is not clear, the various sources all point to Hsieh Huan 謝環 (active 1368–1437), the emperor's favorite court painter. Jealous of Tai Chin's talent, Hsieh Huan criticized Tai Chin's work in front of the emperor. Some records even indicate that Tai Chin had to flee home from the capital to elude Hsieh's persecution. See the brief biography of Tai Chin in Lang Ying, *Ch'i-hsiu lei-kao* 七修類稿 (Notes on Seven Categories of Miscellaneous Topics), *chüan* 卷 (chapter) 45, category *Shih-wu* 事物 (Things in General), pp. 838–39. Tai Chin went to the capital for the third time under the reign of Emperor Ying-tsung 英宗 (r. 1436–50 and 1457–65), perhaps after Hsieh Huan passed away or retired from the court. At the audition, all the painter-candidates were asked to paint a picture depicting "*Wan-lü chih-tou i-tian-hung*" 萬綠枝頭一點紅 (a red dot among the ten thousand green branches). Tai Chin painted a red-crowned crane perched on the top of pine-filled woods. Although it was an excellent work, the emperor preferred another painting that showed a beautiful woman with dainty red lips standing under banana trees. See ibid., pp.

629–30. As Emperor Ying-tsung reigned twice, this episode must have occurred during the emperor's first reign, when Tai Chin was in his fifties. If this audition had taken place after Ying-tsung resumed his throne in 1457, Tai Chin would have been an old man in his seventies! Finally defeated, Tai Chin went home and stayed there until he died in 1462. Years after his death, his reputation, along with the Che school in general, began to suffer, culminating in the antiprofessional movement of the early seventeenth century. During this time, the Che school painters were branded as heterodox by literati masters.

20   According to a eulogy on Tai Chin's portrait by Wang Chih, the artist in later years passed the time improving himself by indulging in poetry and books and cultivating his temperament by painting freely, applying ink without restraint on silk and paper. See Wang Chih, *I-an wen hou-chi* 抑庵文後集 (Sequel to Collected Writings at Wang Chih's I-an Study), p. 45, s.v. "Tai Wen-chin hua-hsiang tsan" 戴文進畫像贊 (A Eulogy for Tai Chin's Portrait).

21   Tai Chin is sometimes referred to as the foremost professional painter of the Ming dynasty. Comments on Tai Chin's accomplishments include those from several prominent writers: 1) Lu Shen 陸深 (1477–1545) offered this evaluation: "Among the professional painters of the Ming dynasty, Tai Wen-chin (Tai Chin) from Ch'ien-t'ang (Hangchou) should be esteemed as foremost." (本朝畫手, 當推錢塘戴文進為第一.) See Lu Shen, "Ch'un-feng-t'ang sui-pi 春風堂隨筆" (Informal Notes on the Spring-Breeze Hall), in *Yen-shan wai-chi* 儼山外集 (Sequel to Lu Shen's Collected Writings), *chüan* 卷 (chapter) 5 (*Ssu-k'u ch'üan-shu* 四庫全書), p. 1–2; 2) Lang Ying considered Tai "indeed a sage among painters" (誠畫中之聖). See Lang Ying, *Qixiu xugao* 七修續稿 (Sequel to Notes on Seven Categories of Miscellaneous Topics), category *Shiwu* 事物 (Things in General), *juan* (*chüan*) 卷 (chapter) 6, p. 839; 3) The famous Suchou calligrapher Chu Yün-ming 祝允明 (1460–1526), who was a close friend of the Wu School master Wen Cheng-ming, once asserted that "Among the painters of the Ming dynasty, Mr. Tai from Ch'ien-t'ang should be considered foremost. His brush and ink are spontaneous and vigorous. His powerful and expressive style possesses long-lasting fame." (有明畫家, 推錢塘戴進. 筆墨淋漓, 以雄老持名.) See Chu Yün-ming, *Chu-shih chi-lüeh* 祝氏集略 (A Brief Account of Chu Yün-ming's Works) in *Chu-shih shih-wen-chi* 祝氏詩文集 (Anthology of Chu Yün-ming's Writings and Poetry), *chüan* 卷 (chapter) 26,

reprinted in *Ming-tai i-shu-chia chi hui-k'an hsü-pien* 明代藝術家集彙刊續編 (A Sequel to the Collected Works of the Artists of the Ming Dynasty) (Taipei: Central Library, 1971), p. 1635; 4) Ho Liang-chün, who detested the Che school, commented on Tai Chin in his *Ssu-yu-chai ts'ung-shuo* 四友齋叢説 (The Collected Notes at Ho's Studio of Four Friends), *chüan* 卷 (chapter) 29, p. 267. Ho wrote, "Although there are many good painters in this [Ming] dynasty, among the professional painters, Tai Chin was the foremost." (我朝善畫者甚多. 若行家, 當以戴文進為第一.) Even Tung Ch'i-ch'ang 董其昌 (1555–1636), the leader of the anti-professional movement in painting of the early seventeenth century, could not ignore Tai Chin's achievements. He compared Tai Chin with the Great Masters of the Yüan dynasty and wrote: "Among the four Yüan masters, three were from Chekiang: Wang Shu-ming (Wang Meng 王蒙, 1308–85), from Huchou, Huang Tzu-chiu (Huang Kung-wang 黄公望, 1269–1354), from Ch'ü-chou, and Wu Chung-kuei (Wu Chen 吳鎮, 1280–1354), from Ch'ien-t'ang. Only Ni Yüan-chen (Ni Ts'an 倪瓚, 1306–74) was from Wu-hsi [in Kiangsu province]. This is because the ethereal supernatural power of the landscape is more lively in a certain area [in Chekiang] during a certain period of time [in the Yüan period]! Among the famous painters of this dynasty, only Tai Chin was from Hangchou [in Chekiang], and he has been classified as a member of the [unworthy] Che school. (元季四大家, 浙人居其三. 王叔明湖州人. 黄子久衢州人. 吳仲圭錢塘人. 惟倪元鎮無錫人耳! 江山靈氣, 盛衰故有時. 國朝名士, 僅僅戴進為武林人. 已有浙派之目.) See Dong Qichang (Tung Ch'i-ch'ang), "Huayuan" 畫源 (The Derivation of Painting), in *Huachanshi suibi* (*Hua-ch'an-shih sui-pi*) 畫禪室隨筆 (Informal Notes at the Painting-Ch'an Studio), preface dated 1720, reprinted in *Yilin mingzhu congkan* (*I-lin ming-chu ts'ung-k'an*) 藝林名著叢刊 (Collected Famous Writings on the Arts) (Beijing: Beijing Zhongguo Shudian, 1983), p. 46.

22  Tai Chin, adept in almost every category of Chinese painting, was especially known for his Buddhist figures. Unfortunately, *Damo zhi Huineng liudai xiangjuan* (*Ta-mo chih Hui-neng liu-tai-hsiang-chüan*) 達摩至慧能六代像卷 (The Handscroll Depicting the Six Patriarchs of Chan), at the Liaoning Provincial Museum 遼寧博物館, and *Zhongkui yeyou tu* (*Chung-k'uei yeh-yu-t'u*) 鍾馗夜遊圖 (An Evening Excursion of Chung K'uei), at the Palace Museum, Beijing, are perhaps the only two extant examples of his figure

paintings. Both are published in *Painters of the Great Ming: The Imperial Court and the Zhe School*, pp. 142 and 178, respectively. Tai Chin's little-known album leaf, *T'ai-p'ing Lo-shih* 太平樂事 (Happy Events in Peaceful Times) belongs to the National Palace Museum, Taipei. It is an excellent work, depicting a group of men watching a puppet show at a banquet. However, whether it is in fact by Tai Chin is difficult to determine. This album is published in *Painters of the Great Ming: The Imperial Court and the Zhe School*, fig. 53, p. 109. One anecdote recounts that when young Tai Chin went to Nanking for the first time during the early years of the Yung-lo 永樂 period (1403–24), he was a little overwhelmed by the bustling crowd in the capital. At the entrance of the city gate, a porter, who carried Tai Chin's luggage on a bamboo pole, disappeared in a throng of people. Although he got only a glimpse of this person, Tai Chin memorized his appearance. Borrowing a brush from the owner of a wine shop, the young painter did a quick portrait based on his recollection. The other porters immediately recognized the face as belonging to one of their fellow porters. They brought Tai Chin to this person's home and retrieved the luggage. See Zhou Hui (Chou Hui) 周暉 (active first quarter of 17th century), *Jinling soshi* (*Chin-ling Suo-shih*) 金陵瑣事 (Trivial Notes of Nanking), preface dated 1610, facsimile reprint, *juan* (*chüan*) 卷 (chapter) 3 (Beijing: Wenxue Guoji Kanxingshe, 1955), pp. 125 a & b. In general, the figures and horses in Tai Chin's landscape paintings are all well defined with proper body proportions. If one compares them with the figures found in paintings of the Wu school, Tai Chin's figures, even though small in size, seem distinct and lively.

23  Tung Ch'i-ch'ang was the first to revere Tai Chin as the founder of the Che school. See Tung's comment on Tai Chin in footnote 18 in his *Hua-ch'an-shih sui-pi*. Chang Keng 張庚 (1685–1760) also stated that the division of Chinese paintings into southern and northern schools began during the T'ang dynasty. Such a classification, he went on, was based on the styles of paintings, not on the geographic locations of the painters' hometowns. He pointed out that it was not until the Ming dynasty that the idea of the Che school (which used the name of Chekiang province) appeared. He named Tai Chin and Lan Ying (1585–after 1664) as the founder and last adherent of the school. (畫分南北, 始於唐世, 然未有以地別為派者. 至明季, 方有浙派之目. 是派也, 始�#於戴進, 成

于藍瑛.) See Chang Keng, *Tu-hua ching-i-shih hua-lun* 圖畫精意識畫論 (A Profound and Discerning Discourse on Painting Technique and Style), preface dated 1881, reprinted in Teng Shih 鄧實 (1865?–1948?) and Huang Pin-hung 黄賓虹 (1865–1955), comps., *Mei-shu ts'ung-shu* 美術叢書 (Anthology of Books on Fine Art), (Shanghai: n.p., 1912–36), *chi* 集 (part) 3, *chi* 輯 (division) 2, reprint, vol. 11 (Taipei: I-wen Press, 1962), p. 103.

24  See Wang Chih 王直, *I-an wen hou-chi* 抑庵文後集 (A Sequel to the Collected Writings at Wang Chih's I-an Study), published in 1568, photo-reprint edition of the Wen-yüan ko 文淵閣 copy, *chüan* 卷 (chapter) 6 (Taipei: Shangwu Press, 1978), pp. 43–44. See also Wu Sheng 吳升, *Ta-kuan-lu* 大觀錄 (A Record of Great Paintings and Calligraphy), preface dated 1712, *chüan* 卷 (chapter) 19, reprint (Taipei: Hanhua Press, 1971), pp. 24–25, s.v. "Hsia T'ai-ch'ang Hsiang-chiang feng-chu Chüan 夏太常湘江風竹卷" (Handscroll of Hsia Ch'ang's *Windy Bamboo at the Hsiang River*).

25  Shen Chou's *Copy of Tai Chin's Hsieh An at East Mountain* is in the Mr. and Mrs. Wan-go H. C. Weng Collection. It is published in *Painters of the Great Ming: The Imperial Court and the Zhe School*, cat. no. 8, p. 38.

26  Tai Chin's 153 paintings in Yen Sung's private collection are recorded in a catalogue by Wang Ke-yu (Wang K'o-yü) 汪珂玉 (1587–after 1643), *Shanhuwang* (*Shan-hu wang*) 珊瑚網 (Nets for Harvesting Corals), 1st edition of 1643, reprinted in *Zhongguo shuhua quanshu* 中國書畫全書 (The Complete Collection of Books on Chinese Painting and Calligraphy), vol. 5 (Shanghai: Shanghai Shuhua Chubanshe, 1992), pp. 1211 and 1214. Tai Chin's other works found in old collections have been included in Chen Fang-mei, *Tai Chin yen-chiu* 戴進研究 (A Study of Tai Chin) (Taipei: National Palace Museum, 1981), pp. 103–31.

27  See Richard M. Barnhart, "Rediscovering an Old Theme in Ming Painting," *Orientations* 26.8 (Hong Kong: Orientations Magazine, September 1995), pp. 115, 140, and 181.

28  For a reproduction of Tai Chin's *Winter* scroll at the Kikuya Kajuro 菊屋嘉十郎 Collection in Japan, see Richard M. Barnhart, *Painters of the Great Ming: The Imperial Court and the Zhe School*, cat. no. 64b, p. 140.

29  For a reproduction of Tai Chin's *Returning Home through the Snow*, see ibid., cat. no. 49, p. 183.

30  Tai Chin's *The Hermit Hsü Yu Resting by a Stream* is published in *Painters of the*

22  *Great Ming: The Imperial Court and the Zhe School*, cat. no. 42, p. 133.

31  Tai Chin's *Returning Home through the Snow* is published in *Painters of the Great Ming: The Imperial Court and the Zhe School*, cat. no. 49, p. 183.

32  *Tao-jen* 道人 means "a cultivated person," or "an expert in the orthodox school of ethics." It is different from *tao-shih* 道士, which means a "Taoist." See *Hanyu dacidian* 漢語大詞典 (Chinese Terminology Dictionary), vol. 10 (Shanghai: Hanyu Dacidian Press, 1988), p. 1065, s.v. "daoren (*tao-jen*) 道人."

33  Tai Chin's followers include his son Tai Ch'üan 戴泉, daughter Ms. Tai 戴氏, son-in-law, Wang Shih-hsiang 王世祥, and a group of disciples. Among them, the two best-known ones were the two brothers, Hsiang Chih 夏芷 and Hsiang K'uei 夏葵. For the names of Tai Chin's followers, see Mu Yiqin, "Daijin chuanpai" (Tai Chin Ch'uan-p'ai) 戴進傳派 (Tai Chin's School and Followers), in *Ming-tai yüan-t'i Che-p'ai shih-liao* 明代院體浙派史料 (Historical Material of the Imperial Court Style and the Che School of the Ming Dynasty), pp. 71–76. A total of fifteen artists are listed in Mu's book.

34  See note 30.

35  Standing behind the half-opened gate, the keeper wears a band on his head, which indicates that he is probably a laborer. This band is also present on the heads of the servants carrying the luggage and tending the hearth.

36  During the Han dynasty (206 B.C.– A.D. 220), it was the custom for people living at the capital of Ch'ang-an 長安 to say goodbye to their friends at the Pa-ch'iao 灞橋 bridge outside the east city gate. Since then, the Pa bridge has been used in literature and art to indicate departure. For the meaning of the bridge, see *Hanyu dacidian* 漢語大詞典 (Chinese Terminology Dictionary), vol. 6, p. 223, s.v. "Baqiao (*Pa-ch'iao*) 灞橋" (The Pa Bridge).

37  See *Hanyu dacidian* 漢語大詞典 (Chinese Terminology Dictionary), vol. 4, p. 588, s.v. "qinjian (*ch'in-chien*) 琴劍" (sword and zither).

38  See ibid., s.v. "qinjian piaoling (*ch'in-chien p'iao-ling*) 琴劍飄零" (roaming zither and sword). One verse found in the dictionary reads, "Isolated like a roaming zither and sword thousands of miles apart, the vagrant life brings tears and mucus flowing down my body." (琴劍飄零千里別, 江湖涕淚一身多.)

39  See ibid.

40  Tai Chin's *Chung K'uei's Evening Excursion* is reproduced in color in Mu Yiqin 穆益勤, *Ming-tai kung-t'ing yü Che-p'ai hui-hua hsüan-chi* 明代宮廷與浙派繪畫選集 (A Selection of Ming Dynasty Court Paintings and Che School Paintings), pl. 8, p. 8.

41  A set of four scrolls by Tai Chin depicting the four seasons is recorded in Gu Fu (Ku Fu) 顧復, *Pingsheng zhuangguan* (P'ing-sheng chuang-kuan) 平生壯觀 (The Great Sights in My Life [a record of paintings and calligraphy viewed by Gu Fu]), preface dated 1692, reprinted in *Chung-kuo shu-hua chüan-shu* 中國書畫全書 (The Complete Collection of Books on Chinese Painting and Calligraphy), vol. 4, p. 1005. According to this record, these four scrolls were painted in the styles of four Southern Sung masters. The spring landscape is in the style of Li T'ang 李唐 (c. 1070s–c. 1150s); the summer work is in the style of Ma Yüan 馬遠 (active c. 1160–after 1125); the autumn piece is after Hsia Kuei 夏圭 (active c. 1160–c. 1240); and the winter landscape is in the style of Liu Sung-nien 劉松年 (active c. 1175–after 1207). Only the winter scroll is signed "Ch'ien-t'ang Tai Chin 錢塘戴進." The other three bear no signature.

42  As this scroll is paired with another entitled *Spring*, it is likely that the two originally belonged to one of Tai Chin's seasonal sets.

43  Hsü Lin's four scrolls formerly belonged to the Hara Hozo 原邦造 Collection. The whereabouts of these scrolls are currently unknown. They are reproduced in *To So Gen Min meiga taikan* 唐宋元明名畫大觀 (A Conspectus of Famous Paintings of the T'ang, Sung, Yüan, and Ming Dynasties) (Tokyo: n.p., 1930), pls. 308–11. See also James Cahill, *Parting at the Shore: Chinese Painting of the Early and Middle Ming Dynasty, 1368–1580* (New York and Tokyo: Weatherhill, 1978), pl. 49, under the title *Winter Landscape with a Man Arriving at a House*.

44  This subject matter comes from a well-known episode in Chinese history, which occurred in winter during the later Han dynasty (25–220). Yüan An 袁安 (?–92) was a poor man from Ju-yang 汝陽, Honan 河南 province. One day there was a heavy snow, which buried many houses. Worried about his people, the local magistrate made an inspection tour in the city with his retinue. The entrance of Yüan An's house was completely buried by snow. After clearing the snow and entering the house, the magistrate found Yüan An, suffering, hungry, and cold, sleeping in his bed. When asked why he did not go out to seek help, Yüan said that there were thousands of people who were hard-pressed and looking for relief, and he did not want to burden anybody further (大雪人皆餓, 不宜干人). The magistrate reported this episode to the emperor, and Yüan An was rewarded by being offered an official position. This story has been used as a literary allusion to indicate that even in a difficult predicament, a gentleman should maintain his honor and dignity. See Tsang Li-ho 臧勵龢 et al., *Chung-kuo jen-ming ta-tz'u-tien* 中國人名大詞典 (Encyclopedia of Chinese Biographies) (Shanghai: Commercial Press, 1924), p. 844, s.v. "Yüan An 袁安." For paintings depicting this theme, see Richard Barnhart's article, "Rediscovering an Old Theme in Ming Painting," *Orientations* 26.8, p. 55. The shared composition of our four scrolls, however, does not appear to depict Yüan An's story. For one thing, the main group of figures in the composition is leaving the house, while *Yüan An Sleeps through the Snow* paintings emphasize the visit. Second, almost all the known pictures on this theme show Yüan An sleeping in bed inside of the house. This is not found in any of our four scrolls. Most important, paintings of *Yüan An Sleeps through the Snow* are supposed to show the poverty and desperate circumstances of Yüan An. If Yüan An were affluent and lived in a big house with gate, courtyards, and a warm hearth, as found in this composition, there would be no need for the local magistrate to worry about him.

45  A biography of Hsü Lin can be found in *Dictionary of Ming Biography, 1368–1644*, vol. 1, pp. 591–93. His most illustrious experience came in 1520 when Emperor Cheng-teh 正德 (r. 1506–22), during his nine months in Nanking, summoned Hsü Lin to the palace and twice visited Hsü's home.

46  These five paintings include four versions under the title *Yüan An wo-hsüeh* 袁安臥雪 (Yüan An Sleeps through the Snow). One version is the scroll by Hsü Lin mentioned in note 43; its whereabouts are unknown. Another, by Zhou Chen (Chou Ch'en) 周臣, (active c. 1500–1535) is at the Shandong Provincial Cultural Relics Bureau 山東省文物局. The third and fourth are unsigned; one is in the collection of the National Palace Museum, Taipei, and the other at Tianjin City Art Museum 天津市立博物館. The fifth is entitled *Qilu fangyou* (Ch'i-lü fang-yu) 騎驢訪友 (Riding a Donkey to Visit a Friend), attributed to Ma Chün 馬俊 (active 15th century) and belonging to the Hashimoto Taitsu 橋本大乙 Collection, Japan. All five paintings are published by Richard M. Barnhart in

"Rediscovering an Old Theme in Ming Painting," *Orientations* 26.8, pp. 52–61.

47 Tai Chin's winter elements were frequently adopted by later Che painters, and one can easily identify them in their works. In a painting by Zhu Duan (Chu Tuan) 朱端, entitled *Hongnong duhu* (*Hung-nung tu-hu*) 弘農渡虎 (Hung Nung Helping a Tiger across a River), at the Palace Museum, Beijing, one finds travelers as well as a servant holding an umbrella and stick. Chu's work is reproduced in *Gugong Bowugyuan cang Ming-dai huihua* (*Ku-kung po-wu-yüan ts'ang Ming-tai hui-hua*) 故宮博物院藏明代繪畫 (Paintings of the Ming Dynasty from the Collection of the Palace Museum) (Beijing: Palace Museum, and Hong Kong: Art Gallery, Chinese University of Hong Kong, 1988), cat. no. 19, pp. 86–87. In a work by Wang E (Wang O) 王諤 (c. late 15th–early 16th century) entitled *Taxue xunmei* (*T'a-hsüeh hsün-mei*) 踏雪尋梅 (Searching for Plum Blossoms in Snow), in the same collection, one finds similar mountains, trees, and travelers, and even the staff, sword, and zither. Notably, however, since this painting depicts a group of travelers in winter instead of a scholar leisurely enjoying plum blossoms, the title is obviously erroneous. It was probably assigned to Wang O's painting by an ignorant person at a later date. Wang's work is reproduced in the same book, cat. no. 17, pp. 82–83. Tai Chin's winter elements were also adopted, at least twice, by Wu Wei: Once in Wu's *Baqiao fengxue* (*Pa-ch'iao feng-hsüeh*) 灞橋風雪 (Travelers in Wind and Snow by the Pa Bridge) and again in *Qiulin guizhuang* (*Ch'iu-lin kuei-chuang*) 秋林歸莊 (Returning to the Village in Autumn Woods), both belonging to the Palace Museum, Beijing. Although the travelers are missing in these two works, the towering mountain of the background, the buildings and withered trees of the middle ground, and the bridge across the stream are all present in both scrolls. Wu's first work is reproduced in the same book, cat. no. 15, pp. 78–79, and his second work appears in Mu Yiqin's *Ming-tai kung-t'ing yü Che-p'ai hui-hua hsüan-chi* 明代宮廷與浙派繪畫選集 (A Selection of Ming Dynasty Court Paintings and Che School Paintings), pl. 77, p. 77. Although the Suchou painter Chou Ch'en has been considered a Wu school artist, his work usually shows noticeable Che school influences. Chou borrowed heavily from these particular winter elements used by Tai Chin. For example, the composition of Chou's *Xuecun fangyou* (*Hsüeh-ts'un fang-yu*) 雪村訪友 (Calling on a Friend at a Snowy Village) at the Palace Museum, Bei-

jing, is undoubtedly an evolved form of this popular layout. Chou's work is found in *Ku-kung Po-wu-yüan ts'ang Ming-tai hui-hua* 故宮博物院藏明代繪畫 (Paintings of the Ming Dynasty from the Palace Museum), cat. no. 22, pp. 92–93.

# 7. Wen Cheng-ming 文徵明
*(1470–1559)*
*Ming dynasty (1368–1644)*

## Mountain Landscape
*Hsi-pi shan-shui*
*(Landscape in Fine Brushwork)*
細筆山水

1 This label, although written in Chinese characters, seems to be the work of a Japanese calligrapher. For example, *ching-mo* 淨墨 (clean ink) and *yu-pi* 幼筆 (young brush) are not customary Chinese terms. *Ching-mo* probably means ink painting without color, which in Chinese should be *mo-pen* 墨本 (ink version). *Yu-pi*, on the other hand, could indicate the painting was either Wen Cheng-ming's early work or work completed with exquisite brushwork. Thus in Chinese, the correct label would read, "Wen Cheng-ming tsao-nien mo-pen shan-shui chou 文徵明早年墨本山水軸" (An Ink Landscape Hanging Scroll by Wen Cheng-ming [executed] in His Early Years) or "Wen Cheng-ming hsi-pi mo-pen shan-shui chou 文徵明細筆墨本山水軸" (An Ink Landscape Hanging Scroll by Wen Cheng-ming [executed] in Exquisite Brushwork).

2 Wu-yen shih 悟言室 (The Conversation Studio) is the name of Wen Cheng-ming's studio. *Wu* 悟, in this case, does not mean "to comprehend" but is equal to *wu* 晤, which means "to meet." *Wu-yen* 悟言, "to meet and talk," is a term borrowed from the Chinese classic *The Book of Odes*. See *Hanyu dacidian* (*Han-yü ta-tz'u-tien*) 漢語大詞典 (Chinese Terminology Dictionary), vol. 7 (Shanghai: Hanyu Dacidian Press, 1994), p. 540, s.v. "Wuyan (wu-yen) 悟言."

3 *Tai-chao* 待詔 (waiting for the emperor's command) was an official court title. It originated during the Han 漢 dynasty (206 B.C.–A.D. 220), when the government selected scholars to help the emperors draft imperial memoranda. During the T'ang 唐 dynasty (618–905), this title was

24    also applied to artisans, who, excelling in all types of skills, specifically served the imperial family. By the time of the Sung 宋 dynasty (960–1279) however, it was reserved especially for painters and calligraphers who worked at the Imperial Art Academy. In Wen Cheng-ming's time, this position at the imperial Han-lin yüan (academy of literature) was equivalent to that of an imperial secretary or editor. Since it was Wen Cheng-ming's official title, it has often been used to refer to him. Wen Chia, his son, used this title to indicate his father because in China children traditionally are not supposed to use or to say the names of family elders.

4    Five of these six seals, excluding the *Fang-lin chu-jen chien-shang*, are known as the *wu-hsi chüan* 五璽全, or "the five imperial seals complete." They were specially prepared by Emperor Ch'ien-lung for the paintings and calligraphic works in his collection deemed especially significant. The seals were used around 1745 when the imperial collection was inventoried and catalogued for the first time. Because they are symbols of the distinguished imperial collection, they have been widely forged, especially during the early twentieth century. The five seals appearing on the Michigan scroll, however, have been thoroughly examined. Their authenticity has been confirmed by first scanning these five seals from the scroll into a computer and then printing them onto a transparent film. For verification, the film was then placed over the genuine Ch'ien-lung seals published in seal catalogues. The seals matched perfectly. For Ch'ien-lung's authentic seals see Shanghai Museum, comp., *Zhonggou shuhuajia yinjan kuan-shi (Chung-kuo shu-hua-chia yin-chien k'uan-shih)* 中國書畫家印鑒款識 (Signatures and Seals of Chinese Painters and Calligraphers), vol. 1 (Shanghai: Wenwu Chubanshe, 1992), seal nos. 93, 107, 112, 146, and 150, pp. 242–47.

5    The term "Hall of the Three Rarities" is derived from three early calligraphic works cherished by Emperor Ch'ien-lung. They are: 1) *K'uai-hsüeh shih-ch'ing t'ieh* 快雪時晴帖 (A Clearing after a Light Snow), a letter to a friend attributed to Wang Hsi-chih 王羲之 (321–79) of the Eastern Tsin dynasty (317–85), who is considered by the Chinese the patriarch of calligraphy; 2) *Chung-ch'iu t'ieh* 中秋帖 (Mid-Autumn), a calligraphic fragment bearing a message concerning the Autumn Moon Festival in August, attributed to Wang Hsien-chih 王獻之 (344–86), who was Wang Hsi-chih's son; and 3) *Po-yüan t'ieh* 伯遠帖 (A Letter to Mr. Po-yüan), which is attributed to Wang Hsün 王珣 (350–401),

who was Wang Hsi-chih's nephew. Emperor Ch'ien-lung so treasured these three examples of calligraphy that he stored them in a special chamber in his study, the Yang-hsin tien 養心殿 (Hall of Mental Cultivation), located in the emperor's private quarters of the Forbidden City. He then named the chamber San-hsi t'ang 三希堂, meaning "Hall of the Three Rarities." While the first of these three calligraphic works currently belongs to the National Palace Museum, Taipei, the second and third are now at the Palace Museum, Beijing. Wang Hsi-chih's *A Clearing after a Light Snow* is reproduced in National Palace Museum Editorial Committee, *Kuo-chih chung-pao* 國之重寶 (Great National Treasures of China: Masterworks in the National Palace Museum) (Taipei: National Palace Museum, 1983), pl. 99, p. 202. Wang Hsien-chih's *Mid-Autumn* is reproduced in Liu Zhengcheng 劉正成 et al., eds., *Zhongguo shufa jian-shang dacidian (Chung-kuo shu-fa chien-shang ta-tz'u-tien)* 中國書法鑒賞大詞典 (The Great Dictionary for Authentication and Appreciation of Chinese Calligraphy), vol. 1 (Beijing: Dadi Chubanshe, 1989), p. 175. Wang Hsün's *A Letter to Mr. Po-yüan* is reproduced in Gugong Bowuyuan Zijincheng Chubanshe 故宮博物院紫禁城出版社, ed., *Gugong bowuyuan cangbaolu (Ku-kung po-wu-yüan ts'ang-pao-lu)* 故宮博物院藏寶錄 (A Catalogue of the Treasures at the Palace Museum) (Shanghai: Wenyi Chubanshe, 1986), p. 51.

6    Teng Shih was a painting connoisseur and author who was active in Shanghai before the Second World War. He was also well known as a publisher.

7    Some have pointed out that as a rule, a person's given name and *tzu* were usually related; consequently, they have suggested that originally Wen's given name was not "pi 璧" meaning "a jade disk," but "pi 壁" meaning "a wall" or "stars." Thus Wen Cheng-ming's *tzu*, "Cheng-ming 徵明," which means "to seek brightness" would more probably relate to "stars" than "jade disk." However, this allegation may be incorrect. First, the character *pi* 璧 (a jade disk) is found in Wen's biography, "Hsien-chün hsing-lüeh" 先君行略 (The Life Story of My Late Father), composed by his son, Wen Chia 文嘉 (1501–83). It is printed in the Fu-lu 附錄 (Appendix) in Wen Cheng-ming's *Fu-t'ien chi* 甫田集 (The Collected Writings of Wen Cheng-ming), *chüan* 卷 (chapter) 36 (Central Library facsimile of Ming edition. Taipei: National Central Library, 1968), pp. 1 a & b (new page nos. 893–94). Second, Wen himself signed his early work with the name Wen Pi 文璧 (Wen, the jade disk). Additionally, there is

evidence in Chinese literary sources of a correlation between, "jade disk" and "seeking brightness," as the character *pi* (jade disk) combines with *jih* 日 (the sun) to form the term "pi-jih 璧日," or "the radiant sun." This term was a symbol for seeking political change. See *Han-yü ta-tz'u-tien* 漢語大詞典 (Chinese Terminology Dictionary), vol. 4, p. 643, s.v. "*biri (pi-jih)* 璧日." See the following note for Wen Cheng-ming's early works signed with the name Wen Pi.

8    The year in which Wen Cheng-ming changed his name may be deduced from the dates and signatures found on his paintings. For example, his *Huang-hua yu-shih t'u* 黃花幽石圖 (Chrysanthemum, Bamboo, and Rock), at the Osaka Municipal Museum of Fine Arts, Japan, is dated 1512, when the artist was forty-two. On this work, he signed his name Wen Pi 文璧. Two years later, in 1514, when he executed *Shu-lin mao-wu* 疏林茆屋 (Thatched Cottage in Sparse Woods), now at the National Palace Museum, Taipei, he signed Cheng-ming 徵明. From this year on, he stopped inscribing his name as Wen Pi. Therefore, he must have changed his name around 1513 or 1514, at age forty-three or forty-four. His *Chrysanthemum, Bamboo and Rock* scroll in Osaka is published in Richard Edwards, *The Art of Wen Cheng-ming* (Ann Arbor: University of Michigan Museum of Art, 1976), pl. 12, p. 67; his *Thatched Cottage in Sparse Woods*, at the Palace Museum, Taipei, is reproduced in *Ku-kung shu-hua t'u-lu* 故宮書畫圖錄 (An Illustrated Catalogue of Calligraphy and Painting at the Palace Museum), vol. 7 (Taipei: National Palace Museum, 1991), p. 51.

9    Wen Cheng-ming chose this name because his ancestors lived by Mount Heng in Hunan 湖南 province. See Wen Chia's "Hsien-chün hsing-lüeh" 先君行略 (The Life Story of My Late Father), pp. 1 a & b (new page nos. 893–94).

10    Apparently, the name of the Wu school, which included the group of painters from Wen Cheng-ming's hometown of Suchou, derived from the character 吳 (Wu) originally used for the name of this district. "Wu school," however, is not a generic Chinese term found in early sources. Rather it was initiated by Western scholars in the sixties to refer to Shen Chou, Wen Cheng-ming, and their followers.

11    The Wen family was originally from Szechwan province. They migrated first to Kiangsi and then to Hunan. During the Yüan period (1280–1368), one of Wen Cheng-ming's ancestors was a general stationed in Wu-ch'ang, Hupei province.

Wen's great-grandfather married a woman from Suchou and moved into his parent-in-law's home; thus the Wens settled permanently in Suchou. See Wen Chia's "Hsien-chün hsing-lüeh" 先君行略 (The Life Story of My Late Father), pp. 1a & b (new page nos. 893–94).

12 See Richard Edwards's entry on Weng Cheng-ming in L. Carrington Goodrich and Chaoying Fang, eds., *Dictionary of Ming Biography, 1368–1644*, vol. 2 (New York and London: Columbia University Press, 1976), pp. 1471–74.

13 For a brief biography of Wu K'uan, see ibid., pp. 1487–89. Wu was a distinguished scholar who occupied high posts at the court. He was a close friend of the painter Shen Chou. Li Ying-chen, on the other hand, was a well-known scholar-calligrapher who executed calligraphy in an unusual manner. Traditionally, Chinese calligraphers rest their wrists on the table and use all four fingers and their thumb to hold the writing brush. Li held the brush with his index finger, middle finger, and thumb, with his wrist and elbow suspended in the air without support. He and his son-in-law, Chu Yün-ming 祝允明 (1460–1526), were the two most celebrated calligraphers of the middle Ming dynasty. Able to inscribe characters in every type of script, Li based his calligraphy on the works of old masters yet maintained his own distinctive style. As Wen Cheng-ming's could also produce calligraphy in every type of script, Li must have provided his student with a model for virtuosity and versatility in calligraphy. For more information on Li, see Yu Jianhua 于劍華 et al., *Zhongguo meishujia renming cidian* (*Chung-kuo mei-shu-chia jen-ming tz'u-tien*) 中國美術家人名詞典 (A Biographical Dictionary of Chinese Artists) (Shanghai: Renmin Meishu Chubanshe, 1981), p. 407.

14 Shen Chou, Wen Cheng-ming's painting teacher, was well known as a great artist. His influence on Wen was also significant. See entry 4, on Shen Chou's *Pine and Hibiscus*, for a discussion of this master painter's life and art.

15 The dates of Wen Cheng-ming's attendance at the civil service examinations are recorded in several places in Zhou Daozhen 周道振, ed., *Wen Zhengming quanji* (*Wen Cheng-ming chüan-chi*) 文徵明全集 (Wen Cheng-ming's Anthology) (Shanghai: Guji Chubanshe, 1987). Yang Xin 楊新 synthesized this information in his article, "Rensheng, gexing yu yishu fengge—luelun Wen Zhengming yu Tang Yin de yitong" (Jen-sheng, ko-hsing yü i-shu feng-ko—lüeh-lun Wen Cheng-ming yü T'ang Yin teh i-t'ung) 人生個性與藝術風格—略論文徵明與 唐寅的異同 (Life, Personality, and Artistic Style—A Brief Discussion on the Similarities and Differences between Wen Cheng-ming and T'ang Yin), in Yang Xin 楊新, ed., *Wumen huapei yanjiu* (*Wu-men hua-p'ai yen-chiu*) 吳門畫派研究 (Research on Paintings of the Wu School) (Beijing: Palace Museum, 1993), p. 355.

16 The *Shih-lu* 實錄, or "official history," is supposed to be a true record of a deceased emperor's life compiled under the supervision of the succeeding emperor. Nevertheless, much of the information was often embellished. Officials compiling the record were afraid to expose the wrongdoings of the former emperor lest the new emperor become offended. On the other hand, if the record was inaccurate, officials would lose respect and be ridiculed by their peers. Emperor Cheng-te was notorious for his wanton, reckless behavior. To compose an honest account of his life would have been a most intricate and difficult task.

17 According to Wen's second son, Wen Chia, his father had great difficulty adjusting to life at the court. Several of his colleagues relentlessly mocked him for his failures at the civil service examinations. They even asserted, "The Han-lin Academy is not an art academy; [we need scholars,] not painters." Besides this, the Emperor Chia-ching 嘉靖 (r. 1522–66) was quick to lose his temper and would often humiliate scholars by flogging them in public. Certain scholars were even reported to have lost their lives. These realities strongly motivated Wen Cheng-ming's departure from the capital. See Wen Chia, "Hsien-chün hsing-lüeh" 先君行略 (The Life Story of My Late Father) in *Fu-t'ien chi, chüan* 卷 (chapter) 36, p. 3b (new page no. 898).

18 Wen Cheng-ming's two sons were Wen Peng 文彭 (1498–1573) and Wen Chia 文嘉 (1501–83). The name of his nephew was Wen Po-jen 文伯仁 (1502–75). A few of Wen Cheng-ming's descendants were also painters, including his grandson, Wen Ts'ung-ch'ang 文從昌 (1574–1648) and his great-granddaughter, Wen Shu 文淑 (1595–1634).

19 *Fu-t'ien* 甫田 is the title of a chapter originally found in the *Shih-ching* 詩經, or *The Book of Odes*. It literally means "a vast section of field." Wen Cheng-ming probably borrowed this term for the title of his anthology to indicate that his writings were like the harvest from a large fertile field. For more information on *fu-t'ien*, see *Tz'u-hai* 辭海 (Sea of Terminology: Chinese Language Dictionary), vol. 2 (Taipei: Chung-hua Press, 1974), p. 1960, s.v. "*fu-t'ien* 甫田."

20 Figure paintings by Wen Cheng-ming are extremely rare. Most of his figures are found in his landscape paintings, the best example of which is his hanging scroll *Xiangjun Xiangfuren tuzhou* (*Hsiang-chün Hsiang fu-jen t'u-chou*) 湘君湘夫人圖軸 (Queen Hsiang and Madame Hsiang Scroll) at the Palace Museum, Beijing. See Palace Museum, comp., *Mingdai Wumen huihua* (*Ming-tai Wu-men hui-hua*) 明代吳門繪畫 (The Wu School Paintings of the Ming Dynasty) (Hong Kong: Commercial Press, 1990), pl. 17, p. 47. The title of this scroll refers to two sisters who married the legendary prehistoric Emperor Shun 舜. When the emperor died during one of his inspection tours of the south, the two sisters drowned themselves in the Hsiang River as a display of devotion. They were subsequently deified as spirits of the river. See *Han-yü ta-tz'u-tien* 漢語大詞典 (Chinese Terminology Dictionary), vol. 5, p. 1448, s.v. "Xiangjun (Hsiang-chün) 湘君."

21 For examples of Northern Sung landscapes, see Fan K'uan's 范寬 (active c. 900–1030) *Hsi-shan hsing-lü t'u-chou* 溪山行旅圖軸 (Travelers Amid Streams and Mountains) and Li T'ang's 李唐 (c. 1070–c. 1150) *Wan-ho sung-feng t'u-chou* 萬壑松風圖軸 (Wind in the Pine: Amid Ten Thousand Valleys), both at the National Palace Museum, Taipei. These two works are reproduced in Wen C. Fong and James C. Y. Watt, *Possessing the Past: Treasures from the National Palace Museum, Taipei* (New York: Metropolitan Museum of Art, and Taipei: National Palace Museum, 1996), pl. 59, p. 126 and pl. 61, p. 132, respectively.

22 For examples of Wen Cheng-ming's paintings in this style, with delicate, dry brushwork, multiple small rock formations, and clusters of miniature trees with detailed foliage, see his hanging scroll at the National Palace Museum, Taipei, entitled *Ch'ien-yen ching-hsiu* 千巖競秀 (A Thousand Cliffs Vying for Splendor), reproduced in *Ku-kung shu-hua t'u-lu* 故宮書畫圖錄 (An Illustrated Catalogue of Calligraphy and Painting at the Palace Museum), vol. 7 (Taipei: National Palace Museum, 1991), p. 101. See also Wen's *Luyin qinghua* (*Lü-yin ch'ing-hua*) 綠蔭清話 (Elegant Conversation in the Green Shades) at the Palace Museum, Beijing. It is reproduced in *Ming-tai Wu-men hui-hua* 明代吳門繪畫 (The Wu School Paintings of the Ming Dynasty), pl. 28, p. 63. In these two scrolls, the arrangement of rocks and trees is far more lucid than in the Michigan scroll and all the details are also defined with more convincing brushwork.

23 If Wen completed the Michigan scroll in his studio, he would have had both

**Wen Cheng-ming**
**Mountain Landscape**
*continued*

26 brushes and seals available. If he were out-
side of the studio, the artist would at least
have had access to the brush used to com-
plete the painting. Even if a painter com-
pleted a work and then left it without seal
or signature, it is unlikely that he would
eventually attach his seal to it without
signing it. Educated people, including
artists, may not have always carried their
seals, but would usually have access to
writing tools such as brush and ink stick.

24 See note 8.

25 For a reproduction of Wen's Lady Hsiang
scroll, see note 20.

26 See note 20. Wen Chia's colophon on his
father's Lady Hsiang scroll states: "When
my late father executed this work, he was
only forty-eight *sui* (which corresponds to
forty-seven years old in the West). Thus,
his brushwork and the way he applied the
colors are extremely refined and skillful.
Its quality is definitely superior to his
other works. Now, a total of sixty-two
years have passed. I hope the owner of this
painting will treasure and cherish it.
Inscribed by the second son, [Wen] Chia,
in the seventh moon, the sixth year (1573)
during the Wan-li reign (1573–1619)." ( 先
君寫此時, 甫四十八歲. 故用筆, 設色之精, 非
他幅可擬. 追數當時, 已六十二寒暑矣! 藏者
其寶惜之. 萬曆六年七月, 仲子嘉體.)

27 See He Liangjun (Ho Liang-chün) 何良俊
(active first half of 16th century), *Siy-
ouzhai congshuo (Ssu-yu chai ts'ung-
shuo)* 四友齋叢説 (Collected Notes at the
Author's Studio of Four Friends) (Beijing:
Zhonghua Bookstore, 1983), pp. 130–31.
According to Ho, when people brought
paintings for Wen Cheng-ming to authen-
ticate, he sometimes offered positive
remarks, even when the objects were
forgeries. When asked about this practice,
Wen replied that the people who came to
him were often poor and in need of
money. This was Wen's way of helping
the less fortunate. Even when people
brought forgeries of Wen's work to him,
the artist was reported to sign and to
stamp his seal without hesitation.

28 See ibid.

29 Several hanging scrolls by Chü Chieh are
painted in this manner. For example, see
his *Kuan-ch'üan t'u* 觀泉圖 (Viewing the
Water Spring), at the Metropolitan
Museum of Art, New York, reproduced in
Suzuki Kei 鈴木敬, comp., *Comprehensive
Illustrated Catalog of Chinese Paintings*,
vol. 1 (Tokyo: University of Tokyo Press,
1982), p. 12, no. A1-053. See also *Shanshui
(Shan-shui)* 山水 (Landscape), in *Ming-tai
Wu-men hui-hua* 明代吳門繪畫 (The
Wumen Paintings of the Ming Dynasty),

no. 64, p. 129 and a work entitled *Land-
scape in the Style of Wen Cheng-ming*, in
Alice R. M. Hyland, *The Literati Vision:
Sixteenth-Century Wu School Painting
and Calligraphy* (Memphis: Memphis
Brooks Museum of Art, 1984), fig. 44, p.
74. See also Sotheby's sales catalogue, *Fine
Chinese Paintings* (New York: Sotheby's,
December 1986), lot no. 37.

30 For information concerning Chü Chieh's
studies with Wen Chia, see Xu Qin's (Hsü
Ch'in) 徐沁 (active first half of 17th cen-
tury) *Ming-hua lu* 明畫録 (Painters of the
Ming Dynasty), *juan (chüan)* 卷 (chapter) 4,
reprinted in Yu Anlan 于安瀾, comp.,
*Huashi congshu (Hua-shih ts'ung-shu)* 畫
史叢書 (Compendium of Painting History),
vol. 5 (Shanghai: Renmin Meishu Chuban-
she, 1962), p. 46. The Chinese text says,
"When Chü Chieh was young, he studied
painting under Wen Chia. Wen Cheng-
ming saw Chü's brushwork and was
pleased. Thus, he began to teach Chü him-
self." ( 少從文嘉習畫, 待詔見其用筆, 驚喜,
遂授以法.)

31 See Chang Chao 張照 (1691–1745) et al.,
*Shih-ch'ü pao-chi* 石渠寶笈 (Precious
Books in a Box at a Rocky Stream [Imperial
Catalogue of Painting and Calligraphy in
Emperor Ch'ien-lung's Collection]), fac-
simile reprint of an original manuscript
copy (Taipei: National Palace Museum,
1971). For unknown reasons, the Michigan
scroll, although bearing the five imperial
seals, is not recorded in this imperial cata-
logue. See also note 4.

32 See Teng Shih 鄧實 (1865?–1948?) and
Huang Pin-hung 黃賓虹 (1865–1955),
comps., *Mei-shu ts'ung-shu* 美術叢書
(Anthology of Books on Fine Art), 25 vols.
(Shanghai: n.p., 1912–36), reprint (Taipei:
I-wen Press, 1963–72).

33 The five paintings the University of Michi-
gan bought from Ch'en Jen-t'ao through
Doue include: 1) *Mountain Landscape*, a
hanging scroll attributed to Wen Cheng-
ming 文徵明, acc. no. 1959/1.109; 2) *Land-
scape in the Style of Huang Kung-wang*, a
hanging scroll by Wang Yüan-ch'i 王原祁
(1642–1715), acc. no. 1959/2.81; 3) *Land-
scape*, an album leaf attributed to Shih-t'ao
石濤 (1642–1707), acc. no. 1959/2.82; 4)
*Landscape*, a hanging scroll attributed to
Hou Mou-kung 侯懋功 (active during the
Wan-li period, 1573–1619), acc. no.
1959/2.83; and 5) *The Hermit T'ao Yüan-
ming Appreciating Chrysanthemums*, a
large hanging scroll by Li Shih-ta 李士達
(active 1580–1620), acc. no. 1960/1.184.
Among the five, the authenticity of nos. 1,
3, and 4 are questionable.

## 8. Chou Ch'en 周臣
*(c. 1450–c. 1535), attributed to*
*Ming dynasty (1368–1644)*

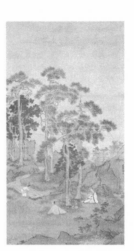

**Brewing Tea under Pines**
**by a Stream**
*Sung-ch'üan chu-ch'a t'u*
*(Brewing Tea under Pines by a Spring)*
松泉煮茶圖

1 Lang-an 朗庵, meaning "a bright hut," is
the *hao* of a twentieth-century collector,
Lin Hsiung-kuang 林熊光. Lin, active in
Japan between 1930 and 1960, was related
to the prestigious Lin clan of the city of
Pan-ch'iao 板橋 in Taiwan.

2 See Lu Yü's 陸羽 *Ch'a-ching* 茶經 (The
Book of Tea), in *Wu-ch'ao hsiao-shuo ta-
kuan* 五朝小説大觀 (Collected Historical
Notes and Novels), in the series *Hsiao-
shuo ts'ung-shu chih-erh* 小説叢書之二
(Second Series of the Collection of Novels),
vol. 17 (Shanghai: Sao-yeh Shan-fang,
1937), pp. 265–76. For a picture of the
sieve, see Shi Xingbang et al., *Precious
Cultural Relics in the Crypt of Famen
Temple* (Xian: Shaanxi People's Fine Arts
Publishing House, 1988), fig 18, p. 37. For a
picture of a grinder, see ibid., fig. 19, p. 39.

3 See Lu Yü's *Ch'a-ching* 茶經 (The Book of
Tea), pp. 265–76.

4 The painting, *Palace Concert*, shows a
group of women sitting around a table. A
large bowl is placed at the center of the
table, and smaller dishes and bowls are
arranged in front of each woman. While
some of the women are playing musical
instruments, others are holding bowls up
to their mouths, indicating eating or drink-
ing. These ladies must be consuming tea
because if they were drinking wine, a wine
bottle or ewer and wine cups would be pre-
sent. Furthermore, the tea utensils
depicted in this painting are similar to
those found inside a crypt under a pagoda
at the Famen Temple 法門寺 in Fu-feng 扶
風 county west of Xian, the old capital of

the T'ang dynasty. According to an unearthed record, the secret chamber, which was sealed in the year 874, housed a large number of treasures that were dedicated to Buddha by members of the T'ang imperial family. These objects reflect the elegant life of T'ang aristocrats. Among the pieces are a silver tea grinder and sieve. The silver salt plate and twenty small metal dishes are almost identical to those depicted in the *Palace Concert* painting. In the crypt, there is also a group of shallow celadon bowls, some of which have shapes and colors very close to those in the *Palace Concert* painting. See Shi Xingbang 石興邦 et al., *Famensi digong zhenbao (Fa-men ssu ti-kung chen-pao)* 法門寺地宮珍寶 (Precious Cultural Relics in the Crypt of Famen Temple) (Xian: Shaanxi People's Fine Arts Publishing House, 1988).

5 For an account of tea drinking in the Sung dynasty, see Marshall P. S. Wu, "Black-glazed Jian Ware and Tea Drinking in the Song Dynasty," *Orientations*, 29.4 (Hong Kong: Orientations Magazine, April 1998), pp. 22–31.

6 See Chao Chi 趙佶 (Emperor Sung Hui-tsung 宋徽宗, r. 1101–26), "Ta-kuan ch'a-lu 大觀茶錄" (A Record of Tea during the Ta-kuan Reign [1107–10]) in T'ao Tsung-i 陶宗儀 (active second half of 14th century), comp., *Shuo-fu* 説郛 (A Collection of Summaries of History and Novels), reprint, vol. 52 (Taipei: Hsin-hsing Press, 1963), pp. 11–16 (new pp. 0822–24). According to Hui-tsung, the best waters for brewing tea were from a certain current in the Yangtze River and from the spring at the Hui-shan 惠山 hill in Wu-hsi 無錫 county.

7 According to Ch'ien Mu 錢穆, *Kuo-shih ta-kang* 國史大綱 (An Outline of Chinese History) (Taipei: Shangwu Press, 1950), pp. 505–33, during the fifteenth and sixteenth centuries, among the 288,487 bolts of tax silk collected nationally, 214,367 bolts were from the south. Clearly the south produced far more tax revenue than the north.

8 See ibid.

9 See Wen Chen-heng 文震亨 (1585–1645), *Ch'ang-wu chih* 長物誌 (A Record of Fine Objects), 1st edition 1637, reprinted in Teng Shih 鄧實 (1865?–1948?) and Huang Pin-hung 黃賓虹 (1865–1955), comps., *Mei-shu ts'ung-shu* 美術叢書 (Anthology of Books on Fine Art) (Shanghai: n.p., 1912–36), reprint, *chi* 集 (part) 3, *chi* 輯 (division) 9, vol. 15 (Taipei: I-wen Press, 1963–72), pp. 165–268. Wen Chen-heng was the great-grandson of Wen Cheng-ming 文徵明 (1470–1559). His book is divided into twelve chapters: 1) House and Rooms; 2) Flowers and Plants; 3) Ponds and Rocks; 4) Animals and Fishes; 5) Calligraphy and Paintings; 6) Furniture; 7) Utensils; 8) Location and Arrangement; 9) Garments; 10) Boats and Vehicles; 11) Vegetables and Fruits; 12) Tea Drinking and Preparation. The term *ch'ang-wu* can refer to an object of excess. In a sense, it means something more extravagant than really required.

10 There are many paintings from this period that focus on tea drinking in Suchou. See Wen Cheng-ming's *P'in-ch'a t'u* 品茶圖 (Picture of Sampling Tea) and *Ch'a-shih t'u* 茶事圖 (Picture of Tea Activities), both at the National Palace Museum, Taipei. These two works are reproduced in *Ku-kung shu-hua t'u-lu* 故宮書畫圖錄 (An Illustrated Catalogue of Calligraphy and Painting at the Palace Museum), vol. 7 (Taipei: National Palace Museum, 1991), pp. 69 and 71. Other examples include works by T'ang Yin 唐寅 (1470–1523), *P'in-ch'a t'u* 品茶圖 (Picture of Sampling Tea), and by Ch'ien Ku 錢穀 (1508–78), *Hui-shan chu-ch'üan* 惠山煮泉 (Boiling Spring Water [for Tea] at Hui Hill) at the National Palace Museum, Taipei. The former is also reproduced in *An Illustrated Catalogue of Calligraphy and Painting at the Palace Museum*, vol. 7, p. 33, and the latter in vol. 8, p. 105.

11 Ku-yü literally means "grain rains" and represents a solar period in the Chinese calendar falling roughly between April 20 and May 4.

12 Hsü Chao's verse is found in his poem "Tseng Ts'ung-shan Shang-jen shih" 贈從善上人詩 (A Poem Presented to Monk Ts'ung-shan). See p. 10 of his anthology *Fang-lan hsüan shih-ch'ao* 芳蘭軒詩鈔 (Poetry Record at the Fragrant Orchid Studio), in volume 2 of Lu Liu-liang 呂留良 (1629–83) et al., eds., *Sung shih-ch'ao* 宋詩鈔 (A Complete Record of Sung Dynasty Poetry), reprinted in Yang Chia-lo 楊家駱, chief ed., *Li-tai shih-wen* 歷代詩文 (Poetry of the Past Dynasties), vol. 9 (Taipei: World Bookstore, 1962).

13 For more on Chou Ch'en, see Mette Siggstedt, *Zhou Chen*, reprinted as a monograph from *Bulletin* no. 54 (Stockholm: Museum of Far Eastern Antiquities, 1982). This is a published copy of Siggstedt's dissertation on Chou Ch'en and contains the most extensive research on this Suchou painter.

14 An illustrious record states that Ch'en's fame lasted sixty years and that he received special favor from the court at age eighty. See Xu Qin (Hsü Ch'in) 徐沁 (active first half of 17th century), *Minghualu (Ming-hua lu)* 明畫錄 (Painters

of the Ming Dynasty), *juan (chüan)* 卷 (chapter) 3, reprinted in Yu Anlan 于安瀾, comp., *Huashi congshu* 畫史叢書 (Compendium of Painting History), vol. 5 (Shanghai: Renmin Meishu Chubanshe, 1962), p. 42. For a brief biography of Chen Hsien, see Yu Jianhua 于劍華 et al., *Zhongguo meishujia renming cidian* 中國美術家人名詞典 (Biographical Dictionary of Chinese Artists) (Shanghai: Renmin Meishu Chubanshe, 1981), p. 1044. The information in Yu's dictionary consists of synthesized material borrowed from seven sources. It seems that Ch'en Hsien had a rather prominent career. If this is true, one wonders why there are almost no extant works by Ch'en Hsien to support such a claim. Based on Chou's extant work, one can assert that his painting was founded on the technique and style of the Che school, yet also possesses some elements associated with the scholarly Wu school, located in the artist's hometown of Suchou. This is due to the fact that during Chou's time, the popularity of these literati painters grew rapidly, and they eventually succeeded the Che painters as the dominant school. Surrounded by a group of talented and active students in Suchou, Wen Cheng-ming, the great master of the Wu school, dominated painting activity during the sixteenth century. Even during his late eighties, Wen was still productive. See entry 7 for more information on Wen.

15 Speculation that Chou Ch'en may have acted as ghost painter for T'ang Yin is recorded in He Liangjun (Ho Liang-chün) 何良俊, *Siyouzhai congshuo (Ssu-yu-chai tsung-shuo)* 四友齋叢説 (The Collected Notes at Ho's Studio of Four Friends), preface dated 1569, *juan (chüan)* 卷 (chapter) 29, reprinted in *Yuan Ming shiliao biji congkan (Yüan-Ming shi-liao pi-chi ts'ung-k'an)* 元明史料筆記叢刊 (A Series of Literary Sketches on Historical Materials of the Yüan and Ming Dynasties) (Beijing: Zhonghua Press, 1959) p. 268.

16 See Zhu Mouyan (Chu Mou-yen) 朱謀垔 (active early 17th century), *Huashi huiyao (Hua-shih hui-yao)* 畫史會要 (An Assembly of Distinguished Figures in Painting History), 1631, reprinted in Lu Fusheng 盧輔聖 et al., comps., *Zhongguo shuhua quanshu (Chung-kuo shu-hua chüan-shu)* 中國書畫全書 (The Complete Collection of Books on Chinese Painting and Calligraphy), vol. 4 (Shanghai: Shanghai Shuhua Chubanshe, 1992), p. 570. As both Chou Ch'en and Ch'iu Ying lacked adequate education, neither inscribed poetry on their work.

17 Chou Ch'en's *Beggar* scroll was originally a set of album leaves with twenty-four fig-

Chou Ch'en
Brewing Tea under Pines by a Stream
*continued*

28   ures on twelve facing pages. The leaves were mounted into two handscrolls in the early 1950s and sold separately to the Honolulu Art Academy and Cleveland Museum of Art. For a reproduction of Chou Ch'en's spectacular beggar scroll, see Gustav Ecke, *Chinese Paintings in Hawaii* (Honolulu: Honolulu Academy of Arts, 1965), pl. 36 and 60; see also Wai-kam Ho et al., *Eight Dynasties of Chinese Painting* (Cleveland: Cleveland Museum of Art, 1980), cat. no. 160, pp. 194–96. As Chou Ch'en is known for his landscapes, this work illustrates his expertise in figure painting. Lively and individual, these figures offer a vivid record of the least fortunate during the Cheng-teh 正德 reign (1506–21), during which the young emperor entrusted the government to a number of powerful eunuchs and ambitious generals, who subsequently committed many atrocities and placed the country in great turmoil. Historically, this is one of the darkest periods in the history of the Ming dynasty.

18   Chou Ch'en's authentic signature, Tung-ts'un Chou Ch'en 東村周臣, is found on his *Pei-ming-t'u* 北溟圖 (North Sea) handscroll and his *Pai-t'an-t'u* 白潭圖 (The Clear Pool) hanging scroll, both at the Nelson-Atkins Gallery, Kansas City. These are published in *Eight Dynasties of Chinese Painting: The Collections of the Nelson Gallery-Atkins Museum and the Cleveland Museum of Art*, pp. 192 and 194. Perhaps the clearest example of his signature we have is found on a fan entitled *Boating by River Reeds*, reproduced in Christie's sales catalogue, *Important Classical Chinese Paintings* (New York: Christie's, May 31, 1990), C, lot no. 20, p. 49. His most reliable seal, Tung-ts'un 東村, is found on his *Beggar* scroll, following his colophon at the Cleveland Museum of Art. Another set of signatures and seals are on his *Chaimen yuese (Ch'ai-men yüeh-se)* 柴門月色 (Bidding Farewell at a Brushwood Fence) at the Nanking Museum, Nanking. This work is reproduced in James Cahill, *Parting at the Shore: Chinese Painting of the Early and Middle Ming Dynasty, 1368–1580* (New York and Tokyo: Weatherhill, 1978), pl. 83, p. 169. For additional reproductions of Chou Ch'en's signatures and seals, see also Shanghai Museum, *Zhongguo shuhuajia yinjian kuanshi (Chung-kuo shu-hua-chai yin-chien k'uan-shih)* 中國書畫家印鑑款識 (Signatures and Seals of Chinese Painters and Calligraphers), vol. 1 (Shanghai: Wenwu Chubanshe, 1987), p. 603.

19   For a comparison of these characteristics, see Wen Cheng-ming's hanging scroll, *Mao-sung ch'ing-ch'üan* 茂松清泉 (Luxuriant Pines and Clear Streams), dated 1542, at the National Palace Museum, Taipei. A color reproduction of this work is found in *Ku-kung shu-hua t'u-lu* 故宮書畫圖錄 (An Illustrated Catalogue of Calligraphy and Painting at the Palace Museum), vol. 7, p. 85. A similar composition of preparing tea can also be found in Ch'iu Ying 仇英 (1502?–1552), *Yudong xianyuan (Yü-tung hsien-yüan)* 玉洞仙源 (The Jade Grotto at the Land of the Immortals), in Palace Museum, *Mingdai wumen huihua (Ming-tai Wu-men hui-hua)* 明代吳門繪畫 (The Wumen Paintings of the Ming Dynasty) (Beijing: Palace Museum, 1990), p. 94, no. 47.

20   These two paintings of Wen Cheng-ming are reproduced in *Ku-kung shu-hua t'u-lu* 故宮書畫圖錄 (An Illustrated Catalogue of Calligraphy and Painting at the Palace Museum), vol. 7, p. 69 and p. 85.

21   For a reproduction of *Brewing Tea on a Spring Evening*, see Richard Edwards, *The Art of Wen Cheng-ming (1470–1559)* (Ann Arbor: University of Michigan Museum of Art, 1976), pl. 27, p. 114.

22   *A Picture of Sampling Tea* at the National Palace Museum, Taipei, is attributed to Wen Cheng-ming's nephew, Wen Po-jen 文伯仁 (1502–75). It is reproduced in *Ku-kung shu-hua t'u-lu* 故宮書畫圖錄 (An Illustrated Catalogue of Calligraphy and Painting at the Palace Museum), vol. 8, p. 87.

23   During the seventeenth century, the cultural center of Suchou also became the center of the antique trade. Dealers from across the country flocked to the city seeking older paintings and other art objects formerly belonging to the collections of the Wu school painters and wealthy local collectors. There was an economic incentive for later Suchou artists to create numerous copies of works by earlier masters, including those of the Wu school. Thus the Michigan scroll, as well as the Palace Museum scroll—both of which belong to the seventeenth century in style and execution—are probably products created in order to fill the demand for works by the great Suchou masters.

24   One of Wen Cheng-ming's prominent students by the name of Lu Chih 陸治 (1496–1576) also produced a similar scroll, entitled *Zhuquan shiming tuzhou (Chu-ch'üan shih-ming t'u-chou)* 竹泉試茗圖軸 (Tasting Tea by the Bamboo Spring), currently at the Jilin Provincial Museum. Although the bamboo grove and the upper part of this painting are different from the corresponding sections of the Michigan work, the two scholars sitting on the ground and two boy-servants preparing tea are remarkably similar. Lu Chih's painting is reproduced in *Jilinsheng bowuguan suocang Zhongguo MingQing huihuazhan tulu (Chi-lin-sheng po-wu-kuan so-ts'ang Chung-kuo Ming-Ch'ing hui-hua-chan t'u-lu)* 吉林省博物館所藏中國明清繪畫展圖錄 (A Pictorial Exhibition Catalogue of Chinese Paintings of the Ming and Ch'ing Periods from the Chi-lin Provincial Museum) (Chi-lin: Jilin Provincial Museum, 1987), p. 32.

## 9. Hsieh Shih-ch'en 謝時臣
*(1487–after 1567)*
*Ming dynasty (1368–1644)*

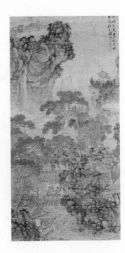

### The Summer Retreat
*Shui-ko hsiao-hsia t'u*
*(Whiling away Summer in Pavilions
by the Water)*

水閣消夏圖

1 Ginpoh Y. King (20th century) 金勤伯 was an artist who specialized in painting flowers and birds. The name King was a westernized form of the Chinese family name Chin 金, which means "gold." This use of King was probably started by European missionaries or Sinologists during the late nineteenth century; by World War II, this practice had died out. The Kings were a distinguished family from Wu-hsing 吳興 Chekiang 浙江 province. Ginpoh King's father, Chin Shu-chu 金叔初, was the younger brother of the painter Chin Ch'eng 金城 (1878–1926). Chin Ch'eng was a prominent artist before World War II who studied law in England and later served as a senator and in other governmental positions in Peking. For more information on Chin Ch'eng, see entry 57. For more information on the Chin family, see *Hu-she yüeh-k'an* 湖社月刊 (Lake Club Monthly), 1st to 10th issues, 1927, reprint, vol. 1 (Tianjin: Tianjin Guji Shudian, 1992), p. 104. During the 1950s, Ginpoh King taught Chinese painting at the National Normal University in Taipei. He visited the United States in the 1960s and sold his collection to several museums. In addition to Hsieh Shih-ch'en's scroll, he also sold a work by Kao Ch'i-p'ei 高其佩 (1660–1734), entitled *Duck and Lotus*, to the University of Michigan; see entry 33. A handscroll by Ch'ien Kung 錢貢 (1508–c. 1578), *Yü-le t'u* 漁樂圖 (Fisherman's Joy) from his collection was sold to the Cleveland Museum of Art. See Wai-kam Ho 何惠鑑 et al., *Eight Dynasties of Chinese Paintings: The Collections of the Nelson Gallery-Atkins Museum, Kansas City, and the Cleveland Museum of Art* (Cleveland: Cleveland Museum of Art, 1980), cat. no. 187, pp. 240–44.

2 This seal of Hsieh Shih-ch'en is not reproduced in the standard seal and signature dictionaries such as Shanghai Museum, *Zhongguo shuhuajia yinjian kuanshi*, (*Chung-kuo shu-hua-chia yin-chien k'uan-shih*) 中國書畫家印鑒款識 (Signatures and Seals of Chinese Painters and Calligraphers), vol. 2 (Shanghai: Wenwu Chubanshe, 1987), pp. 1530–31, or Victoria Contag and Chi-ch'ien Wang, *Seals of Chinese Painters and Collectors of the Ming and Ch'ing Periods* (Hong Kong: Commercial Press, 1940), p. 478. Yet as it also appears on two paintings by Hsieh at the National Palace Museum, Taipei, it seems to be genuine. See National Palace Museum, *Ku-kung shu-hua t'u-lu* 故宮書畫圖錄 (An Illustrated Catalogue of Calligraphy and Painting at the Palace Museum), vol. 7 (Taipei: National Palace Museum, 1991), pp. 331–32, and pp. 341–42.

3 This seal belonging to Hsieh Shih-ch'en has not been previously identified. Possibly it was ignored because its meaning is ambiguous. The text of the seal reads, "An aristocratic or established family from the Chung-chou prefecture." Chung-chou 中州, which means "the center prefecture," was the ancient name for Honan province. Hsieh Shih-ch'en's ancestor was from the "State of Hsieh," which during the Chou dynasty 周 (c. 1045–256 B.C.) was located in Honan province. Thus, the seal indicates that Hsieh Shih-ch'en's ancestors were from an old family in the Chung-chou area. See *Hanyu dacidian* 漢語大詞典 (Chinese Terminology Dictionary), vol. 11 (Shanghai: Hanyu Dacidian Press, 1988), entry no. 19, s.v. "*guyiming* (*ku-i-ming*) 古邑名 (names of ancient states)," p. 374.

4 See entry 5 on Wu Wei.

5 Painters of the Che school who were active in the sixteenth century include: 1) Chang Lu 張路 (c. 1490–c. 1563); 2) Wang O 王諤 (active c. 1462–c. 1541); 3) Wang Shih-ch'ang 王世昌 (active 1462–after 1531); 4) Kuo Hsü 郭詡 (1456–after 1526); 5) Chiang Sung 蔣嵩 (active first half of 16th century); and 6) Wang Chao 汪肇 (active late 15th–first half of 16th century). For more information on these Che school painters and their work, see Richard M. Barnhart, *Painters of the Great Ming: The Imperial Court and the Zhe School* (Dallas: Dallas Museum of Art, 1993).

6 Level of education was the most important factor in determining classification. For example, Chou Ch'en 周臣 (c. 1450–c. 1535) and T'ang Yin 唐寅 (1470–1523) were contemporaries who lived in the same city and painted in a similar style. T'ang, due to his great knowledge, has always been considered a literati painter, even though he sold his work in order to make a living. On the other hand, Chou, as he never composed essays nor inscribed poems on his works, has always been considered professional. For more information on Chou Ch'en, see entry 8.

7 An ailanthus is a plant that does not provide useful timber. Hsieh Shih-ch'en's *hao*, Shu-hsien, which means "an immortal on an ailanthus tree," implies he was a "futile immortal." This polite self-reference was a way for a literati to express humility in a humorous but also elegant manner. During the Ming dynasty, two artists adopted Shu-hsien as a *hao*. The other was Chu Chüan 朱銓, a little-known painter from Ch'ang-sha 長沙, Hunan 湖南 province. See Xu Qin (Hsü Ch'in) 徐沁 (active first half of 17th century), *Minghualu* (*Ming-hua-lu*) 明畫錄 (Painters of the Ming Dynasty), *juan* (*chüan*) 卷 (chapter) 3, reprinted in Yu Anlan 于安瀾, comp., *Huashi congshu* (*Hua-shih ts'ung-shu*) 畫史叢書 (Compendium of Painting History), vol. 5 (Shanghai: Renmin Meishu Chubanshe, 1962), p. 42.

8 Hsieh Shih-ch'en's most notable seal with a date and his age bears the words "Chia-ching jen-tzu shih-nien liu-shih-liu 嘉靖壬子時年六十六" (sixty-six *sui* in the *jen-tzu* year of the Chia-ching reign). The *jen-tsu* year in the Chia-ching period (1522–67) is 1552. Using the traditional Chinese way of counting a person's age, a baby is one *sui* at birth. If Hsieh Shih-ch'en was sixty-six *sui* in 1552, he would have been born in 1487. Other seals bearing his age without specifying the year are found on his dated works. Two examples include "Ch'i-shih-erh-weng 七十二翁" (a seventy-two-*sui* elderly man) on his painting dated 1558 and "Ch'i-shih-ssu-weng 七十四翁" (a seventy-four-*sui* elderly man) on a handscroll dated 1560. The above three seals are all reproduced in *Chung-kuo shu-hua-chia yin-chien k'uan-shih* 中國書畫家印鑒款識 (Signatures and Seals of Chinese Painters and Calligraphers), vol. 2, nos. 28, 29, and 30, pp. 1530–31.

9 This work is reproduced in *Ku-kung shu-hua t'u-lu* 故宮書畫圖錄 (An Illustrated Catalogue of Calligraphy and Painting at the Palace Museum), vol. 7, p. 327.

10 Hsieh Shih-ch'en appears in Lan Ying 藍英 (1585–?) and Xie Bin (Hsieh Pin) 謝彬 (1602–after 1680), eds., *Tuhui baojian xucuan* (*T'u-hui pao-chien hsü-ts'uan*) 圖繪寶鑑續纂 (Supplement of Precious Mirror of Painting, Painters of the Ming and

29

30    Ch'ing Dynasties), *juan (chüan)* 卷 (chapter) 1, reprinted in Yu Anlan 于安瀾, comp., *Huashi congshu (Hua-shih ts'ung-shu)* 畫史叢書 (Compendium of Painting History), vol. 3 (Shanghai: Renmin Meishu Chubanshe, 1962), p. 3, and in Jiang Shaoshu (Chiang Shao-shu) 姜紹書 (active 1635–80), *Wushengshi shi (Wu-sheng-shih shih)* 無聲詩史 (A History of Voiceless Poems), *chüan* 卷 (chapter) 3, reprinted in *Hua-shih ts'ung-shu* 畫史叢書 (Compendium of Painting History), vol. 4, p. 44. Information on Hsieh is also recorded in *Ming-hua-lu* 明畫錄 (Painters of the Ming Dynasty), *chüan* 卷 (chapter) 3, p. 42.

11    At the end of one of his handscrolls, entitled *Lien-hsi chia-sheng t'u-chüan* 練谿佳勝圖卷 (Famous Scenic Spots along the Lien Stream), now at the Kyoto National Museum, there are colophons by well-known Wu school painters such as P'eng Nien 彭年 (1505–66), Wen P'eng 文彭 (1498–1573), Hsü Chu 許初 (active mid-16th century), Wen Chia 文嘉 (1501–83), Ch'ien Ku 錢穀 (1508–?), and collector-dealer Chan Ching-feng 詹景鳳 (active second half of 16th century). See Suzuki Kei 鈴木敬, comp., *Comprehensive Illustrated Catalog of Chinese Paintings*, vol. 3 (Tokyo: University of Tokyo Press, 1982), no. JM11-120, pp. 206–7.

12    See Wen C. Fong and James C. Y. Watt, *Possessing the Past: Treasures from the National Palace Museum, Taipei* (New York: Metropolitan Museum of Art, and Taipei: National Palace Museum, 1996), pls. 199 a & b, pp. 3392–93. At the end of his calligraphy, Wen Cheng-ming praised Hsieh Shih-ch'en as a person who was adept in painting. Wen Cheng-ming's son, Wen P'eng 文彭 (1498–1573), added a colophon and pointed out that the original work of Li Ch'eng had been destroyed in a fire. Perhaps the reason his father executed this exceptional calligraphy for Hsieh Shih-ch'en was that he knew one day Hsieh Shih-ch'en would paint a picture after the original by Li Ch'eng. See National Palace Museum, *Kuo-kung shu-hua-lu* 故宮書畫錄 (A Record of the Paintings and Calligraphy in the Palace Museum Collection), *chüan* 卷 (chapter) 4, vol. 2 (Taipei: National Palace Museum, 1965), pp. 299–300. For a hanging scroll attributed to Li Ch'eng and bearing the same title, *Han-lin p'ing-yeh-t'u* 寒林平野圖 (Wintry Forest on a Level Plain), see *Ku-kung shu-hua t'u-lu* 故宮書畫圖錄 (An Illustrated Catalogue of Calligraphy and Painting at the Palace Museum), vol. 1, p. 147. Although there are similarities between the two, it is not known whether Hsieh used this scroll as his model.

13    See *Ku-kung shu-hua t'u-lu* 故宮書畫圖錄 (An Illustrated Catalogue of Calligraphy and Painting at the Palace Museum), vol. 7, p. 325. Hsien Shih-ch'en's other works executed in the fine linear style include his hanging scroll dated 1527, entitled *Guqin fubie (Ku-ch'in fu-pieh)* 鼓琴賦別 (Playing a Zither and Composing Poems at a Farewell Party), at the Shanghai Museum. See Group for the Authentication of Ancient Works of Chinese Painting and Calligraphy, ed., *Zhongguo gudai shuhua tumu (Chung-kuo ku-tai shu-hua t'u-mu)* 中國古代書畫圖目 (An Illustrated Catalogue of Selected Works of Ancient Chinese Painting and Calligraphy), vol. 3 (Shanghai: Wenwu Chubanshe, 1990), no. 滬 1-0794, p. 54. This work bears the inscriptions of Wen Cheng-ming's sons, nephew, and students.

14    For a comparison between Hsien Shih-ch'en's early works and those by Wen Cheng-ming, see Wen's *Ch'iao-lin zhu-ming-t'u* 喬林煮茗圖 (Brewing Tea under Tall Trees), *Lü-yin ch'ing-hua-t'u* 綠陰清話圖 (Lofty Conversation under the Shade of Green Trees), and *Ying-ts'ui Hsüan-t'u* 影萃軒圖 (A Picture of the Green-shadow Studio), all reproduced in *Ku-kung shu-hua t'u-lu* 故宮書畫圖錄 (An Illustrated Catalogue of Calligraphy and Painting at the Palace Museum), vol. 7, pp. 65, 131, and 155, respectively. These paintings, although listed under the name of Wen Cheng-ming, are most likely works by Wen Cheng-ming's followers painting in his style.

15    At least twenty-two paintings by Hsieh Shih-ch'en at the Shanghai Museum are reproduced in *Chung-kuo ku-tai shu-hua t'u-mu* 中國古代書畫圖目 (An Illustrated Catalogue of Selected Works of Ancient Chinese Painting and Calligraphy), vol. 3, pp. 54–60. Twelve of them are dated from 1527 to 1559. It is easy to distinguish them, as they are painted in fine lines. They include: nos. 滬 1-0794; 滬 1-0795; 滬 1-0796; and 滬 1-0798—all executed before 1540. Those executed in heavy lines include: nos. 滬 1-0799; 滬 1-0801; 滬 1-0804; and 滬 1-0805—all produced after 1540. One hanging scroll, no. 滬 1-0797 dated 1538, already shows signs of the heavy brushwork.

16    Hsü Wei 徐渭 (1521–93), a talented but wild painter from Shao-hsing 紹興, Chekiang, once inscribed one of Hsieh Shih-ch'en's handscrolls: "Artists from Suchou usually produced paintings in light ink tone. Only Hsieh Shih-ch'en utilized dark ink. His fellow townsmen were shocked by his practice, and like short spectators at an open-air theater without

seats, eighty to ninety percent of them followed the judgments of others and blindly criticized him. They did not realize that to judge whether a painting is unsound or not, one does not rely on the darkness and lightness of the ink as criteria. One should consider whether the painting is lively or not. . . . My senior, Mr. Hsieh, once visited Shao-hsing and Hangchou. He was so generous and straightforward that he bestowed four to five paintings upon me. Since then he has passed away. How could I not feel sad when I viewed this painting?" See Hsü Wei, *Hsü Wen-ch'ang ch'üan-chi* 徐文長全集 (The Complete Collected Writings of Hsü Wei) (Hong Kong: Kuang-chih Press, 1956), p. 265. On the surface, Hsü Wei's comment was a compliment. Yet by justifying Hsieh Shih-ch'en's painting style, Hsü Wei exposed the elder artist's deficiencies. Customarily, one is not supposed to criticize a painter's work by inscribing negative opinions on the painting or at the end of the scroll. Hsü Wei cleverly expressed his critique in a complimentary manner. Hsü Wei's other colophons in his anthology demonstrate that he often diplomatically embedded his negative opinions in approving remarks.

17    For a reproduction of *Landscape*, see *Ku-kung shu-hua t'u-lu* 故宮書畫圖錄 (An Illustrated Catalogue of Calligraphy and Painting at the Palace Museum), vol. 7, p. 327.

18    Hsieh painted the previously-mentioned *Wintry Forest on a Level Plain* at age sixty to accompany Wen Cheng-ming's calligraphy. He managed to maintain a greater degree of sparseness by using thinner ink lines and by spreading out the composition. See *Possessing the Past: Treasures from the National Palace Museum, Taipei*, pl. 199a, p. 393. At the age of sixty, Hsieh's technique was mature and he could have chosen to paint in any manner he wished. In all probability, he executed this handscroll with special attention as a result of his respect for Wen Cheng-ming.

19    For a discussion of Tai Chin, see entry 6.

20    There is also the possibility that Hsieh Shih-ch'en added many of these superfluous elements in response to the demands of a not-so-sagacious patron, a dynamic often associated with not especially famous professional painters.

21    When accessioned in 1961, the Michigan painting was in poor condition. The surface had many abrasions, including numerous small holes patched with silk and retouched, most notably in the area of the cliff and central deciduous trees. It was successfully restored in 1993. In the

Yoshiro Murakami 村上與四郎 Collection, Japan, there is a similar hanging scroll by Hsieh Shih-ch'en that has a summer landscape much like that of the Michigan scroll. It belongs to a set of two scrolls depicting winter and summer. See *Comprehensive Illustrated Catalog of Chinese Paintings*, vol. 4, no. JP27-034½, p. 326.

22  *Wei-ch'i* 圍棋, meaning literally "encirclement chess," is called *go* in Japan. To play it, one starts by placing a white piece, which resembles a button, on a checkered game board. The opponent then puts a black piece in place. The additional pieces are placed in separate containers for each player. Each player tries to place pieces in order to surround those of the opponent. It is a complex and difficult game, greatly enjoyed by many intellectuals in the Far East.

23  Hsieh Shih-ch'en made a number of trips up the Yangtze River to visit famous mountains. On one of Hsieh's handscrolls, he inscribed, "In the twenty-sixth year during the Chia-ching reign, the year of *ting-wei* [1547], the sixty-year-old man from Suchou, I traveled far to the Wu-Ch'u (from Kiangsu 江蘇 to Hupei 湖北) region. I climbed the T'ai-ho and Ta-pieh mountains and visited the Yellow-Crane Pavilion. I then went to Mount Lu and sailed down the Yangtze River. On board a boat, I often propped up the window of the cabin and painted the mountains and rivers." (明嘉靖二十六載, 吳門六十老人謝時臣, 遠遊吳楚. 登太和, 次大別. 梯黃鶴, 陟匡廬. 下揚子江舟中, 推蓬取興. 敢與谿山寫真.) See Pien Yüng-yü 卞永譽 (1645–1712), *Shih-ku t'ang shu-hua hui-k'ao* 式古堂書畫彙考 (A Corpus of Studies on Painting and Calligraphy at Pien Yüng-yü's Shih-ku-t'ang Studio), preface dated 1682, facsimile reprint of the original K'ang-hsi edition, vol. 4 (Taipei: Cheng-chung Press, 1958), p. 474. Mount T'ai-ho is better known as Mount Wu-tang 武當, located in northern Hupei province. Mount Ta-pieh is also in Hupei near the Yangtze River. The Yellow-Crane (Huang-ho) Pavilion is one of the most famous buildings in China. Constructed on a large boulder by the Yangtze and Han rivers, it overlooks a panorama of scenic spots in the surrounding area. Hsieh Shih-ch'en's next stop, K'uang-lu, was the famous Mount Lu in Kiangsi. It seems that he ended his trip there, without sailing further to visit the famous three gorges on the Yangtze River in Szechwan. On these trips, he must have witnessed the historical buildings and the large wooden boats sailing through the gorges in turbulent water that later became some of his favorite themes. For an example of Hsieh Shih-ch'en's painting depicting boats sailing through the gorges in turbulent waters, see his *Gaojiang jixiatu* (*Kao-chiang chi-hsia-t'u*) 高江急峽圖 (Rising River and Precipitous Gorges) and *Huanghe yanbotu* (*Huang-ho yen-po-t'u*) 黃鶴煙波圖 (Misty Waves at the Yellow-Crane Pavilion), belonging to the Nanjing Museum and reproduced in *Chung-kuo ku-tai shu-hua t'u-mu* 中國古代書畫圖目 (An Illustrated Catalogue of Selected Works of Ancient Chinese Painting and Calligraphy), vol. 7, nos. 蘇 24-0089 and 蘇 24-0090, p. 40. There are at least four hanging scrolls by Hsieh Shih-ch'en entitled *Wu-hsia yün-t'ao* 巫峽雲濤 (Clouds and Waves at the Yangtze Wu Gorge). One is at the Osaka Municipal Museum, Japan, and is reproduced in *Comprehensive Illustrated Catalog of Chinese Paintings*, vol. 3, no. JM3-80½, p. 113. The second is in the Eda Yuji 江田勇二 Collection, Japan. It is reproduced in ibid., vol. 4, no. JP14-060, p. 265. The third one belongs to the former Inokuma Nobu 豬隈延 Collection, Japan, and is published in Mary S. Lawton, *Hsieh Shih-ch'en: A Ming Dynasty Painter Reinterprets the Past* (Chicago: David and Alfred Smart Gallery, University of Chicago, 1978), fig. 5, p. 16. The last version under this title is at the Cleveland Museum of Art. See *Eight Dynasties of Chinese Paintings: The Collections of the Nelson Gallery-Atkins Museum, Kansas City, and the Cleveland Museum of Art*, cat. no. 169, p. 215. Hsieh Shih-ch'en painted a picture of the Yüeh-yang Pavilion, which he visited on his trip. This hanging scroll, *Yüeh-yang-lou* 岳陽樓 (The Yüeh-yang Pavilion) belongs to the Kyoto National Museum, Japan, and is reproduced in *Comprehensive Illustrated Catalog of Chinese Paintings*, vol. 3, no. JM11-106, p. 199.

24  While the dichotomy of the Che and the Wu schools may have confused Hsieh Shih-ch'en, two of his Suchou contemporaries, Chou Ch'en 周臣 (ca. 1455–after 1536) and T'ang Yin 唐寅 (1470–1524), who employed similar approaches, successfully transcended this obstacle. For works by these two adept painters from Hsieh Shih-ch'en's hometown, see Chou Ch'en's *Pei-ming-t'u* 北溟圖 (The North Sea), which is published in *Eight Dynasties of Chinese Paintings: The Collections of the Nelson Gallery-Atkins Museum, Kansas City, and the Cleveland Museum of Art*, cat. no. 158, pp. 192–93, and T'ang Yin's *Shan-lu sung-sheng* 山路松聲 (Whispering Pines on a Mountain Path) in *Possessing the Past: Treasures from the National Palace Museum, Taipei*, pl. 195, p. 386. One of Chou Ch'en's paintings, *Sung-ch'uang tui-i t'u* 松窗對弈圖 (Playing Chess by the Window under Pine Trees), is similar to Hsieh Shih-ch'en's *The Summer Retreat* at the University of Michigan. Chou's work also depicts figures playing chess with other figures strolling or riding a donkey; however, his painting is more open, lighter, and more unified. Chou Ch'en's painting is reproduced in *Ku-kung shu-hua t'u-lu* 故宮書畫圖錄 (An Illustrated Catalogue of Calligraphy and Painting at the Palace Museum), vol. 6, pp. 303–4.

## 10. Ch'iu Ying 仇英
*(1502?–1552) (painter)*
**Wen Cheng-ming** 文徵明
*(1470–1559) (calligrapher)*
*Ming Dynasty (1368–1644)*

32

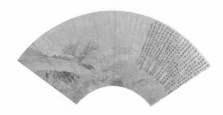

### The Peach Blossom Spring
*T'ao-hua-yüan-chi t'u*
(A Picture of *The Account of the Peach Blossom Spring*)
桃花源記圖

1 Determining Ch'iu Ying's birth and death dates has always been problematic. The best source concerning this issue is a short article by Xu Bangda 徐邦達, "Qiu Ying shengzu niansui kaoding ji qita" (Ch'iu Ying sheng-tsu nien-sui k'ao-ting chi ch'i-t'a) 仇英生卒年歲考訂及其他 (Updated Research on the Birth and Death Dates of Ch'iu Ying, and Other Related Materials), in his *Lidai shuhuajia zhuanji kaobian* (*Li-tai shu-hua-chia chuan-chi k'ao-pien*) 歷代書畫家傳記攷辨 (Research and Revision of the Biographies of Painters and Calligraphers of the Past Dynasties) (Shanghai: Renmin Meishu Chubanshe, 1983), pp. 40–43. Xu calculated that Ch'iu Ying was born around 1502 and died in 1552. This research is based on colophons found on Ch'iu Ying's works or on works executed by his contemporaries. Scholars generally believe that he died in his early fifties.

2 *The Peach Blossom Spring* fan painting was originally attributed to Wen Cheng-ming because his signature and seal are so conspicuously positioned on the fan. This attribution was revised in 1976, when James Robinson, then a History of Art Ph.D. candidate at the University of Michigan studying under Professor Richard Edwards, recognized Ch'iu Ying's nearly illegible seal on the lower left corner. Currently the Curator of Asian Art at the Indianapolis Art Museum, Robinson found that the identical seal had been used on many other authentic Ch'iu Ying paintings. This seal is published in Victoria Contag and Wang Chi-ch'üan, *Maler und Sammler-Stempel aus der Ming und Ch'ing-Zeit* (Shanghai: Commercial Press, 1940), seal no. 3, p. 6.

3 Jean-Pierre Dubosc was one of the most active collector-dealers in the field of Chinese painting from the 1950s to the 1970s. Before World War II, he served as the cultural attaché at the French Embassy in Peking. Dubosc was well known for his

gentle and elegant manner as well as his devotion to Chinese art. He married the daughter of C. T. Loo 盧芹齋, a prominent Chinese art dealer and the owner of prestigious antique shops in Paris and New York. Dubosc's later years, following his separation from his wife, were spent in Tokyo, where he eventually married a Japanese woman. It is safe to say that every major museum in the United States with a Chinese art collection owns objects from Dubosc's collection. After he died, his collection was auctioned at Christie's, New York, on December 1, 1993.

4 T'ao Ch'ien's biography is found in Fang Xuanling (Fang Hsüan-ling) 房玄齡 (578–648) et al., *Jinshu* (*Tsin-shu*) 晉書 (The Book of Tsin), 1st ed. dated 648, reprint, vol. 4, "Biography of Hermits," *juan* (*chüan*) 卷 (chapter) 64 (Beijing: Zhonghua Shuchu, 1974), pp. 2460–65. His prose work *T'ao-hua yüan-chi* 桃花源記 (The Account of the Peach Blossom Spring) is found in volume 6 of his collected writings, *T'ao Yüan-ming chi* 陶淵明集. See T'ao Ch'ien, collated and with commentary by Gong Bin 龔斌, *Tao Yuanminji jiaojian* (*T'ao Yüan-ming chi chiao-chien*) 陶淵明集校箋 (Collated Version of T'ao Yüan-ming's Collected Writings) (Shanghai: Shanghai Guji Chubanshe, 1996), pp. 402–8.

5 *Tzu-chi* 子驥 was the *tzu* of Liu Lin-chih 劉麟之 (active mid-4th century). His biography is found in *Jinshu* (*Tsin-shu*) 晉書 (The Book of Tsin), vol. 4, "Biography of Hermits," *juan* (*chüan*) 卷 (chapter) 64, pp. 2448–49. He was known as a hermit who often wandered in the mountains for several days. One famous story has him discovering two caves in Mount Heng 衡, but he was unable to enter them. Later, he was told that there were treasures hidden in the caves. When he went back to the mountains to revisit the caves, he became lost and could not find the location. It is quite likely that T'ao Ch'ien composed *The Account of Peach Blossom Spring* based on Liu Lin-chih's experience.

6 This type of seal is called *lien-chu-yin* 聯珠印, or "pearl-string seal," because it consists of two individual characters carved on the same seal, thus resembling two pearls strung together. This type of seal usually bears the name of the artist. Its small size makes it especially suitable for albums or fan paintings.

7 During the eighteenth century, this fan belonged to the famous scholar and collector, Juan Yüan 阮元 (1764–1849), who was fond of ancient calligraphy, especially those examples cast in bronze and cut in stone steles. He must have also collected

many fan paintings, as he had this special seal prepared for them. In the early 1790s, he was appointed by Emperor Ch'ien-lung 乾隆 as the editor for the second volume of the catalogue of the imperial painting collection, *Shih-chü pao-chi hsü-pien* 石渠寶笈續編 (Sequel of Treasured Book-Boxes in the Stone Groove [Second Volume of the Imperial Catalogue of Painting and Calligraphy in Emperor Ch'ien-lung's Collection]). Recording colophons and seals, Juan identified and authenticated each work that had been added to the collection since 1744, when the first volume was compiled. Thus, he was able to view the entire imperial collection. From the prestige of his background, one may assume that his knowledge of Chinese painting was considered equal to that of an expert; the inclusion of the Michigan fan in his personal collection indicates that it was a painting of the highest quality.

8 A folding fan has a piece of paper mounted on each side of the bamboo ribs. If Ch'iu Ying's painting with Wen Cheng-ming's calligraphy was on the front side of the fan, there must have been another sheet of paper mounted on the back, which likely would have had inscriptions or some other form of decoration as well. Unfortunately, since the two pieces of fan paper were peeled from the ribs of the fan, separated, and mounted as two album leaves, there is no way to know what the reverse side looked like.

9 Chinese fans were made of a number of various materials including bamboo, paper, silk, feathers, dried banana leaves, and even iron. For a history of Chinese fans, see Helmut Brinker, *Zauber des chinesischen Fächers* (Zürich: Museum Rietberg, 1979).

10 Although the earliest of the folding juniper wood fans were undecorated, later extant examples do bear calligraphy and paintings for decoration. For examples of old juniper fans, see Kuboso Kinen Hokubutsukan 久保總紀念博物館 (Kuboso Memorial Museum), ed., *Ogi-e* 扇繪 (Fan Paintings) (Waizumi-shi 和泉市, Japan: Kuboso Kinen Hokubutsukan, 1990), figs. 11–13 on p. 27, and nos. 1–3, pp. 28–30.

11 See Guo Ruoxu (Kuo Jo-hsü) 郭若虛 (active c. second half of 11th century), *Tuhua jianwenzhi* (*T'u-hua chien-wen-chih*) 圖畫見聞誌 (A Record of Experiences in Painting), completed c. 1075, *juan* (*chüan*) 卷 (chapter) 6, reprinted in Yu Anlan 于安瀾, comp., *Huashi congshu* (*Hua-shih ts'ung-shu*) 畫史叢書 (Compendium of Painting History), vol. 1 (Shanghai: Renmin Meishu Chubanshe, 1962), p. 93, s.v. "*Gaoliguo* (*Kao-li kuo*) 高麗國" (Korea). The text indi-

cates that when the Korean envoys came to China, they often presented folding fans to Chinese people as gifts. These fans were mounted with paper of a dark blue color and decorated with images of Korean aristocrats. Some bore depictions of women, horses, rivers with golden-colored shores, lotus blossoms, and waterfowl. The ornamentations, all ingeniously executed, were exquisite and refined. Other examples bore pictures using silver-colored pigment to depict clouds and the moon. The fans were all attractive and pleasing. People called them "Wo (Japanese) fans" since they originated in that country. (彼使人每至中國, 或用摺扇為私覿物. 其扇用鴉青紙為之, 上畫本國豪貴, 雜以鞍馬, 或臨水為金沙灘, 暨蓮花木水禽之類, 點綴精巧. 又以銀泥為雲氣月色之狀, 極可愛. 謂之倭扇, 本出於倭國也.) A poem about Japanese folding fans is also found in Wu Lai 吳萊 (1297–1340), *Yüan-ying chi* 淵穎集 (Wu Lai's Anthology: A Collection of Versatile and Extensive Writings), preface dated 1354, reprint, vol. 4 (Ch'ang-sha: Shang-wu Press, 1937), *chüan* 卷 (chapter) 6, p. 221. The title reads: *Tung-i Wo-jen hsiao-che-hua-shan-tzu ko* 東夷倭人小摺疊畫扇子歌 (A Song of the Decorated Small Folding Fans [Made by] the Wo [Japanese] People of the East I Tribe). This of course indicates the popularity during the Yüan dynasty (1280–1368) of imported folding fans from Japan. At least one old folding fan, dated 1188, has survived. A set of old surviving paper fans dates from 1188 and belongs to the Shitennoji 四天王寺 temple in Osaka. It is reproduced in Kuboso Memorial Museum, ed., *Ogi-e* 扇繪 (Fan Paintings), no. 4, pp. 32–33. For a history of folding fans, see Tseng Yu-ho Ecke, *Poetry on the Wind: The Art of Chinese Folding Fans from the Ming and Ch'ing Dynasties* (Honolulu: Honolulu Academy of Arts, 1982), pp. 21–35.

12  See Lu Jung 陸容 (1436–94), *Shu-yüan tsa-chi* 菽園雜記 (Miscellaneous Notes at the Bean Garden), reprint, *juan* (chüan) 卷 (chapter) 5 (Beijing: Zhonghua Press, 1985), pp. 52–53.

13  Although there are fan paintings attributed to Shen Chou, their authenticity is questionable. For example, the fan paintings attributed to him from the collection of the National Palace Museum in Taipei are published in two books. The first of these is a fan with an autumn landscape found in *Choice Paintings of the Palace Museum* (Hong Kong: Reader's Digest Association Asia Limited, 1981), p. 194. The painting's composition includes rocks, trees, and figures that have been arranged to create an appearance of Shen Chou's work. The confused and disorderly staccato strokes that

make up the thatching on top of the gate and wall betray the impostor's inferior brushmanship. A second work attributed to Shen Chou, also at the Palace Museum, is published in *Masterpieces of Chinese Album Painting in the National Palace Museum* (Taipei: National Palace Museum, 1971), pl. 41. It depicts a figure sitting under a banana tree and is also painted in Shen Chou's style. In this work, however, the calligraphy, notable for its compact characters and short strokes, is different from Shen Chou's, which customarily employs looser characters with broad and obtuse endings. On the other hand, the fans by Chou Ch'en, Wen Cheng-ming, and T'ang Yin published in the same book are all authentic. Clearly the practice of fan decoration was initiated by these Suchou painters, who lived a generation after Shen Chou.

14  Since horizontal Chinese paintings are viewed from right to left, the upper right corner is considered the most significant area. It was an honor for Wen Cheng-ming to execute his calligraphy on that section.

15  Ch'iu Ying's seal was deciphered by James Robinson. See his article "Postscript of an Exhibition: A Discovery of a Collective Work," *Ars Orientalis* 25 (Ann Arbor: University of Michigan, 1995), pp. 143–48.

16  See entry 7 for more on Wen Cheng-ming's biography.

17  For more on this Wu school master's accomplishments in painting, see entry 7.

18  For a discussion of Wen Cheng-ming's calligraphy, see C. Y. Fu, *Traces of the Brush* (New Haven: Yale University Art Gallery, 1977), pp. 57–58 (seal and clerical scripts), pp. 91–92 (cursive script), pp. 133–34 (running and standard scripts).

19  For other examples of Wen's small regular script calligraphy executed in his old age, see his *The Account of the Drunken Old Man's Pavilion*, which he completed in 1551, when he was eighty-one years old. This work is reproduced in *Masterpieces of Chinese Calligraphy in the National Palace Museum* (Taipei: National Palace Museum, 1970), pl. 37.

20  Whether Ch'iu Ying ever worked as a lacquer painter is still an unsettled issue. This information is recorded only in the footnotes or comments attached at the end of a brief biography of Tai Chin. See Chang Ch'ao 張潮 (active 17th century), *Yü Chu hsin-chih* 虞初新誌 (Yü Chu's Newly Collected Notes), preface dated 1683, vol. 8 (Shanghai: Commercial Press, 1937), p. 77, s.v. "Tai Wen-chin chuan 戴文進傳" (Biography of Tai Chin). The original Chinese

text in Chang Ch'ao's *Yü Chu hsin-chih* may be translated as follows: "It is said by Chang Shan-lai that a certain Ch'iu Shih-chou [Ch'iu Ying] is recorded in painting history of the Ming dynasty. In his early days, he was a lacquer worker who sometimes painted the decorations on the pillars and beams of people's houses. Later he changed his profession and learned to paint paintings. He was adept in executing figures and buildings. I personally dislike his work as it has the flavor of works by artisans. Ch'iu Ying's painting is inferior to those by Tai Chin. Tai Chin could also paint landscapes. In this respect, Ch'iu Ying could not match the achievement of Tai Chin." (張山來曰: 明畫史又有仇十洲者. 其初為漆工, 兼為人綵繪棟宇. 後徙而業畫. 工人物樓閣. 予獨嫌其略帶匠氣. 顧不若戴文進為佳耳! 且戴兼工山水, 則尤不可及也.)

21  See Wang Chi-teng's 王穉登 (1545–1612), *Wu-chün tan-ch'ing chih* 吳郡丹青誌 (A Record of Painters in Wu County), vol. 6, reprinted in Teng Shih 鄧實 (1865?–1948?) and Huang Pin-hung 黃賓虹 (1865–1955), comps., *Mei-shu ts'ung-shu* 美術叢書 (Anthology of Books on Fine Art) (Shanghai: n.p., 1912–36), reprint, *chi* 集 (division) 2, *chi* 輯 (collection) 2 (Taipei: I-wen Press, 1963–72), pp. 136–37.

22  The most reliable information concerning Ch'iu Ying's relationship with wealthy patrons can be found in Wu Sheng 吳升, *Ta-kuan lu* 大觀錄 (An Extensive Record of Wonderful Sights), preface dated 1712, 1st ed. collated by Li Tsu-nien 李祖年, *chüan* 卷 (chapter) 20, reprinted (Shanghai: I-chi-hsüan, 1920), p. 46. Wu provides a brief biography of Ch'iu Ying in the entry on Ch'iu Ying's *Ts'ang-hsi t'u-ch'üan* 滄谿圖卷 (Ts'ang River Handscroll) claiming that the artist worked a little more than ten years for the famous art collector, Hsiang Yüan-pien 項元汴 (1523–90), also known as Hsiang Tzu-ching 項子京. Wu also noted that on Ch'iu Ying's hanging scroll, *La-mei shui-hsien* 臘梅水仙 (Plum Blossoms and Narcissus at Year's End), in an inscription, the artist asserted that in mid-winter of the *ting-wei* year of the Chia-ching reign (1547), he executed the work especially for Hsiang Tzu-ching. (明嘉靖丁未仲冬, 仇英實父為墨林制.) Nevertheless, on p. 61b of the same book, under the entry for Ch'iu Ying's painting, *Ch'iu-yüan lieh-ch'i* 秋原獵騎 (Hunting on Horseback in Autumn Fields), there is a colophon by a Hsiang Sheng-piao 項聲表 (active 17th century), who was a grandson of the younger brother of Hsiang Yüan-pien and Hsiang Sheng-mo 項聖謨 (1597–1658). The colophon states that Ch'iu Ying worked at his grandfather's home for thirty to forty years. When Hsiang Sheng-piao was born, not only had

Ch'iu Ying / Wen Cheng-ming
The Peach Blossom Spring
*continued*

34    Hsiang Yüan-pien passed away, but the wealthy and influential Hsiang family had probably begun to decline. Therefore, the author of the colophon must either have exaggerated or have actually meant thirteen to fourteen years. If Hsiang Yüan-pien was sixteen or seventeen when he first hired Ch'iu Ying (in 1539–40), and Ch'iu Ying died around 1552, then Ch'iu Ying would have served the Hsiang family for only thirteen years or so. Ch'iu Ying's other patron was Ch'en Kuan 陳官, who is also known as Ch'en Te-hsiang 陳德相. His *tzu* was Huai-yün 懷雲. In An Ch'i's 安歧(1683–after 1742) *Mo-yüan hui-kuan lu* 墨緣彙觀錄 (Collected Notes on Painting and Calligraphy Viewed by the Author), preface dated 1742, reprint, *chüan* 卷 (chapter) 3 (Taipei: Shang-wu Press, 1956), pp. 174–75, there is an entry for Ch'iu Ying's hanging scroll *T'ao-yüan hsien-ching* 桃源仙境 (The Immortal Land at the Peach Blossom Spring) that bears the artist's inscription indicating that the painting was specially executed for Ch'en Kuan. Also see ibid., *chüan* 卷 (chapter) 4, p. 246, in which Ch'iu Ying's *Yü-fu-t'u* 漁夫圖 (Fishermen) is recorded also to have been painted for Ch'en. In *Ta-kuan lu* 大觀錄 (An Extensive Record of Wonderful Sights), *chüan* 卷 (chapter) 20, p. 49b, we see that at the end of Ch'iu Ying's handscroll *Chih-kung-t'u* 職貢圖 (Foreign Envoy with Tribute Bearers), Wen Cheng-ming's student, Peng Nien 彭年 (1505–66) added a colophon stating that Ch'en Kuan was from Ch'ang-chou 長州 in Suchou. Ch'en was supposed to be a good friend of Ch'iu Ying and for several years provided accommodation for Ch'iu Ying at his home so that the artist could paint for him. He never pressured Ch'iu Ying to finish his works. Chou Feng-lai 周鳳來, from Kun-shan 昆山, also known as Chou Yü-shun 周于舜 (1523–55), *tzu* Liu-kuan 六觀, was another of Ch'iu Ying's patrons. According to Wen Chia 文嘉 (1501–83), Wen Cheng-ming's son, it took Ch'iu Ying several years to finish the painting *Tzu-hsü shang-lin erh-fu t'u* 子虛上林二賦圖 (A Painting after the Two Poems Entitled *Tzu-hsü* and *Shang-lin*) for Chou Feng-lai, who paid the artist one hundred pieces of gold for it. See Wen Chia, *Ch'ien-shan-t'ang shu-hua chi* 鈐山堂書畫記 (The Painting and Calligraphy Collection of Yen Sung 嚴嵩), preface dated 1568, reprinted in *Mei-shu ts'ung-shu* 美術叢書 (Anthology of Books on Fine Art), vol. 8, *chi* 集 (part) 2 and *chi* 輯 (division) 6, p. 62. Little else is known about the last two collectors except that they were wealthy and appreciated Ch'iu's work.

23    This was a typical practice of the so-called *ch'ing-lü* 青綠, or "blue-and-green school," which originated during the T'ang dynasty (618–905) and created a style that became popular among later professional painters. Ch'iu Ying could also do more spontaneous ink paintings. The best examples of these are the pair of hanging scrolls, *T'ung-yin ch'ing-hua* 桐陰清話 (Conversation under a Wu-t'ung Tree) and *Chiao-yin chieh-hsia* 蕉陰結夏 (To Pass the Summer under the Shade of Banana Leaves) at the National Palace Museum in Taipei. See *Ku-kung shu-hua t'u-lu* 故宮書畫圖錄 (An Illustrated Catalogue of Painting and Calligraphy at the Palace Museum), vol. 7 (Taipei: National Palace Museum, 1991), pp. 269, 271.

24    See Steve Little, "Qiu Ying he Wen Zhengming de guanxi" (Ch'iu Ying ho Wen Cheng-ming te kuan-hsi) 仇英和文徵明的關係 (The Relationship between Ch'iu Ying and Wen Cheng-ming), in Yang Xin 楊新, ed., *Wumen huapai yanjiu* (Wu-men hua-p'ai yen-chiu) 吳門畫派研究 (Research on Paintings of the Wu School) (Beijing: Palace Museum, 1993), pp. 132–39.

25    In China, it is not unusual to ask artists to collaborate. One episode concerning a specific collaboration between Wen Cheng-ming and Ch'iu Ying is recorded in Li Tso-hsien's 李佐賢 *Shu-hua chien-ying* 書畫鑑影 (Reflections on Calligraphy and Painting), preface dated 1871, *chüan* 卷 (chapter) 15, p. 19. In this book, Li transcribes an inscription of Wen, which reads: "On the tenth day of the eighth moon [in 1542] a guest came to visit me [Wen] with a painting by Ch'iu Ying and asked for my calligraphy. I thus inscribed the *Lan-t'ing hsü* 蘭亭序 (Purification Gathering at the Orchid Pavilion) of Wang Hsi-chih 王羲之 on it." (八月十日, 有客持仇實父畫索書, 因為書楔帖。) This episode, which occurred in the same year that the Michigan fan was created, offers evidence of a third party asking one artist to contribute a companion calligraphic work.

26    See note 24.

27    See note 24. Little discusses the association between Ch'iu Ying and Wen Cheng-ming's followers, sons, and nephew.

28    It is important to point out that none of Ch'iu Ying's works bearing Wen Cheng-ming's authenticated inscription contains any indication of a direct relationship between the two artists. Paintings that do refer to a collaborative relationship between the two all are of questionable authenticity based on stylistic analysis and overall quality. This question has been discussed by two specialists, Shan Guolin 單國霖, in his "Qiu Ying shengping huodong kao" (Ch'iu Ying sheng-p'ing huo-tung k'ao) 仇英生平活動考 (A Study of Ch'iu Ying's Life and Activities), in *Wu-men hua-p'ai yen-chiu* 吳門畫派研究 (Research on Paintings of the Wu School), pp. 219–27, and in a short article by Xu Bangda 徐邦達, "Ch'iu Ying sheng-tsu nien-sui k'ao-ting chi ch'i-t'a" 仇英生卒年歲考訂及其他 (Updated Research on the Birth and Death Dates of Ch'iu Ying, etc.), pp. 40–43.

29    See ibid. A listing also appears in Chiang Chao-shen 江兆申 (1925–96), "Commentary" in Chiang's *Wen Cheng-ming hua hsi-nien* 文徵明畫系年 (A Chronology of Wen Cheng-ming's Paintings) (Tokyo: Orijin Bookstore, 1976), no. 6, p. 99; nos. 4 and 12, p. 101; nos. 17, 37, and 44, p. 102; no. 13, p. 103; no. 28, p. 104; no. 6, p. 107; no. 3, p. 109; no. 19, p. 112; nos. 21 and 25, p. 113. Presumably not all of the works listed here are authentic.

30    This work is published in Wai-kam Ho et al., *Eight Dynasties of Chinese Painting: The Collections of the Nelson Gallery-Atkins Museum, Kansas City, and the Cleveland Museum of Art* (Cleveland: Cleveland Museum of Art, 1980), cat. no. 165, pp. 204–6; and Kei Suzuki 鈴木敬, comp., *Comprehensive Illustrated Catalog of Chinese Paintings* (Tokyo: University of Tokyo Press, 1982), vol. 1, no. A22-084, pp. 272–73. Comparison of the calligraphy on the Michigan album leaf with that on the Cleveland scroll reveals many similarities between those characters that appear in both calligraphic works. For example, in both, the characters *nien* 年 (year) and *yin* 寅 (tiger) are written in Wen's distinctly unique manner.

31    Wen Cheng-ming's wife of approximately forty-five years died on the eighth moon in 1542. When he inscribed the Michigan fan, his wife may have already been ill. The distress caused by his wife's failing health and his own increasing age may have caused Wen Cheng-ming to adopt a utopian theme for this fan. Interestingly, one month after his wife passed away, he inscribed the Cleveland scroll with the text of the *Heart Sutra*, an important Mahayana text involving total denial of the mundane world. His wife's death is recorded in the biography of Wen Cheng-ming by his second son Wen Chia 文嘉 (1501–83) in Wen Cheng-ming's *Fu-t'ien chi* 甫田集 (The Collected Writings of Wen Cheng-ming), facsimile reproduction (Taipei: n.p. 1968), *chüan* 卷 (chapter) 36, pp. 899–900.

32    Ch'iu Ying's *The Two Stallions* is reproduced in *Ku-kung shu-hua t'u-lu* 故宮書畫圖錄 (An Illustrated Catalogue of Calligraphy and Painting at the Palace Museum), vol. 7 (Taipei: National Palace Museum, 1993), p. 297.

## 11. Chiang Sung 蔣嵩

*(active 16th century)*
*Ming dynasty (1368–1644)*

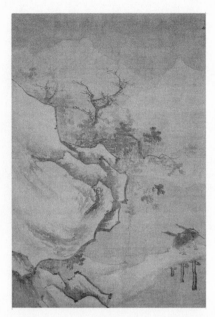

### Fishermen Returning in the Evening Snow

*Mu-hsüeh kuei-yü*
*(Returning Fishermen at Dusk in Snow)*
暮雪歸漁

1 James Freeman is an American dealer based in Kyoto, Japan.

2 In 1981 Chiang Sung's painting at the University of Michigan was reproduced in *I-yüan to-ying* 藝苑 掇英 (Selected Excellent Works in the Realm of Art), vol. 13 (Shanghai: Renmin Meishu Chubanshe, July 1981), p. 13, and mistakenly designated as a work in the collection of the Palace Museum, Beijing. A letter was sent from the Museum to Mr. Yang Boda 楊伯達, the deputy director, for an explanation. He answered that there might have been a second version or copy of the Michigan painting belonging to the Palace Museum. Comparing the reproduction in the book with the Michigan painting, however, one finds that the two are positively the same. Not only are the two compositions exactly alike, but the creases, folds, and repairs are also identical. It is unclear how the Palace Museum procured the photo or negative; most likely, they acquired a photo of the work before it entered the University of Michigan's collection.

3 Formally, the second character of the name Ts'u-lai shan 徂來山 should be written 徕. Ts'u-lai shan is a mountain located in the southeastern section of the famous Mount T'ai 泰山 in Shantung 山東 province. It is sometimes referred to as Yu-lai shan 尤來山, Yu-lai shan 尤徕山, or Yu-lai shan 尤嶪

山. Chiang Sung adopted this designation in order to augment his *hao*, "San-sung 三松," which means "three pine trees." In the Chinese classic *Shih-ching* 詩經 (The Book of Odes), a verse includes the phrase "Ts'u-lai chih-sung" 徂來之松 (the [magnificent] pine trees in the Ts'u-lai mountain). Later scholars borrowed "Ts'u-lai" to represent mountains where large pine trees used for major pillars and beams were grown. Consequently, Chiang Sung's seal *Ts'u-lai shan-jen*, or "a dweller in the Ts'u-lai mountain," implies that the "three pine trees" in his *hao* are all magnificent trees from Mount Ts'u-lai. Thus Chiang Sung is a man of tremendous ability and promise.

4 Chiang Sung's given name, Sung 嵩, is the name of the central and highest peak of the Five Sacred Mountains in China. Mount Sung is located in Honan province. The *sung* 松 in Chiang's *hao* means "pine trees." The two characters, although they sound the same, should not be confused.

5 Chiang Sung's birth and death dates are not found in old records. A dating of about 1500 for his birth is based on several factors. The most reliable is that his son Chiang Ch'ien 蔣乾 (1525–after 1604) was born in 1525, probably when the father was in his twenties. The dating of the son's birth is based on his inscription on his handscroll, *Xuejiang guizhuo (Hsüeh-chiang kuei-cho)* 雪江歸棹 (A Returning Boat in a Snowy River). The inscription indicates that he was eighty years old in 1604, which means, according to Chinese custom, he was born in 1525. Chiang Ch'ien's painting is reproduced in Yang Han 楊涵, chief ed., *Zhongguo meishu quanji (Chung-kuo mei-shu ch'üan-chi)* 中國美術全集 (The Great Treasury of Chinese Fine Arts), vol. 7 (Shanghai: Renmin Meishu Chubanshe, 1989), no. 147, p. 163. This birth date of 1500 is also close to those of two of Chiang Sung's contemporaries, Chang Lu 張路 (c. 1475–c. 1540) and Kuo Hsü 郭詡 (1456–after 1529), mentioned together with Chiang Sung by the Ming critic He Liangjun (Ho Liang-chün) 何良俊 (1506–73) in his *Siyouzhai congshuo (Ssu-yu-chai ts'ung-shuo)* 四友齋 叢說 (Collected Notes at Ho's Studio of Four Friends), preface dated 1569, reprinted in *Yuan Ming shiliao piji congkan (Yüan-Ming shih-liao pi-chi ts'ung-k'an)* 元明史料筆記叢刊 (A Series of Literary Sketches on Historical Materials of the Yüan and Ming Dynasties), *juan (chüan)* 卷 (chapter) 29 (Beijing: Zhonghua Press, 1959) p. 269. The text reads: "[As to the paintings by] Chiang San-sung (Chiang Sung) and Wang Meng-wen (Wang Chih 汪質) in Nanking, Kuo Ch'ing-k'uang (Kuo Hsü 郭詡, 1456–after 1529) in Kiangsi, and Chang P'ing-shan

(Chang Lu 張路) from the north, I would not even use them as dust rags for fear of disgracing my furniture!" (如南京之蔣三松, 汪孟文. 江西之郭清狂. 北方之張平山. 此等雖用以揩抹, 猶懼 辱吾之几揚 也!) Ho's book, with a preface dated 1569, must have been published after the three artists died. Otherwise, Ho might not have felt at ease in making such harsh comments on their work. Thus it is surmised that Chiang Sung probably died between 1550 and 1560.

6 Chiang Yung-wen's official biography is found in Yangshiqi (Yang Shih-ch'i) 楊士奇 (1365–1444), "Taiyiyuanshi yi Gongjing Jianggong Yongwen mubiao (T'ai-i-yüan-shih i Kung-ching Chiang-kung Yung-wen mu-piao) 太醫院使諡恭靖蔣公用文墓表" (Epitaph of Chiang Yung-wen), in the chapter "Taiyiyuan (T'ai-i-yüan) 大醫院" (The Imperial Hospital), in Jiao Hong (Chiao Hung) 焦竑 (1541–1620), comp., *Guochao xianzhenglu (Kuo-chao hsien-cheng-lu)* 國朝獻徵錄 (Biographies of Famous Individuals of the Ming Dynasty), reprint, *juan (chüan)* 卷 (chapter) 78 (Shanghai: Shanghai Shudian, 1987), pp. 13–14 (or p. 3284). Yang Shih-ch'i, the well-known scholar-official, and Chiang Yung-wen were close friends for almost twenty years. The two served together at the palace of the heir apparent. A preface for the *Pedigree of the Yang Family* is found in Yang Shih-ch'i's *Tung-li ch'üan-chi* 東里全集 (The Collected Writings of Yang Shih-ch'i), *chüan* 卷 (chapter) 7, reprinted in *Ssu-k'u ch'üan-shu chen-pen* 四庫全書珍本 (Condensed Version of the Imperial Ch'ien-lung Encyclopedia), vol. 2 (Taipei: Shang-wu Press, 1977), pp. 5–6. In Ku Ch'i-yüan 顧起元 *Kezuo zhuiyu (K'o-tso chui-yü)* 客座贅語 (Notes on Miscellaneous Subjects from the Conversations of My Guests), postscript dated 1618, reprint, *juan (chüan)* 卷 (chapter) 9 (Beijing: Zhonghua Shuju Chubanshe, 1991), p. 240, Ku states that Chiang's family owned a large portfolio of personal notes from the heir apparent, who eventually became the Emperor Jen-tsung 仁宗, whose reign mark was Hung-hsi 洪熙 (1425–26). On each note, the prince left his personal signature and many seals. The informality of the letters illustrates the close relationship of the two. For example, on many of the notes, the prince did not even write the specific name of a requested medication, instead referring to it in code. Since these notes indicate a close relationship between Chiang Yung-wen and the heir apparent, Chiang must have been very influential indeed.

7 In Yang Shih-ch'i's 楊士奇 (1365–1444) *Tung-li wen-chi hsü-pien* 東里文集續編 (Sequel to Yang Shih-ch'i's Collected Writ-

Chiang Sung 蔣嵩
**Fishermen Returning in the Evening Snow**
*continued*

36   ings), *chüan* 卷 (chapter) 60, three of Yang's poems were specifically composed for Chiang Yung-wen's paintings. On p. 13b, there appears *T'i Chiang Yüan-p'an mo-chu* 題蔣院判墨竹 ([A Poem] to Be Inscribed on the Ink Bamboo Painting by Chiang Yung-wen). On p. 23b, there are two poems with the title *T'i Chiang Yüan-p'an hsiao-hua* 題蔣院判小畫 ([Poems] to be Inscribed on Informal Paintings by Chiang Yung-wen). Among the literati officials, Chiang was quite active. At the Shanghai Museum, there is a hanging scroll, dated 1417, by Xie Jin (Hsieh Chin) 謝縉 (active 15th century) entitled *Yunyang zaoxing* (*Yün-yang tsao-hsing*) 雲陽早行 (An Early Journey at Yün-yang). It was specifically executed by the artist for Chiang Yung-wen's colleague, Shen Yin (?–1441), who left Peking to return to his hometown in Suchou. The painting has six colophons; the one by Chiang Yung-wen is the first one on the upper right. See Group for the Authentication of Ancient Works of Chinese Painting and Calligraphy, ed., *Zhongguo gudai shuhua tumu* (*Chung-kuo ku-tai shu-hua t'u-mu*) 中國古代書畫圖目 (An Illustrated Catalogue of Selected Works of Ancient Chinese Painting and Calligraphy), vol. 2 (Shanghai: Wenwu Chubanshe, 1990), no. 滬 1-0285, p. 137.

8   After the first Ming emperor, T'ai-tsu 明太祖 (r. 1368–99), made Nanking the capital and built the city wall, he issued a decree that no coffin or dead person was allowed to be brought into the city through the thirteen city gates. In the history of the Ming dynasty, only the body of Chiang Yung-wen was permitted to be carried inside the city. It is said that the dead body of another official, also named Chiang but not related, was smuggled into the city by being carried like a living person inside a palanquin. For this episode, see Zhou Hui (Chou Hui) 周暉 (active first quarter of 17th century), *Xu Jinling suoshi* (*Hsü Chin-ling suo-shih*) 續金陵瑣事 (A Sequel to Trivial Notes of Nanking), preface dated 1610, facsimile reprint, *juan* (*chüan*) 卷 (chapter) 1 (Beijing: Wenxue Guoji Kanxingshe, 1955), pp. 14 a & b.

9   Biographical material on Chiang Yung-wen's four sons may be found in Ch'en Hao 陳鎬 (who earned the *ch'in-shih* degree during the Ch'eng-hua 成化 period, 1465–87), "Jiang Gongjing biezhuan (Chiang Kung-ching pieh-chuan) 蔣恭靖別傳" (An Unofficial Biography of Chiang Yung-wen), in the *Taiyiyuan* (*T'ai-i-yüan*) 大醫院 (The Imperial Hospital) chapter in Chiao Hung 焦竑 (1541–1620), *Kuo-chao hsien-cheng-lu* 國朝獻徵錄 (Biographies of Famous Individuals of the Ming Dynasty), *chüan* 卷 (chapter) 78, pp. 14–16 (or pp.

3284–85). None of the birth and death dates of the four are found in Chinese historical records, but they seem to have all lived long lives. Since they were one generation younger than Chiang Yung-wen, whose birth and death dates we know, and inasmuch as we know the activities of the sons, it is possible to estimate that they were active between the 1450s and 1460s. For example, the eldest son, Chiang Chu-shan 蔣主善, because the emperor favored his father, inherited his father's governmental position and served as the commissioner of the Imperial Academy of Medicine in the Ching-t'ai 景泰 period (1450–56). It is said that Emperor Hung-hsi 洪熙 (r. 1425–26) conferred upon him a robe made of gold silk and also bestowed upon him three court ladies-in-waiting for concubines. He died at age seventy-seven. The second son, Chiang Chu-ching 蔣主敬, who followed in his father's and elder brother's steps, was a scholar-physician and died at age eighty-five. The third son, Chiang Chu-hsiao 蔣主孝, followed his father and elder brothers in becoming an educated doctor. He was also a well-known poet who died at age eighty-five. Ch'en Hao, the author of this unofficial biography of Chiang Yung-wen, incorrectly attributed some of the fourth son's achievements in poetry to Chiang Chu-hsiao, who was the father of Chiang I 蔣誼 (1439–87), the painter Chiang Sung's uncle. Among Chiang Yung-wen's four sons, Chiang Chu-hsiao was probably the most filial one. Yang Shih-ch'i once composed an article specially praising him. See Yang's *Tung-li ch'üan-chi* 東里全集 (The Collected Writings of Yang Shih-ch'i), *chüan* 卷 (chapter) 7, pp. 21–22. The youngest son, Chiang Chu-chung 蔣主忠, practiced medicine and was better known as a talented poet. His accomplishment in literature won him a place among the Ching-t'ai Shih-tzu 景泰十子, or the "Ten Talents of the Ching-t'ai Period." He may have also been a painter, for he composed several poems to be inscribed on paintings. See his four-volume anthology, *Shen-chai-chi* 慎齋集 reprinted in Yen I-p'ing 嚴一萍, ed., *Hua-ching ts'ung-shu* 華菁叢書 (A Series of Excellent Books), vol. 77 (Taipei: I-wen Press, 1972). His poems in *Shen-chai-chi* document that his collection contained paintings by Tai Chin 戴進 (1388–1462), Shih Jui 石銳 (active c. 1426–70), Wang Pien-chu 王本初 (?), and Wang Fu 王紱 (1362–1416). He also was friends with a number of artists, including Tai Chin, the founder of the Che school, and Tu Ch'iung 杜瓊 (1396–1474), a famous scholar-painter from Suchou and teacher of the painter Shen Chou 沈周 (1427–1509). A biography of Chiang Chu-chung is found in "Chiang

Huai-nan Chung 蔣淮南忠" (Chiang Chu-chung who was from Huai-nan), in Qian Qianyi (Ch'ien Ch'ien-i) 錢謙益 (1522–1644), *Liechao shiji xiaozhuan* (*Lieh-ch'ao shih-chi hsiao-chuan*) 列朝詩集小傳 (Anthologies of the Past Dynasties), reprint, vol. 2 (Shanghai: Gudianwenxue Chubanshe, 1957), pp. 312–14. In Shen Chou's *Shih-t'ien hsien-sheng chi* 石田先生集 (Shen Chou's Anthology), chapter "Ch'i-yen lü" 七言律 (seven-character poems), reprint, vol. 2 (Taipei: National Central Library, 1968), p. 10a (new page no. 463), Shen specifically composed a poem for Chiang Chu-chung.

10  Chiang I was Chiang Chu-hsiao's son and Chiang Sung's uncle. He was a prodigy who had a photographic memory and by the age of seven was adept at composing poems. He then passed the national civil service examination in Peking and obtained the *chin-shih* degree in 1466 at age twenty-eight. He first served as the prefecture judge of Hangchou 杭州 and then, after his father's death sometime in the early 1470s, was transferred to a nearby city, Shao-hsing 紹興. Later, after his mother passed away, he was sent to Chin-hua 金華. He then was promoted to the position of Imperial Censor in Nanking. As the result of a lawsuit, he was arrested but later released. He died at home in 1487 at age forty-eight. None of the many books he wrote survives. For a biography see Chiao Hung's *Kuo-chao hsien-cheng-lu* 國朝獻徵錄 (Biographies of Famous Individuals of the Ming Dynasty), *chüan* 卷 (chapter) 66, p. 15 (or p. 2908). In *Epitaph of Chiang Yung-wen* by Yang Shih-ch'i (see note 6), it is clearly recorded that Chiang Yung-wen had two grandsons. If Chiang I was one of the two, the other one would have been Chiang Sung's father. Unfortunately, no more information is offered in Yang Shih-ch'i's book.

11  Chiang Sung's painting *Yü-fu shan-shui* 漁夫山水 (Landscape with Fisherman), formerly at the Ching Yüan Chai 景元齋 Collection and now part of a private collection in Kyoto, bears a poem by Yüan Kun 袁袞 (1502–47), a member of the literati from a distinguished family in Suchou who rose to be deputy director of a bureau in the Ministry of Rites. For more information on the Yüan family in Suchou, see L. Carrington Goodrich and Fang Chaoying, eds., *Dictionary of Ming Biography, 1368–1644*, vol. 2 (New York and London: Columbia University Press, 1976), pp. 1626–27, s.v. "Yüan Chih." In addition, a poem is found in Hsü Wei's 徐渭 (1521–93) anthology, *Hsü Wen-ch'ang ch'üan-chi* 徐文長全集 (The Complete Collected Writings of Hsü Wei) (Hong Kong: Kuang-chih Press, 1956), p. 181. It

was composed specifically for a hanging scroll by Chiang Sung entitled *Feng-yü kuei-yü* 風雨歸漁 (Returning Fishermen in a Storm). These poems reflect Chiang Sung's association with the elite of his day.

12  See Zhu Mouyin (Chu Mou-yin) 朱謀堲 (active early 17th century), *Huashi huiyao* (*Hua-shih hui-yao*) 畫史會要 (The Assemblage of Distinguished Figures in Painting History), 1631, reprinted in *Zhongguo shuhua quanshu* (*Chung-kuo shu-hua ch'üan-shu*) 中國書畫全書 (The Complete Collection of Books on Chinese Painting and Calligraphy), vol. 4 (Shanghai: Shanghai Shuhua Chubanshe, 1992), p. 568; see also Xu Qin (Hsü Ch'in) 徐 沁 (active first half of 17th century), *Minghualu* (*Ming-hua-lu*) 明畫錄 (Painters of the Ming Dynasty), *juan* (*chüan*) 卷 (chapter) 3, reprinted in Yu Anlan 于安瀾, comp., *Huashi congshu* (*Hua-shih ts'ung-shu*) 畫史叢書 (Compendium of Painting History), vol. 5 (Shanghai: Renmin Meishu Chubanshe, 1962), pp. 32–33. Hsü Ch'in writes, "Chiang Sung, *tzu* San-sung, was from Chiang-ning (Nanking). He painted landscapes in the style of Wu Wei." (蔣嵩, 字三松, 江寧人. 山水派宗吳偉.) For more on Wu Wei's work, see entry 5.

13  For information on Chiang's fans, see Chan Ching-feng 詹景鳳 (active 1567–98), *Chan-shih hsiao-pien* 詹氏小辨 (Mr. Chan's Humble Thesis), vol. 41. The text is cited in Mu Yiqin 穆益勤 *Mingdai yuanti Zhepai shiliao* (*Ming-tai yüan-t'i Che-p'ai shih-liao*) 明代院體浙派 史料 (Historical Material of the Imperial Court Style and the Che School of the Ming Dynasty) (Shanghai: Renmin Chubanshe, 1985), p. 79. Since Chan's book is a rare edition that is difficult to find in libraries, a translation of the relevant text follows: "Chiang Sung, *hao* San-sung, was a native of Chin-ling (Nanking). In his landscapes he followed the style of Ni Yüan-chen (Ni Tsan 倪瓚 [1301–74]) and transformed it stylistically. Chiang's paintings in small scale were natural and unrestrained, full of vigor and originality. His large works, however, were unconvincing and disorganized. When Emperor Wu-tsung (Cheng-te 正德, r. 1506–22) made his southern tour [to Nanking in 1520], he saw Chiang Sung's works and was so pleased that he took the painter by the hand. What a rare honor! Chiang Sung began his career as a painter of fans." (蔣 嵩, 號三松. 金陵人. 山水學倪元 鎮, 而變其法. 小幅亦自蕭灑勁特, 不著塵俗. 大幅強作, 便不成章. 武宗南巡, 見嵩畫大悦 之. 至與攜手. 亦奇遭也. 嵩原自畫扇頭起也.) The factual basis of this episode is difficult to confirm.

14  Such large rocks can be found in many of Chiang Sung's hanging scrolls, including:

1) *Fishermen Returning in the Evening Snow* at the University of Michigan Museum of Art; 2) *Chiang-shan yü-chou* 江山 漁舟 (Landscape with Two Fishing Boats) at the Nanzenji Temple 南禪寺, Kyoto, Japan—see *MinShin no kaiga* 明 清の 繪畫 (Paintings of the Ming and Ch'ing Dynasties) (Tokyo: Benrido 便利堂, 1964), no. 8; 3) *Yü-fu shan-shui* 漁父山水 (Landscape with Fisherman), formerly in the Ching Yüan Chai 景元齋 Collection and currently belonging to a private collection in Kyoto—see Richard M. Barnhart et al., *Painters of the Great Ming: The Imperial Court and the Zhe School* (Dallas: Dallas Museum of Art, 1993), cat. no. 96, p. 304; 4) *Yü-fu shan-shui* 漁父山水 (Playing the Flute in a Boat Beneath a Cliff) in the Suzuki Teruko 鈴木輝子 Collection, Japan—see Suzuki Kei 鈴木敬, *Ri To, Ba En, Ka Kei* 李唐 馬遠 夏圭 (Li T'ang, Ma Yüan, Hsia Kuei) in *Suiboku bijutsu taikei* 水墨美術大系 series (An Outline of Ink Painting), vol. 2 (Tokyo: Kotansha Press 講 談社, 1974), no. 93; 5) *Luzhou fantingtu* (*Lu-chou fan-t'ing-t'u*) 蘆洲泛艇圖 (A Drifting Boat by a Reedy Bank) at the Tianjin 天 津 Museum—see *Zhongguo lidai huihua: Tianjin Yishubowuguan canghuaji* (*Chung-kuo li-tai hui-hua: Tientsin i-shu po-wu-kuan ts'ang-hua-chi*) 中國 歷代繪畫 集 天津藝術博物館藏畫集 ("Paintings at the Tianjin Art Museum" in the series *Paintings of the Past Dynasties*), vol. 1 (Tianjin: Renmin Meishu Chubanshe, 1982), no. 35; and 6) *Yü-fu shan-shui-t'u* 漁父山水圖 (Fisherman in Landscape) at the Fogg Museum—see Suzuki Kei, comp., *Comprehensive Illustrated Catalog of Chinese Paintings*, vol. 1 (Tokyo: University of Tokyo Press, 1982), no. A10-006, p. 54.

15  Among the thirty works of Chiang Sung listed in Rose Lee's M.A. thesis, twenty-three are hanging scrolls. Among them, fourteen depict the theme of returning fishermen or scholars in landscapes, while eight show a river scene with fishing boats. See Rose E. Lee, "The Life and Work of Chiang Sung," unpublished master's thesis (Ann Arbor: University of Michigan, 1983), pls. 1–13, 18, 20–21, 27–28, and 30.

16  "Heterodox" in this case has no religious connotation. Chinese scholars borrowed this term to label the unconventional and untrammeled style preferred by the Che school painters. See *Ming-hua lu* 明畫錄 (Painters of the Ming Dynasty), *chüan* 卷 (chapter) 3, pp. 32–33. The author of this book, Hsü Ch'in, commented on Chiang Sung's work: "[Chiang Sung] was fond of utilizing dark-scorched ink and dry-brush work, which greatly pleased the eyes of his contemporaries. His use of the brush was rough and undisciplined and strayed from

proper standards. Along with Cheng Tien-hsien (?), Chang Fu-yang (Chang Fu 張復 1403–90), Chung Ch'in-li (Chung Li 鍾禮, active late 15th century), and Chang P'ing-shan (Chang Lu 張路, c. 1475–c. 1540), he persisted in the wild and outrageous expression of the heterodox school." (蔣嵩, 字三松. 江寧人. 山水派宗吳偉. 喜用焦墨枯筆 最入時人之眼. 然行筆粗莽, 多越矩度. 時與鄭 顛仙, 張復陽, 鍾欽禮, 張平山, 徒逞狂態目為 邪學.)

17  See note 5. The comments of Ho Liang-chün 何良俊 are found in his *Ssu-yu-chai ts'ung-shuo* 四友齋叢説 (The Collected Notes at Ho's Studio of Four Friends), *chüan* 卷 (chapter) 29, p. 269.

18  See Chiang Shao-shu 姜紹書 (active 1635–80), *Wusheng shishi* (*Wu-sheng shih-shih*) 無聲詩史 (A History of Voiceless Poems), *juan* (*chüan*) 卷 (chapter) 3, reprinted in *Huashi congshu* (*Hua-shih ts'ung-shu*) 畫史叢書 (A Series of Books on the History of Chinese Painting), vol. 5, pp. 40–41. Chiang commented on Chiang Sung's landscapes: "Chiang Sung, *hao* San-sung, was from Nanking. He was adept in painting landscapes. Even in a work that is only one foot square, mists rise from his inch-high mountains and heaving billows appear in the body of water no larger than a ladle. Heavy clouds surge into lively dragon shapes, and a misty evening glow attracts the viewer's gaze. Could it be that because Chiang Sung's family dwelled in the location with layers of mountains and winding rivers in Nanking that he cherishes the beauty of the landscape and imbues himself with the elegance of the hills and valleys? When he uses his brush to paint, his landscape reaches the consummate realm of nature. It is not that San-sung tried to imitate the real landscape but that the landscape resembles San-sung's work!" (蔣嵩, 號三松, 金陵人. 善 畫山水. 雖尺幅中, 直是寸山生霧, 勺水興波. 浮浮然, 雲蒸龍變, 煙霞矚目. 豈金陵江山環 疊, 嵩世居其間. 既鍾其秀, 復醇飲其丘壑之 雅. 落筆時, 遂臻化境. 非三松之似山水, 而山 水之似三松也!) It is important to point out that the estate of the Chiang family was located at Lung-t'an 龍 潭, or Dragon Pond, outside the east gate of the city of Nanking. Situated near the Yangtze River, the property was famous for its ten scenic spots. See "Lung-t'an Shih-ching-hsü 龍潭 十 景 序" (The Preface to the Ten Scenic Spots at Lung-t'an) in Yang Shih-ch'i's *Tung-li ch'üan-chi* 東里全集 (The Collected Writings of Yang Shih-ch'i), *chüan* 卷 (chapter) 7, pp. 6–7b.

19  See note 16.

20  For the source of this anecdote, see note 13.

**Chiang Sung** 蔣嵩
**Fishermen Returning in the Evening Snow**
*continued*

## 12. Ch'en Tsun 陳遵

*(active 1573–1619)*
*Ming dynasty (1368–1644)*

38  21  The imperial secret service was established in 1420 by Emperor Yung-lo 永樂 (r. 1403–25). The squad was called Tung-ch'ang 東廠 (Eastern Depot). Led by powerful eunuchs, the imperial agents spied on bureaucrats as well as on common people. These agents and the dominant high official at the court, Yen Sung 嚴嵩 (1480–1565), made people of Chiang Sung's time palpitate with terror. See *Dictionary of Ming Biography, 1368–1644*, vol. 1, p. 364, s.v. "Chu Ti 朱棣 (1360–1424)" and vol. 2, pp. 1586–91, s.v. "Yen Sung 嚴嵩." There are records indicating officials were brought up on charges because of poems. See "Shih-huo" 詩禍 (Calamity from Poems) in Shen Defu's (Shen Teh-fu) 沈德符 (1578–1642) *Wanli yehuo bian (Wan-li yeh-huo-pien)* 萬曆野獲編 (A Collection of Notes from Unofficial Sources), preface dated 1606, *juan (chüan)* 卷 (chapter) 21, reprint, vol. 2 (Beijing: Zhonghua Shuju, 1959), pp. 635–36.

22  See note 16.

23  For an explanation of the term "orthodox," see note 16.

24  The Japanese have collected many of Chiang Sung's paintings as well as works by contemporaneous Che painters. Japanese scholars are also pioneers in research on these artists. Two major books on the Che school are Suzuki Kei, *Mindai kaiga no kenkyu: Seppa* 明代繪畫の研究: 浙派 (A Study of Ming Painting: The Che School) (Tokyo: n.p., 1968); and Shimada Hidemasa 島田英誠, "Sho So no sansuiga ni tsuite 蔣嵩の山水畫について" (On the Landscape Paintings of Chiang Sung), in *Toyo Bunka Kenkyujo kiyo* 東洋文化所記要 (Memoirs of the Institute of Oriental Culture), vol. 78 (Tokyo: Institute of Oriental Culture, Tokyo University, March 1979), pp. 1–53.

25  The Japanese ink painting of both the Kamakura 鎌倉 (1185–1333) and the Murumachi 室町 (1392–1568) periods both incorporated the Ma Yüan-Hsia Kuei 馬遠夏圭 academic style, which was also the primary foundation for the Che school. Therefore Japanese painters such as Sesshu and Sesson shared a stylistic origin with the Che school painters in China. For a discussion of the Japanese painters of the Muromachi period, see Watanabe Akiyoshi et al., *Of Water and Ink: Muromachi-period Paintings from Japan, 1392–1568* (Seattle: University of Washington Press, 1986). See also Richard Stanley-Baker, "Some Proposals Concerning the Transmissions to Muromachi Japan of Styles Associated with Painters from Chekiang of the Late Yüan and Early Ming, with Particular Reference to the Styles Favored in the

Hung-chih Academy, " in *Suzuki Kei sensei kanreki kinen: Chugoku kaigashi ronshu* 鈴木敬先生還曆記念: 中國繪畫史論集 (In Memory of Professor Suzuki Kei's Retirement: Collected Theses on the History of Chinese Art) (Tokyo: Kadokawa Kobunkan 角川弘文館, 1981), pp. 73–114.

26  Living in Suchou, the center of literati activity, as opposed to Nanking, Chiang's son was surely influenced by the popularity of the Wu school literati painters. A brief biography of Chiang Ch'ien is found in *Ming-hua-lu* 明畫錄 (Painters of the Ming Dynasty), *chüan* 卷 (chapter) 4, p. 56. His paintings include *Xuejiang guizhuo tujuan (Hsüeh-chiang kuei-cho t'u-chüan)* 雪江歸棹圖卷 (A Returning Boat in a Snowy River) at the Palace Museum, Beijing, reproduced in Yang Han 楊涵, chief ed., *Zhongguo meishu quanji (Chung-kuo mei-shu ch'üan-ji)* 中國美術全集 (The Great Treasury of Chinese Fine Arts), vol. 7 (Shanghai: Renmin Meishu Chubanshe, 1989), no. 147, p. 163; *Linliutuzhou (Lin-liu-t'u chou)* 臨流圖軸 (Facing the Water Hanging Scroll) at the Guangdong Provincial Museum, in the same volume, no. 148, p. 164; and *Baoqin duzuotuzhou (Pao-ch'in tu-tzo-t'u chou)* 抱琴獨坐圖軸 (A Lone Scholar with a Zither) at the Palace Museum, Beijing, also in the Yang Han book, no. 149, p. 165.

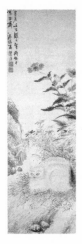

## Cat under Flowers
*Hua-hsia li-mao*
*(Cat under Flowers)*
花下狸貓

1  The Tsun-ku Chai is the name of a painting conservation studio in Taipei. This shop also deals in antiques.

2  While Ju-hsün 汝循 is Ch'en Tsun's *tzu*, "*fu* 甫," is a traditional title for males, roughly comparable to "sir." It often appears in the signature of male painters, following his *tzu*.

3  For Wang Yüan's work, see his *Quails and Sparrows in an Autumn Scene* at the Cleveland Museum of Art, published in Wai-kam Ho 何惠鑑 et al., *Eight Dynasties of Chinese Paintings: The Collections of the Nelson Gallery-Atkins Museum, Kansas City, and the Cleveland Museum of Art* (Cleveland: Cleveland Museum of Art, 1980), p. 108, cat. no. 87.

4  Emperor Hsüan-tsung's work, entitled *Dog and Bamboo*, is found in *Eight Dynasties of Chinese Paintings*, p. 145, cat. no. 120. Three other works by this emperor are included in *Ku-kung shu-hua t'u-lu* 故宮書畫圖錄 (An Illustrated Catalogue of Calligraphy and Painting at the Palace Museum), vol. 6 (Taipei: National Palace Museum, 1991), pp. 139, 141, and 145. In addition to his flower-and-bird paintings, the emperor was also known for his ink animals. For examples of Shen Chou's ink drawing depicting flowers, birds, and animals, see his *Hsieh-sheng ts'e* 寫生冊 (An Album of Plants, Animals, and Insects) at the National Palace Museum, Taipei, reproduced in *Three Hundred Masterpieces of Chinese Painting in the Palace Museum*, vol. 5 (Taichung: National Palace Museum and the National Central Museum, 1959), pl. 221; and *Wuoyoutu ce (Wo-yu-t'u ts'e)* 臥遊圖冊 (Set of Album Leaves Depicting

Vicarious Scenery), reproduced in Palace Museum, *Mingdai wumen huihua* (*Ming-tai Wu-men hui-hua*) 明代吳門繪畫 (The Wumen Paintings of the Ming Dynasty) (Beijing: Palace Museum, 1990), pl. 9, pp. 33–35.

5 See Xu Qin (Hsü Ch'in) 徐沁 (active first half of 17th century), *Ming-hua lu* 明畫錄 (Painters of the Ming Dynasty), *juan* (*chüan*) 卷 (chapter) 6, reprinted in Yu Anlan 于安瀾, comp., *Huashi congshu* (*Hua-shih ts'ung-shu*) 畫史叢書 (Compendium of Painting History), vol. 5 (Shanghai: Renmin Meishu Chubanshe, 1962), p. 85. Hsü asserts that Ch'en's flower-and-bird paintings are lively and that his execution was powerful and imposing.

6 See ibid.; see also Wang Chen (Wang Ch'en) 王宸 (1720–97), *Huilin facai* (*Hui-lin fa-ts'ai*) 繪林伐材 (The Talented Artists in the Painting Circles), preface dated 1780, reprinted in Lu Fu-sheng 盧輔聖 et al. comps., *Zhongguo shuhua quanshu* (*Chung-kuo shu-hua ch'üan-shu*) 中國書畫全書 (The Complete Collection of Books on Chinese Painting and Calligraphy), vol. 9, *juan* (*chüan*) 卷 (chapter) 8 (Shanghai: Shanghai Shuhua Chubanshe, 1992), p. 957. The Chinese text of Wang Ch'en's account states: "Ch'en Tsun's *tzu* was Ju-hsün and he was from Chia-hsing. Even in his youth, he was elegant, learned, and already focused on art. In his middle age, he settled down in Suchou and specialized in flower-and-bird painting. His painting was lively and his brushwork skillful. Patrons and collectors, thronging into his studio, were willing to pay a high price for his work. However, unless the artist considered a collector congenial, he often declined to sell his work. During his leisure time, in order to amuse himself, Ch'en Tsun liked to play music. He also enjoyed wine and intelligent conversation. When he got tipsy, he became contented and happy; without any schemes in mind, he seemed to have totally ignored the worries of this world." (陳遵, 字汝循. 嘉興人. 少博雅, 寄情翰墨. 壯歲來吳, 寫花鳥如生, 而筆更老. 海內賞鑒家, 不惜重金購之. 履盈戶, 然非其人弗與也. 暇則鼓琴自娛, 尤喜清談飲酒. 飲至酣, 陶然忘世.)

7 See ibid. All information given here concerning Chen Tsun's life is from the above entry by Wang Ch'en.

8 There are three paintings by Ch'en Tsun recorded in Osvald Sirén, *Chinese Painting: Leading Masters and Principles*, vol. 7 (New York and London: Ronald Press, 1956), p. 168. One is a fan painting, *Three Birds and Bamboo*, dated 1611, belonging to the former J. P. Dubosc Collection. The other two, in the Palace Museum, Beijing,

are *Two Pheasants by a Blossoming Plum Tree* and *Red Camellia in Snow*. Two more works by Ch'en Tsun in the Palace Museum, Beijing, are also recorded in Yu Jianhua 于劍華 et al., *Zhongguo meishujia renming cidian* (*Chung-kuo mei-shu-chia jen-ming tz'u-tien*) 中國美術家人名詞典 (A Biographical Dictionary of Chinese Artists) (Shanghai: Renmin Meishu Chubanshe, 1981), p. 1044, s.v. "Ch'en Tsun" 陳遵. One is a fan dated 1607 depicting *The Three Friends* (pine, bamboo, and plum), and the other is a handscroll dated 1617, entitled *Autumn River*. His hanging scroll, *Qiushan yetu* (*Ch'iu-shan yeh-t'u*) 秋山野兔 (Hares on Autumn Mountains), now at the Shanghai Museum, is reproduced in Group for the Authentication of Ancient Works of Chinese Painting and Calligraphy, ed., *Zhongguo gudai shuhua tumu* (*Chung-kuo ku-tai shu-hua t'u-mu*) 中國古代書畫圖目 (An Illustrated Catalogue of Selected Works of Ancient Chinese Painting and Calligraphy), vol. 4 (Shanghai: Wenwu Chubanshe, 1990), p. 46, no. 滬 1-1753.

9 As Ch'en Chun, Ch'en K'ua, and Ch'en Tsun all share the same family name and lived in the same city, there is a possibility that Ch'en Tsun was related to this father and son.

10 See *Ku-kung shu-hua t'u-lu* 故宮書畫圖錄 (Illustrated Catalogue of Calligraphy and Painting at the Palace Museum), vol. 6, p. 287.

11 See notes 5 and 6.

12 For T'ao Ch'eng's work, see his handscroll, entitled *Chrysanthemums and White Cabbages*, at the Cleveland Museum of Art. It is reproduced in Suzuki Kei, comp., *Comprehensive Illustrated Catalog of Chinese Paintings*, vol. 1 (Tokyo: University of Tokyo Press, 1982), pp. 266–67, no. A22-074; see also *Eight Dynasties of Chinese Paintings: The Collections of the Nelson Gallery-Atkins Museum, Kansas City, and the Cleveland Museum of Art*), p. 170, cat. no. 145.

13 See entry 60 on Chang Dai-chien.

14 See Shen C. Y. Fu et al., *Challenging the Past: The Paintings of Chang Dai-chien* (Washington, D.C.: Arthur M. Sackler Gallery, 1991), figs. 37–38, pp. 61–62. Chang's colorful copy of Ch'en Tsun's ink scroll is reproduced in Ba Tong's 巴東 *Chang Da-chien yen-chiu* 張大千研究 (Research on Chang Dai-chien) (Taipei: National Museum of History, 1998), color pl. 3.

## 13. Ch'ien Kung 錢貢
*(active Wan-li period, 1573–1619)*
*Ming dynasty (1368–1644)*

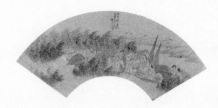

## The Happy Life of Fishermen
*Yü-lo t'u*
*(A Picture of the Happiness of Fishermen)*
漁樂圖

1 On the Michigan fan, the recipient's name, Wen-shan 文善, was obviously interpolated. With careful scrutiny, one is able to detect that the name of the original recipient was removed and replaced. This is evidenced by a smudge beneath the replacement characters, which are executed in calligraphy of inferior quality. While the strokes that belong to the artist's writing were created with a continuous movement, the strokes of these two characters are detached, written stroke by stroke. An alteration of the recipient's name was often the handiwork of a prodigal son selling objects bearing his father's name soon after the father's death, a common practice designed to avoid ridicule. Another possibility is that a son might have stolen the fan from his still-living father; consequently, in order to hide his identity, the son would alter his father's name.

2 Emperor Yü was the legendary founder of the Hsia 夏 dynasty, established circa 2000 B.C. As Yü regulated many flooding rivers, was a benevolent administrator, and provided peace and contentment to his people, he is traditionally evoked as a model emperor.

3 See Jiang Shaoshu (Chiang Shao-shu) 姜紹書 (active 1635–80), *Wusheng shishi* (*Wu-sheng-shih shih*) 無聲詩史 (A History of Voiceless Poems), preface dated 1720, *juan* (*chüan*) 卷 (chapter) 3, reprinted in Yu Anlan 于安瀾, comp., *Huashi congshu* (*Hua-shih ts'ung-shu*) 畫史叢書 (Compendium of Painting History), vol. 4 (Shanghai: Renmin Meishu Chubanshe, 1962), p. 56. The author comments that Ch'ien Kung was adept in painting landscapes but was even more skilled at figure painting (善畫山水, 而人物尤其所長).

4 For a work by Ch'ien Kung in the style of Wen Cheng-ming, see Ch'ien's *Shanshui* (*Shan-shui*) 山水, or "Landscape" hanging scroll, dated 1586, now belonging to the Palace Museum in Beijing. It is published in Palace Museum, *Mingdai wumen huihua*

Ch'ien Kung 錢貢
**The Happy Life of Fishermen**
*continued*

40   (*Ming-tai Wu-men hui-hua*) 明代吳門繪畫 (The Wumen Paintings of the Ming Dynasty) (Beijing: Palace Museum, 1990), no. 82, p. 169. For works by Ch'ien Kung in the style of T'ang Yin, see Ch'ien's *Yujia le tu* (*Yü-chia lo t'u*) 漁家樂圖 (A Picture of the Happy Life of Families of Fishermen), reproduced in Group for the Authentication of Ancient Works of Chinese Painting and Calligraphy, ed., *Zhongguo gudai shuhua tumu* (*Chung-kuo ku-tai shu-hua t'u-mu*) 中國古代書畫圖目 (An Illustrated Catalogue of Selected Works of Ancient Chinese Painting and Calligraphy), vol. 9 (Beijing: Wenwu Chubanshe, 1992), no. 津 7-0286, p. 129.

5   This refers to the painting in the style of Wen Cheng-ming in note 4.

6   See entry 10 for more on Ch'iu Ying.

7   This conclusion is based on two of Ch'ien's paintings that bear actual dates. The first is the above-mentioned landscape painting dated 1586, while the other, bearing the same title as the Michigan fan, *The Happy Life of Fishermen*, is dated 1612; it is now in the Palace Museum in Beijing. See Yu Jianhua 于劍華 et al., *Zhongguo meishujia renming cidian* (*Chung-kuo mei-shu-chia jen-ming tz'u-tien* 中國美術家人名詞典 (Biographical Dictionary of Chinese Artists) (Shanghai: Renmin Meishu Chubanshe, 1981), p. 1430, entry on Ch'ien Kung. While the 1586 landscape painting is reproduced in *Ming-tai Wu-men hui-hua* 明代吳門繪畫, no. 82, p. 169, *The Happy Life of Fishermen* has never been reproduced.

8   An example of Ch'ien Kung's painting depicting local landscape, entitled *Huqiu taying* (*Hu-ch'iu t'a-ying*) 虎丘塔影 (Under the Shadow of the Pagoda at Tiger Hill), can be found in the Palace Museum's *Gugong Bowuyuan cang MingQing shan-mian shuhuaji* (*Ku-kung po-wu-yüan ts'ang Ming-Ch'ing shan-mien shu-hua chi*) 故宮博物院藏明清扇面書畫集 (Ming and Ch'ing Fan Album Leaves at the Palace Museum), vol. 2 (Beijing: Renmin Meishu Chubanshe, 1985), no. 25. In addition to the Michigan work and the above-mentioned work centering on the theme of fishermen, there is also a long handscroll with the same title at the Cleveland Museum of Art. It is reproduced in Suzuki Kei 鈴木敬, comp., *Comprehensive Illustrated Catalog of Chinese Paintings*, vol. 1 (Tokyo: University of Tokyo Press, 1982), no. A22-087, pp. 272–73.

9   For a reproduction of this work, see Teisuke Toda and Hiromitsu Ogawa, comps., *Comprehensive Illustrated Catalogue of Chinese Paintings: Second Series*, vol. 1 (Tokyo: University of Tokyo Press, 1998), no. A49-014-10, p. 237.

10   See note 8.

11   For more information on Ch'ien Ku, see L. Carrington Goodrich and Fang Chaoying, eds., *Dictionary of Ming Biography, 1368–1644*, vol. 1 (New York and London: Columbia University Press, 1976), pp. 236–37.

12   This handscroll, entitled *Fisherman's Joy*, is reproduced in Wai-kam Ho 何惠鑑 et al., *Eight Dynasties of Chinese Paintings: The Collections of the Nelson Gallery-Atkins Museum, Kansas City, and the Cleveland Museum of Art* (Cleveland: Cleveland Museum of Art, 1980), cat. no. 187, pp. 240–41.

13   This favored theme appears in all periods of Chinese painting. Among the numerous extant examples, perhaps the most famous is a work by Hsü Tao-ning 許道寧 (c. 970–1052), *Yü-fu* 漁 夫 (Fishermen) at the Nelson Gallery-Atkins Museum in Kansas City, published in *Eight Dynasties of Chinese Paintings: The Collections of the Nelson Gallery-Atkins Museum, Kansas City, and the Cleveland Museum of Art*, cat. no. 12, pp. 21–24. Other prominent examples include Wu Chen's 吳鎮 (1280–1354) *Fang Ching Hao yü-fu t'u* 仿荊浩漁夫圖 (Fishermen, after a work by Ching Hao [c. 875–940]) and Tai Chin's 戴進 (1388–1462) *Ch'iu-chiang yü-t'ing* 秋江漁艇 (Fishing Boats in an Autumn River), both at the Freer Gallery, Washington, D.C. See *Comprehensive Illustrated Catalog of Chinese Paintings*, vol. 1, nos. A21-034 and A21–042, pp. 198 and 202. However, Wu Chen's work at the Freer Gallery, *Fishermen, after a Work by Ching Hao*, is likely a copy of an identical version by Wu Chen at the Shanghai Municipal Museum. For a reproduction of Wu Chen's handscroll at the Shanghai Museum, see *Chung-kuo ku-tai shu-hua t'u-mu* 中國古代書畫圖目 (An Illustrated Catalogue of Selected Works of Ancient Chinese Painting and Calligraphy, vol. 2, no. 滬 1-0194, p. 99. A work by the Ming painter Wu Wei 吳偉 (1459–1508), also entitled *Yü-lo t'u* 漁樂圖 (The Pleasures of Fishermen), is at the Ching-yüan Chai Collection. See Richard M. Barnhart, *Painters of the Great Ming: The Imperial Court and the Zhe School* (Dallas: Dallas Museum of Art, 1993), cat. no. 67, pp. 234–35. Two other works by Ch'ien Kung centering on this subject are entitled *Yü-chia-lo t'u* 漁家樂圖 (A Picture of the Happy Life of Families of Fishermen). Both hanging scrolls are at the Tianjin Municipal Art Museum 天津市立藝術博物館. They are reproduced in *Chung-kuo ku-tai shu-hua t'u-mu* 中國古代書畫圖目 (An Illustrated Catalogue of Selected Works of Ancient Chinese Painting and Calligraphy), vol. 9, nos. 津 7-0286 and 津 7-0287, p. 129.

## 14. Ch'en Huan 陳煥
*(active late 16th to early 17th century)*
*Ming dynasty (1368–1644)*

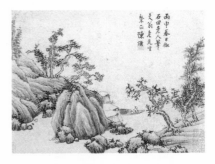

**Boating on a River in Autumn**
*Ch'iu-chiang fang-cho*
*(Boating on a River in Autumn)*
秋江放棹

1   The Western calendar became official in China only after the inauguration of the Communist regime. Thus although this label was inscribed by an anonymous calligrapher, it must have been executed in the twentieth century, sometime after 1949. Chang Chin-fang 張錦芳 (active fourth quarter of 18th century), the former owner of this album leaf, was from Canton. His *tzu* included Ts'an-fu 粲夫 (a bright man) and Hua-t'ien 花田 (flower fields), while his *hao* included Yao-fang 藥房 (house of herbal medicine) and Chü-hung wai-shi 曲紅外史 (historian of Chü-hung). Chang finished first in the provincial civil examinations in 1780 and earned his *chin-shih* degree in 1789. As a traditional literati scholar, he was known for his calligraphy and painting and was especially renowned for his depiction of plum blossoms. See Yu Jianhua 于劍 華 et al., *Zhongguo meishujia renming cidian* (*Chung-kuo mei-shu-chia jen-ming tz'u-tien* 中國美術家人 名詞典 (Biographical Dictionary of Chinese Artists) (Shanghai: Renmin Meishu Chubanshe, 1981), p. 880.

2   This collector's seal is not recorded in early sources. Nevertheless, since it is stamped on the corner opposite to Chang's seal, there is reason to believe the collector might have placed it there in order to balance the composition. Furthermore, the shade of the red pigment used in the two seals is nearly identical. Since this red pigment was usually individually mixed, the two seals probably belonged to the same owner.

3   The name Yao also refers to a legendary monarch in ancient China who was considered an exemplary and just ruler.

4   Ch'en Huan's ancestor, Ch'en I, appears in Tsang Li-ho 臧勵龢 et al., *Chung-kuo jen-ming ta-tz'u-tien* 中國人名大詞典 (Encyclopedia of Chinese Biographies) (Shanghai:

# 15. Ch'en Kuan 陳裸
*(?–after 1638)*
*Ming dynasty (1368–1644)*

Commercial Press, 1924), p. 1105, s.v. "Ch'en I 陳鎰."

5 For more information on this Wu school founder and master, see entry 4 on Shen Chou.

6 See Ch'en Huan's hanging scroll, *Linxi guanquan tu (Lin-hsi kuan-ch'üan t'u)* 臨溪觀泉圖 (Viewing Fountains by a Stream), in Palace Museum, *Mingdai Wumen huihua gailun (Ming-tai Wu-men hui-hua kai-lun)* 明代吳門繪畫概論 (A General Exploration of the Wumen Paintings of the Ming Dynasty) (Beijing: Palace Museum, 1990), no. 92, p. 187. See also his many paintings in Suzuki Kei 鈴木敬, comp., *Comprehensive Illustrated Catalog of Chinese Paintings*, vols. 1 and 2 (Tokyo: University of Tokyo Press, 1982), nos. A30-017, A31-084, S6-010-1, S15-003, E7-026, and E15-286.

7 The statement regarding the efforts of Liu Yüan-ch'i and Ch'en Huan is found in the last colophon on Liu Yüan-ch'i's handscroll, *Lanzhushi tu (Lan-chu-shih t'u)* 蘭竹石圖 (Orchid, Bamboo, and Rock), at the Shanghai Museum. It is reproduced in Group for the Authentication of Ancient Works of Chinese Painting and Calligraphy, ed., *Zhongguo gudai shuhua tumu (Chung-kuo ku-tai shu-hua t'u-mu)* 中國古代書畫圖目 (An Illustrated Catalogue of Selected Works of Ancient Chinese Painting and Calligraphy), vol. 4 (Shanghai: Wenwu Chubanshe, 1990), no. 滬 1-1759, p. 46. For more information on this statement and Liu Yüan-ch'i, see entry 23.

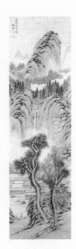

## Landscape
*Shan-shui t'u chou*
*(Landscape Hanging Scroll)*
山水圖軸

1 The second character, *kuan* 裸, which is Ch'en Kuan's given name, literally means "to pour out libations." This character is taken from the ancient Shang dynasty (c. 1600–c. 1100 B.C.) ceremonies surrounding ancestral worship. The radical on the left side of this character, *shih* 示, means "an omen," or "to manifest." It implies revelation through ritual activities. Any character using this radical, such as *kuan* 裸, is always related to religious ceremonies. This character should be distinguished from the character *lo* 裸, which means "naked," or "to strip." Although these two characters look very similar, it is important to realize that the left radical in the second character, *lo* 裸, has an extra dot on the right midsection, which means *i* 衣, or "clothes." Since the difference is so minimal, even Chinese scholars often confuse these two characters. For example, in Yu Jianhua 于劍華 et al., *Zhongguo meishujia renming cidian (Chung-kuo mei-shu-chia jen-ming tz'u-tien)* 中國美術家人名詞典 (A Biographical Dictionary of Chinese Artists) (Shanghai: Renmin Meishu Chubanshe, 1981), p. 1031, where Ch'en Kuan's name is listed, the character *kuan* 裸 has been incorrectly represented as *lo* 裸.

2 Ts'ao Jung-ying is the owner of the Far East Fine Art Company, Inc., located in San Francisco. He inherited an art collection from his grandfather, Ts'ao K'un 曹錕, who in 1923 served as the fourth president of the Republic of China. After the Communist revolution, he and his mother settled in Taipei. Then in the 1970s, he and his American wife immigrated to the

United States and started a business in San Francisco.

3 The "white chamber" in Ch'en Kuan's *hao* "A Cultivated Person at a White Chamber," indicates a plain unadorned house without paint—a poor man's dwelling. See *Hanyu dacidian (Han-yü ta-tz'u-tien)* 漢語大詞典 (Chinese Terminology Dictionary), vol. 8 (Shanghai: Hanyu Dacidian Press, 1988), p. 186, s.v. "*baishi (Pai-shih)* 白室 (white chamber)," "*baiwu (Pai-wu)* 白屋 (white house)," and "*baiwu zhishi (pai-wu chih-shih)* 白屋之士 (a man living in a white house)."

4 For information on Ch'en Kuan's life, see Xu Qin (Hsü Ch'in) 徐沁 (active first half of 17th century), *Minghualu (Ming-hua lu)* 明畫錄 (Painters of the Ming Dynasty), *chüan* 卷 (chapter) 4, reprinted in Yu Anlan 于安瀾, comp., *Huashi congshu (Hua-shih ts'ung-shu)* 畫史叢書 (Compendium of Painting History), vol. 5 (Shanghai: Renmin Meishu Chubanshe, 1962), p. 48. Some sources indicate that Ch'en Kuan was from Yün-chien 雲間, the ancient name of Sung-kiang 松江, or present-day Shanghai. See Lan Ying 藍英 et al., *Tuhui baojian xucuan (T'u-hui pao-chien hsü-ts'uan)* 圖繪寶鑑續篡 (Sequel to Precious Mirror of Painting and Painters of the Ming and Ch'ing Dynasties), *juan (chüan)* 卷 (chapter) 1, reprinted in *Huashih ts'ung-shu* 畫史叢書 (Compendium of Painting History), vol. 4, p. 7.

5 For more on Ch'en Kuan's interest in Ch'ü Yüan's *The Ode of the Grief of Separation*, see *Ming-hua lu*. Ch'ü Yüan was a patriotic poet of the Chu 楚 state during the Warring States period (481–221 B.C.). He composed a long epic poem—the *Li-sao*—and later drowned himself in the Mi-lo 汨羅 River in order to urge the king to disregard calumnious speech. Throughout Chinese history, Ch'ü is remembered each year during the Dragon-Boat Festival on the fifth day of the fifth moon.

6 See *Ming-hua lu* 明畫錄 (Painters of the Ming Dynasty), *chüan* 卷 (chapter) 3, p. 48. This book indicates that Ch'en Kuan painted landscapes emulating the style and conforming to the formats of the Sung and Yüan paintings (畫山水規摹宋元).

## 16. Li Shih-ta 李士達
*(active 1580–1620)*
*Ming dynasty (1368–1644)*

42

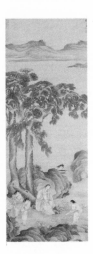

### The Hermit T'ao Yüan-ming (365–427) Enjoying Chrysanthemums
*Yüan-ming shang-chü t'u*
*([T'ao] Yüan-ming Enjoying Chrysanthemums)*

淵明賞菊圖

1 The Li Shih-ta of the Michigan scroll should not be confused with his contemporary of the same name. The other Li Shih-ta was from San-yüan 三原 in Shensi 陝西 province, while the artist of the Michigan painting was from Suchou. The Shensi Li Shih-ta passed the civil service examination and earned his *chin-shih* degree in the second year of the Wan-li period, or 1574. See Zhu Baojiong 朱保炯 and Xie Peilin 謝沛霖, eds., *MingQing jinshi timingbeilu suoyin (Ming-Ch'ing chin-shih t'i-ming-pei-lu so-yin)* 明清進士題名碑錄索引 (An Index of the Stele Bearing the Names of the Holders of the *chin-shih* Degree during the Ming and Ch'ing Dynasties), vol. 2 (Shanghai: Guji Chubanshe, 1980), p. 1272, and ibid., vol. 3, p. 2558.

2 Ch'en Jen-t'ao was a collector-dealer from the Shanghai area. After 1949, he settled in Hong Kong. See the last paragraph of entry 7 on Wen Cheng-ming for more information concerning Ch'en Jen-t'ao and the transaction that brought this work by Li Shih-ta from Ch'en's collection to the University of Michigan.

3 The significance of this seal is unclear.

4 These five seals of Emperor Ch'ien-lung (r. 1736–96) are called *wu-hsi ch'üan* 五璽全 or "the five imperial seals complete," which were specially prepared by Emperor Ch'ien-lung for the important paintings and calligraphic works in his vast collection. For more information on these five

seals, see note 4, entry 7 on Wen Cheng-ming 文徵明 (1470–1559).

5 For the meaning of "The Three Rarities," see note 5 in entry 7 on Wen Cheng-ming.

6 For the two versions of this *hao*, see Jiang Shaoshu (Chiang Shao-shu) 姜紹書 (active 1635–80), *Wusheng shishi (Wu-sheng-shih shih)* 無聲詩史 (A History of Voiceless Poems), *juan (chüan)* 卷 (chapter) 4, reprinted in Yu Anlan 于安瀾, comp., *Huashi congshu (Hua-shih ts'ung-shu)* 畫史叢書 (Compendium of Painting History), vol. 4 (Shanghai: Renmin Meishu Chubanshe, 1962), p. 70. These two *hao* also appear in Xu Qin (Hsü Ch'in) 徐沁 (active first half of 17th century), *Minghualu (Ming-hua-lu)* 明畫錄 (Painters of the Ming Dynasty), *juan (chüan)* 卷 (chapter) 1, reprinted in *Hua-shih ts'ung-shu* 畫史叢書 (Compendium of Painting History), vol. 5, p. 12. See also L. Carrington Goodrich and Fang Chaoying, eds., *Dictionary of Ming Biography, 1368–1644*, vol. 1 (New York and London: Columbia University Press, 1976), p. 868. Li Shih-ta's *hao* also includes Shao-fu 邵夫 (an excellent man).

7 See *Ming-hua lu* 明畫錄 (Painters of the Ming Dynasty), *chüan* 卷 (chapter) 1, p. 12. A summary of this famous incident in English is recorded in *Dictionary of Ming Biography, 1368–1644*, vol. 1, p. 868.

8 See *Ming-hua lu* 明畫錄 (Painters of the Ming Dynasty), *chüan* 卷 (chapter) 1, p. 12.

9 See ibid.

10 Another artist in Suchou, Chü Chieh 居節 (active 1531–85), who was a student of the Wu school master Wen Cheng-ming, also offended Sun Lung. Chü Chieh's house was connected to the imperial silk factory, next to the wall of Sun Lung's living quarters. When Sun wanted to expand his dwelling and summoned Chü Chieh to appear before him, the artist refused. Enraged, Sun Lung tried to ruin Chü Chieh's family. The artist and his family had to move to the suburbs in order to avoid persecution. See *Dictionary of Ming Biography, 1368–1644*, vol. 1, p. 405.

11 See *Ming-hua lu* 明畫錄 (Painters of the Ming Dynasty), *chüan* 卷 (chapter) 1, p. 12.

12 See Li Shih-ta's excellent calligraphy inscribed on the painting entitled *Jui-lan t'u* 瑞蓮圖 (An Auspicious Lotus Blossom), at the National Palace Museum in Taipei, reproduced in *Ku-kung shu-hua t'u-lu* 故宮書畫圖錄 (An Illustrated Catalogue of Calligraphy and Painting at the Palace Museum), vol. 9 (Taipei: National Palace Museum, 1993), p. 17.

13 See *Wu-sheng-shih shih* 無聲詩史 (A History of Voiceless Poems), *chüan* 卷 (chapter) 4, p. 70. According to the author, Li stated that the *mei* 美 (comeliness) of a landscape is primarily derived from its *tsang* 蒼 (mature vigor), *i* 逸 (elegance), *ch'i* 奇 (uniqueness), *yüan* 圓 (dexterous flow), and *yün* 韻 (lingering charm). On the other hand, the *o* 惡 (vices) in painting landscapes included *nen* 嫩 (timidity), *pan* 板 (stiffness), *k'e* 刻 (mechanical execution), *sheng* 生 (lack of skill), and *chih* 癡 (moronic quality).

14 Li Shih-ta's *An Auspicious Lotus Blossom* is surely one of the most exquisite flower paintings of the seventeenth century. It depicts white lotus blossoms accompanied by two green leaves. At the foot of the lotus stems rests a garden rock, executed in ink washes. This work, combined with Li Shih-ta's skillful calligraphy, is an extraordinary painting, reflecting the artist's broad literary background. See note 12 for information on where this painting is reproduced.

15 A biography of T'ao Ch'ien is found in the chapter, "Biography of Hermits," in Fang Xuanling (Fang Hsüan-ling) 房玄齡 (578–648) et al., *Jinshu (Tsin-shu)* 晉書 (The Book of Tsin), 1st ed. dated 648, *juan (chüan)* 卷 (chapter) 64, reprint (Beijing: Zhonghua Shuju, 1974), vol. 4, pp. 2460–65. See entry 55 on Ni T'ien for another work depicting T'ao Yüan-ming and chrysanthemums.

16 See ibid.

17 See ibid.

18 See *Tsin-shu* 晉書 (The Book of Tsin), p. 2461.

19 See ibid. On this occasion T'ao Yüan-ming said, "*wu-pu-neng wei-wu-tou-mi che-yao* 吾不能為五斗米折腰" (I will not bow for the meager allotment of five *tou* of rice). *Tou* is a measure of grain roughly equal to a bushel. This statement has since become a common phrase expressing a proud person's refusal to submit to an unreasonable superior.

20 T'ao Ch'ien's poem, *Let Me Return Home*, is found in Gong Bin's 龔斌 *Tao Yuanming ji jiaojian (T'ao Yüan-ming chi chiao-chien)* 陶淵明集校箋 (T'ao Yüan-ming's Anthology with Collation by Gong Bin), vol. 5 (Shanghai: Shanghai Guji Chubanshe, 1996), pp. 390–401.

21 This poem, no. 5 of T'ao's *Wine-Drinking Poems*, is found in T'ao Ch'ien's *T'ao Ching-chieh chi* 陶靖節集 (Collected Works of T'ao Ch'ien), *chüan* 卷 (chapter) 3 (Taipei: Commercial Press, 1967), pp. 41–42.

## 17. Sheng Mao-yeh 盛茂燁
*(active 1594–1640)*
*Ming dynasty (1368–1644)*

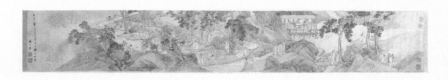

### The Orchid Pavilion Gathering
*Lan T'ing hsiu-hsi t'u*
*(The Orchid Pavilion Purification Gathering)*
蘭亭修禊圖

1  *Hsiu-hsi* is one of the oldest Chinese customs. It usually took place each year on the third day of the third moon. While *hsiu* is a verb meaning "to practice or cultivate," *hsi* is a noun that represents a ceremony of purification with an intent to avert evils. This practice apparently became an official event during the Eastern (or Later) Han dynasty (22–195). It is stated in the chapter, "Li-i chih" 禮儀志 (The Archives of Decorum), in the *Hou-Han shu* 後漢書 (The Book of the Later Han Dynasty) that [each spring,] on the third day of the third moon, government officials, as well as commoners, celebrated the *hsiu-hsi* festival and held drinking parties by the East Creek. (漢書, 禮儀志: 三月上巳, 官民並禊, 飲於東流水上.) Another source found in the chapter "Li-chih" 禮志 (The Document of Decorum) in Fang Hsüan-ling's 房玄齡 (578–648) *Tsin-shu* 晉書 (The Book of Tsin) also discloses that it was the custom of the Han dynasty that on the third day in the late spring season [the third moon], government employees and common people would celebrate the purification ceremony by the East Creek. They rid themselves of evil by washing off the dirt [that had accumulated through the cold winter]. (晉書, 禮志: 漢儀, 季春上巳, 官及百姓, 皆禊於東流水上. 洗濯祓除, 去宿垢.) See Morohashi Tetsuji 諸橋轍次, *Dai Kanwa Jiten* 大漢和詞典 (The Great Chinese-Japanese Dictionary), vol. 8 (Tokyo: Daishukan, 1976), p. 483, s.v. "*hsi* 禊" and "*hsi-yin* 禊飲" (the drinking party of the purification ceremony). To mark this ancient custom, literati traditionally held elegant drinking parties on the third day of the third lunar month at a scenic spot near water. Often poems were composed on these occasions. See *Hanyu dacidian* (*Han-yü ta-tz'u-tien*) 漢語大詞典 (Chinese Terminology Dictionary), vol. 1 (Shanghai: Hanyu Dacidian Press, 1988), p. 1379, s.v. "*xiuxi* (*hsiu-hsi*) 修禊."

2  Nien-an 念庵 (a hut for contemplating) is Sheng Mao-yeh's *hao*. See Lan Ying 藍英 and Xie Bin (Hsieh Pin) 謝彬, eds., *Tuhui*

22  T'ao's *A Biography of Mr. Five Willow Trees* is a story of a scholar whose property was adorned with five beautiful willow trees and who preferred to spend his time drinking, reading, and studying as opposed to pursuing power and position. His quiet and reclusive nature prevented his neighbors from even knowing his name; consequently, he was referred to as "Mr. Five Willow Trees." This work is found in *T'ao Yüan-ming chi chiao-chien* 陶淵明集校箋 (T'ao Yüan-ming's Anthology with Collation by Gong Bin), vol. 6, pp. 420–24.

23  Li Shih-ta's *Listening to the Wind in the Pines* is reproduced in *Ku-kung shu-hua t'u-lu* 故宮書畫圖錄 (An Illustrated Catalogue of Calligraphy and Painting at the Palace Museum), vol. 9, p. 21.

*baojian xucuan* (*T'u-hui pao-chien hsü-ts'uan*) 圖繪寶鑑續纂 (Supplement of Precious Mirror of Painting, Painters of the Ming and Ch'ing Dynasties), *juan* (*chüan*) 卷 (chapter) 1, reprinted in Yu Anlan 于安瀾, comp., *Huashi congshu* (*Hua-shih ts'ung-shu*) 畫史叢書 (Compendium of Painting History), vol. 3 (Shanghai: Renmin Meishu Chubanshe, 1962), p. 6. This name is also recorded as Yen-an 研庵 (a hut for researching). See Jiang Shaoshu (Chiang Shao-shu) 姜紹書 (active 1635–80), *Wusheng shishi* (*Wu-sheng-shih shih*) 無聲詩史 (A History of Voiceless Poems), preface dated 1720, *juan* (*chüan*) 卷 (chapter) 4, reprinted in *Hua-shih ts'ung-shu* 畫史叢書 (Compendium of Painting History), vol. 4, p. 70.

3  *Sheng-hu t'ien-she* 盛湖田舍, or "farm hut on the Sheng Lake," would probably be a group of simple thatched huts built by or on Sheng Lake. This small lake must have been located on the property of the Sheng family. In the lower Yangtze River, or *chiang-nan* 江南, region, many families owned such properties. Such a hut could be used either as a studio or as a study.

4  *Chü-shih* 居士 literally means "a retired scholar." It can also mean "a Buddhist devotee" or "an official out of office." Literati often used it as a humble appellation.

5  These Sheng family painters are listed in *Chung-kuo mei-shu-chia jen-ming tz'u-t'ien* 中國美術家人名辭典 (A Biographical Dictionary of Chinese Artists), p. 919. It is important to point out that in this dictionary, Sheng Mao-yü 盛茂煜 is incorrectly listed as an alternate name for Sheng Mao-yeh. Works of the artists in the Sheng family may be found in the following publications: Sheng Mao-chün's work is illustrated in this catalogue, entry no. 18; Sheng Mao-yü's fan painting, *Hu-hsi san-hsiao* 虎溪三笑 (The Three Laughing Sages at Tiger Creek) is in the collection of the Museum für Ostasiatische Kunst, Cologne, Germany. It is reproduced in Suzuki Kei 鈴木敬, comp., *Comprehensive Illustrated Catalog of Chinese Paintings*, vol. 2 (Tokyo: University of Tokyo Press, 1982), no. E17-011, p. 225; Sheng Mao-chiung's work, *Guanpu tu* (*Kuan-p'u t'u*) 觀瀑圖 (Watching the Cascade), at the Shanghai Museum, is reproduced in Group for the Authentication of Ancient Works of Chinese Painting and Calligraphy, ed.,

Sheng Mao-yeh 盛茂燁
The Orchid Pavilion Gathering
*continued*

44    *Zhongguo gudai shuhua tumu* 中國古代書
畫圖目 (An Illustrated Catalogue of
Selected Works of Ancient Chinese Paint-
ing and Calligraphy), vol. 4 (Shanghai:
Wenwu Chubanshe, 1990), no. 滬 1-1758,
p. 46. In this catalogue, Sheng Mao-chi-
ung's name is listed as Sheng Mao-ying 盛
茂穎. At the Nanking Museum, there is
also a short handscroll, *Lifuo tu* (*Li-fo t'u*)
禮佛圖 (Worshipping Buddha), in the Sheng
family style, by a painter named Sheng
Ying 盛穎. The relationships among Sheng
Mao-chiung, Sheng Mao-ying, Sheng Ying,
and Sheng Mao-yeh need further clarifica-
tion. A landscape painting by Sheng Nien
belongs to the Ching Yüan Chai 景元齋
(James Cahill) Collection. See *Comprehen-
sive Illustrated Catalog of Chinese Paint-
ings*, vol. 1, no. A31-071, p. 354.

6    For the Suchou artists with whom Sheng
Mao-yeh associated with, see Mei-ching
Kao 高美慶, "Sheng Maoye yanjiu" (Sheng
Mao-yeh yen-chiu) 盛茂燁研究 (Research
on Sheng Mao-yeh), in Yang Xin 楊新, ed.,
*Wumen huapai yanjiu* (*Wu-men hua-p'ai
yen-chiu*) 吳門畫派研究 (Research on
Paintings of the Wu School) (Beijing:
Palace Museum, 1993), pp. 205–6. It is
known that, in 1631, Sheng Mao-yeh and
local literati painter Ch'en Yüan-su 陳元
素 (active first half of the 17th century)
jointly completed an ink orchid hand-
scroll. At the beginning of this work, there
is an inscription by Sheng that illustrates
his calligraphic skill and educational back-
ground. This handscroll, entitled *Lanhua
bingshu "Lantingji"* (*Lan-hua ping-shu
"Lan-t'ing chi"*) 蘭花並書蘭亭記 (Orchids
and Calligraphic Work of "The Lan-t'ing
Pavilion Preface"), is now at the Shanghai
Museum. For a reproduction of this hand-
scroll, see Group for the Authentication of
Ancient Works of Chinese Painting and
Calligraphy, ed., *Zhongguo gudai shuhua
tumu* (*Chung-kuo ku-tai shu-hua t'u-mu*)
中國古代書畫圖目 (An Illustrated Cata-
logue of Selected Works of Ancient Chi-
nese Painting and Calligraphy), vol. 2 (Bei-
jing: Wenwu Chubanshe, 1990), no. 滬
1-1574, p. 334. In 1637, Sheng and Shao Mi
邵彌 (c. 1595–1642) collaborated on an ink
plum scroll. See Shanghai Museum,
*Zhongguo shuhuajia yinjian kuanshi*
(*Chung-kuo shu-hua-chia yin-chien k'uan-
shih*) 中國書畫家印鑒款識 (Signatures and
Seals of Chinese Painters and Calligra-
phers), vol. 2 (Shanghai: Wenwu Chuban-
she, 1987), no. 4, p. 1164.

7    See the National Palace Museum's *Wan-
Ming pien-hsing chu-i hua-chia tso-p'in
chan* 晚明變形主義畫家作品展 (Style Trans-
formed: A Special Exhibition of Works by
Five Late Ming Artists) (Taipei: National
Palace Museum, 1977), p. 14.

8    Chan Ching-feng's best-known book is
*Chan Tung-t'u hsüan-lan pien* 詹東圖玄覽
編 (The Author's Descriptive Record of
Paintings), 1st edition 16th century,
reprinted in Lu Fusheng 盧輔聖 et al.,
comps., *Zhongguo shuhua quanshu*
(*Chung-kuo shu-huo ch'üan-shu*) 中國書畫
全書 (The Complete Collection of Books of
Chinese Paintings and Calligraphy), vol. 4
(Shanghai: Shuhua Chubanshe, 1992), pp.
1–59. The relationship between Ting Yün-
p'eng and Chan Ching-feng is found in the
entry for a Yüan dynasty painter, Ts'ung
Tzu-lung 從子龍, recorded in Lu Fusheng,
p. 14: "Yüan dynasty painter Ts'ung Tzu-
lung's work *Transporting Grain on a
Snowy Day* is executed on two pieces of
silk . . . . Formerly, it belonged to the fam-
ily of my student, Ting Nan-yü [Ting Yün-
p'eng's *tzu*]. " (元人從子龍. 雙幅絹. 雪天運
糧圖. . . . 舊為吾門人丁南羽家物.)

9    An "arhat" is a term signifying a Buddhist
monk who has achieved enlightenment.
Sometimes it refers to the specific follow-
ers of Shakyamuni, the founder of Bud-
dhism.

10    See Barry Till, *Art of the Middle Kingdom:
China* (Victoria: Art Gallery of Greater
Victoria, 1986), pl. 83 and *Comprehensive
Illustrated Catalog of Chinese Paintings*,
vol. 3, no. JM11-101, p. 198.

11    There is also stylistic evidence that indi-
cates Sheng had some kind of relationship
with another painter from Suchou, Li
Shih-ta 李士達 (active 1580–1620).
Although no documents verify this rela-
tionship, similarities in their depiction of
figures seem too close to discount. For
example, both painted figures with similar
body types and poses, hair styles, and
small beady eyes. For more on Li Shih-ta
and his work, see entry 16.

12    Such activity was perhaps derived from
ancient bathing customs in China. Lack-
ing the convenience of modern plumbing,
people could rarely afford to bathe during
the winter. By the springtime, when the
weather became warm, a day was desig-
nated for all to bathe in the river. In Tibet,
for example, there is still a national
Bathing Day in the spring. One should also
bear in mind that, in Chinese mythology
and folklore, the third day of the third
moon is supposed to be the birthday of
*Hsi-wang Mu* 西王母, or "the Western
Royal Mother." It is believed that a lavish
birthday party, the *P'an-t'ao hui* 蟠桃會
(Legendary Peach Banquet) is held beside
the *Yao-ch'ih* 瑤池 (Jasper Lake) and
attended by numerous immortals. See E.
T. C. Werner, *A Dictionary of Chinese
Mythology*, reprint (Taipei: Wen-hsing
Press, 1961), p. 164. Such Taoist folklore

could be connected with the elegant gath-
erings beside a stream, attended by the
intelligentsia and held on the same day.

13    The Lan-t'ing 蘭亭, or "Orchid Pavilion,"
is located on the slope of Lan-chu Moun-
tain 蘭渚山, southwest of the present-day
city of Shao-hsing 紹興 in Chekiang 浙江
province.

14    Wang Hsi-chih was considered the greatest
Chinese calligrapher. Although none of his
original work survives today, calligraphic
works attributed to him have been treated
with respect and admiration for thousands
of years. They have also been used by
numerous past calligraphers as models. His
son, Wang Hsien-chih 王獻之 (344–386),
was also a well-known calligrapher. For a
discussion of Wang Hsi-chih's calligraphy,
see Shen C. Y. Fu, *Traces of the Brush*
(New Haven: Yale University Art Gallery,
1977), pp. 5–8 and 89–93.

15    The text of *Lan-t'ing hsü* is recorded in the
biography of Wang Hsi-chih found in *Lieh-
chuan* 列傳 (Collected Biographies) 50, p. 2
of Fang Hsüen-ling's 房玄齡 (578–648)
*Tsin-shu* 晉書 (The Book of the Tsin
Dynasty), vol. 5 (Beijing: Xinhua Shutian,
1976). It is quite common for excerpts
from this piece of writing to be used in lit-
erature and art; however, the whole text is
seldom presented, and it is rare for an
English translation to be provided. The
complete text and translation follow:

> During the tenth oxen annum, the ninth
> year of the Yung-ho reign (353), people
> assembled at the end of late spring to
> participate in the purification gathering
> at the Orchid Pavilion, which is located
> on the north side of a hill in the prefec-
> ture of K'uai-chi. All of the social elite,
> young and old, attended. The area had
> high mountain ridges, luxuriant woods,
> and tall bamboo, as well as limpid
> streams with surging rapids glittering
> like a jade belt on both sides. The water
> was channeled to a meandering rivulet
> for floating the wine cups, with guests
> seated on both banks. Although there
> was no music from string or wind
> instruments, the drink and the recita-
> tion of poems were more than enough to
> cheerfully express our exquisite feelings.
> On that day, the sky was bright and
> clear with a gentle, soothing breeze. We
> gazed up to comprehend the vastness of
> the universe. We looked down and
> observed the numerous species of plants
> and creatures. Our eyes explored freely
> and our minds raced unbridled. This
> was the utmost enjoyment for our
> senses of sight and sound. What a plea-
> sure! Associating with other people is a
> joy that endures over the whole span of

our lives. It may be in the form of an intellectual discussion in a room that draws upon our own hearts and minds or may come from outside stimulation to which we abandon ourselves in unrestrained happiness. The preferences of each individual may be opposite, just as quietude and rowdiness are vastly different. However, when one is exhilarated by something, even if it is ever so fleeting, he often feels so satisfied that he forgets that old age lurks before him. But enthusiasm wanes and emotions fluctuate as situations change, and this occasions our laments! In the blink of an eye, past pleasures become mere traces in history. Despite its ephemeral nature, pleasure is something everyone seeks. Our short lives are in constant flux and eventually come to an end. The ancients used to say, "Birth and death are truly the two grimmest events of life!" It pains one greatly to even think of such a saying! Whenever I examine the manifold reasons for the pleasure of our predecessors, I find they seem to be concordant. Sometimes I regret that when I read others' writings, I do not share their expressed feelings. I know that the idea [of philosopher Chuang-tzu] that life and death are the same is ridiculous. To claim that the thousand-year-old P'eng-tsu died young and unexpectedly is inaccurate and untrue. When the people of the future investigate us, it is the equivalent of our looking back at people from the past. Alas, I have no choice but to pay attention to my contemporaries and record their words. The world will change and events will differ, but perhaps future generations will achieve pleasure in the same way we do. Reading this prose, they will experience some sense of identification.

Composed by General Wang Hsi-chih of the Tsin dynasty.

永和九年, 歲在癸丑. 暮春之初, 會于會稽山陰之蘭亭. 修禊事也. 群賢畢至, 少長咸集. 此地有崇山峻嶺, 茂林修竹. 又有清流激湍, 瑛帶左右. 引以為流觴曲水, 列坐其次. 雖無絲竹管弦之盛, 一觴, 一詠, 亦足以暢敘幽情. 是日也, 天朗氣清, 惠風和暢. 仰觀宇宙之大, 俯察品類之盛. 所以遊目騁懷, 足以極視聽之娛, 信可樂也! 夫人之相與, 俯仰一世. 或取諸懷抱, 悟言一室之內. 或因寄所託, 放浪形骸之外. 雖趣舍萬殊, 靜躁不同; 當其欣於所遇, 暫得於己, 快然自足. 不知老之將至! 及其所之既倦, 情隨事遷, 感慨係之矣! 向之所欣, 俛仰之間, 以為陳跡, 猶不能不以之興懷. 況修短隨化, 終期於盡. 古人云: "死生亦大矣!" 豈不痛哉! 每攬昔人興感之由, 若合一契. 未嘗不臨文嗟悼, 不能喻之於懷. 固知一死生為虛誕, 齊彭殤為妄作. 後之視今, 亦由今

之視昔. 悲夫! 故列敘時人, 錄其所述. 雖世殊事異, 所以興懷其致一也! 後之攬者, 亦將有感於斯文.

晉, 右將軍, 王羲之書.

16    Today, there are numerous versions of the *Lan-t'ing hsü* by Wang Hsi-chih. However, the original manuscript, which was treasured by the calligrapher's descendants for many generations, has long been lost. According to unconfirmed reports, during the seventh century, the best copy of Wang Hsi-chih's original calligraphy ended up in the collection of a talented monk, Pien-ts'ai 辯才 (active c. 627–49). Due to its fame, this calligraphic work was coveted by Emperor T'ai-tsung 太宗, whose name was Li Shih-min 李世民 (597–649), the first emperor of the T'ang dynasty (618–905). Knowing that Pien-ts'ai would deny owning the calligraphy if he were confronted, the emperor sent a clever official, Hsiao I 蕭翼 (active c. 627–49), to trick the monk into revealing that he owned the work. First Hsiao befriended Pien-ts'ai. One day at a drinking party, he bragged to the monk that he owned the genuine *Lan-t'ing* scroll by Wang Hsi-chih. When he showed the imitation to Pien-ts'ai, the monk immediately recognized the poor quality and announced it to Hsiao I. A heated argument followed, and in order to prove his point, Pien-ts'ai brought out the coveted scroll, thus admitting its existence. Consequently Pien-ts'ai had no choice but to reluctantly hand the *Lan-t'ing* scroll over to the emperor. Many copies were then made by famous calligraphers at the court. Obsessed by the beauty of the *Lan-t'ing* scroll, the emperor ordered that it be interred with his remains. This story, called *Hsiao I chuan Lan-t'ing* 蕭翼賺蘭亭 (Hsiao I Gets the *Lan-t'ing* Manuscript through a Trick of Confidence), is found in Ji Yougong (Chi Yu-kung) 計有功 (active 1121–1161), *T'ang-shih chi-shih* 唐詩記事 (Episodes Recorded in T'ang Dynasty Poems), 1st edition dated 1224, *chüan* 卷 (chapter) 5, reprint (Shanghai: Zhonghua Shuju, 1965), pp. 67–68. Today the many copied versions include those made from rubbings. Although the *Lan-t'ing hsü* has been venerated for more than a thousand years in Chinese history, we have learned, thanks to the research of the modern scholar Kuo Mo-jo 郭沫若 (1891–1978), that the text and calligraphy may have been a forgery by one of Wang's followers, made during the later sixth century. For a discussion of the authenticity of *Lan-t'ing hsü*, see Kuo's article, "You WangXie muzhi de chutu lundao Lantingxu de zhenwei" (Yu Wang-Hsieh mu-chih teh chu-t'u lun-tao Lan-t'ing hsü teh chen-wei) 由王謝墓志的出土論到蘭亭序的真偽

45

(The Authenticity of the *Lan-t'ing hsü* in Light of the Epitaphs of Wang Hsing-chih and Hsieh K'un), in *Wen Wu* 文物 (Cultural Relics), no. 6 (Beijing: Wenwu Chubanshe, 1965), p. 1–25 and other discussions in nos. 9–12 in *Wen Wu*, 1965.

17    The relative status of the figures is revealed not only by their physical scale but also by costume and dress. The servants in Sheng's painting wear blue jackets and pants instead of robes, since they must perform physical tasks. Young servants either wore their hair in two tufts or let it loose before they reached adulthood. Because the Chinese regarded beards as a symbol of status deriving from advanced age and wisdom, most men grew beards. Consequently, the scholars in the *Lan-t'ing* painting are bearded. The costumes and accoutrements that Sheng chose—robes that tie over the chest and one scholar's goose feather fan—were popular long before the Ming dynasty setting of this painting and indicate his interest in old style paintings.

18    Although Chinese ink stones typically come in many forms, such as animals and flowers, those in the shape of the character 風 are considered the most refined and suitable for scholars. There is even a special term referring to this type of inkstone, "*feng-tzu yen* 風字硯" (an ink stone in the shape of the character feng). See *Han-yü ta-tz'u-tien* 漢語大詞典 (Chinese Terminology Dictionary), vol. 12, p. 598, s.v. "*fengziyan* (*feng-tzu yen*) 風字硯."

19    For an example of Wu school rocks and trees, see Wen Cheng-ming's painting, *Old Cypress and Rock*, reproduced in Wai-kam Ho 何惠鑑 et al., *Eight Dynasties of Chinese Paintings: The Collections of the Nelson Gallery-Atkins Museum, Kansas City, and the Cleveland Museum of Art* (Cleveland: Cleveland Museum of Art, 1980), cat. no. 175, p. 220.

20    For example, it is well known that Shen Chou possessed a distinguished painting and calligraphy collection. Shen Chou's collection was listed by his student, Wen Cheng-ming. Wen's list was originally found in a colophon he inscribed on a calligraphic work. For Wen's list of Shen Chou's collection, see "Shih-t'ien hsien-sheng shih-lüeh" 石田先生事略 (A Brief Biography of Shen Chou), *chüan* 卷 (chapter) 10, pp. 27–28, in Shen Chou's *Shih-t'ien hsien-sheng chi* 石田先生集 (Shen Chou's Anthology), vol. 2 (Taipei: National Central Library, 1968), new page nos. 915–17.

21    For the Wu school treatment of the same theme, see Wen Cheng-ming's *The Lan-t'ing Preface* handscroll at the Palace

Sheng Mao-yeh 盛茂燁
**The Orchid Pavilion Gathering**
*continued*

18. **Sheng Mao-chün** 盛茂燨
*(active 1600–1645)*
*Ming dynasty (1368–1644)*

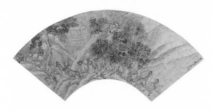

**The Seven Sages Passing through a Gate**
*Ch'i-hsien kuo-kuan t'u*
*(Seven Sages Passing through a Gate)*
七賢過關圖

46  Museum, Beijing, reproduced in Palace Museum, *Ming-tai Wu-men hui-hua* 明代吳門繪畫 (The Wu Paintings of the Ming Dynasty) (Hong Kong: Commercial Press, 1990), pl. 22, p. 53. Another example by Ch'ien Ku 錢穀 (1508–78?) is *Gathering at the Orchid Pavilion* at the Metropolitan Museum of Art. This version by Ch'ien Ku, a near contemporary of Sheng Mao-yeh, exemplifies a more orthodox Wu style with bolder color and looser lines. Sheng's painting is far more refined and more carefully composed. Ch'ien Ku's work is reproduced in Alice R. M. Hyland, *The Literati Vision: Sixteenth-Century Wu School Painting and Calligraphy* (Memphis: Memphis Brooks Museum of Art, 1984), fig. 41, p. 69 and color pl. 8, p. 88. A famous handscroll of the Lan-t'ing pavilion attributed to Li Kung-lin 李公麟 (1049–1106), was incised on a stele during the fifteenth century. Since that time, many rubbing have been made, and Sheng may have also used one of these as a model for his Michigan handscroll.

22  A Japanese provenance is also supported by the existence of a faithful copy of the Michigan scroll, executed by the famous Japanese painter Tessai Tomioka 鐵齋 (1838–1924). For a reproduction of this copy, see *Tessai O sakuhin shu* 鐵齋翁作品集 (Collected Works by Tessai O), preface dated 1947 (N.p.: n.d.), p. 15.

1  Since there is a popular Six Dynasties (220–589) motif centered on the number seven, the *Chu-lin ch'i-hsien* 竹林七賢 or "the seven sages of the bamboo grove," it is tempting to relate this motif to Sheng Mao-chün's fan painting. However, the Michigan work includes neither the bamboo grove setting nor the objects related to these sages: the *jüan-hsien* 阮咸, a string musical instrument, the *ju-i* 如意 back-scratcher, the wine cup, and zither. For a reproduction of four of the seven sages, see Sherman Lee, comp., *China, 5,000 Years: Innovation and Transformation in the Arts* (New York: Guggenheim Museum, 1998), fig. 8, p. 136. The seven famous scholars of the T'ang dynasty depicted in the Michigan fan include: 1) Chang Yüeh 張說 (active 700–50); 2) Li Po 李白 (701–62); 3) Wang Wei 王維 (701–61); 4) Meng Hao-jan 孟浩然 (689–740); 5) Chang Chiu-ling 張九齡 (673–740); 6) Li Hua 李華 (active 710–45); and 7) Cheng Ch'ien 鄭虔 (active 705–50). See *Hanyu dacidian* (*Han-yü ta-tz'u-tien*) 漢語大詞典 (Chinese Terminology Dictionary), vol. 1 (Shanghai: Hanyu Dacidian Press, 1988), p. 165, s.v. "*Qixian guoguan*" (*Ch'i-hsien kuo-kuan*) 七賢過關 (Seven Sages Passing through a Gate). For a discussion of this subject matter, see section "*Shiwu* 事物" (Things in General) in Lang Ying 郎瑛 (1487–after 1566), *Qixiu leigao* (*Ch'i-hsü lei-kao*) 七修類稿 (Notes on Seven Categories of Miscellaneous Topics), *juan* (*chüan*) 卷 (chapter) 25 (Shanghai: Zhonghua Shuju, 1961), p. 374. A painting attributed to Li T'ang 李唐 (c. 1071–c. 1150) depicting this theme is found in Li O's 厲鶚 (1692–1752) *NanSong yuanhualu* (*Nan-Sung yüan-hua lu*) 南宋院畫錄 (Records of Southern Sung Academy Painting), preface dated 1721, *juan* (*chüan*) 卷 (chapter) 2, reprinted in Yu Anlan 于安瀾, comp., *Huashi congshu* (*Hua-shih ts'ung-shu*) 畫史叢書 (Compendium of Painting History), vol. 7 (Shanghai: Renmin Meishu Chubanshe, 1962), p. 9. It is

not clear whether this is the same work now at the Freer Gallery of Art, Washington, D.C. See Suzuki Kei 鈴木敬, comp., *Comprehensive Illustrated Catalog of Chinese Paintings*, vol. 1 (Tokyo: University of Tokyo Press, 1982), no. A21-084, pp. 222–23.

2  This fan was auctioned at Sotheby's, New York, on May 30, 1990. See Sotheby's auction catalogue, *Fine Chinese Paintings* (New York: Sotheby's, May 30, 1990), lot no. 73. It was published as a Ch'ing dynasty work, with little other information in the catalogue entry.

3  See note 1.

4  For an example of Ming dynasty lacquer carving depicting the "seven sages passing through a gate" motif, see Ch'ien-chai 潛齋 (So Yü-ming 索予明), "Ch'i-hsien kuo-kuan wei-ti-shih" 七賢過關為底事 (The Reason Why the Seven Sages Passed through the Gate), in *Ku-kung wen-wu yüeh-k'an* 故宮文物月刊 (National Palace Museum Monthly of Chinese Art), vol. 8, no. 4 (Taipei: National Palace Museum, 1990), pp. 112–14.

5  For more information on Sheng Mao-yeh, see entry 17. In China, children of the same family customarily share the same first or middle name. At other times, the parents may choose characters with the same radicals or roots to identify brothers and sisters. In this case, Sheng Mao-yeh 盛茂燁 and Sheng Mao-chün 盛茂燨 have the same family and middle name. The third character, *yeh* 燁 and *chün* 燨, both carry a *huo* 火, or "fire" radical, on the left-hand side.

6  For the names and works of the painters in the Sheng family, see note 6 in entry 17 on Sheng Mao-yeh.

7  For a discussion of painters and their production processes, see James Cahill, *The Painters' Practice: How Artists Lived and Worked in Traditional China*. (New York: Columbia University Press, 1994).

8  See entry 17 for a discussion on and a reproduction of Sheng Mao-yeh's handscroll *The Orchid Pavilion Gathering*.

## 19. Tseng Ching 曾鯨

*(1564–1647)*
*Ming dynasty (1368–1644)*

### Portrait of P'an Ch'in-t'ai

*P'an Ch'in-t'ai hsien-sheng hsiang*
*(Portrait of Mr. P'an Ch'in-t'ai)*

潘琴台先生像

1 While P'an is a family name, Ch'in-t'ai, meaning "a table for a zither," is apparently the subject's *hao*. His given name is unknown; consequently, he cannot be identified.

2 K'ung-ch'ing kuan 空青館 (The Sky Blue Studio) was the name of the studio belonging to Pien Yü-li 邊浴禮 (active second half of the 19th century). Pien served under the Emperor Kuang-hsü 光緒 (r. 1875–1908) as a provincial official of Honan 河南 province, in charge of civil and financial administration. See Chen Naiqian 陳乃乾, ed., *Shiming biehao suoyin (Shih-ming pieh-hao so-yin)* 室名別號索引 (Index of Style Names) (Beijing: Zhonghua Shuju, 1982), p. 161, and Tsang Li-ho 臧勵和, *Chung-kuo jen-ming ta-tz'u-tien* 中國人名大辭典 (Chinese Biographical Dictionary) (Shanghai: Shangwu Shuju, 1921), p. 1759.

3 Han-ku chai 酣古齋 (The Studio of Intoxicating Antiquity) is probably the name of a conservation shop in Shanghai, active around the turn of this century. Unfortunately, it cannot be verified in early books dealing with the history of Chinese painting restoration. Wang Yikun 王以坤, the former chief-conservator at the Palace Museum in Beijing, listed the names of many studios active around 1900 at the end of his book, *Shuhua zhuanghuang yange kao (Shu-hua chuang-huang yen-ke k'ao)* 書畫裝潢沿革考 (An Investigation into the History of the Mounting and Decorating of Painting and Calligraphy) (Beijing: Forbidden City Press, 1993), pp. 59–60. Given the paucity of this information, as well as the difficulty in procuring

Wang's book, the names of the famous studios are listed as follows:

In Beijing: 存雅齋, 德雅齋, 明雅齋, 竹林齋, 竹實齋, 明正齋, 大樹齋, 尚古齋, 石墨齋, 彝寶齋, 清翰齋, 森古齋, 潤古齋, 清雅齋, 清妙齋, 存古齋, 會文齋, 翰古齋, 舒雲齋, 萃文齋, 正誼齋, 懿雅齋, 汲古齋, 存梓齋, 修古齋, 寶華齋, 觀古齋, 松石齋, 金濤齋, 集賢齋, 觀古閣, 蘊輝閣, 桐體閣, 湘文閣, 春清閣, 松蘊閣, 鑒文閣, 護雲樓, 修本堂, 延華軒, 玉池山房, 松友山房, 二友山房, 智遠山房, 文藝山房, 門古山房, 宛委山房.

In Shanghai: 鑒古齋, 汲古齋, 晉賞齋, 恆晉齋, 翰宜齋, 多寶齋, 沿晉齋, 翰分齋, 集古齋, 味古齋, 翰文齋, 漠石齋, 文薈齋, 文元齋, 華古齋, 永樂齋, 雲寶齋, 時古齋, 古墨齋, 賞古齋, 集寶齋, 佶是齋, 汲寶齋, 集珍齋, 養壽齋, 松文齋, 漢古齋, 采雲齋, 雅竹齋, 愛古齋, 錦文齋, 怡文齋, 汲古閣, 天一閣, 凌雲閣, 清秘閣, 黎清閣, 紫霞閣, 雲霞閣, 雲暉閣, 紫暉閣, 榮華閣, 古文閣, 古華閣, 清霞閣, 墨壽軒, 松鶴軒, 桐蔭軒, 兩宜軒, 雲林書畫社.

In Suchou: 味綠齋, 師古齋, 近清齋, 近文齋, 近宜齋, 迎文齋, 漱雅齋, 晉宜齋, 寶晉齋, 松竹齋, 珍竹齋, 松雪齋, 讀書齋, 永源齋, 佩文齋, 歡文齋, 澤古齋, 溫古齋, 宜古齋, 榮寶齋, 積古齋, 積寶齋, 青雲齋, 古香室, 古歡室, 寶蓮室, 寶古山房, 紅鵝仙館.

In Wu-hsi: 戴正興, 明古齋, 文林齋, 華文齋, 長樂齋, 豎賞齋, 成古齋, 平古齋, 鑒古齋.

Although this is not a complete list, it represents the generally recognized studios of that period.

4 This painting and Shih Ch'ü's *Portrait of Tseng Ching* (entry 41) were purchased together in Seattle in 1966 from Mr. P. S. Chiang, the younger brother of Chiang Ku-sun 蔣穀蓀 (1901–73). P. S. Chiang's collection was inherited from his father, Chiang Ju-tsao 蔣汝藻 (1877–1954), better known by the name of Chiang Meng-p'ing 蔣孟蘋. See note 1 in entry 2, of *Mountain Freshet—Wind and Rain*. The father was a shrewd and experienced collector. Shih Ch'ü's *Portrait of Tseng Ching* at the University of Michigan, a small painting that was probably ignored by other contemporary collectors, was saved thanks to Chiang Meng-p'ing's sharp aesthetic sense. See entry 41 for more information on Shih Ch'ü's *Portrait of Tseng Ching*.

5 Ch'en Chi-ju 陳繼儒 (1558–1639) was one of the leading literati of the Sung-kiang 松江 (Shanghai) area during the late Ming period. Although he did not occupy any official position, he was extremely popular in the lower Yangtze River region. As a writer and art critic, he was highly

esteemed by high officials as well as the lower classes. His friendship with the famous and influential scholar-official Tung Ch'i-ch'ang 董其昌 (1555–1636) was another factor in his popularity. As a result, Ch'en was frequently invited to write epitaphs and birthday congratulations for well-to-do families. Not only did books often bear his preface, but fine silk vendors also used his name in advertisements. For Ch'en's brief biography, see Arthur W. Hummel, ed., *Eminent Chinese of the Ch'ing Period, 1644–1912*, vol. 1 (Washington, D.C.: United States Government Printing Office, 1943–44), pp. 83–84. Ch'en is also known for his calligraphy and painting. For a list of his works, see Osvald Sirén, *Chinese Painting: Leading Masters and Principles* (New York: Ronald Press, 1956), vol. 7 (reprinted New York: Hacker Art Books, 1973), pp. 160–61.

6 The "worries of the man of Ch'i," or *Ch'i-jen yu-t'ien* 杞人憂天, is an expression derived from an ancient Chinese fable found in the *T'ien-jui* 天瑞 chapter of the book of *Lieh-tzu* 列子. It says that a man of the Ch'i state was haunted by the fear that the sky might fall. This alludes to people who harbor paranoid anxieties and fears. See *Hanyu dacidian (Han-yü ta-tz'u tien)* 漢語大詞典 (Chinese Terminology Dictionary), vol. 4 (Shanghai: Hanyu Dacidian Press, 1994), p. 787, s.v. "*Qiren youtian (Ch'i-jen yu-t'ien)* 杞人憂天." "Unexpected luck of an old man on the frontier" is a common Chinese idiom suggesting that a loss may turn out to be a gain. It is based on a story about an old man of the frontier near Mongolia who once lost his best mare. It later returned with a fine stallion. When his son tried to ride the new horse, he fell off and lost a leg. Due to this accident, the son was exempted from military service and fighting in a grim war with the Huns in which many young men were killed. The story was originally recorded in the *Jen-chien hsün* 人間訓 chapter of the book of *Huai-nan tzu* 淮南子. See *Han-yü ta-tz'u tien* 漢語大詞典 (Chinese Terminology Dictionary), vol. 2, p. 1182, s.v. "*Saiweng shima*" (*Sai-weng shih-ma*) 塞翁失馬.

7 Pan-chu chü 伴竹居 literally means "a hermitage that accompanies a bamboo groove."

8 Although the character *mei* 眉 in Ch'en Chi-ju's *hao* literally means "eyebrows," it does have other implications. For example, the term *mei-shou* 眉壽, or "long eyebrows," actually indicates old age or longevity. Thus, the real meaning of Ch'en's *hao* should be "a man with long eyebrows who will live into his old age."

Tseng Ching 曾鯨
Portrait of P'an Ch'in-t'ai
*continued*

48   9   Li Liu-fang 李流芳 (1575–1629), a literati-painter, was originally from She Hsien 歙縣, Anhui 安徽 province, and later moved to Chia-ting 嘉定 near Shanghai. His *tzu* was Ch'ang-heng 長蘅 (a long fragrant plant) and his *hao*, T'an-yüan 檀園 (Sandalwood Garden). For his many accomplishments in painting, he was grouped as one of the "Nine Friends of Painting (*Hua-chung chiu-yu* 畫中九友)." He was a close associate of Tung Ch'i-ch'ang, the great calligrapher-painter and critic of the late Ming dynasty. For his brief biography, see *Chung-kuo jen-ming ta-tz'u-tien* 中國人名大詞典 (Chinese Biographical Dictionary), p. 377. Osvald Sirén provides a long list of Li's works in his *Chinese Painting: Leading Masters and Principles*, vol. 7, pp. 207–8.

10   Wang Hsien-chih 王獻之 (344–86) was the son of Wang Hsi-chih 王羲之 (321–79). Both the father and son were acclaimed calligraphers of the Tsin dynasty (317–419). For a discussion focusing on the Wangs' calligraphy, see entry 17, *The Orchid Pavilion Gathering* by Sheng Mao-yeh. T'ao Yüan-ming 陶淵明 is the sobriquet of T'ao Ch'ien 陶潛 (372–427), the great poet and philosopher who gave up his official position in order to enjoy a life of leisure. See entry 10 for *The Peach Blossom Spring* by Ch'iu Ying 仇英 (1502?–1552) and entry 55 on Ni T'ien's 倪田 (1855–1919) *T'ao Ch'ien Appreciating Chrysanthemums*.

11   Ch'en Kuan 陳祼 was from Suchou, although in some books he is recorded as being from Sung-chiang 松江, or Shanghai. Originally his name was Ch'en Tsan 陳瓚, and his *tzu* was Shu-kuan 叔祼 (a junior official in charge of pouring libations at the ancient libation ceremony). Later, he adopted the second character of his *tzu*, Kuan 祼, as his name, and changed his *tzu* to Ch'eng-chiang 誠將 (an honest general) and his *hao* to Tao-shu 道樗 (an enlightened ailanthus tree). He also had another *hao*, Pai-shih 白室 (a white chamber). His name *Kuan* 祼 is a rare character meaning "to pour out libation." He was a third-generation painter of the Wu school and followed Wen Cheng-ming's landscape style. See entry 15 for more information on Ch'en Kuan's life and work.

12   The "white chamber" in Ch'en Kuan's *hao*, "A Cultivated Person at a White Chamber," indicates an unadorned house without paint—a poor man's dwelling. See *Hanyu dacidian* (*Han-yü ta-tz'u-tien*) 漢語大詞典 (Chinese Terminology Dictionary), vol. 8 (Shanghai: Hanyu Dacidian Press, 1988), p. 186, s.v. "*baishi* (*Pai-shih*) 白室 (white chamber)," "*baiwu* (*Pai-wu*) 白屋 (white house)," and "*baiwu zhishi* (*pai-wu chih-shih*) 白屋之士 (a man living in a white house)."

13   For more information on Ts'ao Hsi, see Howard Rogers, ed., *Kaikodo* 懷古堂 *Journal* (Kamakura, New York: Kaikodo, Autumn 1998), cat. no. 11, pp. 52–53. Apparently, Ts'ao's younger brother, Ts'ao Chen 曹振 (active mid-17th century) and Ts'ao Chen's son, Ts'ao Yu-kuang 曹友光 (active second half of 17th century) were also painters. See also Yu Jianhua 于劍華 et al., *Zhongguo meishujia renming cidian* (*Chung-kuo mei-shu-chia jen-ming tz'u-tien*) 中國美術家人名詞典 (A Biographical Dictionary of Chinese Artists) (Shanghai: Renmin Meishu Chubanshe, 1981), p. 901. A fan by Ts'ao Hsi in the former collection of Jean-Pierre Dubosc (1903–88) was auctioned in 1993. See *Fine Chinese Paintings and Calligraphy from the Jean-Pierre Dubosc Collection* (New York: Christie's, December 1, 1993), lot no. 40, p. 41. For information on Jean-Pierre Dubosc, see entry 10 on Ch'iu Ying.

14   Ku-k'ou 谷口 is the name of a place located in Shensi 陝西 province, where the ancient, legendary Chinese emperor Huang-ti 黃帝 ascended to heaven, riding a flying chariot. During the Han dynasty (206 B.C.–A.D. 220), a person called Cheng Tzu-chen 鄭子真 lived there as a hermit. Consequently, Ku-k'ou has been used as a term to refer to a recluse. The poet Ts'ao Hsi called P'an Ch'in-t'ai by this name to indicate that the latter lived humbly, like a hermit. See *Han-yü ta-tz'u tien* 漢語大詞典 (Chinese Terminology Dictionary), vol. 10, p. 1317 s.v. "*gu-kou* (*ku-k'ou*) 谷口."

15   Lo-fu, located in Canton province, is the name of a famous mountain associated with Taoism.

16   Mt. Tai, located in Shantung province, is considered the sacred mountains of the east.

17   Chung Ch'i 鍾期 is also known as Chung Tz'u-ch'i 鍾子期. He lived in the Ch'u 楚 state during the Spring and Autumn 春秋 period (770–481 B.C.). One day, when a musician named Po Ya 伯牙 played his *ch'in* (zither) and tried to express the majesty of high mountains and the tranquility of flowing water in his music, Chung Ch'i immediately comprehended his implication. Po Ya was delighted. When Chung Ch'i later died, Po Ya, believing that there was no other person who could understand his music, broke his instrument and vowed never to play again. Their story is found in the chapter *Pen-wei* 本味 (Basic Taste) in *Lü-shih ch'un-ch'iu* 呂氏春秋 (Mr. Lü's Collated Annals of Spring and Autumn). It has been adopted as an example of true understanding among friends. See *Han-yü ta-tz'u tien* 漢語大詞典 (Chinese Terminology Dictionary), vol. 11, p. 1351, s.v. "Zhong Ziqi (Chung Tzu-ch'i) 鍾子期."

18   *Yün-tang* 篔簹 is a species of rare bamboo that grows near water. *Yün-tang ku* 篔簹谷 is the name of a valley filled with bamboo, located in Yang county 洋縣 of Shensi 陝西 province. It is said that the great bamboo painter Wen T'ung 文同 (1018–79) of the Northern Sung dynasty (960–1126) built a pavilion in this valley and used the bamboo as his model. See *Tz'u-hai* 辭海 (Sea of Terminology: Chinese Language Dictionary), vol. 2 (Taipei: Chung-hua Press, 1974), p. 29, s.v. "*yün-tang*" and "*yün-tang ku*." *T'u-men ta-chüeh* 屠門大嚼 literally means to stand before a butcher's shop and masticate vigorously—or figuratively, one who ardently desires the unattainable, yet attempts to satisfy himself.

19   A "boiling tea pot" indicates the home of a well-prepared host waiting for his guests.

20   *Kuei-ch'ü-lai* 歸去來 is a term borrowed from the well-known poem *Kuei-ch'ü-lai tz'u* 歸去來辭 or *Poem on Retiring*, by T'ao Ch'ien. It is recorded in an entry on T'ao Ch'ien in the chapter "Yin-i chuan 隱逸傳" or "Lives of the Hermits," *The Book of Tsin* 晉書. For more information on T'ao Ch'ien, see entry 16 of Li Shih-ta, as well as 55 of Ni T'ien.

21   *Ch'uan-shen hsieh-chao* 傳神寫照 is a term found in *The Book of Tsin* and in Zhang Yanyuan (Chang Yen-yüan) 張彥遠 (active 9th century), *Lidai minghuaji* (*Li-tai ming-hua chi*) 歷代名畫記 (Record of Famous Paintings of Successive Dynasties), completed 847, *juan* (*chüan*) 卷 (chapter) 5, reprinted in Yu Anlan 于安瀾, comp., *Huashi congshu* (*Hua-shih ts'ung-shu*) 畫史叢書 (Compendium of Painting History), vol. 1 (Shanghai: Renmin Meishu Chubanshe, 1962), p. 68. Apparently in painting portraits, Ku K'ai-chih often left the eyes unfinished for several years. When asked the reason, he answered that people's four limbs, whether beautiful or ugly, were not essential. The expression of the appearance and spirit of the sitter depended on the depiction of the two eyes. (四體妍蚩，本無關於妙處。傳神寫照，正在阿睹中。) Thus, a painter should be very serious in executing the eyes on a portrait. For more information on Ku K'ai-chih and his famous handscroll, entitled *The Admonitions of the Instructress to the Ladies of the Palace*, now at the British Museum, see Shih Hsiao-yen, "Early Chinese Pictorial Style: From the Later Han to the Six Dynasties" (Ph.D. dissertation, Bryn Mawr College, 1961).

22 For more on these terms, see Lu Yitian (Lu I-t'ien) 陸以湉 (1801–65), *Lenglu zashi* (*Leng-lu tsa-shih*) 冷盧雜識 (Miscellaneous Records at Lu's Cold-hut Studio), *juan* (*chüan*) 卷 (chapter) 5, reprinted (Beijing: Zhonghua Shuju, 1984), p. 294.

23 See ibid. For an example of a *hsing-le t'u* executed during the Ch'ing dynasty (1644–1911), see Wang Yüan-ch'i's 王原祁 (1642–1715) portrait by Yü Chih-ting 禹之鼎 (1647–c. 1716), dated 1707, belonging to the Nanking Museum. It is reproduced in *Zhongguo gudai shuhua tumu* (*Chung-kuo ku-tai shu-hua t'u-mu*) 中國古代書畫圖目 (An Illustrated Catalogue of Selected Works of Ancient Chinese Painting and Calligraphy), vol. 7, no. 蘇 24-0716, p. 190. See also note 34 of entry 32 on Yü Chih-ting.

24 This work is often referred to in English as *A Gentleman with His Portrait*. For a reproduction, see *Masterpieces of Chinese Figure Painting in the National Palace Museum* (Taipei: National Palace Museum, 1973), pl. 14.

25 See Zhou Hui (Chou Hui) 周暉 (active first quarter of 17th century), *Jinling suoshi* (*Chin-ling so-shih*) 金陵瑣事 (Trivial Notes of Nanking), preface dated 1610, facsimile reprint, *juan* (*chüan*) 卷 (chapter) 3 (Beijing: Wenxue Guoji Kanxingshe, 1955), pp. 125 a & b. Another well-known story concerning faithful portraiture concerns a beautiful court lady, Wang Ch'iang 王嬙, who lived during the reign of Emperor Yüan-ti 元帝 (r. 48–33 B.C.) in the Han 漢 dynasty (206 B.C.–A.D. 220). Her popular name was Wang Chao-chün 王昭君. Because of her beauty, she was summoned to the palace for the purpose of winning the emperor's favor. So many women were waiting to be selected that a portrait was made of each of them. The emperor would then use the pictures in choosing the most beautiful. Almost all female candidates bribed the court painter to execute a flattering portrait, but Wang refused to do so. Angered at Wang Chao-chün's stubborn personality, the painter deliberately produced a portrait that did not faithfully represent her beauty. As a result, she was refused an audience with the emperor on the basis of her portrait. Around 33 B.C, she was chosen to be married to a chieftain of a Hun tribe in the desert as an act of matrimonial diplomacy by the Chinese court. Before she was given away, however, the emperor arranged a court meeting with her and the envoy. When her beauty was finally brought to the emperor's attention, the wicked portrait painters at the court were all executed. This story is recorded in *Han-shu* 漢書, or *The Book of Han*, both in the entries for Emperor Yüan-ti, *Yüan-ti chi* 元帝記, and the second part of *Records of the Huns* (*Hsiung-nu chuan* 匈奴傳). See *Han-yü ta-tz'u tien* 漢語大詞典 (Chinese Terminology Dictionary), vol. 4, p. 461, s.v. "Wang Zhaojun (Wang Chao-chün) 王昭君."

26 One example of such portraits is the *Portrait of Emperor T'ai-tsu of the Sung Dynasty* at the National Palace Museum, Taipei. It is reproduced in *Masterpieces of Chinese Portrait Painting in the National Palace Museum* (Taipei: National Palace Museum, 1971), pl. 17. For a discussion of this portrait, see Wen C. Fong, "Sung Imperial Portraits," in *Possessing the Past: Treasures from the National Palace Museum, Taipei* (New York: Metropolitan Museum of Art, and Taipei: National Palace Museum, 1996), pp. 141–45.

27 For a reproduction of Chu Hsi's portrait, see *Masterpieces of Chinese Portrait Painting in the National Palace Museum*, pl. 28. For an example executed in the fourteenth century, see Ni Tsan's 倪瓚 (1306–74) portrait, painted by an anonymous artist, at the National Palace Museum, reproduced in ibid., pl. 37. Other examples include the portraits of Genghis Khan and his wife, Empress Ch'e-po-erh, their son Ogotai Khan, and grandson Kublai Khan. These portraits are also reproduced in ibid., pls. 30, 31, 32, and 34, respectively. During this time, a figure and portrait painter, Wang I 王繹 (active c. mid-14th century), even published a book on techniques of portraiture. His book, entitled *Hsieh-hsiang mi-chüeh* 寫像秘訣 (Secret Methods for Executing Portraits), was originally included in T'ao Tsung-i's 陶宗儀 (active second half of 14th century) *Ch'o-k'eng lu* 輟耕錄 (Notes after Ceasing Farm Labors), and Wang's text has been reprinted in Yu Anlan 于安瀾, comp., *Hualun congkan* (*Hua-lun ts'ung-k'an*) 畫論叢刊 (Compendium of Painting Theory), 1st edition in 1037, reprint, vol. 2 (Beijing: Renmin Meishu Chubanshe, 1989), pp. 852–55.

28 For a reproduction of these two portraits currently at the Palace Museum, Beijing, see Palace Museum Editorial Committee, *Zhongguo lidai huihua* (*Chung-kuo li-tai hui-hua*) 中國歷代繪畫 (Paintings of the Past Dynasties) in *Gugong bowuyuan canghuaji* (*Ku-kung po-wu-yüan ts'ang-hua chi*) 故宮博物院藏畫集 (Paintings in the Collection of the Palace Museum), vol. 5 (Beijing: Renmin Meishu Chubanshe), pp. 50–51. Apparently these two portraits, executed by an anonymous official portrait painter, belonged to a certain government file at the imperial court. At the Nanking Museum there is another interesting group of portraits depicting famous scholars and officials. The individuality of the portraits is remarkable. See *Chung-kuo ku-tai shu-hua t'u-mu* 中國古代書畫圖目 (An Illustrated Catalogue of Selected Works of Ancient Chinese Painting and Calligraphy), vol. 7, no. 蘇 24-0373, pp. 103–105.

29 Yu Jianhua 于劍華 et al., *Zhongguo meishujia renming cidian* (*Chung-kuo mei-shu chia jen-ming tz'u-tien*) 中國美術家人名詞典 (A Biographical Dictionary of Chinese Artists) (Shanghai: Renmin Meishu Chubanshe, 1981), p. 1082.

30 See *T'i Chang Tzu-yu chüan* 題張子遊卷 (A Colophon for a Handscroll by Chang Tzu-yü), found in a work by Huang Tsung-hsi 黃宗羲 (1610–95) entitled *Wu-hui chi* 吾悔集 (Collected Lamentations). Huang's work is included in his *Nan-lei chi* 南雷集 (Collected Writings of [Huang's] Southern-Thunder [Study]), *chüan* 卷 (chapter) 2, reprinted in *Ssu-pu ts'ung-k'an* 四部叢刊 (Selected Volumes from the Ssu-pu Encyclopedia), vol. 5 (Shanghai: Shang-wu Press, 1937–38), pp. 2–3.

31 Tseng Ching's given name, Ching, means "a whale." This is possibly a reference to P'u-t'ien's position on the coast.

32 A brief biographical record of Wu Pin may be found in L. Carrington Goodrich and Chaoying Fang, eds., *Dictionary of Ming Biography, 1368–1644*, vol. 2 (New York and London: Columbia University Press, 1976), pp. 1492–94. The influence of Islamic art on Wu Pin is undeniable. For example see Wu Pin's *Lohan* 羅漢, reproduced in *Ku-kung shu-hua t'u-lu* 故宮書畫圖錄 (An Illustrated Catalogue of Calligraphy and Painting at the Palace Museum), vol. 8 (Taipei: National Palace Museum, 1993), p. 375. In this work, the trees, foliage, thin lines used to define the rocks, and especially the dragon all clearly exhibit traits borrowed from Islamic miniature paintings. See also James Cahill, "Wu Pin, Influences from Europe, and the Northern Sung Revival" in *The Compelling Image: Nature and Style in Seventeenth-Century Chinese Painting* (Cambridge, Mass.: Harvard University Press, 1982), pp. 70–105.

33 Tseng Ching's ink portrait of Hsiang Tzu-ching is recorded in the author's comments, entry of Ku Ming 顧銘 in Zhang Geng's (Chang Keng) 張庚 (1685–1760) *Kuo-ch'ao hua-cheng lu* 國朝畫徵錄 (Biographical Sketches of the Artists of the Ch'ing Dynasty), preface dated 1739, *chüan* 卷 (chapter) 2, reprinted in *Huashi congshu* 畫史叢書 (Compendium of Painting History), vol. 5, pp. 38–39. Chang Keng

Tseng Ching 曾鯨
Portrait of P'an Ch'in-t'ai
*continued*

50  wrote "I once viewed a small ink portrait of Hsiang Tzu-ching by Tseng Ching. It was as realistic as one with color." (余曾見波臣所寫 "項子京水墨小照," 神氣與設色者同.)

34  For a discussion of the portraits of Ch'an abbots in Tseng Ching's home province, see Minoru Nishigami 西上實, *Obaku no bijutsu* 黃檗の美術 (The Art of Obaku) (Kyoto: Kyoto National Museum, 1993), pp. 79–84.

35  Although Tseng Ching was from Fukien province in the south, his name was recorded along with other local painters in the *Hai-yen hsien-chih* 海鹽縣誌 (Gazetteer of Hai-yen) of Chekiang 浙江 province. See Wang Pin 王彬 and Hsü Yung-i 徐用儀, eds., *Hai-yen hsien-chih*, preface dated 1876, *chüan* 卷 (chapter) 19, reprinted, vol. 7 (Taipei: Cheng-wen Press, 1975), p. 19.

36  See Chang Keng's *Kuo-ch'ao hua-cheng lu* 國朝畫徵錄 (Biographical Sketches of the Artists of the Ch'ing Dynasty), preface dated 1739, *chüan* 卷 (chapter) 2, pp. 38–39. Chang Keng stated: "There are two categories of portraiture: one emphasizes ink [lines]. After the ink structure [drawing] is completed, then color [washes] were applied to define the age of a sitter. Thus, the true essence of a portrait had already been decided in the ink drawing! Tseng Ching, who was from Fukien province, was originally trained in this manner. The other method is first to use light ink [lines] in order to roughly outline the positions of the features. Then color washes are applied. This is the traditional way of portraiture prevailing in the *chiang-nan* region." (寫真有兩派: 一重墨骨. 墨骨既成, 然後傅彩 以取氣色之老少. 其精神, 早傳於墨骨中矣! 此閩中曾波臣之學也. 一略用淡墨, 鉤出五官部位之大意, 全用粉彩渲染. 此江南畫家之傳法. 而曾氏善矣.)

37  For a reproduction of Wang Shih-min's portrait by Tseng Ching, see Tianjin Museum of Art, *Tianjin bowuyuan canghuaji* (*Tien-tsin po-wu-yüan ts'ang-hua chi*) 天津博物院藏畫集 (Paintings in the Collection of the Tianjin Museum of Art), vol. 1, in the series of *Zhongguo lidai huihua* (*Chung-kuo li-tai hui-hua*) 中國歷代繪畫 (Paintings of the Past Dynasties) (Tianjin: Tianjin Renmin Meishu Chubanshe), p. 56.

38  Shen Chou's portrait is reproduced in *Art Treasures of the Peking Museum*, trans. Norbert Guterman (New York: Harry N. Abrams, 1978), pl. 25.

39  For a discussion of the effects of European art and culture on Chinese art during the seventeenth century, see James Cahill, "Wu Pin, Influences from Europe, and the Northern Sung Revival," in *The Compelling Image: Nature and Style in Seventeenth-Century Chinese Painting*, pp. 70–105.

40  A short biography of Li Chih is found in *Dictionary of Ming Biography, 1368–1644*, vol. 1, pp. 807–18.

41  For a short biography of Li Jih-hua, see ibid., pp. 826–30. Li Chao-heng's portrait by Tseng Ching is listed in Lu Hsin-yüan's 陸心源 (1834–94) *Jang-li-kuan kuo-yen lu* 穰梨館過眼錄 (Paintings Viewed by Lu Hsin-yüan at His Sharing-Pear Studio), *chüan* 卷 (chapter) 27 (Wu-hsing: n.p., 1891), pp. 26–27.

42  Ku Ch'i-yüan's account of Father Ricci and the Catholic icons is found in his *Kezuo zhuiyu* (*K'o-tso chui-yü*) 客座贅語 (Notes on Miscellaneous Subjects from Conversations with My Guests), postscript dated 1618, reprint, *juan* (*chüan*) 卷 (chapter) 6 (Beijing: Zhonghua Shuju Chubanshe, 1991), pp. 154–55. The author, Ku, was a friend of Father Mateo Ricci. In his book, Ku described the Jesuit as from Europe, of fair complexion, possessing a full beard and deep-set eyes that were as brown as the eyes of a cat. This Jesuit could speak Chinese and resided in Nanking. Ku also commented on a painting of the Madonna and infant Jesus shown to him by Ricci. Ku described the face and body of the figures as resembling that of a real person and almost coming out of the painting. Ku asked Father Ricci how and why the painting looked as it did. Father Ricci replied that Chinese painting only depicts the sunny side, so the paintings are flat. Western paintings depict the sunny side as well as the shadowy side. In ibid., *chüan* 卷 (chapter) 5, p. 122, Ku was told by Father Mateo Ricci that many Western paintings were three dimensional. Since there was no term for this in Chinese, Ku translated the idea as *ao-t'u hua* 凹凸畫, or "intaglio and relief painting." It seems that even people who had access to examples of Western painting and were close to Father Ricci had little understanding of Western painting and its techniques.

43  Ku Ch'i-yüan's colophon is inscribed on the portrait of P'ei-jan 沛然 painted by Tseng Ching. This work is now at the Shanghai Museum and has been published in Zhou Jiyin 周積寅, *Zeng Jing de xiaoxiang hua* (*Tseng Ching teh hsiao-hsiang hua*) 曾鯨的肖像畫 (Portraits by Tseng Ching) (Beijing: Renmin Chubanshe, 1983), fig. 12.

44  Tseng Ching might have incorporated elements from another foreign source. During the seventeenth century, many Arabian merchants came to China to trade and settled in Tseng Ching's hometown in Chüan-chou, bringing with them a variety of art objects. These may have included realistic Islamic portraiture and Indian miniatures, which perhaps had a stronger influence on Tseng Ching as they would have been more plentiful and available than a few Catholic paintings in a single chapel.

45  Examples of seventeenth-century European Catholic paintings imported to Japan are reproduced in Sakamoto Mitsuru 恆本滿編 *Nanban bijutsu to yofuga* 南蠻美術と洋風畫 (The Southern Barbarian [European] Art and Paintings with Western Influences) in *Genshoku-Nihon no bijutsu* 原色日本の美術 (Japanese Art in Polychrome), vol. 25 (Tokyo: Shogakukan, 1970), pls. 5, 8, 9, and 10.

46  Even if Tseng had been exposed to Western painting, without the guidance of a teacher, it would have been impossible for him, or any painter, to fathom the complicated techniques and the distinctly different media central to European portraiture. This difficulty is fully illustrated in the work of several Chinese painters active during the Ch'ien-lung 乾隆 period (r. 1736–96). At that time, there were many Jesuit painters working at the imperial court, including Giuseppe Castiglione (1688–1766), Lang Shih-ning 郎士寧 in Chinese. The emperor admired the works of these Jesuits and selected young apprentices to study Western painting under their tutelage. Yet even in this most favorable of situations, there was not a single Chinese artist who produced an adequate European-style painting. Therefore, it seems highly unlikely that Tseng Ching, who at most viewed only a few European paintings, could have assimilated these complex techniques and successfully merged them into his own work. For Giuseppe Castiglione's activities as an artist in the Emperor Ch'ien-lung's court, see entry 35. For a discussion of Jesuits working at the Manchu court, see Nie Chongzheng 聶崇正, "Xiyanghua dui Qing gongting huihua de yingxiang" (Hsi-yang-hua tui Ch'ing kung-t'ing hui-hua teh ying-hsiang) 西洋畫對清宮廷繪畫的影響 (The Influence of Western Painting on the Court Paintings of the Ch'ing Dynasty), in *Duoyun* 朵雲 (Cloud Art Journal) 5 (Shanghai: Shanghai Shuhua Chubanshe, May 1983), pp. 193–97 and 237.

47  For a biography of Ch'en Hung-shou, see *Style Transformed: A Special Exhibition of Works by Five Late Ming Artists* (Taipei: National Palace Museum, 1977), English abstract, pp. 40–45. Ch'en's career is also recorded in Hummel's *Eminent Chinese of the Ch'ing Period, 1644–1911*, vol. 1, pp.

87–88. See also James Cahill, "Ch'en Hung-shou: Portraits of Real People and Others," in *The Compelling Image: Nature and Style in Seventeenth-Century Chinese Painting* (Cambridge, Mass.: Harvard University Press, 1982), pp. 106–45.

48 For information on the Pu-hsi Yüan 不繫園 (The Unfettered Garden), see Lu I-t'ien's 陸以湉 *Leng-lu tsa-shih* 冷盧雜識, *chüan* 卷 (chapter) 6, pp. 315–16. For the gathering of Ch'en Hung-shou and Tseng Ching on this vessel, see entry for the "Pu-hsi Garden" in Chang Tai's 張岱 (1597–1676) *T'ao-an meng-i* 陶庵夢憶 (A Record of Dreams of T'ao-an), *chüan* 卷 (chapter) 4, reprinted in Yang Chia-lo 楊家駱, comp., *Chung-kuo pi-chi hsiao-shuo ming-chu* 中國筆記小説名著 (Famous Chinese Novels and Literary Sketches Series) (Taipei: World Press, 1959), pp. 1 a & b.

49 The scholar-official Chou Liang-kung 周亮功 (1612–72) was renowned for his knowledge in art as well as his association with artists. Chou's short biography may be found in *Eminent Chinese of the Ch'ing Period, 1644–1911*, vol. 1, pp. 173–74. His portrait by Ch'en Hung-shou is recorded in his *Shu-hua tse-lu* 書影擇錄 (Selected Notes from the Shadows of Books), reprinted in Teng Shih 鄧實 (1865?–1948?) and Huang Pin-hung 黃賓虹 (1865–1955), comps., *Mei-shu ts'ung-shu* 美術叢書 (Anthology of Books on Fine Art) (Shanghai: n.p., 1912–36), reprint, *chi* 集 (part) 1, *chi* 輯 (division) 4, vol. 2 (Taipei: I-wen Press, 1963–72), pp. 207–8. According to Chou, his portrait by Ch'en Hung-shou was excellent, better than that of professional painters like Kuo Kung (active 17th century) from P'u-t'ien county and Hsieh Pin 謝彬 (1602–?). (吾友陳章侯, 偶倣淵明圖, 為予寫照見者, 以為郭謝兩生不能及.)

50 Tseng Ching's followers include: 1) Chin Ku-sheng 金穀生 (active 17th century); 2) Wang Hung-ch'ing 王宏卿 (active 17th century); 3) Chang Ch'i 張琦 (1764–1833), *tzu* Yü-k'o 玉珂, from Chia-hsing 嘉興; 4) Ku Yün-jeng 顧雲仍 (active 17th century); 5) Liao Ta-shou 廖大受 (active 17th century), *tzu* Chün-k'o 君可; 6) Hsieh Pin 謝彬 (1602–?), *tzu* Wen-hou 文侯, from Hang-chou 杭州; 7) Shen Shao (active late 17th century) 沈韶, *tzu* Erh-t'iao 爾調, from Hua-t'ing 華亭; 8) Ku Ch'i 顧企 (active late 17th century), *tzu* Tsung-han 宗漢 from Sung-chiang 松江; and 9) Chang Yüan (active 17th century) 張遠, *tzu* Tsu-yu 子遊, from Hai-yen 海鹽. The above portrait painters are listed in Xu Qin's (Hsü Ch'in) 徐沁 (active first half of 17th century) *Minghualu* (*Ming-hua lu*) 明畫錄 (Painters of the Ming Dynasty), *juan* (*chüan*) 卷 (chapter) 1, reprinted in *Hua-shih ts'ung-shu* 畫史叢書 (Compendium of Painting History), vol. 5, pp. 12–13. According to Chang Keng's *Kuo-ch'ao hua-cheng lu* 國朝畫徵錄 (Biographical Sketches of the Artists of the Ch'ing Dynasty), *chüan* 卷 (chapter) 1, p. 16, s.v. "Hsieh Pin 謝彬," Tseng Ching also taught other students, including: 1) Kuo Kung 郭鞏 (active 17th century), *tzu* Wu-chiang 無彊, from P'u-t'ien 莆田; 2) Hsü I 徐易 (active 17th century), *tzu* Hsiang-chiu 象九, from Shan-yin 山陰 3) Liu Hsiang-sheng 劉祥生 (active 17th century), *tzu* Jui-sheng 瑞生, from Ting-chou 汀州; and 4) Shen Chi 沈紀 (active 17th century), *tzu* Yü-hsiu 聿修, from Hsiu-shui 秀水. None of them, however, achieved the same level of fame as their teacher.

51 See *Ming-hua lu* 明畫錄 (Painters of the Ming Dynasty), *chüan* 卷 (chapter) 1, pp. 12–13.

52 In the past, many Chinese literati were depicted in this pose. For example, a portrait of Su Shih 蘇軾 (1036–1101), attributed to Chao Meng-fu 趙孟頫 (1254–1322) of the Yüan dynasty (1280–1368) at the National Palace Museum, Taipei, is similarly posed. See *Masterpieces of Chinese Portrait Painting in the National Palace Museum*, pl. 25. The white robe in Tseng Ching's work is the typical costume of the Ming period. For example, a brief biography of Hsü Wei 徐渭 (1521–93) by his fellow townsman T'ao Wang-ling 陶望齡, found at the beginning of Hsü Wei's anthology, states that when the governor of Chejiang, Hu Tsung-hsien 胡宗憲 (1511–65), granted Hsü Wei an audience, the latter, to show he had the essential commendable characteristics of a scholar, wore an old black cap and put on a washed white cloth robe. (戴敝烏巾, 衣白浣布衣) Apparently, such garments were the appropriate clothes for an educated man in the Ming dynasty. See Hsü Wei's *Hsü Wen-ch'ang ch'üan-chi* 徐文長全集, (The Complete Collected Writings of Hsü Wei) (Hong Kong: Kuang-chih Press, 1956), p. 3.

53 For examples of figure paintings by other painters of the seventeenth century depicting standardized eyebrows, see *Style Transformed: A Special Exhibition of Works by Five Late Ming Artists* (Taipei: National Palace Museum, 1977), pls. 002, 004, 009, 010, 013, 016, 018, 019, 020, 025, by Ting Yün-p'eng 丁雲鵬 (1547–after 1628). See also ibid., pl. 041, by Wu Pin 吳彬 (active 1591–1643), and pls. 080 and 099 by Ch'en Hung-shou 陳洪綬 (1598–1652).

54 The label of this scroll clearly states that the work was remounted in 1900.

55 The *Portrait of P'an Ch'in-t'ai* at the Shanghai Museum was displayed at the opening exhibition in celebration of the museum's new building in October 1996. Before the exhibition, the Shanghai scroll was neither published nor publicized.

56 The fact that the Michigan work bears a label indicating this painting was remounted in 1900 substantiates the claim that Tseng Ching's work at the Shanghai Museum was copied by a painter in the early twentieth century, as the restored areas on the Michigan scroll have been faithfully copied onto the Shanghai version as part of the original composition. Consequently, this "transcription" must have happened after the Michigan scroll was remounted in 1900.

## 20. Yao Yün-tsai 姚允在
*(active c. 1620–c. 1645)*
*Ming dynasty (1368–1644)*

52

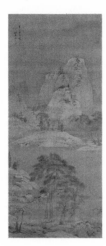

**Waiting for a Ferry by a River in Autumn**
*Ch'iu-chiang tai-tu t'u*
*(Waiting for a Ferry by a River in Autumn)*
秋江待渡圖

1   *T'ieh-hua-lou,* or "The Iron-Painting Pavilion," was the name of Chang Yin-huan's 張蔭桓 (1837–1900) studio. A native of Canton, he was a diplomat of the late Ch'ing dynasty who admired Western civilization. In 1897, he represented China in celebrating the Diamond Jubilee of Queen Victoria in London. Despite his affinity for the West, he was a traditional Chinese poet, writer, and painter. For his brief biography, see Arthur W. Hummel, ed., *Eminent Chinese of the Ch'ing Period (1644–1912),* vol. 1 (Washington, D.C.: United States Government Printing Office, 1943–44), pp. 60–64. However, in modern times, the name T'ieh-hua lou was adopted by Tseng Shao-chieh (c. 1900–c. 1985), the previous owner of this scroll and the person who inscribed the label on this work. Tseng was a well-known calligrapher and seal-carver from Hunan province. He was active in Taipei between c. 1955 and 1980.

2   Tseng Shao-chieh's seal is reproduced in his seal book, *Hsiang-hsiang Tseng Shao-chieh yin-ts'un* 湘鄉曾紹杰印存 (Collected Seals of Tseng Shao-chieh) (Taipei: n.p., 1956), p. 476.

3   For more information on The Revering Antiquity Gallery in Taipei, see entry 12 on Ch'en Tsun 陳遵 (active 1573–1619).

4   Two sources indicate that Yao Yün-tsai was active during the Wan-li period. See Jiang Shaoshu (Chiang Shao-shu) 姜紹書 (active 1635–80), *Wusheng shishi (Wu-sheng-shih shih)* 無聲詩史 (A History of Voiceless Poems), preface dated 1720, *juan*

*(chüan)* 卷 (chapter) 7, reprinted in Yu Anlan 于安瀾, comp., *Huashi congshu (Hua-shih ts'ung-shu)* 畫史叢書 (Compendium of Painting History), vol. 4 (Shanghai: Renmin Meishu Chubanshe, 1962), p. 127. Chiang says that Yao was *Wan-li shih-jen* 萬曆時人, or "a person of the Wan-li period." See also Qin Zuyong (Ch'in Tsu-yung) 秦祖永 (1825–84), *Tongyin lunhua (T'ung-yin lun-hua)* 桐陰論畫 (Discussing Paintings under the Wu-t'ung Tree), preface dated 1864, *juan (chüan)* 卷 (chapter) 1, reprinted in *Yilin mingzhu congkan (I-lin ming-chu ts'ung-k'an)* 藝林名著叢刊 (Collected Famous Writings on Art Series) (Shanghai: World Press, 1936), reprint (Beijing: Beijingshi Zhongguo Shudian, 1983), pp. 10–11. Ch'in not only says that Yao was a famous painter of the Wan-li period but also praises Yao's work as *hsiu-yün ching-mu, ku-i ying-jan* (秀韻靜穆, 古意盈然), or "elegant and solemn, full of classical flavor."

5   These dates are based on credible references, which include a number of Chinese year names inscribed by Yao Yün-tsai on his paintings. Unfortunately, the dates are not definitive and can be construed in two different ways; as either from 1564 to 1581, or from 1624 to 1641. These year names repeat in a cycle of sixty years. Identifying specific years usually requires another chronological notation, such as the reign mark of a ruler. Without a second notation, establishing the exact years recorded on Yao's paintings becomes an intricate puzzle. The year names found on Yao's works include: 1) *chia-tzu* 甲子 (the first rat, either 1564 or 1624) on a fan; 2) *wu-yin* 戊寅 (the fifth tiger, 1578 or 1638) on a fan; and 3) *hsin-ssu* 辛巳 (the eighth snake, 1581 or 1641) on a set of landscape album leaves. All three works are recorded in Shanghai Museum, *Zhongguo shuhuajia yinjian kuanshi (Chung-kuo shu-hua-chia yin-chien k'uan-shih)* 中國書畫家印鑒款識 (Signatures and Seals of Chinese Painters and Calligraphers), vol. 2 (Shanghai: Wenwu Chubanshe, 1987), p. 695. The year *hsin-ssu* (1581 or 1641) also appears on his hanging scroll at the University of Michigan. Another year name, *ping-tzu* 丙子 (the third rat, either 1576 or 1636), is found on a hanging scroll published in Howard Rogers, *Kaikodo Journal* (Kamakura, New York: Kaikodo, Spring 1996), cat. no. 12, pp. 28–29, as well as on a fan painting published in Paul Moss, *Old Leaves Turning: Fans* (London: Sydney L. Moss, 1995), cat. no. 32, p. 73. In order to be able to produce a mature work in 1564, under the earlier group of dates, Yao would have to have been born in the 1530s, which is apparently too early. On the other

hand, if one accepts the later dates, Yao would have been born in the 1590s. Of the two, the latter is more logical than the former. Other sources, mainly colophons by Yao's contemporaries, are also useful as references to help settle the issue. On a scroll by Yao, the great artist-connoisseur Tung Ch'i-ch'ang 董其昌 (1555–1636) claims that he met Yao for the first time in Nanking. This crucial rendezvous seems to have occurred between 1622 and 1625, when Tung went to Nanking in order to assume an official appointment. It is recorded in Ming history that Tung Ch'i-ch'ang was three times officially in Nanking. The first time was in the fall of 1622 when he went to Nanking under imperial decree to collect material for the compiling of the *Shen-tsung shih-lu* 神宗實錄 (Veritable Records of the Emperor Shen-tsung [r. 1573–1619]). It is believed that he stayed there until the summer of 1624. The second time was in the spring of 1625, when Tung Ch'i-ch'ang went to Nanking to undertake the appointment of *Nan-ching li-pu shang-shu* 南京禮部尚書, or "the minister of rites in Nanking." He went to the city in the second or third month of 1625 and retired to his hometown at the end of the same year. The third time was around 1631 when Tung went to Nanking to re-assume his former position. As Tung Ch'i-ch'ang's colophon on Yao's scroll is dated 1628, it seems logical to surmise that it was probably during Tung's second trip to Nanking that he met Yao Yün-tsai. Yao Yün-tsai's handscroll is recorded in Wang Chieh 王杰 (1725–1805) et al., *Shih-chü pao-chi hsü-pien* 石渠寶笈續編 (Sequel to the Precious Books in a Box at a Rocky Stream [Sequel to the Catalogue of Painting and Calligraphy in the Imperial Collection]), completed 1793, *chüan* 卷 (chapter) 57, facsimile of ms. copy (Taipei: National Palace Museum, 1969), p. 2851. For Tung Ch'i-ch'ang's activities in Nanking, see Celia Carrington Riely, "Tung Ch'i-ch'ang's Life," in Wai-kam Ho 何惠鑑, ed., *The Century of Tung Ch'i-ch'ang, 1555–1636,* vol. 2 (Kansas: Nelson-Atkins Museum of Art, 1992), pp. 421–22 and 424–28. Riely's research is based on Chang T'ing-yü 張廷玉 (1672– 1755) et al., *Ming-shih* 明史 (History of the Ming Dynasty [1368–1644]), completed 1736, orig. ed. dated 1739, *chüan* 卷 (chapter) 288, reprint (Taipei: n.p., 1962–63), p. 7396 and Wen T'i-jen 溫體仁 (?–1638), *Ta-Ming Hsi-tsung Che-huang-ti shih-lu* 大明熹宗悊皇帝實錄 (Veritable Records of the Emperor Hsi-tsung), completed c. 1637, *chüan* 卷 (chapter) 24, facsimile of ms. copy (Taipei: n.p., 1966), p. 22. Another inscription by Kung Hsien 龔賢 (c. 1618–89), one of the Eight Masters of Nanking, on a different

work by Yao is also helpful. Kung inscribed his colophon on a long scroll by Yao in 1670 and stated that Yao first learned painting from Lan Ying 藍瑛 (1585–after 1664), the last master of the Che school. If this is true, then Yao must have been born later than his teacher, probably in the 1590s. Furthermore, the later dates also coincide with the dates when Yao's friends were active in Nanking during the first quarter of the seventeenth century. These friends include Hsü Hung-chi 徐弘基 (active late 16th to early 17th century), Hou Chih-p'u 侯執蒲 (1567–1641), his son Hou Hsün 侯恂 (chin-shih in 1616), and his nephew Hou K'o 侯恪 (1592–1635). The only problem with this later date is that Yao would not have been able to be active during the Wan-li reign (1573–1619) as indicated in early sources. It is also important to point out that one of Yao's works, a handscroll entitled *Chunye yan taoliyuan tu* (*Ch'un-yeh yen t'ao-li-yüan t'u*) 春夜宴桃李園圖 (A Banquet at the Peach and Plum Orchard on a Spring Evening) is dated *Wan-li jen-wu* 萬曆壬午 or the "*jen-wu* year of the Wan-li period," which can be specifically designated as the tenth year of the Wan-li reign (1582). See Group for the Authentication of Ancient Works of Chinese Painting and Calligraphy, ed., *Zhongguo gudai shuhua tumu* (*Chung-kuo ku-tai shu-hua t'u-mu*) 中國古代書畫圖目 (An Illustrated Catalogue of Selected Works of Ancient Chinese Painting and Calligraphy), vol. 6 (Shanghai: Wenwu Chubanshe, 1990), no. 蘇 7-02, p. 377. Since this painting is only listed in the catalogue without a reproduction, its authenticity is questionable. If this is a genuine work by Yao executed in 1582, then he would have been born in the early 1550s, around the same time that Tung Ch'i-ch'ang was born. This date would make Yao almost thirty years older than his teacher Lan Ying. In China at that time, it would have been extremely improbable that a teacher would be thirty years younger than his student; thus, although more materials and information are needed to validate Yao's dates faithfully, presently it is most credible to assume he was active c. 1620–c. 1645.

6   For a discussion of Lan Ying, see entry 22. For more information on Yao's relationship with Lan Ying, see the translation of Kung Hsien's colophon later in this entry.

7   Yao Yün-tsai's two teachers, Tu Chi-lung and Wu Huang, are included in Chiang Shao-shu's 姜紹書 *Wu-sheng-shih shih* 無聲詩史 (A History of Voiceless Poems), *chüan* 卷 (chapter) 7, p. 127. They are recorded in Xu Qin's (Hsü Ch'in) 徐沁 (active first half of 17th century)

*Minghualu* (*Ming-hua-lu*) 明畫錄 (Painters of the Ming Dynasty), *juan* (*chüan*) 卷 (chapter) 3, reprinted in *Hua-shih ts'ung-shu* 畫史叢書 (Compendium of Painting History), vol. 5, p. 37. It says that Tu Chi-lung's *tzu* was Shih-liang (a refined scholar) and that he was from Wu-hsien (present-day Suchou). His landscape painting emulated Shen Chou's style with some personal embellishments. (杜冀龍, 字士良. 吳縣人. 山水宗沈周, 而稍自變化.) Yao's second teacher, Wu Huang, is recorded in *Ming-hua lu*, *chüan* 卷 (chapter) 5, pp. 62–63. Wu Huang's *tzu* was Hsien-t'ai (a terrace in the immortal land). He was from Shanyin (present-day Shao-hsing, Chekiang province) and was adept in poetry. His landscape painting emulated the Sung and Yüan masters. Not only is his brushwork graceful and elegant, but his compositions are balanced and well proportioned. He was also adept in painting orchids and bamboo with rocks in odd shapes. (吳晃, 字仙臺. 山陰人. 工詩. 所畫山水, 追摹宋元諸家. 行筆秀潤, 位置無不得宜. 兼善蘭竹怪石.)

8   The early sources that indicate Yao Yün-tsai was not a prolific painter include: 1) Zhou Lianggong's (Chou Liang-kung) 周亮工 (1612–72) *Duhualu* (*Tu-hua lu*) 讀畫錄 (A Record of Examined Paintings), preface dated 1673, *juan* (*chüan*) 卷 (chapter) 1, reprinted in *Hua-shih ts'ung-shu* 畫史叢書 (Compendium of Painting History), vol. 9, pp. 17–18; and 2) Tao Yuanzao's (T'ao Yüan-tsao) 陶元藻 (1716–1801) *Yuehua jianwen* (*Yüeh-hua chien-wen*) 越畫見聞 (Painters from the Yüe Region), preface dated 1795, *juan* (*chüan*) 卷 (chapter) 2, reprinted in *Hua-shih ts'ung-shu* 畫史叢書 (Compendium of Painting History), vol. 6, p. 29. Both books say that Yao Yün-tsai did not paint often and rarely sold or gave his paintings away. In his *Tu-hua lu*, Chou Liang-kung complained that despite his efforts to collect Yao Yün-tsai's paintings, he was only successful in acquiring a set of twelve small album leaves. Refusing to give up hope, Chou even approached the Hou 侯 brothers, whose family used to provide accommodations for the artist in the north, but to no avail. Chou also mentioned that many other collectors in search of Yao's work often journeyed to the artist's hometown with considerable sums of money, yet they too were often disappointed.

9   Yao Yün-tsai's name is found in: 1) Chou Liang-kung's *Tu-hua-lu* 讀畫錄 (A Record of Examined Paintings); 2) T'ao Yüan-tsao's *Yüeh-hua chien-wen* 越畫見聞 (Painters from the Yüe Region), both of which have been mentioned in note 8; 3) Hsü Ch'in's *Minghualu* 明畫錄 (Painters of the Ming Dynasty), *chüan* 卷 (chapter) 5, p.

63; 4) Lan Ying 藍瑛 (1585–?) and Xie Bin (Hsieh Pin) 謝彬 (1602–?) et al., *Tuhui baojian xucuan* (*T'u-hui pao-chien hsü-ts'uan*) 圖繪寶鑑續纂 (Sequel to Precious Mirror of Painting), *juan* (*chüan*) 卷 (chapter) 1, reprinted in *Hua-shih ts'ung-shu* 畫史叢書 (Compendium of Painting History), vol. 4, p. 6; 5) Chiang Shao-shu's *Wu-sheng-shih shih* 無聲詩史 (A History of Voiceless Poems), *chüan* 卷 (chapter) 7, p. 127; and 6) Ch'in Tsu-yung's *T'ung-yin lun-hua* 桐陰論畫 (Discussing Paintings under the Wu-t'ung Tree), *chüan* 卷 (chapter) 1, pp. 10–11. See note 4 for more information on the last two sources.

10   See note 8.

11   Yao Yün-tsai's scroll is recorded in Wang Chieh's 王杰 *Shih-chü pao-chi hsü-pien* 石渠寶笈續編 (Sequel to the Precious Books in a Box at a Rocky Stream [Sequel to the Catalogue of Painting and Calligraphy in the Imperial Collection]), *chüan* 卷 (chapter) 57, p. 2851.

12   The transcription of Tung's colophon in Chinese follows: 石城姚簡叔, 名允在. 書法直追兩宋. 一時賞鑑家, 莫不奇稱之. 余因奉命至陪京, 始得一識其面. 知其風雅豪邁,, 與筆墨吻合. 今春解綬還山, 適儒仲持簡叔長卷見示. 歷仿數家, 而門筍接脈處, 無跡可尋. 且筆力高古. 雖未遽謂在北宋之間, 而亦無忝于南渡諸名家也. 董其昌鑒定.

13   Shih-ch'eng 石城 (meaning "a stone city"), found in Tung Ch'i-ch'ang's colophon, has two different interpretations. One indicates the city of Shao-hsing, Yao Yün-tsai's hometown. It was so named because of the Shih-ch'eng mountain located northeast of the city. Shih-ch'eng can also be used to indicate Nanking, where Yao Yün-tsai sojourned. Among the two, the first is probably more relevant to Yao Yün-tsai. See *Tz'u-hai* 辭海 (Sea of Terminology: Chinese Language Dictionary), vol. 2 (Taipei: Chung-hua Press, 1974), p. 2069, s.v. "*Shih-ch'eng* 石城," definition no. 4, subdefinition, nos. 1 and 3.

14   Although the "Mr. Ju-chung" in Tung Ch'i-ch'ang's colophon has been identified as Wang Tsung-lu 汪宗魯, it remains unclear exactly who this is. See Shi-yee Liu Fiedler, "Chronology of Tung Ch'i-ch'ang's Works and Inscriptions" in Wai-kam Ho 何惠鑑, ed., *The Century of Tung Ch'i-ch'ang, 1555–1636*, vol. 2 (Kansas: Nelson-Atkins Museum of Art, 1992), pp. 4564.

15   To Tung Ch'i-ch'ang, Chinese paintings, like Ch'an 禪 (Zen in Japanese) Buddhism, could be divided into Northern and Southern schools. According to Tung, the founder of the Southern painting school was Wang Wei 王維 (701–61) of the T'ang

Yao Yün-tsai 姚允在
**Waiting for a Ferry by a River in Autumn**
*continued*

54    dynasty (618–905). This school emphasized calligraphic brushwork and ink washes, as well as represented the legitimacy and the virtuous painting style of literati painters. This was the style Tung claimed painters should emulate. The Northern painting school, on the other hand, was founded by Li Ssu-hsün 李思訓 (653–718), also of the T'ang dynasty. This school preferred fine linear work, realistic forms, and colorful pigments. Tung regarded such works as similar to artisans' products, and thought that they should be avoided. For a discussion of the Northern and Southern schools in Chinese painting, see Wai-kam Ho, "Tung Ch'i-ch'ang's New Orthodoxy and the Southern School Theory," in *Artists and Traditions: Uses of the Past in Chinese Culture*, Christian F. Murck, ed. (Princeton: Art Museum, Princeton University, 1976), pp. 113–29, and James Cahill, "Tung Ch'i-ch'ang's Southern and Northern Schools in the History and Theory of Painting: A Reconsideration," in *Sudden and Gradual: Approaches to Enlightenment in Chinese Thought*, Peter N. Gregory, ed. (Honolulu: University of Hawaii Press, 1987), pp. 429–46.

16    Kung Hsien's colophon for Yao Yün-tsai's scroll is reproduced in Christie's sales catalogue, *Important Classical Chinese Paintings* (New York: Christie's, May 31, 1990), lot no. 30, p. 70. This long handscroll is apparently one of the most important works by Yao Yün-tsai. A transcription of Kung's colophon follows: 簡叔初學於田叔, 中年筆力過之, 名譽大噪. 謂之出藍, 不吻合乎? 然余所見姚畫, 皆金粉丹碧. 此卷惟用墨瀋, 猶之乎大小李將軍之有樓臺影子也. 談者謂倪高士清閟閣圖, 亦施淡色. 文人遊戲, 何所不宜? 余正恨簡叔, 畫無此種. 此卷既無刻滯之跡, 而復有渾融之氣. 慰我夙願多多矣! 因喜而誌之. 半畝居人龔賢. 時庚戌夏至.

17    Using two shades of blue to represent the competition between a teacher and his student is an old analogy; yet in this case, Kung Hsien's comparison of Yao Yün-tsai and his teacher, Lan Ying, is a pun. The teacher's family name is *lan* 藍, or "blue." Thus when Kung claims that "indigo blue that is extracted from the indigo plant is bluer than the plant from which it was extracted," he actually implies explicitly that Yao learned under "Lan (blue)" but was better (bluer) than "Lan (blue)."

18    Li Ssu-hsün (653–718) is considered the founder of the blue-green style. He and his son were famous for depicting palaces and houses. Curiously, they never completed any examples depicting shadows. In this colophon, Kung Hsien probably used "shadows" figuratively, in order to express the rarity of Yao Yün-tsai's ink painting. Li

Ssu-hsüan's biography is found in Zhang Yanyuan's (Ch'ang Yen-yüan) 張彥遠 (active 9th century), *Lidai minghuaji* (*Li-tai ming-hua chi*) 歷代名畫記 (A Record of Famous Paintings of Successive Dynasties), completed 847, *juan* (*chüan*) 卷 (chapter) 9, reprinted in *Hua-shih ts'ung-shu* 畫史叢書 (Compendium of Painting History), vol. 1, pp. 110–11. The entry says: "Li Ssu-hsün was a member of the imperial family. He was the uncle of Li Lin-fu 李林甫 (?–752), and was known for his artistic talent at an early age. There were five painters in the Li family. [Besides Li himself, there was his] younger brother, [Li] Ssu-hui (active late 7th to early 8th century) and Ssu-hui's son, [Li] Lin-fu. [There was also] [Li] Lin-fu's younger brother, [Li] Chao-tao (active early 8th century) and [Li] Lin-fu's nephew, [Li] Ts'ou (active mid-8th century). All five were eminent artists and many admired their works. The highest position Li Ssu-hsün reached in the government was the Deputy of the Great, Mighty, and Powerful General. In 718 he was also granted a post as the Military Governor of Ch'in-chou (present-day Kansu province). The trees and rocks in his landscapes were all defined with clear and powerful brushwork. The freshets and streams as well as the misty colorful clouds create an atmosphere associated with the immortal lands. He was called by his contemporaries, "The Elder General Li." ( 李思訓, 宗室也, 即林甫之伯父. 早以藝稱于當時. 一家五人, 並善丹青. 思訓弟思誨, 思誨子林甫, 林甫弟昭道, 林甫侄湊. 世咸重之, 書畫稱一時之妙. 官至左武威大將軍, 封彭城公. 開元六年, 贈秦州都督. 其畫山水樹石, 筆格遒勁. 湍瀨潺湲, 雲霞縹緲, 時睹神仙之事, 窅然巖嶺之幽. 時人謂之大李將軍其人也.) Li's nephew, Li Lin-fu, was a notoriously evil and corrupt prime minister who was traditionally blamed for having caused the downfall of the T'ang dynasty. The above entry contains an obvious error. Li Chao-tao was Li Ssu-hsüan's son, not the younger brother of Li Lin-fu.

19    In addition to the University of Michigan hanging scroll, there is a landscape scroll published by Howard Rogers in his *Kaikodo* 懷古堂 *Journal*, Spring 1996, no. 12, pp. 28–29. A fan painting by Yao Yün-tsai can be found in Paul Moss's *Old Leaves Turning: Fans*, no. 32, p. 73. There have also been a few works by Yao auctioned at Christie's, New York, including: 1) *Landscape of Rivers and Mountains*, reproduced in *Important Classical Chinese Paintings* (New York: Christie's, May 31, 1990), lot no. 30, pp. 68–70; 2) Two of his eight landscape album leaves, reproduced in *Fine Chinese Paintings and Calligraphy* (New York: Christie's, November

25, 1991), lot no. 176, p. 126; 3) a fan painting, *A Scholar Meditating in a Thatched Cottage*, reproduced in *The Chang Family Han Lu Studio: An Important Private Collection of Chinese Paintings and Calligraphy from 1940s Shanghai* (New York: Christie's, May 31, 1990), lot no. 1, p. 2.

20    For a reproduction of Kuo Hsi's *Early Spring*, see Wen C. Fong and James C. Y. Watt, *Possessing the Past: Treasures from the National Palace Museum, Taipei* (New York: Metropolitan Museum of Art, and Taipei: National Palace Museum, 1996), pl. 60, p. 129. Ch'iu Ying's *Waiting for the Ferry by an Autumn River* is reproduced in National Palace Museum, *Ku-kung shu-hua t'u-lu* 故宮書畫圖錄 (An Illustrated Catalogue of Calligraphy and Painting at the Palace Museum), vol. 7 (Taipei: National Palace Museum, 1991), p. 257.

21    For reproductions of Ch'ien Hsüan's painting in the blue-and-green style, see his *Kuei-ch'ü lai t'u-chüan* 歸去來圖卷 (Returning Home) handscroll and *Wang Hsi-chih kuan-o t'u-chüan* 王羲之觀鵝圖卷 (Wang Hsi-chih [321–79] Watching Geese) handscroll, both at the Metropolitan Museum of Art. They are reproduced in Wen C. Fong, *Beyond Representation: Chinese Painting and Calligraphy, 8th–14th Century* (New York: Metropolitan Museum of Art, 1992), pls. 70 and 71, pp. 314–15 and pp. 316–17, respectively. For Chao Meng-fu's work in this style, see his *Yuma tujuan* (*Yü-ma t'u-chüan*) 浴馬圖卷 (Washing the Horses) handscroll at the Palace Museum, Beijing, reproduced in Palace Museum Editorial Committee, *Zhongguo lidai huihua* (*Chung-kuo li-tai hui-hua*) 中國歷代繪畫 (Paintings of the Past Dynasties), vol. 5, pp. 28–35, and his *Yu-yü ch'iu-ho t'u-chüan* 幼輿丘壑圖卷 (The Mind Landscape of Hsieh Yu-yü), published in Wen C. Fong et al., *Images of the Mind, Selections from the Edward L. Elliott Family and John B. Elliott Collections of Chinese Calligraphy and Painting at the Art Museum, Princeton University* (Princeton: Art Museum, Princeton University, 1984), pp. 280–81. Wen Cheng-ming's works executed in this style include his *Fang Chao Po-su "Hou Chih-pi t'u"* 仿趙伯驌後赤壁圖 (After Chao Po-su's Sequel to Red Cliff) and his *Shan-shui* 山水 (Mountain Landscape), both at the National Palace Museum, Taipei, published in Chiang Chao-shen's 江兆申 (1925–96) *Wen Cheng-ming hua hsi-nien* 文徵明畫系年 (Wen Cheng-ming's Paintings at the National Palace Museum in Chronological Order), the pictorial volume (Tokyo: Orijin Bookstore おりじん書房, 1976), no. 29 and no. 30. Ch'iu Ying exe-

cuted many paintings in the blue-and-green style. See his *Han-kung ch'un-hsiao* 漢宮春曉 (Spring Morning in the Han Palace) at the National Palace Museum, published in Wen C. Fong and James C. Y. Watt, *Possessing the Past: Treasures from the National Palace Museum, Taipei*, pl. 203, pp. 400–401.

22  Yao Yün-tsai's colophon is recorded in Wang Chieh's *Shih-chü pao-chi hsü-pien* 石渠寶笈續編 (Sequel to the Precious Books in a Box at a Rocky Stream [Sequel to the Catalogue of Painting and Calligraphy in the Imperial Collection]), *chüan* 卷 (chapter) 57, p. 2851. However, the painting's current whereabouts are unknown. The Chinese text of Yao's inscription follows: 初唐山水，極欲肖形而樸．自輞川而下，筆遂銳利，北宋始盛．關，荊，李，范，猶詩家之高岑：王，孟也．元人直以筆戲，全亡形似．惟人自領其意已耳．中流之砥，賴一孟頫．余小子，窺未半班，志存六法．不敢以非時之尚，而忌率縁之旨．用擬李成，范寬，荊浩，李唐，趙文敏，王叔明，諸家筆意，作南北歷見車馬，帆檣，城郭，人煙，及四序代遷之景．效肇造物 漫成一圖．使古人有知，必謂余强作解事也．戊戌冬莫，允在識．

23  Wang-ch'uan 輞川, literally meaning "the felloe-of-a-wheel river," was the name of a villa where the poet Wang Wei 王維 (701–61) resided. It is located in the Lan-t'ien 藍田 county, about twenty miles southwest of present-day Xian in Shensi province. For the poems by Wang Wei dealing with his Wang-ch'uan villa, see Roderick Whitfield, *In Pursuit of Antiquity* (Princeton: Art Museum, Princeton University, 1969), pp. 199–208.

24  Yao Yün-tsai references these poets in order to make an analogy with the master painters of the Sung dynasty. These four T'ang poets are known for their simple, elegant, and pastoral works. As their poems possess qualities that are suggestive of paintings, this analogy seems particularly appropriate. Interestingly, Wang Wei was also a painter. The famous poet Su Shih 蘇軾 (1036–1101) of the Northern Sung dynasty (960–1125) once inscribed a colophon on Wang Wei's painting, entitled *Lan-kuan yen-yü t'u* 藍關煙雨圖 (The Mists of Lan-t'ien), which says: "When appreciating Wang Wei's poems, one [seems to be able to] find paintings in his poems. When viewing Wang Wei's paintings, one [seems to be able to] find poems in his paintings." (書摩詰藍關煙雨圖味摩詰之詩，詩中有畫 觀摩詰之畫，畫中有詩．) Su Shih, *Dongpo tiba* (*Tung-p'o t'i-pa*) 東坡題跋 (Colophons by Su Shih), *juan* (*chüan*) 卷 (chapter) 5, reprinted, Tu Youxiang, annotator, *Song Ming Qing xiaopin wenji jizhu* (*Sung-Ming-Ch'ing hsiao-p'in wen-chi chi-chu*) 宋明清小品文集輯注 (Series of Col-

lected Essays from the Sung, Ming, and Ch'ing Dynasties with Commentary) (Shanghai: Yuandong Chubanshe, 1996), pp. 261–62.

25  Hsieh Ho's 謝赫 (active 479–502) *Liu-fa* 六法 or *The Six Canons of Painting* is considered the first and among the most important treatises on Chinese painting. The principles outlined by Hsieh have been revered throughout history. They include: 1) *Ch'i-yün sheng-tung* 氣韻生動 (animation through spirit consonance); 2) *Ku-fa yung-pi* 骨法用筆 (using a flexible brush to produce forceful strokes); 3) *Ying-wu hsiang-hsing* 應物象形 (fidelity to the object in portraying forms); 4) *Sui-lei fu-ts'ai* 隨類賦彩 (conformity to type in applying colors); 5) *Ching-ying wei-chih* 經營位置 (proper planning in the placing of elements); and 6) *Ch'uan-i mo-hsieh* 傳移摹寫 (transmission of the experience of the past in making copies). For a discussion of these *Six Canons*, see James Cahill, "The Six Laws and How to Read Them," in *Ars Orientalis* 4 (Ann Arbor: Department of the History of Art, University of Michigan, 1966), pp. 372–81.

26  Although the name of Hsü Hung-chi is unfamiliar to most, he was an important figure in Nanking during the end of the Ming dynasty. He inherited the title of duke in 1595 and died in 1641. Hsü was not only an established calligrapher but also an enthusiastic patron who hosted contemporary painters like Wu Pin 吳彬 (active c. 1591–1643), Kao Yang 高陽 (active c. 1620–44), Cheng Chung 鄭重 (active c. 1610–48), and Yao Yün-tsai. Another well-known scholar-painter in this circle was Mi Wan-chung 米萬鍾 (1570–1628). Hsü Hung-chi was also a collector, and part of his collection was bought from Tung Ch'i-ch'ang. See National Palace Museum, *Wan-Ming pien-hsing-chu-i hua-chia tso-p'in chan* 晚明變形主義畫家作品展 (Style Transformed: A Special Exhibition of Works by Five Late Ming Artists) (Taipei: National Palace Museum, 1977), p. 21. Paintings Hsü purchased from Tung included the famous hanging scroll *Han-lin ch'ung-ting* 寒琳重汀 (Wintry Woods on Layered Banks), attributed to Tung Yüan 董源 (d. 962), now belonging to the Kurokawa Institute of Ancient Cultures 黑川古文化研究所 Collection in Japan. See Hironobu Kohara 古原宏伸, ed., *Bunjinga suihen* 文人畫粹編 (Essence of Collected Literati Paintings), vol. 2 (Tokyo: Chuo Koronsha, 1985), p. 131. For Hsü Hung-chi's ancestor, Hsü Ta, see L. Carrington Goodrich and Fang Chaoying, eds., *Dictionary of Ming Biography, 1368–1644*, vol. 1 (New York and London: Columbia University Press, 1976), pp. 602–8.

27  For more information on the Hou family, see *Eminent Chinese of the Ch'ing Period (1644–1912)*, vol. 1, pp. 291–92, s.v. "Hou Fang-yü 侯方域."

28  1) Hou Fang-yü 侯方域 (1618–55), 2) Fang I-chih 方以智 (?–1671?), 3) Ch'en Ch'en-hui 陳貞慧 (1605–56), and 4) Mao Hsiang 冒襄 (1161–93) are known as the famous "Four Esquires" and were active in Nanking between 1630 and 1644. Chou Liang-kung, who became prominent around 1640, probably approached Hou Fang-yü and his younger brother Hou Fang-hsia 侯方夏 (*chin-shih* degree in 1646) in searching for Yao Yün-tsai's paintings.

29  See Chou Liang-kung's *Tu-hua-lu* 讀畫錄 (A Record of Examined Paintings), *chüan* 卷 (chapter) 1, pp. 17–18.

30  See ibid. Chou Liang-kung states in his book that Yao Yün-tsai regularly made his home at the entertainment quarter in Ch'in-huai district in Nanking. (常流寓秦淮.) For more information on Ch'in-huai, see note 17 in entry 5 on Wu Wei.

31  See Tung Ch'i-ch'ang's colophon on Yao Yün-tsai's handscroll mentioned earlier in this entry. Tung praised Yao as elegant, heroic, and unrestrained (風雅豪邁) In Lan Ying's *T'u-hui pao-chien hsü-ts'uan* 圖繪寶鑑續纂 (Sequel to Precious Mirror of Painting), *chüan* 卷 (chapter) 1, p. 6, the author also asserts that Yao Yün-tsai was heroic, openhearted and friendly. (為人肝膽俠氣.) Given this personality, Yao would have probably joined the patriotic movements against the Manchu invaders around 1645 and, like many others, been killed.

32  During the second half of the seventeenth century, many painters in Nanking developed their own styles. Of Yao Yün-tsai's contemporaries, these include Wu Pin, Lan Ying, Kao Yang, and Cheng Chung, all mentioned in note 26. A group of painters belonging to the following generation were eventually known as the "Eight Masters of Nanking," including: 1) Kung Hsien 龔賢 (1599–1689); 2) Fan Ch'i 樊圻 (1616–?); 3) Kao Ts'en 高岑 (active 1640–80); 4) Tsou Che 鄒喆 (active 1640–80); 5) Wu Hung 吳弘 (active 1640–80); 6) Yeh Hsin 葉欣 (active 1640–75); 7) Hu Tsao 胡慥 (active 1635–60); and 8) Hsieh Sun 謝蓀 (active 1645–80). Among the eight, it is known that Yeh Hsin 葉欣 painted directly in emulation of Yao Yün-tsai. See Chou Liang-kung's *Tu-hua-lu* 讀畫錄 (A Record of Examined Paintings), *chüan* 卷 (chapter) 3, pp. 45–46. Chou claims, "I heard that Yeh Jung-mu 葉榮木 (Yeh Hsin's *tzu*, meaning 'glorious wood') was a student of Yao Chien-shu (Yao Yün-tsai). [Perhaps Yeh] only borrowed conceptually and did not complete a formal ceremony confirming

Yao Yün-tsai 姚允在
Waiting for a Ferry by a River in Autumn
*continued*

## 21. Chang Hung 張宏
*(1577–after 1668)*
*Ming dynasty (1368–1644)*

56  the student-teacher relationship. I also heard that when Yao viewed Yeh's work, it was like [the famous episode of] Madame Wei [Shuo] (272–349) viewing Chung Yü's (151–230) calligraphy. Yao exclaimed, 'The fame of this young fellow will someday eclipse my own.' It is likely that these accounts [concerning their student-teacher relationship] were due to Yao's emotional comments [on Yeh's painting]." (人傳榮木, 出姚簡叔之門. 但師其意耳, 實未執贄撮土也. 相傳簡叔見榮木畫, 如衛夫人見鍾太傅筆畫, 有 "此子必蔽我名" 之歎. 世人之傳, 或簡叔一歎所致歟.) Lan Ying's *T'u-hui pao-chien hsü-ts'uan*) 圖繪寶鑑續纂 (Sequel to Precious Mirror of Painting), *chüan* 卷 (chapter) 2, p. 28, also asserts that Yeh Hsin's landscape was based on the style of Chao Ling-jang 趙令穰 (active 1067–1100) and that he combined it with Yao Yün-tsai's style (山水學趙令穰, 復以姚簡叔參之).

33  For the names of the Eight Masters of Nanking, see ibid.

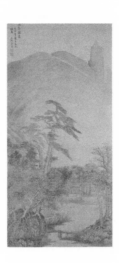

## Reading "The Book of Changes" at a Pavilion in Autumn
*Ch'iu-t'ing tu "I"*
*(Reading "The Book of Changes" at a Pavilion in Autumn)*
秋亭讀 "易"

1  *The Book of Changes*, or *I-ching* 易經, was originally a book of divination divided into two sections. The first section, which contains sixty-four complex symbols, is referred to as *Ching* (classic). The second section, which includes commentary on the symbols of the first section, is referred to as *Ch'uan* (to instruct). Traditionally, Hsi-po 西伯 (active c. 1100 B.C.), the founder of the Chou dynasty, is thought to have been the first to use these symbols to predict the future. Since the book predates the later philosophical schools and is focused on ancient cosmological beliefs such as the definition of the physical elements of the world, it is considered one of the most difficult and profound of Chinese texts. According to Chinese history, *The Book of Changes* is one of the "Five Chinese Classics." The other four are: *Shu-ching* 書經 (The Book of History and Documents); *Shih-ching* 詩經 (The Book of Odes and Songs); *Ch'un-ch'iu* 春秋 (Spring and Autumn Annals); and *Li-chi* 禮記 (The Book of Rites). For a brief description of *I-ching* in Chinese, see *Tz'u-hai* 辭海 (Sea of Terminology, Chinese Language Dictionary), vol. 1 (Taipei: Chung-hua Press, 1974), p. 568, s.v. "*Chou-i* 周易" (*I-ching* of the Chou dynasty). For a chronological list with descriptions of various translations of *The Book of Changes*, see "Translations into European Languages" in Richard Rutt's *Zhouyi: The Book of Changes* (Surrey: Curzon Press, 1996), pp. 60–82. For the translation of the whole book, see Richard

Wilhelm, tr. (German), rendered into English by Cary F. Bayness, *I Ching: or Book of Changes*, 3rd edition (London: Routledge & K. Paul, 1968).

2  James Freeman is an American dealer based in Kyoto, Japan.

3  Neither the "Plum-Hut Studio" nor "Mr. Chu" in Chang Hung's inscription has been identified. Presumably Mr. Chu was a patron, and the Plum-Hut Studio was the name of his studio. It is likely that Chang Hung originally painted the Michigan scroll for this Mr. Chu, in this studio.

4  Lin Hsiung-kuang 林熊光 was a twentieth-century collector from Taiwan who was active in Japan between 1915 and the 1950s. His *hao* was Lang-an 朗庵, meaning "a bright hut." Another work formerly owned by Lin and now belonging to the University of Michigan is Chou Ch'en's 周臣 (c. 1450–c. 1535) *Making Tea under Pines by a Stream*. See the collector's seal on Chou's painting in entry 8.

5  See Zhang Geng (Chang Keng) 張庚 (1685–1760), *Guochao huazhenglu (Kuo-ch'ao hua-cheng lu)* 國朝畫徵錄 (Biographical Sketches of the Artists of the Ch'ing Dynasty), preface dated 1739, *juan* (*chüan*) 卷 (chapter) 1, reprinted in Yu Anlan 于安瀾, comp., *Huashi congshu (Hua-shih ts'ung-shu)* 畫史叢書 (Compendium of Painting History), vol. 5 (Shanghai: Renmin Meishu Chubanshe, 1962), p. 6.

6  The second-generation Wu school painters include: 1) Ch'en Ch'un 陳淳 (1483–1544); 2) Wang Ch'ung 王寵 (1494–1533); 3) Lu Chih 陸治 (1496–1576); 4) Wen Peng 文彭 (1498–1573); 5) Wen Chia 文嘉 (1501–83); 6) Wang Ku-hsiang 王穀祥 (1501–68); 7) Ch'ien Ku 錢穀 (1508–ca. 1578); 8) Chou T'ien-ch'iu 周天球 (1514–95); 9) Chü Chieh 居節 (1527–86); 10) Wen Po-jen 文伯仁 (1502–75); 11) Wang Chih-teng 王穉登 (1535–1612). For a discussion of these artists, see Alice R. M. Hyland, *The Literati Vision: Sixteenth-Century Wu School Painting and Calligraphy* (Memphis: Memphis Brooks Museum of Art, 1984).

7  Ellen J. Laing provided this assessment based on Chang Hung's extant works with dates. See Ellen J. Laing, entry "Chang Hung," in L. Carrington Goodrich and Fang Chaoying, eds., *Dictionary of Ming Biography, 1368–1644*, vol. 1 (New York and London: Columbia University Press, 1976), p. 88.

8  Both Ellen J. Laing and James Cahill calculated that Chang Hung probably stopped painting in his mid-seventies, around 1652. Cahill also suggests that Chang Hung probably died in that year or shortly after.

See ibid. and "Chang Hung and the Limits of Representation," in James Cahill, *The Compelling Image: Nature and Style in Seventeenth-Century Chinese Painting* (Cambridge, Mass.: Harvard University Press, 1982), p. 5.

9   This conclusion is based on the entry for Chang Hung in Yu Jianhua 于劍華 et al., *Zhongguo meishujia renming cidian* (*Chung-kuo mei-shu-chia jen-ming tz'u-tien*) 中國美術家人名詞典 (A Biographical Dictionary of Chinese Artists) (Shanghai: Renmin Meishu Chubanshe, 1981), p. 825. The entry records a work executed in 1668. Thus if the work is authentic, Chang would have lived until at least age ninety-two. Chang Hung's long life is supported by yet another source found in Ellen J. Laing's entry "Chang Hung," in *Dictionary of Ming Biography, 1368–1644*, vol. 1, p. 88. According to Laing, the painter Tsou Che 鄒喆 (1636–1708?), one of the Eight Masters of Nanking during the Ch'ing dynasty, dedicated a painting to Chang in 1668. Thus Chang Hung must have lived at least until that year.

10  For a discussion of Chang Hung's ability to depict actual landmarks, see "Chang Hung and the Limits of Representation," in *The Compelling Image: Nature and Style in Seventeenth-Century Chinese Painting*, pp. 1–18. Paintings by Chang Hung based on the scenic spots he visited include: 1) *Shih-hsieh shan t'u* 石屑山圖 (A Picture of the Shih-hsieh Mountain), dated 1613, at the National Palace Museum, Taipei; 2) *Ch'i-hsia shan t'u* 棲霞山圖 (A Picture of the Ch'i-hsia Mountain), dated 1634, also at the National Palace Museum, Taipei; 3) *Kou-ch'ü sung-feng t'u* 句曲松風圖 (Wind in the Pines at Mount Kou-ch'ü), dated 1650, at the Boston Museum of Fine Arts; and 4) *Yüeh-chung ming-sheng* 越中名勝 (Famous Scenes of Chekiang), dated 1639, currently in the Moriya Tadashi 守屋正 Collection, Kyoto. All of these works by Chang Hung are reproduced in "Chang Hung and the Limits of Representation," in *The Compelling Image: Nature and Style in Seventeenth-Century Chinese Painting*, pp. 1–18.

11  For an example of Chang Hung's works with fine details, see his *A Picture of the Shih-hsieh Mountain*, dated 1613, at the National Palace Museum, Taipei. For reproduction information, see note 10. Chang Hung's coarse and sparse work is exemplified by his *Landscape*, dated 1629, also at the National Palace Museum. See *Ku-kung shu-hua t'u-lu* 故宮書畫圖錄 (An Illustrated Catalogue of Calligraphy and Painting at the Palace Museum), vol. 8 (Taipei: National Palace Museum, 1993), p. 379.

12  The best example of Chang Hung's figure painting is *Pu-tai lo-han t'u* 布袋羅漢圖 (Picture of Arhat Pu-tai) at the National Palace Museum, Taipei. It is published in *Ku-kung shu-hua t'u-lu* 故宮書畫圖錄 (An Illustrated Catalogue of Calligraphy and Painting at the Palace Museum), vol. 9, p. 5. Pu-tai (meaning "a cloth bag") is the Buddhist name of Chang T'ing-tzu 張汀子 (d. 917), a deified Buddhist monk. He was so named because he always carried a calico bag. The Chinese believe that he was the final incarnation of Maitreya, the Future Buddha. Other figure paintings by Chang Hung are his *Yin-chen kuan-mei t'u* 應真觀梅圖 (Picture of an Arhat Enjoying the Plum Blossom), dated 1630, and *Pu-na t'u* 補衲圖 (Picture of an Old Robe Being Mended), dated 1638, reproduced in *An Illustrated Catalogue of Calligraphy and Painting at the Palace Museum*, vol. 8, p. 381 and p. 387, respectively. These two casually executed scrolls are probably Chang Hung's works executed extemporaneously at gatherings away from his studio.

13  Most of Chang Hung's well-known paintings with refined brushwork, such as those listed in note 10, were executed on paper.

14  This work, reproduced in *Ku-kung shu-hua t'u-lu* 故宮書畫圖錄 (An Illustrated Catalogue of Calligraphy and Painting at the Palace Museum), vol. 9, p. 7, bears similar loose brushwork as well as a similar effect from the uneven surface of the silk.

15  See note 1.

16  "Heterodox" in this case has no religious connotation. Chinese scholars borrowed this term to label the unconventional and untrammeled style preferred by the Che school painters. See Xu Qin (Hsü Ch'in) 徐沁 (active first half of 17th century), *Minghualu* (*Ming-hua-lu*) 明畫錄 (Painters of the Ming Dynasty), *juan* (*chüan*) 卷 (chapter) 3, reprinted in Yu Anlan 于安瀾, comp., *Huashi congshu* (*Hua-shih ts'ung-shu*) 畫史叢書 (Compendium of Painting History), vol. 5 (Shanghai: Renmin Meishu Chubanshe, 1962), pp. 32–33. The author of this book, Hsü Ch'in, commenting on Chiang Sung's work, exclaims: "Chiang Sung . . . was fond of utilizing dark-scorched ink and dry-brush work, which greatly pleased the eyes of his contemporaries. His use of the brush was rough and undisciplined and strayed from proper standards. Along with Cheng Tien-hsien (?), Chang Fu-yang (張復陽, 1403–90), Chung Ch'in-li (Chung Li 鍾禮, active late 15th century), and Chang P'ing-shan (Chang Lu 張路, c. 1475–c. 1540), he persisted in the wild and outrageous expres-sion of the heterodox school." (蔣嵩 . . . 喜用焦墨枯筆. 最入時人之眼. 然行筆粗荞, 多越矩度. 時與鄭顛仙, 張復陽, 鍾欽禮, 張平山, 徒逞狂態目為邪學.)

17  The works of many seventeenth-century Suchou painters possess both literati and professional characteristics, including Li Shih-ta 李士達 (active 1580–1620), Ch'en Huan 陳煥 (active late 16th to early 17th century), Ch'en Kuan 陳裸 (?–after 1638), and Liu Yüan-ch'i 劉原起 (1555–after 1632). See entries 16, 14, and 15, respectively.

## 22. Lan Ying 藍瑛
*(1585–after 1664)*
*Ming dynasty (1368–1644)*

58

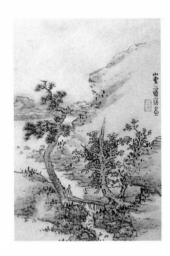

### Landscape
*Shan-shui ts'e-yeh*
*(Landscape Album Leaf)*
山水冊頁

1   James Freeman is an American dealer based in Kyoto, Japan.

2   See Yu Jianhua 于劍華 et al., comp., *Zhongguo meishujia renming cidian (Chung-kuo mei-shu-chia jen-ming tz'u-tien)* 中國美術家人名詞典 (A Biographical Dictionary of Chinese Artists) (Shanghai: Renmin Meishu Chubanshe, 1981), p. 1492, s.v. "Lan Ying 藍瑛" The exact year in which Lan Ying died is not clear. The information provided on Lan Ying's art and life is based on three sources: 1) Lan Ying 藍英 and Xie Bin (Hsieh Pin) 謝彬, eds., *Tuhui baojian xucuan (T'u-hui pao-chien hsü-ts'uan)* 圖繪寶鑑續纂 (Supplement to Precious Mirror of Painting and Painters of the Ming and Ch'ing Dynasties), *juan (chüan)* 卷 (chapter) 2, reprinted in Yu Anlan 于安瀾, comp., *Huashi congshu (Hua-shih ts'ung-shu)* 畫史叢書 (Compendium of Painting History), vol. 4 (Shanghai: Renmin Meishu Chubanshe, 1962), p. 14; 2) Xu Qin (Hsü Ch'in) 徐沁 (active first half of 17th century), *Minghualu (Ming-hua lu)* 明畫錄 (Painters of the Ming Dynasty), *juan (chüan)* 卷 (chapter) 5, reprinted in *Hua-shih ts'ung-shu* 畫史叢書 (Compendium of Painting History), vol. 5, p. 63; 3) Zhang Geng (Chang Keng) 張庚 (1685–1760), *Guochao huazhenglu (Kuo-ch'ao hua-cheng lu)* 國朝畫徵錄 (Biographical Sketches of the Artists of the Ch'ing Dynasty), preface dated 1739, *juan (chüan)* 卷 (chapter) 1, reprinted in *Hua-shih ts'ung-shu* 畫史叢書 (Compendium of Painting History), vol. 5, p. 12. The entry on Lan Ying in Hu Sai-lan's 胡賽蘭 *Style Transformed: A Special Exhibition of Works by Five Late Ming Artists* (Taipei: National Palace Museum, 1977), p. 26, also states that Lan's home was located in the east section of Hangchou and that the name of his house was *Ch'eng-chü mao-t'ang* 城曲茆堂 (A Thatched Hut in the City's Winding Alleys). This must be why Lan adopted the *hao* of Tung-kuo lao-nung 東郭老農 (an old farmer living near the east city wall).

3   Many of these sobriquets, although not found in early books on Lan Ying, are found as seals on his works. They are recorded in Victoria Contag and Wang Chi-ch'ien, *Seals of Chinese Painters and Collectors of the Ming and Ch'ing Periods*, reprint (Taipei: Shang-wu Press, 1965), no. 411, pp. 490–91.

4   While it is also recorded that Lan Ying was adept in figure painting early in his career, there are, unfortunately, no extant examples to verify this claim. For the statements on Lan Ying's figure paintings, see *T'u-hui pao-chien hsü-ts'uan* 圖繪寶鑑續纂 (Supplement to Precious Mirror of Painting and Painters of the Ming and Ch'ing Dynasties), *chüan* 卷 (chapter) 2, p. 14. The text reads, "As to the depiction of female figures dressed in the palace fashion, it was something he [Lan Ying] did in his youth." (至於宮粧仕女乃少年之遊藝) One of Lan's works, a portrait of the artist Shao Mi 邵彌 (c. 1595–1642) now at the Palace Museum in Beijing, was the result of a joint effort by Lan Ying and Hsü T'ai 徐泰 (active 17th century). In this work, Hsü T'ai executed the figure, while Lan Ying painted the landscape setting and inscribed the scroll. This portrait is reproduced in François Fourcade, translated from the French by Norbert Guterman, *Art Treasures of the Peking Museum* (New York: Harry N. Abrams, 1965), pl. 29, p. 79. See also note 18 of the entry 25 on Shao Mi.

5   This anecdote is originally recorded in the *Ch'ien-t'ang hsien-chih* 錢塘縣誌 (Hangchou Gazette). It is cited in Hu Sai-lan's *Style Transformed: A Special Exhibition of Works by Five Late Ming Artists*, p. 26.

6   During the Southern Sung dynasty (1127–1279), Hangchou was the capital and also the location of the imperial art academy. Almost all the talented painters resided there. This tradition persists in the city even up to the present day, due to the presence of the prestigious National Hangchou Art Academy. See "The Southern Sung Academy: Flowers, Birds, Animals, Figures, History Painting, Genre Painting, Landscapes with Buildings and Figures," in Wen C. Fong and James C. Y. Watt, *Possessing the Past: Treasures from the National Palace Museum, Taipei* (New York: Metropolitan Museum of Art, and Taipei: National Palace Museum, 1996), pp. 168–99. For information on Hangchou as a painting center, see James Cahill, *Parting at the Shore: Chinese Painting of the Early and Middle Ming Dynasty, 1368–1580* (New York and Tokyo: Weatherhill, 1978), pp. 4–5, 53–54, 57, 98, 107, and 167. For later painters from Hangchou, see "A Lost Horizon: Painting in Hangzhou after the Fall of the Song," in Richard M. Barnhart's *Painters of the Great Ming: The Imperial Court and the Zhe School* (Dallas: Dallas Museum of Art, 1993), pp. 21–51.

7   For Lan Ying's early work, see his album leaves *Fang-ku ts'e* 仿古冊 (Album Leaves Following Ancient Masters), now at the National Palace Museum, Taipei. This work is dated 1622; in that year, the artist was about thirty-eight years old. The ten leaves in this set follow early masters, including: 1) Wang Wei 王維 (701–61); 2) Fan K'uan 范寬 (d. after 1023); 3) Tung Yüan 董源 (active c. 943–58); 4) Chü-jan 巨然 (active c. 976–93); 5) Chao Ling-jang 趙令穰 (active first quarter of 12th century); 6) Mi Fu 米芾 (1052–1108); 7) Li T'ang 李唐 (c. 1070s–c. 1150s); 8) Chao Meng-fu 趙孟頫 (1254–1322); 9) Huang Kung-wang 黃公望 (1269–1354); and 10) Wang Meng 王蒙 (c. 1308–85). Lan Ying's leaves are published in *Style Transformed: A Special Exhibition of Works by Five Late Ming Artists*, no. 44, pp. 284–95.

8   Among the ten leaves by Lan Ying mentioned in note 7, several can be directly related to well-known old paintings, some of which survive today. For example, leaf two seems to have been derived from Fan Kuan's famous hanging scroll, *Travelers amid Streams and Mountains*, now at the National Palace Museum, Taipei. There is no doubt that leaf five has a kinship with Chao Ling-jang's *Summer Mist along the Lake Shore*, currently at the Museum of Fine Arts, Boston. It is possible Lan Ying studied Li T'ang's *Wind in the Pines amid Ten Thousand Valleys* at the National Palace Museum before he executed his seventh leaf. Furthermore, Lan undoubtedly adopted Chao Meng-fu's *Autumn Colors on the Ch'iao and Hua Mountains*, also at the National Palace Museum, as his model for the eighth leaf. The pointed mountain in Lan's work closely resembles the one in Chao's painting.

9   For Lan Ying's association with Wu Ch'i-chen, see Wu's *Shu-hua chi* 書畫記 (A Record of Paintings and Calligraphy), reprint (Taipei: Wen-shih-che Press, 1971), pp. 328–29. Wu recounts that in 1654 he

and Lan Ying viewed old paintings together at the government office–residence of the local prefect of Chia-hsing, Chekiang. He also records (pp. 603–4) that in 1669 Wu visited Lan's son in Hangchou in order to view two small paintings by Wu Chen 吳鎮 (1280–1354). Presumably, by then, Lan Ying had already died.

10  In *T'u-hui pao-chien hsü-ts'uan* 圖繪寶鑑 續纂 (Supplement to Precious Mirror of Painting and Painters of the Ming and Ch'ing Dynasties), *chüan* (chapter) 卷 2, p. 14, it is asserted that Lan Ying learned painting by following the style of Huang Kung-wang and that he memorized and fully comprehended this experience. (畫從 黃子久入門, 而惺悟焉.) One of the earliest extant works by Lan Ying, dated 1617, is his handscroll entitled *Fang Ta-ch'ih shan-shui* 倣大癡山水 (A Landscape after Huang Kung-wang), now at the Shanghai Museum. It is reproduced in Group for the Authentication of Ancient Works of Chinese Painting and Calligraphy, ed., *Zhongguo gudai shuhua tumu (Chung-kuo ku-tai shu-hua t'u-mu)* 中國古代書畫 圖目 (An Illustrated Catalogue of Selected Works of Ancient Chinese Painting and Calligraphy), vol. 4 (Shanghai: Wenwu Chubanshe, 1990), no. 滬 1-1786, p. 54. Another of Lan's later paintings revealing his emulation of the style of Huang Kung-wang is his handscroll entitled *Fang Huang Kung-wang shan-shui chüan* 仿黃公望山水卷 (A Handscroll after Huang Kung-wang's Landscape), now at the National Palace Museum, Taipei. This work is published in *Style Transformed: A Special Exhibition of Works by Five Late Ming Artists*, no. 49, pp. 314–21. Lan's inscription on this handscroll reads, "I have humbly considered [Huang Kung-wang] as my teacher for thirty years; all I could achieve, [however], is Huang's 'hair and skin' [superficial skills]." (余仰師三十 年; 少得於皮毛.) The scroll was dated 1639, by which time Lan Ying was already in his fifties. Thus, it can be determined that Lan Ying probably started to imitate Huang Kung-wang around the age of twenty-five.

11  See *Ming-hua lu* 明畫錄 (Painters of the Ming Dynasty), *chüan* 卷 (chapter) 5, p. 63. (此如書家真楷, 必由此入門, 始能各極變化.)

12  For an account of Lan Ying's trips, see *T'u-hui pao-chien hsü-ts'uan* 圖繪寶鑑續纂 (Supplement to Precious Mirror of Painting and Painters of the Ming and Ch'ing Dynasties), *chüan* (chapter) 卷 2, p. 14. The text reads, "He [Lan Ying] traveled to Kwangtung, Fukien, Hunan, and Hupei provinces and also covered regions in the Hopei, Shansi, Shensi, and Honan provinces. With extensive exposure, his horizon was broadened." (遊閩、粵、荊、襄. 歷燕、秦、晉、洛. 涉獵既多, 眼界弘遠.)

13  For an example of Lan Ying's later work, see his *Hua hsüeh-ching* 畫雪景 (Painting a Snow Scene) at the National Palace Museum, Taipei. It is published in *Style Transformed: A Special Exhibition of Works by Five Late Ming Artists*, no. 64, pp. 402–3. The painting is dated 1659, when the artist was about seventy-five years old. Although Lan Ying indicated in his inscription on this work that he executed the landscape after Fan K'uan, the composition, trees, and rocks in this large hanging scroll (268 × 68.8 cm) all demonstrate Lan Ying's personal style.

14  See *Style Transformed: A Special Exhibition of Works by Five Late Ming Artists*, p. 27. The author states that Lan Ying consulted eminent scholar-painters like Tung Ch'i-ch'ang 董其昌 (1555–1636) and Ch'en Chi-ju 陳繼儒 (1558–1639) on the subjects of poetry and literature.

15  In Chang Keng's *Kuo-ch'ao hua-cheng lu* 國朝畫徵錄 (Biographical Sketches of the Artists of the Ch'ing Dynasty), *chüan* 卷 (chapter) 1, p. 12, the author records an episode he experienced in Hangchou, the hometown of both Lan Ying and Chang Keng. According to Chang, as a young man he often heard the elders in his hometown criticizing works by Sung Hsü 宋旭 (1525–?) and Lan Ying. Later he viewed Sung's work entitled *Wang-ch'uan Villa* and found that Sung did not merely copy from the Yuan version for his work; instead, he added personal renderings. His technique in executing the texture of the rocks, while modeled after the great master Huang Kung-wang, was natural, spontaneous, and profound. Thus he considered Sung one of the truly outstanding painters of the Ming period. To the author [Chang Keng] Sung Hsü should not be criticized; rather he should be emulated by later painters. He also wondered how people could categorize him with Lan Ying and discount them both. Chang considered the elders' opinions on painters not dependable. (余少時, 聞鄉前輩論畫. 每至宋旭、藍 瑛, 輒深詆娸之. 後見宋所畫輞川卷, 不襲元 本, 自出機抒. 皴擦則用黃鶴山樵法. 恣極浚 邃, 而一出自然. 實為有明一代作手. 不獨不 可詆娸, 乃學者所當急摹者也. 奈何與田叔一 例抹倒, 前輩之論畫疏矣.)

16  See ibid. Chang Keng also states in his book that T'ai Chin inaugurated the Che school, and when this school evolved to the point that it produced Lan Ying, it reached its utmost point. (畫之有浙派, 始 自戴進, 至藍瑛為極.) As a matter of fact, Lan Ying's style is rather different from that of the Che school, especially from that of the degenerated Che paintings of the seventeenth century. Lan Ying was probably grouped into this tradition due to his professional background, as well as to the fact that his hometown was Hangchou, where Tai Chin had initiated the Che school.

17  All the names of Lan Ying's students, except Liu Tu, are found in *Ming-hua lu* 明 畫錄 (Painters of the Ming Dynasty), *chüan* 卷 (chapter) 5, p. 63. The information on Liu Tu is found in *Chung-kuo mei-shu-chia jen-ming tz'u-tien* 中國美術家人名詞 典 (A Biographical Dictionary of Chinese Artists), p. 1315. None of these students was as successful as Lan Ying.

18  Lan Ying's son Lan Meng 藍孟 (active during the K'ang-hsi period, 1644–1722) is mentioned in *Ming-hua lu* 明畫錄 (Painters of the Ming Dynasty), *chüan* 卷 5, p. 63. Lan Meng's two sons were Lan Shen 藍深 and Lan T'ao 藍濤 (both active between second half of 17th and first quarter of 18th century). They are listed in *T'u-hui pao-chien hsü-ts'uan* 圖繪寶鑑續纂 (Supplement to Precious Mirror of Painting and Painters of the Ming and Ch'ing Dynasties), *chüan* 卷 (chapter) 2, pp. 48–49. It is important to point out that Chang Keng mistakenly named Lan T'ao as Lan Ying's son in his *Kuo-ch'ao hua-cheng lu* 國朝畫徵錄 (Biographical Sketches of the Artists of the Ch'ing dynasty), *chüan* 卷 (chapter) 1, p. 12. As the characters of the given names of both Lan Shen and Lan T'ao bear a radical, *shui* 水, or "water," represented by three dots on the left side, it is clear that they belonged to the same generation.

19  For a discussion of the teacher-student relationship between Lan Ying and Ch'en Hung-shou, see entry on Lan Ying by Hugh Wass and Fang Chaoying in L. Carrington Goodrich and Fang Chaoying, eds., *Dictionary of Ming Biography, 1368–1644*, vol. 1 (New York and London: Columbia University Press, 1976), p. 787. Several sources are given in this entry. The two artists' teacher-student relationship is also found in T'ao Yüan-tsao's 陶元藻 (1716–1801) *Yuehua jianwen (Yüeh-hua chien-wen)* 越 畫見聞 (Painters from the Yüe Region), preface dated 1795, reprinted in Lu Fusheng 盧輔聖, ed., *Zhongguo shuhua quanshu (Chung-kuo shu-hua ch'üan-shu)* 中國書畫全書 (The Complete Collection of Books on Chinese Painting and Calligraphy), vol. 10 (Shanghai: Shanghai Shuhua Chubanshe, 1992), p. 771. The entry in T'ao's book indicates that when Lao Lien [Ch'en Hung-shou] was young and began to paint, he studied under Lan Ying, who was from Hangchou, and was deft in the prac-

Lan Ying 藍瑛
**Landscape**
*continued*

60    tice of painting after real objects. However, Ch'en soon felt that his teacher's skill could not help him fulfill his goal, and Lan Ying also admitted that Ch'en's painting already surpassed his own work. After Ch'en finished studying under Lan Ying, for the rest of his painting career, he stopped painting still lifes. (老蓮初法傳染時, 錢唐藍瑛工寫生。蓮請瑛法傳染。已爾, 輕瑛。瑛亦自以為不逮。蓮終其身, 不為寫生。)

20    Album leaves of this format were almost always completed and distributed in sets.

21    In many of Lan Ying's other works, in order to fill out the composition, the artist added specks of white pigment on the black ink dots. For example, see Lan Ying's *Streams and Mountains after Snow*, dated 1623, at the National Palace Museum in Taipei. The painting is reproduced in *Style Transformed: A Special Exhibition of Works by Five Late Ming Artists*, no. 45, p. 297.

22    See note 15.

23    For examples of Lan Ying's unconventional birds and rocks, see *Style Transformed: A Special Exhibition of Works by Five Late Ming Artists*, nos. 56-1 to 56-10, pp. 37–80.

24    See note 19 for the entry on Lan Ying in *Dictionary of Ming Biography, 1368–1644*, vol. 1, p. 788.

## 23. Liu Yüan-ch'i 劉原起
*(1555–after 1632)*
*Ming dynasty (1368–1644)*

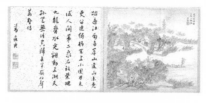

### Sailing under the Moonlight
*Yüeh-hsia fan-chou*
*(Sailing under the Moonlight)*
月下泛舟

1    In 1966, the University of Michigan Museum of Art purchased both this Liu Yüan-ch'i album leaf and another one by Shao Mi 邵彌 (c. 1595–1642) (accession no. 1966/1.92) from the same dealer. The Museum was told at that time that these two leaves had belonged to a set of album leaves containing many works by late Ming painters. Unfortunately, the names of the other painters were unclear. For Shao Mi's album leaf, see entry 25.

2    These two lines are quoted from a poem by Meng Hao-jan 孟浩然 (689–740) of the T'ang dynasty (618–905). Meng's poem is included in his anthology. See Hsiao Chi-tsung 蕭繼宗, *Meng Hao-jan shih-shuo* 孟浩然詩説 (An Explanation of Meng Hao-jan's Poetry), *chüan* 卷 (chapter) 2, reprint (Taipei: Commercial Press, 1985), p. 136. For information on the poet, see Herbert A. Giles, *A Chinese Biographical Dictionary* (London and Shanghai: B. Quaritch, 1898), no. 1518, or idem, *A History of Chinese Literature* (New York and London: D. Appleton and Company, 1937), reprint (New York: Grove Press, 1958), p. 149. The complete poem and translation appear in the commentary of this entry.

3    The calligraphy on the accompanying leaf was executed by the calligrapher Ko Ying-tien 葛應典 (active early 17th century) in the running script. The poem was originally composed by the most celebrated artist-poet of the Sung dynasty (960–1279), Su Shih 蘇軾 (1036–1101), better known as Su Tung-p'o 蘇東坡. It records the poet's trip to Mount Hui 惠山 in Wu-hsi 無錫, where he made tea using water from a local spring. The title of the poem is *On Mount Hui Visiting Ch'ien Tao-jen, Brewing a Small Pressed Tea [Cake] with Coiled-Dragon Imprint and Climbing to the Top to Look at Lake T'ai* (惠山謁錢道人烹小龍團登絕頂望太湖). The poem can be found in *Su-wen-chung-kung shih-pien-chu chi-ch'eng* 蘇文忠公詩編注集成 (The Complete Compilation of Su Shih's Poetry with Commentary and Explanation), 1st

   edition dated 1819, *chüan* 卷 (chapter) 11, reprint, vol. 4 (Taipei: Student Press, 1967), p. 7a (or new page no. 2027).

4    The *chiang-nan* region indicates the area along the lower Yangtze River delta and includes the important cultural centers of Nanking, Yangchou, Suchou, Shanghai, and Hangchou.

5    The "small full moon" in Su Shih's poem denotes the "Small Dragon-Coil" tea cake he brought with him to Mount Hui. In ancient times, tea leaves were steamed, baked, and ground into a fine powder, which was then pressed into a cake. Each of the cakes was wrapped separately, and a silver ring was fitted around it to keep it protected. Su Shih used the term "a small full moon" to represent the pale color of his tea cake because, during the Sung dynasty, the most desirable tea was a milky white, due to the fact that it was made from young tea leaves containing low levels of chlorophyll. For more on the white tea cakes of the Sung dynasty, see Hsiung Fan 熊蕃 (active c. 12th century), *Hsüan-ho pei-yüan kung-ch'a lu* 宣和北苑貢茶錄 (A Record of the Imperial Tea from the North Garden during the Hsüan-ho Period, 1119–1125), reprinted in *Wu-ch'ao hsiao-shuo ta-kuan* 五朝小説大觀 (The Grand Spectacle of Notes and Novels of the Previous Five Dynasties), vol. 29 (Shanghai: Sao-yeh Shan-fang, 1937), pp. 362b–367a. See also Marshall P. S. Wu, "Black-glazed Jian Ware and Tea Drinking in the Song Dynasty," in *Orientations* 29.4 (Hong Kong: Orientations Magazine, April 1998), pp. 22–31. The nomenclature "a full moon" is derived from another literary source. The great tea master of the T'ang period, Lu T'ung 盧仝 (?–835), once composed a poem entitled *Tsou-pi hsieh Meng chien-i chi hsin-ch'a* 走筆謝孟諫議寄新茶 (Picking Up My Brush to Compose a Poem Thanking the Imperial Counselor Meng for Sending Me New Tea). It contains a line, "Shou-yüeh yüeh-t'uan san-pei-p'ien 手閱月團三百片" (My hands have examined 300 "full moon" tea cakes), which uses the "full moon" to refer to the white tea cakes his friend Censor Meng sent to him. Lu T'ung's poem may be found in *Quan Tangshi* (*Ch'üan T'ang-shih*) 全唐詩 (The Complete Collection of T'ang Poetry), *juan* (*chüan*) 卷 (chapter) 388, reprint, vol. 12 (Beijing: Zhonghua Shuju, 1985), p. 4379.

6    Chang Yu-hsin 張又新 (active first half of 9th century), a tea master of the T'ang dynasty (618–905), tested the water from different sources and graded each according to taste and quality. The premier sample was from a spring that flowed on

Mount Chin 金山, located on a small island on the Yangtze River. The second-ranked sample was from the spring at Mount Hui in Wu-hsi, which is the spring mentioned in this poem. See Chang Yu-hsin, *Chien-ch'a-shui ji* 煎茶水記 (A Record of Water for Brewing Tea) reprinted in *Wu-ch'ao hsiao-shuo ta-kuan* 五朝小說大觀 (The Grand Spectacle of Notes and Novels of the Previous Five Dynasties), vol. 17, pp. 279a–280a.

7  The "Nine-Dragon Mountain" is another name for the famous Mount Hui in Wu-hsi. The "nine dragons" indicate the mountain's winding terrain. It is a name often used by artists and scholars. For example, Wang Fu 王紱 (1362–1416), a well-known painter from Wu-hsi, called himself Chiu-lung shan-jen 九龍山人, or "Dweller of the Nine-Dragon Mountain."

8  The Five Lakes is another name for Lake Tai 太湖, the large lake near Suchou and Wu-hsi. See *Tz'u-hai* 辭海 (Sea of Terminology, Chinese Language Dictionary), vol. 1 (Taipei: Chung-hua Press, 1974), p. 144, s.v. "Wu-hu 五湖."

9  Sun Teng 孫登 was a well-known historical figure of the Wei dynasty (220–64). It is said that he lived in a grotto at Mt. Hui without any family members. He was a musician and philosopher who studied the *I-ching* 易經, or *The Book of Changes*. When an envoy sent by the emperor visited him, he would not utter a response. A brilliant eccentric scholar, Juan Chi 阮籍 (210–63), stayed with him for three years, attempting to learn the secret of the Taoist arts of freeing the spirit and regulating the breath. Sun Teng remained silent. At the time of Juan's departure, Sun Teng finally said to him that although he was intelligent and educated, he nevertheless lacked necessary common sense. Sun warned Juan that this would result in future trials and tribulations. Juan uttered a long cry and departed. Halfway down the mountain, he heard a sound, like that of a phoenix, coming from Sun Teng and echoing in the valleys. As Sun Teng had predicted, the young student was subsequently executed by the ruler. Sun Teng's silence symbolized a wise and philosophical manner of addressing difficult issues. See the biography of Juan Chi in Fang Xuanling (Fang Hsüan-ling) 房玄齡 (578–648) et al., *Jinshu (Tsin-shu)* 晉書 (The Book of Tsin), 1st edition dated 648, *juan (chüan)* 卷 (chapter) 49, reprint, vol. 3 (Beijing: Zhonghua Shuchu, 1974), p. 1362. Sun Teng's biography may be found in the same volume, *chüan* 卷 (chapter) 94, p. 2426.

10  Ko Ying-tien, a scholar from Suchou, was active during the early 17th century. For his biography, see Yu Jianhua 于劍華 et al., *Zhongguo Meishujia Renming Cidian (Chung-kuo mei-shu-chia jen-ming tz'u-tien)* 中國美術家人名詞典 (A Biographical Dictionary of Chinese Artists) (Shanghai: Renmin Meishu Chubanshe, 1981), p. 1214.

11  Not only do most of Liu Yüan-ch'i 's paintings bear his seal, *Liu-shih Chen-chih* 劉氏振之 (Mr. Liu whose *tzu* is Chen-chih), but he was repeatedly addressed as Mr. Chen-chih by other scholars. See the colophons attached to his handscroll *Lanzhushi tu (Lan-chu-shih t'u)* 蘭竹石圖 (Orchid, Bamboo, and Rock), at the Shanghai Museum, reproduced in Group for the Authentication of Ancient Works of Chinese Painting and Calligraphy, eds., *Zhongguo gudai shuhua tumu (Chung-kuo ku-tai shu-hua t'u-mu)* 中國古代書畫圖目 (An Illustrated Catalogue of Selected Works of Ancient Chinese Painting and Calligraphy), vol. 4 (Shanghai: Wenwu Chubanshe, 1990), no. 滬 1-1759, p. 46.

12  Liu Yüan-ch'i's hanging scroll *Snowy Landscape* is reproduced in Palace Museum, *Mingdai wumen huihua (Ming-tai Wu-men hui-hua)* 明代吳門繪畫 (The Wumen Paintings of the Ming Dynasty) (Beijing: Palace Museum, 1990), no. 89, p. 181.

13  Liu Yüan-ch'i's hanging scroll *Sui-ch'ao feng-lo t'u* 歲朝豐樂圖 (A Joyful and Abundant New Year's Day), dated *jen-shen* 壬申 year (1632), is reproduced in *Ku-kung shu-hua t'u-lu* 故宮書畫圖錄 (An Illustrated Catalogue of Calligraphy and Painting at the Palace Museum), vol. 9 (Taipei: National Palace Museum, 1993), p. 169. Born in 1555, Liu would have been seventy-seven years old in 1632.

14  For the source indicating Liu studied painting from Ch'ien Ku, see Xu Qin (Hsü Ch'in) 徐沁 (active first half of 17th century), *Ming-hua lu* 明畫錄 (Painters of the Ming Dynasty), *chüan* 卷 (chapter) 4, reprinted in Yu Anlan 于安瀾, comp., *Huashi congshu (Hua-shih ts'ung-shu)* 畫史叢書 (Compendium of Painting History), vol. 5 (Shanghai: Renmin Meishu Chubanshe, 1962), p. 47.

15  The statement regarding the efforts of Liu Yüan-ch'i and Ch'en Huan is found in the last colophon on Liu Yüan-ch'i's handscroll *Lan-chu-shih t'u* 蘭竹石圖 (Orchid, Bamboo, and Rock), at the Shanghai Museum. See note 11 for information regarding a reproduction of Liu's scroll. For more information on Ch'en Huan, see entry 14.

16  The only book that provides any information on Liu Yüan-ch'i is *Ming-hua lu* 明畫錄 (Painters of the Ming Dynasty), *chüan* 卷 (chapter) 4, p. 47. See note 11 for information regarding a reproduction of the colophons attached to Liu's *Orchid, Bamboo, and Rock* handscroll at the Shanghai Museum. There are a total of five colophons by five scholars, including: Hsü Shu-p'i 徐樹丕 (active early 17th century); Wen Jan 文柟 (1596–1667); Chin Chün-ming 金俊明 (1602–1675); and Ch'en Mai 陳邁 (active 17th century). The name of the last contributor is written in small script and cannot be positively identified from the reproduction.

17  Ch'in Chi's *tzu* was Yüan-yu 遠猷. The second character of his name was also written as 遊. A brief biography of Ch'in may be found in *Chung-kuo mei-shu-chia jen-ming tz'u-tien* 中國美術家人名詞典 (A Biographical Dictionary of Chinese Artists), p. 1083.

18  As prescribed by Confucian doctrine, Liu took good care of his widowed elder sister and prepared a proper funeral for her when she died.

19  Wen Cheng-ming was a strict Confucian, known for his inflexible attitude towards dissolute gatherings attended by courtesans. It is said that his friends often teased him for his uprightness. One day when he was young, his close friend Ch'ien T'ung-ai 錢同愛 (1475–1549) invited him to sail on the Stone Lake and hid a courtesan in the cabin. The woman emerged after the boat had sailed to the center of the lake. Wen asked to leave, but the host refused to sail back to the shore. In desperation, Wen Cheng-ming took off his shoes and threw his dirty sock on the head of Ch'ien T'ung-ai. Finally, he was allowed to leave. This episode is recorded in He Liangjun (Ho Liang-chün) 何良俊 (1506–73), *Siyouzhai congshuo (Ssu-yu chai ts'ung-shuo)* 四友齋叢說 (Collected Notes at Ho's Four-Friend Studio), preface dated 1569, *juan (chüan)* 卷 (chapter) 29, reprinted in *Yuan Ming shiliao biji congkan (Yüan-Ming shih-liao pi-chi ts'ung-k'an)* 元明史料筆記叢刊 (A Series of Literary Sketches on Historical Materials of the Yüan and Ming Dynasties) (Beijing: Zhonghua Shuju, 1959), p. 158.

20  According to the colophon by Ch'en Mai 陳邁 (active 17th century) on Liu's *Orchid, Bamboo, and Rock*, Liu Yüan-ch'i's two nephews were close friends of Ch'en's father, Ch'en Yüan-su 陳元素 (1526–?), a literati artist in Suchou. When Liu's nephews came to visit the Ch'en family, Liu Yüan-ch'i often came along and thus became friends with Ch'en Yüan-su. Their

Liu Yüan-ch'i 劉原起
**Sailing under the Moonlight**
*continued*

62 relationship is attested by two collaborative handscrolls recorded in P'ang Yüan-chi 龐元濟 (1864–1949), *Hsü-chai ming-hua lu* 虛齋名畫錄 (A Catalogue of Paintings in the Collection of the Author's Studio of Humility), *chüan* 卷 (chapter) 8 (Shanghai, 1909), pp. 60a–61b; and also in P'ang's *Hsü-chai ming-hua lu pu-i* 虛齋名畫補遺 (A Catalogue of Paintings in the Collection of the Author, supplement) (Shanghai, 1924 and addendum, 1925), pp. 2a–3a. According to Osvald Sirén, *Chinese Painting*, vol. 7 (New York and London: Ronald Press, 1956), p. 213, the former handscroll is now at the Palace Museum, Beijing.

21 The upper part of the pagoda seen in this painting also appears in other Liu Yüan-ch'i paintings, including his hanging scroll *Huqiu guizhuo tu* (*Hu-ch'iu kuei-chao t'u*) 虎丘歸棹圖 (Returning Boat at the Tiger Hill), at the Palace Museum, Beijing, reproduced in *Ming-tai Wu-men hui-hua* 明代吳門繪畫 (The Wumen Paintings of the Ming Dynasty), no. 88, p. 180. The pagoda also appears in the hanging scrolls by Liu entitled *Ling-yen chi-hsüeh* 靈巖積雪 (Accumulated Snow at the Ling-yen Hills) and *Hsüeh-ching* 雪景 (The Snow Scene), also known as *Han-han Spring* 憨憨泉 both at the National Palace Museum, Taipei. See *Ku-kung shu-hua t'u-lu* 故宮書畫圖錄 (An Illustrated Catalogue of Calligraphy and Painting at the Palace Museum), vol. 9, pp. 165 and 167. The pagoda again appears in his *Chengguan zouyu* (*Ch'eng-kuan tsou-yü*) 城關驟雨 (A City Gate in a Sudden Shower) at the Guangzhou (Canton) 廣州 Museum. See Mayching Kao 高美慶 et al., *Paintings of the Ming and Qing Dynasties from the Guangzhou Art Gallery* (Hong Kong: Chinese University of Hong Kong, 1986), no. 17, pp. 94–95. Even today in Suchou, the pagoda can still be seen on top of Tiger Hill. For more information on Tiger Hill, see "Shen Chou and the Ming," in Richard Edwards, *The World around the Chinese Artist: Aspects of Realism in Chinese Painting* (Ann Arbor: University of Michigan, 1987), pp. 82–86, and also the map of Suchou and its surroundings on p. 63.

22 For an example of trees in Ch'ien Ku's work, see his *Huqiu qianshan tu* (*Hu-ch'iu ch'ien-shan t'u*) 虎丘前山圖 (The View of the Mountain in Front of Tiger Hill), at the Palace Museum, Beijing, reproduced in *Ming-tai Wu-men hui-hua* 明代吳門繪畫 (The Wumen Paintings of the Ming Dynasty), no. 60, p. 119.

23 See note 2.

24 The T'ung-lu River 桐廬江 mentioned in Meng Hao-jan's poem is another name for the better-known Fu-ch'un River 富春江, where Huang Kung-wang 黃公望 (1269–1354), the great master of the Yüan dynasty (1280–1368), painted his famous handscroll, *Fu-ch'un shan-chü t'u-chüan* 富春山居圖卷 (Dwelling in the Fu-ch'un Mountains Handscroll). It was so called because the city of T'ung-lu is located on the north bank of the river. For Huang Kung-wang's famous handscroll, see Wen C. Fong and James C. Y. Watt, *Possessing the Past: Treasures from the National Palace Museum, Taipei* (New York: Metropolitan Museum of Art, and Taipei: National Palace Museum, 1996), pl. 151, pp. 300–301.

25 The term "western shore of the sea" in Meng's poem apparently refers to Kuang-ling, the ancient name for Yangchou, a city located near the coastline and connected to the sea by the Yangtze River. For many centuries, Yangchou served as the embarkation point for sea voyages to Korea and Japan. For example, the famous Buddhist priest Chien-chen 鑑真 (Ganjin in Japanese, active mid-8th century) sailed to Japan from Yangchou during the T'ang dynasty (618–905).

26 In Chinese, the quote is: "*Shih-shih wu-hsing-hua, hua-shih yu-hsing-shih* 詩是無形畫，畫是有形詩." See Kuo Hsi, *Lin-chüan kao-chih* 林泉高致 (Lofty Ambition in Forests and Streams), Kuo Ssu 郭思 (*chin-shih* degree in 1082), comp., preface dated 1117, chapter "Huayi" (Hua-i) 畫意 (The Conception of Painting), reprinted in Yu Anlan 于安瀾, comp., *Hualun congkan* (*Hua-lun ts'ung-k'an*) 畫論叢刊 (Collected Writings on Painting Theories), vol. 1 (Beijing: Renmin Meishu Chubanshe), p. 24. For a translation of Kuo Hsi's whole essay in English, see Shio Sakanishi, trans., *An Essay on Landscape Painting* (London: John Murray, 1949).

27 For the reproductions of Liu's paintings at the National Palace Museum, see *Ku-kung shu-hua t'u-lu* 故宮書畫圖錄 (An Illustrated Catalogue of Calligraphy and Painting at the Palace Museum), vol. 9, pp. 165, 167, 169, 171, and 173.

28 Liu's painting at the Nanjing Museum is reproduced in *Chung-kuo ku-tai shu-hua t'u-mu* 中國古代書畫圖目 (An Illustrated Catalogue of Selected Works of Ancient Chinese Painting and Calligraphy), vol. 7, no. 蘇 24-0299, p. 88,

29 See note 3 for information on Ko.

30 See the last colophon on Liu Yüan-ch'i's handscroll, *Lanzhushi tu* (*Lan-chu-shih t'u*) 蘭竹石圖 (Orchid, Bamboo, and Rock) at the Shanghai Museum. See note 11 for information regarding a reproduction of Liu's scroll.

31 For information on Su Shih, see Lin Yü-t'ang 林語堂 (1895–1976), *The Gay Genius: The Life and Times of Su Tung-p'o* (New York: J. Day Co., 1947).

32 See note 1.

33 See *Ming-hua lu* 明畫錄 (Painters of the Ming Dynasty), *chüan* 卷 (chapter) 4, p. 47.

34 Ibid. For an example of Chang Fu's work executed in the Ma-Hsia style, consider his *Xuge shensong tu* (*Hsü-ko shen-sung t'u*) 虛閣深松圖 (A Vacant Pavilion amidst the Deep Pine Forest), at the Palace Museum, Beijing. It is reproduced in *Ming-tai Wu-men hui-hua* 明代吳門繪畫 (The Wumen Paintings of the Ming Dynasty), no. 80, p. 165.

35 For Hou Mao-kung's work in the Yüan style, see his hanging scroll *Fang Yüan-jen pi-i* 倣元人筆意 (Landscape in the Yüan Style), at the National Palace Museum, Taipei. It is reproduced in *Ku-kung shu-hua t'u-lu* 故宮書畫圖錄 (An Illustrated Catalogue of Calligraphy and Painting at the Palace Museum), vol. 8, p. 123.

36 The Hua-t'ing 華亭 school, the Nanking school, the Four Wangs, and the Anhui school were but a few of the new painting movements that sprang up during the seventeenth century.

## 24. Cha Chi-tso 查繼佐
*(1601–76)*
*Ch'ing dynasty (1644–1911)*

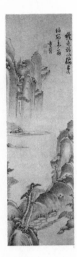

### Conversing Midway up the Mountain in Late Autumn
*Ch'iu-lao hua shan-yao t'u*
*(A Picture of Conversing Midway up the Mountain in Late Autumn)*

秋老話山腰圖

1  The character of Cha Chi-tso's family name, 查, is commonly pronounced "ch'a." According to Chinese tradition, whenever it is used as a family name, "cha" is the correct pronunciation.

2  A chronological biography of Cha Chi-tso was published along with other related materials concerning his life in Shen Qi (Shen Ch'i) 沈起 (active 1660–76), *Zha Dongshan xiansheng nianpu* (*Cha Tung-shan hsien-sheng nien-p'u*) 查東山先生年譜 (The Chronological Biography of Cha Tung-shan [Chi-tso]) (Beijing: Zhonghua Press, 1992). The book also includes biographical information on another Ch'ing dynasty scholar, Cha Shen-hsing 查慎行 (1650–1727). Although these two scholars shared the family name 查, or Cha, they were not related.

3  Po-an (a peaceful elder) is a *tzu* of Chou Liang-kung 周亮工 (1612–72). It is rarely mentioned in early sources. Chou used this name in one of his seals stamped at the end of his colophon on a painting by Wang Hui 王翬 (1632–1717). The seal reads: *Po-an shih Chou Liang-kung ssu-yin* 伯安氏周亮工私印, or "A private seal of Chou Liang-kung, whose *tzu* is Po-an." See Shanghai Museum, *Zhongguo shuhua-jia yinjian kuanshi* (*Chung-kuo shu-hua-chia yin-chien k'uan-shih*) 中國書畫家印鑒款識 (Signatures and Seals of Chinese Painters and Calligraphers), vol. 1 (Shanghai: Wenwu Chubanshe, 1987), seal no. 16, p. 606.

4  All of this information on Cha Chi-tso's life is drawn from Shen Ch'i, *Cha Tung-shan hsien-sheng nien-p'u* 查東山先生年譜 (The Chronological Biography of Cha Chi-tso). See note 2.

5  The character *chih* 支 in Cha Chi-tso's second *tzu*, Chih-san, means a descendant or heir. For example, the Chinese term *chih-tzu* 支子 simply signifies "younger sons." As a matter of fact, all younger sons and sons of concubines were referred to as *chih-tzu* in ancient China. This term is often used to distinguish such offspring from the *tsung-tzu* 宗子, or the eldest son of the formal wife. See *Hanyu dacidian* (*Han-yü ta-tz'u-tien*) 漢語大詞典 (Chinese Terminology Dictionary), vol. 4 (Shanghai: Hanyu Dacidian Press, 1988), p. 1374, s.v. "zhizi (chih-tzu) 支子."

6  See *Cha Tung-shan hsien-sheng nien-p'u* 查東山先生年譜 (The Chronological Biography of Cha Tung-shan [Chi-tso]), p. 16.

7  See *Cha Tung-shan hsien-sheng nien-p'u* 查東山先生年譜 (The Chronological Biography of Cha Tung-shan [Chi-tso]), p. 32. According to this biography, although Cha was married in 1619 at age eighteen and had two concubines, he had intimate relations with all these musicians and actresses. This entry also records the names of these women, their skills, and their talents. One episode describes a specific account that purposefully emphasizes the romantic and passionate side of this accomplished scholar. It states that a thirteen-year-old dancer in the troupe experienced her first night with Cha. Afterward, the other women in the troupe teased her so severely that she stayed in bed behind the curtain all day.

8  For more information on theatrical and dancing groups owned by scholars, see Chun-shu Chang, *Crisis and Transformation in Seventeenth-Century China: Society, Culture, and Modernity in Li Yu's World* (Ann Arbor: University of Michigan Press, 1992).

9  For a biography of Chou Liang-kung, see Arthur W. Hummel, ed., *Eminent Chinese of the Ch'ing Period (1644–1912)*, vol. 1 (Washington, D.C.: United States Government Printing Office, 1943–44), pp. 173–74. One famous painter patronized by Chou Liang-kung was Ch'en Hung-shou 陳洪綬 (1598–1652). Ch'en's painting completed for Chou, entitled *The Story of T'ao Yüan-ming*, is now at the Honolulu Academy of Arts. See reproduction in Suzuki Kei 鈴木 敬, comp., *Comprehensive Illustrated Catalog of Chinese Paintings*, vol. 1 (Tokyo: University of Tokyo Press, 1982), no. A38-001, pp. 388–89. For

a detailed examination of Chou Liang-kung's career, see Hongnam Kim, *The Life of a Patron: Zhou Lianggong (1612–1672) and the Painters of Seventeenth-Century China* (New York: China Institute in America, 1996). For Chou's involvement in Cha's case, see Shen Ch'i, *Cha Tung-shan hsien-sheng nien-p'u* 查東山先生年譜 (The Chronological Biography of Cha Chi-tso), p. 44.

10  For the biography of general Wu Liu-ch'i, see *Eminent Chinese of the Ch'ing Period (1644–1912)*, vol. 1, p. 18.

11  See *Cha Tung-shan hsien-sheng nien-p'u* 查東山先生年譜 (The Chronological Biography of Cha Tung-shan [Chi-tso]), p. 52.

12  For more on Chuang T'ing-lung, see *Eminent Chinese of the Ch'ing Period (1644–1912)*, vol. 1, pp. 205–6. This tragic case is also recorded in Weng Kuang-p'ing 翁廣平 (1760–1842), "Shu Huzhou Zhuangshi shiyu (Shu Hu-chou Chuang-shih shih-yü) 書湖州莊氏史獄" (The History of the Legal Case against the Chuang Family from Hu-chou), in Shen Ch'i, *Cha Tung-shan hsien-sheng nien-p'u* 查東山先生年譜 (The Chronological Biography of Cha Chi-tso), pp. 152–58.

13  An old fictional account that merges some biographical information on Cha Chi-tso and Wu Liu-ch'i states that it was this general, Wu Liu-ch'i of Canton, who saved Cha Chi-tso from the trial. The story recounts how before Cha Chi-tso went to Canton, he found Wu as a young beggar on a snowy day by West Lake in Hangchou and rescued him from poverty. When Wu later became a general and discovered Cha was in trouble, he used his new power and influence to rescue his benefactor. This story of Cha Chi-tso and Wu Liu-ch'i is recorded in Niu Hsiu 紐琇 (active late 17th to early 18th century), *Hui-t'u ku-sheng cheng-hsü-pien* 繪圖觚賸 正續編 (Illustrated Random Notes Left in a *Ku* Cup, and its Sequel [Anecdotes of the Late Ming to Early Ch'ing Period]), preface dated 1702, *chüan* 卷 (chapter) 7, pp. 2a–4a, reprint (Taipei: Kuang-wen Press, 1969), pp. 174–77, s.v. "Hsüeh-kou 雪遘" (The Rendezvous on a Snowy Day). In reality, however, the families of Cha and his two friends, numbering more than three hundred, were saved by the provincial commissioner of education of Chekiang. See *Eminent Chinese of the Ch'ing Period (1644–1912)*, vol. 1, pp. 18–19.

14  For Cha Chi-tso's accomplishments as a teacher and writer, see the editor's comments on p. 3 of Shen Ch'i, *Cha Tung-shan hsien-sheng nien-p'u* 查東山先生年

**Cha Chi-tso** 查繼佐
**Conversing Midway up the Mountain
in Late Autumn**
*continued*

64 譜 (The Chronological Biography of Cha Chi-tso). This document claims that Cha published about twenty-three articles and books and that his students, numbering close to a thousand, were located in several provinces.

15 See ibid., p. 4. Shen Ch'i was Cha Chi-tso's most loyal student. Beginning in 1637, he followed Cha for almost forty years and was familiar with his teacher's life. Cha Chi-tso's second biography was compiled by two other students, Liu Chen-lin 劉振麟 and Chou Hsiang 周驤 (both active mid-17th century). This second biography was edited by Cha's seventy-two students in Canton.

16 For a discussion of this dry-brush technique's popularity during the seventeenth century, see Fu Shen 傅申, "An Aspect of Mid-Seventeenth Century Chinese Painting: The 'Dry Linear' Style and the Early Work of Taochi," *Journal of the Institute of Chinese Studies of the Chinese University of Hong Kong*, no. 8 (Hong Kong: Chinese University of Hong Kong, December 1976).

17 Although Cha's technique displays neither the light sources nor the play of light across object surfaces commonly associated with Western drawings, his dry and coarse linear work in ink does resemble Western charcoal drawings. Furthermore, Cha's rubbing technique applied on rocks is also comparable to the shading effect found in drawing. On the other hand, Cha's rocks, which are defined with straight, even lines, are similar to those reproduced by woodblock. During the seventeenth century, woodblock-printed painting manuals became prevalent. Although Wang Kai's 王概 (active second half of 17th century) famous painting manual, *Chieh-tzu Yüan hua-chuan* 芥子園畫傳 (The Record of Painting at the Mustard Seed Garden), which is also known as *Chieh-tzu Yüan hua-p'u* 芥子園畫譜 (The Painting Manual at the Mustard Seed Garden), was published in 1679, shortly after Cha's death in 1676, there were many other sources that could have influenced Cha, including the elaborate illustrations found in late Ming novels and reproduced works of contemporary painters. Among these, perhaps the best-known is the set of Hsiao Yün-ts'ung's 蕭雲從 (1596–1674) album leaves entitled *T'ai-p'ing shan-shui shih-hua ts'e* 太平山水詩畫冊 (Landscapes of and Poems of the T'ai-p'ing Area), 1st edition dated c. 1650, reprint, 2 vols. (Osaka: n.p., 1931). For more woodblock-printed landscapes of Cha's time, see also "Topography and the Anhui School, " in James Cahill, ed., *Shadows of Mt. Huang, Chinese Painting and Printing of the Anhui School* (Berkeley: University Art Museum, 1981), pp. 43–53.

18 See note 8.

19 See Chou Liang-kung's *Duhualu* (*Tu-hua-lu*) 讀畫錄 (A Record of Examined Paintings), preface dated 1673, reprinted in Yu Anlan 于安瀾, comp., *Huashi congshu* (*Hua-shih ts'ung-shu*) 畫史叢書 (Compendium of Painting History), vol. 9 (Shanghai: Renmin Meishu Chubanshe, 1962).

20 Instead of stressing the importance of elaborate details and attractive compositions, Cha's work is based on his calligraphic training and an aesthetic philosophy that was also favored by Tung Ch'i-ch'ang. With eccentric forms and simplistic execution, Cha followed the example of Tung, whose work was impressionistic and semi-abstract. For a comparison, see Tung's works entitled *Landscape* (Nanjing Museum) and *Misty River and Piled Peaks* (National Palace Museum, Taipei). These two handscrolls are reproduced in Wai-kam Ho 何惠鑑, ed., *The Century of Tung Ch'i-ch'ang 1555–1636*, vol. 1 (Kansas: Nelson-Atkins Museum of Art, 1992), figs. 25 and 26, pp. 58–59.

21 For comparison, see trees in Kung Hsien's work entitled *Jianbi shanshui* (*Chien-pi shan-shui*) 簡筆山水 (A Landscape Executed with Simplified Brush Strokes), reproduced in Yang Han 楊涵 et al., eds., *Zhongguo meishu quanji* (*Chung-kuo mei-shu ch'üan-chi*) 中國美術全集 (The Great Treasury of Chinese Fine Art), vol. 9 (Shanghai: Renmin Meishu Chubanshe, 1988), pl. 109. See also the trees in Kung Hsien's hanging scroll entitled *Guabi feiquan tuzhou* (*Kua-pi fei-chüan t'u-chou*) 掛壁飛泉圖軸 (The Overhanging Mountains and Cliff Side Springs on a Hanging Scroll) at the Tianjin Museum, reproduced in Tianjin Museum of Art, *Tianjin bowuyuan canghuaji* (*T'ien-tsin po-wu-yüan ts'ang-hua chi*) 天津博物院藏畫集 (Paintings in the Collection of the Tianjin Museum of Art), vol. 1, in the series *Zhongguo lidai huihua* (*Chung-kuo li-tai hui-hua*) 中國歷代繪畫 (Paintings of the Past Dynasties) (Tianjin: Tianjin Renmin Meishu Chubanshe), pp. 66–67.

22 Such "deliberate awkwardness" found in Chinese literati paintings is known as *sheng* 生, meaning "rawness" or "crudeness." For a discussion of this term in literati painting, see Xue Yongnian 薛永年, "Declining the Morning Blossom and Inspiring the Evening Bud: The Theory and Practice of Tung Ch'i-ch'ang's Calligraphy," a paper delivered at the International Symposium on Tung Ch'i-ch'ang, the Nelson-Atkins Museum of Art, Kansas City, April 17–19, 1992. Xue's paper is published in Wai-ching Ho et al., eds., *Proceedings of the Tung Ch'i ch'ang International Symposium* (Kansas City: Nelson-Atkins Museum of Art, 1991), no. 6, pp. 1–30.

## 25. Shao Mi 邵彌

*(c. 1595–1642)*

*Ch'ing dynasty (1644–1911)*

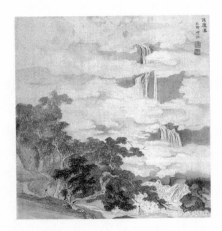

### The Waterfall at Mount Lu

*K'uang-lu kuan-p'u t'u*

*(Viewing the Waterfall at Mount K'uang-lu)*

匡廬觀瀑圖

1 A brief biography of Shao Mi can be found in Ellen J. Laing's entry on the artist in L. Carrington Goodrich and Fang Chaoying, eds., *Dictionary of Ming Biography*, vol. 2 (New York and London: Columbia University Press, 1976), pp. 1166–67. In this reference, Liang designates 1626 to 1660 as Shao Mi's most active period. Her essay is based on several short biographies of Shao Mi found in Chinese sources, including: 1) Xu Qin (Hsü Ch'in) 徐沁 (active first half of 17th century), *Minghualu (Ming-hua lu)* 明畫錄 (Painters of the Ming Dynasty), *juan (chüan)* 卷 (chapter) 5, reprinted in Yu Anlan 于安瀾, ed., *Huashi congshu (Hua-shih ts'ung-shu)* 畫史叢書 (Compendium of Painting History), vol. 5 (Shanghai: Renmin Meishu Chubanshe, 1962), p. 68; 2) Zhou Lianggong (Chou Liang-kung) 周亮工 (1612–72), *Duhualu (Tu-hua lu)* 讀畫錄 (A Record of Examined Paintings), *juan (chüan)* 卷 (chapter) 1, reprinted in *Hua-shi cong-shu* 畫史叢書 (Compendium of Painting History), vol. 9, pp. 13–14; 3) Zhang Geng (Chang Keng) 張庚 (1685–1760), *Guochao huazhenglu (Kuo-ch'ao hua-cheng lu)* 國朝畫徵錄 (Biographical Sketches of the Artists of the Ch'ing Dynasty), preface dated 1739, *juan (chüan)* 卷 (chapter) 1, reprinted in *Hua-shi ts'ung-shu* 畫史叢書 (Compendium of Painting History), vol. 5, p. 7; and 4) Qin Zuyong (Ch'in Tsu-yung) 秦祖永 (1825–84), *Tongyin lunhua (T'ung-yin lun-hua)* 桐陰論畫 (Discussing Paintings under the *Wu-t'ung* Tree), preface dated 1864, *juan (chüan)* 卷 (chapter) 1, reprinted in *Yilin mingzhu congkan (I-lin ming-chu ts'ung-k'an)* 藝林名著叢刊 (Collected

Famous Writings on Art Series) (Beijing: Zhongguo Shudian, 1983), p. 9. In addition, Xu Bangda 徐邦達, at the Palace Museum, Beijing, updated the information concerning Shao Mi's life in his article, "Shao Mi shengzu niansui kaoding (Shao Mi sheng-tsu nien-sui k'ao-ting) 邵彌生卒年歲考訂" (Revision of Shao Mi's Birth and Death Dates), included in his *Lidai shuhuajia zhuanji kaobian (Li-tai shu-hua chia chuan-chi k'ao-pien)* 歷代書畫家傳記考辯 (A Verification of Biographies of Past Calligraphers and Painters) (Shanghai: Renmin Meishu Chubanshe, 1984), pp. 47–49. In order to establish the dates of the artist's birth and death, Xu used dates in colophons that appear on a short handscroll by Shao Mi, *Shese shanshui xiaojuan (She-se shan-shui hsiao-chüan)* 設色山水小卷 (Landscape in Color on a Short Handscroll), now at the Palace Museum in Beijing. According to Xu, Shao was born in either 1592 or 1593 and died sometime before 1642. Shao Mi's birth and death dates were also discussed by Zheng Wei 鄭威 of the Shanghai Museum. See Zheng Wei's "Shao Mi de mingzi ji shengzu nian kao (Shao Mi teh ming-tzu chi sheng-tsu nien k'ao) 邵彌的名字及生卒年考" (A Study of Shao Mi's Names, Birth and Death Dates) in *Duoyun (To-yün)* 朵雲 (Cloud Art Journal) 8 (Shanghai: Meishu Chubanshe, December 1985), pp. 175–76. Zheng Wei used the same short handscroll by Shao Mi in Xu's article as his principal source of evidence but claimed that Shao Mi was born around 1593 and died in 1641.

2 The original title of this album leaf is *The Waterfall at Mount K'uang-lu*. Mount K'uang Lu 匡廬 can be translated either as Mount K'uang 匡 or Mount Lu 廬, although its original name was Mount Lu. According to legend, there was once a hermit named K'uang Su 匡俗 who lived in a hut *(lu* 廬 in Chinese) on this mountain. Thus people often used his name, K'uang 匡, to refer to the mountain. On the other hand, the name of Mount Lu must refer to this hermit's hut. See *Tz'u-hai* 辭海 (Sea of Terminology: Chinese Language Dictionary), vol. 1 (Taipei: Chung-hua Press, 1974), p. 1068, s.v. "Lu-shan 廬山." See also Anne Burkus-Chasson, "'Clouds and Mists that Emanate and Sink Away': Shitao's *Waterfall on Mount Lu* and Practices of Observation in the Seventeenth Century," *Art History* 19.2 (June 1996), pp. 169–90.

3 Although *ts'ao-hsüan* literally means "grass and abstruseness," the term, deriving from a historical episode of the Han dynasty (206 B.C.–A.D. 220), came to signify the state of being indifferent to

wealth and fame. The episode involved a scholar whose name was Yang Hsiung 楊雄 (53 B.C.–A.D. 18). Yang lived during a period of time when the Emperor Ai-ti 哀帝 (r. 6–1 B.C.) was under the influence of a notorious prime minister named Tung Hsien 董賢 (23 B.C.–1 A.D.). Any official who wanted to be promoted in the government had to submit to Tung. Yang Hsiung, placing his morals above his desire for promotion, distanced himself from Tung's clique and composed an article entitled *Ts'ao-hsüan*. Later people borrowed this title as a term indicating indifference to wealth and fame.

4 The calligraphy on this album leaf is executed in small seal script on sprinkled gold paper. The seal script was the official script of the Chou 周 dynasty (c. 1122–255 B.C.). The calligraphy is the transcription of a poem composed by Li Po 李白 (699–762), the most celebrated poet of the T'ang dynasty (618–905). The name of the Five-elder Peaks, the subject of the poem, was derived from the shapes of an assembly of five mountain peaks that resemble a group of five old men. The Five-elder Peaks is one of the most famous scenic locations on Mount Lu; from this vantage point, one may enjoy a most magnificent view of the sunrise. The second line of the poem, "Resemble golden hibiscus carved from the heavenly blue sky," is especially composed to indicate the five peaks basking under the golden rays of the rising sun. It is also common for climbers atop the Five-elder Peaks to look down at the lakes below. Thus the third line of the poem mentions that this location provides a panoramic vista of the Chiu-chiang 九江, or the "nine-river" area.

5 In Chinese, *ch'ing-t'ien* 青天, or "blue sky," refers to Heaven or Mother Earth. The third character 芄 of the second line is one of the old forms of the modern character *t'ien* 天, which means "sky" or "heaven." It is recorded that in 1446, the eleventh year of Emperor Cheng-t'ung 正統 (r. 1436–49) during the Ming dynasty, all the candidates for the governmental examination of the *chin-shi* 進士 degree were told to write the character *t'ien* 天 in this form. See *Hanyu dacidian (Han-yü ta-tz'u-tien)* 漢語大詞典 (Chinese Terminology Dictionary), vol. 9 (Shanghai: Hanyu Dacidian Press, 1988), p. 378.

6 Chiu-chiang 九江, which literally means "the nine rivers," refers to the region surrounding the city of Chiu-chiang, located in northern Kiangsi province. In ancient times, this area was called Hsün 潯. Chiu-chiang is situated on the south bank of the Yangtze River and the famous Mount Lu is positioned on the city's south side.

Shao Mi 邵彌
The Waterfall at Mount Lu
*continued*

66 See *Zhongguo diming cidian* (*Chung-kuo ti-ming tz'u-tien*) 中國地名詞典 (A Dictionary of Names of Places in China) (Shanghai: Shanghai Cishu Chubanshe, 1990), p.13.

7 This line is unrelated to the preceding poem. It was probably the title of a following poem, the rest of which has been separated from this leaf. The Censer Peak derived its name from its shape, which resembles that of an incense burner. Moreover, the mists and clouds that usually surround the peaks look like the smoke from burning incense. There are four peaks at Mount Lu referred to as censer peaks. The one in the south, called South Censer Peak, contains the famous waterfall Mount Lu, which is depicted in Shao Mi's painting. Nevertheless, the title inscribed by the artist emphasizes the famous waterfall, not the South Censer Peak, while the poem is on the Five-elder Peaks. Thus this title, the poem, and the painting do not focus on exactly the same subject matter.

8 The information on Shao Mi's names is based on Zheng Wei's 鄭威, "Shao Mi teh ming-tzu chi sheng-tsu-nien k'ao 邵彌的名字及生卒年考" (Research on Shao Mi's Names, Birth and Death Dates), p. 175.

9 Shao Mi's other *hao* include Kuan-yüan sou 灌園叟 (an old man who waters his garden); Ch'ang-chai 長齋 (Elongated Studio); Mi-yüan 彌遠 (remote and eternal); and Ch'ing-men yin-jen 青門隱人 (a hermit inside a blue gate). See Chinese Painting and Calligraphy Research Association, *Chung-kuo li-tai shu-hua chuan-k'o-chia tzu-hao suo-yin* 中國歷代書畫篆刻家字號索引 (Index of the Names of the Painters, Calligraphers, and Seal-carvers of the Past Dynasties), vol. 2 (Hong Kong: Pacific Press, 1974), p. 386. The "blue gate" in "a hermit inside a blue gate" refers to the southeast city gate of Ch'ang-an 長安 during the Han dynasty (206 B.C.–A.D. 220). Its name derived from the color of the gate. This area was famous for its delicious melons, cultivated by a famous hermit named Chao-p'ing 召平. In Chinese literature, the blue gate also symbolizes a hermit. Thus all of Shao Mi's *haos* are related and emphasize escapism. See *Han-yü ta-tz'u-tien* 漢語大詞典 (Chinese Terminology Dictionary), vol. 11, pp. 528–29, s.v. "qingmen (ch'ing-men) 青門" and related idioms.

10 The Chinese character *mi* 彌, although literally meaning "full or overflowing," is often used in Chinese for translating the Buddhist term *sha-mi* 沙彌, meaning "a young acolyte."

11 Information on Shao Mi's family is supported by colophons appearing on Shao Mi's *Liu-ching liu-t'i ts'e* 六景六題冊 (Six Album Leaves of Paintings and Inscriptions), recorded in Lu Shih-hua, 陸時化 (1714–79) *Wuyue suojian shuhualu* (*Wu-yüeh so-chien shu-hua lu*) 吳越所見書畫錄 (Paintings and Calligraphy Viewed in the Wu and Yüeh Regions), *juan* (*chüan*) 卷 (chapter) 5, reprinted in Lu Fusheng 盧輔聖 et al., comps., *Zhongguo shuhua quanshu* (*Chung-kuo shu-hua ch'üan-shu*) 中國書畫全書 (The Complete Collection of Books on Chinese Painting and Calligraphy), vol. 8 (Shanghai: Shanghai Shuhua Chubanshe, 1992), p. 1137. The name of Shao Mi's hometown, Lu-mu, literally means "Lu's tomb." It was derived from the local tomb site of a certain Mr. Lu, a high official of the T'ang dynasty (618–905).

12 See ibid. It seems that Shao Mi's father was not only a famous physician but was also considered a venerable elder in Suchou. The original text reads: "[Shao Mi's] father, Shao K'ang-ch'ü, was a physician who possessed the demeanor of a senior." (尊翁 [邵] 康衢先生業醫, 有長者風.)

13 See ibid. The text reads: "When [Shao Mi,] a lay Buddhist devotee, was in his early twenties, he gave up a civil service career due to a lung ailment" (居士 弱冠時, 以肺疾棄舉子業).

14 For more information on the Sungkiang group, see Wang Shiqing 汪世清, "Tung Ch'i-ch'ang teh chiao-yu 董其昌的交遊" (Tung Ch'i-ch'ang's Circle), in Wai-kam Ho 何惠鑑, ed., *The Century of Tung Ch'i-ch'ang, 1555–1636*, vol. 1 (Kansas: Nelson-Atkins Museum of Art, 1992), pp. 459–83.

15 For information on how Shao Mi was obsessed with cleanliness and order, see Wu Wei-yeh 吳偉業 (1609–71), *Wu Mei-ts'un shih-chi chien-chu* 吳梅村詩集箋注 (Wu Wei-yeh's Collated Poetry Anthology), preface dated 1814, collated by Wu I-feng 吳翌鳳, *chüan* 卷 (chapter) 6, reprinted (Shanghai: Kuo-hsüeh cheng-li-she, 1936), pp. 174–76. Wu's poem describing Shao Mi's odd habits is translated in note 19. Shao Mi's eccentricities are also referred to in Ch'in Tsu-yung's *T'ung-yin lun-hua* 桐陰論畫 (Discussing Paintings under the Wu-t'ung Tree), *chüan* 卷 (chapter) 1, p. 9, in a comment following the entry for Shao Mi. Printed in smaller-sized type, the text reads: "[Shao Mi] had a mild disposition. He was obsessed with cleanliness. His servants complained, while even his wife and children sometimes condemned such inclinations behind his back. However, he would not change his practice." (性舒緩, 有潔癖. 童僕患苦, 妻子竊罵. 終其身不為改.)

16 See Ch'in Tsu-yung's *T'ung-yin lun-hua* 桐陰論畫 (Discussing Paintings under the Wu-t'ung Tree), *chüan* 卷 (chapter) 1, p. 9. According to Ch'in, Shao Mi was unsociable and his disposition was proud and aloof. He used painting and calligraphy to amuse himself. In Ch'in's opinion Shao Mi was a true noble-scholar. (邵彌, 性情孤僻, 以書畫自娛, 蓋高士也!)

17 See ibid. The original text reads: "[Shao Mi] was born a handsome man." (生而韶秀.) According to the same source, Shao also collected paintings and calligraphy of ancient masters as well as those by his contemporary artists, old bronze vessels, and other precious curios. (購求古今名人書畫, 鼎彝珍物.)

18 See ibid. One of the colophons states, "[Shao Mi] was born with extreme intelligence and sharp sensitivity; he did not have to learn painting and calligraphy from a teacher. He was able to assimilate aspects from whatever work of art he viewed and skillfully create his own version. (然其天資敏妙, 法書繪染, 不煩師匠 過目則能愜心應手.)

19 The Nine Painter-Friends were originally grouped by Wu Wei-yeh, a famous scholar of the seventeenth century. A short biography of Wu is found in Arthur W. Hummel, ed., *Eminent Chinese of the Ch'ing Period (1644–1912)*, vol. 2 (Washington, D.C.: United States Government Printing Office, 1943–44), pp. 882–83. Wu Wei-yeh's poem, *Hua-chung chiu-yu ko* 畫中九友歌 (Song of the Nine Painter-Friends) is recorded in his *Wu Mei-ts'un shih-chi chien-chu* 吳梅村詩集箋注 (Wu Wei-yeh's Collated Poetry Anthology), *chüan* 卷 (chapter) 6, pp. 174–76. According to Wu, the Nine Painter-Friends were: 1) Tung Ch'i-ch'ang 董其昌 (1555–1636); 2) Ch'eng Chia-sui 程嘉燧 (1565–1643); 3) Li Liu-fang 李流芳 (1575–1629); 4) Pien Wen-yü 卞文瑜 (c. 1576–1654); 5) Wang Shih-min 王時敏 (1592–1680); 6) Wang Chien 王鑑 (1598–1677); 7) Yang Wen-ts'ung 楊文聰 (1597–1646); 8) Shao Mi 邵彌 (c. 1595–1642); and 9) Chang Hsüeh-ts'eng 張學曾 (fl. c. 1634–57). Wu composed a short poem on each of these nine artists. His poem dealing with Shao Mi says: "The refined and intellectual bearing of my Kuo-ch'ou [Shao Mi], now is gone. His obstinate habit of cleanliness made him unpopular. His servants spoke ill of him behind his back and his wife and children were embarrassed. His emaciated body was like that of a yellow snow-goose; but his demeanor was relaxed like a sea gull. Assiduously he drew ink lines and applied ink-washes without rest." (風流已矣吾瓜疇, 一生迂僶為人尤. 童僕竊罵妻孥愁, 瘦如

黃鵠閉如鷗. 煙驅墨染何曾休.) Wu Wei-yeh, a close friend, also composed Shao Mi's epitaph.

20 The portrait of Shao Mi is a joint work by Hsü T'ai and the famous painter Lan Ying 藍瑛 (1585–after 1664). For a biography of Hsü T'ai, see Yu Jianhua, 于劍華 et al., *Zhongguo meishujia renming cidian* (*Chung-kuo mei-shu-chia jen-ming tz'u-tien*) 中國美術家人名詞典 (Biographical Dictionary of Chinese Artists) (Shanghai: Renmin Meishu Chubanshe, 1981), p. 711. For a biography of Lan Ying and an example of his work, see entry 22. Hsü T'ai executed the figure, which is undated. The setting, executed by Lan Ying, is dated 1657, about fifteen years after Shao Mi died, around 1642. It is not clear whether Hsü T'ai executed this portrait during Shao Mi's lifetime or posthumously. In China, a portraitist can finish a work without background and wait for years until another painter completes it. Shao Mi's portrait is reproduced in François Fourcade, *Art Treasures of the Peking Museum* (translated from the French by Norbert Guterman) (New York: Harry N. Abrams, 1965), pl. 29, p. 79. Another portrait of Shao Mi, supposedly by Tseng Ching 曾鯨, is reproduced in Osvald Sirén, *Chinese Painting: Leading Masters and Principles*, vol. 6 (New York and London: Ronald Press, 1956), pl. 320.

21 It is also recorded that Shao Mi's elder son died soon after Shao Mi and that his younger son was left destitute. See Lu Shih-hua's *Wu-yüeh so-chien shu-hua lu* 吳越所見書畫錄 (Paintings and Calligraphy Viewed in the Wu and Yüeh Regions), *chüan* 卷 (chapter) 5. The Chinese text says "[Shao Mi's] elder son, Chang-yü 長豫, died soon [after Shao Mi passed away] and the younger son I-t'ang was orphaned and helpless. (令子長豫, 尋亦下世. 頤堂幼子, 零替靡依.)

22 The numerous poems on Mount Lu by poets of different periods have been compiled into one book, edited by Feng Zhaoping 馮兆平 and Hu Cao 胡操, entitled *Lushan lidai shixuan* (*Lu-shan li-tai shih-hsüan*) 廬山歷代詩選 (Selected Poems on Mount Lu by Poets of Past Dynasties) (Nanchang: Jiangxi Renmin Chubanshe, 1980). Li Po's poem on the Five-elder Peaks, which currently accompanies the Michigan album leaf by Shao Mi, is included in this book on p. 20.

23 For examples of paintings depicting the waterfall at Mount Lu, see the large hanging scroll, entitled *Lu-shan kao* 廬山高 (Lofty Mount Lu) by Shen Chou 沈周 (1427–1509), currently at the National

Palace Museum, Taipei. It is published in Wen C. Fong and James C. Y. Watt, *Possessing the Past: Treasures from the National Palace Museum, Taipei* (New York: Metropolitan Museum of Art, and Taipei: National Palace Museum, 1996), pl. 187, p. 373. A work by Tao-chi 道濟 (1642–1707) entitled *Lu-shan p'u-pu t'u* 廬山瀑布圖 (The Waterfall at Mount Lu), belonging to the Sumitomo 住友 Collection in Japan, is published in Richard Edwards, *The Painting of Tao-chi* (Ann Arbor: University of Michigan Museum of Art, 1967), pl. 22, p. 151.

24 For information on *Riverside* by Liu Yüan-ch'i, see entry 23. Traditionally, it has been a common practice to group album paintings of similar sizes by various painters into a set, regardless of the dates or subject matter of the paintings. For examples of this type of album leaf set, see the many recorded in *Ku-kung shu-hua lu* 故宮書畫錄, vol. 4 (Taipei: National Palace Museum, 1965), pp. 240–87. Groupings tend to be flexible, owing more to the whim of the dealer and owner than to any fixed rules.

25 See Ellen J. Laing, "*Riverside* by Liu Yüan-ch'i and *The Waterfall on Mt. K'uang-Lu* by Shao Mi," *University of Michigan Museum of Art Bulletin* 5 (Ann Arbor: University of Michigan Museum of Art, 1970–71), pp. 1–16.

26 The calligraphers of the Ming dynasty usually used earlier calligraphic examples written on paper or silk as models for learning calligraphy. Thus, their calligraphic strokes are flexible and modulated with pointed endings. Such a practice is called *t'ieh-hsüeh* 帖學 or "copybook study." After the seventeenth century in the Ch'ing dynasty (1644–1911), on the other hand, scholars emphasized the use of rubbings of calligraphic examples carved on ancient stone steles or cast on old bronze vessels for calligraphic models. As a result, their strokes are stiff and even, often with rounded endings. This practice is called *pei-hsüeh* 碑學 or "stele study." In addition, the seal scripts, originally found on bronzes of the Chou dynasty (c. 1122– 255 B.C.), became particularly popular among nineteenth-century calligraphers. The seal script on the accompanying leaf of Shao Mi's painting is precisely the type of seal script used extensively during this period.

27 It was a common practice to mount a set of square paintings into album leaves, each with a matching calligraphic work. For examples of this combination of painting and calligraphy, see Group for the

Authentication of Ancient Works of Chinese Painting and Calligraphy, ed., *Zhongguo gudai shuhua tumu* (*Chung-kuo ku-tai shu-hua t'u-mu*) 中國古代書畫圖目 (An Illustrated Catalogue of Selected Works of Ancient Chinese Painting and Calligraphy), vol. 4 (Shanghai: Wenwu Chubanshe, 1990), no. 滬 1-1720, p. 38.

28 Along the left edge of the poem there is also a small line indicating the title of the poem. It reads, "On the Right is [a poem of] the Censer Peak of Mount Lu." If this poem was indeed inscribed there for Shao Mi's work, the Censer Peaks is perhaps another name for the Five-elder Peaks.

29 For examples of paintings accompanied by poems written in seal script and followed by a title in a short line on the left, see Guo Cunren's (Kuo Ts'un-jen) 郭存仁 (active during the Wan-li reign [1573–1619]) *Jinling bajing tu* (*Chin-ling pa-ching t'u*) 金陵八景圖 (The Eight Views of Nanking) at the Nanking Museum. Kuo's work is reproduced in Group for the Authentication of Ancient Works of Chinese Painting and Calligraphy, ed., *Zhongguo gudai shuhua tumu* (*Chung-kuo ku-tai shu-hua t'u-mu*) 中國古代書畫圖目 (Illustrated Catalogue of Selected Works of Ancient Chinese Painting and Calligraphy), vol. 7, no. 蘇 24-0163, pp. 60–61.

30 The authenticity of Shao Mi's album leaf at Michigan is evidenced by the existence of a similar work by the artist, an album leaf belonging to a set of four leaves at the Shanghai Museum. Depicting the same subject matter, the Shanghai leaf shows almost identical rocks, trees, figure, clouds, and waterfall. Nevertheless, its composition is somewhat simpler. The album leaf in Shanghai is reproduced in Group for the Authentication of Ancient Works of Chinese Painting and Calligraphy, ed., *Zhongguo gudai shuhua tumu* (*Chung-kuo ku-tai shu-hua t'u-mu*) 中國古代書畫圖目 (Illustrated Catalogue of Selected Works of Ancient Chinese Painting and Calligraphy), vol. 4, no. 滬 1-1723, p. 41.

## 26. Sun I 孫逸
*(active mid-17th century)*
*Ch'ing dynasty (1644–1911)*

### The Cinnabar Peak
*Chu-sha feng t'u*
*(Picture of the Cinnabar Peak)*
硃砂峰圖

1 Chien-lu 簡廬 (The Thatched Hut of Simplicity) is the name of Professor and Mrs. Richard Edwards' art collection. Professor Edwards taught the history of Chinese art at the University of Michigan for twenty-five years.

2 For a discussion of the "boneless wash" technique, see note 54 of entry 4, Shen Chou's *Pine and Hibiscus*. The term *chiashu* 家數 in Wang Chi-chung's original writing, cited by Sun I, literally means "skill, manner, or style." See *Hanyu dacidian (Han-yü ta-tz'u-tien)* 漢語大詞典 (Chinese Terminology Dictionary), vol. 3 (Shanghai: Hanyu Dacidian Press, 1988), p. 1478, s.v. "*jiashu (chia-shu)* 家數."

3 Wang Chi-chung 王季重 is the *tzu* of Wang Ssu-jen 王思任 (1575–1646), a popular essayist of the Ming dynasty. The original passage cited in Sun I's inscription on *The Cinnabar Peak* is found in Wang's *Wang Chi-chung yu K'uang-Lu chi* 王季重游匡廬記 (The Record of Wang Ssu-jen's Travels to Mount Lu), published in his *Wang Chi-chung tsa-chu* 王季重雜著 (Miscellaneous Writings by Wang Chi-chung), reprint (Taipei: Wen-wen Tu-shu Press, 1977), p. 825. For Wang Ssu-jen's biography, see L. Carrington Goodrich and Fang Chaoying, eds., *Dictionary of Ming Biography, 1368–1644*, vol. 2 (New York and London: Columbia University Press, 1976), pp. 1120–25. It seems that Wang was also a painter and that there is a landscape attributed to him at the Shandong Provincial Museum. It is reproduced in Group for the Authentication of Ancient Works of Chinese Painting and Calligraphy, ed.,

*Zhongguo gudai shuhua tumu (Chung-kuo ku-tai shu-hua t'u-mu)* 中國古代書畫圖目 (An Illustrated Catalogue of Selected Works of Ancient Chinese Painting and Calligraphy), vol. 16 (Shanghai: Wenwu Chubanshe, 1990), no. 魯 1-084, p. 194.

4 T'ung Ch'i-ch'ang 董其昌 (1555–1636) was the most influential scholar-artist of the late Ming dynasty. In this colophon, he is referred to as Jung-t'ai 容臺, a name derived from his book, *Jung-t'ai chi* 容臺集 (Collected Writings from [T'ung's] Capacity of a Terrace Studio). A preface to the book was written by Ch'en Chi-ju 陳繼儒 (1558–1639) and dated 1630. See facsimile reprint (Taipei: National Central Library, 1968).

5 The Ch'ing-chüan mentioned in this colophon must have been the owner of this painting, probably during the 1940s. Unfortunately, details of his life are obscure. The "Chin-ch'eng" in the text is a literary name for the city of Ch'eng-tu 成都, in Szechwan 四川 province. This is the city where the Edwards lived and the author of this colophon, I Chung-lu, visited after World War II.

6 I Chung-lu 易忠籙 (1886–?), whose *tzu* was Chün-shih 均室, was from Ch'ien-kiang 潛江, Hupei 湖北 province. In addition to painting landscapes, he was a calligrapher and seal carver. He was also a close friend of the painter Huang Pin-hung 黃賓虹 (1865–1955). See Yu Jianhua 于劍華 et al., *Zhongguo meishujia renming cidian (Chung-kuo mei-shu chia jen-ming tz'u-tien)* 中國美術家人名辭典 (Chinese Artists' Biographical Dictionary) (Shanghai: Renmin Meishu Chubanshe, 1981), p. 520.

7 See Lu Hsin-yüan 陸心源 (1834–94), *Jang-li-kuan kuo-yen lu hsü-chi* 穰梨館過眼錄續集 (Sequel to Paintings Viewed at [Lu Hsin-yüan's] Sharing-Pear Studio), *chüan* 卷 (chapter) 13 (Wu-hsing: n.p., 1891), pp. 1–4. Lu's book includes a set of album leaves by Sun I, dated 1652. Two of the four colophons following the painting are dated 1658, one year after Sun I completed *The Cinnabar Peak* scroll. These two colophons clearly state that Sun I had already died. If these colophons are authentic, Sun I must have died about 1657–58.

8 Sun I's hometown, Hai-yang 海陽, is the name of a prefecture in the southern part of Anhui province. *Hai* 海, meaning "sea," refers to the thick clouds surrounding the famous Mount Huang. *Yang* 陽, the second character in the name, means "sun." In China, it is customary to refer to the southern slope of a mountain as the sunny side. Combined, the two characters signify

the "southern side of Mount Huang," indicating the geographic position of the prefecture. During the Ming and Ch'ing dynasties, this prefecture was comprised of six counties: 1) She-hsien 歙縣; 2) Hsiu-ning 休寧; 3) Wu-yüan 婺源; 4) Ch'i-men 祁門; 5) I-hsien 黟縣; and 6) Chi-hsi 積溪.

9 For more information on the affluence of Anhui, see Sandy Chin and Cheng-chi (Ginger) Hsü, "Anhui Merchant Culture and Patronage," in James Cahill, ed., *Shadows of Mt. Huang: Chinese Painting and Printing of the Anhui School* (Berkeley: University Art Museum, 1981), pp. 19–24.

10 During the early seventeenth century, there were several prominent collectors and art dealers from Sun I's hometown. These included: 1) Chan Ching-feng 詹景鳳 (active late 17th century); 2) Wu T'ing 吳廷 (ca. 1555–1626); 3) Wu Ting's cousin, Wu Hsi-yüan 吳希元 (1551–1606); 4) Ch'eng Chi-pai 程季白 (active late 16th–early 17th century); and 5) Wu Ch'i-chen 吳其貞 (1605–after 1677). In Wu Ch'i-chen's *Shu-hua chi* 書畫記 (A Record of Paintings and Calligraphy), reprint (Taipei: Wen-shih-che Press, 1971), the author listed the famous paintings and calligraphic works he viewed as well as documented many episodes concerning antique dealing in the Hsin-an area. See *Wang Shiqing* 汪世清, "Tung Ch'i-ch'ang's Circle," in Wai-kam Ho 何惠鑑, ed., *The Century of Tung Ch'i-ch'ang, 1555–1636*, vol. 2 (Kansas City: Nelson-Atkins Museum of Art, 1992), pp. 473–75. See also Li Ta-k'ung 李大空 (pseudonym of Jason Chi-sheng Kuo), "Mingqing zhiji zanzhu yishu de Huizhou shangren (Ming-Ch'ing chih-chi tsan-chu i-shu teh Hui-chou shang-jen) 明清之際贊助藝術的徽州商人" (Merchants in the Hui-chou Area Who Patronized Art during the Ming and Ch'ing Periods), in Anhuisheng Wenxue yishu yanjiusuo (Anhui-sheng Wen-hsüeh i-shu yen-chiu so) 安徽省文學藝術研究所 (The Anhui Provincial Research Institute of Literature and Art), *Lun Huangshan zhu hua-pai wenji (Lun Huang-shan chu-hua-p'ai wen-chi)* 論黃山諸畫派文集 (Collected Essays of the Painting Schools of Huang-shan) (Shanghai: Renmin Meishu Chubanshe, 1987), pp. 334–50. For the English version of Kuo's article, see "Huichou Merchants as Art Patrons in the Late Sixteenth and Early Seventeenth Centuries," in Chu-tsing Li 李鑄晉, ed., *Artists and Patrons: Some Social and Economic Aspects of Chinese Painting* (Lawrence: Kress Foundation, Department of Art History, University of Kansas, 1989), pp. 177–88.

11 Hsin-an is another name for Sun I's hometown. As early as the Sui 隋 dynasty (581–601), this area was known as Hsin-an

新安 a name that was later changed to Hui-chou 徽州. For a discussion of the painters from the Hsin-an area, see *Shadows of Mt. Huang: Chinese Painting and Printing of the Anhui School.*

12 The other three Great Masters from Hsin-an were Wang Chih-jui 汪之瑞 (active mid-17th century), Hung-jen 弘仁 (1610–64), and Cha Shih-piao 查士標 (1615–98). It is recorded that twenty-six of Sun I's paintings of Mount Huang were transferred to woodblock and reproduced by the local administrator. For information on Sun I's paintings published as woodblocks, see the entry for Hsiao Yün-ts'ung and Sun I in Zhang Geng (Chang Keng) 張庚 (1685–1760), *Guochao huazhenglu (Kuo-ch'ao hua-cheng lu)* 國朝畫徵錄 (Biographical Sketches of the Artists of the Ch'ing Dynasty), preface dated 1739, *juan (chüan)* 卷 (chapter) 5, reprinted in Yu Anlan 于安瀾, comp., *Huashi congshu (Hua-shih ts'ung-shu)* 畫史叢書 (Compendium of Painting History), vol. 5 (Shanghai: Renmin Meishu Chubanshe, 1962), pp. 18–19.

13 One well-known painting, dated 1639, is a collaborative work by five local artists from Hsin-an. The fourth section contains Sun I's painting, entitled *Gangling tujuan (Kang-ling t'u-chüan)* 岡陵圖卷 (A Hand-scroll Showing Hills and Mountains). This work, now at the Shanghai Museum, is published in Yang Han 楊涵 et al., eds., *Zhongguo meishu quanji (Chung-kuo mei-shu ch'üan-chi)* 中國美術全集 (The Great Treasury of Chinese Fine Art), vol. 9 (Shanghai: Renmin Meishu Chubanshe, 1988), pl. 81. Another work by Sun I, dated 1654, is published in Teng Shih's 鄧實 (1865?–1948?) *Shen-chou ta-kuan hsü-pien* 神州大觀續編 (Continuation of Selected Works of Chinese Painting), vol. 5 (Shanghai: Shen-chou Kuo-kuang She, 1927), no page number.

14 Although Hung-jen was the most prominent of the four masters of the Hsin-an painting school, Cha Shih-piao was more versatile. For reproductions of these artists' works, see *Shadows of Mt. Huang*, pl. 18 on p. 74; pl. 22 on p. 80; pl. 29 on p. 88; fig. 16 on p. 79; and fig. 17 on p. 103.

15 Ni Tsan's style is known for its compositional simplicity and economical application of brush strokes. This style could have originated with the famous painter Li Ch'eng 李成 (919–67) of the Northern Sung dynasty (960–1126). The term *hsi-mo ju-chin* 惜墨如金 (treasuring one's ink brush strokes as if they were made of gold) can already be found in writings of that period concerning Li's work. See *Han-yü ta-tz'u-tien* 漢語大詞典 (Chinese Terminology Dictionary), vol. 7, p. 591, s.v. "*ximorujin (hsi-mo ju-chin)* 惜墨如金"

(treasuring one's ink brush strokes as if they were made of gold). During the Yüan dynasty (1280–1368), another term, *hsi-mo fa* 惜墨法 (the technique of using ink economically), was also used to describe Li's sparse style. See Xia Wenyan (Hsia Wen-yen) 夏文彥 (active mid-14th century), ed., *Tuhui baojian (T'u-hui pao-chien)* 圖繪寶鑑 (Precious Mirror of Painting), preface 1365, *juan (chüan)* 卷 (chapter) 3, reprinted in *Hua-shih ts'ung-shu* 畫史叢書 (Compendium of Painting History), vol. 3, p. 88, entry for Guo Xin (Kuo Hsin) 郭信. Tung Ch'i-ch'ang 董其昌 (1555–1636), the great master and famous critic of the Ming dynasty (1368–1644), also used *hsi-mo ju-chin* to describe Li Ch'eng's work, in order to contrast the simplicity of Li's work with the splashing ink technique of Wang Ch'ia 王洽 (?–805) of the T'ang dynasty (618–905). See Tung's *Hua-chüeh* 畫訣 (Secret Formula of Painting) in his *Huachanshi suibi (Hua-ch'an-shih sui-pi)* 畫禪室隨筆 (Casual Notes at the [Author's] Painting-Ch'an Studio), preface dated 1720, reprinted in *Yilin mingzhu congkan (I-lin ming-chu ts'ung-k'an)* 藝林名著叢刊 (Collected Famous Writings on the Arts) (Beijing: Beijing Zhongguo Shudian, 1983), p. 35. Tung also inscribed this phrase on one of his works entitled *Landscape after Wang Ch'ia and Li Ch'eng*, a work currently at the Shanghai Museum and reproduced in *The Century of Tung Ch'i-ch'ang 1555–1636*, vol. 1, pp. 421–22 and 424–28. Other terms for this style are *chien-pi shan-shui* 減筆山水 (diminished brush stroke landscape) and *shu-pi shan-shui* 疏筆山水 (sparse brush stroke landscape). See Lin Shuzhong 林樹中 et al., eds., *Meishu cilin, Zhongguo huihua juan (Mei-shu tz'u-lin, Chung-kuo hui-hua chüan)* 美術辭林, 中國繪畫卷 (Dictionary of Terminology in Fine Art, Chinese Painting Section), vol. 1 (Xian: Renmin Meishushe, 1995), pp. 693–94, s.v. "*jianbi shanshui huafa (chien-pi shan-shui hua-fa)* 減 (or 簡) 筆山水畫法" (the diminished brush stroke landscape technique). During the early Ming dynasty, Ni Tsan's work was the most popular and sought-after type of painting in the region of the lower Yangtze River delta. Later, during the sixteenth and seventeenth centuries, this area was dominated by the Wu school and subsequently by Tung Ch'i-ch'ang. These styles were widely emulated in the Hsin-an prefecture. For example, local artist Ch'eng Chia-sui 程嘉燧 (1565–1643) imitated the style of Ni Tsan. Li Yung-ch'ang 李永昌 (active 1590–1635) painted in the tradition of the Wu master Shen Chou 沈周 (1427–1509), as well as in emulation of Tung Ch'i-ch'ang. All of these artists, who preceded Sun I, may have influenced the

Hsin-an painters of the seventeenth century, including Hung-jen, Sun I, and their contemporaries. Nevertheless, the works by earlier painters show distinct stylistic differences from those of the later artists. See Susan Nelson, "Ni Tsan and the Image of Yüan Painting," (Ph.D. dissertation, Harvard University, 1977), and Kuo Chi-sheng 郭繼生 (Jason Kuo) "Ming-tai Wu-men hui-hua tui Hsin-an hua-p'ai te ying-hsiang, che-yao" 明代吳門繪畫對新安畫派的影響, 摘要 (A Summary of the Influences Received by the Hsin-an Painting School from the Works of the Wu School during the Ming Dynasty), in Yang Xin 楊新, ed., *Wumen huapai yanjiu (Wu-men hua-p'ai yen-chiu)* 吳門畫派研究 (Research on Paintings of the Wu School) (Beijing: Palace Museum, 1993), pp. 360–63.

16 As these painters were all from the same region, they may have influenced one another. Still another possibility is that they all learned from the same sources or teachers, which would account for the development of a definitive local style. It is to be hoped that more works by local Hsin-an artists prior to Sun I's period will surface in the future so that these issues can be further understood.

17 See the entry for Sun I in Lan Ying 藍英 and Xie Bin (Hsieh Pin) 謝彬, eds., *Tuhui baojian xucuan (T'u-hui pao-chien hsü-tz'uan)* 圖繪寶鑑續纂 (Sequel to Precious Mirror of Painting), *juan (chüan)* 卷 (chapter) 1, reprinted in *Hua-shih ts'ung-shu* 畫史叢書 (Compendium of Painting History), vol. 4, p. 21.

18 It is stated in both *T'u-hui pao-chien hsü-tz'uan* 圖繪寶鑑續纂 (Sequel to Precious Mirror of Painting), *chüan* 卷 (chapter) 1, p. 21, and *Kuo-ch'ao hua-cheng lu* 國朝畫徵錄 (Biographical Sketches of the Artists of the Ch'ing Dynasty), *chüan* 卷 (chapter) 5, pp. 18–19, that Sun I, "*liu-yü Wu-hu* 流寓蕪湖," or "sojourned in Wu-hu."

19 Chang Keng, an eighteenth-century scholar, considered Sun I to be a reincarnation of the great Wu master Wen Cheng-ming 文徵明 (1470–1559). See the entry for Hsiao Yün-ts'ung and Sun I in Chang Keng's *Kuo-ch'ao hua-cheng lu* 國朝畫徵錄 (Biographical Sketches of the Artists of the Ch'ing Dynasty), *chüan* 卷 (chapter) 5, pp. 18–19. Although Sun's work does exhibit some influence from the Wu school, there are fundamental differences. To compare Sun I with Wen Cheng-ming is somewhat far-fetched. On the other hand, Sun I's work does display a conspicuous similarity to one of Wen Cheng-ming's students, Lu Chih 陸治 (1496–1576). Both Sun I's and Lu Chih's paintings are distinguished by thin linear work with slender forms and exquisite execution.

Sun I 孫逸
The Cinnabar Peak
*continued*

70 20 Traditionally, the Chinese people tended to resist resettling and often remained in the same location for generations. Yet disruptions such as those caused by war, famine, or floods forced many to migrate. In 1644, the Manchurian invasion and subsequent fall of the Ming dynasty caused multitudes to flee their hometowns.

21 Scholars have associated Sun I's literati persona and formal references in the depiction of trees and rocks with the Wu school master Wen Cheng-ming. In *T'u-hui pao-chien hsü-tz'uan* 圖繪寶鑑續纂 (Sequel to Precious Mirror of Painting), the author pointed out that Sun I was quiet and gentle, indifferent to fame and wealth. His friends, as well as those who barely knew him, all considered him a reverent elder. ( 且性情恬淡, 識與不識 咸稱為長者.)

22 One of Hsiao Yün-ts'ung's paintings, *Shulin xiezhang tu (Shu-lin i-chang t'u)* 疏林曳杖圖 (Dragging a Staff in Sparse Woods), dated 1648, has the same slender figure with a staff walking behind tall trees along a narrow bank found in Sun I's *The Cinnabar Peak*. Hsiao's work is now at the Tientsin Municipal Museum and is reproduced in *Shadows of Mt. Huang: Chinese Painting and Printing of the Anhui School*, fig. 14, p. 71. Another painting by Hsiao that is painted in the Hsin-an style is his hanging scroll, entitled *Landscape*, now at the Freer Gallery of Art, Washington, D.C. It is reproduced in Suzuki Kei 鈴木敬, comp., *Comprehensive Illustrated Catalog of Chinese Paintings*, vol. 1 (Tokyo: University of Tokyo Press, 1982), no. A21-182, p. 248.

23 For the source of the phrase, "Sun and Hsiao," see *Kuo-ch'ao hua-cheng lu* 國朝畫徵錄 (Biographical Sketches of the Artists of the Ch'ing Dynasty), *chüan* 卷 (chapter) 5, p. 19. As a matter of fact, in this book the entries for these two artists are combined into one.

24 See note 3.

25 The invading Manchus' conquest of the Ming court in 1644 was one of the most tragic occurrences in Chinese history. Thousands of Chinese were massacred during the invasions, and the new ruler imposed many humiliating regulations upon the indigenous Chinese. Numerous intellectuals and talented painters remained loyal to the Ming court and harbored bitterness over the loss of their traditional culture. They are generally referred to as *i-min* 遺民, or "leftover subjects." Among the many accomplished artists, the best known are referred to as the four monks: 1) Chu Ta 朱耷, or Pa-ta Shan-jen 八大山人 (1624–1705); 2) Shih-t'ao 石濤 (1642–1707); 3) K'un-ts'an 髡殘, or Shih-hsi 石谿 (1612–74); and 4) Hung-jen 弘仁, or Chien-chiang 漸江 (1610–64). They all used their painting as a vehicle to express their frustration. Although Sun I was not as well known as these four, he was their contemporary and peer, and his *Cinnabar Peak* is probably more blatantly patriotic than any of the works of the four monks. For more information on these *i-min* artists, see *Proceedings of the Symposium on Ming I-min* (Journal of the Institute of Chinese Studies of the Chinese University of Hong Kong 8) (Hong Kong: Chinese University of Hong Kong, 1976). For information on the political situation of occupied China under foreign invaders, see Lynn A. Strure, *Voice from the Ming-Qing Cataclysm: China in Tigers' Jaws* (New Haven: Yale University Press, 1993).

26 For more information on Chu Yu-lang, see Arthur W. Hummel, ed., *Eminent Chinese of the Ch'ing Period (1644–1912)*, vol. 1 (Washington, D.C.: United States Government Printing Office, 1943–44), pp. 193–95.

27 The character *ch'ing* 青 can also represent blue or even black, although it most commonly indicates green.

28 For more information on Wang Ssu-jen, see *Dictionary of Ming Biography, 1368–1644*, vol. 2, p. 1424.

## 27. Cha Shih-piao 查士標
*(1615–98)*
*Ch'ing dynasty (1644–1911)*

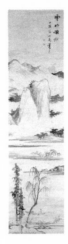

## Cloudy Mountains and Misty Trees after Tung Yüan (?–962)
*Fang Tung Yüan yün-shan yen-shu (Cloudy Mountains and Misty Trees after Tung Yüan)*
仿董源雲山煙樹

1 Although the character 查 in Cha Shih-piao's family name is commonly pronounced "ch'a," according to Chinese tradition, whenever it is used as a family name, it must be enunciated as "cha."

2 Tung Yüan was the leading landscape master of the Southern T'ang 南唐 dynasty (923–75), one of the regimes of the Five Dynasties period (907–60). For a discussion of this artist and his work, see "Pictorial Representation in Chinese Landscape Painting," in Wen C. Fong et al., *Images of the Mind: Selections from the Edward L. Elliott Family and John B. Elliott Collections of Chinese Calligraphy and Painting at the Art Museum, Princeton University* (Princeton: Art Museum, Princeton University, 1984), pp. 33–35.

3 Mei-huo, meaning "plum ravine," is Cha Shih-piao's *hao*. Pei Yüan, meaning "north garden," is a *hao* of the great tenth-century master Tung Yüan (d. 962).

4 Teh-fu, meaning "a virtuous man," is the *tzu* of this unidentified collector-calligrapher.

5 For information on Tseng Shao-chieh, see note 2 of entry 20 on Yao Yün-tsai's 姚允在 (active 1573–1620) *Waiting for a Ferry by a River in Autumn*.

6 T'ieh-hua-lou was the studio name of Chang Yin-huan 張蔭桓 (1837–1900). It was adopted by Tseng Shao-chieh in the twentieth century. See note 1 of entry 20 of Yao Yün-tsai's *Waiting for a Ferry by a River in Autumn*.

7 This collector is unidentified. This *hao*, Tan-yüan, means "a simple dispassionate garden."

8 This seal probably also belongs to the above unidentified collector. This *hao* means "a dignified and cultivated person with a confused mind."

9 See Zhang Geng (Chang Keng) 張庚 (1685–1760), *Guochao huazhenglu* (*Kuo-ch'ao hua-cheng lu*) 國朝畫徵錄 (Biographical Sketches of the Artists of the Ch'ing Dynasty), preface dated 1739, *juan* (*chüan*) 卷 (chapter) 1, reprinted in Yu Anlan 于安瀾, comp., *Huashi congshu* (*Hua-shih ts'ung-shu*) 畫史叢書 (Compendium of Painting History), vol. 5 (Shanghai: Renmin Meishu Chubanshe, 1962), pp. 15–16.

10 See ibid.

11 See ibid.

12 Ni Tsan was one of the Four Great Masters of the Yüan dynasty (1280–1368). The other three were Wu Chen 吳鎮 (1280–1354), Huang Kung-wang 黃公望 (1269–1354), and Wang Meng 王蒙 (1309–85). Ni Tsan was known for his uniquely simple and elegant painting style. He also preferred the use of delicate brushwork. During the Ming dynasty, Ni Tsan's work was the most popular and sought-after type of painting in the lower Yangtze River delta region. His style was widely emulated in Cha Shih-piao's home in the Hsin-an prefecture. See entry 26 on Sun I.

13 Tung Ch'i-ch'ang was the most influential painter and critic of the seventeenth century. His painting style, as well as his sense of aesthetics, had a tremendous impact on literati painters during the early Ch'ing period. For a thorough discussion of Tung Ch'i-ch'ang, see Wai-kam Ho 何惠鑑, ed., *The Century of Tung Ch'i-ch'ang, 1555–1636*, vol. 2 (Kansas City: Nelson-Atkins Museum of Art, 1992).

14 Cha Shih-piao's seal bearing the legend *hou i-mao jen* 後乙卯人 is reproduced in Shanghai Museum, *Zhongguo shuhuajia yinjian kuanshi* (*Chung-kuo shu-hua-chia yin-chien k'uan-shih*) 中國書畫家印鑒款識 (Signatures and Seals of Chinese Painters and Calligraphers), vol. 1 (Shanghai: Wenwu Chubanshe, 1987), seal no. 42, p. 652.

15 See *Kuo-ch'ao hua-cheng lu* 國朝畫徵錄 (Biographical Sketches of the Artists of the Ch'ing Dynasty), *chüan* 卷 (chapter) 1, p. 16.

16 For information on Cha Shih-piao's move to Yangchou, see "Caohe luxia (Ts'ao-ho lu-hsia) 草河錄下 (The Accounts of the Grass River, part 2)," in Li Tou 李斗 (active second half of 18th century), *Yangzhou huafang lu* (*Yang-chou hua-fang lu*) 揚州畫舫錄 (The Accounts of the Gaily Painted Pleasure Boats in Yangchou), preface dated 1795, *juan* (*chüan*) 卷 (chapter) 2, reprint (Yangzhou: Jiangsu Guangling Guji Keyinshe, 1984), p. 39.

17 For more information on the salt trade, see Jonathan D. Spence, *Ts'ao Yin and the K'ang-hsi Emperor: Bondservant and Master* (New Haven: Yale University Press, 1966), pp. 166ff.

18 See *Yang-chou hua-fang lu* 揚州畫舫錄 (The Accounts of the Gaily Painted Pleasure Boats in Yangchou), p. 39.

19 For Cha's seal bearing the legend of "lazy old man," see *Chung-kuo shu-hua-chia yin-chien k'uan-shih* 中國書畫家印鑒款識 (Signatures and Seals of Chinese Painters and Calligraphers), vol. 1, seal nos. 40 and 41, p. 652.

20 See *Kuo-ch'ao hua-cheng lu* 國朝畫徵錄 (Biographical Sketches of the Artists of the Ch'ing Dynasty), *chüan* 卷 (chapter) 1, p. 16.

21 See ibid. For a discussion of the painter Wang Hui, see entry 30. The names of the Four Masters of the Yüan dynasty are found in note 12. For a discussion of their styles and works, see Maxwell K. Hearn, "The Artists as Heroes," in Wen C. Fong and James C. Y. Watt, *Possessing the Past: Treasures from the National Palace Museum, Taipei* (New York: Metropolitan Museum of Art, and Taipei: National Palace Museum, 1996), pp. 299–323.

22 Wang Yüan-ch'i was the grandson of the famous painter Wang Shih-min 王時敏 (1592–1680). His comments on Wang Hui are found in *Kuo-ch'ao hua-cheng lu* 國朝畫徵錄 (Biographical Sketches of the Artists of the Ch'ing Dynasty), p. 52. For a discussion of Wang Yüan-ch'i and his work, see entry 31.

23 For a discussion of Sung Lo, see Arthur W. Hummel, ed., *Eminent Chinese of the Ch'ing Period (1644–1912)*, vol. 2 (Washington, D.C.: United States Government Printing Office, 1943–44), pp. 689–90.

24 One of the four famous gardens in Suchou, the Stone Lion Grove Garden was originally constructed during the Yüan (1280–1368) dynasty in memory of the Abbot Chung-feng 中峰 (1263–1325) and has been depicted many times throughout the centuries. For a particularly elegant example, see the Yüan dynasty master Ni Tsan's (1301–74) painting, *Lion Grove in Suchou*, reproduced in Sherman E. Lee, *A History of Far Eastern Art* (New York: Harry N. Abrams, 1964), fig. 546, p. 412.

25 See *Kuo-ch'ao hua-cheng lu* 國朝畫徵錄 (Biographical Sketches of the Artists of the Ch'ing Dynasty), p. 16. Chang Keng's statement that Sung Lo composed a biography of Cha Shih-piao and a preface for his anthology cannot be verified, since these two articles are not found in Sung Lo's collected writings, *Hsi-p'i lei-kao* 西陂類稿 (Sung Lo's Collected Writings), 1st edition dated 1711, reprint (Taipei: Taiwan Student Press, 1973).

26 See *Kuo-ch'ao hua-cheng lu* 國朝畫徵錄 (Biographical Sketches of the Artists of the Ch'ing Dynasty), p. 16.

27 Cha Shih-piao was so named because his hometown was located near the famous Mount Huang 黃山, a prefecture under the Hsin-an 新安 jurisdiction. The other three Great Masters from Hsin-an were Wang Chih-jui 汪之瑞 (active mid-17th century), Hung-jen 弘仁 (1610–64), and Sun I 孫逸 (active mid-17th century). See also entry 26, *The Cinnabar Peak*, by Sun I, and note 11 of that entry.

28 For examples of Tung Yüan's work, see his *Xiajing shankou daidutu* (*Hsia-ching shan-k'ou tai-tu t'u*) 夏景山口待渡圖 (The Entrance of the Mountain with Passengers Waiting for the Ferry in Summer), reproduced in Group for the Authentication of Ancient Works of Chinese Painting and Calligraphy, ed., *Zhongguo gudai shuhua tumu* (*Chung-kuo ku-tai shu-hua t'u-mu*) 中國古代書畫圖目 (An Illustrated Catalogue of Selected Works of Ancient Chinese Painting and Calligraphy), vol. 15 (Beijing: Wenwu Chubanshe, 1997), no. 遼 1-015, pp. 20–21.

## 28. Kung Hsien 龔賢
*(c. 1618–89)*
*Ch'ing dynasty (1644–1911)*

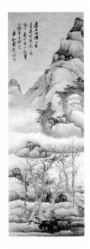

### Mountain Dwelling
*Shan-chü t'u*
*(A Picture of the Mountain Dwelling)*
山居圖

1  While it is clear that Kung Hsien died in 1689, the year of his birth is less certain. In the many sources dealing with the artist, several different years have been assigned. In Yu Jianhua 于劍華 et al., *Zhongguo meishujia renming cidian* (*Chung-kuo mei-shu-chia jen-ming tz'u-tien*) 中國美術家人名詞典 (Biographical Dictionary of Chinese Artists) (Shanghai: Renmin Meishu Chubanshe, 1981), p. 1554, Yu asserts that Kung was born in 1599, the twenty-seventh year of the Wan-li 萬曆 reign (1573–1619) of the Ming dynasty (1368–1644). This same year is listed in Sotheby's sales catalogue, *Fine Classical Chinese Paintings* (Hong Kong: Sotheby's, April 26, 1999), lot no. 8, p. 19, as well as in Liu Gangji's 劉綱紀 "Gong Xian (Kung Hsien) 龔賢" in *Lidai huajia pingzhuan: Ming* (*Li-tai hua-chia p'ing-chuan: Ming*) 歷代畫家評傳：明 (The Series of Biographies and Commentaries of Chinese Painters of the Past Dynasties: Ming Dynasty) (Hong Kong: Chunghua Shuchü, 1979), p. 1. If this date is correct, Kung Hsien would have lived into his nineties. In Liu Yujia's 劉宇甲 "Gong Xian de shengping (Kung Hsien teh sheng-p'ing) 龔賢的生平" (The Life of Kung Hsien), found in Liu Haisu 劉海粟, ed., *Gong Xian yanjiuji* (*Kung Hsien yen-chiu chi*) 龔賢研究集 (Collected Research Materials on Kung Hsien) (Nanjing: Jiangsu Meishu Chubanshe, 1988), vol. 2, p. 3, Liu Yujia asserts that Kung was born around 1619, which seems more in accordance with Kung Hsien's life and activities. When Liu Gangji's book was reissued by Renmin Meishu Chubanshe 人民美術出版社 (The

People's Fine Art Press) in 1981 as a single volume, the date of Kung Hsien's birth was revised to 1618. In the chapter "Hung-jen and Kung Hsien: Nature Transfigured" in James Cahill's *The Compelling Image: Nature and Style in Seventeenth-Century Chinese Painting* (Cambridge, Mass: Belknap Press of Harvard University Press, 1982), pp. 168–83, the author also assigns 1618 as Kung Hsien's birth date. On the other hand, Xu Bangda 徐邦達 claims that Kung Hsien was born in 1621. See Xu's "Gong Xian shengping ji kaoding (Kung Hsien sheng-p'ing chi k'ao-ting) 龔賢生平及考訂" (Research on Kung Hsien's Life and Emendations), in Xu Bangda, *Lidai shuhuajia zhuanji kaobian* (*Li-tai shu-hua-chia chuan-chi k'ao-pien*) 歷代書畫家傳記考辯 (Verification of Biographies of Past Calligraphers and Painters) (Shanghai: Renmin Meishu Chubanshe, 1984), pp. 54–60.

2  While silk and paper are the standard media for Chinese painting, satin is less common. Ink on satin is difficult to control, due mostly to the way this material absorbs water and ink. But the surface of satin is extremely smooth and less resistant to the movement of a brush. As these qualities allow for a more expressive application of ink, many skilled painters, especially in the seventeenth century, actually preferred satin. Relatively speaking, a counterfeiter would less likely choose satin, as it is more difficult to age the surface by applying even, colorful washes.

3  The Michigan work by Kung Hsien is published in the Sotheby's catalogue as *Winter Landscape*.

4  The term *Pan-ch'ien* 半千 (half-thousand) is derived from a famous historical episode. It is recorded that during the T'ang dynasty (618–905), a distinguished scholar named Yüan Ch'ing-yü 員慶餘 (621–714), highly esteemed by his superior, was told by the latter that in every five-hundred-year interval, a sage would emerge and that Yüan was one of these five-hundred-year sages. As a result, Yüan adopted the name Pan-ch'ien, or "five hundred years." Thus the term, "five hundred years" is often used to represent a sage in Chinese literature. See *Hanyu dacidian* (*Han-yü ta-tz'u-tien*) 漢語大詞典 (Chinese Terminology Dictionary), vol. 1 (Shanghai: Hanyu Dacidian Press, 1988), p. 708, s.v. "*banqian (pan-ch'ien)* 半千" (literally meaning "half-thousand"). As Kung Hsien's given name Hsien literally means "sage," he evidently adopted the *tzu* "half-thousand" to refer to his given name.

5  Although Kung Hsien lived in Nanking for many years and is considered a representative artist of the Nanking school, he was originally from K'un-shan. This is based on sources such as Zhang Geng (Chang Keng) 張庚 (1685–1760), *Guochao huazhenglu* (*Kuo-ch'ao hua-cheng lu*) 國朝畫徵錄 (Biographical Sketches of the Artists of the Ch'ing Dynasty), preface dated 1739, *juan* (*chüan*) 卷 (chapter) 1, reprinted in Yu Anlan 于安瀾, comp., *Huashi congshu* (*Hua-shih ts'ung-shu*) 畫史叢書 (Compendium of Painting History), vol. 5 (Shanghai: Renmin Meishu Chubanshe, 1962), p. 11.

6  Kung Hsien was also known as P'eng-hao jen 蓬蒿人 (a person who appreciates crown daisies [a type of edible chrysanthemum]), Pan-an 半庵 (half-hut), Pan-shan 半山 (half-mountain), Tung-hai yin-shih 東海隱士 (a recluse from the East Sea), Ta-pu-i 大布衣 (a great commoner), Ch'ing-liang-shan hsia-jen 清涼山下人 (a person from the foot of the clear and cool hill), Chung-shan Yeh-lao 鍾山野老 (a rustic elder at Mount Chung), An-chieh T'ang 安節堂 (Peaceful Integrity Hall), and Ts'ao-hsieng T'ang 草香堂 (The Grass-fragrance Hall).

7  Yeh-i, or "remnant in the wild" may also allude to a line from the Shu-ching 書經 (Book of History), one of the *Five Classics*. It reads: "Yeh-wu i-hsien 野無遺賢," literally meaning, "In the wilderness, no virtuous man will be neglected."

8  See Liu Yujia's "Kung Hsien teh sheng-p'ing 龔賢的生平" (The Life of Kung Hsien), in *Kung Hsien yen-chiu chi* 龔賢研究集 (Collected Research Materials on Kung Hsien), vol. 2, p. 3.

9  The affluence of Kung Hsien's childhood can be inferred from a poem he composed in the 1650s. This poem, entitled *Chi-meng* 記夢 (Recording a Dream), is found in his anthology, *Caoxiangtang ji* (*Ts'ao-hsiang t'ang chi*) 草香堂集 (The Grass-fragrance Hall Anthology), which is reprinted in *Kung Hsien yen-chiu chi* 龔賢研究集 (Collected Research Materials on Kung Hsien), vol. 1, p. 32. Kung's poem reads:

> For now I live by the Han River [in Yangchou],
> Yet I dreamed that I was still at my old home.
> My brothers all wore fur coats,
> [And] the *pi-li* flowers were blooming along the stone corridor.*
> [We were] wagering gold on chess games and drinking contests.
> During the day, [we] sat talking boisterously.
> When [I] woke up, the birds by the window had all flown away.

The cold sky casts light on the green
silk-gauze [curtain].

客居邘水上，有夢未離家.
兄弟羽毛氅，岩廊薜荔花.
黃金睹棋酒，白日坐喧嘩.
覺後窗禽散，涼天映碧紗.

*The *pi-li* flower (*Ficus Pumila*) is also
known as *mu-lien* 木蓮 (wood lotus). It is a
perennial vine with edible seeds. See *Tz'u-
hai* 辭海 (Sea of Terminology: Chinese
Language Dictionary), vol. 2 (Taipei:
Chung-hua Press, 1974), p. 2524, s.v. "*pi-li*
薜荔."

10  This information is based on an entry enti-
tled "Gong Xiang er jiefu zhuan (Kung
Hsiang erh chieh-fu chuan) 龔項二節婦傳"
(The Biographies of the Two Virtuous
Ladies of the Kung and Hsiang Families)
found in Zhang Fuxiang's (Chang Fu-
hsiang) 張符驤 (active 19th century) *Yigui
cao chuke* (*I-kuei ts'ao chu-k'e*) 依歸草初刻
(The First Edition of the Ascending and
Eternally Returning Grass), *juan* (*chüan*)
卷 (chapter) 2. Although Chang's book is
difficult to locate in Western libraries, the
text is cited in Xiao Ping 蕭平 and Liu
Yujia 劉宇甲, *Gong Xian* (*Kung Hsien*) 龔
賢, in *Mingqing Zhongguohua dashi yan-
jiu congshu* (*Ming-Ch'ing Chung-kuo-hua
ta-shih yen-chiu ts'ung-shu*) 明清中國畫大
師研究叢書 (Series of Studies on Master
Chinese Painters of the Ming and Ch'ing
Periods) (Jilin: Jilin Meishu Chubanshe,
1996), note 23, p. 31. It says: The virtuous
lady was from the Wang family. She was
the mother of Kung Han in Nanking. The
name of Kung Han's father was [Kung]
Yüan-mei. [It was during] the beginning
years of the Ch'ung-chen reign (1628–44)
that Yüan-mei married Wang. It was his
second marriage. Eight moons later, Yüan-
mei followed his father, who had been
transferred to Szechwan in order to occupy
an official position. The two never
returned. It was unclear how they died.
Three months after Yüan-mei left, [Kung]
Han was born. (節婦王氏者，江寧龔翰母也.
翰父元美，崇禎初再娶婦. 八月，而從其親長
更于蜀. 遂不復返. 死狀不可知. 元美去三月，
而翰生.) This note also continues to assert
that Kung Han was Kung Hsien's younger
brother. If the father remarried during the
beginning years of the Chung-chen reign
(1628–30), this marriage must have
occurred when Kung Hsien was about ten
to thirteen years old.

11  See ibid.

12  See ibid. Kung Hsien's poem entitled
"Yizu (I-tsu) 憶祖" (Recollection of My
Grandfather), clearly alludes to this
tragedy. It says: [My grandfather] traveled

to the Pa River (Szechwan) twenty years
[ago]. Not one single bit of news has been
sent back to the Nanking sky. (一去巴江二
十年，總無消息到南天.) This poem is origi-
nally found in Kung's anthology and is
reprinted in *Kung Hsien yen-chiu chi* 龔賢
研究集 (Collected Research Materials on
Kung Hsien), vol. 1, p. 50.

13  The *tzu* of Kung Hsien's younger brother
Kung Han was Wen-ssu 文思, meaning
"literary contemplation." He was a minor
poet and painter. A set of album leaves
executed by Kung Han is recorded in
*Shibaizhai shuhualu* (*Shih-pai chai shu-
hua lu*) 十百齋書畫錄 (A Record of the
Painting and Calligraphy at the Ten-hun-
dred Studio), *juan* (*chüan*) 卷 (chapter) 5
(戊), reprinted in Lu Fusheng 盧輔聖 et al.,
*Zhongguo shuhua quanshu* (*Chung-kuo
shu-hua ch'üan-shu*) 中國書畫全書 (The
Complete Collection of Books on Chinese
Painting and Calligraphy), vol. 7 (Shang-
hai: Shanghai Shuhua Chubanshe, 1992),
pp. 561–62. At the beginning of the set of
album leaves by Kung Han, there is a title
page inscribed by his elder brother Kung
Hsien. It says: "*Zhongyun yubo* (*Chung-
yün yü-po*) 中允餘波 (The Repercussions of
an Official of Rite), inscribed by elder
brother [Kung] Hsien." It is possible that
*Chung-yün* was the official title of Kung
Hsien's grandfather. Kung Han's signatures
on his paintings indicate that he had many
sobriquets, including: 1) Yü-feng 玉峰 (jade
peak); 2) Lou-shan Yeh-ho 樓山野鶴 (wild
crane at a mountain pavilion); 3) K'uo-
yüan 廓園 (extensive garden); 4) Nan-po 南
搏 (to fight in the south); 5) Chüeh-hua
tao-jen 覺花道人 (a cultivated person who
appreciates flowers); and 6) Mei-lin 梅鄰
(plum blossom's neighbor).

14  Kung Hsien must have studied painting
with Tung Ch'i-ch'ang sometime around
1631, when Tung went to Nanking to reas-
sume the official position of Nanking Li-
pu Shang-shu 南京禮部尚書, or "prime
minister of the Rites Department." The
duration of this teacher-student relation-
ship was probably quite brief, as Tung did
not stay in Nanking very long. According
to an inscription on one of his album
leaves dated 1688, Kung asserted: "To
paint, it is not necessary to follow the
ancients. The lofty and elegant brushwork
of contemporary painters such as Tung
Hua-t'ing (Tung Chi-chang's *hao*, meaning
"floral pavilion") is also enchanting. After
I finished this painting, I found it resem-
bled a work of Lung-yu (Yang Wen-ts'ung's
[ 楊文聰，1597–1645] *tzu*, meaning "a friend
of dragons") This is because when I was
young, Lung-yu and I both learned paint-
ing from Hua-t'ing. (畫不必遠師古人. 近日
如董華亭，筆墨高逸，亦自可愛. 此作成，反

似龍友. 以余少時 與龍友同師華亭故也.) For
more information on Yang Wen-ts'ung, see
Arthur W. Hummel, ed., *Eminent Chinese
of the Ch'ing Period (1644–1912)*, vol. 2
(Washington, D.C.: United States Govern-
ment Printing Office, 1943–44), pp.
895–96. The album leaf bearing this
inscription is reproduced in *Kung Hsien
yen-chiu chi* 龔賢研究集 (Collected
Research Materials on Kung Hsien), vol. 2,
pl. 155-2. In the reproduction of the eight
leaves from this set, this book mistakenly
lists the ownership as the Metropolitan
Museum of Art, New York. In actuality,
this set belongs to a private collector.
Three leaves from this set are reproduced
in Suzuki Kei 鈴木敬, comp., *Comprehen-
sive Illustrated Catalog of Chinese Paint-
ings*, vol. 1 (Tokyo: University of Tokyo
Press, 1982), no. A18-061,1/3–33/3, p. 173.
At the beginning of Kung's inscription
attached to his long handscroll entitled
*Xishan wujin* (*Hsi-shan wu-chin*) 溪山無盡
(Endless Mountains and Rivers), currently
at the Palace Museum, Beijing, Kung
asserts: "I remember that I could paint by
age thirteen. Yet it was not until my fifties
that I dedicated myself to painting." (憶余
十三，便能畫. 垂五十年，而力硯田.)

15  During the reign of the first emperor of the
Ming dynasty, Chu Yüan-chang 朱元璋 (r.
1368–98), Nanking was chosen as the capi-
tal. He was succeeded by his grandson,
Emperor Hui-ti 惠帝 (r. 1399–1402). In
1403, however, the fourth son of the Ming
founder Chu Ti 朱棣 (1360–1424) usurped
the throne; he was also the uncle of the
young emperor. He moved the capital to
Peking in 1409. For a record of this histori-
cal event, see *Dictionary of Ming Biogra-
phy, 1368–1644*, vol. 1, pp. 355–65, s.v.
"Chu Ti."

16  The Fu-she Society, led by two radical
savants, Chang P'u 張溥 (1602–41) and
Ch'en Chen-hui 陳貞慧 (1605–56), was an
influential political organization formed
by a group of scholars during the T'ien-ch'i
reign 天啟 (1621–27). For the activities of
the Fu-she, see *Eminent Chinese of the
Ch'ing Period (1644–1912)*, vol. 1, pp.
52–53. For Ch'en's brief biography, see
ibid., pp. 82–83.

17  Ch'in-huai was the demimonde district in
Nanking famous for its wine shops, tea
houses, restaurants, and courtesans. Many
talented poets, writers, and artists were
attracted to this vibrant section of the city.
Information on Kung Hsien's involvement
in the poetry guild is found in one of his
poems entitled "Ji Fan xiqing shezhang"
(Chi Fan Hsi-ch'ing she-chang) 寄范璽卿社
長 (Sent to Fan Hsi-ch'ing, the President of
[our] Poetry Guild). This poem, included
originally in Kung's *Ts'ao-hsiang t'ang chi*

**Kung Hsien** 龔賢
**Mountain Dwelling**
*continued*

74  草香堂集 (The Grass-fragrance Hall Anthology), is reprinted in Xiao Ping 蕭平 and Liu Yujia's 劉宇甲 *Kung Hsien* 龔賢, pp. 313–14. Kung's poem says:

Fifteen years ago, I made a call to display respect to my Elder,
[Whose] hair was as [shining] as the hair of a beautiful woman, and [whose] face as [fair] as a child.
In front of the table and on the altar at the lofty [poetry] guild,
Among the one hundred twenty poets, [you] were the distinguished champion.

十五年前曾拜翁,
髮如好女朱顏童.
秦淮大社壇坫上,
百二十人詩獨雄.

For more on Kung Hsien's poetry guild, see Hua Derong 華德榮, *Gong Xian yanjiu* (*Kung Hsien yen-chiu*) 龔賢研究 (A Study on Kung Hsien) (Shanghai: Renmin Meishu Chubanshe, 1988), pp. 6–7.

18  See note 14.

19  For more information on Li Tzu-ch'eng, see *Eminent Chinese of the Ch'ing Period (1644–1912)*, vol. 1, pp. 491–93.

20  Emperor Ssu-tsung's reign title was Ch'ung-chen 崇禎, and his given name was Chu Yu-chien 朱由撿 (1611–44). For more information on Emperor Ssu-tsung, see *Eminent Chinese of the Ch'ing Period (1644–1912)*, vol. 1, pp. 191–92.

21  Prince Fu's name was Chu Yu-sung 朱由崧 (?–1646). He was a grandson of the Ming emperor Shen-tsung 神宗 (r. 1573–1619). His father was killed by Li Tzu-ch'eng in Honan. After the fall of Peking in 1644, Chu Yu-sung ruled in Nanking for one year under the reign mark of Hung-kuang 弘光 (r. 1644–45). For his brief biography, see *Eminent Chinese of the Ch'ing Period (1644–1912)*, vol. 1, pp. 195–96.

22  For a brief biography of Ma Shih-ying (1591–1646), see *Eminent Chinese of the Ch'ing Period (1644–1912)*, vol. 1, p. 558. Juan Ta-ch'eng's 阮大鋮 (c. 1587–1646) biography can be found in the same book, pp. 398–99.

23  Ma Shih-ying and Yang Wen-ts'ung were both from the province of Kueichou 貴州; consequently, they established a close relationship.

24  The exact circumstances surrounding Kung Hsien's loss of family remain unclear. In one of his poems, entitled "Jiang zhi Guangling liubie Nanzhong zhuzi" (Chiang chih Kuang-ling liu-pieh Nan-chung chu-tzu) 將之廣陵留別南中諸子" (Before I Leave for Kuang-ling [Yang-chou] I Composed This Poem for My Many Friends in Nanking), he writes:

[Although] I longed for this adventurous trip,
My departure was indeed filled with sadness.
Earlier eight persons in my family all died;
My lonely body seems to belong to someone else.

壯遊雖我志,
此去實悲幸.
八口早辭世;
一身猶傍人.

This poem was originally included in Kung Hsien's *Ts'ao-hsiang t'ang chi* 草香堂集 (The Grass-fragrance Hall Anthology) and is reprinted in *Kung Hsien yen-chiu chi* 龔賢研究集 (Collected Research Materials on Kung Hsien), vol. 1, p. 13. Another poem Kung composed about this time is entitled "Shitoucheng" (Shih-t'ou Ch'eng) 石頭城 (The Stone City [Nanking]):

While the clear [Yangtze River] flows outside of the Stone City,
The inhabitants inside of the Stone City tread with anxiety.
Amid the cold gusts, how many of those gardens in the distance are still occupied [by their owner]?
In the day time, the abandoned chickens call from a lonely place.
From the ancient time, the [situation] was jumbled and chaotic.
Today, fortunately, there is no more war.
[I wonder whether] my past wife's old tomb still exists?
Standing at a forked road, [my] useless tears fall involuntarily and run down my face.

石頭城外江清流,
石頭城里人難行.
寒風遠圃幾家在,
白日荒雞一處鳴.
自昔已如遭喪亂,
到今猶幸未戈兵.
老妻故冢得見否,
歧路空催涕縱橫.

Evidently, Kung Hsien's first wife died before the Manchu invasion around 1644. This poem can be found in *Kung Hsien yen-chiu chi* 龔賢研究集 (Collected Research Materials on Kung Hsien), vol. 1, p. 51.

25  The name of this pro-Ming priest was Sheng Shang-jen 剩上人 (1611–59). His religious name Sheng literally means "remnant," while Shang-jen means "priest." This name indicates he was a remnant monk [of the Ming dynasty]. His secular name was Han Tsung-lai 韓宗騋, and he was also known as Han K'o-she 韓可舍. His *tzu* was Tsu-hsin 祖心 (the hearts of my ancestor). A native of Canton, Sheng Shang-jen was Kung Hsien's close friend, and Kung composed many poems for Sheng, nineteen of which are included in his anthology. For more information on this priest, see an anonymous Korean author, *Huang-ming i-min chuan* 皇明遺民傳 (Biographies of Remnants of The Emperor's Ming Dynasty), *chüan* 卷 (chapter) 7, p. 162b, reprint (Jiangsu Guangling Guji Keyinshe, 1991). The name of the town where Kung Hsien taught was Hai-an 海安 county in Taichou 泰州, and the name of his host was Hsü I 徐逸 (active mid-17th century). The information concerning Kung's tutoring is based on his poems composed when he was leaving Hai-an county. One of these is entitled "Hsü I from Hai-an Invited Me to Study for Five Years and [Now I Have] Come to Realize That It Is Time to Return to [Yangchou which Is Located in] the West. I Composed This Poem to Bid Farewell" (海上徐逸, 招余讀書五年. 偶憶西歸, 書此志別). Another poem by Kung listed next to the above poem is entitled "To Bestow a Poem When Departing from My Student, Hsü Ning" ( 留別弟子徐凝). Apparently, Hsü Ning was the son of Kung Hsien's host Hsü I. These two poems were originally found in Kung Hsien's anthology *Ts'ao-hsiang t'ang chi* 草香堂集 (The Grass-fragrance Hall Anthology), reprinted in *Kung Hsien yen-chiu chi* 龔賢研究集 (Collected Research Materials on Kung Hsien), vol. 1, p. 32.

26  Although Kung Hsien's anthology was recorded in many old bibliographies, it was thought that this anthology had disappeared. Fortunately, a hand-copied version was discovered in the Anhui Provincial Library about 1977 and was republished. The poems from this anthology are also reproduced in *Kung Hsien yen-chiu chi* 龔賢研究集 (Collected Research Materials on Kung Hsien), pp. 9–122. For more information on Kung's anthology, see Wang Shiqing's 汪世清 article, "Gong Xian de *Caoxiangtang ji* (Kung Hsien teh *Ts'ao-hsiang-t'ang chi*) 龔賢的草香堂集" (Kung Hsien's Anthology Entitled *The Grass-fragrance Hall*), *Wenwu* 文物 (Cultural Relics Magazine) (Beijing: Wenwu Chubanshe, May 1978), pp. 45–49.

27  Kung Hsien's poem entitled "Dangzi zhong-nian fuyoujia (Tang-tzu chung-nien fu-yu-chia) 蕩子中年復有家" (A Middle-aged Vagrant Once More Possesses a Family) explicitly expresses his joy over his new marriage. It says: "A middle-aged vagrant once more possesses a family. [The home's] humble gate [made of branches is located]

74

by a creek and near a hill. [My] newly married young wife [is so pretty that] I believe she might be a fairy. She has transplanted blossoms from heaven for me." (蕩子中年復有家, 柴門流水向山涯. 娶來小婦疑仙女, 為我移栽天上花.) The last sentence indicates that the young wife apparently gave birth to children. Kung Hsien had at least one son by his second wife. The son's name was Kung Chu 龔柱 (c. 1658–?). Kung Hsien's poem is originally found in his anthology, Ts'ao-hsiang t'ang chi 草香堂集 (The Grass-fragrance Hall Anthology) and is reprinted in Kung Hsien yen-chiu chi) 龔賢研究集 (Collected Research Materials on Kung Hsien), vol. 1, p. 81.

28 In 1662, the first year of the K'ang-hsi reign (1662–1722), Prince Chu Yu-lang 朱由榔 (1623–62), the last ruler of the Ming government-in-exile, was captured in Burma and later put to death by strangulation in Yunnan 雲南 province. Thus, the last legitimate Ming royal heir was eliminated. For more information on Chu Yu-lang, see Eminent Chinese of the Ch'ing Period (1644–1912), vol. 1, pp. 193–95. In that same year, Cheng Ch'eng-kung 鄭成功 (1624–62), the Chinese general who fought against the Manchus and made a base in Taiwan, died from an illness, and Chang Huang-yen 張煌言 (1620–64), a Chinese general who led a rebel army stationed in the southeast region, was arrested and executed. For more on Chang's activities, see Eminent Chinese of the Ch'ing Period (1644–1912), vol. 1, pp. 41–42. Meanwhile, the peasant army, known as the K'uei-tung shih-san-jia chün 夔東十三家軍 (The Thirteen Battalions from the East K'uei Area) was entirely defeated. Thus, by late in 1664, the year when Kung Hsien moved back to Nanking, the Chinese resistance to the Manchus had finally collapsed.

29 The Chinese text of Kung Hisen's colophon is transcribed as follows: "余家草堂之南, 餘地半畝, 稍有花竹, 因以名之, 不足稱園也! 清涼山上有臺, 亦名清涼臺. 登臺而觀, 大江橫於前, 鍾阜枕於後. 左有莫愁, 勺水如鏡. 右有獅嶺, 撮土若眉. 余家即在此臺之下. 轉身引客指視; 則柴門吠犬, 髣彿見之. 野賢紀." Kung 's colophon is included in Wang Hui's Ch'ing-hui tseng-yen 清暉贈言 (Words Presented to Ch'ing-hui [Wang Hui's hao, meaning "pure and bright"]), chüan 卷 (chapter) 3, reprint (Shanghai: Fen-yü lou Studio, 1911), pp. 6 a & b. Unfortunately, Wang Hui's painting depicting Kung Hsien's Half-acre Garden does not exist today.

30 Chung Shan 鍾山, or Mount Chung, is a small hill in Nanking where the first emperor of the Ming dynasty is buried. It seems that Kung Hsien deliberately described this hill as resembling a pillow, thus indicating Kung's head, probably as well as his mind, rested on the Ming court.

31 Lake Mo-ch'ou, literally meaning "no grief," is a small lake known for its scenic beauty. Based on the description in Kung's writing, the site of his home, although located away from the downtown section in Nanking, provided the perfect situation for a recluse-artist.

32 The Mount Lion Range is an area of small rolling hills located in the northwestern section of Nanking, near the city wall. It is not far from the bank of the Yangtze River and the entrance to the great modern bridge that spans across it.

33 Kung says, "I remember that I could paint by age thirteen. Yet it was not until my fifties that I dedicated myself to painting." See note 14.

34 The Chinese text of Kung Hsien's inscription is transcribed as follows: "十年前, 余游于廣陵. 廣陵多賈客, 家藏巨蹟者, 其主人具鑒賞, 必蓄名畫. 余最厭造其門, 然觀畫則稍柔順. 一日, 堅欲盡其篋笥. 每有當意者, 歸來則百遍摹之. 不得其梗概不止." Kung's inscription originally appears on the two leaves at the end of his Twenty-four Large Album Leaves, dated 1676 and currently at the Shanghai Municipal Museum. Painted by Kung Hsien when he was fifty-seven years old, this set of album leaves is considered a masterpiece. For a reproduction of Kung Hsien's twenty-four album leaves see Group for the Authentication of Ancient Works of Chinese Painting and Calligraphy, ed., Zhongguo gudai shuhua tumu (Chung-kuo ku-tai shu-hua t'u-mu) 中國古代書畫圖目 (Illustrated Catalogue of Selected Works of Ancient Chinese Painting and Calligraphy), vol. 4 (Shanghai: Wenwu Chuban-she, 1990), no. 滬 1-2569, 1–24, pp. 274–79. Kung Hsien's inscription is not reproduced in this book. For the reproduction of Kung's inscription, see Kung Hsien yen-chiu chi 龔賢研究集 (Collected Research Materials on Kung Hsien), vol. 2, attachment no. 1 to pls. 84–107.

35 This long handscroll at the Nelson Gallery-Atkins Museum is considered one of Kung Hsien's finest extant works. The Chinese text of Kung Hsien's poem-inscription follows:

山水董源稱鼻祖. 范寬 僧巨繩其武.
復有營丘與郭熙. 支分 派別翻新譜.
襄陽米芾更不然. 氣可 食牛力如虎.
友仁傳法高尚書. 畢竟 三人異門戶.
後來獨數倪黃王. 孟端 石田抗今古.
文家父子唐解元. 少真 多贗休輕侮.
吾生及見董華亭. 二李 惲鄒尤所許.
晚年酷愛兩貴州. 筆聲 墨態能歌舞.
我于 此道無所知. 四十 春秋茹荼苦.

友人索畫雲峰圖. 藹苔 蓮花相競吐.
凡有 師承不敢忘. 因之 一一書名甫.

36 Tung Yüan was a great master from Nanking active during the Five Dynasties (907–60) period. He is considered one of the founders of the so-called Southern school. Kuo Jo-hsü 郭若虛 (active mid-9th century) asserted: "Tung Yüan's tzu was Shu-ta 叔達 (an uncle who takes things philosophically). He was a native of Nanking and served at the court of the Southern T'ang dynasty (923–34) as the deputy commissioner of the imperial garden. He was adept in painting landscapes. While his brushwork was similar to that of Wang Wei (701–61), his coloring scheme was close to that of Li Ssu-hsün (653–718). He was also known for his buffalo and tiger paintings." (董源, 字叔達. 鍾陵人. 事南唐, 為後苑副使. 善畫山水. 水墨類王維. 著色如李思訓. 兼工畫牛虎.) See Kuo's Tuhua jianwenzhi (T'u-hua chien-wen-chih) 圖畫見聞誌 (A Record of Experiences in Painting), completed c. 1075, juan (chüan) 卷 (chapter) 3, reprinted in Hua-shih ts'ung-shu 畫史叢書 (Compendium of Painting History), vol. 1, p. 37. In addition, Hsia Wen-yen 夏文彥 (active mid-14th century) asserted: "The trees and rocks in [Tung Yüan's landscapes] are elegant and luxuriant. The peaks and rolling ranges are clear and profound, possessing the very essence of mountains. [His painting was] naive, natural, and unrestrained, with an exalted and classical flavor. His dragons and bodies of water were all eminently wonderful. Some of his rocks bear hemp textures, while others are colored; while the textures are sparse, the colors are rich and of classic beauty. [He] often applied red and blue pigments on the figures [in his painting] and white powder on their faces; all were superb works." (樹石幽潤, 峰巒清深, 得山之神氣. 天真爛漫, 意趣高古. 兼工龍水, 無不臻妙. 其山石, 有作麻皮皴者, 有著色. 皴紋甚少, 用色穠古. 人物多用青紅衣, 人面亦用粉素. 皆佳作也.) See Hsia's T'u-hui pao-chien 圖繪寶鑑 (Precious Mirror of Painting), preface dated 1365, juan (chüan) 卷 (chapter) 3, reprinted in Hua-shih ts'ung-shu 畫史叢書 (Compendium of Painting History), vol. 3, pp. 47–48. Extant landscape paintings attributed to Tung Yüan are 1) Lung-su chiao-min t'u 龍宿郊民圖 (The Dragon Sojourning amid the Suburbanites) at the National Palace Museum, Taipei, reproduced in Ku-kung shu-hua t'u-lu 故宮書畫圖錄 (Illustrated Catalogue of Calligraphy and Painting at the Palace Museum), vol. 1 (Taipei: National Palace Museum, 1993), p. 77; 2) handscroll entitled Xiao Xiang tu (Hsiao-Hsiang t'u) 瀟湘圖 (The Hsiao and Hsiang Rivers) at the Palace Museum, Beijing. It is reproduced in Palace Museum Editorial Committee, Gugong bowuyuan

**Kung Hsien** 龔賢

**Mountain Dwelling**

*continued*

76  *canghuaji* (*Ku-kung po-wu-yüan ts'ang-hua chi*) 故宮博物院藏畫集 (Paintings in the Collection of the Palace Museum) in the series *Zhongguo lidai huihua* (*Chung-kuo li-tai hui-hua*) 中國歷代繪畫 (Paintings of the Past Dynasties), vol. 1 (Beijing: Ren-min Meishu Chubanshe), pp. 98–100; 3) handscroll entitled *Xiajing shankou daidu tu* (*Hsia-ching shan-k'ou tai-tu t'u*) 夏景山口待渡圖 (A Summer Landscape of Waiting for the Ferry at the Entrance of Mountains) at the Liaoning Museum, reproduced in Group for the Authentication of Ancient Works of Chinese Painting and Calligraphy, ed., *Zhongguo gudai shuhua tumu* (*Chung-kuo ku-tai shu-hua t'u-mu*) 中國古代書畫圖目 (Illustrated Catalogue of Selected Works of Ancient Chinese Painting and Calligraphy), vol. 15 (Beijing: Wenwu Chubanshe, 1997), no. 遼 1-015, pp. 20–21.

37  Fan K'uan was a great master from Hua-yüan, present-day Yao-hsien 耀縣 county in Shensi 陝西 province. Fan was considered one of the founders of the Northern school. Kuo Jo-hsü asserted: "Fan K'uan's *tzu* was Chung-li (standing in the middle). He was a native of Hua-yüan. Adept in painting landscapes, [he] thoroughly understood the principles and comprehended the essence [of nature]. [His] unusual skill was unmatched in the world. Although stylistically different from that of Kuan T'ung (active c. 907–23) and Li Ch'eng (c. 919–67), the rules and forms of his work rival that of these two painters. Fan K'uan's old-fashioned demeanor was solemn, while his poise was aloof and rustic. He was fond of wine and was fascinated by the teachings of Taoism. He used to travel between the Yung (an area between present-day Shensi 陝西, Kansu 甘肅, and Ch'inghai 青海 provinces) and Lo (present-day Lo-yang 洛陽 in Honan 河南 province) regions. He was still alive during the T'ien-sheng reign (1023–31). Many of the venerable seniors knew him. . . . It is said that his name [originally] was Chung-li. He was called Fan K'uan (Fan, the broad-[minded]) because his personality was lenient and genial." (范寬, 字中立, 華原人. 工畫山水, 理通神會, 奇能絕世. 體與關李特異, 而格律相抗. 寬儀狀峭古, 進止疏野. 性嗜酒好道. 嘗往來雍雒間. 天聖中猶在, 耆舊多識之 . . . 或云名中立. 以其性寬, 故人呼為范寬也.) See Kuo's *T'u-hua chien-wen-chih* 圖畫見聞誌 (A Record of Experiences in Painting), *chüan* 卷 (chapter) 4, reprinted in *Hua-shih ts'ung-shu* 畫史叢書 (Compendium of Painting History), vol. 1, p. 51. Hsia Wen-yen claimed: "Fan K'uan was also known as [Fan] Chung-cheng and his *tzu* was Chung-li. From Huan-yüan, he had a genial disposition, was fond of wine,

and was unconventional and uninhibited. [People] called him K'uan because he was generous and tolerant. In painting landscapes, at the beginning, he followed [the style of] Li Ch'eng and then Ching Hao (active c. 870–c. 930). [Fan K'uan] liked to execute dense thickets on the mountain tops and large boulders by the water. Finally, he lamented: 'I would rather model myself after nature than study with a teacher.' Thus, he discarded his old practice and lived in the Chung-nan and T'ai-hua Mountains. [There] he viewed all the extraordinary scenic places, and his brush-work became forceful and skillful, truly representing the structure of a mountain. [He could then] keep abreast of Kuan T'ung and Li Ch'eng. In [Fan's] late years, he applied excessive ink, and the rocks and clay masses [in his paintings] are difficult to distinguish." (范寬, 一作中正, 字中立, 華原人. 性溫厚, 嗜酒落魄, 有大度, 人故以寬名之. 畫山水, 始師李成. 又師荊浩. 山頂好作密林, 水際作突兀大石. 既乃嘆曰, '與其師人, 不若師諸造化.' 乃捨舊習, 卜居終南, 太華. 偏觀奇勝. 落筆雄威老硬, 真得山骨. 而與關李並馳方駕也. 晚年用墨太多, 土石不分.) See Hsia's *T'u-hui pao-chien* 圖繪寶鑑 (Precious Mirror of Painting), *chüan* 卷 (chapter) 3, reprinted in *Hua-shih ts'ung-shu* 畫史叢書 (Compendium of Painting History), vol. 3, p. 48. The best example of Fan K'uan's work, a magnificent large hanging scroll entitled *Hsi-shan hsing-lü* 谿山行旅 (Travelers amid Streams and Mountains), at the National Palace Museum, Taipei, is reproduced in Wen C. Fong and James C. Y. Watt, *Possessing the Past: Treasures from the National Palace Museum, Taipei* (New York: Metropolitan Museum of Art, and Taipei: National Palace Museum, 1996), pl. 59, p. 126. The monk Chü-jan mentioned in Kung Hsien's colophon was a follower of Tung Yüan. Kuo Jo-hsü asserted: "Monk Chü-jan, who was from Nanking, was proficient in painting landscapes. His brushwork and ink washes are elegant and lush. He was good at depicting the appearance of misty and cloudy hills, as well as scenes with high and distant mountains and rivers. However, [depicting] woods and trees were not his strengths." (鍾陵僧巨然, 工畫山水. 筆墨秀潤, 善為煙嵐氣象, 山川高曠之景. 但林木非其所長.) See Kuo's *T'u-hua chien-wen-chih* 圖畫見聞誌 (A Record of Experiences in Painting), *chüan* 卷 (chapter) 4, reprinted in *Hua-shih ts'ung-shu* 畫史叢書 (Compendium of Painting History), vol. 1, p. 55. One work attributed to Chü-jan at the National Palace Museum, Taipei, entitled *Ch'iu-shan wen-tao* 秋山問道 (Seeking Taoism in the Autumn Mountains) is reproduced in *Ku-kung shu-hua t'u-lu* 故宮

書畫圖錄 (Illustrated Catalogue of Calligraphy and Painting at the Palace Museum), vol. 1 (Taipei: National Palace Museum, 1993), p. 93. Another hanging scroll at the Cleveland Museum of Art, entitled *Hsi-shan lan-jo* 谿山蘭若 (Buddhist Retreat by Stream and Mountain) is reproduced in Wai-kam Ho 何惠鑑 et al., *Eight Dynasties of Chinese Paintings: The Collections of the Nelson Gallery-Atkins Museum, Kansas City, and the Cleveland Museum of Art* (Cleveland: Cleveland Museum of Art, 1980), cat. no. 11, p. 16.

38  Ying-ch'iu was the *hao* of Li Ch'eng (c. 919–67), one of the pioneers of landscape painting. Kuo Jo-hsü stated: "Li Ch'eng's *tzu* was Hsieh-hsi, meaning "all are splendid and intelligent." His ancestors were related to the imperial family of the T'ang dynasty (618–905). In order to escape calamity, the Li family moved to Ying-ch'iu [an area between present-day Zhibo 淄博 and Changle 昌樂 counties in Shantung 山東 province]. Li's forefathers were well known for their efforts in pursuing scholarly studies and civil service appointments. Yet Li Ch'eng was determined instead to live a quiet and peaceful life and to avoid the glorious and affluent [government] positions. In addition to extensive studies of history and the classics, he was especially adept in painting landscapes. His wintry forests were as clever as divine manifestations and were far superior to anyone else's depictions. During the K'ai-pao reign (964–68), the princes, dukes, and other nobility in the capital often sent him invitations; [however], Li Ch'eng usually never responded. [The purpose of] his learning and [painting skill] were to entertain himself, not to amuse other people. Later, he traveled to Huai-yang [present-day Hui-yang in eastern Honan 河南 province] and died due to an illness in the fifth year of the Ch'ien-teh reign (963–67) (李成, 字咸熙. 其先唐宗室, 避地營丘, 因家焉. 祖父皆以儒學吏事聞於時. 至成, 尚沖寂. 高謝榮進. 博涉經史外, 尤善山水. 寒林神化精靈, 絕人遠甚. 開寶中, 都下王公貴戚, 屢馳書延請, 成多不答. 學不為人, 自娛而已. 後遊淮陽, 以疾終於乾德五年.) See Kuo's *T'u-hua chien-wen-chih* 圖畫見聞誌 (A Record of Experiences in Painting), *chüan* 卷 (chapter) 4, reprinted in *Hua-shih ts'ung-shu* 畫史叢書 (Compendium of Painting History), vol. 1, p. 37. Kuo evidently made a mistake concerning the dates of Li Ch'eng's life. If Li died in 967, the fifth year of Ch'ien-teh, he could

not have been invited to go to the capital during the K'ai-pao reign, which was after the Ch'ien-teh reign. Apparently one of these two reign marks is wrong. Due to Li Ch'eng's great fame, his work was already rare during the early twelfth century. Today the best example attributed to this great master is a large landscape hanging scroll at the Nelson-Atkins Museum, Kansas City, entitled *Ch'ing-luan hsiao-ssu* 晴巒蕭寺 (A Solitary Temple amid Clearing Peaks). It is reproduced in *Eight Dynasties of Chinese Paintings: The Collections of the Nelson Gallery-Atkins Museum, Kansas City, and the Cleveland Museum of Art*, cat. no. 10, p. 14. The second Sung painter mentioned is Kuo Hsi. In Kuo Jo-hsü's *T'u-hua chien-wen-chih*, Kuo states: "Kuo Hsi was a native of Wen county in Hoyang district [present-day Wen county located on the north bank of the Yellow River in northern Honan province]. Kuo presently [the author's lifetime, c. the reigns of Emperor Shen-tsung 神宗 (r. 1068–85) and Emperor Che-tsung 哲宗 (r. 1086–1100)] serves as an artist at the Imperial Art Academy. He was especially accomplished in painting landscapes and wintry forests. His execution is skillful and expressive, while his layout is profound and precipitous. Although he admired and imitated Ying-ch'iu (Li Ch'eng), he could deliver the ideas in his own mind. [The more one views his paintings] on the many large screens as well as on the high walls, the more one feels the grandeur of his [work]. At present, no other painter can equal him!" (郭熙, 河陽溫人. 今為御書院藝學. 工山水寒林, 施為巧贍, 位置淵深. 雖復學慕營丘, 亦能自放胸臆. 巨障高壁, 多多益壯. 今之世為獨絕矣!) See Kuo's *T'u-hua chien-wen-chih* 圖畫見聞誌 (A Record of Experiences in Painting), *chüan* 卷 (chapter) 4, reprinted in *Hua-shih ts'ung-shu* 畫史叢書 (Compendium of Painting History), vol. 1, p. 54. The best example of Kuo Hsi's work, entitled *Tsao-ch'un t'u* 早春圖 (Early Spring) and dated 1072, is at the National Palace Museum, Taipei. It is reproduced in Wen C. Fong and James C. Y. Watt, *Possessing the Past: Treasures from the National Palace Museum, Taipei* (New York: Metropolitan Museum of Art, and Taipei: National Palace Museum, 1996), pl. 60, p. 129.

39 Teng Ch'un 鄧椿 (active 12th century) states: "The bohemian scholar Mi Fu was from Hsiang-yang and his *tzu* was Yüan-chang [meaning 'the original order or constitution']. Mi once stated: 'the character *fu* [of my name] can also be written as *fu*.' Since that time on, he adopted *fu* as his given name. His ancestors were from the city of T'ai-yüan [in Shansi 山西 province]. Later the Mi family moved to the Wu area [present-day Suchou 蘇州]. When Empress Hsüan-jen Sheng-lieh [literally meaning 'the sacred and chaste empress who proclaims righteousness,' the posthumous title of the wife of Emperor Shen-ts'ung 神宗 who reigned from 1068–85] was still a maiden, Mi Fu's mother was her nanny. Later, due to this old relationship, Mi Fu was appointed to the official position of collating book commissioner. He was then promoted to extensive learned scholar of painting and calligraphy and often summoned [by the ruler] to the imperial living quarters [to discuss art]. After being transferred to be the chief secretary of the Ministry of Rites, due to the harsh language in his memorial to the throne, he was demoted to head the army stationed in the Huai-yang area [present-day northern Kiangsu 江蘇 and Anhui 安徽 regions]. Mi Fu was known for his unrestrained lifestyle. He usually wore a costume of the T'ang period, and his associates were all celebrities of his time." (襄陽漫士米黻, 字元章. 嘗自述云: "黻即芾也, 即作芾. 世居太原, 後徙於吳. 宣仁聖烈皇后在藩, 其母出入邸中. 後以舊恩, 遂補校書郎. 復入為書畫學博士, 賜對便殿. 擢禮部員外郎, 以言罷知淮陽軍. 芾人物蕭散, 被服效唐人. 所與遊皆一時名士.) See Teng Ch'un's 鄧椿 *Huaji* (*Hua-chi*) 畫繼 (Sequel to Painting [a book discussing painters and paintings between 1070 and 1160]), preface dated 1167, *juan* (*chüan*) 卷 (chapter) 2, reprinted in *Hua-shih ts'ung-shu* 畫史叢書 (Compendium of Painting History), vol. 1, pp. 13–14. Mi Fu was also famous for his expertise in connoisseurship and was considered a master calligrapher. However, his unique painting style, which utilized ink dots, is perhaps his most important and influential accomplishment. There is a passage in Chao Hsi-ku's 趙希鵠 (active c. second half of 12th century) essay entitled "Tung-t'ien ch'ing-lu chi 洞天清祿集" (Pure Happiness in a Taoist Grotto) concerning Mi Fu. Chao, who lived about two generations later than Mi, stated: "Mi Nan-kung [Mi Fu's *hao*, meaning 'southern palace,' which was a reference to Mi's official position] traveled and moved frequently. When he chose a site for his home, he always preferred a scenic spot with beautiful mountains and rivers. At the beginning, he could not paint. Later, after viewing [so much scenery,] he started to paint after the real landscape and [eventually] attained the essence of nature. He considered paint-ing as 'ink play.' In addition to brushes, he often executed his painting with rolled paper, stalks of chewed sugarcane, or even the tissue of a lotus pod. He did not use glue or alum to seize the surface of his paper and never painted on silk. The works attributed to Mi on silk we witness today are all by later artists. Mi and his son would not do this [use silk]." (米南宮多遊江湖. 每卜居, 必擇山水明秀處. 其初, 本不能畫. 後以目所見, 日漸模仿之, 遂得天趣. 其作墨戲, 不專用筆. 或以紙筋, 或以蔗滓, 或以蓮房, 皆可為畫. 不用膠礬, 不肯於絹上作一筆. 今所見米畫, 或用絹, 皆後人偽作. 米父子不如此.) Chao Hsi-ku's essay is reprinted in Teng Shih 鄧實 (1865?–1948?) and Huang Pin-hung 黃賓虹 (1865–1955), comp., *Mei-shu ts'ung-shu* 美術叢書 (Anthology of Writings on Fine Art) (Shanghai: n.p., 1912–36), *chi* 集 (division) 1, *chi* 輯 (collection) 9, reprinted in vol. 5 (Taipei: I-wen Press, 1963–72), p. 272. For more information on Mi Fu, see Lothar Ledderose, *Mi Fu and the Classical Tradition of Chinese Calligraphy* (Princeton: Princeton University Press, 1979). A hanging scroll attributed to Mi Fu at the Freer Gallery, Washington, D.C., entitled *Yün-ch'i lou t'u* 雲起樓圖 (Picture of a Pavilion Surrounded by Clouds [often listed in English as *Grassy Hills and Leafy Trees in Mist*]) is reproduced in Sherman E. Lee, *A History of Far Eastern Art* (New York: Harry N. Abrams, 1964), fig. 454, p. 349.

40 Mi Yu-jen was considered a child prodigy. Teng Ch'un (active 12th century) stated: "Mi Yu-jen was Mi Fu's son. During the Hsüan-ho reign (1119–25), he served as the deputy mayor of Ta-ming [present-day Beijing]. Endowed with extraordinary natural gifts, he did not have to learn or practice the established styles and rules of painting. He dotted his mists and clouds in a cursory manner, finishing them without losing [a sense of their] naturalness. [His work is] stylistically related to the work of his father. [Mi Yu-jen] often inscribed his works with the term ink play. Emperor Kao-tsung (r. 1127–62) recognized Mi Yu-jen's talent and commissioned him as the deputy minister of the Board of Works. [Later, he was also] appointed an imperial scholar and served at the Fu-wen (Literary Advocating) Pavilion. Day after day, he attended the ruler's carefree, leisurely banquets. Before Mi Yu-jen became eminent, scholar-officials were easily able to acquire his work. However after he became prominent, he guarded his paintings as if they were hidden treasures. Even his longtime close associates could not obtain his work. . . . He lived to his eighties, and his mind and sense were still as clear as when he was a young man. He died of natural

Kung Hsien 龔賢
Mountain Dwelling
*continued*

78 causes. (米友仁, 元章之子也. 宣和中, 為大名少尹. 天機超逸, 不事繩墨. 其所作 山水, 點滴煙雲, 草草而成, 而不失天真. 其風氣肖乃翁也. 每自題其畫曰:"墨戲." 被遇 光堯, 官至工部侍郎, 敷文閣直學士. 日奉清閑之燕. 方其未遇之時, 士大夫往往可得 其筆. 既貴, 甚自秘重. 雖親舊間, 亦無緣得之.... 後享年八十, 神明如少壯時. 無疾而逝.) See Teng's *Hua-chi* 畫繼 (Sequel to Painting), *chüan* 卷 (chapter) 2, reprinted in *Hua-shih ts'ung-shu* 畫史叢書 (Compendium of Painting History), vol. 1, p. 19. The best example of Mi Yu-jen's work is a short handscroll at the Cleveland Museum of Art entitled *Yün-shan t'u* 雲山圖 (Cloudy Mountains). It is reproduced in *Eight Dynasties of Chinese Paintings: The Collections of the Nelson Gallery-Atkins Museum, Kansas City, and the Cleveland Museum of Art*, pl. 24, pp. 43–44. "Kao, the Minister" in Kung Hsien's colophon refers to Kao K'o-kung. Hsia Wen-yen claimed: "Kao's *tzu* was Yen-ching (elegant reverence) and his *hao*, Fang-shan (a house in the mountains). His ancestor was [originally] from Chinese Turkistan who later settled down in Yan-ching [present-day Peking]. Kao's highest official title was minister of justice. He was an accomplished landscape painter. At first, he followed the painting style of the two Mis [Mi Fu and Mi Yu-jen]. Later, he imitated [the works of] Tung Yüan and Li Ch'eng. Kao's ink bamboo was after the style of Huang-hua [Wang T'ing-yün 王庭筠 c. 1151–1202, a famous literati painter of the Chin dynasty 1115–1234.] Kao's bamboo was unique, [executed in a manner] that evoked meaning. The jagged and grotesque shaped rocks [amid] bellowing waves and banks with rushing currents as well as the way he controlled the ink splashes and washes are rarely matched by other artists." (高克恭, 字彥敬, 號房 山. 其先 西域人, 後居燕京. 官刑部尚書. 善山水. 始師二米, 後學董源, 李成, 墨竹學黃華. 大有思致 怪石噴浪, 灘渭水口, 烘鎖潑染, 作者鮮及.) See Hsia's *T'u-hui pao-chien* 圖繪寶鑑 (Precious Mirror of Painting), *chüan* 卷 (chapter) 3, reprinted in *Hua-shih ts'ung-shu* 畫史叢書 (Compendium of Painting History), vol. 5, p. 138. The best example of Kao's work is a hanging scroll entitled *Kao-shan pai-yün* 高山白雲 (Verdant Peaks above the Clouds), currently at the National Palace Museum, Taipei. It is reproduced in *Ku-kung shu-hua t'u-lu* 故宮書畫圖錄 (Illustrated Catalogue of Calligraphy and Painting at the Palace Museum), vol. 4, p. 21.

41 Three masters of the Yüan dynasty are referred to in this line. For a discussion of these three painters, see Maxwell K. Hearn, "The Artist as Hero," in Wen C. Fong and James C. Y. Watt, *Possessing the Past: Treasures from the National Palace Museum, Taipei* (New York: Metropolitan Museum of Art, and Taipei: National Palace Museum, 1996), pp. 299–323.

42 Hsü Ch'in 徐沁 (active first half of 17th century) stated: "Wang Fu's *tzu* was Meng-tuan (eminent and upright) and his *hao* included Yu-shih (friend of stone) and Chiu-lung shan-jen (mountain-dweller at Mt. Nine-dragon [in Wu-hsi]). From Wu-hsi [in Kiangsu province] his official title was Chung-shu she-ren (Scholar of the Central Drafting Office). During the Yung-lo reign (1403–24), he was well known for his ink bamboo painting." (王紱, 字孟端, 號友石, 別 號九龍山人. 無錫人. 官中舍. 永樂間, 以墨竹名天下.) See Hsü Ch'in, *Minghualu* 明畫錄 (Painters of the Ming Dynasties), *juan* (*chüan*) 卷 (chapter) 7, reprinted *Hua-shih ts'ung-shu* 畫史叢書 (Compendium of Painting History), vol. 5, p. 92. Besides his ink bamboo, Wang Fu was also known for his landscape painting, which is stylistically related to the works of the literati painters of the prior Yüan dynasty. As a prominent scholar-artist, Wang was one of the early Ming painters who acted as a bridge between the two dynasties. His work directly influenced later painters, especially those of the Wu school. His most famous landscape is entitled *Shan-t'ing wen-hui* 山亭文會 (A Literary Gathering at a Mountain Pavilion). His most famous ink bamboo is entitled *Ch'i-wei t'u* 淇渭圖 (A Picture of the [Bamboo] by the Ch'i and Wei [Rivers]). Both works are at the National Palace Museum, Taipei, and are reproduced in *Ku-kung shu-hua t'u-lu* 故宮書畫圖錄 (Illustrated Catalogue of Calligraphy and Painting at the Palace Museum), vol. 6, p. 35 and p. 55, respectively. For more information on Wang Fu, see Sung Hou-mei, "Wang Fu and the Formation of the Wu School" (Ph.D. dissertation, Case Western Reserve, 1984). See also Kathlyn Lannon Liscomb, "Wang Fu's Contribution to the Formation of a New Painting Style in the Ming Dynasty," *Artibus Asiae*, 49.1/2 (New York: Institute of Fine Arts, New York University, 1988–89), pp. 127–52. For information on Shen Chou, see entry 4.

43 For more information on Wen Cheng-ming and his son, Wen Chia, see entry 7. T'ang Yin was a contemporary and friend of Wen Cheng-ming. Gifted with innate talent, T'ang lived a romantic and unrestrained life, inundated with wine and women. Nevertheless, he was truly accomplished in poetry, calligraphy, and painting. For more information on T'ang Yin, see T. C. Lai, *T'ang Yin: Poet-Painter (1478–1524)* (Hong Kong: Kelly and Walsh, 1971). For examples of T'ang Yin's work, see James Cahill, *Parting at the Shore: Chinese Painting of the Early and Middle Ming Dynasty, 1368–1580* (New York and Tokyo: Weatherhill, 1978), pls. 90–94, pp. 74–78.

44 In this line, the family names of six later painters are mentioned. The two Lis refer to Li Liu-fang 李流芳 and Li Chou-sheng 李周生. Hsü Ch'in asserts: "Li Liu-fang's *tzu* was Ch'ang-heng (lasting fragrant plant). From Ch'ang-shu [in Kiangsu province], he succeeded in the local civil service examination [and thus earned a *hsiu-ts'ai* 秀才 degree]. He was adept in poetry and essay writing, and his calligraphy was after the style of Su Shih (1036–1101). Although his landscape painting contains the styles of many Sung and Yüan masters, he was especially skilled in emulating the work of Wu Chung-kuei (Wu Chen 吳鎮, 1280–1354). Li Liu-fang's flower painting, including bamboo and rocks, is lively, elegant, and dynamic." (李流芳, 字長蘅, 常熟 人. 登鄉薦, 工詩文. 書法蘇東坡. 畫山水, 出入宋元諸家, 而于 吳 仲圭, 尤為精詣. 竹石花卉, 逸氣飛動.) See Hsü Ch'in's *Ming-hua lu* 明畫錄 (Painters of the Ming Dynasty), *juan* (*chüan*) 卷 (chapter) 5, reprinted in *Hua-shih ts'ung-shu* 畫史叢書 (Compendium of Painting History), vol. 5, p. 59. Li Liu-fang was a close friend of Tung Ch'i-ch'ang who was Kung Hsien's teacher. Kung admired Li and on one of his paintings openly admitted that his *huang-liu* 荒柳, or "desolate willow trees," were actually after those in Li Liu-fang's work. Kung painted several such works, and on each one he made the same assertion. On one hanging scroll, Kung wrote: "After Li Ch'ang-heng's *Huang-liu t'u*." (摹李長蘅 "荒柳圖".) This work is reproduced in *Kung Hsien yen-chiu chi* 龔賢研究集 (Collected Research Materials on Kung Hsien), vol. 2, pp. 153–52. Its whereabouts are unclear. Based on the imprecise brushwork of this scroll, it seems that the painting belongs to Kung Hsien's early works. In his *Hua-chüeh* 畫訣 (Secret Painting Formula), Kung also asserts: "It is most difficult to paint willow trees. I attained the skill from Li Ch'ang-heng." (畫柳最不易, 余得之李長蘅.) See Kung Hsien's *Hua-chüeh*, reproduced in Chen Xizhong 陳希仲, ed., *Gong Banqian shanshuihua ketugao (Kung Pan-ch'ien shan-shui-hua k'o-t'u-kao)* 龔半千山水畫課徒稿 (Kung Hsien's Landscape Painting Models for Tutoring Students) (Chengdu: Sichuan Renmin Chubanshe, 1981), pp. 56–62. The entry concerning the skill of painting willow trees is found on p. 58. Interestingly, on an album leaf by Kung, he also hesitated by saying: "While it is true that my 'desolate willow trees' are after those by Li

Ch'ang-heng, the same type of trees I viewed in Li's work do not meet my criterion. Could this be because my trees are now better than his? From now on, I will carefully search and study all the desolate willow trees by Li Ch'ang-heng I can find." (余 "荒柳," 實師李長蘅. 然後來所見長蘅 "荒柳" 皆不滿意. 豈余反過之耶？而今後, 仍 欲痛索長蘅 "荒柳圖" 一見.) This inscription is found on an album leaf by Kung Hsien belonging to a set of leaves currently in a private collection in the United States. See note 14. The leaf bearing Kung's comment is reproduced in *Kung Hsien yen-chiu chi* 龔賢研究集 (Collected Research Materials on Kung Hsien), vol. 2, pl. 154-1. Li Yung-ch'ang, although not as well known as Li Liu-fang, was a founder of the Hsin-an school. Chiang Shao-shu 姜紹書 (active 1635–80) stated: "Li Yung-ch'ang's *tzu* was Chou-sheng (a scholar of the Chou state), and he was from Hsin-an [in Anhui province]. He possessed an elegant and dignified demeanor. He was deft at painting and calligraphy. Li's calligraphy, which emulates Tung Ch'i-ch'ang, is as good as that of Wu Ch'iao (*tzu* of Wu I 吳易, active late 16th to early 17th century). Li executed his painting, which is full of literati flavor, in the style of the Yüan dynasty. Coming from a wealthy family, Li had an active social life." (李永昌, 字周生. 新安人. 儀觀都雅, 工書畫. 書宗董華亭, 可與吳翹相 伯仲. 畫仿元人, 饒有士氣. 家固素封, 而亦好 事.) See Chiang's *Wusheng shishi* (*Wu-sheng-shih shih*) 無聲詩史 (A History of Voiceless Poems), preface dated 1720, *juan* (*chüan*) 卷 (chapter) 4, reprinted in *Hua-shih ts'ung-shu* 畫史叢書 (Compendium of Painting History), vol. 4, pp. 76–77. The third painter in this line, Yün Tao-sheng, was also known as Yün Hsiang 惲向 and Yün Pen-ch'u 惲本初. Different early sources provide different information concerning his given name and sobriquets. Chang Keng 張庚 (1685–1760) stated: "Yün Pen-chu's *tzu* was Tao-sheng (the way is born), who later changed his name to Hsiang. His *hao* was Hsiang-shan (fragrant mountain), and he was from Wu-chin. Familiar with the *Five Classics*, he was a well-known learned scholar. During the Ch'ung-chen reign (1628–44), the government invited honest scholars with high moral standards to serve. Although Yün was recommended to be scholar of the Central Drafting Office, he refused. Yün was an accomplished landscape painter and followed the styles of Tung Yüan and Chü-jan. He executed his painting with the center tip of his brush while his wrist was sustained in the air. Using dense and flowing ink, he structured brushstrokes that are rounded and imposing, smooth and powerful. These strokes, saturated in ink, are

bold and unhindered; they possess personal characteristics. In his later years, he concentrated on the styles of Ni Tsan (1306–1374) and Huang Kung-wang (1269–1354). Sung Man-t'ang (*hao* of Sung Lo 宋犖, 1634–1713) once stated: 'Hsiang-shan (*hao* of Yün Hsiang) painted in two different styles. One, derived from Tung Yüan, is powerful and imposing. He completed this type of painting in his earlier years. In the other style, he utilizes sparse brushwork; it is as if he valued ink like gold. Such paintings are elegant with a [desolate] magnitude, and [Yün] attempted to create an atmosphere between that of Ni Tsan's and Huang Kung-wang's works.' These are truly pertinent comments." (惲 本初, 字道生, 後改名向. 號香山, 武進人. 明 經, 博學有文名. 崇禎間, 舉賢良方正, 授中書 舍人, 不拜. 工山水, 學董巨二家法. 懸筆中 鋒, 骨力圓勁, 而用墨濃濕, 縱橫淋漓. 自成一 派. 晚乃斂筆於倪黃. 宋漫堂云: '香山畫有二 種; 一種氣厚力沉, 全學董源, 為早年筆. 一種 惜墨如金, 脩然自適, 意興 在倪黃之間. 晚年 筆也.' 斯言得之.) See Chang Keng's *Kuo-ch'ao hua-cheng lu* 國朝畫徵錄 (Biographical Sketches of the Artists of the Ch'ing Dynasty), preface dated 1739, *juan* (*chüan*) 卷 (chapter) 1, reprinted in *Hua-shih ts'ung-shu* 畫史叢書 (Compendium of Painting History), vol. 5 (Shanghai: Ren-min Meishu Chubanshe, 1962), pp. 10–11. The artist Tsou mentioned in Kung Hsien's colophon is probably Tsou Chih-lin 鄒之麟 (active first half of 17th century). Hsü Ch'in remarked: "Tsou Chih-lin's *tzu* was Ch'en-hu (to be a servitor of a tiger) and his *hao*, I-pai 衣白 (to attire in white). He was from Wu-chin [in Kiangsu province]. After achieving his *chin-shih* degree, his highest official position was circuit intendant. Deft in poetry, he painted landscapes with free and untrammeled movement. [In his work, one finds] elegance amid rustic atmospheres. He was especially skillful in painting with scorched (extremely dark and thick) ink, and the overall style of his work is refined. Able to surpass the traditional and ordinary artist, Tsou is qualified to be considered a master." (鄒之麟, 字臣虎, 號白 衣. 武進人. 由進士, 官至觀察. 工詩, 所作山 水, 縱筆自如. 蒼莽中, 具有逸氣. 善用焦墨. 氣韻標格, 超出畛畦之外. 居然名家.) See Hsü's *Ming-hua lu* 明畫錄 (Painters of the Ming Dynasty), *chüan* 卷 (chapter) 5, p. 62. For more information on Tsou, see Stephen Little, "Notes on Zou Zhilin," *Artibus Asiae*, 54.3/4 (New York: Institute of Fine Arts, New York University, 1994), pp. 327–46.

45 The two painters from Kuei-chou are probably Ma Shih-ying and Yang Wen-ts'ung. For a brief biography of Ma Shih-ying, see *Eminent Chinese of the Ch'ing Period (1644–1912)*, vol. 1, pp. 558. For more on

Yang Wen-ts'ung, see same book, vol. 2, pp. 895–96. Kung seems to have intentionally made the identification of these two artists ambiguous, as they were high officials considered corrupt by Kung Hsien's other scholar-artist friends.

46 Both waterlilies and lotus blossoms in Kung Hsien's verse indicate the quality of his later works.

47 The loess plateau is the result of millions of years of accumulation of loamy deposits blown in from Mongolia. As the loess cliffs have been exposed for a long period of time, they are characteristically weathered and extremely rugged. Fan K'uan's rain-drop brushwork was an ingenious way to depict such texture.

48 Mi dots, as they came to be called, were invented by Mi Fu specially to depict the misty rolling mountains in the south of the lower Yangzte River region. This technique is quite similar to the dots used for "pointillism" in European Impressionism, except that, in the Chinese context, they are used only for monochromatic ink stippling. For examples of paintings utilizing this technique, see notes 39 and 40.

49 Kung Hsien's inscription was originally written on the upper section of an album leaf belonging to his famous *Twenty-four Large Album Leaves*, dated 1676 and currently at the Shanghai Municipal Museum. See note 34. The Chinese text follows: "余 弱冠時, 見米氏雲山圖. 驚魂動魄, 殆是神物. 幾欲擬作, 而伸紙呪毫, 竟不能下. 何以故？小 巫之氣縮也. 歷今四十年, 而此一片雲山常懸 之意表. 不意從無意中得之."

50 Although there was not one single style that characterized the Nanking painters, their spirit was fundamentally anti-Tung, and they freely adopted styles from the more realistic Northern school. The Chekiang painter Yao Yün-tsai 姚允在 (active c. 1620–c. 1645), who spent some time in Nanking, also influenced the Nanking painters to pursue this practice. See entry 20 on Yao Yün-tsai. Wang Yüan-ch'i 王原祁 (1642–1715), a follower of Tung Ch'i-ch'ang, criticized the Nanking painters by asserting: "During the end of the Ming dynasty, there were prevailing pestilent habits in painting, as well as heretical painting schools, the Che school being the worst. In the Wu-men (Suchou) and Yün-chien (Sung-kiang near Shanghai) area, there were good painters like Wen Cheng-ming (1470–1559) and Shen Chou (1427–1509) and a great school founder like Tung Ch'i-ch'ang. The many counterfeits of their paintings are, unfortunately, so confusing that distinguishing between imitations and genuine works is difficult. This

**Kung Hsien** 龔賢
**Mountain Dwelling**
*continued*

80  malady has become prevalent. The vicious practice of the painters in Nanking and Yangchou is just like that of the Che school. Those who wish to learn painting should always bear this in mind." ( 明末畫中有習氣惡派, 以浙派為最. 至吳門雲間, 大家如文沈, 宗匠如董, 贗本淆涌, 以訛傳訛, 竟成流弊. 廣陵白下, 其惡習與浙派無異. 有志筆墨者, 切須戒之.) See Wang Yüan-ch'i, *Yü-ch'uang man-pi* 雨窗漫筆 (Casual Notes by a Window on a Rainy Day), reprinted in Yu Anlan 于安瀾, *Hualun congkan (Hua-lun ts'ung-k'an)* 畫論叢刊 (Compendium of Painting Theory), 1st edition dated 1937, reprint, vol. 1 (Beijing: Renmin Meishu Chubanshe, 1989), p. 206. For a discussion on Kung Hsien and the other masters in Nanking, see Xiao Ping 蕭平, "Yi Gong Xian wei daibiaode 'Jinling bajia' de yishu (I Kung Hsien wei tai-piao teh 'Chin-ling pa-chia' teh i-shu) 以龔賢為代表的 '金陵八家' 的藝術" (Kung Hsien as a Representative of the Art of "the Eight Masters of Nanking"), in *Kung Hsien yen-chiu chi* 龔賢研究集 (Collected Research Materials on Kung Hsien), vol. 2, pp. 78–86.

51  There is evidence that Kung Hsien greatly admired Yao Yün-tsai. Kung was elated when he acquired a long handscroll by Yao, one of the artist's most important works. Kung inscribed a long colophon at the end of the scroll, which is reproduced in Christie's sales catalogue: *Important Classical Chinese Paintings* (New York: Christie's, May 31, 1990), lot no. 30, p. 70. A transcription and translation of Kung's colophon is found in entry 20 on Yao Yün-tsai.

52  This inscription was originally written on Kung Hsien's album leaf belonging to a set of leaves entitled *Qingchuren huace (Ch'ing-ch'u-jen hua-ts'e)* 清初人畫冊 (Album Leaves by Early Ch'ing [Dynasty] Painters), currently at the Taizhou Museum 泰州博物館 See *Kung Hsien yen-chiu chi* 龔賢研究集 (Collected Research Materials on Kung Hsien), vol. 2, p. 63. The Chinese text follows: "不可學古人, 不可不合古人. 學古人則為古人所欺 吾常欲欺古人, 然古人卒不可欺. 久之, 然後見古人之道, 勢不能不合乎古人也. 此善于學古人者也!"

53  There are several different versions of Kung Hsien's models for teaching painting, all in the album leaf format. The best-known is currently at the Sichuan Provincial Museum. See Chen Xizhong 陳希仲, ed., *Gong Banqian shanshuihua ketugao (Kung Pan-ch'ien shan-shui-hua k'o-t'u-kao)* 龔半千山水畫課徒稿 (Kung Hsien's Landscape Painting Models for Tutoring Students) (Chengdu: Sichuan Renmin Chubanshe, 1981). This set has two parts.

The first includes instructions and basic landscape elements, such as various types of rocks and trees. The second part, in addition to these two elements, also contains models of houses and simple landscape compositions, complete with instructive inscriptions. At the end of the second part, there are also several leaves bearing Kung Hsien's aesthetic theories, painting techniques, and a brief history of Chinese painting. The painting section in the second part was reproduced as a single pamphlet in Shanghai before World War II. See *Kung Pan-ch'ien shou-t'u hua-kao* 龔半千授徒畫稿 (Kung Hsien's Painting Models for Tutoring Students) (Shanghai: Commercial Press, 1935).

54  In Chinese painting studios today, most students begin by observing their teacher paint. Then each is issued a painting model prepared by the teacher. Students are encouraged to copy the model several times until they memorize the composition and details. Yet few of these painting models bear step-by-step instructions like those found on Kung Hsien's teaching models.

55  Wang Kai's *Chieh-tzu-yüan hua-p'u* 芥子園畫譜 (The Mustard Seed Garden Manual of Painting), preface dated 1782, documented methods of executing Chinese painting and included models of every item typically found in Chinese painting. The title of this book, "The Mustard Seed Garden," was derived from the well-known private garden in Nanking belonging to the famous 17th-century dramatist Li Yü 李漁 (1611–80?). Li wrote the preface for the first series of this book, which comprises examples of landscape paintings collected by Li Yü's son-in-law Shen Hsin-yu 沈心友 (active second half of 17th century) and methods of painting composed and illustrated by Wang Kai. The second, third, and fourth series were issued after Li's death. This book has been translated into several foreign languages, including French, German, and English. For the English version, see Sze Mai-mai, *The T'ao of Painting: A Study of the Ritual Disposition of Chinese Painting (or Mustard Seed Garden Manual of Painting, 1679–1701)* (New York: Pantheon Books, 1956). For more information on Li Yü, see his entry in *Eminent Chinese of the Ch'ing Period (1644–1912)*, vol. 1, pp. 496–97. For an intensive discussion on this famous and influential scholar, as well as his social background, see Chun-shu Chang and Shelley Hsueh-lun Chang, *Crisis and Transformation in Seventeenth-Century China: Society, Culture, and Modernity in Li Yü's World* (Ann Arbor: University of Michigan Press, 1992).

56  Kung Hsien had a large circle of scholars and poets, which included Wang Shih-chen 王士禎 (1634–1711), Chu I-tsun 朱彝尊 (1629–1709), Ku Meng-yu 顧夢游 (active 17th century), Hu Chieh 胡介 (1616–64), Fang Wen 方文 (1612–69), Wu Wei-yeh 吳偉業 (1609–72), Wang Yu-ting 王猷定 (1598–1662), Ku Yen-wu 顧炎武 (1613–81), Kung Ting-tz'u 龔鼎孳 (1615–73), and others. His painter friends included famous artists such as Chang Feng 張風 (active mid-17th century), Shih-t'ao 石濤 (1642–1707), Shih-hsi 石谿 (also known as K'un-ts'an 髡殘, 1612–?), Tai Pen-hsiao 戴本孝 (1612–after 1691), Cha Shih-piao 查士標 (1615–98), Wang Hui 王翬 (1632–1717), Ch'eng Sui 程邃 (1605–91), Ch'eng Cheng-k'uei 程正揆 (active c. 1631–60), Hung-jen 弘仁 (1610–63), Liu Yü 柳堉 (active second half of 17th century), T'ang Yen-sheng 湯燕生 (active 17th century), and others. Kung Hsien was also acquainted with two official-patrons, Chou Liang-kung 周亮工 (1612–72) and K'ung Shang-jen 孔尚任 (1648–1708).

57  For a brief biography of Chou Liang-kung, see *Eminent Chinese of the Ch'ing Period (1644–1912)*, vol. 1, pp. 173–74. For a detailed examination of Chou Liang-kung's career, see Hongnam Kim, *The Life of a Patron: Zhou Lianggong (1612–1672) and the Painters of Seventeenth-Century China* (New York: China Institute in America, 1996).

58  See Chou Liang-kung, *Duhualu (Tu-hua lu)* 讀畫錄 (A Record of Examined Paintings), preface dated 1673, *juan (chüan)* 卷 (chapter) 2, reprinted in *Hua-shih ts'ung-shu* 畫史叢書 (Compendium of Painting History), vol. 9, pp. 29–30, s.v. "Gong Banqian 龔半千" (Kung Pan-ch'ien, *tzu* of Kung Hsien).

59  For more information on K'ung Shang-jen, see *Eminent Chinese of the Ch'ing Period (1644–1912)*, vol. 1, pp. 434–35.

60  For an English translation of this book, see Ch'en Shih-hsiang and Harold Acton, *The Peach Blossom Fan* (Berkeley: University of California Press, 1976). For a discussion of this work, see Richard E. Strassberg, "The Peach Blossom Fan: Personal Cultivation in a Chinese Drama" (Ph.D. dissertation, Princeton University, 1975).

61  A poem written by K'ung Shang-jen says: "Unexpectedly, [Kung Hsien] sent me a letter, [and] pronounced that [he] was taken with a serious illness [and in deep trouble.] A person [was] demanding calligraphy [and painting who] had come several times exerting his power. [Kung] asked me to advise him on how best to guard against such ruthless tyranny. [However,] what [power and] influence did I possess?" ( 尺素

**29. Shih-t'ao** 石濤
*(1642–1707)*
*Ch'ing dynasty (1644–1911)*

忽相投. 自言羅大病. 緣有索書人, 數來肆其
橫. 問我禦暴方, 我有奚權柄?) K'ung did not
identify this powerful individual, who per-
haps might have been a Manchurian occu-
pying a high official position. K'ung
Shang-jen's poem is number three in a set
of poems entitled "K'u Kung Pan-ch'ien 哭
龔半千" (Weeping for Kung Hsien). It is
included in his *Hu-hai chi* 湖海集 (The
Lake and Sea of the Author's Collected
Writings), *chüan* 卷 (chapter) 2, reprint,
vol. 7 (Taipei: World Press, 1964), p. 151.
Kung Hsien's letter mentioned in K'ung
Shang-jen's poem is reprinted in the same
book, vol. 13, pp. 294–95.

62  The Chinese text of K'ung's poem follows:
"野遺歸命辰, 己巳秋之半. 予時僑金陵, 停車
哭其間. 疏竹風蕭蕭, 書籍已零亂. 子女繞床
啼, 鄰父隔籬嘆. 君寐不復興, 天地自昏旦."
Attached to this poem is an annotation
provided by a mutual friend, Tsung Yüan-
ting 宗元鼎 (1620–98). Tsung wrote: "The
life of Pan-weng (The Elder Mr. Pan, refer-
ring to Kung Hsien's *tzu* Pan-ch'ien) was
lost unexpectedly in the hand of a despotic
person who ruthlessly demanded [Kung
Hsien's] work. Could this be the result of a
retribution in [Kung's] fate? I was told that
when Pan-weng died, Mr. K'ung was in
Nanking and made arrangements for the
funeral. [Kung also] took care of Kung
Hsien's orphans and gathered the [paint-
ings and] writings that he [Kung] left
behind. Many of the old acquaintances
were moved by K'ung's genuine friendship
and wept." (半翁之命, 竟喪於豪橫索書之手,
或亦業報當爾耶? 聞半翁蓋時, 孔公適在金
陵. 為經理其後事, 撫其孤子, 收其遺書. 一時
故老, 皆感高誼, 泣下沾巾.)

63  These elements can be repeatedly wit-
nessed in his other landscapes, including
trees with sparse branches, pines with
thick foliage, and small rocks placed along
a shore.

64  For Kung Hsien's works depicting the
landscape of his home site, see his album
leaf, entitled *Ch'ing-liang t'ai* 清涼臺 (The
Ch'ing-liang Terrace), in the Ching Yüan
Chai 景元齋 Collection, reproduced in
Suzuki Kei 鈴木敬, comp., *Comprehensive
Illustrated Catalog of Chinese Paintings*,
vol. 1 (Tokyo: University of Tokyo Press,
1982), no. A31-093-5, p. 357. See also the
hanging scroll in the same collection,
entitled *Landscape*, reproduced in ibid.,
no. A31-165, p. 366. Kung Hsien's hand-
scroll, entitled *Qingliang huancui*
(*Ch'ing-liang huan-ts'ui*) 清涼環翠 (The
Clear-cold Hill amid Jade Green [Foliage])
is at the Palace Museum, Beijing. It is
reproduced in Richard M. Barnhart et al.,
*Three Thousand Years of Chinese Paint-
ing* (New Haven: Yale University Press,

1997), pl. 246, pp. 268–69. See also Kung
Hsien's hanging scroll, *Landscape,* in the
Shen Fu Collection, reproduced in *Com-
prehensive Illustrated Catalog of Chinese
Paintings,* vol. 1, no. A20-001, p. 189.
Kung Hsien's hanging scroll, entitled *Pie-
kuan kao-chü* 別館高居 (To Live at an Ele-
vated Villa), in a private collection, is
reproduced in ibid., no. A18-021, p. 163.
Still another work by Kung, entitled *Land-
scape,* formerly belonging to the J. M.
Crawford., Jr. Collection, is currently at
the Metropolitan Museum of Art. It is
reproduced in ibid., no. A15-010, p. 96.

65  See *Comprehensive Illustrated Catalog of
Chinese Paintings,* vol. 1, no. A38-038, p.
396.

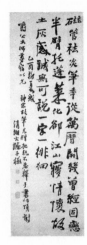

81

### A Poem Concerning an Imperial Porcelain-handled Brush from the Wan-li Period (r. 1537–1620) (Calligraphy)

*Wan-li tz'u-kuan ch'ü-yen pi
(An "Easing-heat" Brush with a
Porcelain Handle from the Wan-li
Period)*

萬曆瓷管祛炎筆

1  The exact dates of Shih-t'ao's birth and
death are a matter of debate among schol-
ars. For example, Wu T'ung assigned
1641–1720 as Shih-t'ao's dates in his essay
"Tao-chi, a Chronology," in Richard
Edwards, *The Painting of Tao-chi* (Ann
Arbor: University of Michigan Museum of
Art, 1967) pp. 53–61. Fu Shen, on the other
hand, in his *Traces of the Brush: Studies in
Chinese Calligraphy* (New Haven: Yale
University Art Gallery, 1977), p. 18,
ascribed 1641–c. 1710. Ju-hsi Chou, in
Arthur W. Hummel, ed., *Eminent Chinese
of the Ch'ing Period (1644–1912),* vol. 2
(Washington, D.C.: United States Govern-
ment Printing Office, 1943–44), p. 1259,
stated that Shih-t'ao died c. 1719. All of
these assertions were made obsolete after
Wang Shiqing 汪世清 published his article
"Qiufeng wenji zhong youguan Shitao de
shiwen (Ch'iu-feng wen-chi chung yu-kuan
Shih-t'ao teh shih-wen) 蚯蜂文集中有關石
濤的詩文" (Poems and Articles Related to
Shih-t'ao Found in the Collected Writings
of Li Lin [李驎, 1634–c. 1707]) in *Wenwu* 文
物 (Cultural Relics), no. 12 (Beijing:
Wenwu Chubanshe, 1979), pp. 43–48.
According to Wang Shiqing, Li Lin, who
was Shih-tao's close friend in Yangchou,
published at least five poems and six short
articles related to Shih-t'ao. One of the
most valuable of these documents is a
short biography of Shih-t'ao that provides

Shih-t'ao 石濤
A Poem Concerning an Imperial Porcelain-
  handled Brush from the Wan-li Period
  (r. 1537–1620) (Calligraphy)
*continued*

82

vital information about the artist's life. Wang also used Li Lin's writings in determining that the years 1642–1707 were, in fact, the dates marking Shih-t'ao's life.

2  The handle of a Chinese writing brush can be made from all kinds of solid materials, including jade, metal, bamboo, wood, ivory, and porcelain; however, most commonly, they are made from bamboo. During the Ming dynasty, there were decorative porcelain brush holders made for the imperial court at the ceramic center of Ching-teh-chen 景德鎮, in Kiangsi 江西 province. For more on Ching-teh-chen, see note 22. For objects made during the Wan-li period (1537–1620) as described in Shih-t'ao's poem, see 48.

3  Shih-t'ao named the porcelain-handled brush he received "The Easing Heat" brush. Presumably, he did so because of the cool and soothing feeling obtained while holding porcelain.

4  The Hua brothers are descendants of Hua Hsia 華夏 (active late 15th–16th century), whose *tzu* was Chung-fu 中甫. From a wealthy family in Wuhsi 無錫 Hua Hsia built a studio by Lake T'ai and named it Chen-shang chai 真賞齋 (The Studio of True Appreciation). He was close friends with the leading scholar-artists of his time, including Wen Cheng-ming 文徵明 (1470–1559) and Chu Yün-ming 祝允明 (1502?–52). Wen Cheng-ming painted at least two short handscrolls for Hua Hsia, using Hua's studio as the subject matter. The first one, dated 1549, now belongs to the Shanghai Museum. See Group for the Authentication of Ancient Works of Chinese Painting and Calligraphy, ed., *Zhongguo gudai shuhua tumu (Chung-kuo ku-tai shu-hua t'u-mu)* 中國古代書畫圖目 (An Illustrated Catalogue of Selected Works of Ancient Chinese Painting and Calligraphy), vol. 2 (Shanghai: Wenwu Chubanshe, 1990), no. 滬 1-0566, pp. 314–15. The second one, executed in 1557, is currently at the Chinese Historical Museum 中國歷史博物館, Beijing, and is recorded in Wu Sheng's 吳升 (active K'ang-hsi period 1662–1722), *Ta-kuan lu* 大觀錄 (An Extensive Record of Works Observed), preface 1712, *juan (chüan)* 卷 (chapter) 20, reprint (Shanghai: I-chi-hsüan, 1920), pp. 36–37. This painting is reproduced in *Chung-kuo ku-tai shu-hua t'u-mu* 中國古代書畫圖目 (An Illustrated Catalogue of Selected Works of Ancient Chinese Painting and Calligraphy), vol. 1, no. 京 2-05, p. 35. A full-color plate is published in Zhuang Jiayi's 莊嘉怡, chief ed., *Zhongguo gudai shuhua jingpin lu (Chung-kuo ku-tai ching-p'in lu)* 中國古代書畫精品錄 (Selected Painting and Calligraphy of the Past

Dynasties), vol. 1 (Beijing: Wenwu Chubanshe, 1984), no. 23. The major works of painting and calligraphy in Hua Hsia's collection are listed in the colophon by Yü Yün-wen 俞允文 (1512–79) attached to the end of the *Chen-shang chai* 真賞齋 handscroll at the Shanghai Museum. One of the most famous scrolls in his collection was Wang Meng's 王蒙 (1308–85) *Qingbian yinjutu (Ch'ing-pien yin-chü t'u)* 青卞隱居圖 (Living in Seclusion in the Ch'ing-pien Mountains) at the Shanghai Museum, reproduced in *Chung-kuo ku-tai shu-hua t'u-mu* 中國古代書畫圖目 (An Illustrated Catalogue of Selected Works of Ancient Chinese Painting and Calligraphy), vol. 2, no. 滬 1-0247, p. 121. Hua Hsia is often confused with another member of the Hua family, Hua Yün 華雲 (1488–1560 and his *chin-shih* degree awarded in 1541), as both were well-known collectors. Hua Yün's estate is called Chen-hsiu yüan 真休園 (The Garden of True Relaxation). The confusion between the two Huas seems to center on a *hao*, Pu-an 補庵 (The Hut of Supplement). According to Marc F. Wilson and Kwan S. Wong's *Friends of Wen Cheng-ming: A View from the Crawford Collection* (New York: China Institute of America, 1975), p. 90, Pu-an should be the *hao* of Hua Yün. But in the Shanghai Museum's *Zhongguo shuhuajia yinjian kuanshi (Chung-kuo shu-hua-chia yin-chien k'uan-shih)* 中國書畫家印鑒款識 (Seals and Inscriptions of Chinese Painters and Calligraphers), vol. 2 (Shanghai: Wenwu Chubanshe, 1987), pp. 1171–72, Buan (Pu-an) is the *hao* of Hua Xia (Hua Hsia). Richard Edwards thought Pu-an was Hua Hsia in the entry of Wen Cheng-ming in L. Carrington Goodrich and Fang Chaoying, eds., *Dictionary of Ming Biography*, vol. 2 (New York and London: Columbia University Press, 1976), p. 1473. Yet in his *Art of Wen Cheng-ming (1470–1559)* (Ann Arbor: University of Michigan Museum of Art, 1976), no. 68, p. 162, he accepted that Pu-an was Hua Yün. Since Wen Cheng-ming's *Magnolia* scroll, executed in 1549 and reproduced in Richard Edwards et al., *The Art of Wen Cheng-ming (1470–1559)* (Ann Arbor: University of Michigan Museum of Art, 1974), no. 67, pp. 162–63, was given to Pu-an and the scroll bears Hua Hsia's seal, *Chen-shang chai t'u-shu chi* 真賞齋圖書記 (Seal for the painting and calligraphy at the Studio of True Appreciation), it is more likely that Pu-an was Hua Hsia's *hao*. Apparently, the Hua brothers named their collection "The Later Studio of True Appreciation" after the name of their ancestor Hua Hsia's studio. Their collection, how-

ever, has no relationship to Hua Hsia's old collection.

5  In this line, the term *pan-pi* literally means "half-arm" and should be translated as "forearm." It refers to the Ming Emperor Wan-li, who once owned and wielded the brush mentioned in Shih-t'ao's poem. The P'eng-lai Isles, usually indicate the immortals' land, which represents a classical Chinese utopia. Here in Shih-t'ao's mind, P'eng-lai seems to represent the vanished Ming empire.

6  In this line, Shih-t'ao lamented the Ming empire once ruled by his ancestors of the Chu 朱 clan.

7  In Shih-t'ao's inscription, he respectfully addressed the recipient of his calligraphy, "Chüeh-kung ta-shih tsun-su 嚼公大師尊宿," an appellation containing three parts. Chüeh-kung 嚼公 means "the revered Chüeh." Thus "Chüeh" (literally meaning "chewing") should be this person's given name. *Ta-shih* 大師, or "great master," can be used to address either a learned scholar or a virtuous and important Buddhist abbot. See *Hanyu dacidian (Han-yü ta-tz'u-tien)* 漢語大詞典 (Chinese Terminology Dictionary), vol. 2 (Shanghai: Hanyu Dacidian Press, 1988), p. 1363, s.v. "*dashi (ta-shih)* 大師." The last part, *tsun-su* 尊宿, definitely indicates a respected elderly monk. See ibid., p. 1285, s.v. "*zunsu (tsun-su)* 尊宿" Unfortunately, this old abbot in Shih-t'ao's poem cannot be identified. Emperor Shen-tsung was the posthumous imperial title for Emperor Wan-li (1573–1620), a distant ancestor of Shih-t'ao. In his poem, Shih-t'ao emphasizes this familial relationship by using the character "*hsien* 先," which indicates a deceased relative.

8  Shih-t'ao's signature, "Ch'ing-hsiang, Ta-ti-tzu, Chi 清湘大滌子極," carries several meanings. As the Hsiang River originates in Kwangsi province, "Ch'ing-hsiang 清湘 (clear Hsiang River)" indicates Shih-t'ao's hometown. "Ta-ti-tzu 大滌子 (a person of great purity)" is derived from the name of his two-story house Ta-ti-t'ang 大滌堂 (Hall of Great Purity), which he built in 1697 in Yangchou. "Chi 極 (utmost)" was the last word of Shih-t'ao's lay name, Chu Jo-chi 若極 (Chu is his last name; Jo-chi means "to conform to the utmost").

9  Shih-t'ao used this seal, "a solitary old man," to imply two aspects of his life. First, he was an orphan and a monk without any close family members. Second, when he executed the Michigan scroll in 1705, he was in his sixties; consequently, he was feeble and old.

10 The seal, *Meng-tung-sheng* 懵懂生 or "a dull-witted man," is Shih-t'ao's self-deprecatory expression. It is rather common for a Chinese artist to adopt such self-abasing names. For example, Chu Ta 朱耷 (1626–after 1705), often known as Pa-ta shan-ren 八大山人, called himself Lü-wu 驢屋, meaning "donkey-house."

11 This seal is discussed later in the text.

12 See *Dictionary of Ming Biography*, vol. 1, p. 382. During the many grim campaigns before the establishment of the new regime, the two brothers fought side by side. The elder Chu unfortunately died at an early age and left a young son. This orphan, Chu Wen-cheng 朱文正 (?–1365), grew up under the care of his uncle and became an outstanding general who fought bravely in many important battles. He made a considerable contribution to his uncle's ascension to power in 1368. But the young warrior became arrogant and imperious. Subsequently, he was placed under house arrest. For Chu Wen-cheng's biography, see Jiao Hong (Chiao Hung) 焦竑 (1541–1620), comp., *Guochao xianzhenglu (Kuo-chao hsien-cheng-lu)* 國朝獻徵錄 (Biographies of Famous Individuals of the Ming Dynasty), *juan* (chüan) 卷 (chapter) 2, reprint, vol. 1 (Shanghai: Shanghai Shudian, 1987), pp. 74–76 (or 95–96). In 1370, in order to honor his deceased elder brother and the deeds in battle of his imprisoned nephew, the new ruler designated the nephew's son, Chu Shou-ch'ien 朱守謙 (1361–c. 1408), as the Ching-chiang Wang 靖江王, or "Prince of the Ching-chiang Region." This principality was located in present-day Ch'üan-chou 全州 a city in the remote northeast section of Kwangsi province, near the border between Kwangsi and Hunan. At that time, this area was occupied by the ethnic minority known as the Chuang 壯族 people. For Chu Shou-ch'ien's biography, see *Kuo-chao hsien-cheng-lu* 國朝獻徵錄 (Biographies of Famous Individuals of the Ming Dynasty), *chüan* 卷 (chapter) 2, pp. 77–79 (or 97–98). Although Chu Shou-ch'ien accepted this title, he continued to stay in the capital of Nanking. Once Chu Shou-ch'ien accepted this title, the young prince, like his imprisoned father, also became tyrannical. Due to corruption, his title was eventually revoked by the emperor, but his son, Chu Tsan-i 朱贊儀 (?–1408), was known for his good deeds. He inherited the Ching-chiang Wang title in 1403, the first year of the Yung-lo 永樂 period (r. 1403–24). Chu Tsan-i was the first of his line to act responsibly and actually go to Kwangsi in order to live in his principality.

13 See ibid., pp. 78–79 (or 97–98). The eleven generations of the Ching-chiang monarchy who were Shih-t'ao's ancestors were: 1) Chu Shou-ch'ien 朱守謙; 2) Chu Tsan-i 朱贊儀; 3) Chu Tso-ching 朱佐敬; 4) Chu Hsiang-ch'eng 朱相承; 5) Chu Kuei-ssu 朱規嗣 6) Chu Yüeh-ch'i 朱約麒; 7) Chu Ching-fu 朱經扶; 8) Chu Pang-ning 朱邦寧; 9) Chu Jen-ch'ang 朱任昌; 10) Chu Lü-yu 朱履祐; 11) Chu Heng-chia 朱亨嘉; 12) Chu Jo-chi 朱若極 (Shih-t'ao). Shih-t'ao refers to himself as the eleventh generation because he is not counting Chu Shou-ch'ien, whom he considered cruel and tyrannical and who never traveled to this principality in Kwangsi.

14 Emperor Huang-kuang's name was Chu Yu-sung 朱由崧 (?–1646). Before he became emperor, he was also known as Prince Fu 福王. For his biography, see *Eminent Chinese of the Ch'ing Period (1644–1912)*, vol. 1, pp. 195–96.

15 Prince T'ang's full name was Chu Yü-chien 朱聿鍵 (1602–46). For his biography, see *Eminent Chinese of the Ch'ing Period (1644–1912)*, vol. 2, pp. 196–98.

16 See *Ming-shih* 明史 (History of the Ming Dynasty) in *Erh-shih wu-shih* 二十五史 (History in Twenty-five Books), *chüan* 卷 (chapter) 118 (Shanghai: K'ai-ming Book Company, 1934), pp. 293–95. Few people understand why Chü Shih-ssu, the governor of Kwangsi and an honest scholar-official, turned against Shih-t'ao's father, Chu Heng-chia. Apparently Chü Shih-ssu simply could not accept Chu Heng-chia's claim, as Chu was not a direct descendant of the first Ming emperor; rather he was a descendant of the emperor's brother. Thus traditionally and legally, Chu was not qualified to assume the title of Chien-kuo.

17 See Wang Shiqing 汪世清, "Qiufeng wenji zhong youguan Shitao de shiwen (Ch'iu-feng wen-chi chung yu-kuan Shih-t'ao yeh shih-wen) '虬蜂文集' 中有關石濤的詩文 (Poems and Articles Related to Shih-t'ao Found in the Collected Writings of Li Lin 李驎 [1634–ca. 1707]) in *Wenwu* 文物 (Cultural Relics), no. 12 (Beijing: Wenwu Chubanshe, 1979), p. 44. Wang points out that in Li Lin's "Dadizi zhuan (Ta-ti-tzu chuan) 大滌子傳" (Biography of Shih-t'ao), Li asserts that Shih-t'ao was carried to safety by a servant from the palace. He was then tonsured in Wu-chang.

18 Although this information is found in almost every article concerning Shih-t'ao's life and art, it is unclear from which source this information is based.

19 Bordu, a Manchu literati-painter, was the grandson of Taibai 塔拜 (1589–1639) who was the sixth son of Nurhaci 努爾哈赤

(1559–1626), the Manchu founder of the Ch'ing dynasty. See *Eminent Chinese of the Ch'ing Period (1644–1912)*, vol. 2, p. 934, s.v. "Yolo." See also Jonathan D. Spence, "Tao-chi, An Historical Introduction," in Richard Edwards, *The Painting of Tao-chi*, pp. 11–20.

20 For more on "The Four Wangs," see entry 30 on Wang Hui.

21 Shih-t'ao's *Hua-yü-lu* can be found in Teng Shih 鄧實 (1865?–1948?) and Huang Pin-hung 黃賓虹 (1865–1955), comps., *Mei-shu ts'ung-shu* 美術叢書 (Anthology of Writings on Fine Art) (Shanghai: n.p., 1912–36), *chi* 集 (part) 1, *chi* 輯 (division) 1, vol. 1 (Taipei: I-wen Press, 1963–72), pp. 41–59. Chapter 3 on p. 41, dealing with "transmutation," says: "*wu-fa erh-fa, nai-wei chih-fa.* 無法而法, 乃為至法" (the ultimate method is to follow no method). Shih-t'ao's *Hua-yü-lu* is translated into English by Ju-hsi Chou in *The Hua-yü-lu and Tao Chi's Theory of Painting* (Tempe: Arizona State University, 1977).

22 Ching-teh chen has been a ceramic center since the tenth century. During the Ming and Ch'ing dynasties, this city contained the imperial kilns. Even today it is still the primary center for the production of porcelain objects. For more information on Ching-teh chen, see Robert Tichane, *Ching-yeh-chen: Views of a Porcelain City* (Painted Post, N.Y.: New York State Institute for Glaze Research, 1983).

23 Two types of porcelain brush holders were made during the Wan-li period for imperial use. One is decorated with a blue and white design, while the other is a five-color polychrome design. For examples, see National Palace Museum, *Masterpieces of Chinese Writing Materials in the National Palace Museum* (Taipei: National Palace Museum, 1971), cat. no. 2.

24 Stylistically, Shih-t'ao's calligraphy corresponds somewhat with the graphology of the official script found on wooden tablets of the Han dynasty, known as *chang-ts'ao* 章草 or "official memoranda script." For a discussion of *chang-ts'ao*, see *Traces of the Brush: Studies in Chinese Calligraphy*, p. 81.

25 See ibid., p. 51, s.v. "The Late Ming Trend."

26 See ibid., p. 52, s.v. "The Mid-Ch'ing Chin-shih-hsüeh and Pei-hsüeh Movements." A stele is a stone pillar. In ancient China, steles were used to bear incised eulogies, much like a gravestone. Steles were also used to preserve long texts, many executed by famous calligraphers; subsequently, rubbings were often made from these steles in order to preserve literary content as

Shih-t'ao 石濤
A Poem Concerning an Imperial Porcelain-
handled Brush from the Wan-li Period
(r. 1537–1620) (Calligraphy)
*continued*

84    well as calligraphic style. For more on ste-
les, see Tseng Yu-ho Ecke, *Chinese Callig-
raphy* (Philadelphia: Philadelphia Museum
of Art, 1971), entries 4–11 and 13–17.

27    For more on Chin Nung and Cheng Hsieh's
calligraphy, see ibid., cat. no. 77, p. 175
and cat. no. 78a, p. 193. See also entries 38
on Chin Nung and 40 on Cheng Hsieh.

28    There are two versions of Shih-t'ao's self-
portrait. The one he painted in 1674 at age
thirty-three belongs to the National Palace
Museum in Taipei. It is reproduced in the
National Palace Museum, *Chang Yüeh-
chün hsien-sheng, Wang Hsüeh-t'ing
hsien-sheng, Lo Chih-hsi fu-jen chüan-
tseng shu-hua t'e-chan mu-lu* 張岳軍先生,
王雪艇先生, 羅志希夫人, 捐贈書畫特展目錄
(The Catalogue of the Special Exhibition
of the Painting and Calligraphy Donated
by Mr. Chang Yüeh-chün, Mr. Wang
Hsüeh-t'ing, and Mrs. Lo Chih-hsi) (Taipei:
National Palace Museum, 1978), pp.
186–88. Shih-t'ao's self-portrait was copied
by the Yangchou painter Lo P'in 羅聘
(1737–99) and is mounted in Shih-t'ao's
calligraphic album leaves recording the
*Tao-yeh ching* 道德經 (The Taoist Sutra),
now also belonging to the National Palace
Museum in Taipei. Lo P'in's copy is repro-
duced in the same catalogue, p. 26. The
portrait of Shih-t'ao used for comparison
in this entry is a reversed version of the
original.

## 30. Wang Hui 王翬
*(1632–1717)*
*Ch'ing dynasty (1644–1911)*

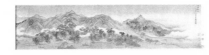

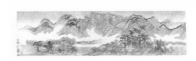

### Autumn Colors at Mount Yü
*Yü-shan ch'iu-se*
*(Autumn Colors at Mount Yü)*
虞山秋色

1    This seal belongs to the unidentified callig-
rapher who inscribed this label.

2    Hsi-shuang ko 西爽閣 was the name of
Wang Hui's studio. See Shanghai Museum,
*Zhongguo shuhuajia yinjian kuanshi*
(*Chung-kuo shu-hua-chia yin-chien k'uan-
shih*) 中國書畫家印鑒款識 (Signatures and
Seals of Chinese Painters and Calligra-
phers), vol. 1 (Shanghai: Wenwu Chuban-
she, 1987), Wang Hui's seals no. 42, p. 102
and no. 87, p. 103. According to this vol-
ume, these two seals, bearing the legend
"Hsi-shuang 西爽" appear on two of Wang
Hui's works, both dated 1712.

3    For information on Weng T'ung-ho 翁同龢
(1830–1904), the former owner of this
scroll, see note 1 in entry 4, on Shen Chou.
Weng was a native of Wang Hui's home-
town, Ch'ang-shu, Kiangsu.

4    Wan-go Weng is Weng T'ung-ho's grand-
son. See note 1 in the entry 4 on Shen
Chou for the background of Wan-go
Weng's collection.

5    This collector's seal, *Ts'ai Wei-kung chen-
wan* 蔡巍公珍玩 (Treasured and enjoyed by
Tsai Wei-kung), belongs to Ts'ai Ch'i 蔡琦
(c. late 17th–early 18th century), who was
one of Wang Hui's acquaintances. A letter
from Ts'ai Ch'i is found in Wang Hui's
*Ch'ing-hui-ko tseng-i ch'ih-tu* 清暉閣贈貽
尺牘 (Correspondences Received at [Wang
Hui's] Pure and Bright Pavilion) (Shanghai:
Kuo-kuang Press, 1924), p. 10a. Ts'ai Ch'i
may possibly have been the original owner
of the Michigan scroll.

6    For Wang Hui's important works at the
National Palace Museum, Taipei, see the
National Palace Museum, comp., *Wang
Hui hua-lu* 王翬畫錄 (Catalogue of Wang
Hui's Painting in the Collection of the
National Palace Museum) (Taipei:
National Palace Museum, 1970). The Six
Great Masters of the early Ch'ing period
were: 1) Wang Shih-min 王時敏
(1592–1680); 2) Wang Chien 王鑑

(1598–1677); 3) Wang Hui 王翬
(1632–1717); 4) Wang Yüan-chi 王原祁
(1642–1715); 5) Wu Li 吳歷 (1632–1718);
and 6) Yün Shou-p'ing 惲壽平 (1633–90).

7    This information is found in Hu Peiheng
胡佩衡, "Wang Shigu (Wang Shih-ku) 王石
谷" (Wang Hui) in *Zhongguo huajia cong-
shu* (*Chung-kuo hua-chia ts'ung-shu*) 中國
畫家叢書 (Chinese Painters Series) (Shang-
hai: Renmin Meishu Chubanshe, 1963),
pp. 3–4. According to Hu, Wang Hui's
father, Wang Yün-k'o 王雲客 (active first
half of 17th century), painted elegant land-
scapes. His great-grandfather, Wang Tsai-
shih 王載仕 (active c. 16th century),
although qualified to pursue civil service,
concentrated on painting and was a well-
known artist. Wang Hui's great-great-
grandfather, Wang Po-ch'en 王伯臣 (active
c. second half of 15th century), was a real-
istic flower-and-bird painter whose work
was lauded by the great master Shen Chou
沈周 (1427–1509). According to Yu Jianhua
于劍華 et al., *Zhongguo meishujia ren-
ming cidian* (*Chung-kuo mei-shu-chia jen-
ming tz'u-tien*) 中國美術家人名詞典 (Bio-
graphical Dictionary of Chinese Artists)
(Shanghai: Renmin Meishu Chubanshe,
1981), p. 75, Wang Po-ch'en was Wang
Hui's great-grandfather. It is not clear
which source is accurate.

8    For a brief biography of Wang Chien, see
Arthur W. Hummel, ed., *Eminent Chinese
of the Ch'ing Period (1644–1912)*, vol. 2
(Washington, D.C.: United States Govern-
ment Printing Office, 1943–44), p. 812.
Wang Chien's collection of early painting
was said to have been inherited from his
great-grandfather, Wang Shih-chen 王世貞
(1526–90), an influential scholar of the six-
teenth century. The tale of the meeting
between Wang Hui and Wang Chien is
recorded in Zhang Geng (Chang Keng) 張
庚, *Kuo-ch'ao hua-cheng-lu* 國朝畫徵錄
(Biographical Sketches of the Artists of the
Ch'ing Dynasty), *juan* (*chüan*) 卷 (chapter)
1, reprinted Yu Anlan 于安瀾, comp.,
*Huashi congshu* (*Hua-shih ts'ung-shu*) 畫
史叢書 (Compendium of Painting History),
vol. 5 (Shanghai: Renmin Meishu Chuban-
she, 1962), p. 25, entry on Wang Hui.

9    For a brief biography of Wang Shih-min,
see *Eminent Chinese of the Ch'ing Period
(1644–1912)*, vol. 2, pp. 833–34. Wang
Shih-min admitted that he accumulated
the paintings in his collection from several
private collectors in Peking and from the
most distinguished collection of Tung
Ch'i-ch'ang 董其昌 (1555–1636). This
information is based on Wang Shih-min's
colophon, inscribed on the brocade border
of Wang Hui's *Hsing-lu t'u* 行旅圖 (Travel-
ers amid Streams and Mountains) after Fan

K'uan at the National Palace Museum in Taipei. See *Ku-kung shu-hua t'u-lu* 故宮書畫圖錄 (Illustrated Catalogue of Calligraphy and Painting at the Palace Museum), vol. 1 (Taipei: National Palace Museum, 1991), p. 170. Although the *Hsing-lü t'u* is obviously a copy of Fan Kuan's work by Wang Hui, it is nonetheless listed as Fan Kuan's genuine work in the book.

10 See Wang Shih-min's *Hsi-lu hua-pa* 西廬畫跋 (Colophons on Paintings by Hsi-lu [Wang Shih-min's *hao*, meaning "West Hut"]), in Ch'in Tzu-yung 秦祖永 (1825–84), *Hua-hsüeh hsin-yin* 畫學心印 (The Study of Paintings Impressed on the Heart), *chüan* 卷 (chapter) 3 (Shanghai: Sao-yeh Shan-fan Press, 1936), p. 16. In this colophon Wang Shih-min greatly praises the skill and accomplishments of his student Wang Hui. Describing his student's popularity, he writes: "Hsi-ku (Wang Hui) due to his profound knowledge in painting, is able to execute even the finest detail. [He has] assimilated the best qualities from the masterpieces of the T'ang, Sung, and Yüan dynasties. [Now that he is able] to combine these elements, he has become a great master. Suddenly [his] fame exploded and is everywhere. People from near and far come to purchase paintings. There are always large piles of his guests' sandals and shoes outside his door; for many years he desired an iron gate to keep away [these customers]!" (石谷於畫道, 研深入微. 凡唐宋元名蹟, 已悉窮其精蘊. 集以大成. 聲名驚爆海內. 遠近丐求者, 戶外屢滿. 欲作鐵門限, 久矣!)

11 Wang Hui received this prestigious appointment on the recommendation of Sung Chün-yeh 宋駿業 (1661–1713), a high official at the court. Although the project received financial support from the emperor, it was not a part of the governmental activities in Peking. Thus, Wang Hui and his assistants probably executed the many long scrolls at a studio outside of the forbidden city. See Marshall P. S. Wu (武佩聖), "Wang Hui kejingshi qijian zhi jiaowang yu huihua huodong (Wang Hui k'o-ching-shih ch'i-chien chih chiao-wang yü hui-hua huo-tung)' 王翬客京師期間之交往與繪畫活動' (Wang Hui's Painting Activities and Social Life in Beijing), in Editorial Department of the Douyun Press, comp., *Qingchu siWang huapai yanjiu* (Ch'ing-ch'u ssu-Wang hua-p'ai yen-chiu) 清初四王畫派研究 (Research of the Paintings of the Four Wangs of the Early Ch'ing Dynasty) (Shanghai: Shuhua Chubanshe, 1993), pp. 607–27.

12 See ibid.

13 Wang Hui's *Snow Scene* is published in National Palace Museum, comp., *Wang*

*Hui hua-lu* 王翬畫錄 (Catalogue of Wang Hui's Painting in the Collection of the National Palace Museum) (Taipei: National Palace Museum, 1970), pl. 30, pp. 103–4. Fan K'uan was a great master of landscape painting during the early eleventh century. His spectacular and overpowering work *Hsüeh-shan hsiao-ssu* 雪山蕭寺 (Solitary Temple on a Snowy Mountain) belongs to the National Palace Museum, Taipei. It is published in *Ku-kung shu-hua t'u-lu* 故宮書畫圖錄 (Illustrated Catalogue of Calligraphy and Painting at the Palace Museum), vol. 1 (Taipei: National Palace Museum, 1991), p. 163.

14 Wang Yüan-ch'i was the grandson of Wang Shih-min. His comments on Wang Hui are found in Chang Keng 張庚 *Kuo-ch'ao hua-cheng-lu* 國朝畫徵錄 (Biographical Sketches of the Artists of the Ch'ing Dynasty), vol. 3, p. 52. See entry 31 on Wang Yüan-ch'i and his work.

15 For Wang Hui's masterpieces executed in Peking, see Marshall P. S. Wu, "Wang Hui's Painting Activities and Social Life in Beijing," pp. 622–24.

16 See ibid., p. 621.

17 Documentation of Wang Hui's collaboration with his students can be found in the entry on his student Yang Chin 楊晉 (1644–1728) in Chang Keng's 張庚 (1685–1760) *Kuo-ch'ao hua-cheng lu* 國朝畫徵錄 (Biographical Sketches of the Artists of the Ch'ing dynasty), *chüan* 卷 (chapter) 2, p. 56. There is some evidence suggesting that Wang may have even signed his students' works with his own signature.

18 Wang Hui's hometown, Ch'ang-shu 常熟, literally means "constantly ripening," indicating the consistently successful grain harvest. Using studies of the ancient jade objects belonging to the Liang-chu 良渚 culture excavated in this area, the history of the city can be traced back to the Neolithic period of 2500 B.C.

19 Huang Kung-wang was one of the Four Masters of the Yüan dynasty. His famous handscroll *Fu-ch'un shan-chü* 富春山居 (Dwelling in the Fu-ch'un Mountains) was later copied by Wang Hui several times. See Fu Shen 傅申, "Foruier cang Wang Hui Fuchun juan de xiangguan wenti (Fo-jui-erh ts'ang Wang Hui Fu-ch'ün chüan teh hsiang-kuan wen-t'i) 佛瑞爾藏王翬富春卷的相關問題" (Related Issues Concerning Wang Hui's *Fu-ch'un* Scroll at the Freer Gallery), in *Qingchu siWang huapai yanjiu* 清初四王畫派研究 (Research on the Paintings of the Four Wangs of the Early Ch'ing Dynasty), pp. 629–53. Huang Kung-wang's trip to Mount Yü is documented in Wang

Yüan-ch'i 王原祁 (1642–1715), "Yü-ch'uang man-pi 雨窗漫筆"(Casual Writings by a Rainy Window), collected in Ch'in Tzu-yung 秦祖永 (1825–84), *Hua-hsüeh hsin-yin* 畫學心印 (The Study of Paintings Impressed on the Heart), *chüan* 卷 (chapter) 7 (Shanghai: Sao-yeh Shan-fang Press, 1936), p. 3. The great Wu school master Shen Chou also frequently traveled to Ch'ang-shu and Mount Yü. See the record of his trips to this area with his friend Wu K'uan 吳寬 (1435–1504) listed in "Shih-t'ien hsien-sheng shih-lüeh 石田先生事略" (A Brief Biography of Shen Chou), *chüan* 卷 (chapter) 10, pp. 17b–20b, in Shen Chou's *Shih-t'ien hsien-sheng chi* 石田先生集 (Shen Chou's Anthology), reprint, vol. 2 (Taipei: The National Central Library, 1968), new page nos. 896–902. It was during one of these trips to Ch'ang-shu county that Shen Chou was impressed by a group of old juniper trees, which were supposed to have been planted during the sixth century. Consequently, he executed his famous handscroll entitled *Sangui tu* (*San-kuei t'u*) 三檜圖 (Three Juniper Trees), dated 1484 and currently at the Nanking Museum. Two of these trees are published in James Cahill, *Parting at the Shore: Chinese Painting of the Early and Middle Ming Dynasty, 1368–1580* (New York and Tokyo: Weatherhill, 1978), pls. 42–43, p. 76

20 The name of Mount Yü is derived from the name of a prince of the Chou 周 dynasty (ca. 1027–256 B.C.). According to Chinese history, during the end of the Shang 商 period, around 1100 B.C., the eldest son, T'ai-po 泰伯, of the King of the Chou State, Chou Tai-wang 周太王, abdicated his heirship to his younger brother, Hsi-po 西伯, who then successfully defeated the Shang army and established the Chou dynasty. T'ai-po and another prince, Yü-chung 虞仲 (also known as Chung-yung 仲雍), left their father's land in Shensi 陝西 and went to the south. Later, they settled down near the present-day Ch'ang-shu area and became the founders of the Wu 吳 culture. When Yü-chung died, he was buried at the foot of the mountain, and the local inhabitants named the mountain Mount Yü, after Prince Yü-chung. This story is recorded in Ssu-ma Ch'ien 司馬遷, *Shih-chi* 史記 (The Historical Records), reprinted in *Gudien mingzu puchi wenku* (*Ku-tien ming-chu p'u-chi wen-k'u*) 古典名著普及文庫 (Popular Edition of Famous Classics), *Zhoubenji* (*Chou pen-chi*) 周本記 (Records of the Chou dynasty), *juan* (*chüan*) 卷 (chapter) 4 (Changsha: Yuelu Chubanshe, 1988), p. 21.

21 See Yün Shou-p'ing 惲壽平 (1633–90),"Ou-hsiang kuan hua-pa 甌香館畫跋 "(Colophons on Paintings by Ou-hsiang

**Wang Hui** 王翬
**Autumn Colors at Mount Yü**
*continued*

86 Studio [Yün Shou-p'ing's *hao*, meaning "the fragrance from a small cup"]), in Ch'in Tzu-yung, 秦祖永 (1825–84) *Hua-hsüeh hsin-yin* 畫學心印 (The Study of Paintings Impressed on the Heart), *chüan* 卷 (chapter) 5, p. 8b. Yün's colophon says, "In the summer of the sixth moon in 1670, I and Wang Hui from Yü-shan [pre-fecture] hiked from the [Ch'ang-shu] city [to Mount Yü] with walking sticks. After three or four *li* (Chinese mile) along the mountain path, we rested at the Wu Valley. While both were in high spirits, we continued [the expedition] and reached the Sword Gate. Sword Gate was the most unusual scenic spot on Mount Yü because it resembled the unfolded wing of a gigantic bird. The multiple rock surfaces extended across the cliff wall, which was so steep that it looked as if it had been cut by a sword. Some of the recessions are almost like a window leading to other mountains and valleys: thus it was dubbed "Sword Gate." [Elated by the spectacular scenery], I and Wang Hui shouted and howled in a sustained voice under the cliff wall. After the trip, we each painted a picture of this incredible scene viewed during the excursion, which [I have] roughly recorded." (庚戌夏六月, 同虞山王子石谷, 從城攜筇, 循山行三四里, 憩吾谷. 乘興; 遂登劍門. 劍門; 虞山最奇勝處也! 亦如扶搖之翼下垂也! 石壁連袤中陡, 削勢下絕, 若劍截狀. 闢一牖, 如可通他徑者, 因號為劍門云. 余與石谷, 高嘯劍門絕壁之下. 各為圖記之. 寫遊時所見, 大略如此.)

22 See Hu Peiheng 胡佩衡, "Wang Shih-ku 王石谷" (Wang Hui), p. 35 and figs. 2, 3, and 4. The twelve views of Wang Hui's *Mount Yü* are:

1. *Chin-ch'eng ch'un-se* 錦城春色 (Springtime Colors at the Brocadelike City [Ch'ang-shu])

2. *Shuang-t'a ch'en-chung* 雙塔晨鐘 (Morning Bell from the Twin Pagoda)

3. *Ch'in-p'o kuan-p'u* 秦坡觀瀑 (Watching the Cascade at the Ch'in Hillside)

4. *Hsi-ch'eng lou-ko* 西城樓閣 (The Towers at the West City )

5. *Chung-feng chu-yüan* 中峰竹院 (Bamboo Courtyard at the Chung-feng Temple)

6. *Fu-shui shan-chuang* 拂水山莊 (Caressing the Water Mountain Villa)

7. *Wei-mo hsiao-jih* 維摩曉日 (Rising Sun at the Vimalakirti Shrine)

8. *Nan-hu yen-yü* 南湖煙雨 (Mist and Rain at the South Lake)

9. *Hu-Ch'iao yüeh-se* 湖橋月色 (Moonlight on the Bridge by the Lake)

10. *Wu-ku feng-lin* 吾谷楓林 (The Maple Trees of the Wu Valley)

11. *Hsing-t'an ch'i-k'uai* 星壇七檜 (The Seven Juniper Trees at the Star Altar)

12. *Shu-t'ai chi-hsüeh* 書臺積雪 (Heavy Snow at the Book Terrace)

Another set of album leaves by Wang Hui, *Ten Scenes of Mount Yü*, was reproduced in Christie's sales catalogue, *Fine Chinese Paintings and Calligraphy* (New York: Christie's, May 31, 1990), lot no. 178, p. 99.

23 This pavilion on top of the small hill is known as Hsin-feng t'ing 辛峰亭 (The Laborious Peak Pavilion).

24 The Fu-shui shan-chuang, or Caressing the Water Mountain Villa, was a famous location in the painter's hometown. The well-known scholar Ch'ien Ch'ien-i 錢謙益 (1582–1664) built a studio named *Ou-keng t'ang* 藕耕堂 (The Plowing Lotus-roots Hall) in 1630 in this country villa. This was the place where Ch'ien married his concubine, a popular singer, and where young Cheng Ch'eng-kung 鄭成功 (1624–62) studied under Ch'ien. Cheng later became the prominent Ming general who fought against the Manchu invaders in Taiwan.

25 See Wang Hui, "Ch'ing-hui hua-pa 清暉畫跋" (Colophons on Paintings by Ch'ing-hui [Wang Hui's *hao*, meaning "pure and bright"]) in *Hua-hsüeh hsin-yin* 畫學心印 (The Study of Paintings Impressed on the Heart), *chüan* 卷 (chapter) 4, p. 11b. Wang Hui's colophon says, "When a painter applies blue and green on his work, it is critical that the color applied to objects emphasize their mass, while the color applied for creating a mood emphasize lightness. One can only attain these effects by the careful application of colorful washes. After thirty years of experimenting with and comprehending this technique, I am able finally to master the secrets of painting with blue and green pigments." (凡設青綠, 體要嚴重, 氣要清輕. 得力全在渲暈. 余於青綠法., 靜悟三十年., 始盡其妙.)

26 For a discussion of painter Tung Yüan and his follower Chü-jan, a Buddhist monk, see Wen C. Fong et al., *Images of the Mind: Selections from the Edward L. Elliott Family and John B. Elliott Collections of Chinese Calligraphy and Painting at the Art Museum, Princeton University* (Princeton: Art Museum, 1984), pp. 33–39.

27 Li T'ang's best extant work, *Wan-huo sung-feng* 萬壑松風 (Wind in the Pines amid Ten Thousand Valleys), belongs to the National Palace Museum, Taipei. See

Wen C. Fong and James C. Y. Watt, *Possessing the Past: Treasures from the National Palace Museum, Taipei* (New York: Metropolitan Museum of Art, and Taipei: National Palace Museum, 1996), pl. 61, p. 132.

28 See note 2.

29 See Louise Yuhas, entry 11 in *Eighty Works in the Collection of the University of Michigan Museum of Art* (Ann Arbor: University of Michigan Museum of Art, 1979). According to this entry, there is a second scroll in the series, *Spring Dawn at Yen-chi*, belonging to a private collection in New York.

30 See Sheng Ta-shih 盛大士 (1771–after 1834), *Hsi-shan wo-yu lu* 谿山臥遊錄 (A Collection of the Streams and Mountains I Visited [When Lying on] My Couch), epilogue dated 1833, *chüan* 卷 (chapter) 4, reprinted in Teng Shih 鄧實 (1865?–1948?) and Huang Pin-hung 黃賓虹 (1865–1955), comps., *Mei-shu ts'ung-shu* 美術叢書 (Anthology of Writings on Fine Art) (Shanghai: n.p., 1912–36), *chi* 集 (part) 3, *chi* 輯 (division) 1, vol. 11 (Taipei: I-wen Bookstore, 1963–72), p.152. Sheng claimed that his hometown (T'ai-ts'ang 太倉), was located less than one-hundred *li* with Suchou, Ch'ang-shu and other nearby counties. In this area, the many local families that were prominent in the old days, often possessed good paintings by famous artists of the late Ming and early Ch'ing periods. Their collections, carefully authenticated by connoisseurs, were usually genuine works. (吾鄉距吳門, 虞山, 鹿城, 儸城, 皆百里. 而近舊家所藏名畫甚多. 明季迄國初諸小名家, 各有流傳手蹟. 而賞鑒家皆能別其真贋.) Sheng's assertion thus confirms that fact that old families at Ch'ang-shu owned many works by seventeenth-century famous painters like Wang Hui.

## 31. Wang Yüan-ch'i 王原祁
*(1642–1715)*
*Ch'ing dynasty (1644–1911)*

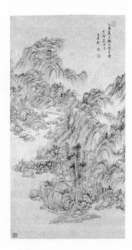

### Landscape in the Style of Huang Kung-wang (1269–1354)
*Fang Huang kung-wang shan-shui (Landscape in the Style of Huang Kung-wang)*

仿黃公望山水

1 Huang Kung-wang 黃公望 (1269–1354) was a famous painter of the Yüan dynasty (1280–1368). Due to his extraordinary accomplishments, he is acknowledged as one of the Four Great Masters of the Yüan period. For a discussion of Huang Kung-wang, see Maxwell K. Hearn, "The Artist as Hero," in Wen C. Fong and James C. Y. Watt, *Possessing the Past: Treasures from the National Palace Museum, Taipei* (New York: Metropolitan Museum of Art, and Taipei: National Palace Museum, 1996), pp. 299–306. The Four Great Masters of the Yüan dynasty are: 1) Huang Kung-wang 黃公望 (1269–1354); 2) Wu Chen 吳鎮 (1280–1354); 3) Ni Tsan 倪瓚 (1306–74); and 4) Wang Meng 王蒙 (c. 1308–85).

2 This scroll was one of the five paintings acquired by the University of Michigan under "Constructive Seizure" by U.S. Customs when J. D. Ch'en attempted to bring a portion of his Chinese painting collection into the United States in 1959. For the provenance and titles of these five paintings, see note 33 of entry 7 on Wen Cheng-ming.

3 According to Zhang Geng (Chang Keng) 張庚 (1685–1760), the text of Wang Yüan-ch'i's seal, "Executing paintings and leaving them for the enjoyment of later generations," was originally composed by Emperor K'ang-hsi 康熙 (r. 1662–1722), who inscribed this sentence and bestowed it upon Wang Yüan-ch'i when the artist served at the Nan-shu-fang 南書房, or the

"imperial study." The ruler watched Wang paint and was so fascinated that he stayed there until the shadow on the sun dial moved one full demarcation. The use of this description indicated K'ang-hsi's approval of Wang's painting. In memory of the emperor's praise, Wang carved it onto his seal. See Chang Keng's *Guochao huazhenglu (Kuo-ch'ao hua-cheng lu)* 國朝畫徵錄 (Biographical Sketches of the Artists of the Ch'ing Dynasty), preface dated 1739, *juan (chüan)* 卷 (chapter) 3, reprinted in Yu Anlan 于安瀾, comp., *Huashi congshu (Hua-shih ts'ung-shu)* 畫史叢書 (Compendium of Painting History), vol. 5 (Shanghai: Renmin Meishu Chubanshe, 1962), p. 52. (聖祖嘗幸南書房, 時公為供奉, 即令畫山水. 聖祖憑几而觀, 不覺移晷 嘗賜詩, 有 "畫圖留與後人看" 句. 公鐫石為印章, 紀恩也.)

4 The name of Wang Yüan-ch'i's studio in the capital, Ku-i Hall 穀貽堂, was derived from a term found in the Chinese classic *Book of Odes*. Originally the sequence of these two characters was written reversed as *i-ku* 貽穀 which signifies the good fortune inherited from one's ancestors. Thus, Wang Yüan-ch'i must have fully realized the advantages he inherited from his ancestors. See *Hanyu dacidian (Han-yü ta-tz'u-tien)* 漢語大詞典 (Chinese Terminology Dictionary), vol. 10 (Shanghai: Hanyu Dacidian Press, 1988), p. 182, s.v. "*yigu (i-ku)* 貽穀."

5 Yüan Pei-yeh was an unidentified late-nineteenth or early twentieth-century collector.

6 For a discussion of the eminent families of the *chiang-nan* region, see P'an Kuang-tan 潘光旦, *Ming-Ch'ing liang-tai Chia-hsing teh wang-tsu* 明清兩代嘉興的望族 (The Eminent Families in the Chia-hsing Area during the Ming and Ch'ing Dynasties) (Shanghai: Commercial Press, 1936).

7 Wang Hsi-chüeh shared the administrative authority of a prime minister with several other statesmen and, despite threats from the powerful leader of the collective ruling circle, spoke his mind openly. For Wang Hsi-chüeh's biography, see L. Carrington Goodrich and Fang Chaoying, eds., *Dictionary of Ming Biography, 1368–1644*, vol. 2 (New York and London: Columbia University Press, 1976), pp. 1376–79.

8 See entry 30 of Wang Hui for a discussion of Wang Shih-min's relation to Wang Hui.

9 As Wang K'uei earned his *chin-shih* degree and associated with high officials in the capital, he established a relationship that was vital to his son's future career. Wang Yüan-ch'i must have fully realized the

advantages he inherited from his ancestors. See also note 4.

10 For a description of Wang Yüan-ch'i's appearance, see Lu Shih-hua 陸時化, *Wu Yue suojian shuhualu (Wu-Yüeh so-chien shu-hua lu)* 吳越所見書畫錄 (A Record of the Painting and Calligraphy Viewed in the Kiangsu and Chekiang Region), preface dated 1776, *juan (chüan)* 卷 (chapter) 6, reprinted in Lu Fusheng 盧輔聖 et al., *Zhongguo shuhua quanshu (Chung-kuo shu-hua ch'üan-shu)* 中國書畫全書 (The Complete Collection of Books on Chinese Painting and Calligraphy), vol. 8 (Shanghai: Shanghai Shuhua Chubanshe, 1994), p. 1163, entry on *Guochao Wang Sinong fang Huanghe Shanqiao "Qiushan dushu tu" lizhou (Kuo-ch'ao Wang Ssu-nung fang Huang-ho Shan-ch'iao "Ch'iu-shan tu-shu t'u" li-chou)* 國朝王司農仿黃鶴山樵 "秋山讀書圖" 立軸 (A Hanging Scroll by Wang Yüan-ch'i of the Ch'ing Dynasty, [Entitled] After Huang Kung-wang's "Studying in the Autumn Mountains"). One of Wang Yüan-ch'i's portraits by Yü Chih-ting, dated 1707, currently belongs to the Nanking Museum. It is reproduced in *Zhongguo gudai shuhua tumu (Chung-kuo ku-tai shu-hua t'u-mu)* 中國古代書畫圖目 (An Illustrated Catalogue of Selected Works of Ancient Chinese Painting and Calligraphy), vol. 7, no. 蘇 24-0716, p. 190. See also note 35 of entry 32 on Yü Chih-ting. The other portrait, currently at the Palace Museum, Beijing, is reproduced in this entry, fig. 54, and was originally reproduced in a catalogue, (Anonymous) *Zhongguo lidai renwu huaxuan (Chung-kuo li-tai jen-wu hua-hsüan)* 中國歷代人物畫選 (Selected Figure Paintings from the Past Dynasties) (Nanjing: Jiangsu Meishu Chubanshe, 1985), p. 171. The whole handscroll bearing Wang's portrait is reproduced in Yang Xin et al., *Three Thousand Years of Chinese Painting*, (New Haven: Yale University Press; Beijing: Foreign Language Press, 1997), pl. 252, p. 272. There is also another portrait of Wang found in Yeh Kung-cho's 葉公綽 (1880–1968) *Ch'ing-tai hüeh-che hsiang-chuan* 清代學者像傳 (Biographies and Portraits of Ch'ing Dynasty Scholars), reprint (Taipei: Wen-hai Press, 1969), p. 77.

11 See Lu Shih-hua's *Wu-Yüeh so-chien shu-hua lu* 吳越 所見書畫錄 (A Record of the Painting and Calligraphy Viewed in the Kiangsu and Chekiang Region), *chüan* 卷 (chapter) 6, p. 1163. The original text says: "[Wang Yüan-ch'i] was of stocky build and possessed prominent features. [He also] had a heavy beard and mustache. In his dealings with others, he was calm and broad-minded, never calculating nor

*The Orchid Pavilion Gathering*
Notes

Wang Yüan-ch'i 王原祁
Landscape in the Style of Huang Kung-wang
    (1269–1354)
*continued*

88  scheming. . . . He had many pock marks; subsequently, people referred to him as a 'pock-marked stone lion,' and he adopted the *hao* 'a dignified and cultivated person resembling a stone-lion.'" (體貌瑰偉, 虬髯豐頤. 遇物坦易, 不設機變. . . . 多麻, 人呼麻石獅子. 自號石獅道人.)

12  See ibid.

13  For Wang Yüan-ch'i's official career, see the eulogy for Wang Yüan-ch'i written by T'ang Sun-hua 唐孫華 (1634–1723) found in Li Huan 李桓 (1827–1891), comp., *Kuo-ch'ao ch'i-hsien lei-cheng ch'u-pien* 國朝耆獻類徵初編 (A Preliminary Compilation of Biographies of the Eminent Individuals of the Ch'ing Dynasty), 1st edition dated 1884, *chuan* 卷 (chapter) 56, pp. 9–12, reprint (Taipei: Wen-hai Press, 1966), pp. 3460–61. See also Wang's brief autobiography composed by Wang Ch'ang 王昶 (1725–1806), in ibid., pp. 3461–62.

14  See ibid.

15  The official title Ssu-nung literally means "in-charge of agriculture," and designated a government position that started during the Han dynasty (206 B.C.–A.D. 220). This administrator was also responsible for the government's financial affairs. See *Tz'u-hai* 辭海 (Sea of Terminology: Chinese Language Dictionary), vol. 1 (Taipei: Chung-hua Press, 1974), p. 533 , s.v. "Ssu-nung 司農."

16  See Wang Yüan-ch'i's biography in *Kuo-ch'ao ch'i-hsien lei-cheng ch'u-pien* 國朝耆獻類徵初編 (A Preliminary Compilation of Biographies of the Eminent Individuals of the Ch'ing Dynasty), *chuan* 卷 (chapter) 56, pp. 3460–61.

17  See ibid.

18  See ibid.

19  See ibid.

20  Wang Yüan-ch'i's employer, Chao Shen-ch'iao, often bullied and humiliated him, occasionally bringing him to tears. For the details of Chao Shen-ch'iao's life, see Arthur W. Hummel, ed., *Eminent Chinese of the Ch'ing Period (1644–1912)*, vol. 1 (Washington, D.C.: United States Government Printing Office, 1943–44), p. 80, and Wang Zhengyao 王政堯, "Zhao Shenqiao (Chao Shen-ch'iao) 趙申喬," in Wang Sizhi 王思治 et al., *Qingdai renwu zhuangao (Ch'ing-tai jen-wu chuan-kao)* 清代人物傳稿 (Biographical Manuscripts of the Personages of the Ch'ing Dynasty) (Beijing: Zhonghua Bookstore, 1988), pp. 200–208. For some time after Wang died, officials at the court attempted to persuade the emperor to fill his vacant position. The emperor angrily responded, "I have heard that the officials at the Ministry of Revenue constantly quarrel with one another. Wang Yüan-ch'i used to complain that he could not stand it. He wept and died because of his deep anxiety and sorrow." The incident between Wang Yüan-ch'i and his superior, Chao Shen-ch'iao, is recorded in Chinese First Historical Document Bureau, ed., *Kangxi qiju zhu (K'ang-hsi ch'i-chü chu)* 康熙起居注 (A Record of Emperor K'ang-hsi's Life and Activities), vol. 3 (Beijing: Zhonghua Bookstore, 1984), day thirty of the tenth moon in the fifty-fourth year during the K'ang-hsi reign, p. 2211. (聞得戶部堂官, 每日鬥氣. 王原祁自謂如何度日, 哭泣而死.) On another occasion, the emperor also said: "One minister like Chao in the Ministry of Revenue is sufficient. There is no need to fill in the [Wang's] vacancy. Even [Chao's] Manchurian colleague has abandoned him. Wang Yüan-ch'i had become despondent and died due to this harsh treatment and now another one is dying." See ibid., on day twenty-three of the eleventh moon in the same year, p. 2225. (戶部有一趙申喬足矣! 何必再行補授? 滿州尚書業已避去, 一漢侍郎為彼抑郁而死, 一漢侍郎又已成疾瀕死.) Although the emperor was truly angry, he tolerated Chao Shen-ch'iao because, despite his bad temperament, Chao was a capable and honest administrator.

21  While Wang Yüan-ch'i served at the court in Peking, his aged grandfather Wang Shih-min remained at their old home in T'ai-ts'ang. In a letter to his grandson, Wang Shih-min complained about the exorbitant taxes and levies imposed upon the Wang family. See Chiang Ch'un 江春, "Wang Shih-min yü Wang Hui te kuan-hsi 王時敏與王翬的關系" (The Relationship between Wang Shih-min and Wang Hui) in *I-lin ts'ung-lu* 藝林叢錄 (A Collection of Articles on Art), vol. 2 (Hong Kong: Shang-wu Press, 1961), pp. 312–13. Wang Shih-min's letter describing the embarrassing situation of owing tariffs to the government and not being able to pay is moving. It exposes the difficulties of the Wang family, as well as those of other people in the area. The letter says, "[Because] the official in charge of the county incurred a deficit of forty to fifty thousand teals of silver, he is going to sacrifice the lives of the local people to make up the difference. With three moons, he prepared a heavy paddle weighing nine *chin* (about 4.5 kilograms). He used it to punish prisoners who could not pay. Nobody could survive fifteen lashes. Within three days, he killed many people. Fortunately, the governor was there and demanded that he stop. After that, punishment was lax for a while. As a rule, when a *hsiu-ts'ai* (a graduate of the first degree) was punished, the Director of Studies would intercede. In many districts the punishment seems to have slowed down. Only in our county are people inevitably whipped whenever they are called to the court. Recently, our acquaintance Mr. Ch'ien Lu-ssu was punished again; he received twenty lashes and was locked up. [Fortunately,] he was bailed out the next morning. I think Ch'ien is unwise and his two sons are peculiar [because they did not opt to pay the taxes]. At the beginning of this month, the local government issued a new tax. People now have to pay forty percent instead of twenty and are obligated to pay the whole amount at once. A clerk is appointed for each household and presses them to pay immediately. Locally, only two wealthy gentry families were able to deliver sixty to eighty teals of silver the next morning [on time]. Among the large and eminent households, Mr. Peng Ch'eng-hsien paid his dues. Because our family owns so much land, we desperately need to pay something in order to resolve this pressing situation. I urged each of our family heads to provide their share, but all the brothers told me they do not have the money. Nobody has paid yet, and this has caused much trouble. [In order to] encourage people to pay their principal within three days, [the government] also recently waived the extra allowance of tribute-rice penalty. Within three days, the government collected almost five thousand teals of silver. If our family could have taken advantage of this proposal, we would have been able to save some money. Since we were not able to amass even one dime, we let this good opportunity slip away as if our hands were tied. Our poverty and calamity are such burdens; how can we find an excuse for not paying if the senior officials have no sympathy? Caught in a situation such as this, with the harsh government oppression and people being so poor, I fear that in the near future we will not be able to escape disaster. Great are [my] worries and anxieties. (當事因空四五萬, 欲將州民性命填補 三月中比較 造九斤大板. 打十五未有不死者. 三日內, 連斃數人. 幸府尊在州, 極口言其不當如此 遂復稍寬 然庠友加刑, 則文宗中飭. 後各邑稍覺衰止. 惟吾州帶上, 無不鞭撻 近錢魯斯又責二十板收監, 次早保出 此君固頑鈍, 二子尤可怪也 月初, 又立一法條. 除徵二分所生外, 更徵四分. 俱要一時清完 每戶各一書手守催. 鄉紳, 惟兩顯者, 次早各先送一六十一八十金. 大戶, 亦惟彭城先有所納. 我家田多, 亦宜少有輸助 以見急公. 曾批各分湊處, 而諸兄弟皆罄空無措. 至今未有, 甚為不便. 近又免耗三日, 鼓勵投納者. 三日內, 遂收五千餘金. 我家若乘此隙, 少有投納 亦得小便宜. 而無奈莫措毫末, 亦竟束手磋過. 事勢窮迫至此; 無論官長

不肯體詧 自家何計支吾? 處此廠令嚴急, 民
窮無告之日, 恐將來終不免禍 大是可憂)

22  See ibid. In another letter from Wang Shih-
min to Wang Yüan-ch'i, the old man com-
plained that he was bullied by a number of
art collectors, who insisted that the aged
Wang Shih-min show them the master-
pieces and then forced him to sell the
scrolls to them at prices far below their
market value. This letter says, "Chi
Ts'ang-wei (*hao* of Chi Chen-i 季振宜
[1630–?]) recently collected a large number
of antiques. Yet he is like a blind person in
authentication and had to rely on the judg-
ment of the dealer Ch'en Ting (active 17th
century). Chi Ts'ang-wei also associates
with Ch'ien Tsun-wang (*hao* of Ch'ien
Tseng 錢曾 [1629–1701]). [Chi Ts'ang-wei]
purchased from the latter a group of books
printed during the Sung dynasty
(960–1279), and in one exchange, he paid
three thousand teals of silver. Chi is stay-
ing at the house of Ch'ien. Only yesterday,
he sent his greetings by a messenger and
told me that he would come to our house
to view our collection of painting and cal-
ligraphy. From what I heard, Chi Ts'ang-
wei is a despicable person and intimate
friends with Ch'en Ting. During the past
few years, Ch'en has defrauded more than
ten thousand teals of silver from Chi, but
Chi still trusts him. If Chi comes, it must
be at the instigation of the dealer Ch'en,
who might forcibly seize our art works as
he did last time. In addition, Ch'ien Tseng
is an evil person who would drill a hole
through my bone to pick my marrow!
Both are dangerous to associate with.
When I heard that they intended to come
together, I became very frightened! Since I
cannot excuse myself by claiming that I
am ill, I am caught in a serious dilemma. I
do not know whether to let them come or
to turn them away. (季滄葦, 近日大收古董.
然有目無睹, 惟藉陳定為眼 近又與錢遵王往
來甚密. 買其宋板書, 一次便有三千金交易. 今
在其家. 昨託伊人來云, 先特致意, 要到我家看
書畫. 聞此公最刻, 惟與陳定膠漆. 連年被其騙
取幾萬餘金, 然信之不疑. 此來, 必受其心印.
或仍如前強奪, 皆未可知. 遵王亦一鑽骨剔髓
之人, 俱非好相識. 聞欲之偕來, 我甚怖愯! 然
不能引疾以謝之, 正在躊躇未決辭見兩難也!)
Although Chi Chen-i's official position
was only a "censor," he was notorious for
accumulating wealth through illegitimate
means. One entry entitled "Chi-shih chih-
fu 季氏之富" (The Wealth of Mr. Chi) found
in Niu Hsiu's 紐琇 (active late 17th–early
18th century) *Hui-t'u ku-sheng cheng-hsü-
pien* 繪圖觚賸正續編 (Sequel to Illustrated
Random Notes Left in a Ku Cup, a book
dealing with the anecdotes of the late
Ming to early Ch'ing period), preface dated
1702, *chüan* 卷 (chapter) 3, p. 4b, reprint

(Taipei: Kuang-wen Press, 1969), p. 284,
gives a vivid description of the luxurious
life of the Chi family. It seems that the
Chi family amassed an immense amount
of wealth through corruption.

23  When Wang Yüan-ch'i painted, he required
antique paper manufactured during the
Hsüan-te 宣德 reign (1426–36); brushes lay-
ered with hair from multiple sources such
as goat, mink, and weasel; and only the
finest grades of ink. See *Kuo-ch'ao hua-
cheng lu* 國朝畫徵錄 (Biographical Sketches
of the Artists of the Ch'ing Dynasty),
*chüan* 卷 (chapter) 3, p. 52. The Chinese
text is given as: "每作畫, 必以宣德紙, 重毫
筆, 頂煙墨." The first item, the paper of the
Hsüan-te reign, is a type of paper that was
produced during the Ming dynasty. It has a
dense surface that can hold ink and water
without absorbing them into the tissue too
quickly. It is different from the paper made
during Wang Yüan-ch'i's lifetime, on which
the ink and color washes tend to seep.
Many literati painters of Wang's period,
such as Shih-t'ao and Pa-ta Shan-jen,
emphasized running-ink effects when they
painted; consequently they preferred the
new paper. Wang Yüan-ch'i, on the other
hand, would apply many layers of ink and
color washes to his painting. If the paper
had been absorbent, the ink and color
washes would have mixed and merged, and
the layering effect would be totally lost.
Thus, he required older, denser paper.
Emperor Hsüan-te was famous for produc-
ing objects of fine quality such as porce-
lains, carved lacquer ware, and bronze
incense burners. The second item, the
brush with layers of hair from multiple fur
sources, demonstrates the desirable flexi-
bility of a good brush. The goat hair is
absorbent but too soft, while the mink and
weasel bristles are resilient but lack
absorption. Ideally, a brush consists of bris-
tles in the center surrounded by many lay-
ers of other types of hair. The finest grades
of ink were made from the soot of burned
pine wood. A brush stroke with this kind
of ink would not be as iridescent as a
stroke using ink made from the soot of oil,
but is darker and has a soft black surface
resembling black velvet. Wang was also a
gourmand who constantly pursued epi-
curean delights; in order to assure the ful-
fillment of this pleasure, he employed in
his home a culinary expert. He also invited
a national champion to reside with the
family in order to polish his skill at chess.
See Jason Kuo's *Wang Yüan-ch'i te shan-
shui-hua i-shu* 王原祁的山水畫藝術 (The
Art of Wang Yüan-ch'i's Landscape Paint-
ing), p. 21. Checking the source of the
information given by Kuo in note 89, one
finds that the chess master's name, Hsü

Ssu-min 徐司民, is indeed mentioned in the
inscription on Wang Yüan-ch'i's painting
*Fang Chao Ta-nien chiang-nan ch'un ts'an
Sung-hsüeh pi-i* 倣趙大年江南春參松雪筆意
(After Chao Ling-jeng's [active 1067–1100]
*Spring in the Chiang-nan Area* with brush-
work by Chao Meng-fu [1254–1322]),
recorded in Lu Shih-hua's 陸時化 *Wu-Yüeh
so-chien shu-hua lu* 吳越所見書畫錄 (A
Record of the Painting and Calligraphy
Viewed in the Kiangsu and Chekiang
Region), *chüan* 卷 (chapter) 6, pp. 1163–64.
The name of Wang's culinary expert, Kuo
Nien-ch'eng 郭念澄, however, is not found
in Kuo's source. Wang Yüan-ch'i enjoyed a
warm relationship with his resident guests
and many followers. It is recorded that
when Wang served in Peking, in the late
fall of every year he presented each of them
with a painting that they could sell in order
to purchase new winter clothing. Many col-
lectors would save their money and wait
for the once-a-year opportunity to purchase
one of these works as they became avail-
able on the market. See *Kuo-ch'ao hua-
cheng lu* 國朝畫徵錄 (Biographical Sketches
of the Artists of the Ch'ing Dynasty),
*chüan* 卷 (chapter) 3, p. 52.

24  For Wang Shih-min's influences on his
grandson, see Wang Yüan-ch'i's *Lutai
tihua gao (Lu-t'ai t'i-hua kao)* 麓臺題畫稿
(Manuscripts of Wang Yüan-ch'i's Painting
Inscriptions), reprinted in Yu Anlan 于安瀾,
*Hualun congkan (Hua-lun ts'ung-k'an)* 畫
論叢刊 (Compendium of Painting Theory),
1st edition dated 1937, reprint, vol. 1 (Bei-
jing: Renmin Meishu Chubanshe, 1989),
pp. 220–21, s.v. "Fang Dachi shoujuan
(Fang Ta-ch'ih shou-chüan) 倣大癡手卷"
(A Handscroll in the Style of Huang Kung-
wang). Wang says that when he was young,
he attended to his grandfather so that the
latter would provide him with introduc-
tory instruction. (余少時侍先大父, 得聞緒
論.)

25  See *Kuo-ch'ao hua-cheng lu* 國朝畫徵錄
(Biographical Sketches of the Artists of the
Ch'ing Dynasty), *chüan* 卷 (chapter) 3,
p. 51.

26  In Wang Yüan-ch'i's *Yü-ch'uang man-pi* 雨
窗漫筆 (Casual Notes by a Window on a
Rainy Day), reprinted in Yu Anlan's 于安瀾
*Hua-lun ts'ung-k'an* 畫論叢刊 (Com-
pendium of Painting Theory), vol. 1, p.
206, Wang says, "During the end of the
Ming dynasty, there were prevailing pesti-
lent habits in painting, as well as heretical
painting schools, the Che school being the
worst. In the Wu (Suchou) and Yün-chien
(Shanghai) area, there were good painters
like Wen Cheng-ming (1470–1559) and
Shen Chou (1427–1509) and a great school
founder like Tung Ch'i-ch'ang. The many

Wang Yüan-ch'i 王原祁
Landscape in the Style of Huang Kung-wang
  (1269–1354)
*continued*

90    counterfeits of their paintings are, unfortunately, so confusing that distinguishing between imitations and genuine works is difficult. This malady has become prevalent. The vicious practice of the painters in Nanking and Yangchou is just like that of the Che school. Those who wish to learn painting should always bear this in mind." (明末, 畫中有習氣惡派, 以浙派為最. 至吳門雲間, 大家如文沈, 宗匠如董. 贋本淴涗, 以訛傳訛, 竟成流弊. 廣陵白下, 其惡習與浙派無異. 有志筆墨者切須戒之.) See also Wang's *Lu-t'ai t'i-hua kao* 麓臺題畫稿 (Manuscripts of Wang Yüan-ch'i's Painting Inscriptions), p. 226, s.v. "Huajia zonglun, tihua cheng bashu (Hua-chia tsung-lun, t'i-hua ch'eng pa-shu) 畫家總論題畫呈八叔" (A Summary of the Past Painters, Inscribed on a Painting to Be Presented to My Eighth Uncle). His opinions on the southern and northern Chinese painting schools are fully revealed in this inscription, written in 1713 at age seventy, on a painting presented to his uncle, Wang Shan 王掞 (1645–1728). In it, Wang Yüan-ch'i admitted the accomplishments of the so-called northern painters of the Southern Sung period by saying, "It does not mean that Liu Sung-nien (active c. 1175– after 1207), Li T'ang (c. 1070–c. 1150s), Ma Yüan (active c. 1160–after 1225), and Hsia Kuei (active c. 1200–c. 1240) did not produce works that startle the mind and dazzle the eye. Their paintings do possess painstakingly and attractively executed details. [However, when these achievements are] compared with the vigor and boundless majesty found in works by Tung Yüan (active c. 943–58), Chü-jan (active c. 976–93), and Mi Fu (1051–1107), [their] superiority and inferiority are quite discernible. . . . My Eighth Uncle asked me to elucidate the authentic southern painting school. I immodestly answered his question in the above inscription." (如南宋之 劉, 李, 馬, 夏, 非不驚心炫目, 有刻畫精巧處. 與董, 巨, 老米元氣磅礴, 則大小徑庭矣. . . . 八叔父問南宗正派, 敢以是對.)

27    For the names of the Four Yüan masters, see note 1. Wang Yüan-ch'i actually stated that Huang Kung-wang's style was carried on by Tung Ch'i-ch'ang during the Ming period. During the Ch'ing dynasty, this tradition was practiced by his own grandfather, Wang Shih-min. Wang Yüan-ch'i himself naturally inherited everything from Wang Shih-min. This statement is found in one of Wang Yüan-ch'i's inscriptions on his hanging scroll entitled *Fang Huang Kung-wang shan-shui* 倣黃公望山水 (Landscape after the Style of Huang Kung-wang), dated 1706, now at the Freer Gallery of Art, Washington, D.C. It is reproduced in Suzuki Kei 鈴木敬, comp.,

*Comprehensive Illustrated Catalog of Chinese Paintings*, vol. 1 (Tokyo: University of Tokyo Press, 1982), no. A21-199, p. 249. The text says: "Among the Four Yüan Masters, Huang Kung-wang best encapsulates the styles of Tung Yüan and Chü-jan, and [Huang] truly broke fresh ground. During the next three hundred years of the Ming dynasty, Tung Ch'i-ch'ang, born with the bones of an immortal [blessed with elegance and talent] obtained access to Huang's essence. My grandfather, Wang Shih-min, was the only heir of this legacy. [I was immersed in this family aesthetic early.] My ears were saturated, my eyes tinted early; thus I have a superficial knowledge of this tradition." (董巨風韻, 元季四家中, 大癡得之最深, 另并生面. 明季三百年來, 董宗伯仙骨天成, 入其堂奧. 衣鉢正傳, 先奉常一人而已. 余幼稟家訓, 耳濡目染, 略有一知半解.) See also *Kuo-ch'ao hua-cheng lu* 國朝畫徵錄 (Biographical Sketches of the Artists of the Ch'ing Dynasty), *chüan* 卷 (chapter) 3, pp. 51–52.

28    See Wang Yüan-ch'i's *Lu-t'ai t'i-hua kao* 麓臺題畫稿 (Manuscripts of Wang Yüan-ch'i's Painting Inscriptions), pp. 210–33. Another Yüan dynasty master who influenced Wang Yüan-ch'i was Ni Tsan. Wang Yüan-ch'i esteemed Ni Tsan almost as much as he did Huang Kung-wang. On his painting entitled *Fang Ni Tsan shan-shui* 倣倪瓚山水 (After Ni Tsan's Landscape), executed in 1712 at age seventy-one, he stated that among past masters, "Yün-lin (Ni Tsan's *hao*, meaning "forest with clouds") was the most elegant; thus, Ni Tsan could become famous alongside Huang Kung-wang." (畫家惟雲林最為高逸, 故與大癡同時相傳.) Wang's painting is reproduced in *Ku-kung shu-hua t'u-lu* 故宮書畫圖錄 (An Illustrated Catalogue of Calligraphy and Painting at the Palace Museum), vol. 10 (Taipei: National Palace Museum, 1993), p. 337. Other works by Wang Yüan-ch'i after Ni Tsan are reproduced in the above book, p. 273 and p. 289. In some of his works, Wang would merge the styles of Huang Kung-wang and Ni Tsan into one composition. For an example, see his work reproduced in the same book, p. 325. Wang Yüan-ch'i also respected Wang Meng and asserted: "By the time of Wang Meng, the painting of the Yüan dynasty had a new appearance. His [Wang Meng] work was of equal quality with that of Tzu-chiu (*tzu* of Huang Kuang-wang, meaning "ever-lasting scholar"), Yün-lin (Ni Tsan's *hao*, meaning "forest with clouds"), and Chung-kuei (*tzu* of Wu Chen, meaning "the second jade *kuei* scepter"). While their work is stylistically different, their taste and objective were identical."(元畫至黃鶴山樵而一變. 與子久, 雲林, 仲圭, 相伯仲. 跡雖異, 而趣則同

也.) See Wang Yüan-ch'i's *Lu-t'ai t'i-hua kao* 麓臺題畫稿 (Manuscripts of Wang Yüan-ch'i's Painting Inscriptions), p. 227, s.v. "Fang Wang Shu-ming wei Chou Ta-yu tso 倣王叔明 為周大酉作" ([A Painting] after Wang Meng, executed for Mr. Chou Ta-yu). Wang Yüan-ch'i painted many scrolls in the style of Wang Meng. See *Ku-kung shu-hua t'u-lu* 故宮書畫圖錄 (An Illustrated Catalogue of Calligraphy and Painting at the Palace Museum), vol. 10, pp. 259, 267, 313, and 333. Although Wang Yüan-ch'i's student T'ang Tai 唐岱 (1673–after 1752) asserted, "In Wang's late years, he had a comprehensive understanding of Mei Tao-jen's [Wu Chen's *hao*, meaning 'a cultivated person who appreciates plum blossoms'] brushwork" (麓臺晚年, 深知梅道人墨法) thus implying that Wang followed the style of this Yüan master, in reality Wu Chen's influence on Wang Yüan-ch'i is not as visible as that of the other three Yüan painters. For T'ang's comments, see T'ang Tai's *Hui-shih fa-wei* 繪事發微 (Revealing the Abstruse Aspects of Painting), prefaces dated 1717 and 1718, reprinted in Yü Shao-sung 余紹宋 (1882–1949), *Hua-fa yao-lu* 畫法要錄 (A Compilation of Painting Methods), *chüan* 卷 (chapter) 5 (Taipei: Chung-hua Press, 1967), p. 16. For examples of Wang Yüan-ch'i's paintings in the style of Wu Chen, see *Ku-kung shu-hua t'u-lu* 故宮書畫圖錄 (An Illustrated Catalogue of Calligraphy and Painting at the Palace Museum), vol. 10, p. 331.

29    For the names of the Six Masters of the Early Ch'ing Period, see note 6 in entry 30 on Wang Hui.

30    The two elder Wangs, Wang Shih-min, who was Wang Yüan-ch'i's grandfather, and Wang Chien 王鑑 (1598–1677), no relation, enthusiastically pursued Tung Ch'i-ch'ang's traditional approach in painting. As a result, their works, conservative and conventional, lack vitality. Once Wang Chien saw the painting of young Wang Yüan-ch'i, he was greatly impressed and reportedly said to Wang Shih-min: "We two old men should move aside and give way to this young artist." See *Kuo-ch'ao hua-cheng lu* 國朝畫徵錄 (Biographical Sketches of the Artists of the Ch'ing Dynasty), *chüan* 卷 (chapter) 3, p. 51. The third Wang, Wang Hui, was a professional painter whose style also depended heavily upon early masters. While his skill in replicating older techniques was impressive, his work lacks originality. Compared to the lively works by more creative painters of the time, such as Shih-t'ao 石濤 (1642–1707), and Pa-ta Shan-jen 八大山人 (1624–1705), as well as painters of the later

Yangchou school, the painting of the other three Wangs is indeed dull and insipid.

31 See Wang Yüan-ch'i's *Lu-t'ai t'i-hua kao* 麓臺題畫稿 (Manuscripts of Wang Yüan-ch'i's Painting Inscriptions), pp. 220–21. The text says: "For almost fifty years [I] dabbed and smeared [painted] here and there. Early on, I regretted that my work did not more closely resemble that of the old masters. However now, I dare not be too similar to those of the old masters. (東塗西抹, 將五十年. 初恨不似古人, 今又不敢似古人.)

32 See *Kuo-ch'ao hua-cheng lu* 國朝畫徵錄 (Biographical Sketches of the Artists of the Ch'ing Dynasty), *chüan* 卷 (chapter) 3, p. 52. The author cites this passage from the inscription on a painting by Wang Yüan-ch'i entitled *Ch'iu-shan ch'ing-shuang t'u* 秋山晴爽圖 (The Cheerful and Clear Weather at the Autumn Mountains). (不在古法, 不在吾手. 而又不出古法, 吾手之外. 筆端金鋼杵, 在脫盡習氣.) In Sanskrit, *vajra* means "thunderbolt." Originally, it was an Indo-Aryan symbol to suggest the diamond-like, indestructible character of ultimate truth. In esoteric Buddhism, *vajra* is a ritual implement for defense against evil spirits. Thus it implies supernatural power.

33 Wang Yüan-ch'i's assertion about Shih-t'ao has appeared in many publications. For example, Feng Jinbo (Feng Chin-po) 馮金伯 (active second half of 18th century) cited it for the entry on Shih-t'ao in *Guochao huashi* (*Kuo-ch'ao hua-shih*) 國朝畫識 (Identification of Painters of the Ch'ing Dynasty), 1st edition dated 1797, reprinted in *Chung-kuo shu-hua ch'üan-shu* 中國書畫全書 (The Complete Collection of Books on Chinese Painting and Calligraphy), vol. 10, *juan* (*chüan*) 卷 (chapter) 14, p. 667. This comment is also found in modern books dealing with Chinese painting, such as the entries on Shih-t'ao in both Sun Ta-kung's 孫諸公, *Chung-kuo hua-chia jen-ming ta-tz'u-tien* 中國畫家人名大詞典 (A Dictionary of the Names of the Chinese Painters) (Shanghai: Shen-chou Kuo-kuang Press, 1934), p. 562, and Yu Jianhua 于劍華 et al., *Zhongguo meishujia renming cidian* (*Chung-kuo mei-shu-chia jen-ming tz'u-tien*) 中國美術家人名詞典 (A Biographical Dictionary of Chinese Artists) (Shanghai: Renmin Meishu Chubanshe, 1981), p. 1243. Few people realize, however, that the original source of this comment is found in Niu Hsiu's 紐琇, *Ku-sheng hsü-pien* 觚賸續編 (Sequel to Illustrated Random Notes Left in a Ku Cup, a book dealing with anecdotes of the late Ming to early Ch'ing period), *chüan* 卷 (chapter) 3, pp. 13 a & b (modern pp. 301–2). Niu Hsiu's original text of Wang Yüan-ch'i's

comments on Shih-t'ao is attached to the end of a humorous note about how Shih-t'ao pacified a demon who was the incarnation of a thousand-year-old tree. When Feng Chin-po cited the text of this comment from Niu Hsiu's book, he neither cited the whole passage, nor did he point out the playful nature of Niu Hsiu's story. Since then, this comment has become Wang Yüan-ch'i's serious evaluation of a contemporary peer. Even though Wang Yüan-ch'i may have respected Shih-t'ao a great deal, the authenticity of the source of this comment is somewhat questionable. The text of Wang Yüan-ch'i's statement on Shih-t'ao follows: "[While I] do not know all of the living artists in China, [I believe the Monk] Shih-t'ao is the greatest [painter] south of the Yangtze River. Shih-ku (Wang Hui's *hao*, meaning "stone valley") and I are both inferior." (海內丹青家, 不能盡識 而大江以南, 當推石濤第一. 余與石谷, 皆所未逮.)

34 This scroll is reproduced in *Possessing the Past: Treasures from the National Palace Museum, Taipei*, pl. 285, p. 499. The painting was originally presented to Po-erh-tu 博爾都 (active 17th–early 18th century), a Manchu imperial kinsman. See also Shih Shou-ch'ien 石守謙, "A Study on an Orchid-Bamboo Scroll Collaborated on by Shih-t'ao and Wang Yüan-ch'i," in *Proceedings of the International Colloquium on Chinese Art History, 1991: Painting and Calligraphy*, part 2 (Taipei: National Palace Museum, 1991), pp. 491–511.

35 Wang Yüan-ch'i's comments on Wang Hui and Cha Shih-piao are found in *Kuo-ch'ao hua-cheng lu* 國朝畫徵錄 (Biographical Sketches of the Artists of the Ch'ing Dynasty), *chüan* 卷 (chapter) 3, p. 52. For more information on Cha Shih-piao's life and work, see entry 27. For Wang Hui's life, see entry 30.

36 Wang Yüan-ch'i's principal writings concerning painting concepts, aesthetic values, and techniques are found in his book, *Yü-ch'uang man-pi* 雨窗漫筆 (Casual Notes Written by a Window on a Rainy Day). His inscriptions on paintings were collected posthumously by later scholars and printed in a book, entitled *Lu-t'ai t'i-hua kao* 麓臺題畫稿 (Manuscripts of Wang Yüan-ch'i's Painting Inscriptions). For the different editions of these two books, see Jason Kuo's *Wang Yüan-ch'i teh shan-shui-hua i-shu* 王原祁的山水畫藝術 (The Art of Wang Yüan-ch'i's Landscape Painting), n. 61 in chap. 3, p. 54.

37 See Wang Yüan-ch'i's *Yü-ch'uang man-pi* 雨窗漫筆 (Casual Notes Written by a Window on a Rainy Day), p. 207. (作畫但須顧氣勢輪廓, 不必求好景. 亦不必拘舊稿. 若於開

合起伏得法, 輪廓氣勢已合, 則脈絡頓挫轉折處, 天然妙景自出, 暗合古法矣!)

38 Wang Yüan-ch'i's theory on "dragon vein" appears in his *Yü-ch'uang man-pi* 雨窗漫筆 (Casual Notes Written by a Window on a Rainy Day), pp. 206–7. The Chinese text is as follows: "龍脈為畫中氣勢源頭, 有斜有正, 有渾有碎. 有斷有續, 有隱有現. 謂之體也. . . . 賓主歷然." For a discussion of this topic, see Susan Bush's article, "Lung-mo, K'ai-ho, and Ch'i-fu: Some Implications of Wang Yüan-ch'i's Three Compositional Terms," *Oriental Art* 8 (Autumn 1962), pp. 120–27.

39 In several of his inscriptions, Wang Yüan-ch'i stated that his paintings were inspired by his trips to famous mountains. See Wang's *Lu-t'ai t'i-hua kao* 麓臺題畫稿 (Manuscripts of Wang Yüan-ch'i's Painting Inscriptions), pp. 213–14, s.v. "*Fang Dachi wei Qian Changhuang zhiren Xianan zuo* (*Fang Ta-ch'ih, wei Ch'ien Ch'ang-huang chih-jen Hsin-an tso*) 倣大癡為 錢長黃之任新安作" (After Ta-ch'ih [*hao* of Huang Kung-wang, meaning "big dull-witted person"], Painted for Ch'ien Ch'ang-huang, Leaving to Assume the Prefectureship of Hsin-an). In this inscription, Wang Yüan-ch'i spoke of his trip to the Shansi 山西 area via Lo-yang 洛陽, crossing the Lo 洛 and I 伊 Rivers, and portrayed this experience in a landscape using the painting style of Huang Kung-wang. See above source, p. 215, s.v. "*Fang Meidaoren, wei Xuechao zuo* (*Fang Mei-t'ao-jen, wei Hsüeh-ch'ao tso*) 倣梅道人為雪巢作" (After Wu Chen, painted for Hsüeh-ch'ao). In the inscription on this work, Wang said that this painting was based on his impressions from his trip to the Honan 河南 area in 1698. Wang Yüan-ch'i also visited Mount Hua 華山 in 1693 and painted a scroll entitled *Hua-shan ch'iu-se* 華山秋色 (Autumn Colors of Mount Hua), now belonging to the National Palace Museum, Taipei. It is reproduced in *Ku-kung shu-hua t'u-lu* 故宮書畫圖錄 (An Illustrated Catalogue of Calligraphy and Painting at the Palace Museum), vol. 10 (Taipei: National Palace Museum, 1993), p. 359.

40 According to Chang Keng, *Kuo-ch'ao hua-cheng lu* 國朝畫徵錄 (Biographical Sketches of the Artists of the Ch'ing Dynasty), Wang Yüan-ch'i was often entertained by a certain Mr. Wen-jen 聞人 in the capital. These visits occurred for several years, but Wang had yet to present any paintings to his host. When Wang learned that his host's son was to be married, he decided to give the young man a painting as a wedding gift. He called the groom-to-be to his study so that he could demonstrate his painting process. The son told Chang Keng

Wang Yüan-ch'i 王原祁
Landscape in the Style of Huang Kung-wang
  (1269–1354)
*continued*

32. Yü Chih-ting 禹之鼎
*(1647–c. 1716)*
*Ch'ing dynasty (1644–1911)*

92 later that Wang first spread a blank sheet of paper on the table and contemplated for a while. He started by using light ink to create a layout for the landscape. He then executed the tall trees in the valley and slowly built up the rocks on the many layers of the mountains. Afterwards, small trees and foliage were added. Prior to each stroke, Wang would pause for a moment, and this time-consuming process lasted well into the evening. In the morning, the young man returned and found that Wang, by use of both linear work and a rubbing technique, had started to add some texture to the rocks. At that point, the artist applied washes of light ochre and yellow pigment over the texture. A small iron, heated with charcoal, was employed to speed the drying of the wash. Wang then rubbed his dry ink brush over the colored wash, creating even more texture. He then embellished the landscape by adding details such as tree leaves, houses, bridges, boats, and sandbars. His next step was to use a mixture of ink and light green pigment to create shadow effects on the rocks, and again he used the iron to dry the second wet application. Outlines were strengthened with additional ink and more color washes, and accent dots were applied. The light surface of the painting became progressively darkened, the sparse scenery now packed with layered details. After almost half a month of painstaking effort, the painting was finally completed. Wen-jen 閏人 is a Chinese compound surname. Unfortunately, it is not possible to identify this person, although, according to Chang Keng, the son's given name was Wen-jen K'o-ta 閏人克大. See *Kuo-ch'ao hua-cheng lu* 國朝畫徵錄 (Biographical Sketches of the Artists of the Ch'ing Dynasty), *chüan* 卷 (chapter) 3, p. 53.

41 Wang's use of layered brushwork and a combination of warm and cool color tones have led some scholars to liken Wang's painting to the works of Paul Cézanne (1839–1906). In comparing Wang's work with that of later European painters, one is indeed tempted to avow that Wang seemed to understand the importance of exaggeration and distortion. One should realize, however, that while similar concepts are embedded in Western abstract painting, Wang lived about two hundred years earlier than the first modern European painters! For a discussion of Wang Yüan-ch'i and Cézanne, see: 1) Jean-Pierre Dubosc, "A New Approach to Chinese Painting," *Oriental Art* 3 (Summer 1950), pp. 51–53; 2) Osvald Sirén, *Chinese Painting*, vol. 5 (New York: Ronald Press, 1958), p. 206; 3) Sherman Lee, *Chinese Landscape Painting* (Cleveland: Cleveland Museum of Art, 1960), p. 70; 4) Michael Sullivan, *A Short History of Chinese Art* (Berkeley: University of California Press, 1967), pp. 245–46; and 5) James Cahill, *Chinese Painting* (Cleveland: World Publishing Co., 1960), p. 167.

42 Although this school was named after the Wangs' hometown, it included artists from all of China. Many of these painters, including several women, were related to the Wangs. For a list of the followers of Wang Shih-min and Wang Yüan-ch'i, see Jason Kuo's *Wang Yüan-ch'i te shan-shui-hua i-shu* 王原祁的山水畫藝術 (The Art of Wang Yüan-ch'i's Landscape Painting), pp. 88–91. Since these followers' collective goal was to mimic the style of the teacher as closely as possible, few of them ever became recognized on their own merits. According to *Kuo-ch'ao hua-cheng lu* 國朝畫徵錄 (Biographical Sketches of the Artists of the Ch'ing Dynasty), *chüan* 卷 (chapter) 3, p. 52, in Wang's later years, he was inundated with official business for the imperial court. To satisfy the large demand for his work, Wang often let his students and resident artists substitute for him and then added his signature. Approximately 70 to 80 percent of his later paintings belong to this category. Thus if a connoisseur authenticates Wang's work based on the genuineness of his signature and seals, he is bound to make a mistake. (平時以應詔不遑, 凡求者, 屬賓客及弟子代筆, 而自題其名. 大率十之七八. 鑒者徒憑款識, 則失也.) As a rule, the paintings presented to well-known scholar-officials on which Wang inscribed long passages generally involved more personal attention from the master. Among Wang Yüan-ch'i's extant works, the University of Michigan scroll would probably not be considered a masterpiece. Although Wang's seals and signature on the Michigan scroll are genuine, this work neither has an inscription nor does it display the powerful and expressive style found in Wang's best paintings. Therefore it is possible that some of the brushwork on the Michigan scroll may have been executed by one of Wang Yüan-ch'i's followers.

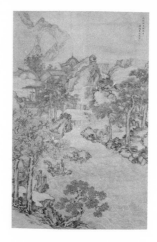

A Han Dynasty (206 B.C.–A.D. 220 ) Envoy Navigating on a Tree Raft
*Han-shih ch'eng-ch'a*
*(A Han Dynasty Envoy Navigating on a Tree Raft)*
漢使乘槎

1 Yü Chih-ting's birth date is based on the inscription found on his painting entitled *Pu-chü t'u* 卜居圖 (Selecting a Dwelling Site). Yü's inscription says, "In the fall of the *ping-yin* year (1686), I am forty *sui* (39 years)." Thus, he would have been born in 1647. Yü's *Selecting a Dwelling Site* scroll is recorded in Liang Zhangju's (Liang Chang-chü) 梁章鉅 (1775–1849) *Tuian suocang jinshi shuhua bawei* (*T'ui-an so-ts'ang chin-shih shu-hua pa-wei*) 退庵所藏金石書畫跋尾 (Colophons for the Bronze Vessels, Stone Steles, Paintings and Calligraphy in the Collection at [Liang Chang-chü's] Reticence Hut Studio), preface dated 1845, reprint in Lu Fu-sheng 盧輔聖 et al., *Zhongguo shuhua quanshu* (*Chung-kuo shu-hua ch'üan-shu*) 中國書畫全書 (The Complete Collection of Books on Chinese Painting and Calligraphy), vol. 9 (Shanghai: Shanghai Shuhua Chubanshe, 1992), p. 1111. Although the whereabouts of this scroll are unknown today, this source is reliable, as Yü's *Selecting a Dwelling Site* scroll is also recorded in several other contemporary books. The date of Yü Chih-ting's death, on the other hand, is a source of controversy. In Hu Yi's 胡藝 "Yu Zhiding nianbiao" (Yü Chih-ting nien-piao) 禹之鼎年表 (Chronological Table of Yü Chih-ting ), in *Duoyun* (*To-yün*) 朵雲 (Cloud Art Journal) 3 (Shanghai: Shanghai Shuhua Chubanshe, September 1982), p. 215, entry for the year 1716, the author tentatively assigned that year as the year of Yü Chih-ting's death. Hu deduced this year by using

the dates of a set of album leaves, entitled *Cao Sancai ji tongren shuhua ce* (*Ts'ao San-ts'ai chi t'ung-jen shu-hua ts'e*) 曹三才同人書畫冊 (A Set of Album Leaves of Colleagues' Painting and Calligraphy Assembled by Ts'ao San-ts'ai). Ts'ao's colophon, dated 1716, indicates that Yü Chih-ting and several of his contemporaries had all died. This set of album leaves is recorded in Ko Chin-lang's 葛金烺 (1837–90) *Ai-jih-yin lu shu-hua lu* 愛日吟盧書畫錄 (Catalogue of the Painting and Calligraphy at [Ko Chin-lang's] Enjoying Daily Poetry Chanting Cottage), preface dated 1881, *chüan* 卷 (chapter) 3, reprint (Taipei: Wen-shih-che Press, 1977), pp. 202–12.

2  The character, *han* 漢, in the Chinese title may also mean the "Milky Way." In ancient China, the Milky Way was referred to as *yin-han* 銀漢 (Silver River), *t'ien-han* 天漢 (Heavenly River), and *hua-han* 華漢 (Lustrous River), etc. Thus, the Chinese title can also be interpreted as "An Envoy Rides on a Tree Raft Sailing to the Milky Way."

3  This date is based on the artist's inscription, which indicates the work was painted during the Dragon Boat Festival. Although the subject matter is not directly related to this festival, the motifs of rafts and water are similar. For more on the Dragon Boat Festival, see Robert E. Murowchick, ed., *Cradles of Civilization: China* (Sydney: Weldon Russell Publishing, 1994), pp. 83–84.

4  For a discussion of Yü Chih-ting's hometown, see *Yü Chih-ting nien-piao* 禹之鼎年表 (Chronological Table of Yü Chih-ting), p. 206.

5  Yü Chih-ting apparently adopted Yangchou as his hometown. For example, he signed his name on the Michigan scroll as "Kuang-ling Yü Chih-ting 廣陵禹之鼎," or "Yü Chih-ting from Kuang-ling." Kuang-ling was the ancient name for Yangchou. The same signature appears on many of Yü's other works.

6  Yü Chih-ting's *tzu*, Shang-chi 尚基, can be written with several different characters, although the pronunciations are all the same. For example, it can also be written as 尚稽, 尚吉, and 上吉. On some paintings, Yü used the name Kuang-ling T'ao-shang Yü-jen 廣陵濤上漁人 (A Fisherman on the Waves in Yangchou). See Victoria Contag and Wang Chi-ch'üan 王季銓, *Seals of Chinese Painters and Collectors of the Ming and Ch'ing Periods* (Taipei: Shang-wu Press, 1965), p. 216, s.v. "Yü Chih-ting."

7  For information on Yü Chih-ting's employment as a servant for the Li family, see "Volume for Literature, Art, Drama, and Music," in *Qingbai leichao xuan* (*Ch'ing-pai lei-ch'ao hsüan*) 清稗類鈔選 (Selected Anecdotes of the Ch'ing Dynasty Grouped into Categories) (Beijing: Shumu Wenxian Chubanshe, 1983–84), p. 242, s.v. "*Yu Zhiding hua shanshui renwu* (*Yü Chih-ting hua shan-shui jen-wu*) 禹之鼎畫山水人物" (Landscape and Figure Paintings by Yü Chih-ting). It says, "Yü Chih-ting's *tzu* was Shang-chi, and he was a native of Hsing-hua. When he was young, he worked as a servant for the Li family. After work, he would covertly try to paint. His master [found out and encouraged him to] concentrate on painting lessons." (禹之鼎, 字尚基, 興化人. 初為李氏青衣. 公事畢, 竊弄筆墨. 主人教其專習繪事.) The four distinguished clans in Yü Chih-ting's hometown, Hsing-hua, were the Wus 吳, Lis 李, Hsiehs 解, and Weis 魏. These families are listed in *Yü Chih-ting nien-piao* 禹之鼎年表 (Chronological Table of Yü Chih-ting), p. 207, entry for year 1660. The Li family in Hsing-hua became prosperous under Li Ch'un-fang 李春芳 (1511–85), who served as grand secretary (prime minister) at the Ming court. For Li Ch'un-fang's biography, see L. Carrington Goodrich and Fang Chaoying, eds., *Dictionary of Ming Biography, 1368–1644*, vol. 1 (New York and London: Columbia University Press, 1976), pp. 818–19. By the second half of the seventh century, Li's descendants populated the Hsing-hua area. Among these was the artist Li Shan 李鱓 (1686–c. 1760), one of the Eight Eccentrics of Yangchou. For more information about Li Shan and his creative career, see entry 37. In addition, Li Shan's cousin Li Ping-tan 李炳旦 (1670–1715) was also a talented scholar-artist. Thus, it is possible that Yü Chih-ting's old master was related to Li Shan and Li Ping-tan.

8  See *Yü Chih-ting nien-piao* 禹之鼎年表 (Chronological Table of Yü Chih-ting), p. 207, entry for year 1660.

9  For details about the art and life of Lan Ying, see entry 22.

10  This handscroll, *Yunlin tongdiao* (*Yün-lin t'ung-tiao*) 雲林同調 (Harmonizing with Yün-lin [Ni Tsan, 1306–74]), shows three gentlemen in white robes resting beneath trees by a creek. The two seated figures are supposed to represent Kao Shih-ch'i 高士奇 (1645–1703), a famous scholar-official, and a literati-monk named Ch'ang-hsiu 常岫. The one standing under the trees is meant to depict Lan Ying's grandson, Lan Shen. This painting, now at the Zhejiang Provincial Museum, is reproduced in Group for

the Authentication of Ancient Works of Chinese Painting and Calligraphy, ed., *Zhongguo gudai shuhua tumu* (*Chung-kuo ku-tai shu-hua t'u-mu*) 中國古代書畫圖目 (An Illustrated Catalogue of Selected Works of Ancient Chinese Painting and Calligraphy), vol. 11 (Beijing: Wenwu Chubanshe, 1994), no. 浙 1–369, p. 101. This handscroll is also recorded in Li Yü-fen's 李玉棻 (active second half of 19th century) *Ou-po-lo-shih shu-hua kuo-mu k'ao* 甌鉢羅室書畫過目考 (Study of the Painting and Calligraphy Viewed at [Li's] the Studio of a Buddhist Monk's Clay Begging Bowl), preface dated 1873, reprinted in Teng Shih 鄧實 (1865?–1948?) and Huang Pin-hung 黃賓虹 (1865–1955), comps., *Mei-shu ts'ung-shu* 美術叢書 (Anthology of Writings on Fine Art) (Shanghai: n.p., 1912–36), *chi* 集 (division) 5, *chi* 輯 (collection) 9, *chüan* 卷 (chapter) 2, reprint, vol. 25 (Taipei: I-wen Bookstore, 1963–72), p. 121.

11  Although Wu's original portrait by Yü Chih-ting is not extant today, it is recorded and reproduced in Wu Wei-yeh's *Meicunji* (*Mei-ts'un chi*) 梅村集 (Collection of Wu Wei-yeh), reprint (Shanghai: Guji Chubanshe, 1990), pl. 2, p. 2. Wu Wei-yeh's brief biography can be found in Arthur W. Hummel, ed., *Eminent Chinese of the Ch'ing Period (1644–1912)*, vol. 2 (Washington, D.C.: United States Government Printing Office, 1943–44), pp. 882–83.

12  For a brief biography of Wang Mao-lin, see Morohashi Tetsuji 諸橋轍次, *Dai Kanwa Jiten* 大漢和詞典 (The Great Chinese-Japanese Dictionary), vol. 6 (Tokyo: Daishukan, 1976), p. 948 (6660), s.v. "no. 341."

13  When Wang Mao-lin was young, he was accepted into the local government school through the sponsorship of Wang Shih-chen. Traditionally such a connection would have bonded the two as teacher and student. For information on Wang Shih-chen's life, see *Eminent Chinese of the Ch'ing Period (1644–1912)*, vol. 2, pp. 831–33.

14  These two imperial envoys happened to be Wang Shih-chen's students, and it was probably through this connection, as well as his skill in portraiture, that Yü Chih-ting received this assignment. His trip to Okinawa is documented in the preface for his famous scroll entitled *Wang-hui-t'u* 王會圖 (An Assemblage for Adoration of the King), dated 1688. This preface was composed by Wu Ching 吳暻 (1662–1707), who was Wu Wei-yeh's son. The text is found in Wu Ching's anthology entitled *Hsi-chai chi* 西齋集 (Collected Writings at [Wu Ching's] West Studio), vol. 2. The text has been transcribed in *Yü Chih-ting nien-piao*

Yü Chih-ting 禹之鼎
A Han Dynasty (206 B.C.–A.D. 220 ) Envoy
  Navigating on a Tree Raft
*continued*

94  禹之鼎年表(Chronological Table of Yü Chih-ting ), p. 208, entry for year 1682. It says: "Young Mr. Yü was talented and charming, one that would not fail the expectation of forefathers. He holds the official position of the master of ceremonies at the court. He was assigned to accompany the imperial envoys to Okinawa and was ordered to [board the ship] to Fukien. (禹生天才雋妙, 無愧古人 今為鴻臚序班, 方充琉球伴使, 衝命入閩.)

15  In Wang Shih-chen's *Chibei outan* (*Ch'ih-pei ou-t'an*) 池北偶談 (Casual Conversations at the North of the Pond), preface dated 1691, reprint, vol. 1 (Beijing: Zhonghua Shuju, 1984), pp. 72–73, it is recorded: "in the *chia-tzu* year during the K'ang-hsi reign (1684), Mr. Lin Yü-yen, whose *hao* was Lin-ch'ang, a native of P'u-t'ien [in Fukien province], returned from [his commission as an] envoy to Okinawa. He composed a volume of popular folk songs [recording his trip]. . . . Traveling with him was Mr. Wang Chi, the official compiler. In addition, [Wang] wrote a book entitled *A Record of the Development of the Chung-shan Region* in several volumes and presented it to the emperor. These two gentlemen were both my students." ( 康熙甲子, 莆田林舍人玉爓麟倡使琉球歸, 有竹枝詞一卷. . . . 與林同使者, 為汪撿討舟次楫. 別撰 "中山沿革誌" 若干卷, 進呈御覽. 二君皆予門人也.)

16  For more information on the P'eng-lai immortal isles, see "P'eng-lai shan 蓬萊山" (The P'eng-lai Mountains) in E. T. C. Werner, *A Dictionary of Chinese Mythology*, reprint (Taipei: Wen-hsing Press, 1961), p. 372. According to Werner, P'eng-lai is the most famous among the Eastern Isles, which consist of a large number of lesser paradises, including the thirty-six heavenly grottoes and seventy-two happy lands of the Taoists.

17  The diplomatic event to Okinawa was a popular theme for many celebrated writers of the time, including Yü Chih-ting's sponsor, Wang Shih-chen, who composed several poems in memory of this voyage. See Wang's *Ch'ih-pei ou-t'an* 池北偶談 (Casual Conversations at the North of the Pond), vol. 1, pp. 72–73, s.v. "*Lin sheren shi Liuqiu shi* (*Lin she-jen shih Liu-ch'iu shih*) 林舍人使琉球詩" (Poems on Mr. Lin's Diplomatic Mission to Okinawa).

18  The best known portrait of Wang Shih-chen by Yü Chih-ting, entitled *Youhuang zuoxiaotu* (*Yu-huang tso-hsiao t'u*) 幽篁坐嘯圖 (Sitting among the Bamboo Grove and Uttering a Sustained Sound), is now at the Shandong 山東 Provincial Museum. In this work Wang is depicted sitting beneath a cluster of bamboo with a zither on his

lap. It is reproduced in *Shandongsheng bowuguan shuhuaxuan* (*Shantung-sheng po-wu-kuan shu-hua-hsüan*) 山東省博物館書畫選 (Selected Calligraphy and Paintings from the Collection of the Shandong Provincial Museum) (Shanghai: Renmin Meishu Chubanshe, n.d.), p. 40. In another portrait, entitled *Fangxian tu* (*Fang-hsien t'u*) 放鷳圖 (Setting the White Pheasant Free), Yü depicts Wang sitting on a couch with his boy-servant opening the door of a cage to release a bird. This work is currently at the Palace Museum in Beijing and is reproduced in color in The Editorial Committee of the Palace Museum Bulletin, *Gugong bowuyuan yuankan* (*Ku-kung po-wu-yüan yüan-k'an*) 故宮博物院院刊 (Palace Museum Bulletin), no. 25 (Beijing: Palace Museum, Fall 1984), p. 1. It is also reproduced in Kao Mayching 高美慶, ed., *Qingdai Yangzhou huajia zuopin* (*Ch'ing-tai Yangchou hua-jia tso-pin*) 清代揚州畫家作品 (Paintings by Yangzhou Artists of the Qing Dynasty from the Palace Museum) (Hong Kong: Art Gallery, Institute of Chinese Studies, Chinese University of Hong Kong, 1984), pl. 26, p. 118, with color detail on p. 44. The "white pheasant" is one of the birds that appeared on the rank insignia of the officials during the Ch'ing dynasty. Thus, this fowl represents a person's official career. To set the bird free implies an official who wishes to give up his governmental career. When Wang Shih-chen published his poetry anthology, Yü Chih-ting executed another portrait of Wang, entitled *Yü-yang shan-jen tai-li hsiang* 漁洋山人戴笠像 (A Portrait of Wang Shih-chen Wearing a Straw-Hat). See Wang Shih-chen's *Yü-yang ching-hua lu* 漁洋精華錄 (The Essence of Wang Shih-chen's Poems), reprint (Taipei: World Press, 1960). Wang's portrait by Yü Chih-ting is placed between the preface and the lists of this book.

19  Hsü Ch'ien-hsüeh, along with his two younger brothers, were known as the *san-Hsü* 三徐, or the "Three [Distinguished] Hsü [Brothers]," as they all received high marks at the examinations and all rose to eminent official positions. In 1682, Hsü Ch'ien-hsüeh was put in charge of the compilation of the *History of the Ming Dynasty*, a major imperial project. A well-known scholar, Hsü won the trust of Emperor K'ang-hsi and became an important figure at the court. Although embroiled in many intriguing political power struggles, he was nevertheless one of Yü's closest supporters. For Hsü's life and career, see *Eminent Chinese of the Ch'ing Period (1644–1912)*, vol. 1, pp. 310–12.

20  The grand banquets for the ambassadors, held sometime between 1686 and 1687, are documented by Wu Ching in the preface for Yü Chih-ting 's painting. See notes 4 and 27.

21  Although Yen Li-pen's painting, *An Assembly Waiting to Be Received by the King*, has been recorded in many early books on Chinese painting, the original work is no longer extant. The version at the National Palace Museum in Taipei is probably a fourteenth-century copy. See *Ku-kung shu-hua t'u-lu* 故宮書畫圖錄 (Illustrated Catalogue of Calligraphy and Painting at the Palace Museum), vol. 15 (Taipei: National Palace Museum, 1993), pp. 25–27. Another work attributed to Yen Li-pen, *Chih-kung t'u* 職貢圖 (Foreign Envoy with Tribute Bearers), also depicts foreign envoys and is reproduced in *Illustrated Catalogue of Calligraphy and Painting at the Palace Museum*, pp. 21–24.

22  In Hsü Ch'ien-hsüeh's *Tan-yüan wen-chi* 憺園文集 (The Collected Writings of [Hsü Ch'ien-hsüeh at his] Garden of Tranquillity), *chüan* 卷 (chapter) 7, pp. 23 a & b, reprint, vol. 1 (Taipei: Han-hua Wen-hua-shih-yeh Co., 1979), pp. 515–16, there is a poem entitled "Tseng Yü Hung-lu ch'i-hua Sui-yüan hsiu-hsi t'u-chüan 贈禹鴻臚乞畫遂園修楔圖卷" (Composed for Yü, the Official of State Ceremonies, Requesting Him to Paint the Handscroll Documenting the Purification Gathering at the Sui Garden). In this poem, Hsü says, "Yü, the official of state ceremonies from Yangchou, is an excellent painter. I rushed to the south. . . . I was commissioned to edit *The National Atlas* and, thus, invited him to be the illustrator." ( 廣陵禹鴻臚, 丹青藝稱最. 往余請急歸. . . . 余方志皇輿請君任繪圖.)

23  For the official record of Yü Chih-ting's appointment, see "Chapter 291 in the Biographical Category, Art Section 3," in Chao Erxuan 趙爾巽 et al., *Qingshigao* (*Ch'ing-shih-kao*) 清史稿 (Manuscripts of the History of the Ch'ing Dynasty), vol. 504, reprint, vol. 45 (Beijing: Zhonghua Shuju Chubanshe, 1977), p. 13902.

24  Yü Chih-ting's connections in the capital were extensive. His painting, *The Elegant Gathering at the South of the City*, is recorded in several books written by his contemporaries, including Wang Mao-lin's collected writings, *Baichi wutongge ji* (*Pai-chih wu-tung-ko chi*) 百尺梧桐閣集 ([Wang's] Collected Writings at [His] Pavilion of the One Hundred-Foot-Tall Wu-tung Tree), 1st edition dated 1715, *juan* (*chüan*) 卷 (chapter) 3, reprint, vol. 2 (Shanghai: Guji Chubanshe, 1979), pp. 37–38. Another source documenting Yü's scroll is Weng Fang-kang's 翁方綱 (1733–1818) *Fu-chu shih-chi* 復初詩集 (Anthology of [Weng

Fang-kang's] Beginning Again [Studio]), vol. 42. According to *Yü Chih-ting nien-piao* 禹之鼎年表 (Chronological Table of Yü Chih-ting ), p. 208, entry for year 1682, Yü's scroll was also reproduced in *Yü-wai so-ts'ang Chung-kuo ming-hua chi* 域外所藏中國名畫集 (Famous Chinese Paintings in Overseas Collections), vol. 8, no. 2. The five scholars in Yü's painting were Wang Shih-chen, Ch'en T'ing-ching 陳廷敬 (1639–1712), Hsü Ch'ien-hsüeh, Wang Mao-lin, and Wang Yu-tan 王又旦 (1639–89); all were well-known poets. This handsome handscroll is rarely displayed or reproduced. However, it was exhibited at the show entitled *Meishin no bijutsu* 明清の美術 (Art of the Ming and Ch'ing Dynasties), the fifth in the *Chugoku bijutsu ten* 中國美術展 (Chinese Art Exhibition) series. A section of this scroll is reproduced in the catalogue *Chugoku bijutsu ten shiris 5, Meishin no bijutsu* 中國美術展シリス 5, 明清の美術 (Chinese Art Exhibition Series 5, Art of the Ming and Ch'ing Dynasties) (Osaka: Osaka Municipal Museum and Asahi News, 1980), cat. no. 4-97, p. 90. In the capital, Yü also executed several portraits for Chen T'ing-ching 陳廷敬 (1639–1712), Emperor K'ang-hsi's favorite high official. Ch'en T'ing-ching's short biography can be found in *Eminent Chinese of the Ch'ing Period (1644–1912)*, vol. 1, p. 101. Yü Chih-ting did at least three portraits for Ch'en. In addition to *The Elegant Gathering at the South of the City* scroll, in which Ch'en was included, Yü also painted for Ch'en *Yanju keertu* (*Yenchü k'e-erh t'u*) 燕居課兒圖 (Instructing Sons in One's Leisure) in 1685. This scroll is currently at the Shanghai Museum. See *Chung-kuo ku-tai shu-hua t'u-mu* 中國古代書畫圖目 (An Illustrated Catalogue of Selected Works of Ancient Chinese Painting and Calligraphy), vol. 5, no. 滬 1-3322, pp. 115–16. The subject should have a special significance to Ch'en since his youngest son, Ch'en Chuang-li 陳壯履 (1681–?), earned his *chin-shih* degree at the age of sixteen. This is recorded by the painter Chin Nung 金農 (1687–1764) in the preface of his *Tung-hsin hsien-sheng hsü-chi* 冬心先生續集 (Sequel to Chin Nung's Anthology), preface dated 1752, reprint (Shanghai: Pa-ch'ien-chüan-lou Studio, 1883), p. 3. Another famous portrait of Ch'en executed by Yü Chih-ting, entitled *Ch'u-ch'uang t'u* 楮窗圖 (A Window by the Mulberry Tree), depicts Ch'en at work in his office, sitting by a window in front of a mulberry tree. This portrait remained in the Ch'en family until the twentieth century. It now belongs to the Shanxi 山西 Provincial Museum and is reproduced in *Chung-kuo ku-tai shu-hua t'u-mu* 中國古代書畫圖目 (An Illustrated Catalogue of Selected Works of Ancient Chinese Painting and Calligraphy), vol. 8, no. 晉 1-095, p. 136. Another of Yü Chih-ting's benefactors at the court was Wu Ching 吳暻 (1662–1707). Early in his career, Yü had painted a portrait of Wu Ching's father, Wu Wei-yeh. Since then, the two had been close friends. Yü painted Wu's portrait, entitled *Hsi-chai hsing-lo t'u* 西齋行樂圖 (A Portrait of Wu Ching Indulging in Pleasures [of Collecting Antiques]), now at the Shanghai Museum and reproduced in *Chung-kuo ku-tai shu-hua t'u-mu* 中國古代書畫圖目 (An Illustrated Catalogue of Selected Works of Ancient Chinese Painting and Calligraphy), vol. 5, no. 滬 1-3327, p. 118. Wu composed a number of prefaces and long colophons for Yü's paintings. Information on Wu Ching is attached to the end of the entry on his father, Wu Wei-yeh, in *Eminent Chinese of the Ch'ing Period (1644–1912)*, vol. 2, pp. 882–83. Yü's portrait shows Wu Ching strolling by a creek near his study. Wu Ching's preface and long poem for Yü Chih-ting's famous handscroll, *Wang-hui-t'u* 王會圖 (An Assembly Waiting to Be Received by the King), dated 1688, has been transcribed in *Yü Chih-ting nien-piao* 禹之鼎年表 (Chronological Table of Yü Chih-ting), pp. 209–10, entry for year 1688. It says: "Between the *ping-yin* (1686) and *ting-mao* (1687) years in the K'ang-hsi reign, ten countries, including Korea, Vietnam, Okinawa, Holland, West-ocean (usually meaning Europe), Turfan, Thailand, Lama (Tibet), Russia, and K'e-erh-k'ai (possibly a nomadic tribe from Chinese Turkistan), like the [Korean] King, Li Tsung, all send emissaries to offer tribute [to the emperor]. Led by the chief of state ceremonies, the emperor granted them all an audience. Then, they were invited to a state banquet held by the Ministry of Rites. At that time, Mr. Hsü Hsüeh-ch'ien was the deputy minister of that department. Yü Chih-ting from Yangchou served under him. Yü was adept in portraiture. Mr. Hsü often brought Yü, who was adept in painting figures, with him to these occasions and told him to carry his painting tools. At this particular banquet, Yü held a small ink stone and sketched the foreign envoys on a stack of paper. Returning to his studio, he copied the drafts onto silk scrolls. In this work, all of the attire, swords, shoes, and even their hair, beards, and demeanors, were documented realistically." (康熙丙寅, 丁卯間. 朝鮮, 安南, 琉球, 賀藍, 西洋, 土魯番, 暹羅, 喇嘛, 阿羅斯, 喀爾凱兄十國, 其國王李悰等, 各遣使入貢. 故事大鴻臚引使臣見朝畢, 賜宴禮部. 時東海公官禮部侍郎. 公之客廣陵禹之鼎, 善人物. 公陪宴日, 輒命生囊筆以隨. 生從旁端硯, 疊小方紙, 粗寫大概. 退而圖之絹素. 凡其衣冠劍履, 毛髮神骨之屬, 無不畢肖.)

25 Among these three collectors, Chu I-tsun was a celebrated man of letters and painting, as well as an antique aficionado, who owned a large collection of calligraphy and rubbings of old inscriptions. For Chu's biographical information, see *Eminent Chinese of the Ch'ing Period (1644–1912)*, vol. 1, pp. 182–85. Chu's *P'u-shu-t'ing shu-hua pa* 曝書亭書畫跋 (Colophons for Paintings and Calligraphy Composed at [Chu's] Airing-books Pavilion) is reprinted in *Mei-shu ts'ung-shu* 美術叢書 (Anthology of Writings on Fine Art), *chi* 集 (part) 1, *chi* 輯 (division) 9, vol. 5 (Taipei: I-wen Bookstore, 1963–72), pp. 153–85. It is also recorded that in 1689 Yü Chih-ting executed a portrait depicting Chu and his son fishing by the reeds in a river. See *Yü Chih-ting nien-piao* 禹之鼎年表 (Chronological Table of Yü Chih-ting), p. 210, entry for year 1689. The second person, Sung Lo, was a high official who was a well-known poet, bibliophile, painter, connoisseur, and collector of Chinese painting and calligraphy. He was also known for his skill in horsemanship. Sung Lo's father and his younger brother all occupied official positions as well. Sung's distinguished collection, although not catalogued, is renowned in Chinese history. When Sung retired in 1708, Yü produced a long handscroll, *Kuo-men sung-pieh t'u* 國門送別圖 (Farewell at the Gate in the Capital) depicting the distinguished Sung leaving the capital for his hometown, with a large group of people seeing him off. In 1710 Yü diligently executed another long handscroll for Sung Lo entitled *Hsi-p'i shou-yen t'u* 西陂授硯圖 (Sung Lo Presenting an Ink Stone). Both paintings are currently at the Historical Museum in Beijing and are reproduced in *Chung-kuo ku-tai shu-hua t'u-mu* 中國古代書畫圖目 (Illustrated Catalogue of Selected Works of Ancient Chinese Painting and Calligraphy), vol. 1, no. 京 2-439, pp. 250–51 and no. 京 2-440, pp. 251–52, respectively. For Sung Lo's biography, see *Eminent Chinese of the Ch'ing Period (1644–1912)*, vol. 2, pp. 688–90. Furthermore, Sung's book, *Man-t'ang shu-hua pa* 漫堂書畫跋 (Colophons for Paintings and Calligraphy [Composed] at [Sung's] Hall of Boundlessness) is reprinted in *Mei-shu ts'ung-shu* 美術叢書 (Anthology of Writings on Fine Art), *chi* 集 (part) 1, *chi* 輯 (division) 5, vol. 3, pp. 67–90.

26 Kao Shih-ch'i's rapid rise in the court was legendary. Although he was poor and forlorn as a youth, by 1677, his literary knowledge had so deeply impressed Emperor K'ang-hsi that the ruler not only invited him to serve in the Imperial Study but also bestowed upon him a home west of the palace. Because of his closeness to the emperor, Kao became an influential

Yü Chih-ting 禹之鼎
A Han Dynasty (206 B.C.–A.D. 220 ) Envoy
   Navigating on a Tree Raft
*continued*

96  figure in the capital. He was an expert in authenticating paintings and antiques, and amassed one of the largest collections, which was recorded in two catalogues: *Chiang-ts'un shu-hua mu* 江村書畫目 (A List of Painting and Calligraphy in Chiang-ts'un's Collection) and *Chiang-ts'un hsiao-hsia lu* 江村消夏錄 (Chiang-tsun's [*hao* of Kao Shih-ch'i] Catalogue for Whiling away the Hot Summer Days: Paintings and Calligraphy Seen and Owned by Kao Shih-ch'i between 1690 an 1693), completed and preface dated 1693. These two works are reprinted in *Chung-kuo shu-hua ch'üan-shu* 中國書畫全書 (The Complete Collection of Books on Chinese Painting and Calligraphy), vol. 7, pp. 988–1040 and pp. 1068–78, respectively. Kao Shih-ch'i's biography is found in *Eminent Chinese of the Ch'ing Period (1644–1912)*, vol. 1, pp. 413–15.

27  Yü Chih-ting's painting for Kao Shih-ch'i's retirement is recorded in Ko Chin-lang's *Ai-jih-yin lu shu-hua lu* 愛日吟廬書畫錄 (Catalogue of the Painting and Calligraphy at [Ko Chin-lang's] Enjoying Daily Poetry Chanting Cottage), *chüan* 卷 (chapter) 3, pp. 35b–37b (modern pp. 200–204). In Ko's book is an inscription by Kao Shih-ch'i that reads, "I came to the capital in the third moon of the *chia-ch'en* year (1664) and lived there until winter of *chi-ssu* year (1689). Then I returned to the south. I casually composed many poems and asked Yü, the official of state ceremonies, *hao* Shen-chai, to paint a picture for me." (余自康熙甲辰三月入都 今己巳冬日, 始得南還偶成小詠, 索禹慎齋鴻臚作圖.)

28  Yü Chih-t'ing's *Lichee Nuts*, specially painted for Kao Shih-ch'i, belongs to the Beijing Municipal Antique Shop (Bejingshi Wenwu Shangdian 北京市文物商店). It is only listed in the *Chung-kuo ku-tai shu-hua t'u-mu* 中國古代書畫圖目 (An Illustrated Catalogue of Selected Works of Ancient Chinese Painting and Calligraphy), vol. 1, no. 京 12-235, p. 58, without a reproduction.

29  See Kao Shih-ch'i's *Chiang-ts'un shu-hua mu* 江村書畫目(Painting and Calligraphy in Kao Shih-ch'i's Collection), pp. 1075 and 1077. The three handscrolls by Yü Chih-ting found in Kao Shih-ch'i's catalogue include copies of Chou Wen-chü's 周文矩 (active 937–46) *Tung-shan hsieh-chao* 東山寫照 (Painting a Portrait for Hsieh An [320–85]), Chao Meng-fu's 趙孟頫 (1254–1322) *Ch'üeh-hua ch'iu-se* 鵲華秋色 (Autumn Colors on the Ch'üeh and Hua Mountains), and Han Huang's 韓滉 (723–87) *Wu-niu t'u* 五牛圖 (The Five Oxen). The models of Yü's painting are all important masterpieces. While the whereabouts of the painting by Chou Wen-chü is unknown, Chao Meng-fu's *Autumn Colors on the Ch'üeh and Hua Mountains* is at the National Palace Museum in Taipei. Han Huang's *Five Oxen* currently belongs to the Palace Museum in Beijing.

30  The Four Wangs of the Ch'ing dynasty are: 1) Wang Shih-min 王時敏 (1592–1680); 2) Wang Chien 王鑑 (1598–1677); 3) Wang Hui 王翬 (1632–1717); and 4) Wang Yüan-ch'i 王原祁 (1642–1715). Among them, Wang Hui was the most popular. The other three Wangs, in addition to being famous painters, were also influential scholar-officials.

31  For information on Wang Hui, see entry 30. More on Wang Yüan-ch'i's life and his artistic career can be found in entry 31.

32  In 1697, Wang Hui and Yü Chih-ting completed a scroll entitled *T'ing-ch'üan t'u* 聽泉圖 (Listening to a Brook), which depicts a mandarin sitting beneath a bamboo grove by a creek tended by two young servants. This work is now at the Nanking Museum. Their collaboration is reproduced in *Chung-kuo ku-tai shu-hua t'u-mu* 中國古代書畫圖目 (An Illustrated Catalogue of Selected Works of Ancient Chinese Painting and Calligraphy), vol. 7, no. 蘇 24-0715, p. 190.

33  For information on Wang Hui's *Southern Tour* scrolls, see Maxwell Hearn, "Document and Portrait: The Southern Tour Paintings of Kangxi and Qianlong," in Ju-hsi Chou and Claudia Brown, eds., *Chinese Painting under the Qianlong Emperor: The Symposium Papers in Two Volumes* (*Phœbus* 6.1) (Tempe: Arizona State University, 1988), pp. 91–117.

34  Yü's despondent letter to Wang Hui says, "I, Yü Chih-ting, am not a talented or ambitious person. Now I wander destitute, far from home in the capital. I have nothing to be proud of. I am ashamed to be restrained [in the capital] by the commission of a humble position. Nevertheless, year after year, I cannot think of a way to return to the south so that I could listen to your admonition and guidance. I have no money to purchase luggage or pay for the journey." (鼎, 不材, 流落長安 毫無善狀. 自慚猥以末員 所羈, 謀歸之計拙 年復一年, 刻刻欲侍先生教誨 祇緣束裝乏資, 艱澀所阻耳.) Wang Hui saved this and many other letters from his friends and compiled them into a book, *Ch'ing-hui-ke tseng-i ch'ih-tu* 清暉閣 贈貽尺牘 (Correspondences Received at [Wang Hui's] Clear-radiant Pavilion) (Shanghai: Kuo-kuang Press, 1935), pp. 20 a & b for Yü's letter.

35  The portrait of Wang Yüan-ch'i, belonging to the Nanking Museum, is reproduced in *Chung-kuo ku-tai shu-hua t'u-mu* 中國古 代書畫圖目 (An Illustrated Catalogue of Selected Works of Ancient Chinese Painting and Calligraphy), vol. 7, no. 蘇 24-0716, p. 190. A faithful copy of this 1707 portrait of Wang Yüan-ch'i, including the long colophon by Cha Sheng 查昇 (1650–1707), is currently at the Kunizo Agata 阿形邦三 Collection in Japan. The copy is reproduced in Suzuki Kei 鈴木敬, comp., *Comprehensive Illustrated Catalog of Chinese Paintings*, vol. 4 (Tokyo: University of Tokyo Press, 1982), no. JP8-033, p. 217.

36  For a reproduction of Yü Chih-ting's *Wang Yüan-ch'i Cultivating Chrysanthemums*, currently at the Palace Museum in Beijing, see fig. 54 in entry 31 on Wang Yüan-ch'i. Originally, it was reproduced in a catalogue entitled *Zhongguo lidai renwu huaxuan* (*Chung-kuo li-tai jen-wu hua-hsüan*) 中國歷代人物畫選 (Selected Figure Paintings from the Past Dynasties) (Nanking: Jiangsu Meishu Chubanshe, 1985), p. 171. A color plate of the entire handscroll is found in Yang Xin et al., *Three Thousand Years of Chinese Painting* (New Haven: Yale University Press; Beijing: Foreign Language Press, 1997), pl. 252, p. 272.

37  This unfortunate incident experienced by Yü is recorded in Zhang Geng's (Chang Keng) 張庚 (1685–1760) *Guochao huazhenglu* (*Kuo-ch'ao hua-cheng lu*) 國朝畫徵錄 (Biographical Sketches of the Artists of the Ch'ing Dynasty), preface dated 1739, vol. 5, *juan* (*chüan*) 卷 (chapter) 2, reprinted in Yu Anlan 于安瀾, comp., *Huashi congshu* (*Hua-shih ts'ung-shu*) 畫史叢書 (Compendium of Painting History) (Shanghai: Renmin Meishu Chubanshe, 1962), p. 34.

38  Yü Chih-ting's *Selecting a Dwelling Site* scroll is recorded in Liang Chang-chü's *T'ui-an so-ts'ang chin-shih shu-hua pa-wei* 退庵所藏金石書畫跋尾 (Colophons for the Bronze Vessels, Stone Steles, Paintings and Calligraphy in the Collection at [Liang Chang-chü's] Reticence Hut Studio), p. 1111. Liang's book also provides additional information on Yü's painting career at the court. It seems that Yü was summoned to paint in the imperial Ch'ang-ch'un 暢春 (Carefree Spring) Garden, located in a north suburb of the capital, for a short period of time around 1681. Although Yü's assignment to paint at this imperial villa is not clearly documented, his own colophon clearly indicates that he once painted for the emperor. Liang recorded in his book, ibid., p. 1112, that he once saw a handscroll by Yü, entitled *Yü Hung-lu pa-chün t'u chüan* 禹鴻臚八駿卷 (Yü Chih-ting's *The Eight Stallions* Scroll), and Yü inscribed at the beginning of this painting the following passage: "At the beginning of

the second moon in the *hsin-mao* year during the K'ang-hsi reign (1681), I was summoned to paint at the Ch'ang-ch'un Garden and [painted this painting] using Chao Meng-fu's (1254–1322) original work as my model." (康熙辛卯二月初吉. 入直暢春園 撫趙吳興本.) Liang Ch'ang-chü provided detailed descriptions of Yü's paintings in his book, recording all the major colophons. Thus, although Yü's painting is not extant today, Liang's writing on Yü's assignment is still considered trustworthy.

39 In China, magic mushrooms are called *ling-chih* 靈芝 (the divine fungus). They have purplish stalks and keep for a long time; thus they represent longevity and prosperity. As a rule, this kind of mushroom is related to either longevity or immortals in Chinese mythology.

40 Chang Ch'ien was a diplomat under Emperor Wu 武 (139–87 B.C.). Chang was renowned for his adventurous mission as an envoy to the Bactrian region in Central Asia to establish diplomatic relationships with nomad tribes. For his biography, see Pan Ku's 班固 (32–92) *Han-shu* 漢書 (The Book of the Han Dynasty), *juan* (*chüan*) 卷 (chapter) 61, reprint, vol. 9 (Shanghai: Zhonghua Shuju, 1975), pp. 2687–95. See also W. Scott Morton, *China, Its History and Culture*, 3rd ed. (New York: McGraw-Hill, 1995), pp. 55–56.

41 Tung-fang Shuo's biography is found in *Han-shu* 漢書 (The Book of the Han Dynasty), pp. 2841–76.

42 In Chinese history, people believed that this tale was included in Tsung Lin's 宗懍 (active mid-6th century) *Ching-Chu sui-shih-chi* 荊楚歲時記 (A Record of the Festival Activities in the Hunan and Hupei Region). For example, see Wu Lai's 吳萊 (1297–1340) *Yüan-ying chi* 淵穎集 (A Collection of Versatile and Extensive Writings: Wu Lai's Anthology), preface dated 1354, *chüan* 卷 (chapter) 6, reprint, vol. 4 (Ch'ang-sha: Commercial Press, 1937), p. 192. This citation appeared during succeeding centuries and has even appeared in recent publications. Apparently no one bothered to check the source. Contrary to these claims, today this tale is not found in the book *Ching-Chu sui-shih-chi*. One possibility is that the tale may have originally been in the book, but as the book is currently incomplete, this story could belong to one of the lost sections. It is also important to point out that the official biography of Chang Ch'ien only says that one of Chang's commissions was to trace the origin of the Yellow River. There is no reference to reaching the constellations. *Han-shu* 漢書 (The Book of the Han Dynasty), *chüan* 卷 (chapter) 61, vol. 9, p. 2705, says: "After Chang Ch'ien went to

Bactria on a diplomatic mission, he left to trace the origin of the River" (自張騫使大夏之後, 窮河源). On the other hand, there are also books that record the same story of the Milky Way and the two stars yet fail to mention Chang Ch'ien. A similar story is included in the chapter "*Tsa-shuo hsia* 雜説下" (The Second Section of Miscellaneous Writings), in vol. 3 of Chang Hua's 張華 (232–300) *Po-wu-chih* 博物志 (An Encyclopedic Record). It says: "According to ancient myth, the Milky Way was the source of the seas. Year after year, during the eighth moon, people who lived along the coast used to see a large raft floating to the shore, which would then sail away by itself. One adventurous person built a shelter on the raft, prepared a hoard of food, and sailed away with the raft. During the first few weeks, he still could see the sun, moon, and stars. After that, everything became boundless and indistinct. Days and nights could not be distinguished. After another ten days, he reached a city with imposing palaces where he saw, from afar, many [female] weavers working inside. A stout man watering his buffalo at the bank was surprised to see him. When he asked where he was, he was told that he should go back and ask Yen Chün-p'ing 嚴君平 (c. 1st century B.C.), who lived in Ch'eng-tu 成都, Szechwan 四川. Without going ashore, this person sailed home on the same raft. When he did ask Yen after returning, Yen told him that on a certain night in a certain month of a certain year, Yen observed the sky and found a guest star disturbing the Herdsman Constellation near the Milky Way, thus indicating that this person had actually reached the stars in heaven." Yen Chün-p'ing's biography, included in *Han-shu* 漢書 (The Book of the Han Dynasty), *chüan* 卷 (chapter) 71, vol. 10, pp. 3056–57, says that Yen was a well-known professional fortune teller. He performed divination in Ch'eng-tu and was believed to be able to calculate the fates of his clients accurately. He accepted only a few customers each day and used the rest of his time to instruct Lao-tzu's Taoism. Notably, in the above story, Chang Ch'ien's name is not mentioned.

43 Two paintings are recorded in Wu Lai's 吳萊 *Yüan-ying chi* 淵穎集 (A Collection of Profoundly Insightful Writings: Wu Lai's Anthology), *chüan* 卷 (chapter) 6, p. 191. According to a poem by Wu entitled "Chu-chi Chang Chung-ching Chia Yu T'ai-i Chen-jen Lien-chou chi Hai-shang Jen-ch'a Erh-hua-chou 諸暨張仲敬家有太乙真人蓮舟及海上人槎二畫軸" (Chang Chung-ching, from Chu-chi, Owns Two Painting Scrolls: One Depicts the Taoist T'ai-i on a Lotus Boat, While the Second Depicts a

Person Riding on a *Ch'a* Raft on the Sea) the second painting uses the motif of a *ch'a* raft.

44 Chu Pi-shan is unique among Chinese silversmiths. For more information on Chu's life and his *ch'a* cups, see Sherman E. Lee and Wai-kam Ho, *Chinese Art under the Mongols: The Yüan Dynasty (1279–1368)* (Cleveland: Cleveland Museum of Art, 1968), no. 37, pp. 144–45 and Zheng Minzhong 鄭岷中, "Zhu Bishan longcha ji (Chu Pi-shan lung-ch'a chi) 朱碧山龍槎記" [A Record of Chu Pi-shan's Dragon Tree Raft [Shaped] Cups] in *Gugong bowuyuan yuan-kan (Ku-kung po-wu-yüan yüan-k'an)* 故宮博物院院刊 (Palace Museum Bulletin) (Beijing: Palace Museum, 1960), vol. 2, pp. 165–69. Later, the fantastic designs of Chu's silver cups were copied, using rhinoceros horn or other types of materials. For an example of a *ch'a* cup made from a rhinoceros horn, see Wen C. Fong and James C. Y. Watt, *Possessing the Past: Treasures from the National Palace Museum, Taipei* (New York: Metropolitan Museum of Art, and Taipei: National Palace Museum, 1996), pl. 331, p. 531. Another such rhinoceros horn cup at the same museum is reproduced in James Cahill et al., *Chinese Art Treasures* (Geneve: Editions d'Art Albert Skira, 1961), pl. 228, p. 285. For a ceramic example at the Musée Guimet, Paris, see Yu Jiming 余繼明 and Yang Yinzong 楊寅宗, eds., *Zhongguo gudai ciqi jianshang cidian (Chung-kuo ku-tai tz'u-ch'i chien-shang tz'u-tien)* 中國古代瓷器鑒賞辭典 (Dictionary for Examination and Appreciation of Ancient Chinese Porcelain) (Beijing: Xinhua Chubanshe, 1992), color pl. 31.

45 According to one of Yü's patrons, Wang Shih-chen, one of these cups, dated 1362, belonged to a scholar-official, Sung Wan 宋琬 (1614–73), who was coincidentally also one of Yü's associates. Sung Wan's brief biography is found in *Eminent Chinese of the Ch'ing Period (1644–1912)*, vol. 2, p. 690. For the silver *ch'a* cup in Sung's collection, see "Hanci yincha (Han-tz'u yin-ch'a) 漢瓷銀槎" (Han Dynasty Porcelain and Silver Ch'a Cups) in Wang Shih-chen's *Chibei outan (Ch'ih-pei ou-t'an)* 池北偶談 (Casual Conversations at the North of the Pond), vol. 2, p. 347. Wang's original text says "Mr. Sung Wan, who was a circuit intendant, owned two glazed pottery bowls of the Han dynasty. . . . [Sung] also possessed a silver tree raft cup made by a [silversmith] of the Yüan dynasty, which is very rare and of classic beauty. On the bottom of this cup is an inscription that says, 'Made in the *jen-yin* year (1362) of the Chih-cheng period (1341–67) by Mr. Chu Hua-yü from Suchou.' Chu's *hao* was

Yü Chih-ting 禹之鼎
A Han Dynasty (206 B.C.–A.D. 220 ) Envoy
   Navigating on a Tree Raft
*continued*

98   Pi-shan. He was from Wu-t'ang (in Chia-hsing). [For information on Chu's life] see T'ao Tsung-i's [active second half of 14th century] book entitled *Cho-keng lu* (Notes Taken after Ceasing Farm Labors)." ( 宋荔裳㻞觀察, 藏漢瓷盞二.... 又有元人所造銀槎, 最奇古. 腹有文曰:「至正壬寅, 吳門朱華玉甫製.」華玉號碧山, 武塘人. 見陶南村輟耕錄.) After Sun Wan died in 1673, his collection was dispersed, and this cup disappeared. According to Zheng Minzhong's article, "Chu Pi-shan lung-ch'a chi 朱碧山龍槎記"(A Record of the Dragon Tree Raft [Shaped] Cup Made by Zhu Bishan), Wang Shih-chen also wrote about the *ch'a* cup in his other books, including Wang's *I-chü lu* 易居錄 (A Record of Wang's Relaxed Life) and *Hsiang-tsu pi-chi* 香祖筆記 (Miscellaneous Notes of Fragrant Ancestor [Wang's sobriquet]). Another *ch'a* cup, dated 1345, was originally owned by Sun Ch'eng-tse 孫承澤 (1592–1676). Yü's patron, Chu I-tsun, once saw this cup at a banquet and composed a poem praising its beauty and rarity. See Chu I-tsun's 朱彝尊 (1629–1709) *P'u-shu-t'ing chi* 曝書亭記 (Collected Writings at [Chu's] Airing Books Pavilion), *chüan* (chapter) 7, reprint, vol. 2 (Shanghai: Kuo-hsüeh Cheng-li she, 1937), pp. 88–89, s.v. "*Chu Pi-shan yin-ch'a ko* 朱碧山銀槎歌" (A Song for the Silver Tree Raft Cup Made by Chu Pi-shan). Later this cup also entered the collection of Sung Wan. After Sung died, the whereabouts of this cup were unknown for ten years. In 1683, Yü's most powerful acquaintance, Kao Shih-ch'i, was exhilarated when he found and purchased this example in an antique shop in Peking. Kao composed a poem entitled "Chu Pi-shan yin-ch'a ko 朱碧山銀槎歌" (A Song for the Silver Tree Raft Cup Made by Chu Pi-shan), which is published in his anthology. Kao's preface for his poem recorded the episode of how he collected this cup. This preface has been transcribed in Zheng Minzhong's "Chu Pi-shan lung-ch'a chi 朱碧山龍槎記" (A Record of Chu Pi-shan's Dragon Tree Raft [Shaped] Cups), p. 166. Kao asserts, "This Tree Raft cup used to be in the collection of Sun Ch'eng-tse, the deputy chief councilor. My classmate Chu I-tsun once wrote a long poem to document it. Later, this cup entered the collection of Sung Wan from Shantung, who was a circuit intendant. Shih Jun-chang (1619–38) and Ts'ao Erh-k'an (1617–79) both composed long poems [with the cup as subject]. After Sung Wan passed away, the whereabouts of this cup were unknown. In the summer, the fourth moon of this year, someone in the capital tried to sell it at the market. I was informed by a member of my entourage and immediately sent a friend to purchase it and finally acquired it." ( 向為孫北海少宰所藏. 余同年朱竹垞, 詩記其事. 後歸蓬萊宋荔裳. 觀察與施愚山, 曹顧庵, 皆有長歌. 觀察沒後, 不知流落何所. 今年夏四月, 忽易錢京師市上. 客來告余, 余急託友人往貨, 乃得之.) The silver tree raft cup owned by Kao Shih-ch'i and two other cups were all dated 1645 and eventually entered the imperial collection in the eighteenth century during the Ch'ien-lung period (r. 1736–96); all still survive. After Kao Shih-ch'i's cup entered the imperial collection, it was stored at the imperial summer palace in the Yüan-ming yüan 圓明園 Garden. In 1860, the joined Franco-British forces led by Lord Elgin and General Cousin-Montauban pillaged the palace in Peking. This cup was among the treasures looted and removed to England. In 1861, it was bought by General Sir Robert Biddulph and was eventually sold to the Cleveland Museum of Art in the 1960s. See *Chinese Art under the Mongols: The Yüan Dynasty (1279–1368)*, entry no. 37, p. 145. During the Ch'ing dynasty, another cup was stored in the imperial villa in Jehol, Inner Mongolia. It was later shipped to Taiwan in 1949 along with other treasures from the old palace collection in Peking. Currently, it belongs to the National Palace Museum in Taipei. For information on the silver tree raft cup in Taipei, see Tseng Yü 曾堉, "Huang-ho teh shui na-li-lai 黃河的水那裡來" (From Where Did The Water of the Yellow River Come), in *Ku-kung yüeh-k'an* 故宮月刊 (The National Palace Museum Monthly of Chinese Art), 1.2 (Taipei: National Palace Museum, May 1983), pp. 90–3. The third cup used to be displayed in the Chung-hua Hall 重華宮 in the Forbidden City and remains in the collection of the Palace Museum, Beijing. For more information on this cup, see Zheng Minzhong's "Zhu Bishan longcha ji (Chu Pi-shan lung-ch'a chi) 朱碧山龍槎記"(A Record of the Dragon Tree Raft [Shaped] Cup Made by Chu Pi-shan), pp. 165–69. In recent years, the authenticity of these three surviving silver cups has been a topic for debate. After 1960, when Zheng Minzhong at the Palace Museum in Beijing published his article, "A Record of the Dragon Tree Raft Cup Made by Zhu Bishan" discussing the *ch'a* cup in the collection of the Palace Museum in Beijing, Tseng Yü 曾堉, at the National Palace Museum in Taipei, in 1983 published "The Water of the Yellow River Comes from Heaven," in which he pointed out that the *ch'a* cup in Taipei was genuine, while the cup in Beijing was an eighteenth-century imitation. The next year, in 1984, in order to rebut Tseng's assertion, Zheng Minzhong published a second article, "Guanyu Zhu Bishan yin-cha de bianwei wenti: yu Taiwan wenwu gongzuozhe Tseng Yü shangque (Kuan-yü Chu Pi-shan yin-ch'a te pien-wei wen-t'i: yü Taiwan wen-wu kung-tso-che Tseng Yü shang-ch'üeh)" 關於朱碧山銀槎的辨偽問題: 與台灣文物工作者曾堉商榷" (Concerning the Questions of the Authenticity of the Silver Tree Raft [Shaped] Cup Made by Zhu Bishan: A Discussion with Tseng Yü, a Taiwanese Cultural Relics Professional) in *Ku-kung po-wu-yüan yüan-k'an* 故宮博物院院刊 (Palace Museum Bulletin), no. 3, 1984, pp. 52–57. Tseng Yü responded to Zheng's challenge by publishing yet another article: "Tsai-t'an Chu Pi-shan yin-ch'a yü tiao-ke de chien-ting" 再談朱碧山銀槎與雕刻的鑒定" (An Additional Discussion of Chu Pi-shan's Silver Tree Raft [Shaped] Cup and the Authentication of Sculptures) in *Ku-kung yüeh-k'an* 故宮月刊 (The National Palace Museum Monthly of Chinese Art) 3.3, June 1985, pp. 128–33.

46   A portrait of Sung Wan by Yü Chih-ting is recorded in *Yü Chih-ting nien-piao* 禹之鼎年表 (Chronological Table of Yü Chih-ting), p. 207, entry for year 1677. It is not known, however, whether this work is genuine or not. For Chu I-tsun's portrait by Yü, which shows Chu and his son fishing, see *Chronological Table of Yü Chih-ting*, p. 210, entry for year 1689. According to this source, Yü Chih-ting did several portraits of Kao Shih-ch'i. One was executed in the same year as Chu's portrait.

47   See Wang Mao-lin's *Pei-chih wu-tun-ko i-kao* 百尺梧桐閣遺稿 (Wang's Posthumously Collected Writings at His Hall of the One Hundred Foot Tall Wu-tung Tree), *chüan* 卷 (chapter) 6, p. 1. Wang's poem was composed after he heard the news that the imperial envoy had safely returned from Okinawa. It says, "[When I] heard that the passengers on the *ch'a* rafts had sailed [back] safely, [I] was truly elated!" ( 聞道乘槎客, 安流實快哉.)

48   Although the subject matter is closely intertwined with Yü's life experiences, the style of the Michigan scroll is somewhat different from what is generally recognized as Yü's typical style. The fact that Yü Chih-ting's two seals on this work are not found in any seal books adds to questions regarding its authenticity. This could be the reason why in 1985 Sotheby's, New York, listed this scroll in its catalogue as "attributed to Yü Chih-ting." See the sales catalog, *Fine Chinese Paintings* (New York: Sotheby's, June 3, 1985), lot no. 49. Yü Chih-ting's painting generally follows the style of Ma Ho-chih

馬和之 (active c. 1130–c. 1170) of the Southern Sung dynasty (1127–1279). Yü mimicked this master's brushwork with modulated lines that alternate between thin and thick. This type of linear work is known as the *lan-yeh miao* 蘭葉描 ([elongated, narrow] orchid-leaf linear brushstroke), also called "*ma-huang miao*" 螞蟥描 (linear brushstroke resembling the slender body of a leech). The term *ma-huang* can also be understood as "the torso of a wasp." People also credit this kind of linear work to the T'ang dynasty (618–905) painter Wu Tao-tzu 吳道子 (?–792). For an example of Ma Ho-chih's brushwork, see Wen C. Fong, *Beyond Representation: Chinese Painting and Calligraphy, 8th–14th Century* (New York: Metropolitan Museum of Art, 1992), pls. 28a–c, pp. 218–19. However the brushwork in the Michigan painting, which exhibits more even lines, is different. A careful examination of Yü's work reveals that there is indeed a small group of works that were executed in a slightly variant style, some of which use lines of even thickness. In another painting, Yü even emulated the style of Ma Yüan 馬遠 (active c. 1190–1225), employing more expressive, imposing brushwork than that demonstrated in his soft lines after Ma Ho-chih. For an example of Yü Chih-ting's painting in the style of Ma Yüan, see his *Zhuxi duyi tu* (*Chu-hsi tu-i t'u*) 竹溪讀易圖 (Studying the Book of Changes by the Bamboo Creek) at the Shoudu (Capital) Museum 首都博物館 in Beijing, reproduced in *Chung-kuo ku-tai shu-hua t'u-mu* 中國古代書畫圖目 (An Illustrated Catalogue of Selected Works of Ancient Chinese Painting and Calligraphy), vol. 1, no. 京 5–435, p. 299. If these variations are accepted as genuine works by Yü, it seems fair to accept the Michigan scroll as genuine. In addition, a few linear works on the garment of the figures and on the foliage in the Michigan scroll do show some modulation, which is stylistically similar to Ma Ho-chih's brushwork. On the whole, the extraordinary quality of the Michigan scroll, as well as the connection between its subject matter and the artist himself, are indisputable. These convincing factors further compel us to embrace this magnificent large hanging scroll as an authentic work by Yü Chih-ting. The condition of the silk, with its natural aging and lack of tinted artificial aging provides even more support for this conclusion. Any artist who could produce such a superb painting as the Michigan scroll would probably not need to forge a Yü Chih-ting in order to make a profit. Moreover, if a later painter were to fabri-

cate a Yü Chih-ting, he would more likely forge one of Yü's portraits of the well-known scholar-officials from the seventeenth century. He would also probably choose to execute it in orchid-leaf linear work, his most famous style.

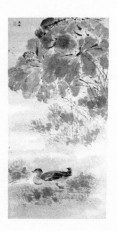

## 33. Kao Ch'i-p'ei 高其佩
*(1660–1734)*
*Ch'ing dynasty (1644–1911)*

99

## Duck and Lotus
*Ho-t'ang yu-ch'in*
*(Swimming Waterfowl in a Lotus Pond)*
荷塘游禽

1 There are several possibilities for Kao Ch'i-p'ei's exact birthdate. Arthur W. Hummel, in his *Eminent Chinese of the Ch'ing Period (1644–1912)*, vol. 1 (Washington, D.C.: United States Government Printing Office, 1943–44), p. 259, lists it as simply unknown. A prevalent projection is 1672. See Yu Jianhua 于劍華 et al., *Zhongguo meishujia renming cidian* (*Chung-kuo mei-shu-chia jen-ming tz'u-tien*) 中國美術家人名詞典 (A Biographical Dictionary of Chinese Artists) (Shanghai: Renmin Meishu Chubanshe, 1981), pp. 780–81. Ju-hsi Chou and Claudia Brown also adopted this date (1672) in their entry on Li Shizhou in *The Elegant Brush: Chinese Painting under the Qianlong Emperor, 1735–1795* (Phoenix: Phoenix Art Museum, 1985), p. 100, s.v. "Li Shizhuo (Li Shih-cho) 李士倬 (c. 1690–1770)." Li Shih-cho was Kao Ch'i-p'ei's nephew. See note 27 for more on their relationship. Yet an essay by Kao Ping 高秉 (active second half of 18th century) in *Chih-t'ou hua-shuo* 指頭畫說 (Treatise on Finger Painting), 1st edition dated c. 1771, contradicts this date. See Kao Ping's essay reprinted in Teng Shih 鄧實 (1865?–1948?) and Huang Pin-hung 黃賓虹 (1865–1955), comps., *Mei-shu ts'ung-shu* 美術叢書 (Anthology of Writings on Fine Art), Shanghi: n.p., 1912–36, reprint, *chi* 集 (part) 1 and *chi* 輯 (division) 8, vol. 4 (Taipei: I-wen Press, 1963–72), p. 60. According to Kao Ping, Kao Ch'i-p'ei, at age seven, visited the famous Yen-ch'ing 延慶 temple with his father. If Kao Ch'i-p'ei was born in 1672, he must have visited the temple in 1678. Nevertheless, it is recorded in historical documents that his father Kao T'ien-

100

chüeh 高天爵 (?–1676, *tzu* Chün-ch'ung 君寵) was killed by the enemy in 1675. See Kao T'ien-chüeh's biography in *Ch'ing-shih lieh-chuan* 清史列傳 (Biographies of the Ch'ing Dynasty), vol. 6 (Shanghai: Chung-hua Bookstore, 1928), pp. 31a–32a. As Kao Ping was Kao Ch'i-p'ei's grand nephew, his account is somewhat credible. Howard Rogers points out that Kao Ch'i-p'ei's inscription on one of his paintings dated 1728 was painted when he was sixty-eight years old, indicating that Kao Ch'i-pei was born in 1660. See Howard Rogers and Sherman E. Lee, *Masterworks of Ming and Qing Painting from the Forbidden City* (Lansdale: International Arts Council, 1985), cat. no. 62, p. 191. The most convincing source for this 1660 date is found on a portrait of Kao Ch'i-p'ei by T'u Lo 涂洛 (active early 18th century) and Lu Wei 陸鼎 (active early 18th century), now at the Shanghai Museum. See Group for the Authentication of Ancient Works of Chinese Painting and Calligraphy, ed., *Zhongguo gudai shuhua tumu* (*Chung-kuo ku-tai shu-hua t'u-mu*) 中國古代書畫圖目 (An Illustrated Catalogue of Selected Works of Ancient Chinese Painting and Calligraphy), vol. 5 (Shanghai: Wenwu Chubanshe, 1990), no. 滬 1-3480, p. 154. This portrait bears an inscription of Kao Ch'i-p'ei stating that he inscribed this portrait in the fifty-second year during the K'ang-hsi reign (1713), at age fifty-four. Since the Chinese traditionally consider a child one year old the day he is born, Kao Ch'i-p'ei was actually fifty-three years old in 1713 according to Western custom. Thus, Kao Ch'i-p'ei should have been born in 1660.

2   For information on Professor Ginpoh Y. King, see note 1 in entry 9 on Hsieh Shih-ch'en 謝時臣 (1487–after 1567).

3   The first character in Kao Ch'i-p'ei's *hao*, 且園, has two different meanings and two different pronunciations. When it is pronounced "ch'ieh," it means "moreover," "now," "still," and "further." When it is pronounced "chü," it means "dignified," "a final particle," and "many and great." See R. H. Mathews, *Mathews' Chinese-English Dictionary* (Cambridge, Mass.: Harvard University Press, 1963), pp. 109–10. Among these meanings, the most appropriate for Kao's *hao* should be "dignified," pronounced "chü." Unfortunately, over the years, people have adopted the more commonly known sound of this character pronounced *ch'ieh* and ignored the correct pronunciation.

4   See the biography of Kao Ch'i-p'ei's father, Kao T'ien-chüeh, in *Ch'ing-shih lieh-chuan* 清史列傳 (Biographies of the Ch'ing Dynasty), vol. 6, pp. 31a–32a, and *Chung-*

*kuo mei-shu-chia jen-ming tz'u-tien* 中國美術家人名詞典 (Biographical Dictionary of Chinese Artists), p. 780, s.v. "Gao Qipei (Kao Ch'i-p'ei) 高其佩."

5   T'ieh-ling 鐵嶺 (literally meaning "the iron mountain range") is located approximately one hundred miles northeast of the present-day city of Shen-yang 瀋陽 (also known as Mukden) in Liaoning 遼寧 province, Manchuria. Over the centuries, the fertile steppes on the banks of the Liao 遼 River in Manchuria have been inhabited by Eskimos or Aleutians, Mongols, Koreans, various tribes of Scythian descent often referred to as Tartars, and Chinese. Quarrels over fishing and grazing rights, as well as the ownership of farm land, have plagued this area since the Shang 商 (c. 1600–c. 1100 B.C.) dynasty. The Tartars, by far the most numerous ethnic group in the region, were often a dominant and aggressive force, especially in periods when the Chinese sovereign was weak. During these periods, the Tartars expanded their territory by occupying vast areas of northern China, where they established their own dynasties. The first major dynasty the Tartars established in China was the Northern Wei dynasty (368–420) under the Toba Tartars. The Northern Ch'i (550–57) and Northern Chou (557–81) dynasties followed. Later, the Khitan Tartars inaugurated the Liao dynasty (907–119), and the Jurchen (Nü-chen 女真 in Chinese) Tartars initiated the Chin dynasty (1115–1234). Lastly, the Ch'ing dynasty (1644–1911) was founded by a clan of the Jurchen Tartars known as Manchus. It is quite possible that both Koreans and Tartars are remote descendants of Scythians, a nomadic tribe who, from the seventh century B.C. to the second century A.D., occupied the steppes between Central Asia and Manchuria. For more detailed explorations of these nomadic tribes, see Denis Sinor, ed., *The Cambridge History of Early Inner Asia* (New York: Cambridge University Press, 1990). For more information on the history and art of the Scythians, see Emma C. Bunker et al., *"Animal Style" Art from East to West* (New York: The Asia Society, 1970) and Editors of the Bulletin, *From the Lands of the Scythians* (New York: Metropolitan Museum of Art, 1975). During the Yüan dynasty (1280–1368), under the powerful rule of the Mongols, China and Manchuria were unified. In the late fourteenth century, when the Ming court (1368–1644) defeated the Mongols, the Chinese inherited the entire Yüan territory, including Manchuria. In order to escape local famines, many ethnic Chinese families in the provinces of Shantung

山東, Hopei 河北, and Honan 河南 migrated to Manchuria and settled on the uncultivated fertile land along the Liao River. The Kao family was one of these pioneer families.

6   By the sixteenth century, the Chinese central government was enervated due to corrupt bureaucracies run by wicked eunuchs. For a brief exploration of the turmoil of the late Ming period, see the biography of Chu Yu-chien 朱由檢 (1611–44), the last emperor of the Ming dynasty, in *Eminent Chinese of the Ch'ing Period (1644–1912)*, vol. 1, pp. 191–92. Meanwhile the Manchus became belligerent and conquered many of the lands along the Liao River formerly occupied by ethnic Chinese and other ethnicities. Consequently, the Manchus established their own court. Those who surrendered or joined the conquerors were granted the status of subjects under one of the *Pa-ta-chia* 八大家 or the "Eight Great Families," which were Manchurian clans distinguished by different colored banners. The members of these subject-families were known as *pao-i* 包衣. Originally this was a Manchu term meaning "bond-servant." In Chinese, it literally means, "to carry or to wrap the clothes package." This status, once established, was passed along to subsequent generations. See *Tz'u-hai* 辭海 (Sea of Terminology: Chinese Language Dictionary), vol. 1 (Taipei: Chung-hua Press, 1974), p. 434, s.v. "pao-i 包衣." There is evidence suggesting that Kao Ch'i-p'ei, an ethnic Han Chinese, descended from a *pao-i* family. For more on the Eight Great Families, see *Sea of Terminology: Chinese Language Dictionary*, vol. 1, pp. 218–19. The colors of the eight banners were: 1) yellow; 2) white; 3) blue; 4) red; 5) yellow-bordered; 6) white-bordered; 7) blue-bordered; and 8) red-bordered. For more on the Eight Banners, see *Sea of Terminology: Chinese Language Dictionary*, vol. 1, pp. 596–97. Finally, in 1644, the Manchu invaded China and inaugurated the Ch'ing dynasty. For the biographies of the founder of the Manchu court, Nurhaci (1559–1626) and his successor, Abahai (1592–1643), see *Sea of Terminology: Chinese Language Dictionary*, vol. 1, pp. 594–99 and pp. 1–3, respectively.

7   The Kao family was elevated from the clan of the white-bordered banner to the clan of the yellow-bordered banner due to the merits of Kao Ch'i-wei 高其位 (?-before 1734), the artist Kao Ch'i-p'ei's elder brother. Kao Ch'i-wei was a competent general and administrator. In 1725, he was appointed grand secretary and counseled Emperor Yung-cheng (r. 1723–35). See his

biography in *Ch'ing-shih lieh-chuan* 清史列傳 (Biographies of the Ch'ing Dynasty), vol. 12, pp. 46a–47a.

8 Kao Ch'i-p'ei's grandfather, Kao Shang-i 高尚義, was a brave warrior who fought alongside the Manchus against the Chinese. When he died, he was awarded a Manchurian title *adaha hafan* (a captain of the swift chariot squadron), an inheritable military title. In Chinese, this title is *ch'ing-ch'e tu-wei* 輕車都尉. It was due largely to Kao Shang-i's loyalty to the Manchus that the Kao family enjoyed the blessing of the Manchu court. For more on Kao Shang-i, see *Ch'ing-shih-kao chiao-chu* 清史稿校注 (The Collated Draft of the History of the Ch'ing Dynasty with Commentary), vol. 11 (Taipei: Kuo-shih-kuan, 1990), pp. 8829–30, s.v. "biography of Kao Ch'i-wei." This volume was originally published by Kuo-shih-kuan 國史館 (The National Historical Bureau).

9 Because of Kao Shang-i's great achievements, in 1647 Kao Ch'i-p'ei's father, Kao T'ien-chüeh, was appointed a county magistrate in Shantung and then, in 1659, promoted to prefect of Chien-ch'ang 建昌 in Kiangsi 江西 province. Kao Ch'i-p'ei was born in this county the following year. When Keng Ching-chung 耿精忠 (?–1682), a Chinese general who had earlier pledged allegiance to the Manchu court, rebelled in 1674 and assailed Kao T'ien-chüeh's prefecture, Kao T'ien-chüeh had already been promoted to salt distribution commissioner in the Kiangsu and Anhui region. People persuaded him to leave immediately in order to assume the lucrative new appointment, but he declined. Unfortunately he stayed, was captured by the enemy, and was executed after two years in captivity due to his loyalty to the Manchus. At that time, Kao Ch'i-p'ei was sixteen years old and had spent his whole life in the south of China. See Kao T'ien-chüeh's biography in *Ch'ing-shih lieh-chuan* 清史列傳 (Biographies of the Ch'ing Dynasty), vol. 6, pp. 31a–32a. The date Kao T'ien-chüeh assumed his appointment as prefect of Chien-ch'ang is incorrectly recorded in his biography in *Ch'ing-shih lieh-chuan* 清史列傳 (Biographies of the Ch'ing Dynasty) as 1647, the fourth year of Emperor Shun-chih. This mistake is revised in *Ch'ing-shih-kao chiao-chu* 清史稿校注 (The Collated Draft of the History of the Ch'ing Dynasty with Commentary), vol. 14, p. 11254; the correct date is 1659.

10 Kao Ch'eng-chüeh's short biography is found in *Chung-kuo mei-shu-chia jen-ming tz'u-tien* 中國美術家人名詞典 (A Biographical Dictionary of Chinese Artists), p. 781. For information on Kao Ch'eng-chüeh as the prefect and as a calligrapher in Yangchou, see Li Tou's 李斗 (active c. end of 18th to early 19th century) *Yang-chou hua-fang lu* 揚州畫舫錄 (A Record of the Gaily Painted Pleasure Boats in Yangchou), preface dated 1795, reprint (Yangzhou: Jiangsu Guangling Guji Keyinshe, 1984), p. 48. Li's book states that Kao Ch'i-p'ei's uncle, Kao Ch'eng-chüeh, was from San-han (The Three Korean States) and that he was adept in executing calligraphy with large characters. When he served as the prefect of Yangchou, the citizens adored him. At the end of each year, local people often asked him to inscribe for them the character *fu* 福 (good luck), to be used as an amulet. (高承爵，三韓人. 善擘窠書. 為揚州太守，民人愛慕 每歲暮，鄉民求書福字以為瑞.) Evidently, the author mistook Kao's hometown, T'ieh-ling in Manchuria, as part of the Korean territory.

11 See Pien Yüng-yü 卞永譽 (1645–1712), *Shih-ku-t'ang shu-hua hui-k'ao* 式古堂書畫彙考 (Compilation of Writings on Calligraphy and Painting from [Pien's] Modeling Antiquity Hall), preface dated 1682, reprint of the 1921 facsimile (Taipei: Cheng-chung Shu-chü, 1958). When Kao Ch'i-p'ei's father, Kao T'ien-chüeh, was killed, Emperor K'ang-hsi rewarded the Kao family by building a shrine in memory of Kao T'ien-chüeh's loyalty. This special grace was petitioned by Pien Yüng-yü, who was also a Chinese bannerman and had a close friendship with Kao Ch'i-p'ei's father and uncle. See *Ch'ing-shih-kao chiao-chu* 清史稿校注 (The Collated Draft of the History of the Ch'ing Dynasty with Commentary), vol. 14, p. 11254.

12 Kao Ch'eng-chüeh served first as the prefect in Yangchou, then the administrative commissioner in Fukien (?–1693), governor of Anhui (1693–1694), governor of Canton (1695–1696), and again governor of Anhui (1701). See Qian Shifu 錢實甫, *Qingdai zhiguan nianbiao* (*Ch'ing-tai chih-kuan nien-piao*) 清代職官年表 (A Chronological Table of the Officials and Officers of the Ch'ing Dynasty), vol. 2 (Beijing: Zhonghua Shuju, 1980), pp. 1557–58 and 1562. See Klaas Ruitenbeek, "Gao Qipei and the Art of Finger Painting" in *Proceedings of the International Colloquium on Chinese Art History, 1991: Painting and Calligraphy*, part 1 (Taipei: National Palace Museum, 1991), pp. 458–59. The information concerning the friendship between artist Wu Wei and Kao Ch'eng-chüeh, Kao Ch'i-p'ei's uncle, is based on an article by Professor Jao Tsung-i 饒宗頤 published in 1985. According to Jao, this relationship might have been established as early as the 1660s to 1670s, when Kao Ch'i-p'ei was less than ten years old. Jao also used a finger painting by Wu Wei in his personal collection to point out that Wu was adept in this type of art. Jao's article, entitled "Qingchu Guangdong zhihuajia Wu Wei yu Tieling Gaoshi (Ch'ing-ch'u Kuang-tung chih-hua-chia Wu Wei yü T'ieh-ling Kao-shih) 清初廣東指畫家吳韋與鐵嶺高氏" (The Relationship between the Early Ch'ing Finger Painter Wu Wei of Canton and Mr. Kao from T'ieh-ling) is published in Zhongguo Yishu Yanjiusuo *Meishushilun* bianjibu (Chung-kuo I-shu Yen-chiu-so *Mei-shu shih-lun pien-chi pu*) 中國藝術研究院, 美術研究所, "美術史論" 編輯部 (Editorial Committee of the *History and Theory of Fine Arts* at the Institute of Fine Art, Chinese Art Research Academy), *Meishushilun* (*Mei-shu-shih lun*) 美術史論 (*History and Theory of Fine Arts*), vol. 14 (Beijing: Wenhua Yishu Chubanshe, Summer 1985), pp. 70–74. For Wu Wei's biography, see Wang Chao-yung 汪兆鏞 (20th century), *Lingnan huazhenglu* (*Ling-nan hua-cheng-lu*) 嶺南畫徵錄 (A Record of Painters from Canton) (Guangdong: Guangdong Renmin Chubanshe, 1988), pp. 89–91. The friendship between Kao Ch'eng-chüeh and Wu Wei was so close that in 1696, Wu was asked by Kao to accompany the latter's son to Peking for the national examination. Unfortunately, Wu was sick and died before he could reach the capital.

13 See note 3.

14 See *Chung-kuo mei-shu-chia jen-ming tz'u-tien* 中國美術家人名詞典 (Biographical Dictionary of Chinese Artists), pp. 780–81. Kao Ch'i-p'ei's eldest brother was Kao Ch'i-wei 高其位. See note 7. The name of Kao Ch'i-p'ei's second brother is unknown. But it is also possible that Kao Ch'i-p'ei was considered the third son because he had an elder cousin instead of another elder brother. In ancient China, the sons of fathers and uncles were often grouped together and referred to as brothers. At least one of Kao Ch'i-p'ei's younger cousins, Kao Ch'i-cho 高其倬 (1676–1738), was well known. This cousin was an artist and a well-known administrator-general. See *Ch'ing-shih lieh-chuan* 清史列傳 (Biographies of the Ch'ing Dynasty), vol. 14, pp. 43a–47a or *Chung-kuo mei-shu-chia jen-ming tz'u-tien* 中國美術家人名詞典 (Biographical Dictionary of Chinese Artists), p. 781. Another source claims that Kao Ch'i-p'ei was the fifth son in the family. See Kao Ch'i-p'ei's biography in Li Huan 李桓 (1827–91), comp., *Kuo-ch'ao ch'i-hsien lei-cheng ch'u-pien* 國朝耆獻類徵初編 (Biographies of Senior Scholars of the Ch'ing Dynasty), 1st edition, *chüan* 卷 (chapter) 283, p. 17, reprinted, vol. 16 (Taipei: Wen-hai Press, 1966), p. 9412. According to Jao Tsung-i, however, Kao

Kao Ch'i-p'ei 高其佩
Duck and Lotus
*continued*

102

Ch'i-p'ei was the fifth son and the seventh one among his cousins. See Jao's article, "Ch'ing-ch'u Kuang-tung chih-hua-chia Wu Wei yü T'ieh-ling Kao-shih 清初廣東指畫家吳韋與鐵嶺高氏" (The Relationship between the Early Ch'ing Finger Painter Wu Wei of Canton and Mr. Kao from T'ieh-ling), p. 71.

15 There is no record indicating that Kao Ch'i-p'ei passed any civil service examination. His first appointment was referred to as *yin-kuan* 蔭官, which is an official position based on the meritorious services rendered by one's forefathers. See *Chung-kuo mei-shu-chia jen-ming tz'u-tien* 中國美術家人名詞典 (Biographical Dictionary of Chinese Artists), p. 780, s.v. "Kao Ch'i-p'ei 高其佩." Kao's first position was as mayor of Su-chou 宿州, a small county located in the northern section of Anhui province.

16 The information on Kao Ch'i-p'ei's career as an administrator is recorded in his biography found in *Kuo-chao ch'i-hsien lei-cheng ch'u-pien* 國朝耆獻類徵初編 (Biographies of Senior Scholars of the Ch'ing Dynasty), 1st edition, *chüan* 卷 (chapter) 283, p. 17, reprinted, vol. 16, p. 9412.

17 This episode is recorded in Kao Ping's *Chih-t'ou hua-shuo* 指頭畫説 (Treatise on Finger Painting), p. 39. Among Kao's three assistant artists, Yüan Chiang was the most illustrious. For more information on Yüan, see entry 34. A brief biography of the second painter, Lu Wei, is found in *Chung-kuo mei-shu-chia jen-ming tz'u-tien* 中國美術家人名詞典 (Biographical Dictionary of Chinese Artists), p. 983. Lu was also known as Lu Ch'ih 陸癡 (Lu the idiot). His *tzu* was Jih-wei 日為 (daily conduct), and his *hao*, Sui-shan-ch'iao 遂山樵 (a wood-cutter at Mt. Sui). For Lu Wei's work, see his *Guanshan xinglu* (*Kuan-shan hsing-lü*) 關山行旅 (Mountain Travelers) in *Chung-kuo ku-tai shu-hua t'u-mu* 中國古代書畫圖目 (An Illustrated Catalogue of Selected Works of Ancient Chinese Painting and Calligraphy), vol. 5, no. 滬 1-3229, p. 92. The third painter, Shen Ao, was an obscure artist. No information on his life is found in early books. Yang Renkai 楊仁愷, the former director of the Liaoning Museum, published an article concerning Kao Ch'i-p'ei's life and work entitled "Shilun zhitou huajia Gao Qipei de yishu chengjiu (Shih-lun chih-t'ou hua-chia Kao Ch'i-p'ei teh i-shu ch'eng-chiu) 試論指頭畫家高其佩的藝術成就" (A Preliminary Discussion of the Artistic Accomplishments of the Finger Painter Kao Ch'i-p'ei) in Yang's *Muyulou shuhua lungao* (*Mu-yü-lou shu-hua lun-kao*) 沐雨樓書畫論稿 (The Collected Research Papers on Painting and Calligraphy at [Yang's]

Immersed in Rain Pavilion) (Shanghai: Renmin Meishu Chubanshe, 1988), pp. 186–99. In section 4 of Yang's article, page 193, the author claims that at the Liaoning Museum is a work by Kao entitled *Zahua shierfu* (*Tsa-hua shih-erh fu*) 雜畫十二幅 (A Set of Twelve Album Leaves Depicting Miscellaneous Subjects), which was completed when Kao was only twenty-two *sui* (twenty-one years old). Yang also lists another work by Kao, entitled *Qiuyingtu* (*Ch'iu-ying t'u*) 秋鷹圖 (Autumn Eagle), dated 1691, when Kao was thirty years old. The present location of the second work is unknown. These two should be considered examples of Kao's early works. Yet neither is included in the *Chung-kuo ku-tai shu-hua t'u-mu* 中國古代書畫圖目 (An Illustrated Catalogue of Selected Works of Ancient Chinese Painting and Calligraphy), vol. 15, which contains Kao's works at the Liaoning Museum (nos. 遼 1-456 to 遼 1-471, p. 336) and Shenyang Museum (nos. 遼 2-207 to 遼 2-219, p. 374). At the Liaoning Museum, the earliest work is dated 1711; the earliest work at the Shenyang Museum is dated 1709. Both works were completed when Kao served in Chekiang, from 1705 to 1713. Furthermore, in "Ch'ing-ch'u Kuang-tung chih-hua-chia Wu Wei yü T'ieh-ling Kao-shih 清初廣東指畫家吳韋與鐵嶺高氏" (The Relationship between the Early Ch'ing Finger Painter Wu Wei of Canton and Mr. Kao from T'ieh-ling), p. 70, Jao Tsung-i points out that Yang Renkai claims that at the Shenyang Museum there was a painting by Kao entitled *Yuxiatu* (*Yü-hsia t'u*) 魚蝦圖 (Fish and Prawn), which is dated 1684. In that year, Kao was only twenty-three years old. Thus this work should be the earliest example of Kao's finger painting. Unfortunately, this work is also absent from *Chung-kuo ku-tai shu-hua t'u-mu* 中國古代書畫圖目 (An Illustrated Catalogue of Selected Works of Ancient Chinese Painting and Calligraphy), vol. 15. It is not clear whether the three above works mentioned in Yang's articles were simply overlooked in the catalogue or were eliminated by the group of experts who authenticated the paintings at museums before the works were qualified to be published.

18 The portrait of Kao Ch'i-p'ei, dated 1713, was executed one year after he was dismissed from his official position in Chekiang. It was executed by a little-known painter named T'u Lo 涂洛, with Lu Wei, one of the three painters Kao had hired to finish his finger paintings, adding washes and scenery. This portrait of Kao is published in *Chung-kuo ku-tai shu-hua*

*t'u-mu* 中國古代書畫圖目 (An Illustrated Catalogue of Selected Works of Ancient Chinese Painting and Calligraphy), vol. 5, no. 滬 1-3480, p. 154.

19 Kao's dismissal from the Ministry of Justice indicates that he was probably not an adept judge. For more on these jobs, see Kao Ch'i-p'ei's biography in *Kuo-chao ch'i-hsien lei-cheng ch'u-pien* 國朝耆獻類徵初編 (Biographies of Senior Scholars of the Ch'ing Dynasty), 1st edition, *chüan* 卷 (chapter) 283, p. 17, reprinted, vol. 16, p. 9412.

20 See Kao Ping's *Chih-t'ou hua-shuo* 指頭畫説 (Treatise on Finger Painting), pp. 53–54.

21 *Life Painting of Flower and Bird* is also known as *Ch'un-ching hua-niao* 春景花鳥 (Springtime Flower and Bird). See *Ku-kung shu-hua t'u-lu* 故宮書畫圖錄 (Illustrated Catalogue of Calligraphy and Painting at the Palace Museum), vol. 11 (Taipei: National Palace Museum, 1993), pp. 29 and 31.

22 *Rising Sun against Sky and Sea* measures 223.7 × 132 cm (88 × 48⅜ in.), while *Life Painting of Flower and Bird* measures 213.8 x 123.6 cm (84 × 48⅝ in.).

23 See Kao Ping's *Chih-t'ou hua-shuo* 指頭畫説 (Treatise on Finger Painting), pp. 53–54.

24 For Kao Ch'i-p'ei's painting executed specially for Emperor Ch'ien-lung when still a prince, see *Ku-kung shu-hua t'u-lu* 故宮書畫圖錄 (Illustrated Catalogue of Calligraphy and Painting at the Palace Museum), vol. 1, p. 27.

25 For information on the relationship between Li Shan and Kao Ch'i-p'ei, see Wang Luyu 王魯豫, "Li Shan nianpu (Li Shan nien-p'u) 李鱓年譜" (A Chronicle of Li Shan's Life) in Qiu Youxuan 丘幼宣, ed., *Yangzhou baguai nianpu* (*Yangchou pa-kuai nien-p'u*) 揚州八怪年譜 (Chronicles of the Yangchou Eight Eccentrics' Lives) (Jiangsu: Meishu Chubanshe, 1992), p. 23, entry for 1734. See also entry 37 on Li Shan.

26 See entry 34 on Yüan Chiang.

27 Kao Ch'i-p'ei also left a poetry anthology entitled *Chü-yüan shih-ch'ao* 且園詩鈔 (A Copy of Kao Ch'i-p'ei's Poems). See *Chung-kuo mei-shu-chia jen-ming tz'u-tien* 中國美術家人名詞典 (Biographical Dictionary of Chinese Artists), p. 781. Kao also had two followers: Chu Lun-han 朱倫瀚 (1680–1760) and Li Shih-cho 李世倬 (c. 1690–1770). Both were Chinese bannermen and nephews of Kao Ch'i-p'ei. Although an intrepid officer, Chu was deft in calligraphy and painting. One day, when

he was young, he fell while climbing up a coal cart to fetch fuel. The middle finger of his right hand was injured. After it healed, the nail of this damaged finger grew thick, with an indentation where ink could be held. From that time on, his finger became his primary painting tool, and his accomplishments in this art were nearly as impressive as those of Kao Ch'i-p'ei. Chu Lun-han's biography is attached to the entry for Kao Ch'i-p'ei in "Biographical Category-Art," section 3, Chao Erh-hsün 趙爾巽 et al., *Qingshigao* (*Ch'ing-shih-kao*) 清史稿 (Historical Manuscripts of the Ch'ing Dynasty), vol. 504, chap. 29, reprint, vol. 45 (Beijing: Zhonghua Shuju Chubanshe, 1977), p. 13909. Li Shih-cho was also Kao Ch'i-p'ei's nephew. Either Li's mother was Kao's sister or cousin, or one of the boys in the Kao family married Li's aunt. Li Shih-cho's biography is also found in *Historical Manuscripts of the Ch'ing Dynasty*, p. 13909. In addition to learning from his uncle, Li Shih-cho also received instruction from Wang Hui and Wang Yüan-ch'i, both of whom were traditional painters. Li mainly painted with a brush, and his work shows little resemblance to his uncle's. When he was older however, he sometimes used his fingers to produce figure or flower-and-bird paintings. In Ch'ing sources, Li Shih-cho's ancestry is listed as Korean, but this origin has been contested in recent years. See *The Elegant Brush: Chinese Painting under the Qianlong Emperor, 1735–1795*, p. 100. In this catalogue, the authors suggest that Li's hometown, either T'ieh-ling or San-han 三韓 (The Three Korean States), is located inside Chinese territory. Thus, he should be of Chinese origin. Nevertheless, the Manchus and Koreans have always been closer than the Manchus and Chinese, as the former share the same ancestry. In the sixteenth century, the founder of the Manchu court, Nurhaci, went to Korea and helped the Korean king resist a Japanese invasion. Therefore, many Korean families later moved to Manchuria and mingled with populations of other ethnicities. Many Koreans, like the Chinese, joined the Manchus and became subjects. It would not have been surprising that Kao Ch'i-p'ei married a Korean woman from his neighborhood since intermarriage between Chinese and Koreans was a common practice in that region, especially if both families were bannermen. Additionally, Li (Rhee in Korean) is a major name among the Korean families. Until more information is available, the possibility that Li Shih-cho's ancestors were from Korea should not be overlooked.

28 There were a few finger painters recorded in Chinese history, one of whom was Wu Hsü 吳序 of the Ming dynasty. His brief biography can be found in *Chung-kuo mei-shu-chia jen-ming tz'u-tien* 中國美術家人名詞典 (Biographical Dictionary of Chinese Artists), p. 284. Li Shan 李山 (active 18th century), from Hangchou, was another artist who used his fingers to paint. For Li's work, see Editorial Committee of the Complete Collection of Chinese Art, *Zhongguo meishu quanji* (*Chung-kuo mei-shu ch'üan-chi*) 中國美術全集 (A Complete Collection of Chinese Art), vol. 10 (Shanghai: Renmen Meishu Chubanshe, 1988), album leaf 1, no. 24, p. 26.

29 See Kao Ping's *Chih-t'ou hua-shuo* 指頭畫說 (Treatise on Finger Painting), pp. 37–64.

30 See ibid., p. 37. The text reads: "Reverent and Industrious Elderly Gentleman (Kao Ch'i-p'ei's posthumous title) started to learn painting at the age of eight." (恪勤公八齡學畫)

31 See ibid., pp. 39–40: "After [Kao] completed many finger paintings, he needed to ask someone to add the final washes. When he served in Chekiang, he invited Lu Wei from Hua-t'ing, Yüan Chiang from Yangchou, and Shen Ao from Hangchou. These three were all established artists. Although Kao's finger painting was still in an early stage, he himself was middle aged and energetic, and his work benefited from the wonderful washes from these three skilled gentlemen's brushes. Thus his finished paintings looked as if they descended from heaven, as opposed to being produced by someone who eats cooked food [a mortal]. Later, Kao invited Lu Ch'ing from Hua-t'ing and Wu Li from Chekiang. Although this collaboration was not as accomplished as the earlier collaboration, Kao still produced a work of high quality. When Kao was the vice minister of justice [in Peking] these two assistants [Lu Ch'ing and Wu Li] returned to the south, and he could not find anyone to assist him! In his late years, his work seemed inferior to that which he produced during his middle age, as he could not find anyone to add the final washes and had no time to apply them himself." (指畫過多, 必倩人烘染. 昔遊兩浙時, 延請華亭陸日為繭; 邗上袁文濤江; 虎林沈禹門鰲; 皆能自豎一幟者. 以公之指墨草枊, 而用三君秀筆妙染, 且當壯盛之年; 每一畫出, 如天上神仙, 非煙火食者所能望見. 繼延華亭陸遂萬青, 丹徒吳欽序禮雖不可與君同日語, 然尚能領略大意. 後官司寇, 二君南歸, 則不得其人矣! 晚年所作, 較遜少壯一籌者, 苦無人助, 而又無暇自染也.)

32 While much about Lu Ch'ing's life is unclear, Wu Li's short biography is found in *Chung-kuo mei-shu-chia jen-ming tz'u-*

tien 中國美術家人名詞典 (Biographical Dictionary of Chinese Artists), p. 317. He was from Anhui but lived in Suchou. He painted in the style of Shen Chou 沈周 (1427–1509). Wu once presented a painting to Emperor Ch'ien-lung in 1757 during one of the ruler's tours to the south, and it was accepted with approval. Wu died shortly after that year.

33 See *Treatise on Finger Painting*, pp. 63–64: "In order to produce excellent calligraphy and painting, one should possess a tranquil mind." (書畫至于成就 必有靜氣.)

34 There are two other duck paintings by Kao Ch'i-p'ei. One, at the Royal Ontario Museum, entitled *Liu-chih yü-ya* 柳枝浴鴨 (Bathing Duck by a Willow Tree), is reproduced in Teisuke Toda 戶田禎佑 and Hiromitsu Ogawa 小川裕充, comps., *Comprehensive Illustrated Catalog of Chinese Paintings: Second Series*, vol. 1 (Tokyo: University of Tokyo Press, 1982), no. A9-034, p. 87. The second one, entitled *Liu-tang yuanyang tu* (*Liu-t'ang yüan-yang t'u*) 柳塘鴛鴦圖 (Mandarin Ducks in a Pond by the Willow Trees), belongs to the Shenyang Palace Museum and is reproduced in *Chung-kuo ku-tai shu-hua t'u-mu* 中國古代書畫圖目 (Illustrated Catalogue of Selected Works of Ancient Chinese Painting and Calligraphy), vol. 15, no. 遼 2-205, p. 271.

35 Kao Ping claims in his essay that when Kao Ch'i-p'ei signed only his name, he used a seal that bore the legend "Finger painting." As Kao signed the Michigan scroll with only his given name, his seal under his signature is consistent with what is recorded in Kao Ping's essay.

36 *Treatise on Finger Painting* recounts that due to Kao Ch'i-p'ei's great fame, the artist was hounded by requests for work. People would deliver paper to his house daily, in order to solicit his work. Kao Ch'i-p'ei would allow forty to fifty pieces to accumulate. Before he began to paint, he usually spent a whole day grinding ink and contemplating. Around nine o'clock in the morning of the following day, he would begin executing the paintings, which he would finish by the early evening. He followed this routine twice a month and in this manner was able to produce about 1,000 paintings a year. This practice lasted from when Kao was in his late teens until he was seventy years old and resulted in almost 50,000 paintings during his lifetime. This number does not include the casual execution of fans and album leaves done at impromptu gatherings. Thus, the total number of paintings Kao created was surprisingly large, somewhere in the area of 50,000–60,000. Few artists in Chinese history could match

Kao Ch'i-p'ei 高其佩
Duck and Lotus
*continued*

## 34. Yüan Chiang 袁江
*(active c. 1690–c. 1730)*
*Ch'ing dynasty (1644–1911)*

this artistic output. See *Chih-t'ou hua-shuo* 指頭畫說 (Treatise on Finger Painting), p. 39.

37  There are significant stylistic similarities between Kao's work and those by earlier painters like Hsü Wei 徐渭 (1521–93) and Ch'en Ch'un 陳淳 (1483–1544), both of whom utilized the play of ink and water, spontaneously executed forms, and rich ink tones.

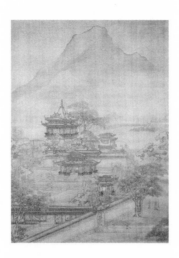

**Spring Dawn at the Han Dynasty (206 B.C.–A.D. 220 ) Palace**
*Han-kung ch'un-hsiao*
*(Spring Dawn at the Han Dynasty Palace)*
漢宮春曉

1  This quote is attributed to Ku Kai-chih 顧愷之 (c. 344–c. 406), the great master of the Tsin 晉 dynasty (265–419). He asserted that among the many categories of painting, the most difficult was portraiture. He placed landscape next in order of difficulty, then the formation of animals, such as dogs and horses. Since buildings and pavilions were fixed forms, they were inherently easier. (畫人最難. 次山水, 次狗馬. 其臺閣, 一定器耳! 差易為也.) See Zhang Yanyuan (Chang Yen-yüan) 張彥遠 (active c. 9th century), *Lidai minghuaji (Li-tai ming-hua chi)* 歷代名畫記 (Record of Famous Paintings in Successive Dynasties), completed 847, *juan (chüan)* 卷 (chapter) 1, reprinted in Yu Anlan 于安瀾, comp., *Huashi congshu (Hua-shih ts'ung-shu)* 畫史叢書 (Compendium of Painting History), vol. 1 (Shanghai: Renmin Meishu Chubanshe, 1962), p. 15. Chang Yen-yüan also said in his book that because rulers were used to guide the brush, that kind of ruled-line painting was "dead painting" (夫用界筆. 直尺界筆, 是死畫也.) See ibid., *chüan* 卷 (chapter) 2, p. 22. For more information on the original text, see the translated and annotated version by William Reynolds Beal Acker in his *Some T'ang and Pre-T'ang Texts on Chinese Painting* (Leiden: E.J. Brill, 1954), pp. 182–83.

2  Examples of religious paintings with elaborate palaces from the T'ang period can still be witnessed in the many murals in the Mo-kao grottos 莫高窟 at Tun-huang 敦煌. These Buddhist caves are located in the northwestern desert in Kansu 甘肅 province. The best-known murals are those depicting the imaginary surroundings of the West Paradise, referred to as *ching-t'u pien* 淨土變, or "painting of the West Paradise in the Pure-land sect." This sect taught that after death, believers traveled to the West Paradise in order to await reincarnation. The character *pien* 變 indicates religious paintings depicting Buddhist paradises. For reproductions of such murals, see Editorial Committee of the Complete Collection of Chinese Art and Dunhuang Research Academy, *Dunhuang bihua (Tun-huang pi-hua)* 敦煌壁畫 (Murals at Tun-huang), vol. 2, in *Zhongguo meishu quanji (Chung-kuo mei-shu ch'üan-chi)* 中國美術全集 (A Complete Collection of Chinese Art), vol. 15 (Shanghai: Renmin Meishu Chubanshe, 1988), pls. 84–85. These two plates show the scene of the paradise of Wu-liang-shou Fo 無量壽佛, or "Amitayus, the Lord of the Pure Land in Buddhism." This Buddhist deity is also known as A-mi-t'o 阿彌陀, or "Amitabha."

3  For this commentary on "ruled-line painting," see "Kung-shih 宮室" (Palaces and Buildings) in *Hsüan-ho hua-p'u* 宣和畫譜 (Catalogue of the Imperial Painting Collection during the Hsüan-ho Era [1119–25]), preface dated 1120, reprint (Taipei: National Palace Museum, 1771), p. 1. The original text is: "[Although] only one dot or one brushstroke, they must be executed with the aid of an instrument; consequently, it is more difficult to produce refined work in this genre than other types." (雖一點, 一筆, 必求諸繩矩. 比他畫為難工.)

4  Although many of these artists remain anonymous, their works on extant fans illustrate their accomplishments in this genre. For examples of Southern Sung paintings using ruled lines, see reproductions in *Masterpieces of Chinese Album Painting in the National Palace Museum* (Taipei: National Palace Museum, 1971), pls. 5, 13, 14, 23, and 24. Although these album leaves were executed by painters of the Southern Sung, several of them have been published as works by artists of earlier dynasties. Among the few artists whose names and works are both known to us is Li Sung 李嵩 (active c. 1190–c. 1230). For an example of Li Sung's work, see the album leaf entitled *Knickknack Peddler*, dated 1210, at the National Palace Museum. It is published in Wen C. Fong and James C. Y. Watt, *Possessing the Past: Treasures from the National Palace Museum, Taipei* (New York: Metropolitan Museum of Art, and Taipei: National Palace Museum, 1996), pl. 84, p. 181. Another album leaf attributed to Li Sung is

The Hangchou Bore in Moonlight, reproduced in *Possessing the Past: Treasures from the National Palace Museum, Taipei*, fig. 105, p. 237. A third leaf under his name entitled *T'ien-chung shui-hsi* 天中水戲 (The Dragon Boat, Water-sport on the Fifth Day of the Fifth Moon) is actually a work of the fourteenth century, during the Yüan dynasty (1280–1368). See Wang Yao-t'ing 王耀庭, *Chieh-hua t'e-chan mu-lu* 界畫特展目錄 (A Catalogue of the Special Exhibition of Ruled-line Painting) (Taipei: National Palace Museum, 1986), pl. 12, pp. 24–25.

5   In many books on Chinese art, the authors suggest that ruled-line paintings with elaborately executed architectural designs may have been used as blueprints for construction. In reality, Chinese workers in the past built houses based on small models called *t'ang-yang* 燙樣 as opposed to using architectural drawings as in the West. For a discussion of the Ch'ing dynasty practice of using small models, see Huang Ximing 黃希明 and Tian Guisheng 田貴生, "Tantan 'Yangshi Lei' tangyang (T'an-t'an 'Yang-shih Lei' t'ang-yang) 談談 '樣式雷' 燙樣 (General Discussion on the Small Models by Lei, the Model-designer), in Editorial Committee of the Palace Museum Bulletin, *Gugong bowuyuan yuankan (Ku-kung po-wu-yüan yüan-k'an)* 故宮博物院院刊 (Palace Museum Bulletin), vol. 26 (Beijing: Palace Museum, Winter 1984), pp. 91–94. Pictures of such small models are reproduced on the page inside the back cover of this issue.

6   For examples of Li Jung-chin's work, see *Possessing the Past: Treasures from the National Palace Museum, Taipei*, pl. 148, p. 190. For examples of Wang Chen-p'eng's work, see *Chieh-hua t'e-chan mu-lu* 界畫特展目錄 (Catalogue of the Special Exhibition of Ruled-line Painting), pl. 19, pp. 24–25 and pp. 46–47. For a discussion of Hsia Yung and his painting, see Wei Dong 魏冬, "Xia Yong ji qi jiehua (Hsia Yung chi ch'i chieh-hua) 夏永及其界畫" (Hsia Yung and His Ruled-line Paintings) in *Ku-kung po-wu-yüan yüan-k'an* 故宮博物院院刊 (Palace Museum Bulletin), vol. 26, Winter 1984, pp. 68–83.

7   For Ch'iu Ying's work, see his *Spring Morning at the Han Palace* reproduced in *Possessing the Past: Treasures from the National Palace Museum, Taipei*, pl. 202, pp. 400–401. Wu Pin's *Sui-hua chi-sheng t'u-ts'e* 歲華記勝圖冊 (A Record of Yearly Observances) is found in the same catalogue, pl. 206 a–d, pp. 406–407.

8   Yüan Yao was a younger painter from Yangchou, most probably Yüan Chiang's son. Yüan Yao's *tzu* was Chao-tao 昭道 (meaning "an illuminated way").

9   For the source of Yüan Chiang's *tzu*, see Zhang Geng (Chang Keng) 張庚 (1685–1760), *Guochao huazheng xulu (Kuo-ch'ao hua-cheng hsü-lu)* 國朝畫徵續錄 (Sequel to the Biographical Sketches of the Artists of the Ch'ing Dynasty), preface dated 1739, *juan (chüan)* 卷 (chapter) 1, reprinted in *Hua-shih ts'ung-shu* 畫史叢書 (Compendium of Painting History), vol. 5, p. 99. For Yüan Chiang's *hao*, see Yang Chenbin 楊臣彬, "Yuan Jiang de Penglai xiandao tu (Yüan Chiang teh P'eng-lai hsien-tao t'u) 袁江的蓬萊仙島圖" (The Painting *Immortal Isles* by Yüan Chiang) in Gugong Bowuyuan Zijincheng Chubanshe, ed., *Gugong bowuyuan cangbaolu (Ku-kung po-wu-yüan ts'ang-pao lu)* 故宮博物院藏寶錄 (A Catalogue of the Treasures at the Palace Museum) (Shanghai: Wenyi Chubanshe, 1986), p. 178. Unfortunately, Yang did not provide his source.

10   The two Yüans often inscribed their works with poetic verses. This practice indicates that their calligraphy was fairly proficient. For a sample of poems by Yüan Chiang, see his landscape album leaves at the Shanghai Museum reproduced in *Chung-kuo ku-tai shu-hua t'u-mu* 中國古代書畫圖目 (An Illustrated Catalogue of Selected Works of Ancient Chinese Painting and Calligraphy), vol. 5, no. 滬 1-3418, p. 140. There are twelve leaves in this set, at least five of which bear poems.

11   Alfreda Murck counted almost one hundred works currently identified as painted by Yüan Chiang in her article, "Yuan Jiang: Image Maker" in Chou Ju-hsi and Claudia Brown, eds., *Chinese Painting under the Qianlong Emperor: The Symposium Papers in Two Volumes (Phœbus 6.2)* (Tempe: Arizona State University, 1991), pp. 228–49. See the table of the artist's work on pp. 251–59. The actual number should be even larger as Yüan Chiang's works are often revealed in new publications.

12   For a discussion of the artist Ch'iu Ying, see entry 10.

13   See *Kuo-ch'ao hua-cheng hsü-lu* 國朝畫徵續錄 (The Sequel of the Biographical Sketches of the Artists of the Ch'ing Dynasty), *chüan* 卷 (chapter) 1, p. 99. See also Li Tou's 李斗 (active second half of 18th century), *Yangzhou huafanglu (Yang-chou hua-fang-lu)* 揚州畫舫錄 (A Record of the Gaily Painted Pleasure Boats in Yangchou), preface dated 1796, reprint, *juan (chüan)* 卷 (chapter) 2 (Yangzhou: Jiangsu Guangling Guji Keyinshe, 1984), p. 39.

14   Yüan Chiang's six scrolls at the Tianjin Museum are reproduced in Group for the Authentication of Ancient Works of Chinese Painting and Calligraphy, ed., *Zhongguo gudai shuhua tumu (Chung-kuo ku-tai shu-hua t'u-mu)* 中國古代書畫圖目 (An Illustrated Catalogue of Selected Works of Ancient Chinese Painting and Calligraphy), vol. 10 (Beijing: Wenwu Chubanshe, 1993), no. 津 7-1016, p. 74. Interestingly, these six scrolls are all executed in ink, as opposed to the colorful professional style with which the artist is associated. Although these examples are signed, they are all undated. Combined with the fact that none of these examples resembles the style of his mature period, the possibility that these were completed early in his career seems most plausible.

15   In the past the relationship of the two Yüans has confused several scholars. For example, in the chapter, "A Study of Yuan Yao" in Chou Ju-hsi and Claudia Brown, eds., *The Elegant Brush: Chinese Painting under the Qianlong Emperor, 1735–1795* (Phoenix: Phoenix Art Museum, 1985), p. 117, is the statement: "son or nephew of Yuan Jiang (active 1680–1740) demonstrates the continuity of Qing painting from the Kangxi to Qianlong era." Alfreda Murck refers to Yüan Yao as "his [Yüan Chiang's] putative son" in her article, "Yuan Jiang: Image Maker," p. 230.

16   The *Hua-jen pu-i* 畫人補遺 (An Addendum of the Painters' Biographies) is a rare catalogue published in the eighteenth century during the Ch'ien-lung reign (1736–96) by an anonymous author. It is reprinted in William Yeh Hung 洪業, ed., *Ch'ing hua-chuan chi-i san-chung fu yin-teh* 清畫傳輯佚三種附引得 (Biographies of Ch'ing Dynasty Painters in Three Collections, with an Index) (Supplement no. 8, Harvard-Yenching Institute Sinological Index Series) (Peking: Offices in Yenching University Library, 1934). The entry on Yüan Chiang is found on page 37b. The original Chinese text, which is cited in several articles concerning the two Yüans, says: "Yüan Chiang's *tzu* was Wen-t'ao. From Chiang-tu (Yangchou), he was adept in painting landscapes and buildings. In his middle-age, he acquired a group of painting models copied by an anonymous artist after works of early masters. [As a result,] Yüan's artistic skill greatly improved. He was summoned to serve at the Outer Hall of Mental Cultivation [the emperor's outer living quarter]. Yüan Chiang had a son named Yao, who could paint landscapes and edifices in the style characteristic of the Yüan family." At the end of this entry in smaller type, the editor added: "The character ' 曜 yao,' should be the other character, ' 耀 yao.' On Yüan Yao's works, only the second 'yao' character is used for his signature." (袁江, 字文濤, 江都人, 善山

Yüan Chiang 袁江
Spring Dawn at the Han Dynasty
(206 B.C.–A.D. 220 ) Palace
*continued*

106 水樓閣. 中年得無名氏所臨古人畫稿, 技遂大
進. 曾遊入外養心殿. 有子名曜. 山水樓閣, 尚
能守家法. 曜, 應作耀. 曾見其畫, 自署袁耀.)

17 Another issue in the study of the two
Yüans is the existence of a few unknown
painters who bore the same family name,
Yüan, and painted in the same "Yüan"
style. One hanging scroll, entitled *Xiting
duiyi (Hsi-t'ing tui-i)* 溪亭對弈 (Playing
Chess in a Pavilion by a Creek) at the
Tianjin 天津 Municipal Art Museum, is
signed Yuan Xue (Yüan Hsüeh) 袁雪,
whose *hao* was Li-ch'ao 櫟巢 (a nest in an
oak tree). The style of this work is defi-
nitely similar to that of the two Yüans.
Yüan Hsüeh's work is reproduced in
*Chung-kuo ku-tai shu-hua t'u-mu* 中國古
代書畫圖目 (An Illustrated Catalogue of
Selected Works of Ancient Chinese Paint-
ing and Calligraphy), vol. 10, no. 津
1-1133, p. 97. This painter, however,
should not be confused with another artist
under the same name recorded in *Chung-
kuo mei-shu-chia jen-ming tz'u-tien* 中國
美術家人名詞典 (Biographical Dictionary of
Chinese Artists), p. 759. The date on Yüan
Hsüeh's painting, *keng-tzu* 庚子 could be
either 1720 of the K'ang-hsi period, or
sixty years later, 1780 under the Ch'ien-
lung reign. According to Nie Chongzheng
聶崇正, there is also a large horizontal
hanging scroll, entitled *Luyetang tu (Lü-
yeh t'ang t'u)* 綠野堂圖 (Green Wilderness
Hall), by a painter named Yüan Piao 袁杓,
at the Palace Museum in Beijing. See Nie
Chongzheng, *Yuan Jiang yu Yuan Yao
(Yüan Chiang yü Yüan Yao)* 袁江與袁耀
(Yüan Chiang and Yüan Yao) (Shanghai:
Renmin Meishu Chubanshe, 1982), p. 19.
Although this work is not reproduced in
Nie's book, he points out that, based on
the inscription, Yüan Piao, who was from
Yangchou, executed this painting in 1778
(the forty-third year of the Ch'ien-lung
reign). It is important to bear in mind not
only that Yüan Piao bore the same family
name as the two Yüans and was from the
same city but even that the subject mat-
ter, the Green Wilderness Hall, had been
depicted by both of the two Yüans. See
note 18. Thus, Yüan Hsüeh and Yüan Piao
could be descendants of the two Yüans.
The exact kinship of these Yüans is a mys-
tery that requires further research and new
materials. There is still another unknown
painter called Shih Shan-hui 石山暉 who
also painted in a similar manner as the
two Yüans. A painting by Shih entitled
*Hangong chunxiao (Han-kung ch'un-
hsiao)* 漢宮春曉 (Spring Morning at the
Han Palace) is reproduced in *Chung-kuo
ku-tai shu-hua t'u-mu* 中國古代書畫圖目
(An Illustrated Catalogue of Selected
Works of Ancient Chinese Painting and

Calligraphy), vol. 8, no. 津 6-171, p. 46.
Unfortunately, the identity of this obscure
painter is difficult to clarify. One possibil-
ity is that Shih was a professional painter
at the two Yüans' studio.

18 Alfreda Murck ("Yüan Jing: Image Maker,"
p. 229) lists three dated works of Yüan
Chiang that include an inscription with
the reign mark of K'ang-hsi emperor:
1) *Jiu-ch'eng kung* 九成宮 (The Palace of
Nine Perfections), dated 1691, now at the
Metropolitan Museum of Art. It is repro-
duced in Richard M. Barnhart, *Peach Blos-
som Spring: Garden and Flowers in Chi-
nese Painting* (New York: Metropolitan
Museum of Art, 1983), pp. 105–11;
2) *Shuige duiyi tu (Shui-ko tui-i t'u)* 水閣對
弈圖 (Playing Chess in a Pavilion by the
Water), dated 1716, now at the Anhui 安徽
Provincial Museum. For a reproduction of
this work, see *Chung-kuo ku-tai shu-hua
t'u-mu* 中國古代書畫圖目 (An Illustrated
Catalogue of Selected Works of Ancient
Chinese Painting and Calligraphy), vol. 12,
no. 皖 1-490, p. 260; and 3) *Lü-yeh t'ang* 綠
野堂 (The Green Wilderness Hall), dated
1720, belongs to an anonymous collection
in Japan. It is reproduced in Koyama Fujio
小山富士夫 (1900–1982?), ed., *Sekai bijutsu
zenshu* 世界美術全集 (An Encyclopedia of
World Art), vol. 17: Chugoku 中國 (China),
section 6, Minshin 明清 (Ming and Ch'ing
Dynasties) (Tokyo: Kadokawa Shoten 角川
書店, 1968), p. 15. Besides these three
listed by Murck, there are also a few oth-
ers; for example, a painting by Yüan Chi-
ang with a K'ang-hsi reign mark, entitled
*Chunlai tiandi (Ch'un-lai t'ien-ti)* 春來天
地 (Heaven and Earth in the Spring Sea-
son), a set of twelve scrolls dated 1711,
now belonging to a private collection in
China. These twelve scrolls are published
in Ho Kung-shang 何恭上, *Yüan Chiang
and Yüan Yao* 袁江與袁耀 (Taipei: Art
Book Co., 1984), pls. 45–54, pp. 64–88. The
Green Wilderness Hall depicted in Yüan's
painting was originally the name of a
famous hall belonging to the T'ang
dynasty (618–905) official P'ei Tu 裴度
(765–839). In the Ming period (1368–1644),
this name was adopted by Ming dynasty
scholar-official Cheng Hsü-teh 鄭須德
(active Wan-li 萬曆 period 1573–1619). See
*Tz'u-hai* 辭海 (Sea of Terminology: Chi-
nese Language Dictionary), vol. 2 (Taipei:
Chung-hua Press, 1974), p. 90, s.v. "Lü-yeh
t'ang 綠野堂." Yüan Chiang painted sev-
eral versions of this Green Wilderness Hall
between 1719–20. Presumably Yüan
adopted the name of this famous building
in Chinese history because of its poetic
connotation.

19 See Alfreda Murck, "Yuan Jiang: Image
Maker," p. 229. See also Nie

Chongzhong's *Yüan Chiang yü Yüan Yao*
袁江與袁耀 (Yüan Chiang and Yüan Yao), p.
3. The author of the second book was unfa-
miliar with the two Yüans' works in West-
ern collections; consequently, he desig-
nated Yüan Chiang's earliest active year as
1693. He also extended this artist's cre-
ative years to 1746. In Nie's book, a total
of fifty-three years were given to Yüan
Chiang's career.

20 Among these late seventeenth-century
Yangchou painters, Hsiao Ch'en's works
are reproduced in Kao Mayching 高美慶,
ed., *Qingdai Yangzhou huajia zuopin
(Ch'ing-tai Yangchou hua-chia tso-p'in)* 清
代揚州畫家作品 (Paintings by Yangzhou
Artists of the Qing Dynasty from the
Palace Museum) (Hong Kong: Art Gallery,
Institute of Chinese Studies, Chinese Uni-
versity of Hong Kong, 1984), pls. 6–11, pp.
67–79. For Li Yin's works, see the same
catalogue, pls. 1–5, pp. 55–65. Yen I's paint-
ings are also found in this catalogue, pls.
12–15, pp. 81–89. For Wang Yün's work,
see Ho Wai-kam 何惠鑑 et al., *Eight
Dynasties of Chinese Paintings: The Col-
lections of the Nelson Gallery-Atkins
Museum, Kansas City, and the Cleveland
Museum of Art* (Cleveland: Cleveland
Museum of Art, 1980), pl. 257, p. 349.

21 For a discussion of the painter Shih-t'ao,
see entry 29.

22 For the names of "The Eight Eccentrics of
Yangchou," see note 21 of entry 36 on
Huang Shen.

23 The source for the two Yüans' trip to
Shansi province is Li Chaozhi's 李超智
article, "Jiehua de fazhan he jiehua goutu
de yanjiu (Chieh-hua teh fa-chan ho chieh-
hua kou-t'u teh yen-chiu)" 界畫的發展和界
畫構圖的研究" (A Study of the Develop-
ment and the Composition of the Ruled-
line Paintings), in the first issue of the
periodical *Zhongguo hua (Chung-kuo hua)*
中國畫 (Chinese Painting) (Beijing: Wenwu
Chubanshe, 1957), pp. 66–68. According to
Li, in the early 1950s, he was told by a
friend, a certain Mr. Wei 尉 from Shansi
province, that the Wei clan had been
prominent in the city of T'ai-yüan 太原,
capital of Shansi, since the Ming dynasty.
The Weis were wealthy landowners, and in
the Ch'ing period, the family invited Yüan
Chiang and Yüan Yao to their hometown
in order to hire the two painters as artists-
in-residence. Li's story asserts that the two
artists stayed there for many years, with
Yüan Yao remaining in the province for a
longer period of time. While in Shansi, the
two Yüans executed numerous paintings
to decorate the many gigantic houses of
the Wei family, including large hanging
scrolls, screens, hand scrolls, album leaves,

lanterns, and room partitions. They even prepared extra copies of each so that in case a work was damaged, it could be easily replaced. Later, during the twilight of the Ch'ing dynasty, from the 1910s to the 1940s, many antique dealers from Peking went to Shansi searching for old art objects and brought many works of the two Yüans back to the capital. The total number of Yüan Chiang's and Yüan Yao's paintings transferred from Shansi to the capital was estimated at approximately one hundred, the majority of which were painted by Yüan Yao. Li Chaozhi admitted that there was no written material to verify this legend. Yet he also pointed out that what he knew concerning the sources of the two Yüans' paintings seems to correspond with Mr. Wei's story. Li Chaozhi appears to have been ignorant of the Wei family's economic circumstances. As Mr. Wei was a descendant of one of the three wealthy Shansi salt merchants in Yangchou, his story gains greater legitimacy. See *Yang-chou hua-fang-lu* 揚州畫舫錄 (A Record of the Gaily Painted Pleasure Boats in Yangchou), *chüan* 卷 (chapter) 1, p. 54, which says that Wei Chi-mei 尉濟美 and Wang Lü-t'ai 王履泰 were both from Shansi and both were merchants dealing salt in Yangchou. They also owned a famous garden, Shih-yüan 是園 in that city. The third northern salt dealer in Yangchou was Ho Chün-chao 賀君召. According to the book, Ho was from Linfen 蕗汾 in Shensi, and his *tzu* was Wuts'un 吳村. See *A Record of the Gaily Painted Pleasure Boats in Yangchou*, *chüan* 卷 (chapter) 13, p. 300. Moreover, the ascendancy of these three families during the first half of the eighteenth century coincides with the productive years of the two Yüans, and there is direct evidence that the Yüans knew these northern businessmen. For example, Ho Chün-chao was the owner of the famous "Ho 賀 garden" in Yangchou. It is recorded in the same book that Ho commissioned Yüan Yao to depict the twelve celebrated views in this garden. Finally, at the Cultural Relics Bureau in Tianjin (天津文物管理處), there is a set of album leaves by Yüan Yao entitled *Guangling songbie tu* (*Kuang-ling sung-pieh t'u*) 廣陵送別圖 (Farewell in Yangchou). This work, dated 1747, includes ten leaves of paintings and poems. Yüan Yao presented these album leaves as a farewell memento to Ho Chünchao. See Nie Chongzheng, "Yuan Yao youguan Yangzhou de liangjian zuopin (Yüan Yao yu-kuan Yangchou teh liangchien tso-p'in) 袁耀有關揚州的兩件作品" (Two Works by Yüan Yao Related to Yangchou), in the journal *Wenwu* 文物 (Cultural Relics), vol. 4 (Beijing: Wenwu

Chubanshe, 1979), p. 46. Thus, Yüan Yao's friendship with Ho makes Wei's story even more credible.

24   See entry 33 on Kao Ch'i-p'ei for more information on this episode.

25   The assertion that Yüan Chiang remained in Chekiang until around 1720 is based on his artistic activities in that area. For example, in 1719, Yüan Chiang executed a set of four hanging scrolls depicting four gentlemen in their official uniforms amid a landscape setting. From the poems on these scrolls, one learns that these four figures represent four scholars of the Shaohsing area in Chekiang. Thus, the scrolls seem to indicate that in the late 1710s, Yüan Chiang was still active in the south. See Nie's *Yüan Chiang yü Yüan Yao* 袁江與袁耀 (Yüan Chiang and Yüan Yao), p. 4. The author states that these four scrolls belong to the Tianjin Wenwu Gongsi (Tientsin Wen-wu Kung-ssu) 天津文物公司 (Tianjin Antique Company). Unfortunately, Yüan Chiang's four scrolls are not reproduced in the *Chung-kuo ku-tai shuhua t'u-mu* 中國古代書畫圖目 (An Illustrated Catalogue of Selected Works of Ancient Chinese Painting and Calligraphy), vol. 8, where the painting collection of the Tianjin Antique Company is reproduced.

26   Evidence of the two Yüans' sojourn to the capital is found on one of Yüan Chiang's works, a landscape dated 1724. This work is recorded in Guo Weiqu's 郭味蕖 *Song Yuan Ming Qing shuhuajia nianbiao* (*Sung-Yüan- Ming-Ch'ing shu-hua-chia nien-piao*) 宋元明清書畫家年表 (A Chronological Table of Painters and Calligraphers of the Sung, Yüan, Ming and Ch'ing Dynasties) (Beijing: Renmin Meishu Chubanshe, 1958), p. 329. According to Guo, Yüan Chiang's inscription on this painting states that this work was executed at Yen-t'ai 燕台 (The Swallow Terrace), a geographical name referring historically to Peking. Thus, this indicates Yüan Chiang's trip to the capital. Unfortunately, this painting has never been published. Nie Chongzheng also mentioned this work in his *Yüan Chiang yü Yüan Yao* 袁江與袁耀 (Yüan Chiang and Yüan Yao), p. 5. In her article "Yuan Jiang: Image Maker," Alfreda Murck offers more evidence that Yüan Chiang was in the capital. Murck mentions an undated river landscape scroll by Yüan Chiang that bears the seal of Prince I 怡, *I-ch'in-wang pao* 怡親王寶 (treasures owned by Prince I). Murck, based on Richard Barnhart's hypothesis, asserts that this seal may belong to Yin Hsiang 胤祥 (1686–1730), the first Prince I, and suggests that Yüan Chiang may have worked for

Prince I in the capital between 1723 and 1730, the seven years in which the prince held the title. See note 6 in Murck's article. However, the seal should probably be credited to Yin Hsiang's son, Hung-hsiao 弘曉 (*tzu* Hsiu-t'ing 秀亭, meaning "an elegant pavilion" and *hao* Ping-yü tao-jen 冰玉道人, a dignified and cultivated person who is as pure as jade and ice, ?–1778). While Yin Hsiang, the first generation Prince I, was mainly a politician, Hung-hsiao, who inherited the status in 1730, was known as a poet and collector. In his famous studio, the Lo-shan t'ang 樂善堂 (The Benevolence Hall), Hung-hsiao assembled a large collection of rare edition books and old paintings, including many famous handscrolls such as *Fishermen* by Hsü Tao-ning 許道寧 (c. 970–1052), now at the Nelson Gallery-Atkins Museum, Kansas City. Therefore, the seal on the painting by Yüan Chiang perhaps indicates only that this work existed in the collection of the second Prince I, Hung-hsiao. For the history of the first Prince I and his son, see Arthur W. Hummel, ed., *Eminent Chinese of the Ch'ing Period (1644–1912)*, vol. 2 (Washington, D.C.: United States Government Printing Office, 1943–44), pp. 923–24. In Hummel's book, Hung-hsiao's studio is erroneously referred to as Ming-shan t'ang 明善堂 (The Illustrious Benevolence Hall), the studio of another Manchu imperial family member, I-hui 弈繪 (1799–1838). Hsü Tao-ning's *Fishermen* is published in *Eight Dynasties of Chinese Paintings: The Collections of the Nelson Gallery-Atkins Museum, Kansas City, and the Cleveland Museum of Art*, pp. 20–24. Alfreda Murck ("Yuan Jiang: Image Maker," p. 230) also mentioned another work by Yüan Chiang as "persuasive visual evidence for a [Yüan Chiang's] sojourn in Beijing." This work is a hanging scroll now in a private collection in Phoenix, Arizona that depicts "Chinese scholars in blue robes and queue setting off past willow trees for the triennial examination." The scroll bears a colophon by a certain Fu Wang-wen 傅王雯 (active c. early 18th century). Based on information provided by Howard Rogers, Murck proposes that this painting depicts the palace examination, thus indicating Yüan Chiang was in the capital. Yet further examination of Fu Wang-wen reveals that he was from Shaohsing, Chekiang, and passed his imperial examination for the *chin-shih* degree in 1706, the 45th year of the K'ang-hsi reign. In that year, Yüan Chiang was still working for Kao Ch'i-p'ei in Chekiang in the south. It seems more likely that Yüan Chiang executed the painting for Fu Wang-wen in 1706 in Chekiang before Fu started his journey to Peking for the examination, as a gift to wish Fu, the recipient, a successful

Yüan Chiang 袁江

**Spring Dawn at the Han Dynasty**

　　(206 B.C.–A.D. 220 ) Palace

*continued*

108　　test in the capital. Fu was from a distin-
guished family of scholars. Two other
members of this family, Fu Wang-lu 傅王露
and Fu Wang-sha 傅王霎, presumably Fu
Wang-wen's brothers or cousins, later also
passed the imperial examination in 1715
and 1718, respectively. The names of these
three scholars in the Fu family are recorded
in Zhu Baojiong 朱保炯 and Xie Peilin 謝沛
霖, *MingQing jinshi timingbeilu suoyin*
(*Ming-Ch'ing chin-shih t'i-ming-pei lu so-
yin*) 明清進士題名碑錄索引 (An Index of the
Stele Bearing the Names of the Holders of
the *chin-shih* Degree during the Ming and
Ch'ing Dynasties) (Shanghai: Guji Chuban-
she, 1980), vol. 1, p. 734.

27　Although some sources, such as Chang
Keng's *Kuo-ch'ao hua-cheng hsü-lu* 國朝畫
徵續錄 (The Sequel of the Biographical
Sketches of the Artists of the Ch'ing
Dynasty), *chüan* 卷 (chapter) 1, p. 99,
assert that Yüan Chiang worked as a court
painter during the Yung-cheng period, this
assertion does not hold much merit. Not
only are the Yüans' works absent from the
imperial collection, but their signatures
fail to contain the character *ch'en* 臣, or
"the [emperor's] servitor," a designation
that traditionally signifies court status. In
addition to their low social status, the dec-
orative nature of their paintings probably
impeded them from being recognized as
official court painters.

28　For an example of Yüan Chiang's flower-
and-bird painting, see his *Fruits and Veg-
etables* album leaves in Ancient Chinese
Calligraphy and Painting Authentication
Group, ed., *Zhongguo gudai shuhua jing-
pinlu* (*Chung-kuo ku-tai shu-hua ching-
p'in lu*) 中國古代書畫精品錄 (Masterpieces
of Ancient Chinese Calligraphy and Paint-
ing) (Beijing: Wenwu Chubanshe, 1984),
pls. 65 a & b.

29　For an example of Yüan Chiang's individ-
ual works that function as screens, see his
*Zhubao songmao* (*Chu-pao sung-mao*) 竹
苞松茂 (Landscape with Pavilions among
Luxuriant Pines and Bamboo), reproduced
in *Ch'ing-tai Yangchou hua-chia tso-p'in*
清代揚州畫家作品 (Paintings by Yangzhou
Artists of the Qing Dynasty from the
Palace Museum), pl. 19, pp. 100–101. This
work, which consists of twelve hanging
scrolls, is also reproduced in color in the
above catalogue, pp. 42–43.

30　Due to the monumental quality of the two
Yüans' work, their large landscape scrolls
have been compared to those of the Sung
dynasty (960–1279). This similarity
accounts for one particular scroll's mis-
taken attribution. A painting entitled *Ssu-
lo t'u* 四樂圖 (The Four Pleasant Occupa-
tions) entered the imperial collection dur-

ing the Ch'ing period and is currently at
the Palace Museum, Taipei. Although
bearing the signature of Yen Tz'u-p'ing 閻
次平 (active second half of 12th century)
from the Sung dynasty, it is more likely a
work of one of the two Yüans. The pres-
ence of stylized trees, anchored structures,
and swirling rock formations are all hall-
marks of the Yüans' oeuvre. It is ironic
that the only work of the two Yüans to
make it into the imperial collection is
attributed to an earlier master! This paint-
ing is reproduced in *Ku-kung shu-hua t'u-
lu* 故宮書畫圖錄 (An Illustrated Catalogue
of Calligraphy and Painting at the Palace
Museum), vol. 2 (Taipei: National Palace
Museum, 1989), p. 95. It is also interesting
to point out that during the seventeenth
century, this painting belonged to Liang
Ch'ing-piao 梁清標 (1620–91), a distin-
guished connoisseur and collector. It is
unlikely that Liang would have accepted
the wrong attribution since he was a con-
temporary of the artist. Therefore the sig-
nature of Yüan Chiang or Yüan Yao was
probably removed and Yen Tz'u-p'ing's
name added when this work entered the
imperial collection during the latter part
of the eighteenth century.

31　*Kuei-mien ts'un* 鬼面皴 is also known as
*Kuei-p'i ts'un* 鬼皮皴, or "ghost skin tex-
ture."

32　For Kuo Hsi's work, see his famous scroll,
*Tsao-ch'un t'u* 早春圖 (Early Spring), pub-
lished in *Possessing the Past: Treasures
from the National Palace Museum, Taipei*,
pl. 60, p. 129.

33　In Chinese literature, *Han Palace in
Spring*, as well as *Han Palace in Autumn*,
are popular *tz'u-p'ai* 詞牌, or "verse forms"
of the *tz'u* poetry, which is characterized
by lines of irregular length. See *Tz'u-hai* 辭
海 (Sea of Terminology: Chinese Language
Dictionary), vol. 1 (Taipei: Chung-hua
Press, 1974), p. 154, s.v. "*Han-kung ch'un*
漢宮春" (Han Palace in Spring) and "*Han-
kung ch'iu* 漢宮秋" (Han Palace in
Autumn). There is a well-known hand-
scroll with this title by Ch'iu Ying 仇英
(1502?–1552) at the National Palace
Museum, Taipei. It is published in *Pos-
sessing the Past: Treasures from the
National Palace Museum, Taipei*, pl. 203,
pp. 400–401.

34　For Yüan Chiang's work under the same
title, see Christie's sales catalogue, *Impor-
tant Classical Chinese Paintings* (New
York: Christie's, May 31, 1990), lot no. 43.
For Yüan Yao's work depicting this topic,
see *Chung-kuo ku-tai shu-hua t'u-mu* 中國
古代書畫圖目 (An Illustrated Catalogue of
Selected Works of Ancient Chinese Paint-
ing and Calligraphy), vol. 6, no. 蘇 10-219,

p. 258. Interestingly, Yüan Yao's scroll,
dated 1752, is a copy of Yüan Chiang's
scroll, dated 1722.

35　The reason for this reference was mainly
that there were many famous palaces dur-
ing and associated with the Han period,
such as the Wei-yang ([Pleasure Has] Not
Yet Come to Cease) Palace 未央宮, Ch'ang-
lo (Everlasting Happiness) Palace 長樂宮,
and the Kan-ch'üan (Sweet-water Spring)
Palace 甘泉宮. The Wei-yang Palace was
constructed in 200 B.C. by Emperor Kao-
tsu 高祖 (r. 206–195 B.C.), the first emperor
of the Han dynasty. See *Hanyu dacidian*
(*Han-yü ta-tz'u-tien*) 漢語大詞典 (Chinese
Terminology Dictionary), vol. 4 (Shanghai:
Hanyu Dacidian Press, 1988), p. 686, s.v.
"Weiyanggong 未央宮" (Wei-yang Palace).
Ch'ang-lo Palace was also constructed a
few years later by the same ruler. See ibid.,
vol. 11, p. 606, s.v. "Changle gong 長樂宮"
(Ch'ang-lo kung). The Kan-ch'üan Palace
was constructed even earlier. It was built
by Ch'in-shih Huang 秦始皇 (r. 246–10
B.C.), the founder of the Ch'in dynasty
(221–206 B.C.). See *Chinese Terminology
Dictionary*, vol. 7, p. 972, s.v. "Ganquan
gong 甘泉宮" (Kan-ch'üan kung). The
sumptuous Kuei-kung 桂宮 (Cassia Palace)
was another even better-known ornate
Han palace. It was erected in the fourth
year (101 B.C.) of the T'ai-ch'u 太初 reign
(104–101) under Emperor Wu-ti 武帝 (r.
140–87 B.C.) and was specially built for his
numerous imperial ladies-in-waiting. Orig-
inally, this palace was located northwest of
present-day Xian, and it is believed that
Wu-ti had 2,000 beautiful women living
there. For more information on the Cassia
Palace, see *Han-yü ta-tz'u-tien* 漢語大詞 典
(Chinese Terminology Dictionary), vol. 4,
p. 958, s.v. "Guigong" (Kuei-kung) 桂宮"
(Cassia Palace). For the archaeological
record of the Han palaces in Ch'ang-an
(present-day Xian), see Huang Zhanyue 黃
展岳, "Handai de chengyi yu biansai yizhi
(Han-tai teh ch'eng-i yü pien-sai i-chih) 漢
代的城邑與邊塞遺址" (The Han Dynasty
Archaeological Sites of the Cities and
Frontier) in the Institute of Archaeology,
CASS, *Archaeological Excavation and
Researches in New China* (Beijing: Wenwu
Chubanshe, 1984), pp. 393–97.

36　The central palaces' pointed roofs and gate
with extended walls in the Michigan scroll
also appear in Yüan Chiang's other paint-
ings, such as his *Chenxiang ting* (*Ch'en-
hsiang t'ing*) 沉香亭 (The Eaglewood Pavil-
ion), reproduced in Editorial Group of
Tianjin Art Museum, ed., *Tianjin yishu
bowuguan canghuaji* (*Tientsin i-shu po-
wu-kuan ts'ang-hua chi*) 天津藝術博物館藏
畫集 (Paintings in the Collection of the
Tianjin Art Museum), vol. 1, in the series

## 35. Lang Shih-ning 郎士寧 (Giuseppe Castiglione)

*(1688–1766), attributed to Ch'ing dynasty (1644–1911); with calligraphy attributed to Liu T'ung-hsün 劉統勳 (1700–1773)*

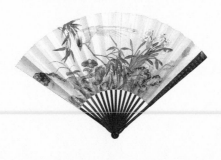

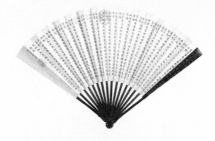

### Bird on a Bamboo Branch

*Han-hsiang yu-niao t'u*
*(An Elegant Bird amid Wintry Fragrance)*

寒香幽鳥圖

*Zhongguo lidai huihua (Chung-kuo li-tai hui-hua)* 中國歷代繪畫 (Paintings of the Successive Dynasties) (Tianjin: Renmin Meishu Chubanshe, 1985), pp. 85–86. The pointed roofs also appear in Yüan Chiang's *Penglai xiandao (P'eng-lai hsien-tao)* 蓬萊仙島 (The P'eng-lai Immortals' Isles), published in Howard Rogers and Sherman E. Lee, *Masterworks of Ming and Qing Paintings from the Forbidden City* (Lasdale: International Arts Council, 1988), no. 58, p. 92.

37 For a reproduction and discussion of these two gates, see Sherman E. Lee, *A History of Far Eastern Art* (New York: Harry N. Abrams, 1964), fig. 612, p. 462 and fig. 614, p. 463.

38 The proximity of the mountain's peak to the border in Yüan Chiang's painting at Michigan is further evidence that a top section of the composition, where Yüan Chiang typically inscribed the title along with his signature, is missing. Fortunately, the remainder of the scroll maintains its original silk with few restorations. The Michigan scroll was purchased from David W. Thomas, who had bought it at a garage sale for $200. Recognizing it as a genuine work by Yüan Chiang, the Museum quickly moved to acquire the scroll for a modest amount.

39 Similar mountains in the background can also be found in Yüan Chiang's *The Eaglewood Pavilion*. See note 36.

40 For a discussion of Tung Ch'i-ch'ang and his aesthetic philosophy, see chapter, "Tung Ch'i-ch'ang's Transcendence of History and Art" in Wai-kam Ho 何惠鑑 ed., *The Century of Tung Ch'i-ch'ang, 1555–1636*, vol. 1 (Kansas City: Nelson-Atkins Museum of Art, 1992), pp. 3–41.

1 Frank Caro was a well-known dealer in New York who was active in the 1950s–70s. For many years he worked as a photographer for the Chinese art dealer C. T. Loo. After Loo died in the late 1940s, Caro took over Loo's antique business in New York. For more information on these collectors, see entry 54 on Lu Hui. Unfortunately, little is known about the donor, Alfred L. Aydelott.

2 Mikinosuke Ishida's article was translated into Chinese by Ho Ch'ang-ch'üan 賀昌群 and was included in Teng Shih 鄧實 (1865?–1948?) and Huang Pin-hung 黃賓虹 (1865–1955), comps., *Mei-shu ts'ung-shu* 美術叢書 (Anthology of Writings on Fine Art) (Shanghai: n.p., 1912–36), reprint, *chi* 集 (division) 5, *chi* 輯 (collection) 2, vol. 21 (Taipei: I-wen Bookstore, 1963–72), pp. 143–236.

3 This type of seal is called *lien-chu-yin* 聯珠印, or "pearl-string seal," because the seal consists of two individual characters carved on the same seal. This type of seal usually bears the name of the artist. Its small size makes it especially suitable for albums or fan paintings. See note 4 in entry 10 of Ch'iu Ying's fan painting for more information.

4 The *pa-chen* 八珍, or the "eight treasures," can be interpreted either as the eight ways

to cook food, such as to steam, boil, broil, stir-fry, bake, deep-fry, cure, and pickle, or the eight types of rare delicacies, including chimpanzee lip, bear paw, leopard fetus, camel hump, roasted swan, carp tail, koumiss or liquor made from mare's milk, and cicada cured in koumiss. In common parlance, it indicates the rare delicacies at a banquet. These two lines in Emperor Ch'ien-lung's poem are borrowed from the famous poet Lu Yu 陸游 (1125–1210) of the Southern Sung dynasty (1127–1279). See *Hanyu dacidian (Han-yü ta-tz'u-tien)* 漢語大詞典 (Chinese Terminology Dictionary), vol. 2, p. 9, s.v. *"bazhen (pa-chen)* 八珍"

5 Man-t'ing is another name for Mt. Wu-i 武夷山 in Fukien. In this line, Ch'ien-lung uses the idiom *"Man-t'ing-ch'iu* 幔亭秋" (the Autumn festival at Mt. Wu-i ). According to Taoist mythology, the *Yün-chi ch'i-ch'ien* 雲笈七籤 (The Seven Divining Tallies in the Sacred Notes in the Clouds), an immortal living at Mt. Wu-i erected tents on the mountain on the fifteenth day of the eighth moon every fall and invited the local inhabitants to attend his banquets. See *Han-yü ta-tz'u-tien* 漢語大詞典 (Chinese Terminology Dictionary), vol. 3, p. 757, s.v. *"manting (man-t'ing)* 幔亭." The emperor implies in his poem that he had many opportunities to seek enlightenment in Taoism.

6 In this line *heng-men* 衡門 indicates a crude wooden door carelessly put together, thus representing the household of a common person. It is the opposite of *"hou-men* 侯門," which characterizes the door at the home of an aristocrat. See *Han-yü ta-tz'u-tien* 漢語大詞典 (Chinese Terminology Dictionary), vol. 3, p. 1102, s.v. *"hengmen (heng-men)* 衡門."

7 This type of censer, known as *kou* 簍, was designed to scent one's clothing. Typically made of bamboo, smaller *kou* were often carried around in one's sleeves; whole garments were scented by using larger ones.

8 In this stanza, the first two lines refer to the beautiful scenery viewed by a hermit. The next two lines describe his living conditions. This recluse states that he has so few provisions that he has to live a simple and lonely life. The idiom *ho-k'ou* 鶴口, or the "crane's mouth," means the members of a poor family who are constantly underfed. See *Chinese Terminology Dictionary*, vol. 12, p. 1143, s.v. *"hekou (ho-k'ou)* 鶴口." The last line describes the lonely life of this hermit. Devoid of social activities, he makes friends with the birds in order to avoid the discord one experiences with people. The idiom *ou-meng* 鷗盟, or "seagull-friendship," refers to the seagulls with

**Lang Shih-Ning** 郎士寧
(Giuseppe Castiglione)
**Bird on a Bamboo Branch**
*continued*

110

whom a recluse makes friends in his solitude. See ibid., vol. 12, p. 1157, s.v. "*oumeng* (*ou-meng*) 鷗盟." These last two lines were actually borrowed from the poem *Autumn Evening* by the poet Lu Yu of the Sung dynasty. See ibid., vol. 12, p. 1143, s.v. "*hekou* (*ho-k'ou*) 鶴口."

9 The term *ku-p'u* 菰蒲 has two meanings. Its literal meaning indicates mushrooms and dandelions. In Chinese poetry, however, it represents a lake. See ibid., vol. 9, p. 454, s.v. "*gupu* (*ku-p'u*) 菰蒲."

10 The real meaning of this line is not clear. It could have a connection with a certain anecdote or literary source.

11 This "elegant flower" most likely indicates chrysanthemums in the fall.

12 In this line, the term *yeh-tzu* 椰子, although commonly meaning a coconut, indicates a person's humble body. It is a Buddhist connotation found in the biography of Abbot Chih-ch'ang 智常禪師 in *Jingde chuandenglu* (*Ching-teh ch'uan-teng-lu*) 景德傳燈錄 (Biographies of Chan Masters). See *Han-yü ta-tz'u-tien* 漢語大詞典 (Chinese Terminology Dictionary), vol. 4, p. 1080, s.v. "*yezishen* (*yeh-tzu-shen*) 椰子身" (the coconut body).

13 To describe a destitute person, Emperor Ch'ien-lung used the idiom *ch'an-fu kuei-ch'ang* 蟬腹龜腸, literally meaning the "cicada's stomach and tortoise's intestines." The stomach of a cicada is very tiny and the intestines of a tortoise are thin, and neither can hold much food. Thus, the idiom uses the hungry condition of a poor person to indicate his poverty. See ibid., vol. 8, p. 969, s.v. "*chanfu guichang* (*ch'an-fu kuei-ch'ang*) 蟬腹龜腸."

14 The Chih-tun Mountain 支遁山 derived its name from a famous Buddhist monk of the Tsin 晉 dynasty (265–419) whose name was Chih-tun 支遁. He first lived at the Chih-p'eng Mountain 支硎山 near Suchou. He later settled at the Yü-hang 餘杭 Mountain near Hangchou. When he promulgated *chan* Buddhism, he caused a sensation throughout the country. The well-known calligrapher Wang Hsi-chih 王羲之 (321–79) was his close friend. See *Tz'u-hai* 辭海 (Sea of Terminology: Chinese Language Dictionary), vol. 1 (Taipei: Chung-hua Press, 1974), p. 1292, s.v. "Chih-tun 支遁."

15 The name of the Ko Hung Well 葛洪井 is derived from the name of Ko Hung, who lived during the Tsin dynasty (265–419) and called himself Pao-p'u tzu 抱扑子. People referred to him as Hsiao-Ko hsien-weng 小葛仙翁 (Mr. Ko, the Junior Immortal) because he was known for his magic power and his Taoist cultivation. It is said

that he was an expert in alchemy who could prepare elixir pills. For more information on Pao, see E. T. C. Werner, *Dictionary of Chinese Mythology*, reprint (Taipei: Wen-hsing Press, 1961), p. 589, s.v. "*Yeh-jen* 野人" (The Desert Savage).

16 This line means that although a person is poor, if he has a good donkey, his desire to travel afar is still strong.

17 The "sword" in this line represents a person's ambition. It indicates that although a hero is destitute and wanders about without shelter, his aspiration for accomplishment does not decline due to the beckoning of the sword.

18 A lonely *t'ung* tree refers to the *wu-t'ung* 梧桐 tree, a plant with large leaves that can grow to more than twenty feet. The wood from this tree is optimal for making zithers, the traditional instrument for a Chinese scholar. The *wu-t'ung* tree is also a popular choice for gardens and is often placed in the courtyard near a scholar's study. In autumn, the leaves of this tree all drop; consequently, the *wu-t'ung* tree possesses a melancholy connotation and appears often in Chinese literature and poetry.

19 T'ang and Yü refer to two legendary prehistoric emperors. T'ang is the reign mark of emperor Yao, who was supposed to have ruled from 2347–2246 B.C. Yao was considered a great emperor because he listened to his subjects and put their well-being ahead of his own. He considered his son an irresponsible profligate and passed the throne instead to an unrelated responsible farmer named Shun. When Shun abdicated, he designated Yü as his successor. Yü was also a diligent, capable, and unselfish ruler who worked ceaselessly to solve the severe flooding that plagued his empire. For more on Yao and Yü, see W. Scott Morton, *China: Its History and Culture* (New York: McGraw-Hill, 1995), pp. 13–14.

20 The Yen River runs through an area famous for the production of paper. Thus the poem suggests that by settling close to the Yen River, a scholar would enjoy a bountiful supply of paper. See *Tz'u-hai* 辭海 (Sea of Terminology: Chinese Language Dictionary), vol. 1 (Taipei: Chung-hua Press, 1974), p. 404 , s.v. "Yen-hsi 剡溪" (Yen River).

21 The term *she-kung-yü* 社公雨 (local deity rain) refers to spring rain. In ancient China, there were two major festivals held in honor of local deities: one in the fall, the other in the spring. Typically the spring festival occurred during the rainy season. Thus the rain during this festival

was considered a good omen and was given the special name *she-kung-yü*. It is also known by its abbreviated form, *she-yü* or "festival rain." See *Han-yü ta-tz'u-tien* 漢語大詞典 (Chinese Terminology Dictionary), vol. 7, p. 832, s.v. "*sheyu* (*she-yü*) 社雨" (festival rain).

22 In this poem, the term *nü-lang hua* (young woman blossom) indicates a magnolia. See *Han-yü ta-tz'u-tien* 漢語大詞典 (Chinese Terminology Dictionary), vol. 4, p. 260, s.v. "*nu lang hua* (*nü-lang hua*) 女郎花" (young woman blossom).

23 This poem by Ch'ien-lung is found in his *Ch'ing Kao-tsung yü-chih shih-wen ch'üan-chi* 清高宗御製詩文全集 (The Complete Anthology of Emperor Ch'ien-lung), reprint (Taipei: National Palace Museum, 1976). A total of 37,000 poems are collected in this anthology. As a Manchurian, Ch'ien-lung had a somewhat limited knowledge of Chinese literature. Nevertheless, he truly enjoyed poetry. His zeal for verse is manifested by the gigantic number of poems found in his anthology. Unfortunately, his poetry is not very elegant. Although he borrowed numerous idioms from Chinese history and literature, the contexts are often loosely composed. In this long poem, he praised the simple lives of farmers, recluses, and scholars. In reality, he personally could not have experienced much if any of the suffering of poor people. Enjoying his power and wealth, he merely wanted to use this conceit, thus imagining himself living in the rustic, isolated mountains like a destitute and burdened scholar.

24 Liu T'ung-hsün 劉統勳 (1700–1773) was one of the most outstanding statesmen during the Ch'ien-lung period. He was also one of the most famous members of an illustrious family of scholar-officials. He achieved his *chin-shih* degree in 1724 and held many top positions at the court, both civil and military. He served as grand secretary under Emperor Ch'ien-lung. One of the most celebrated officials of his day, he was considered incorruptible. When he passed away, the emperor visited his home to convey his condolences and was impressed by the simplicity and frugality of his household. See Arthur W. Hummel, ed., *Eminent Chinese of the Ch'ing Period (1644–1912)*, vol. 1 (Washington, D.C.: United States Government Printing Office, 1943–44), pp. 533–34.

25 For information on *lien-chu-yin* 聯珠印, or "pearl-string seal," see note 3.

26 Although literally translated as "rare old emperor," this term can be translated as "an emperor who is over seventy years old." This meaning derived from an old

Chinese expression, "jen-sheng ch'i-shih ku-lai hsi 人生七十古來稀 (From ancient times, it is a rare thing for a person to live past seventy years.) This seal originally belonged to Emperor Ch'ien-lung. However the seal found on the Michigan fan is different from the genuine one published in Shanghai Museum's *Zhongguo shuhuajia yinjian kuanshi* (*Chung-kuo shu-hua-chia yin-chien k'uan-shih*) 中國書畫家印鑒款識 (Signatures and Seals of Chinese Painters and Calligraphers), vol. 1 (Shanghai: Wenwu Chubanshe, 1987), no. 153, p. 247.

27  *Pao-chi san-pien* literally means "the third volume of the precious books," the imperial painting and calligraphy collection of the Ch'ing dynasty. Art objects bearing this seal were originally recorded in the third volume of the imperial painting catalogue, entitled *Shih-ch'ü pao-chi san-pien* 石渠寶笈三編 (Treasured Book-boxes in the Stone Groove), facsimile reprint of an original manuscript copy (Taipei: National Palace Museum, 1971). Emperor Ch'ienlung's (r. 1736–96) collection was initially inventoried and compiled into two catalogues, the *Shih-ch'ü pao-chi* and *Pao-chi hsü-pien* 寶笈續編 (The Sequence of the Catalogue, *Treasured Book-boxes in the Stone Groove*). The third volume was compiled during the reign of Ch'ien-lung's son, Emperor Chia-ch'ing 嘉慶 (r. 1796–1820).

28  Pao-p'u ts'ao-t'ang (The Encompassing Simplicity Hut) was the name of a simple studio in the imperial garden outside of the capital. It was often used for the emperor's summer retreat. From the name, "The Encompassing Simplicity Hut," one can conjecture that it was a building imitating the farmers' huts.

29  Chin Teh-ying 金德瑛 (1701–62) was from Hangchou. He was the champion of the national civil service examination in Peking in 1736, the first year of the Ch'ienlung reign. Although he was not well known in Chinese history, he must have been a brilliant scholar. Painter Chin Nung 金農 (1687–1764), who was from Hangchou and a member of the same Chin family, referred to him as a cousin. See Gu Linwen (Ku Lin-wen) 顧麟文, *Yangzhou bajia shiliao* (*Yang-chou pa-chia shih-liao*) 揚州八家史料 (Historical Material of the Eight Masters in Yangchou), vol. 1 (Shanghai: Renmin Meishu Chubanshe, 1962), p. 67.

30  See Cécile and Michel Beurdeley, *Giuseppe Castiglione: A Jesuit Painter at the Court of the Chinese Emperors* (Rutland, Vermont, and Tokyo: Charles E. Tuttle Co., 1971), p. 11.

31  Castiglione's two works executed during this period, entitled *Christ Appearing to

St. Ignatius* and *St Ignatius Writing the "Spiritual Exercises"* are reproduced in ibid., pp. 11 and 12.

32  Father Matteo Ricci (1552–1610) from Italy is known in Chinese history as Li Ma-tou 利瑪竇. See L. Carrington Goodrich and Fang Chaoying, eds., *Dictionary of Ming Biography, 1368–1644*, vol. 2 (New York and London: Columbia University Press, 1976), pp. 1137–44. For a thorough discussion of Father Ricci, see Jonathan D. Spence, *The Memory Palace of Matteo Ricci* (New York: Viking Penguin, 1984.) See also the letter by Jean de Fontaney written in 1704, which is included in *Lettres édifiantes et curieuses écrites des missions étrangères. Mémoires de la Chine*, new edition, vol. 17 (Toulouse: Noël-Etienne Sens et Auguste Gaude, 1810), p. 348.

33  This information is based on young Castiglione's letter and a manuscript in the National Library, Lisbon. It states that he did several portraits of young princes and murals for the chapel of the College of Coïmbra. See *Giuseppe Castiglione: A Jesuit Painter at the Court of the Chinese Emperors*, p. 12.

34  See ibid., p. 29. This enamel should not be confused with what is today commonly used to paint walls. In ancient times, enamel was a type of powdered mineral pigment. By choosing the appropriate mineral, one could produce a variety of colors. Originally, these enamel pigments were used for decorating *cloisonné*. To produce *cloisonné* a metal object such as a vase or box had to be made, on which wires were soldered on the surface in order to form complex designs. Enamel powders were then used to fill in the background, as well as the space between the wires. After firing, the enamel, fused with the metal, becoming bright in color. The enamel powder could also be mixed with water and applied with a brush. During the Ch'ing dynasty, the Chinese also used enamel pigment for decorating porcelain objects, which were referred to by Europeans as *Famille-rose* ware. For more on Ming dynasty enamel ware, see Wen C. Fong and James C. Y. Watt, *Possessing the Past: Treasures from the National Palace Museum, Taipei* (New York: Metropolitan Museum of Art, and Taipei: National Palace Museum, 1996), pp. 453–55. For more on Ch'ing dynasty enamel ware, see pp. 507–21 in the same book. Today there is no sure way to identify which enamel ware was decorated by Castiglione. Yet at the Palace Museum, Taipei, there is enamel ware bearing decorations extremely similar to that of Castiglione's

paintings. See figs. 173 and 174, p. 515, in the above source.

35  See *Giuseppe Castiglione: A Jesuit Painter at the Court of the Chinese Emperors*, p. 29.

36  See ibid., p. 30.

37  See note 32 and also ibid., p. 22. This information is found in a letter by Jean de Fontaney written in 1704. The letter is included in *Lettres édifiantes et curieuses écrites des missions étrangères. Mémoires de la Chine*, new edition, vol. 17 (Toulouse: Noël-Etienne Sens et Auguste Gaude, 1810), p. 348.

38  See *Giuseppe Castiglione: A Jesuit Painter at the Court of the Chinese Emperors*, p. 19.

39  See ibid., p. 19.

40  See ibid., p. 21.

41  It is well known that Emperor Yung-cheng associated with Tibetan lamas when he was a prince. As a matter of fact, after his inauguration, he donated his old residence to the lamas, and the building is the present-day Yung-ho kung 雍和宮, a Tibetan Buddhist temple in Peking. Being a resolute Buddhist, he had little interest in Christianity. See Emperor Yung-cheng's biographical material in *Eminent Chinese of the Ch'ing Period (1644–1912)*, vol. 2, pp. 915–20, s.v. "Yin-chen 胤禛."

42  See *Giuseppe Castiglione: A Jesuit Painter at the Court of the Chinese Emperors*, p. 32.

43  In the scroll *Collection of Auspicious Tokens* at the National Palace Museum, Taipei, Castiglione depicts several stalks of two-eared millet and two lotus pods on one stem arranged with lotus blossoms and leaves in a celadon porcelain vase. Such plants are considered auspicious objects found in the field and pond in the year when the new emperor was enthroned. This scroll is published in Wen C. Fong and James C. Y. Watt, *Possessing the Past: Treasures from the National Palace Museum, Taipei* (New York: Metropolitan Museum of Art, and Taipei: National Palace Museum, 1996), pl. 354, p. 557.

44  Castiglione's *One Hundred Horses* is published in ibid., pp. 558–59. A preparatory drawing for this handscroll by Castiglione, currently at the Metropolitan Museum of Art, is also reproduced in the same book on p. 559.

45  Castiglione's book, *Shih-hsüeh*, was written in Chinese by a Chinese bannerman, Nien Hsi-yao 年希堯 (?–1739), under Castiglione's supervision. It was first printed in 1729, and then, in 1735, a revised and

Lang Shih-Ning 郎士寧
(Giuseppe Castiglione)
Bird on a Bamboo Branch
*continued*

112  enlarged edition was published. Nien Hsi-yao, a member of the Chinese Yellow-bordered Banner, had learned painting and mathematics from the Jesuit painter. In the preface to the first edition, Nien indicates that he learned perspective in Western painting from Castiglione, and in the second edition, Nien not only added more diagrams to illustrate the principles of perspective but also thanked Castiglione again for his contribution to this project. Nien Hsi-yao was also commissioned by the emperor to supervise the manufacture of imperial porcelain at Ching-teh-chen 景德鎮 while serving as superintendent of customs at Huai-an 淮安 in Kiangsu 江蘇 province. The fine porcelain made under his direction came to be known as Nien-yao 年窯 ([from] Nien [Hsi-yao's] kilns). Nien's younger brother, Nien Keng-yao 年羹堯 (?–1726) was a well-known general. See *Eminent Chinese of the Ch'ing Period (1644–1912)*, vol. 1, pp. 587–90.

46  According to Nie Chongzheng's 聶崇正 book, *Lang Shining* 郎世寧 (Giuseppe Castiglione) (Beijing: Renmin Meishu Chubanshe, 1984), p. 36, such assignments were recorded in the imperial document files of the Nei-wu-fu 內務府, or "Office of the Imperial Household."

47  Among the first group of young artists who studied painting with Castiglione was a young Manchurian named Pan-ta-li-sha 班達里沙. His hanging scroll entitled *Ch'ing Pan-ta-li-sha jen-shen-hua* 清班達里沙人參花 (The Ginseng Blossom by Pan-ta-li-sha of the Ch'ing Dynasty) is currently at the National Palace Museum, Taipei. This work is painted on paper with oil pigments. Interestingly, its composition is copied from a work completed in Western style by a court painter named Chiang T'ing-hsi 蔣廷錫 (1669–1732). Pan-ta-li-sha's painting probably represents one of his exercises in oil painting learned by copying Chiang's painting in the imperial collection. For a reproduction of Pan-ta-li-sha's work, see *Ku-kung shu-hua t'u-lu* 故宮書畫圖錄 (An Illustrated Catalogue of Calligraphy and Painting at the Palace Museum), vol. 11 (Taipei: National Palace Museum, 1993), p. 145. Chiang T'ing-hsi's painting is reproduced in the same book, p. 79. There is also a set of album leaves by another follower of Castiglione, entitled *Ch'ing Fo Yen hua yu-hua shan-shui-t'u* 清佛延畫油畫山水圖 (Oil Paintings of Landscapes by Fo Yen of the Ch'ing Dynasty). It is recorded in National Palace Museum Editorial Committee, ed., *Ku-kung shu-hua lu* 故宮書畫錄 (Catalogue of Calligraphy and Painting at the Palace Museum) (Taipei: National Palace Museum, 1965), *chüan* 卷 (chapter) 8, vol. 4, p. 157.

48  This situation is reminiscent of Tseng Ching 曾鯨 (1564–1647), the famous portrait painter of the seventeenth century. See entry 19 on Tseng Ching for more information on this artist's creative career. Today, when scholars try to allege the Western influence in Tseng Ching's portrait painting, they often neglect the difficulties involved in adopting a foreign style. If the court artists of the eighteenth century could not assimilate Western art taught by a European painter, how could Tseng Ching have incorporated Western techniques into his painting through mere observation of only a few examples of Catholic paintings almost one hundred years earlier?

49  Another reason for the failure of Castiglione's attempt to teach Western art to Chinese students was due to his limited access to the Chinese populace. He probably had only a small group of not-so-talented followers, and his contact was restricted to people at the court. One should bear in mind, however, that during the same period, innovative southern painters in Yangchou craved new inspirations and began to reject traditional painting styles. Had they the opportunity to view and study Western art, one can only speculate on the results.

50  Fifty-five works by Castiglione are listed in the three series of the imperial painting catalogues, *Shih-ch'ü pao-chi* 石渠寶笈 (Treasured Book-boxes in the Stone Groove) 1, 2, 3. Castiglione's best-known portrait for the emperor now belongs to the Cleveland Museum of Art. Dated 1736, this long handscroll, entitled *Hsin-hsieh chih-p'ing* 心寫治平 (A Wholehearted Execution of a Well-Governed and Tranquil Reign), is the inauguration portrait of Emperor Ch'ien-lung, his empress, and eleven imperial consorts. The first three portraits, those of the emperor, his empress, and first court lady, are no doubt from the hand of Castiglione. The portraits of the other seven ladies on this scroll, which were executed after the artist died, were works by other court painters. See Wai-kam Ho 何惠鑑 et al., *Eight Dynasties of Chinese Paintings: The Collections of the Nelson Gallery-Atkins Museum, Kansas City, and the Cleveland Museum of Art* (Cleveland: Cleveland Museum of Art, 1980), no. 262, pp. 355–56. See also Ju-hsi Chou and Claudia Brown, *The Elegant Brush: Chinese Painting under the Qianlong Emperor, 1735–1795* (Phoenix: Phoenix Art Museum, 1985), no. 4, pp. 23–24.

51  For Castiglione's animal paintings, see *Ku-kung shu-hua t'u-lu* 故宮書畫圖錄 (An Illustrated Catalogue of Calligraphy and Painting at the Palace Museum), vol. 14, pp. 9–93.

52  This is based on Sir George Staunton's book, *An Authentic Account of an Embassy from the King of Great Britain to the Emperor of China*, which reports of an embassy led by Lord George Macartney (1737–1806), a Knight of Bath, from the King of Great Britain, to Emperor Ch'ien-lung in 1793. Although by then, Castiglione had been dead for twenty-seven years, the restrictions placed upon him must have been well known among his peers. Staunton's book was originally printed for Robert Campbell by John Bioren in Philadelphia, 1799. Today, the book, which was published 200 years ago, is difficult to find in Western libraries. Fortunately, there is a modern Chinese translation. It says that an Italian Jesuit painter whose name was Castiglione was ordered by the emperor to paint several pictures. Meanwhile, the emperor told him to paint in the Chinese style, not in the Western style, which was so "unnatural." (一位名叫卡斯提略恩的意大利傳教士畫家, 奉命畫幾張畫. 同時指示他, 按中國法, 而不要按他們認為不自然的西洋畫法.) See Yeh Tu-yi 葉篤義, trans., *Ying-shih yeh-chien Ch'ien-lung chi-shih* 英使謁見乾隆記實 (An Authentic Account of an Embassy from the King of Great Britain to Emperor Ch'ien-lung) (Hong Kong: San-lien Bookstore, 1994), p. 345. Other information concerning European priest-artists' restrictions at the court are found in letters of Jesuit missionaries. One Father de Ventavon (1733–87) in a letter dated 1769 complained, "[A European Jesuit artist] has real difficulties from the outset. He has to renounce his own taste and his ideas on many points, in order to adapt himself to those of the country. There is no way of avoiding this. Skillful as he may be, in some respects he has to become an apprentice again. Here they want no shadow in a picture, or as good as none; almost all paintings are done in water-color, very few in oil. The first of this kind shown to the Emperor are said to have been done on badly prepared canvases and with badly prepared paints. Shortly afterwards they turned black in a manner that displeased the Emperor, who wants almost no more of them. Finally, the colors have to be unbroken and the lines as delicate as in a miniature." See *Giuseppe Castiglione: A Jesuit Painter at the Court of the Chinese Emperors*, pp. 100–101. Father de Ventavon arrived in Canton in 1766 and immediately began working as a clock maker and machine constructor once he reached Peking. Although these two above sources are dated after Castiglione died in 1766, the restrictions on Jesuit artists must have been generally known during the eighteenth century at the Manchu court.

53  The majority of the works completed by Castiglione in Peking center on the impe-

rial court. These include many portraits of different emperors and their families, depictions of the emperor's many activities and military campaigns, and even depictions of the emperor's horses, dogs, and other exotic animals. Castiglione completed a number of works in the flower-and-bird genre as well.

54  See "Castiglione the Architect," in *Giuseppe Castiglione: A Jesuit Painter at the Court of the Chinese Emperors*, pp. 65–75.

55  See ibid.

56  For a description of the pillage, see ibid., p. 74. It is said that many of the treasures looted from the Summer Palace were divided by the French and British soldiers and are now displayed at the Victoria and Albert Museum, London, and at the Palace of Fontainebleau, Paris. It is also believed that the earliest example of Chinese painting, the *Nü-shih-chen t'u* 女史箴圖 (Admonitions of the Instructress to the Ladies of the Palace) attributed to Ku K'ai-chih 顧愷之 (ca. 344–406), now at the British Museum, London, was part of this disgraceful plunder. The British, however, claim that the scroll was stolen from the Summer Palace by a Chinese farmer during the war in 1860 and was sold to a British soldier.

57  For photos of the ruins, see Zhu Chuan-rong 朱傳榮, ed., *Dijing Jiuying* (*Ti-ching chiu-ying*) 帝京舊影 (As Dusk Fell on the Imperial City) (Beijing: Forbidden City Publishing House of the Palace Museum, 1994), pp. 225–46.

58  The set of sixteen drawings, depicting Emperor Ch'ien-lung's conquests of the Eleuths Turks, was prepared by four Jesuits, headed by Castiglione. The other three Jesuit artists were Father Jean-Denis Attiret (Chinese name Wang Chih-cheng 王致誠, 1702–68), Father Ignatius Sickelpart (or Sichelbart) (Chinese name Ai Ch'i-meng, whose *hao* was Hsing-an 醒庵, 1708–80), and Father Jean Damascene (Chinese name An-t'ai 安泰, also known as An Che-wang 安者望, who died in 1781). For the brief biographies of these missionaries, see "Biographical Notes of Some European Persons Referred to in the Text" in *Giuseppe Castiglione: A Jesuit Painter at the Court of the Chinese Emperors*, pp. 194, 195, and 197. In 1995, thirteen prints from this set, *Emperor Ch'ien-lung's Conquests of the Eleuths Turks*, were auctioned by Sotheby's, New York. See the sales catalogue *Fine Chinese Ceramics, Furniture and Works of Art* (New York: Sotheby's, March 22, 1995), lot no. 339.

59  Later, similar prints were also made by other missionaries and by Chinese engravers to document other regional campaigns, including the Manchus subduing rebellions in Tibet, Formosa (present-day Taiwan), Yünnan 雲南 province, Nepal, and Annam (present-day Vietnam). These later prints, less realistic and less careful in execution, are not as artistic as those done in Paris based on Castiglione's drawings. A set of sixteen prints after Castiglione et al., c. 1775, was auctioned at Sotheby's, New York, in 1986. See the sales catalogue *Fine Chinese Decorative Works of Art, Including Furniture, Paintings and Japanese Works of Art* (New York: Sotheby's, April 10 and 11, 1986), lot no. 71.

60  For a summary of Castiglione's work, see *Giuseppe Castiglione: A Jesuit Painter at the Court of the Chinese Emperors*, p. 161. See also ibid. for the 126 works attributed to Castiglione. It is apparent that many works reproduced in this book are not genuine paintings by the artist.

61  See ibid., p. 45. According to this source, around 1747, there were twenty-two Jesuits in Peking, ten of whom were French, while the remainder were comprised of Italians, Portuguese, and Germans. Seven of the twenty-two worked exclusively at the court. The source goes on to note that there were many jealousies and quarrels among them.

62  See *Giuseppe Castiglione: A Jesuit Painter at the Court of the Chinese Emperors*, p. 42. Castiglione's appeal to the emperor was courageous but dangerous. According to Chinese tradition, he was prohibited from addressing the ruler except when answering a question. Presenting such a petition could have resulted in his being sentenced to death. This happened to five Spanish Dominicans who had been arrested and brought to trial. In 1747, the leader, Father Pedro Sanz (1680–1747), was executed. The other four met similar fates the following year.

63  See ibid., p. 60. Castiglione was buried in the southern suburbs of Peking near a town called Chang-hsin-tien 長辛店. A Catholic missionary rediscovered its location at the beginning of this century. Ch'ien-lung's epitaph is engraved on a large stele in front of Castiglione's tomb. The inscription is flanked by two dragons. The imperial epitaph states that it is the emperor's wish to reward the services of this Western Jesuit by erecting this stele in his memory and by bestowing on the dead artist all the surrounding land. The text of this epitaph is translated by Howard Rogers from text given in Mikinosuke Ishida's "A Biographical Study of Giuseppe

Castiglione (Lang Shih-ning), A Jesuit Painter in the Court of Peking under the Ch'ing Dynasty," *Toyo Bunka Kenkyujo kiyo* 東洋文化所記要 (Memoirs of the Institute of Oriental Culture), vol. 19 (Tokyo: Institute of Oriental Culture, Tokyo University, 1960), p. 111. Rogers's translation is as follows: "On the 10th day of the 6th moon in the 30th year of Emperor Ch'ien-lung, the imperial decrees said: 'The Western Lan Shih-ning entered service to the Inner Court during the K'ang-hsi era. He was very diligent and willing and was once awarded the third official degree. Now that he has fallen ill and passed away, we think on his long years of duty and the fact that his years were close to eighty. Following the precedent established in the case of Tai Chin-hsien (the Jesuit Father Ignatius Kögler 1680–1744), we bestow on him the official rank of Board Vice-president as well as three hundred teals of silver from the Imperial Treasury and will arrange the burial so as to manifest our abundant distress.'" See Howard Rogers, "For Love of God: Castiglione at the Imperial Court," in Ju-hsi Chou and Claudia Brown, eds., *Chinese Painting under the Qianlong Emperor: The Symposium Papers in Two Volumes* (*Phoebus* 6.1) (Tempe: Arizona State University, 1991), pp. 159–60. (乾隆三十一年初十日奉旨 "西洋人, 郎世寧. 自康熙間, 入值內廷, 頗著勤慎. 曾賞給三品頂帶. 今患病溘逝. 念其行走年久, 齒近八旬. 著照戴進賢之例, 加恩給予侍郎銜, 並賞內府銀三百兩, 料理喪事, 以示優恤. 欽此.)

64  For information on Chin Teh-ying, see note 29.

65  For information on Liu Tung-hsün, see note 24.

66  See also entry 58 on Chin Chang for more on the long-tailed *shou-tai* bird.

67  Traditionally, Chinese believe that this particular type of rare fungus requires a century to mature and that a person would achieve longevity, possibly even immortality, by ingesting it. For more information on "magic fungus," see also note 39 in entry 32 of Yü Chih-ting.

68  When *shou-tai* is written 綬帶, it implies a person being given an official seal that represents governmental position, power, and wealth. On the other hand, *shou-tai* can also be written 壽帶, which indicates longevity.

69  Because the narcissus blooms in the early spring, it is associated with the Chinese lunar New Year, which occurs in February. Bamboo was often thrown into fires in ancient times on New Year's Eve in order to make the air-tight stem explode. This activity was intended to scare away evil

**Lang Shih-ning** 郎士寧
**(Giuseppe Castiglione)**
**Bird on a Bamboo Branch**
*continued*

**36. Huang Shen** 黃慎
*(1687–1770?)*
*Ch'ing dynasty (1644–1911)*

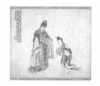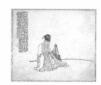
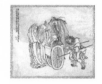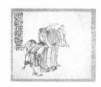

114   ghosts so that peacefulness and tranquillity would be maintained for the coming year. Today, the Chinese still refer to firecrackers at New Year's festivities as *pao-chu* 爆竹, or "exploding bamboo," and the phrase, *chu-pao p'ing-an* 竹報平安, meaning "the bamboo announces peacefulness," is a common, auspicious expression used at the beginning of each year.

70   See *Giuseppe Castiglione: A Jesuit Painter at the Court of the Chinese Emperors*, p. 28. This information is based on a record found in J. Amiot's "Extrait d'une lettre du I$^{er}$ mars 1769 de Pékin, contenant l'éloge du Père Attiret," in *Journal des Savants* (Paris: Chez Lacombe, June 1971), p. 407.

71   The detailed modeling of leaves typically associated with authentic works by Castiglione can be found on *Bamboo and Morning Glory*, in the reproduced set of Castiglione's sixteen flower study album leaves entitled *Hsien-o ch'ang-ch'un* 仙尊長春 (Everlasting Verdure of the Immortal Calyx) (Taipei: National Palace Museum, 1971), leaf no. 12.

72   Reproductions of the genuine imperial seals can be found in Shanghai Museum, *Zhongguo shuhuajia yinjian kuanshi* (*Chung-kuo shu-hua-chia yin-chien k'uan-shih*) 中國書畫家印鑒款識 (Signatures and Seals of Chinese Painters and Calligraphers), vol. 1 (Shanghai: Wenwu Chubanshe, 1987), no. 158, seal nos. 146, 147, and 153, p. 247.

73   For more on the establishment of China's first public museum, see entry 57 on Chin Cheng.

74   For a discussion of the counterfeits fabricated at the studios located near the Rear Gate Bridge in Peking, see Yang Xin 楊新, "Shangpin jingji, shifeng yu shuhua zuowei (Shang-p'in ching-chi, shih-feng yü shu-hua tso-wei) 商品經濟, 世風與書畫作偽" (Merchandise, Economy, Ethics, and Counterfeiting Calligraphy and Paintings), in his *Yang Xin meishu lunwenji (Yang Hsin mei-shu lun-wen chi)* 楊新美術論文集 (The Collected Theses on Art by Yang Xin) (Beijing: Zijincheng Chubanshe, 1994), p. 16. See also Lin Shuzhong 林樹中 et al., *Meishu cilin: Zhongguo huihua juan (Mei-shu tz'u-lin: Chung-kuo hui-hua chüan)* 美術辭林: 中國繪畫卷 (Dictionary of Fine Art Terminology: Chinese Painting Section), vol. 1 (Xian: Renmin Meishushe, 1995), pp. 589–90, s.v. "Beijing houmenzao (Pei-ching hou-men tsao) 北京後門造" ([Paintings] Counterfeited [at the Studio] by the Rear Gate [of the Forbidden City]). According to Lin, artists from this studio specialized in counterfeiting Castiglione's paintings. These works were accompanied by

spurious calligraphic works attributed to either Emperor Ch'ien-lung or other court officials. The forgeries from these studios were then mounted in a style consistent with the authentic works in the imperial collection.

75   One early twentieth-century painter known for imitating Castiglione's style was Ma Chin 馬晉 (1900–1970). See Yu Jianhua 于劍華 et al., *Zhongguo meishujia renming cidian (Chung-kuo mei-shu-chia jen-ming tz'u-tien)* 中國美術家人名詞典 (Biographical Dictionary of Chinese Artists) (Shanghai: Renmin Meishu Chubanshe, 1981), p. 770. Ma's works often appear in the sales catalogues of Sotheby's and Christie's. For two of Ma Chin's horse paintings in Castiglione's style, see Robert Hatfield Elisworth, *Later Chinese Painting and Calligraphy, 1800–1950*, 2: *Painting* (New York: Random House, 1987), p. 263. The entries on these two works are found in vol. 1, p. 193. Ma Chin was a member of the famous Hu-she 湖社 (the Lake [Painting] Guild) in Peking. He and his peers from this artistic association were possibly responsible for the production of the Michigan fan as well as the three other similar fans. For painters of this artistic society, see entry 57 on Chin Cheng.

76   This fan painting attributed to Castiglione is reproduced in *Giuseppe Castiglione: A Jesuit Painter at the Court of the Chinese Emperors*, p. 30 and fig. 99 on p. 182. It is also published in *The Elegant Brush: Chinese Painting under the Qianlong Emperor, 1735–1795*, pl. 8, p. 38. Alice Boney was a famous collector-dealer active in Tokyo after the Second World War. She sold paintings to almost every major collection in the United States. She even had a seal carved bearing her Chinese name, P'ang Nai 龐耐, which is found on many of the paintings that entered her collection. This seal has confused a number of scholars in both the East and West.

77   The second fan is published in Wai-kam Ho 何惠鑑 et al., *Eight Dynasties of Chinese Paintings*, no. 261 on p. 354.

**Figures from Chinese History**
*Ku-shih jen-wu ts'e*
*(Album Leaves of Historical Figures)*
故事人物冊

1   The date of Huang Shen's death has been the subject of debate. His grave stele was discovered in March 1983 near a tea plantation in a northern suburb of his hometown, Ning-hua 寧化, Fukien province. This discovery was first published in Xue Feng 薛峰 and Zhang Yuming 張郁明, eds., "Qingdai Yangzhou huapai yanjiu zongshu (Ch'ing-tai Yangchou hua-p'ai yen-chiu tsung-shu) 清代揚州畫派研究綜述" (A General Survey and Research on the Yangchou Painting School), *Meishu yanjiu (Mei-shu yen-chiu)* 美術研究 (Art Scholarship) (Beijing: Central Art Academy, 1984), no. 4, p. 81. Due to the poor condition of this stele, the burial date of Huang Shen was initially read as the "eighteenth year of the Ch'ien-lung period," or 1752. This date, however, contradicts many of the dates on his later paintings, as well as the dates of many of his known later activities. A more acceptable reading would be the "thirty-eighth year of the Ch'ien-lung period," or 1772. Several American scholars believe that this date should be the year of Huang Shen's death. For example, Ju-hsi Chou and Claudia Brown adopted the 1772 date in their *Elegant Brush: Chinese Painting under the Qianlong Emperor, 1735–1795* (Phoenix: Phoenix Art Museum, 1985), p. 211. However, Chinese scholar Qiu Youxuan 丘幼宣 later transcribed the almost illegible contents of this stele in his "Huang Shen nianpu (Huang Shen nien-p'u) 黃慎年譜 (A Chronicle of Huang Shen's Life) in Qiu Youxuan 丘幼宣, ed., *Yangzhou baguai nianpu (Yangchou pa-kuai nien-p'u)* 揚州八怪年譜 (Chronicles of the Eight Eccentrics of Yangchou) (Jiangsu: Meishu Chubanshe, 1992), p. 69. Qiu pointed out that 1772 was actually Huang Shen's burial date. According to Chinese tradition, a person would often be buried

several years after death. This period, called *t'ing-chiu* 停柩, *t'ing-sang* 停喪, or *t'ing-ling* 停靈 (to delay the burial of a coffin), allowed the family to construct a decent tomb for the deceased and to select an auspicious day for the burial. For the meaning of these three terms, see *Hanyu dacidian* (*Han-yü ta tz'u-tien*) 漢語大詞典 (Chinese Terminology Dictionary), vol. 1 (Shanghai: Hanyu Dacidian Press, 1988), pp. 1558, 1559, and 1561. Based on the dates of Huang Shen's later works, Qiu tentatively concluded that Huang Shen died in 1770 at age eighty-four, two years before the date of his burial.

2 The "Liu K'uan chuan 劉寬傳" (Biography of Liu K'uan) can be found in "Biography 15" of Fan Yeh's 范曄 (398–445) *Hou-Han shu* 後漢書 (The Book of the Later Han Dynasty), reprint, vol. 3 (Beijing: Zhonghua Shuju, 1973), pp. 886–88.

3 There is another version of this album leaf by Huang Shen, dated 1725, at the Anhui Provincial Museum. It is reproduced in Group for the Authentication of Ancient Works of Chinese Painting and Calligraphy, ed., *Zhongguo gudai shuhua tumu* (*Chung-kuo ku-tai shu-hua t'u-mu*) 中國古代書畫圖目 (An Illustrated Catalogue of Selected Works of Ancient Chinese Painting and Calligraphy), vol. 12 (Beijing: Wenwu Chubanshe, 1993), no. 皖 1-552, p. 270.

4 Yen Kuang 嚴光 (37 B.C.–A.D. 43) won great fame for his modesty. Kuang-wu, meaning "bright and brief," was the reign mark of the Later Han dynasty (25–220). Emperor Kuang-wu's family and given name was Liu Hsiu 劉秀 (6 B.C.– A.D. 57). See note 23 for more information on Yen Kuang.

5 The term "*chih-fu* 赤符" (crimson amulet) refers to the auspicious talisman made by Liu Hsiu's followers to promote the idea that he had received a divine mandate to rule. See *Han-yü ta tz'u-tien* 漢語大詞典 (Chinese Terminology Dictionary), vol. 9, p. 1160, s.v. "*chifu fu* (*ch'ih-fu fu*) 赤伏符." *Liu-lung* 六龍 (six-dragon) indicates the emperor's carriage, which was pulled by six horses. See ibid., vol. 2, p. 52, s.v. "*liulongju* (*liu-lung chü*) 六龍車"or "*liulongyu* (*liu-lung-yü*) 六龍輿."

6 *Ch'ing-ni* 青泥 (green clay) in the Chinese text refers to the sealing clay used on official documents. See *Han-yü ta tz'u-tien* 漢語大詞典 (Chinese Terminology Dictionary), vol. 11, p. 527. This green stamp and ceremonial hat would signify that Yen was a close associate of the emperor.

7 The upper-nine premonition of the *gu* diagram states that refusing to serve kings and nobles is considered dignified behav-ior. (蠱卦, 上九: "不事王侯 高尚其事.") See Zhang Yuanqi 張園齊, ed., *Baihua yijing* (*Pai-hua i-ching*) 白話易經 (*I-Ch'ing* in Colloquial Chinese) (Beijing: Gongming Daily News Chubanshe, 1989), p. 107.

8 The primary-nine premonition of the *t'un* diagram states that when blocked by an immovable boulder, it is best to stay stationary. This is a good time to pursue one's goal of empire. (屯卦, 初九: "磐桓, 利居貞 利建侯.") See *Pai-hua i-ching* 白話易經 (*I-Ch'ing* in Colloquial Chinese), p. 30.

9 The text on this leaf is adopted from Fan Chung-yen's 范仲淹 (989–1052) *T'ung-lu chün Yen hsien-sheng ssu-t'ang chi* 桐廬郡嚴先生祀堂記 (A Record of the Shrine in Memory of Mr. Yen [Kuang] in T'ung-lu County). Fan was a great administrator and a well-known scholar of the Northern Sung dynasty (960–1127). The text is published in Fan Chung-yen's *Fan Wen-cheng-kung chi* 范文正公集 (The Anthology of Mr. Fan, the Literary and Upright [Fan Chung-yen's posthumous title]), *chüan* 卷 (chapter) 7, reprinted in Wang Yün-wu 王雲五, ed., *Wan-yu wen-k'u* 萬有文庫 (The All-inclusive Literary Collection Series), vol. 1 (Taipei: Commercial Press, 1965), p. 93.

10 Lo Kung-yüan 羅公遠 was a well-known Taoist of the T'ang dynasty, active during the reign of Emperor Ming-huang (712–55). His allegories are found in a book from the T'ang period. See Li Fang 李昉 (925–96), *Taiping guangji* (*T'ai-p'ing kuang-chi*) 太平廣記 (Records of the Peaceful Years), preface dated 977, no. 22, *juan* (*chüan*) 卷 (chapter) 1, reprint, vol. 1 (Shanghai: Shanghai Guji Chubanshe, 1990), pp. 119–122 (modern p. 1043).

11 This text is a direct transcription of a poem, *Fang-ho chao-ho chih-ko* 放鶴招鶴之歌 (Song of Release and Recall of the Cranes) attached to the end of Su Shih's 蘇軾 (1036–1101) essay, entitled *Fang-ho t'ing chi* 放鶴亭記 (A Record of the Crane-releasing Pavilion). It is found in the "Records" section in Su Shih's *Su Tung-p'o chi* 蘇東坡集 (Su Tung-p'o's [Su Shih's *hao*, meaning "the east slope"] Anthology), *chüan* 卷 (chapter) 32, reprinted in Wang Yün-wu , ed., *Kuo-hsüeh chi-pen ts'ung-shu* 國學基本叢書 (The Basic Chinese Classics Collection Series) (Taipei: Commercial Press, 1967), pp. 31–32. Although there were at least five Crane-releasing Pavilions recorded, the one in Su Shih's writing was located at the foot of the Yün-lung 雲龍 (Cloud-Dragon) Mountain in T'ung-shan 銅山 county, Kiangsu province. A recluse named Chang T'ien-chi 張天驥 (active second half of 11th century), whose *hao* was Yün-lung Shan-jen 雲龍山人, meaning "The Knobbed-gourd Ladle-mountain Recluse," was supposed to have lived there during the Hsi-ning 熙寧 reign (1068–78) of the Northern Sung dynasty (960–1126). Chang had two domesticated pet cranes. He built a pavilion on the east side of his house where he would exercise the birds by releasing them from their cages in the morning, allowing them to soar above the ravine. See *Dai kanwa jiten* 大漢和詞典 (The Great Chinese-Japanese Dictionary), vol. 5, p. 478, s.v. "*Fang-ho t'ing* 放鶴亭" (The Crane-releasing Pavilion). In comparing this transcription on Huang Shen's album leaf with Su's original text, one may note that the character 兮 (*hsi*, a character in Chinese poetry used to indicate a pause) should follow "*kuei-lai, kuei-lai* 歸來歸來" (come home, come home). Evidently Huang Shen missed this character when he transcribed the text onto his painting.

12 The artist's seal "Huang Shen" is a type of seal known as "string-of-pearls." This type of seal usually bears two characters that are incised separately on the same stone, as opposed to two different stones. Thus the impression looks as if two seals might have been used.

13 See Yu Jianhua 于劍華 et al., *Zhongguo meishujia renming cidian* (*Chung-kuo mei-shu-chia jen-ming tz'u-tian*) 中國美術家人名詞典 (A Biographical Dictionary of Chinese Artists) (Shanghai: Renmin Meishu Chubanshe, 1981), p. 1156.

14 See Qiu Youxuan 丘幼宣, "Huang Shen nianpu (Huang Shen nien-p'u) 黃慎年譜" (A Chronicle of Huang Shen's Life) in Qiu Youxuan, ed., *Yangzhou baguai nianpu* (*Yangchou pa-kuai nien-p'u*) 揚州八怪年譜 (Chronicles of the Eight Eccentrics of Yangchou), p. 69.

15 See ibid.

16 See ibid., pp. 69–71.

17 For a discussion of merchant patronage in Yangchou, see Ginger Cheng-chi Hsu, "Merchant Patronage of the Eighteenth-Century Yangchou Painting," in Chu-tsing Li 李鑄晉, ed., *Artists and Patrons: Some Social and Economic Aspects of Chinese Painting* (Lawrence: Kress Foundation, and Department of Art History, University of Kansas, 1989), pp. 215–21.

18 See Qiu Youxuan 丘幼宣, "Huang Shen fengmu gui Min niandai kaobian (Huang Shen feng-mu kuei-Min nien-tai k'ao-pien) 黃慎奉母歸閩年代考辨" (Inquiry into the Date of Huang Shen Returning with his Mother Back to their Hometown in Fukien) in Xue Yongnian 薛永年, ed., *Yangzhou baguai kaobian ji* (*Yangchou pa-kuai k'ao-pien chi*) 揚州八怪考辨集 (A Collection of

116    Essays Examining the Writings on the Eight
       Eccentrics of Yangchou) (Jiangsu: Meishu
       Chubanshe, 1992), pp. 220–23.

19     In the old days in China, a *p'ai-fang* gate
       symbolized a woman's chastity and was
       among the utmost honors a woman could
       receive. The gate was usually constructed
       near the woman's home, either during her
       lifetime or after her death, with "official
       permission," which often required bribing
       local officials.

20     See note 1.

21     The term *Yang-chou pa-kuai* 揚州八怪, or
       "The Eight Eccentrics of Yangchou," first
       appeared in an entry on Yü Ch'an 虞蟾
       (active c. 18th century) found in Wang
       Chün's 汪鋆 (active second half of 18th
       century) *Yang-chou hua-yüan-lu* 揚州畫苑
       錄 (Painters of Yangchou), preface dated
       1883, *chüan* 卷 (chapter) 2, reprinted in
       *Yang-chou ts'ung-k'e* 揚州叢刻 (Miscella-
       neous Books on Yangchou), vol. 3, p. 14b
       (modern p. 866). However, Wang Chün did
       not provide all the names of the eight
       eccentric artists; consequently, the exact
       identity of these "eight" has been a source
       of controversy among scholars. Eight
       names appeared in Li Yü-fen's 李玉棻
       (active late 19th–early 20th century) *O-po-
       lo shih shu-hua kuo-mu k'ao* 甌缽羅室書畫
       過目考 (A List of Painting and Calligraphy
       Viewed at the Author's O-po-lo Studio),
       preface dated 1897, reprinted in Teng Shih
       鄧實 (1865?–1948?) and Huang Pin-hung 黃
       賓虹 (1865–1955), comps., *Mei-shu ts'ung-
       shu* 美術叢書 (Anthology of Writings on
       Fine Art) (Shanghai: n.p., 1912–36), *chi* 集
       (division) 5, *chi* 輯 (collection) 9, *chüan* 卷
       (chapter) 3, second reprint, vol. 25 (Taipei:
       I-wen Bookstore, 1963–72), p. 229, s.v. "Lo
       P'in 羅聘." According to Li Yü-fen, the
       Eight Eccentric Painters of Yangchou
       include: 1) Chin Nung 金農 (1687–1764); 2)
       Huang Shen 黃慎 (1687–1770?); 3) Wang
       Shih-shen 汪士慎 (1686–1759); 4) Kao
       Hsiang 高翔 (1687–?);
       5) Cheng Hsieh 鄭燮 (1693–1765); 6) Li
       Shan 李鱓 (1686–1760?); 7) Li Fang-ying 李
       方膺 (1695–1754); and 8) Lo P'in 羅聘
       (1733–99). Thereafter, these eight painters
       have commonly been considered the Eight
       Eccentrics of Yangchou.

22     See note 2.

23     Yen Kuang's birth and death dates are
       based on Yang Chia-lo 楊家駱 et al.,
       comps., *Li-tai jen-wu nien-li t'ung-p'u* 歷
       代人物年里通譜 (A Register of the Dates of
       Birth, Death, and Birthplaces of Famous
       Figures in Chinese History) (Taipei: World
       Bookstore Press, 1974), p. 12. However,
       these dates may not be accurate. If Yen

Kuang, according to the dates found in the
book, was born in 37 B.C., he would have
been thirty-one years older than his friend
Liu Hsiu, who was born in 6 B.C.; it would
have been unlikely that the two studied
together. Furthermore, according to histor-
ical records, Yen Kuang changed his name
from Chuang 莊 to Kuang 光 in order to
avoid using the same character that
appears in the name of the Emperor Ming-
ti 明帝 (r. 58–74), whose name was Liu
Chuang 劉莊. This practice was called *pi-
hui* 避諱 or "taboo on using the personal
names of emperors and one's elders."
Depending on the strictness of the govern-
ment, one could be sentenced to death due
to a careless slip of the brush. Therefore, if
Yen Kuang died in A.D. 43, as recorded in
Yang Chia-lo's book, he would not have
had to change his name, since he would
have died before Emperor Ming-ti
ascended the throne. Yen Kuang's *tzu* was
Tzu-ling 子陵 (a subordinate mountain
range) and he also had another name, Tsun
遵 (to comply). He was a native of K'uai-
chi 會稽, in present day Chekiang
province. His biography can be found in
"I-min lieh-chuan" 逸民列傳 (Biographies
of Cultivated Persons Living in Retire-
ment) in Fan Yeh's 范曄 (398–445) *Hou-
Han shu* 後漢書 (The Book of the Later
Han Dynasty), *chüan* 卷 (chapter) 83,
reprint, vol. 10 (Beijing: Zhonghua Shuju,
1973), p. 2763.

24     In ancient China, many believed that all
       important individuals were represented by
       a star or constellation. Any change in the
       position of a star would indicate a change
       in the life of the person represented. Con-
       sequently, astronomers studied the stars in
       the sky in order to predict an important
       person's fate.

25     See note 9.

26     Yen-chou 嚴州 was the ancient name of a
       small district near Tung-lu 桐廬 county in
       Chekiang province at the foot of the Fu-
       ch'un 富春 Mountains. Yen Kuang's shrine
       is believed still to exist there today.

27     Offering food and wine as an ancestral sac-
       rifice is one of the most important cus-
       toms in China. This tradition has lasted
       several thousand years, from the Shang
       dynasty, approximately 1500 B.C., to the
       present.

28     See note 9.

29     As the Taoists characteristically do not
       cut their hair, it grows quite long. Thus
       when dressing up, they would often put up
       their hair and secure it with a metal crown
       of this sort. In Chinese, this is called a *tao-
       kuan* 道冠 (a Taoist crown).

30     See note 11.

31     Although Shang-kuan Chou could also
       paint landscapes, he is better known as a
       figure painter because he usually included
       figures in his landscape painting. For a
       short biographical record of Shang-kuan
       Chou, see *Chung-kuo mei-shu-chia jen-
       ming tz'u-tian* 中國美術家人名詞典 (Bio-
       graphical Dictionary of Chinese Artists),
       p. 12.

32     The notion that Huang Shen learned from
       Shang-kuan Chou was refuted by Qiu
       Youxuan 丘幼宣 in his article "Huang Shen
       shaoxuehua yu Shangguan Zhou zhiyi
       (Huang Shen shao hsüeh-hua yü Shang-
       kuan Chou chih-i) 黃慎少學畫于上官周質
       疑" (Inquiry into Whether Huang Shen in
       His Youth Studied under Shang-kuan
       Chou), in *Yangchou pa-kuai k'ao-pien-chi*
       揚州八怪考辨集 (A Collection of Essays
       Examining the Writings on the Eight
       Eccentrics of Yangchou), pp. 216–19.

33     Two of Shang-kuan Chou's figure album
       leaves are reproduced in the Editorial
       Committee of the Complete Collection of
       Chinese Art, *Zhongguo meishu quanji*
       (*Chung-kuo mei-shu ch'üan-chi*) 中國美術
       全集 (A Complete Collection of Chinese
       Art), vol. 11 (Shanghai: Renmen Meishu
       Chubanshe, 1988), album leaves 1–2, no. 2,
       pp. 2–3.

34     The fan painting, *Crushing the Zither*, is
       published in Xie Congrong 謝從榮 and Qiu
       Youxuan 丘幼宣, eds., *Yingpiao shanren
       Huang Shen shuhuace* (*Ying-p'iao shan-
       jen Huang Shen shu-hua-ts'e*) 癭瓢山人黃
       慎書畫冊 (An Album of Huang Shen's
       Paintings and Calligraphies) (Fuzhou:
       Shuhua Chubanshe, 1988), pl. 1, p. 5. The
       actual signature on this fan is "Jiang Xia
       Sheng" (Chiang-hsia Sheng) 江夏盛.
       Unable to decipher the true meaning of
       this name, the Capital Museum in Beijing
       attributed this fan to a painter whose fam-
       ily name was Jiang 江 and given name,
       Hsia-sheng 夏盛. In actuality, the first two
       characters in this name, Chiang-hsia, rep-
       resented the name of a place in present-
       day Wu-ch'ang 武昌 in Hupei province. It
       is the *chün-wang* 郡望 (name of an ancient
       political prefecture where a certain clan
       originated) of the Huang 黃 clan. Accord-
       ing to history, the Huangs were originally
       the descendants of Lu Chung 陸終 from
       Chiang-hsia. They were ordered by the
       Chou 周 court to reside in the fiefdom of
       Huang and thus changed their family
       name to Huang. See *Tz'u-hai* 辭海 (Sea of
       Terminology: Chinese Language Dictio-
       nary), vol. 1 (Taipei: Chung-hua Press,
       1974), p. 1650, s.v. "Chiang-hsia 江夏."
       Thus, in literature, Chiang-hsia is equal to
       Huang, and Chiang-hsia Sheng, as signed

on the *Crushing the Zither* fan painting, signifies Huang Sheng.

35  The subject matter of Huang Shen's fan, *Crushing the Zither,* is derived from the story of a poet named Ch'en Tzu-ang 陳子昂 (656–95) of the T'ang dynasty. Ch'en went to the capital as an obscure individual. At a party one day, he took out an expensive *hu-ch'in* 胡琴, or "Chinese violin," a two-stringed bowed musical instrument valued at one hundred ounces of gold, and crushed it to pieces in front of the guests. He then distributed his writings among the crowd, thus achieving immediate notoriety. Ch'en's biography, including this anecdote in detail, is found in Ji Yougong (Chi Yu-kung) 計有功 (active 1121–61), *T'ang-shih chi-shih* 唐詩記事 (Episodes Recorded in T'ang Dynasty Poems), 1st edition dated 1224, *chüan* 卷 (chapter) 8, reprint (Shanghai: Zhonghua Shuju, 1965), pp. 102–6. Note, however, that in Huang Shen's fan painting, the stringed instrument recorded in Ch'en's biography has been replaced with a zither, which is associated with Chinese scholars. This may reflect somewhat Huang's background as a professional painter who treated literary sources as folklore and ignored the actual historical details.

36  The ten leaves in Huang Sheng's *Album of Figures* are published in Liu Gangji's 劉綱紀 *Huang Yingpiao renwuce* (Huang Ying-p'iao jen-wu-ts'e) 黃癭瓢人物冊 (A Set of Album Leaves of Huang Shen's Figure Painting) (Shanghai: Shuhua Chubanshe, 1982). Of the ten leaves, only one is dated. The *gengzi* (*keng-tzu*) 庚子 (1720) year appears on the album leaf entitled *Siluntu* (*Ssu-lun t'u*) 絲綸圖, or "Twisting Silk into Threads." See also Liu's article, "Huang Yingpiao renwuce chutan (Huang Ying-p'iao jen-wu-ts'e ch'u-t'an) 黃癭瓢人物冊初探" (A Preliminary Inquiry into Huang Shen's *Album of Figures*), *Duoyun* 朵雲 2 (Shanghai: Meishu Chubanshe, 1982), p. 204. The artist's signatures on these ten leaves are Huang Sheng 黃盛, preceded by Ning-hua 寧化, the geological location of the artist's hometown. Ning-hua is indeed Huang Shen's hometown. Furthermore, the artist's seal Huang Sheng is also a "string-of-pearls" seal with two characters carved from one piece of stone, similar to the Huang Shen seal used on Huang Shen's later works, including the four Michigan leaves. There is, of course, the possibility that the ten leaves might be the work of one of Huang Shen's followers or imitators. By signing a name so close to that of the artist, the impostor would have been attempting to perform what the Chinese used to call *yü-mu hun-chu* 魚目混珠, or

"passing off fish eyes as real pearls." Nevertheless, the similarities between this set of album leaves and his other works are highly conspicuous. Furthermore, if someone had attempted to counterfeit Huang Shen's work, they probably would have signed Huang Shen on the fabricated painting, instead of using a different name, Huang Sheng. After all, paintings by little-known "Huang Sheng" would not bring as good a price. Therefore, all these factors substantiate that the *Album of Figures* is Huang Shen's early work and that Huang Sheng was a name used by Huang Shen in his youth.

37  The title of this handscroll is *Huang Shen Ch'iu-liu t'u-chüan* 黃慎秋柳圖卷 (Huang Shen's *Autumn Willow Handscroll*). The painting is dated to the thirteenth year of Emperor Yung-cheng 雍正 (r. 1723–36) [1735], when Huang Shen was forty-nine years old. The painting was donated to the Tokyo National Museum by Mr. Takashima Kikujiro 高島菊次郎寄贈. The colophon bearing information regarding Huang Shen's name change is at the end of the scroll and is dated 1739, four years after Huang Shen completed this work. Unfortunately, the scholar who wrote the colophon cannot be identified. Huang Shen's *Autumn Willow Handscroll* is reproduced in Suzuki Kei 鈴木敬, comp., *Comprehensive Illustrated Catalog of Chinese Paintings,* vol. 3 (Tokyo: University of Tokyo Press, 1982), no. JM1-130. The colophon reads: "Knobbed-gourd Ladle-mountain Recluse [Huang Shen] originally had the given name of Sheng and his *tzu* was Kung-mao. Later he changed it to Kung-shou and his given name to Shen. When young, he imitated Li Kung-lin (1049–1106). Around the *chi-wei* year under the reign of Yung-cheng (1739), [Huang's] style became less complicated. He changed the style of Ni Tsan (1301–74), yet seemed to have achieved the very essence of this [early] master. This is because Huang Shen has read thousands of books, and this knowledge was expressed in his painting. Signed: Shu-t'ien chü-shih (The Field of Books Recluse)." (癭瓢老人初名盛 字公茂. 後易恭壽 而名慎. 為少年, 學李伯時. 雍正己未, 更簫疏澹遠. 變倪高士之面, 而得其神骨. 蓋胸有數千卷書, 見諸於楮墨間耳. 題跋之次夕, 書田居士)

38  For a discussion on Huang Shen's name change, see Qiu Youxuan 丘幼宣, "Huang Shen zihao yanbian kao (Huang Shen tzu-hao yen-pien k'ao) 黃慎字號演變考" (Research on Huang Shen's Name Change), in *Yangchou pa-kuai k'ao-pien-chi* 揚州八怪考辨 集 (A Collection of Essays Examining the Writings on the

Eight Eccentrics of Yangzhou), pp. 205–10.

39  Duoyunxuan is the name of a famous bookstore in Shanghai. In addition to dealing in art tools and materials such as brushes, ink sticks, and all types of rice paper, it is also the art bookstore in China best-known for reproductions of old paintings and calligraphy.

## 37. Li Shan 李鱓
*(1686–c. 1760)*
*Ch'ing dynasty (1644–1911)*

118

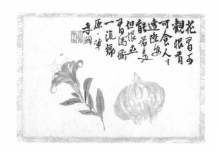

### Day Lily and Bulb
*Pai-ho*
*(Lily)*
百合

1   The dates of birth and death given here for Li Shan are based on information found in Wang Luyu 王魯豫, "Li Shan nianpu (Li Shan nien-p'u) 李鱓 年譜 (A Chronicle of Li Shan's Life), in Qiu Youxuan 丘幼宣 ed., *Yangzhou baguai nianpu (Yangchou pa-kuai nien-p'u)* 揚州八怪年譜 (Chronicles of the Eight Eccentrics of Yangchou) (Jiangsu: Meishu Chubanshe, 1992), pp. 11–62.

2   The person mentioned in Li Shan's inscription, Feng Tao 馮道 (882–954), was a notorious figure in Chinese history. Feng occupied the position of prime minister for twenty years. During his political career, he served under ten emperors belonging to four different dynasties. He apparently valued power, wealth, and position over loyalty and honor. His casual attitude toward the defeat of his country, or the murder of his ruler, was considered despicable and shameless. He is considered one of the most detested individuals in Chinese history. See Tsang Li-ho 臧勵龢 et al., *Chung-kuo jen-ming ta-tz'u-tien* 中國人名大詞典 (Encyclopedia of Chinese Biographies) (Shanghai: Commercial Press, 1924), p. 1225, s.v. "Feng Tao 馮道." Another term in Li Shan's inscription, *hsiang-yüan* 鄉原, denotes the hypocritical villagers who appear modest and prudent but in reality are sly and deceitful. The term is originally derived from Confucius' classic work, *Lun-yü* 論語 (The Analects of Confucius). See *Hanyu dacidian (Han-yü ta-tz'u-tien)* 漢語大詞典 (Chinese Terminology Dictionary), vol. 10 (Shanghai: Hanyu Dacidian Press, 1988), p. 665, s.v. "*xiangyuan (hsiang-yüan)* 鄉原."

3   All of this information about Li Shan's life is clearly given in his autobiographical writings. See Xue Yongnian 薛永年, "Li Shan de jiashi yu zaoqi zuopin (Li Shan te chia-shih yü tsao-ch'i tso-p'in) 李鱓的家世與早期作品 (Li Shan's Family History and His Early Works), in Xue Yongnian, ed.,

*Yangzhou baguai kaobian ji (Yang-chou pa-kuai k'ao-pien chi)* 揚州八怪考辨集 (A Collection of Essays Examining the Writings on the Eight Eccentrics of Yangzhou) (Jiangsu: Meishu Chubanshe, 1992), pp. 103–13. See also Wang Luyu 王魯豫, "Li Shan nien-p'u 李鱓 年譜" (A Chronicle of Li Shan's Life). The history of Li Shan's family came into much clearer focus when Xue Yongnian 薛永年, a professor of Chinese art history at the Central Art Academy, Beijing, discovered the genealogy of the Li family at the Yangchou Municipal Library in 1984.

4   See "Li Shan te chia-shih yü tsao-ch'i tso-p'in 李鱓的家世與早期作品 (Li Shan's Family History and His Early Works). A brief biography of Li Shan's ancestor, Li Ch'un-fang, is found in L. Carrington Goodrich and Fang Chaoying, eds., *Dictionary of Ming Biography, 1368–1644*, vol. 1 (New York and London: Columbia University Press, 1976), pp. 818–19. During the early Ch'ing dynasty, around 1650, the Li family was one of four prestigious clans in Hsing-hua. The other three were the Wu 吳, Hsieh 解, and Wei 魏 families. See Hu Yi 胡藝, "Yu Zhiding nianbiao (Yü Chih-ting nien-piao) 禹之鼎年表" (Chronological Table of Yü Chih-ting ), in *Duoyun (To-yün)* 朵雲 (Cloud Art Journal) 3 (Shanghai: Shanghai Shuhua Chubanshe, September 1982), p. 207. According to Xue Yongnian, Li Shan had three older brothers: Li Piao 李鱶, Li Lu 李魯, and Li Ch'ing-yen 李慶衍. Even though Li Shan was the youngest, he was sometimes referred to as the third son of the Li family. This is because Li Ch'ing-yen, his third elder brother, was adopted by a relative at a young age. See "Li Shan te chia-shih yü tsao-ch'i tso-p'in 李鱓的家世與早期作品 (Li Shan's Family History and His Early Works), p. 212.

5   The assertion that Li Shan emulated the style of Huang Kung-wang is based on an inscription on one of his works. In 1753, Li Shan executed ten flower and two calligraphic scrolls, possibly intended to be mounted into a screen. On the first calligraphic scroll, he states: "When I was young, I studied the landscape painting of Tzu-chiu (tzu of Huang Kung-wang, 1269–1354)." (余幼學子久山水) This work now belongs to the Shanghai Museum and is reproduced in Group for the Authentication of Ancient Works of Chinese Painting and Calligraphy, ed., *Zhongguo gudai shuhua tumu (Chung-kuo ku-tai shu-hua t'u-mu)* 中國古代書畫圖目 (Illustrated Catalogue of Selected Works of Ancient Chinese Painting and Calligraphy), vol. 5 (Shanghai: Wenwu Chubanshe, 1990), no. 11, no. 滬 1-3699, p. 213. The claim that Li Shan learned painting from a local

painter is found in a colophon by Cheng Hsieh 鄭燮 (1693–1765) following a set of Li Shan's flower album leaves at the Sichuan Provincial Museum. The colophon indicates that Li Shan learned landscape painting from a certain Wei Ling-ts'ang 魏凌蒼 in his hometown. *Li Shan huahuice (Li Shan hua-hui ts'e)* 李鱓花卉冊 (A Set of Flower Album Leaves by Li Shan) (Shanghai: Renmin Meishu Chubanshe, 1984), colophon no. 1, asserts: "Fu-t'ang's (tzu of Li Shan) painting changed three times. In the beginning, he studied landscape painting from Wei Ling-ts'ang, a native artist of Li's hometown. Even at that stage, [Li's work] was elegant with vigorous brushwork and already surpassed the work of his teacher. Later he went to the capital and was granted an audience with Emperor Jen-tsung (K'ang-hsi, r. 1662– 1722), who was pleased and kind to him. Under the imperial decree, Li Shan studied under Chiang T'ing-hsi (1669–1732), whose *hao* is Nan-sha, and started to execute lively, colorful flower paintings. This set of album leaves is [a work he] painted after the age of thirty, under the instruction of Chiang [T'ing-hsi]. Afterwards, he experienced many adversities in his life. When he went to the capital [for the second time], he served Kao Ch'i-p'ei, the minister of crime. Then later, in Yangchou, he saw [many works] of the monk Shih-t'ao. Consequently, he started utilizing broken brushstrokes (strokes executed as if there were insufficient ink in the brush and leaving white spaces) and flung ink; thus his paintings became increasingly unusual. The first time he went to the capital, he changed his painting style. During his second trip to the capital, he changed it again. Each time he modified his style, his painting greatly improved. This is because he followed certain rules and because the forms, sizes, and shades of the colors [in his painting] are all well organized. All these characteristics are imbedded in his work, [while on the outside, one finds] liberation and spontaneity. All of these are truly wonderful! After sixty, his painting style changed once again. At this time, his work, containing sloppy brushwork, appeared dejected and disorganized. This is so pitiful! [Nevertheless], in this set of album leaves, the red, black, brown, blue, and green are all lively; it appears as if the colors are about to fly away! It is impossible to confine. People who love the painting of Li Shan [should] collect only the works he did in his early and middle ages and burn the spiritless ones, including the many counterfeits. [If they do so] then the genuine spirit and appearance of Li Shan's painting will last forever! In the *keng-ch'en* (1760) year dur-

ing the Ch'ien-lung reign (1736–96), Cheng Hsieh, whose *tzu* is Pan-ch'iao, inscribed [this colophon]. (復堂之畫, 凡三變. 初從里中魏凌蒼先生學山水, 便爾明秀蒼雄 過於所師. 其後入都 謁仁皇帝馬前, 天顏霽悦 令從南沙蔣廷錫學畫. 乃為作色, 花卉如生. 此冊是三十外, 學蔣時筆也. 後經崎嶇患難 入都, 得侍高司寇其佩 又在揚州, 見石濤龢尚畫 因作破筆潑墨 畫益奇. 初入都, 一變. 再入都, 又一變 變而愈上. 蓋規矩方圓尺度, 顏色淺深離合, 絲毫不亂 藏在其中, 而外之揮灑脱落, 皆妙諦也! 六十外, 又一變. 則散慢頹唐, 無復筋骨. 老可悲也! 冊中一脂一墨, 一耦一青綠, 皆欲拭去 不可攀留. 世之愛復堂者, 存其少作壯年筆, 而焚其衰年, 贗筆 則復堂之真精神, 真面目, 千古常新矣! 乾隆庚辰, 板橋鄭燮記.)

6 For more on the assertion that Li Shan learned from his cousin's wife, see the artist's inscription on his ten flower and two calligraphic scrolls at the Shanghai Museum listed in note 5. Li Ping-tan, Li Shan's cousin, achieved his *chin-shih* 進士 degree in 1715; his *tzu* was Chen-nan 震男. Li Ping-tan's birth and death dates come from an article by Hu Yi 胡藝, "Dui *Zhongguo meishujia renming cidian (Qingdai bufen) de buzheng (Tui Chung-kuo mei-shu-chia jen-ming tz'u-tien (Ch'ing-tai pu-fen) te pu-cheng)* 對 [中國美術家人名辭典] (清代部分) 的補正" (A Revision [of the Ch'ing Dynasty Section] in *A Biographical Dictionary of Chinese Artists*), in *To-yün* 朵雲 (Cloud Art Journal) 4 (Shanghai: Shuhua Chubanshe, 1982), p. 235.

7 Although there were no prominent statesmen in the Li family during Li Shan's and his father's generations, there were several famous figures among his relatives, including his cousin Li Ping-tan 李炳旦 and Li Ping-tan's father. The wife of Li Ping-tan, from whom Li Shan learned flower painting, was also from an illustrious family. See "Li Shan teh chia-shih yü tsao-ch'i tso-p'in 李鱓的家世與早期作品" (Li Shan's Family History and His Early Works), p. 217.

8 For a record of Li Shan presenting a poem to the Emperor K'ang-hsi, see *Kiangsu-sheng ch'ung-hsiu Hsing-hua hsien-chih* 江蘇省重修興化縣誌 (The Revised District Gazette of Hsing-hua, Kiangsu Province), reprint of 1852 ed., vol. 18 (Taipei: Cheng-wen Press, 1970), p. 1210.

9 Emperor K'ang-hsi was known for stressing the importance of education. He created the imperial Nan-shu-fang Study in order to recruit capable scholars to be his personal secretaries and study companions. See Arthur W. Hummel, ed., *Eminent Chinese of the Ch'ing Period (1644–1912)*, vol. 1 (Washington, D.C.: United States Government Printing Office, 1943–44), p.

329. For a discussion of the Imperial Study, see Zhu Jinfu, "Lun Kangxi shidai de Nanshufang (Lun K'ang-hsi shi-tai-teh Nan-shu-fang) 論康熙時代的南書房" (The Nan-shu-fang Study during the Reign of Emperor K'ang-hsi) in *Qingdai gongshi tanwei (Ch'ing-tai Kung-shih t'an-wei)* 清代宮史探微 (Preliminary Research on the History of the Palace of the Ch'ing Dynasty) (Beijing: Forbidden City Press, 1991), pp. 1–24.

10 Li Shan related this experience in the inscription on his calligraphic scroll now at the Shanghai Museum. See his ten flower and two calligraphic scrolls mentioned in note 5. For a brief biography of Chiang T'ing-hsi, see *Eminent Chinese of the Ch'ing Period (1644–1912)*, vol. 1, pp. 142–43.

11 Hsü Hsi and Huang Chüan were two flower-and-bird painting masters during the Five Dynasties (907–60) period. For a discussion of these two artists, see Osvald Sirén, *Chinese Painting: Leading Masters and Principles*, vol. 2 (New York and London: Ronald Press, 1956), pp. 27–28.

12 See *Eminent Chinese of the Ch'ing Period (1644–1912)*, vol. 2, p. 925.

13 Wang Shan 王掞 (1645–1728) was imprisoned and later released. See ibid, vol. 2, pp. 830–31. For an account of how Wang Shan and eight censors jointly petitioned the emperor to designate a successor, see "Kangxi jianchu an (K'ang-hsi chien-ch'u an) 康熙建儲案" (The Case of the Petitioning of Emperor K'ang-hsi to Designate an Heir) in *Wen-hsien ts'ung-pien* 文獻叢編 (A Collection of Historical Documents), no. 4 (Taipei: Kuo-feng Press, 1964), pp. 106–9.

14 Many years later, after Li Shan left the court and returned to the south, Cheng Hsieh attended a drinking party at Li Shan's home. Cheng Hsieh composed a poem for the host entitled "Yin Li Fu-t'ang chai fu-tseng 飲李復堂宅賦贈" (Drinking at Li Shan's House and Presenting Him with This Poem). The poem reads: "On the fifteenth day of the fourth moon, the moon [shone] above the trees. The shadows on the windows swung in the breeze. As [the host] lifted the wine cup, the grievance weighing on his mind also arose. Both the host and guests were speechless; [thus] the guests stood up and departed. Our host rose in his career at a young age. He first rode on a fine stallion and held a horsewhip decorated with corals. As a member of the imperial retinue, he accompanied the emperor as he passed through the Ku-pei Gate [of the Great Wall]. Carrying his brushes, he was on duty at Emperor K'ang-hsi's court. People were jealous of his talent and ability. [Although] praise was in

their mouths, their hearts were not in accord." (四月十五月在樹, 淡風清影搖窗戶. 舉酒欲飲心事來, 主客無言客起去. 主人起家最少年, 驊騮初試珊瑚鞭. 護蹕出入古北口, 橐筆侍直仁皇前. 才雄頗為世所忌, 口雖贊嘆心不然.) See Cheng Hsieh, *Cheng Pan-ch'iao ch'üan-chi* 鄭板橋全集 (The Complete Collection of Cheng Hsieh's Writing), reprint (Taipei: T'ien-jen Press, 1968), p. 19.

15 See ibid. In the same poem, Cheng Hsieh continues, "Lonely and with only the company of his horse, he left the capital. Dressed in a colorful brocade garment, he (then) visited the singing courtesans (in the boats) on the river. He indulged himself in song, women, and passion for twenty years." (蕭騷匹馬離都市, 錦衣江上尋歌妓. 聲色荒淫二十年.)

16 See Wang Luyu 王魯豫, "Li Shan nien-p'u 李鱓年譜" (A Chronicle of Li Shan's Life), entry for year 1734, on p. 23.

17 See ibid. See also *Kiangsu-sheng ch'ung-hsiu Hsing-hua hsien-chih* 江蘇省重修興化縣誌 (The Revised District Gazette of Hsing-hua, Kiangsu Province), vol. 18, p. 1210.

18 See both sources in note 17.

19 See Xue Yongnian's "Li Shan Tengxian ciguan ji dingju Yangzhou kaobian (Li Shan T'eng-hsien tz'u-kuan chi ting-chü Yang-chou k'ao-pien) 李鱓滕縣辭官及定居揚州考辨" (A Study of Li Shan's Dismissal from Official Position in T'eng County and His Settling in Yangchou), in *Yang-chou pa-kuai k'ao-pien chi* 揚州八怪考辨集 (A Collection of Essays Examining the Writings on the Eight Eccentrics of Yangzhou), pp. 117–23.

20 For the names of the "Eight Eccentrics of Yangchou," see note 21 in entry 36 on Huang Shen.

21 Chang Keng 張庚 (1685–1760) stated that Li's flower and bird paintings emulated those of Lin Liang 林良 (c. 1416–80). See Chang's *Guochao huazhenglu (Kuo-ch'ao hua-cheng lu)* 國朝畫徵錄 (Biographical Sketches of the Artists of the Ch'ing Dynasty), preface dated 1739, *juan (chüan)* 卷 (chapter) 3, reprinted in Yu Anlan 于安瀾, comp., *Huashi congshu (Hua-shih ts'ung-shu)* 畫史叢書 (Compendium of Painting History), vol. 5 (Shanghai: Renmin Meishu Chubanshe, 1962), p. 67. Lin Liang was a Ming dynasty court painter famous for his Che school style flower and bird painting. For a discussion of Lin Liang and his work, see Richard M. Barnhart, "Great Masters of the Ming Court and the Zhe School: Lin Liang, Lü Ji, and the Golden Age of Bird and Flower Painting," in Richard M. Barnhart, ed., *Painters of the*

Li Shan 李鱓
**Day Lily and Bulb**
*continued*

**38. Chin Nung** 金農
*(1687–1764)*
*Ch'ing dynasty (1644–1911)*

120   *Great Ming: The Imperial Court and the Zhe School* (Dallas: Dallas Museum of Art, 1993), pp. 195–204. For Cheng Hsieh's remarks, see his colophon, translated in note 5, attached to Li Shan's flower album leaves at the Sichuan Provincial Museum.

22   See note 5. Shih-t'ao settled in Yangchou around 1692 and concentrated on painting and calligraphy for the rest of his life. Cheng Hsieh pointed out that after Li Shan returned to the south and began to be active in Yangchou, he would have had many opportunities to encounter Shih-t'ao's work. For a discussion of Shih-t'ao, see entry 29.

23   This is supported by the fact that Li Shan produced many album leaves depicting flowers in this format. For example, see his flower album leaves now at the Chinese Historical Museum, Beijing, *Li Shan huahuice* (*Li Shan hua-hui ts'e*) 李鱓花卉冊 (A Set of Flower Album Leaves by Li Shan) (Beijing: Chinese Historical Museum, 1980).

24   In Chinese, a day lily bulb is called *pai-ho* 百合 (meaning "the gathering of hundreds of [petals]"). It is used in Chinese medicine as well as Chinese cooking, as the flowers of the day lily are also considered a delicacy. In Chinese literature, the day lily symbolizes the mother of a son. This plant is also known by several other names, including: 1) *i-nan* 宜男 ([it is] suitable [to bear] a son); 2) *wang-yu* 忘憂 (to forget sorrow); and 3) *hsüan-ts'ao* 萱草 (beautiful grass). The second meaning suggests that a mother with a son is able to put aside her sorrow. See R. H. Mathews, *Mathews' Chinese-English Dictionary*, rev. American ed. (Cambridge, Mass.: Harvard University Press, 1963), p. 429.

25   This second leaf is reproduced in Li Shan's flower album leaves, now at the Chinese Historical Museum, Beijing. See *Li Shan huahuice* (*Li Shan hua-hui ts'e*) 李鱓花卉冊 (A Set of Flower Album Leaves by Li Shan), pl. 7.

26   Li Shan's *Holly*, now at the Tianjin 天津 Art Museum, is reproduced in *Yangzhou bajia huaxuan* (*Yangchou pa-chia hua-hsüan*) 揚州八家畫選 (Selected Works by the Eight Masters of Yangchou) (Tianjin: Renmin Meishu Chubanshe, 1983), no. 16. In Li Shan's poem on this painting, he personifies the holly as a woman in the palace who has lost the favor of the emperor. The poem reveals Li Shan's feelings toward Emperor K'ang-hsi: "Since entering the Gate of Disfavor [at the palace, I am allowed only to apply] inconspicuous make-up. My garment in the [cold] autumn, however, still carries the faded imperial yellow. Until the end of my

life, I refuse to believe that the ruler's kindness is thin (insufficient). [Like the holly, I will] wholeheartedly face the sun." (自入長門著淡粧, 秋衣猶染舊宮黃。到頭不信君恩薄, 猶是傾心向太陽。) In Chinese literature, the holly symbolizes admiration and adoration because the plant usually faces the sun. The flower also symbolizes a shield or the taking of a person under one's wing. See *Han-yü ta-tz'u-tien* 漢語大詞典 (Chinese Terminology Dictionary), vol. 9, p. 493, s.v. "*kuei* (*k'uei*) 葵" (holly).

27   For a discussion of Li Shan's *Five Pine Trees*, see Xue Yongnian 薛永年, "Cong 'Wusongtu' shuo Li Shan de shengping yu yishu (Ts'ung '*Wu-sung t'u*' shuo Li Shan teh sheng-p'ing yü i-shu) 從五松圖説李鱓的生平與藝術" (Using Li Shan's *Five Pine Trees* to Examine the Artist's Art and Life) in Xue Yongnian, *Shuhuashi luncong gao* (*Shu-hua-shih lun-ts'ung kao*) 書畫史論叢稿 (A Collection of Papers on the History of Chinese Painting and Calligraphy) (Chengdu: Sichuan Educational Press, 1992), pp. 222–37. According to Xue, at least eleven extant works of Li Shan incorporate the theme of the five pine trees.

28   The inscription on Li Shan's *Five Pine Trees* reads: "One [of the pines] is unyieldingly upright, like an ancient loyal and honest statesman. With [his] official tablet attached to his girdle, he stands [attentively] in the Examining Hall of the Hanlin Graduates." (一株勁直古臣工, 搢笏垂紳立辟雍.) The Hanlin Academy was an imperial institute reserved for those possessing the highest literary degree.

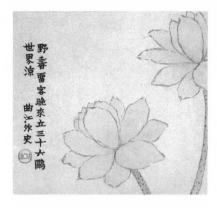

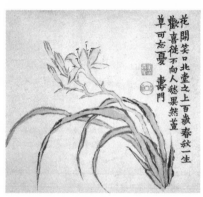

**Two Flower Album Leaves**
*Hua-hui ts'e-yeh*
*(Flower Album Leaves)*
花卉冊頁

1   Chin Nung adopted the *hao* Tung-hsin, meaning "a wintry heart," in 1716 at the age of thirty. For an explanation of this name, see note 27.

2   Yang Hsiao-ku was a professor at Hua-hsi 華西 University, a school established during World War II in Ch'eng-tu 成都, Szechwan 四川 province. The purpose of this school was to provide an education to students fleeing the Japanese occupation of the coastal area. Chu-fei, which means "a bamboo door," was Yang's *hao*.

3   The date assigned to these two Michigan album leaves is based on the fact that Chin Nung concentrated on painting miscellaneous subject matter, including flower paintings, between 1754 and 1756. See "Miscellaneous Subjects," in Marshall P. S. Wu's "Jin Nong (Chin Nung): The Eccentric Painter with a Wintry Heart," in Ju-hsi Chou and Claudia Brown, eds., *Chinese Painting under the Qianlong Emperor: The Symposium Papers in Two Volumes* (*Phœbus* 6.2) (Tempe: Arizona State University, 1991), pp. 272–79.

4  The two leaves at the University of Michigan originally belonged to a set in which Chin Nung depicted various kinds of flowers. The set was dispersed at the end of the Second World War when the owner, an antique dealer from Peking, decided to sell the leaves individually in Ch'eng-tu, Szechwan province. Only three paintings from this set are accounted for. In addition to the lotus and day lily album leaves at the University of Michigan, another leaf, illustrating a cluster of orchids, belongs to the Chien-lu 簡廬 Collection of Professor Richard Edwards, Ann Arbor. The composition of Dr. Edwards's leaf is almost identical to another version of Chin Nung's orchids now at the Palace Museum in Beijing. Although Chin Nung's *Orchid* in the Chien-lu Collection has never been published, the version at the Palace Museum collection, entitled *Honglan* (*Hung-lan*) 紅蘭 (Red Orchids), is published in Mayching Kao 高美慶, ed., *Paintings by Yangzhou Artists of the Qing Dynasty from the Palace Museum* (Hong Kong: Chinese University of Hong Kong, 1984), no. 61, pp. 198–99, with a color plate on p. 49. The University of Michigan acquired the two leaves from Dr. Charles Ling, Richard Edwards's brother-in-law. According to Dr. Edwards, the Michigan leaves were sold by their owner to a professor from Sweden. It was through Edwards's recommendation that Dr. Ling purchased them in the 1960s. Chin Nung's two leaves were then remounted by a well-known Japanese conservator, C. Yamanouchi 山內, Asaka 淺賀 City, Saitama-ken 埼玉縣. The mounter attempted to protect the fragile paintings by mounting them onto hard thick paper boards. Each painting, along with a colophon, was then bound into a heavy book and a protective jacket prepared for the two volumes.

5  The number *san-shih-liu* 三十六, or "thirty-six," in Chin Nung's poem refers to the *San-shih-liu pei* 三十六陂. The character 陂 has two meanings. When it refers to a "slope," its pronunciation is *p'o*. When this character means a "shore" or a "pond," it is pronounced *pei* or *p'i*. *San-shih-liu pei* refers to the well-known "thirty-six ponds of Yangchou." See *Hanyu dacidian* (*Han-yü ta-tz'u-tien*) 漢語大詞典 (Chinese Terminology Dictionary), vol. 1 (Shanghai: Hanyu Dacidian Press, 1988), p. 171, s.v. "sanshiliu bei (san-shi-liu-pei) 三十六陂."

6  Ch'ü-chiang wai-shih 曲江外史 (an informal historian from the Ch'ü River) is one of Chin Nung's many sobriquets. The Ch'ü River is the old name of the Ch'ien-t'ang 錢塘 River, near the city of Hangchou, Chin Nung's hometown. Ch'ü-chiang liter-

ally means a "winding river" and was so named due to its meandering course. For more on Chin Nung's many sobriquets, see note 27.

7  The rationale behind Chin Nung's choice of the term *Ku-ch'üan* for his seal is complex. For an explanation, see note 27.

8  The seals preceding a calligraphic work are usually for decorative purposes. It is not clear whether *T'ai-kuang*, meaning "an extensive terrace," was one of Professor Yang Hsiao-ku's sobriquets or was only used as a poetic term.

9  Apparently, Professor Yang Hsiao-ku in his colophon mistook the period in which the poet Chiang K'uei lived. Chiang, a master poet of the Southern Sung dynasty (1127–1279), was born in 1155, the twenty-fifth year of Emperor Kao-tsung 高宗 (r. 1127–62). This date excludes the possibility that he lived during the Northern Sung period (960–1126), as stated in Yang's colophon.

10  It is a common practice in China to correct errors in calligraphy by adding the correct characters at the end of the text as an amendment, as correcting or crossing a mistake out would be unsightly.

11  *Pei-t'ang* 北堂 literally means "northern hall." Although this term has many meanings, in Chinese literature it is generally used to indicate the chamber where a mother lives. See *Han-yü ta-tz'u-tien* 漢語大詞典 (Chinese Terminology Dictionary), vol. 2, p. 201, s.v. "*beitang* (*pei-t'ang*) 北堂."

12  In Chinese literature, the day lily symbolizes "the mother of a son." This plant is known by several different names in China, including: 1) *i-nan* 宜男, or "[it is] suitable [to bear] a son"; 2) *wang-yu* 忘憂 or "to forget sorrow"; 3) *pai-ho* 百合, or "the hundred-fold harmony," referring to the layered cloves on its bulb; and 4) *hsüan-ts'ao* 萱草, or "beautiful grass." The second meaning suggests that a mother with a son is able to put aside her sorrow. See R. H. Mathews, *Mathews' Chinese-English Dictionary*, rev. American ed. (Cambridge, Mass.: Harvard University Press, 1963), p. 429. See also note 35 for a discussion of this inscription.

13  Shou-men 壽門 ("gate of longevity") is Chin Nung's *tzu*. For more information on this name, see note 27.

14  Chin Chi-chin 金吉金, or "gold, lucky gold," is one of Chin Nung's many sobriquets. For a discussion of this name, see note 27.

15  The original text of this colophon is found in section "Po-hsi 伯兮" (My Valiant Husband), chapter "Wei-feng 衛風" (The Cus-

toms of the Wei State). It is a poem regarding a lonely wife pining for her husband away at battle. She would like to find the day lily, the forget sorrow plant, in order to ease her grief. See Jin Qihua 金啟華, trans., *Shijing quanyi* (*Shih-ching ch'üan-i*) 詩經全譯 (The Complete [Modern Chinese] Translation of *The Book of Odes*) (Jiangsu: Jiangsu Guji Chubanshe, 1984), p. 143.

16  Shih-shih lao-jen (meaning "an old man in a stone chamber") was the *hao* of Wen T'ung, the most celebrated bamboo painter of the Northern Sung period. For his magnificent work, see *Ink Bamboo*, reproduced in National Palace Museum, *Ku-kung shu-hua t'u-lu* 故宮書畫圖錄 (An Illustrated Catalogue of Calligraphy and Painting at the Palace Museum), vol. 1 (Taipei: National Palace Museum, 1991), p. 265.

17  Ko Ch'ang-keng was a legendary plum blossom painter of the Southern Sung period. Today, unfortunately, there are no extant paintings that can positively be identified as his work. For the meaning of Chin Nung's *hao*, "Hsi-yeh chü-shih," which he used when painting in emulation of Ko, see note 27.

18  Both Ts'ao Pa and Han Kan were famous horse painters of the T'ang dynasty (618–905) who served at Emperor Hsüan-tsung's 玄宗 (r. 712–55) court. While no works by Ts'ao Pa survive, there are still a couple of Sung dynasty copies of Han Kan's horse that provide some evidence of his accomplishment. An album leaf attributed to Han Kan, entitled *Mu-ma t'u* 牧馬圖 (A Rider with Two Horses), is reproduced in Editorial Committee of the Joint Board of Directors of the National Palace Museum and the National Central Museum, *Ku-kung ming-hua san-pai-chung* 故宮名畫三百種 (Three Hundred Masterpieces of Chinese Painting in the Palace Museum), vol. 1 (Taichung: National Palace Museum and National Central Museum, 1959), no. 16. Another horse album leaf attributed to Han Kan, the famous *Chao-yeh pai* 照夜白 (The Night-shining White), which depicts a spirited white stallion, now belongs to the Metropolitan Museum of Art, New York. For a reproduction of this work, see Wen C. Fong, *Beyond Representation: Chinese Painting and Calligraphy 8th–14th Century* (New York: Metropolitan Museum of Art, 1992), pp. 16–17.

19  Hsin-ch'u-jia-an chou-fan-seng 心出家庵粥飯僧 literally means "The Tonsured-mind Studio belonging to a monk who craves the rice and gruel of the temple." It implies a lazy person who wishes to lead an easy life with all meals provided. By calling himself a not-so-enlightened monk and mocking

122

himself, Chin Nung humbly expresses his frustration in his pursuit of Buddhism. Although he wished to become a faithful, enlightened Buddhist, all he could do was think of the free meals provided by the temples.

20 For more on the salt trade in Yangchou, see Ho Ping-ti 何秉棣, "The Salt Merchants of Yangchou: A Study of Commercial Capitalism in Eighteenth-Century China," *Harvard Journal of Asiatic Studies*, no. 17 (Cambridge, Mass.: Harvard University Press, June 1954), pp. 130–68.

21 For the names of "The Eight Eccentrics of Yangchou," see note 21 in entry 36 on Huang Shen 黃慎 (1687–1770?).

22 For more on Shih-t'ao's calligraphy, see entry 29.

23 Chin Nung's "printing script" is known as *fang-Sung* 仿宋, or "imitating after the [calligraphy of the] Sung dynasty." *Fang-Sung* is a square script that evolved from the wooden types used for printing during the Ming dynasty (1368–1644), a period noted for its beautifully printed books. The calligraphic examples of the Northern Sung dynasty, on which the Ming printing types were based, were probably the elegant regular script found in Emperor Hui-tsung's (r. 1101–25) calligraphy, known as the *shou-chin t'i* 瘦金體 (slender-gold style). For an example of the Emperor's calligraphy in this style, see Wen C. Fong and James C. Y. Watt, *Possessing the Past: Treasures from the National Palace Museum, Taipei* (New York: Metropolitan Museum of Art, and Taipei: National Palace Museum, 1996), pl. 73, pp. 166–67. For a discussion of Chin Nung's calligraphy, see Marshall P. S. Wu, "Chin Nung: An Artist with a Wintry Heart," Ph.D. dissertation, vol. 1 (Ann Arbor: University of Michigan, 1989), pp. 118–89.

24 Exactly when this term was applied to this style of Chin Nung's calligraphy is unclear. In all probability, the descriptive term "lacquer" was used because of Chin Nung's choice of a particular ink, which was quite glossy. Chin Nung's best work in this script includes his *Quotation from the Confucian Classic "Chou Li"* and his *Bamboo and Calligraphy*. The first work once belonged to the former John Crawford, Jr. Collection, New York; the second belongs to the Jeannette Shambaugh Elliott Collection, The Art Museum, Princeton University. These two works are published in Yujiro Nakata 中田勇次郎 and Fu Shen 傅申, *Masterpieces of Chinese Calligraphy in American and European Collections* (Tokyo: Chuokoron-sha, 1983), no. 66, p. 56, and no. 67, p. 57, respectively.

25 Chin Nung was primarily a calligrapher before he switched to painting in his early sixties. When he finally turned to painting, his brushwork, deeply rooted in the execution of calligraphy, carried over into his painting. Many later artists followed Chin Nung in this respect, including: 1) Chao Chih-ch'ien 趙之謙 (1829–84); 2) Wu Ch'ang-shih 吳昌碩 (1844–1927); and 3) Ch'i Pai-shih 齊白石 (1863–1957).

26 For Chin Nung's birth date, see his *Tung-hsin hsien-sheng hsü-chi* 冬心先生續集 (Sequel to Chin Nung's [Poetry] Anthology), ed. by Lo P'in 羅聘 (1733–99), preface dated 1773, reprinted in *Hsi-ling wu-pu-i i-chu* 西泠五布衣遺著 (The Written Legacies of Five Deceased Scholars from Hangchou Who Never Occupied Any Official Positions) (Hangchou: Hsi-ling Seal Guild, 1904), p. 12. Chin Nung wrote, "The twenty-second day of the third moon, eleventh year (1746) of Emperor Ch'ien-lung (r. 1736–96) was my sixtieth year birthday." (乾隆十一年, 三月二十有二日, 乃予六十犬馬之辰.) In this inscription, Chin Nung humbly used the term "the dog and horse day" to indicate his birthday. According to Chinese custom, a baby is one year old at his birth. Therefore, in 1746 Chin Nung would have been 59 years old according to the Western system. Consequently, Chin Nung must have been born in 1687.

27 Each of Chin Nung's *hao*, or sobriquets has a special connotation. For example, he adopted the name Tung-hsin, or "wintry heart," in 1716 after a long, sleepless night when he suffered insomnia due to illness and depression. The term was borrowed from the verse *Chi-liao pao tung-hsin* 寂寥抱冬心, or "I held my wintry heart in desolation," found in a poem of the T'ang dynasty poet Ts'ui Kuo-fu 崔國輔 (active mid-8th century). See Chin Nung's preface for his *Dongxinji (Tung-hsin chi)* 冬心集 (Chin Nung's Anthology), preface dated 1733, reprint (Shanghai: Shanghai Guji Chubanshe, 1979), p. 5 (冬心先生者; 予丙申病江上, 寒宵懷人不寐. 申旦, 遂取崔國輔; "寂寥抱冬心" 之語, 以自號.) Ts'ui's poem, entitled *A Wintry Midnight Song*, describes the lonely feeling of a young woman sewing in the night. It says: "I hold my wintry heart in desolation, while cutting silk gauze for a plain garment. [Working] late into the night [I had to] raise the wick of [my dim] light many times. [Under the] chilly frost, [my] scissors became cold to touch." (子夜冬歌: 寂寥抱冬心, 裁羅文裂褧. 夜久頻挑燈, 霜寒剪刀冷.) Ts'ui's poem is found in *Ch'üan T'ang-shih* 全唐詩 (The Complete Anthology of T'ang Dynasty Poems), *juan* (*chüan*) 卷 (chapter) 119, reprint, vol. 4 (Beijing:

Zhonghua Shuju, 1985), p. 1203. This name accentuates Chin Nung's melancholy personality. He used the name "a scholar from the Chü River" because his home was located by the Chü River, the old, popular name for the famous Ch'ien-t'ang 錢塘 River near Hangchou. In Chin Nung's old age, he enjoyed using especially auspicious terms. For example, Chi-chin 吉金 literally means "lucky gold." As commercial as it sounds, it expresses his sense of humor. This is because Chin Nung's family name *Chin* 金 simply means "gold." When he combined his family name with Chi-chin, the three characters, *chin-chi-chin* (gold lucky gold) form a phrase that has the term "gold" on both ends connected by "lucky." The character *ku* 古 in Chin Nung's *hao* "Ku-ch'üan," means "ancient," and the second character, *ch'üan* 泉, literally means "water-spring." In classical Chinese, the same character for "water-spring" also means "currency," indicating money flowing like a spring. Thus Ku-ch'üan refers to "old coins." His seal bearing this *hao* is rather cleverly arranged in a circular shape similar to ancient coins that contained a square hole in the center. On the other hand, as gold was actually used as currency in ancient China, "old coin" or "old currency" could be interpreted as "gold," which is a direct allusion to Chin Nung's family name. His motivation for choosing the name "Gate of Longevity" is not apparent. Possibly, he adopted it due to its auspicious implication. Hsi-yeh Chü-shih, or "a retired scholar of green moss," indicates the houses he dwelled in were surrounded by green moss. The character *yeh* 耶 in the term *hsi-yeh* 昔耶, or "green moss," is also written as *yeh* 邪. See *Han-yü ta-tz'u-tien* 漢語大詞典 (Chinese Terminology Dictionary), vol. 5, p. 585, s.v. "*xiye (hsi-yeh)* 昔邪." For Chin Nung' many style names and seals, see Marshall P. S. Wu's dissertation, "Chin Nung: An Artist with a Wintry Heart," appendix A, pp. 388–408.

28 For more discussion of Chin Nung's life, see ibid., chapter 1: "Chin Nung's Life," vol. 1, pp. 10–117.

29 See ibid., vol. 1, pp. 40–44.

30 See ibid., vol. 1, pp. 38–49.

31 Chin Nung also accepted a lesser-known student named Hsiang Chün 項均 (active second half of 18th century). See Chin Nung's *Tung-hsin hua-mei t'i-chi* 冬心畫梅題記 (A Collection of Chin Nung's Inscriptions on His Plum Blossom Paintings), reprinted in Teng Shih 鄧實 (1865?–1948?) and Huang Pin-hung 黃賓虹 (1865–1955), comps., *Mei-shu ts'ung-shu* 美術叢書 (Anthology of Writings on Fine Art), *chi* 集

(part) 1, *chi* 輯 (division) 3 (Shanghai: n.p., 1912–36), reprint, vol. 2 (Taipei: I-wen Bookstore, 1963–1972), p. 91. It says: "Two young scholars studying under me presented their poetry as tuition; one was Lo P'in and the other, Hsiang Chün." (以 詩為 贄遊吾門者; 有二士焉. 羅生聘, 項生均.) Chin Nung probably accepted his second student, Hsiang Chün, in 1756. See Chin Nung's *Tung-hsin tzu-hsieh-chen t'i-chi* 冬心自寫真題記 (Chin Nung's Inscriptions on His Self-portraits), preface dated 1760, reprinted in *Mei-shu ts'ung-shu* 美術叢書 (Anthology of Writings on Fine Art), *chi* 集 (part) 1, *chi* 輯 (division) 3, vol. 2, p.113.

32 The exact date when Chin Nung formally began to paint bamboo is a critical factor in tracing his evolution from a scholar-calligrapher to a skilled painter. The most reliable date for the beginning of Chin Nung's painting career can be decided by examining his writings. In the preface of his *Tung-hsin hua-chu t'i-chi* 冬心畫竹題記 (A Collection of Chin Nung's Inscriptions on His Bamboo Paintings), preface dated 1750, reprinted in *Mei-shu ts'ung-shu* 美術 叢書 (An Anthology of Writings on Fine Art), *chi* 集 (part) 1, *chi* 輯 (division) 3, vol. 1, p. 61, Chin Nung clearly states that he started to paint bamboo after the age of 60. (冬心先生, 年踰六十, 始學畫竹.) This statement was made when he was sixty-three years old. If he had painted previously, he did not feel he was especially serious. For more discussion on this issue, see Marshall P. S. Wu, "Chin Nung: An Artist with a Wintry Heart," vol. 1, pp. 192–96.

33 See ibid.

34 Chin Nung produced the majority of his bamboo paintings in Yangchou around 1750. The tremendous response to Chin Nung's bamboo painting is further evidenced by information found in his own writings. In 1762, he inscribed a long passage on a bamboo painting he executed for his student Hsiang Chün, which says: "People loved my bamboo paintings and were willing to pay me several hundred times what I had paid for the bamboo roots [which I planted in my garden]!" See Chin Nung's *Tsa-hua t'i-chi* 雜畫題記 (Inscriptions on Paintings of Miscellaneous Subjects), reprinted in *Mei-shu ts'ung-shu* 美術叢書 (Anthology of Writings on Fine Art), *chi* 集 (part) 3, *chi* 輯 (division) 3, vol. 11, p. 171. (又有愛而求之 者; 酬直之數 百倍于買竹.) By 1753, however, Chin Nung suddenly gave up bamboo as his primary subject. Coincidentally, in 1753, another famous bamboo painter, Cheng Hsieh 鄭燮 (1693–1765), returned to Yangchou after serving in the north as a government official. Since Cheng Hsieh

possessed a higher social status and was better known, it is reasonable to assume that competition from Cheng was the main reason Chin Nung altered his subject matter. As Cheng's bamboo paintings often included additional elements such as rocks and orchids, thus making the works more attractive, his decision to retreat might have been as wise as it was timely. Whatever the reason, around 1754 Chin began to paint other subjects, such as flowers and figures. For more on Chin Nung's bamboo paintings, see Marshall P. S. Wu, "Chin Nung: An Artist with a Wintry Heart," vol. 1, pp. 197–226, and ibid., vol. 4, Appendix B, nos. 43–52, pp. 511–33. See also note 16 in entry 40 on Cheng Hsieh.

35 As the dates of Chin Nung's choice of subject matter during his painting career sometimes overlap, this sequencing is only a rough estimate. For more on his inscriptions on paintings, see: 1) *Tung-hsin hua-chu t'i-chi* 冬心畫竹題記 (A Collection of Chin Nung's Inscriptions on his Bamboo Paintings), preface dated 1750; 2) *Tung-hsin hua-mei t'i-chi* 冬心畫梅題記 (A Collection of Chin Nung's Inscriptions on His Plum Blossom Paintings), with one entry found at the beginning of this book dated 1750; 3) *Tung-hsin hua-ma t'i-chi* 冬 心畫馬題記 (A Collection of Chin Nung's Inscriptions on His Horse Paintings), last entry dated 1762; 4) *Tung-hsin hua-fo t'i-chi* 冬心畫佛題記 (Chin Nung's Inscriptions on His Buddhist Image Paintings), with the first entry indicating that he started to paint Buddhist images after the age of seventy (after 1757); 5) *Tung-hsin tzu-hsieh-chen t'i-chi* 冬心自寫真題記 (Chin Nung's Inscriptions on His Self-portrait Paintings), with the first entry dated 1759 at the age of seventy-three. These books are all reprinted in *Mei-shu ts'ung-shu* 美術叢書 (An Anthology of Writings on Fine Art), *chi* 集 (part) 1, *chi* 輯 (division) 3, vol. 2, pp. 61–114.

36 There are at least two other versions of Chin Nung's *Day Lily* bearing the exact same inscription found on the Michigan album leaf. One, at the Tianjin Museum, is reproduced in Tianjin Art Museum, *Yangzhou bajia huaxuan* (*Yang-chou pa-chia hua-hsüan*) 揚州八家畫選 (Selected Works by the Eight Masters of Yangchou) (Tianjin: Renmin Meishu Chubanshe, 1983), no. 36. The second one, dated 1754, belongs to the Zhejiang Provincial Museum in Hangzhou. It is reproduced in Group for the Authentication of Ancient Works of Chinese Painting and Calligraphy, ed., *Zhongguo gudai shuhua tumu* (*Chung-kuo ku-tai shu-hua t'u-mu*) 中國古 代書畫圖目 (An Illustrated Catalogue of

Selected Works of Ancient Chinese Painting and Calligraphy), vol. 11 (Beijing: Wenwu Chubanshe, 1994), no. 浙 1–462, p. 120. This inscription is also recorded in Chin Nung's *Tung-hsin hsien-sheng san-t'i-shih* 冬心先生三體詩 (Chin Nung's Poems in Three Different Styles), preface dated 1752, published in 1773, reprinted in *Hsi-ling wu-pu-i i-chu* 西泠五布衣遺著 (The Written Legacies of Five Deceased Scholars from Hangchou Who Never Occupied Any Official Positions), p. 41.

37 See note 23.

38 Chin Nung's poem appears on a calligraphic work reproduced in Yujiro Nakata et al., *Shodo geijutsu* 書道藝術 (Calligraphic Art), vol. 9 (Tokyo: Heibonsha, 1976), nos. 116–17.

39 The information concerning Chin Nung's death and burial is found in Lo P'in's epilogue attached to Chin Nung's *Tung-hsin hsien-sheng hsü-chi* 冬心先生續集 (Sequel to Chin Nung's [Poetry] Anthology), p. 30a.

## 39. Ch'ien Tsai 錢載
*(1708–93)*
*Ch'ing dynasty (1644–1911)*

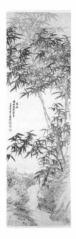

### Ink Bamboo and Rocks
*Chu-shih t'u*
*(Bamboo and Rocks)*
竹石圖

1 This label, written in even, graceful, regular script, includes several unidentified names. First, the name of the original owner, Hsiao-fo (meaning "laughing Buddha"), is difficult to identify. In all probability, he was a collector active before the Second World War, as is indicated by the date 1922 provided by the calligrapher. The title of his studio clearly states that, in his collection, he possessed a Han dynasty tile that bore twenty-four incised characters. Such information, however, does not help us to find the owner's true identity. Since the University of Michigan purchased Ch'ien Tsai's painting from the famous professor Ho Ping-ti in 1970, presumably he could have been this mysterious owner. The calligrapher's name is even more difficult to decipher, as he used a character absent from most Chinese dictionaries. He also chose a rare character to represent Hangchou. An old registration card at the Museum states that this label was written by a certain Li Chi. Since no Chinese characters are given, it is still impossible to identify this calligraphy. It is entirely possible that the information on the registration card is erroneous.

2 The first character of Ch'ien Tsai's *tzu, t'o,* is written two different ways. In some books it is written as 蓏, while in others 籜. The first has a *ts'ao* 草 (grass) radical on its top, while the second has a *chu* 竹 (bamboo) radical. Both are pronounced *t'o*. Although the difference is minute, these two characters do possess different meanings. The first character with the grass radical means "fallen

leaves and bark," while the second, with the bamboo radical, means "sheath that envelops the joints of the bamboo, or the young leaves of bamboo shoots." In all probability, the first character, as it appears in Ch'ien Tsai's seals, is the correct one. Yet even in Chinese seal books, this character is mistakenly interpreted as the second. For Ch'ien Tsai's seals, in addition to those found on the Michigan scroll, see Shanghai Museum, *Zhongguo shuhuajia yinjian kuanshi (Chung-kuo shu-hua-chia yin-chien k'uan-shih)* 中國書畫家印鑒款識 (Signatures and Seals of Chinese Painters and Calligraphers), vol. 2 (Shanghai: Wenwu Chubanshe, 1987), pp. 1493–96. See also Victoria Contag and Wang Chi-ch'üan 王季銓, *Seals of Chinese Painters and Collectors of the Ming and Ch'ing Periods* (Taipei: Shang-wu Press, 1965), pp. 469–70. For the meanings of these two characters, see R. H. Mathews, *Mathews' Chinese-English Dictionary*, rev. American ed. (Cambridge, Mass.: Harvard University Press, 1963), p. 937.

3 It is a Chinese tradition to call oneself a *ti* 弟, or "junior," when addressing a friend, no matter who is younger. Among Confucians, it is a way to express modesty and courtesy, although in a rather feigned manner.

4 See Jiang Bao-ling (Chiang Pao-ling) 蔣寶齡 (1781–1840), *Molin jinhua (Mo-lin chin-hua)* 墨林今話 (Recent Conversations in the Ink Circles), preface dated 1851, *juan (chüan)* 卷 (chapter) 3, p. 2, reprint (Hefei: Huangshan Shushe, 1992), p. 75. Chiang's book comments on painters of the eighteenth and nineteenth centuries.

5 This collecting seal belongs to Mr. Yü Kuang-pi, an unidentified twentieth-century collector from Hsin-fan in Szechwan province.

6 This collecting seal also belongs to Mr. Yü Kuang-pi. This seal identifies Mr. Yu as from Hsin-fan, a small town located in Szechwan province.

7 For more on Ch'ien Tsai's hometown, see Qian Yong's (Ch'ien Yung) 錢泳 (1759–1844) *Luyuan huaxue (Lü-yüan hua-hsüeh)* 履園畫學 (The Knowledge of Painting at the Author's Garden of Fulfillment), preface dated 1822, reprinted in Yu Anlan 于安瀾, comp., *Huashi congshu (Hua-shih ts'ung-shu)* 畫史叢書 (Compendium of Painting History), vol. 9 (Shanghai: Renmin Meishu Chubanshe, 1962), p. 3.

8 For the history of the Ch'ien family, see P'an Kuang-tan 潘光旦, *Ming-Ch'ing liang-tai Chia-hsing teh wang-tsu* 明清兩代嘉興的望族 (The Distinguished Families in the Chia-hsing Area during the Ming and

Ch'ing Dynasties) (Shanghai: Commercial Press, 1947), pp. 24b–26.

9 See ibid.

10 According to P'an Kuang-tan, the author of the *Ming-Ch'ing liang-tai Chia-hsing teh wang-tsu* 明清兩代嘉興的望族 (The Distinguished Families in the Chia-hsing Area during the Ming and Ch'ing Dynasties), Ch'ien Tsai's real ancestor was originally from a certain Ho 何 family and was adopted by the Ch'iens at the beginning of the Ming dynasty. Traditionally, an adopted son must bear his foster father's family name; thus, the Ho boy became a member of the Ch'ien family.

11 See Zhang Geng (Chang Keng) 張庚 (1685–1760), *Guochao huazhengxulu (Kuo-ch'ao hua-cheng hsü-lu)* 國朝畫徵續錄 (Sequel to Biographical Sketches of the Artists of the Ch'ing Dynasty), *juan (chüan)* 卷 (chapter) 2, reprinted in *Hua-shih ts'ung-shu* 畫史叢書 (Compendium of Painting History), vol. 5, p. 102. Wei Chung-hsien was an evil eunuch notorious for his corruption and lust for power. After gaining the favor of the Emperor Hsi-tsung 禧宗 (r. 1621–27), he persecuted a number of generals and tortured a number of politicians in an effort to consolidate his influence over the ruler. This resulted in a weakened military and loss of territory. He dealt ruthlessly with anyone who disagreed with him; consequently, it was an act of great courage for Ch'ien Chia-cheng to report Wei Chung-hsien's crimes to the emperor. For information on Wei Chung-hsien, see Arthur W. Hummel, ed., *Eminent Chinese of the Ch'ing Period (1644–1912)*, vol. 2 (Washington, D.C.: United States Government Printing Office, 1943–44), pp. 846–47.

12 For information on Ch'ien Ch'en-ch'ün, see *Eminent Chinese of the Ch'ing Period (1644–1912)*, vol. 1, pp. 146–47.

13 The importance of Ch'ien Tsai's teachers on his life and art cannot be minimized. Foremost among them was his great grand aunt, Ch'en Shu. For her brief biography, see *Eminent Chinese of the Ch'ing Period (1644–1912)*, vol. 1, p. 999. The extent of Ch'en Shu's education was extraordinary; she possessed a thorough knowledge of Chinese history, literature, and painting. Her ability in composing poems was also quite developed. Her intense dedication to educational pursuits is probably the reason why she waited until her mid-twenties to marry, at the time considered rather late for a Chinese woman. The second wife of Ch'ien Lun-kuang 錢綸光 (1655–1718), she had three sons and one daughter. Because her husband was away working for his father, Ch'en assumed

responsibility for the household and for the education of her three sons. She often sold paintings to supplement the family's income, and her actions won great respect. As the grand madam of her husband's clan, she often settled disputes even between members of her extended family. The great success of her eldest son, Ch'ien Ch'en-ch'ün 錢陳群 was a testament to her endeavors. He became a capable official and eminent poet, winning the favor of the emperor. The mother's careful cultivation of her son's sense of aesthetics was extremely important. At age twenty-eight, Ch'ien Ch'en-ch'ün was in Tientsin 天津, and his knowledge of painting won him the friendship of An Ch'i 安歧 (1683?–?), the great Korean connoisseur and owner of one of the largest and most important collections of paintings in all of China. Many of the masterpieces in the Palace Museum in Taipei today were originally in this most famous collection. Ch'ien Ch'en-ch'ün's association with An must have given him access to these fabulous works. For Ch'ien Ch'en-ch'ün's impressive career, see *Eminent Chinese of the Ch'ing Period (1644–1912)*, vol. 1, pp. 146–47. Ch'en Shu's youngest son, Ch'ien Chieh 錢界 (1691–1758), also studied painting from his mother. Although skilled in an untrammeled style, he remained overshadowed by the success of his older brother. For more information on Ch'ien Chieh, see *Kuo-ch'ao hua-cheng hsü-lu* 國朝畫徵續錄 (Sequel to Biographical Sketches of the Artists of the Ch'ing Dynasty), *chüan* 卷 (chapter) 2, pp. 109–10. Another of Ch'en Shu's famous students was Chang Keng 張庚 (1685–1760), whose mother was the sister of Ch'en Shu's husband. Chang wrote several extensive works on painters and paintings of the Ch'ing period. Chang Keng's best-known book is, of course, *Kuo-ch'ao hua-cheng lu* 國朝畫徵錄 (Biographical Sketches of the Artists of the Ch'ing Dynasty), which is considered the most comprehensive work dealing with painters active from the early Ch'ing dynasty to the mid-eighteenth century. One can assume that much of his knowledge and commentary was indebted to Ch'en Shu's instruction. Ch'ien Tsai was probably the last and youngest student of Ch'en Shu. By the time Ch'ien Tsai began studying with her as a young teenager around 1725, she would have been in her mid-sixties. Free of the obligations of raising her children as well as providing for her household, Ch'en Shu must have had more time to dedicate to Ch'ien Tsai's training. In many books dealing with Ch'en Shu and Ch'ien Tsai, however, one often encounters two mistakes. The first

is a story that Chang Keng and Ch'ien Tsai studied together under Ch'en Shu. See Chiang Pao-ling's *Mo-lin chin-hua* 墨林今話 (Recent Conversations in the Ink Circles), *chüan* 卷 (chapter) 3, p. 1 (or reprint, p. 73). As Chang Keng was more than 20 years older than Ch'ien Tsai, this seems highly unlikely. It is possible, however, that Chang Keng studied with Ch'en Shu's two sons, Ch'ien Ch'en-ch'ün and Ch'ien Chieh, as they were closer in age. The second misconception is the claim by some scholars that a court painter of the Ch'ing dynasty, Ch'ien Wei-ch'eng 錢維城 (1720–92), studied with Ch'en Shu along with the above-mentioned students. See also *Mo-lin chin-hua* 墨林今話 (Recent Conversations in the Ink Circles) *chüan* 卷 (chapter) 3, p. 1 (or reprint, p. 73). This is also highly unlikely, as Ch'ien Wei-ch'eng was far younger and also descended from a totally different family of Ch'iens, from the province of Kiangsu 江蘇.

14 For the source of Ch'ien Tsai's nickname, see Yu Jianhua 于劍華 et al., *Zhongguo meishujia renming cidian (Chung-kuo mei-shu-chia jen-ming tz'u-tien)* 中國美術家人名詞典 (A Biographical Dictionary of Chinese Artists) (Shanghai: Renmin Meishu Chubanshe, 1981), p. 1434.

15 The relationship between Ch'ien Tsai and Chiang P'u is found in Chang Keng's *Kuo-ch'ao hua-cheng hsü-lu* 國朝畫徵續錄 (Sequel to Biographical Sketches of the Artists of the Ch'ing Dynasty), *chüan* 卷 (chapter) 2, p. 102.

16 According to Chiang Pao-ling, Ch'ien Tsai was an expert on authenticating antiques, calligraphy, and paintings. See Chiang's *Mo-lin chin-hua* 墨林今話 (Recent Conversations in the Ink Circles), *chüan* 卷 (chapter) 3, p. 2, (or reprint, p. 75).

17 For information on Ch'ien Tsai's painting in the manner of Yün Shou-p'ing, see ibid.

18 Ch'ien Tsai's grandson, Ch'ien Ch'ang-ling 錢昌齡 (1771–1827), was an orchid and bamboo painter. Ch'ang-ling's daughter, Ch'ien Chü-ying 錢聚瀛 (active mid-19th century), and nephew, Ch'ien Chü-ch'ao 錢聚朝 (1806–60), excelled in both painting and poetry. Ch'ien Chang-ling's brief biography can be found in *Chung-kuo mei-shu-chia jen-ming tz'u-tien* 中國美術家人名詞典 (Biographical Dictionary of Chinese Artists), p. 1428. His daughter, Ch'ien Chü-ying, is also recorded in this book, p. 1435. The University of Michigan owns one of her fan paintings. It is reproduced in Marsha Weidner et al., *Views from the Jade Terrace: Chinese Women Artists, 1300–1912* (Indianapolis: Indianapolis Museum of Art, 1988), cat. no. 57, pp. 145–76. The entry on Ch'ien Chü-ying was written by Ellen Johnston Laing.

19 See *Eminent Chinese of the Ch'ing Period (1644–1912)*, vol. 1, p. 157.

20 See Chiang Pao-ling's *Mo-lin chin-hua* 墨林今話 (Recent Conversations in the Ink Circles), *chüan* 卷 (chapter) 3, p. 3a (or reprint, p. 75).

21 See Ch'ien Yung's *Lü-yüan hua-hsüeh* 履園畫學 (The Knowledge of Painting at the Author's Garden of Fulfillment), p. 3.

22 This episode is recorded in *Mo-lin chin-hua* 墨林今話 (Recent Conversations in the Ink Circles), *chüan* 卷 (chapter) 18, p. 9 (or reprint, p. 461). The name of this counterfeiter was Ts'ao Jung 曹溶, and his *tzu* was Hua-yin 花尹, meaning "the flower that rules." According to this source, demand for these forgeries was so great that the artist finally had to stop his practice when he was overwhelmed by numerous commissions. He should not be confused with the better-known Ts'ao Jung 曹溶 (1613–85), a scholar and official during the K'ang-hsi period 康熙 (r. 1662–1722). The biography of the famous Ts'ao Jung is found in *Eminent Chinese of the Ch'ing Period (1644–1912)*, vol. 2, p. 740.

23 The term "raw paper" indicates a type of rice paper without a sized surface. Paper with a sized surface is usually called *fan-chih* 礬紙, literally meaning "alum paper," referring to the mineral substance used in the process of sizing. Ink is much easier to control on a sized surface. However, for literati artists favoring semi-abstract and untrammeled work, raw paper is usually preferred, as ink on this surface immediately spreads out, providing a more spontaneous application of ink and water.

24 The Michigan scroll by Ch'ien Tsai is dated 1787. Ch'ien himself stated in his inscription that he executed it when he was eighty years old. (According to the Western system, he would have been only 79.) Ch'ien died in 1793. Thus, the Michigan scroll was completed six years before he passed away.

25 Among the three, Liang asserted that Ch'ien was best at orchid and bamboo and least accomplished in the depiction of old, gnarled trees.

26 For Liang T'ung-shu's comments on Ch'ien Tsai's painting, see Chiang Pao-ling's *Mo-lin chin-hua* 墨林今話 (Recent Conversations in the Ink Circles), *chüan* 卷 (chapter) 3, p. 2 (reprint, p. 76). (此翁一派天趣, 雖不佳亦佳.)

27 Ch'ien Tsai's poem is also cited in ibid. (胸中空癖無一物 筆與造化相淋漓.)

## 40. Cheng Hsieh 鄭燮
*(1693–1765)*
*Ch'ing dynasty (1644–1911)*

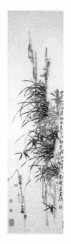

### Bamboo and Orchids
*Lan-chu t'u chou*
*(Hanging Scroll with Bamboo and
   Orchids)*
蘭竹圖軸

1  Cheng Hsieh signed his name on the
Michigan scroll as *Pan-ch'iao tao-jen,
Cheng Hsieh* 板橋道人鄭燮, or "Cheng
Hsieh, a cultivated person on a wood-plank
bridge." *Tao-jen* 道人 means "a cultivated
person." It is different from *tao-shih* 道士,
which means a "Taoist." See *Hanyu dacid-
ian* 漢語大詞典 (Chinese Terminology Dic-
tionary), vol. 10 (Shanghai: Hanyu Dacid-
ian Press, 1988), p. 1065, s.v. "*daoren (tao-
jen)* 道人." The "wood-plank bridge" indi-
cates a rough and rudimentary bridge in a
rural region. It implies a desolate environ-
ment in which the cultivated person
dwells. Sometimes people simply refer to
Cheng by the first half of this name, Pan-
ch'iao.

2  The meanings of Cheng Hsieh's seals are
addressed at the end of the commentary.

3  *Ya-t'ou* 丫頭 literally means "a young girl
with two tufts on her head," a coiffeur
characteristic of maidens or maid servants.
It was a somewhat derogatory manner of
addressing a young girl or a slave girl.
Either way, it denigrates the value of
young women in a male-dominated soci-
ety. The term *ma ya-t'ou* refers to a young
woman with pock marks on her face, an
unattractive maid.

4  Ch'ing-t'eng, meaning "green rattan," was
Hsü Wei's 徐渭 (1521–93) *hao.* Hsü, a
famous artist of the Ming dynasty
(1368–1644), was well known for his talent
and eccentric behavior. For his biography,
see L. Carrington Goodrich and Fang
Chaoying, eds., *Dictionary of Ming Biogra-
phy, 1368–1644,* vol. 1 (New York and Lon-

don: Columbia University Press, 1976), pp.
609–12.

5  Nien-hsien is the given name of Ting
Nien-hsien 丁念先 (1906–69), a collector
from Shanghai who settled in Taipei after
the Communist revolution in 1949. The
name of his collection was *Nien-sheng lou*
念聖樓 (Remembering the Sages Pavilion).
Most of the paintings and calligraphic
works in his collection were from the
Ming and Ch'ing dynasties. Encountering
difficulties with the Taiwanese govern-
ment and under financial pressure, he sold
many works between 1960 and 1969. One
of the better-known paintings in his collec-
tion, a set of twelve album leaves of vari-
ous subjects by Min Chen 州貞 (1730–after
1788), was sold by his descendants to the
Cleveland Museum of Art in 1985 through
auction. See Sotheby's sales catalogue, *Fine
Chinese Paintings* (New York: Sotheby's,
June 3, 1985), lot no. 69.

6  See note 5.

7  The moving and poignant story of Cheng
Hsieh's faithful nanny can be found in
*Cheng Pan-ch'iao ch'üan-chi* 鄭板橋全集
(Complete Collection of Cheng Hsieh's
Writing), reprint (Taipei: T'ien-jen Press,
1968), p. 33. Traditionally, the relationship
between master and servant in China was
defined by lifelong loyalty. A faithful, kind
servant would take care of the master's
orphans and would even try to earn money
to support a poor master. Cheng Hsieh's
nanny, a mother of several children, could
have left her master's home and returned
to her own home to be supported by her
offspring. Nevertheless, after Cheng's
mother died, she stayed with the Cheng
family and cared for young Cheng Hsieh
with allegiance and compassion. According
to Cheng's account, his nanny's family
name was Fei 費; she was originally a maid
serving Cheng's grandmother. Cheng
Hsieh was only four years old when his
mother died. Fei took over the responsibil-
ity of raising the young orphan during a
time of great difficulty. In order to make
money to support herself and her master's
family, she had to find an outside job.
Every morning, she would carry the young
Cheng on her back and go to the market-
place to buy him a bun. Only then did she
begin her daily routine. Any delicious food,
such as meat or fruits, she would offer to
Cheng instead of to her own children, who
were about the same age. Later, the finan-
cial situation of the Cheng family became
worse, and Fei's husband told her to return
home. She wept but dared not disobey. She
washed and mended Cheng Hsieh's old gar-
ments and filled the urns in the kitchen
with fresh water, which was probably
drawn from a water well and carried home.

She also bought several bundles of wood
and put them beside the stove in the
kitchen. Before she departed, she prepared
a bowl of rice and a meager dish, which
she usually fed her young master. In the
morning, the young Cheng woke up and
went to her room and found it was empty.
This separation brought great sorrow—
Cheng was completely devastated and
could not even eat the food she prepared.
Such a difficult childhood trauma perhaps
contributed to Cheng's eccentric personal-
ity in later years. Three years later, when
the situation of Fei's family improved, she
came back and once again resumed the
responsibility of caring for her young mas-
ter. Later, her own son became a minor
civil official, in charge of the river dike.
Although the son tried to take his aged
mother home, she declined. She stayed
with the Cheng family for another thirty-
four years and died at the age of seventy-
six. When Cheng Hsieh wrote poetry as an
adult, he often reminisced about the kind-
ness of this nanny. By the time he became
established, this good woman had already
died. Lamenting her kindness and love,
Cheng composed an emotional and nostal-
gic poem in memory of her:

A Poem [in Memory] of My Nanny

Throughout my life, [I] owe many for
   [their] kindness;
My nanny is not the only one.
However, I lament that my prosperity
   came so late, [and I could not recip-
   rocate her grace];
This makes me feel tremendously
   ashamed.
[Her] road to the nether world is wind-
   ing and treacherous,
Her hair was already white and her face
   wrinkled.
Now with my ample salary, I can afford
   rich delicacies;
Yet nothing tastes as good as the buns
   she, years ago, bought for me!

乳母詩

平生所負恩, 不獨一乳母.
長恨富貴遲, 遂令慚恩久.
黃泉路迂闊, 白髮人老醜.
食祿千萬鍾, 不如餅在手!

8  The old-style private school in China was
called *ssu-shu* 私塾, literally "a private
study place." As a rule, such schools had
only one room and housed students from
ages six to fifteen. One teacher was respon-
sible for tutoring all of the children at their
respective levels. There were no classes on
physical education, music, science, or art.
Only Chinese history and literature were
taught. Students were encouraged to mem-

orize a whole text without much explanation from the tutor. Anyone who wished to get an education was compelled to attend this kind of school. This system was finally abolished at the turn of this century when Western school systems were introduced.

9   By the time Cheng Hsieh moved to Yangchou, it is unclear with whom he studied; however, it is clear he was selling his paintings.

10  The prince with whom Cheng Hsieh was acquainted, Yün-hsi 允禧 (1710–58), was the twenty-first son of Emperor K'ang-hsi 康熙 (r. 1663–1722). Yün-hsi was given the title of Shen Chün-wang 慎郡王 (Prince of Prudence). His *tzu* was Ch'ien-chai 謙齋 (Hall of Humbleness) and his *hao*, Tzu-ch'iung 紫瓊 (purple jade). He was an accomplished poet who could also paint. For his brief biography, see Yu Jianhua 于劍華 et al., *Zhongguo meishujia renming cidian (Chung-kuo mei-shi-chia jen-ming tz'u-tien)* 中國美術家人名詞典 (A Biographical Dictionary of Chinese Artists) (Shanghai: Renmin Meishu Chubanshe, 1981), p. 21. For more information on the friendship between Cheng Hsieh and Prince Yün-hsi, see Xu Shiqiao 徐石橋 and Huang Shucheng 黃淑成, "Zheng Banqiao yu Kangxi ershiyi zi (Cheng Pan-ch'iao yü K'ang-hsi erh-shih-i tzu)" 鄭板橋與康熙二十一子 (Cheng Hsieh and the Twenty-first Son of Emperor K'ang-hsi), in Xue Yongnian 薛永年, ed., *Yangzhou baguai kaobian ji (Yang-chou pa-kuai k'ao-pien chi)* 揚州八怪考辨集 (A Collection of Essays Examining the Writings on the Eight Eccentrics of Yangzhou), contained in *Yangzhou baguai yanjiu ziliao congshu (Yang-chou pa-kuai yen-chiu tzu-liao ts'ung-shu)* 揚州八怪研究資料叢書 (Series of Books on the Eight Eccentrics of Yangzhou) (Jiangsu: Meishu Chubanshe, 1992), pp. 325–28.

11  This episode is found in Zeng Yan's (Tseng Yen) 曾衍 (1750–1825) *Xiaotoupeng xuan (Hsiao-tou-p'eng hsüan)* 小豆棚選 (Selected Anecdotes Told under a Small Bean Trellis), reprint, selected and edited by Xu Zhenglun 徐正倫 and Chen Ming 陳銘 (Hangzhou: Zhejiang Gujichubanshe, 1986), p. 99.

12  For a detailed discussion of how Cheng Hsieh was dismissed from his official position, see Huang Shucheng 黃淑成, "Zheng Xie diuguan kao (Cheng Hsieh tiu-kuan k'ao)" 鄭燮丟官考 (An Investigation into Cheng Hsieh's Loss of Official Position) in Xue Yongnian's 薛永年 *Yang-chou pa-kuai k'ao-pien chi* 揚州八怪考辨集 (A Collection of Essays Examining the Writings on the Eight Eccentrics of Yangzhou), pp. 387–92.

13  Among the Eight Eccentrics of Yangchou, Cheng Hsieh enjoyed greater popularity than other members of the group, and episodes from his life were well known, even among ordinary people. Even today, when dealing with these painters, people often use Cheng's name to represent the whole group; few can provide the names of the other Yangchou Eccentrics.

14  The source for Cheng Hsieh's price list can be found in Gu Linwen 顧麟文, ed., *Yangzhou bajia shiliao (Yang-chou pa-chia shih-liao)* 揚州八家史料 (Historical Materials of the Eight Eccentrics of Yangzhou) (Shanghai: Renmin Chubanshe, 1962), pp. 118–19. For a discussion of Cheng Hsieh's price list, see Ginger Cheng-chi Hsü, "Zheng Xie's Price List: Painting as a Source of Income in Yangzhou," in Ju-hsi Chou and Claudia Brown, eds., *Chinese Painting under the Qianlong Emperor: The Symposium Papers in Two Volumes (Phœbus 6.2)* (Tempe: Arizona State University, 1991), pp. 261–71.

15  For the names of the Eight Eccentrics of Yangchou, see note 21 of entry 36 on Huang Shen 黃慎 (1687–1770?).

16  Chin Nung once composed an inscription for his bamboo painting dated 1761. His writing seems to suggest the competition between him and Cheng Hsieh. Chin Nung's inscription says: "My friend Cheng Pan-ch'iao (Cheng Hsieh), a *chin-shih* from Hsing-hua, was skilled in depicting the sparse and thin branches [of bamboo]. His works [truly] possessed the plant's characteristic simplicity and elegance. I am also a [bamboo] painter of the same style. If someone compares our works, [he will find that I am] an inferior artist [who does not] retain the 'breath of the forest' (the lofty demeanor of a recluse) like him (my friend Cheng Hsieh)." (吾友興化鄭板橋進士, 擅寫疏篁瘦篠. 頗得蕭爽之趣. 予寫此者, 亦其流派也. 設有人相較吾兩人畫品, 終遜其具有林下風度耳.) See Chin Nung's *Tsa-hua t'i-chi* 雜畫題記 (Inscriptions on Paintings of Miscellaneous Subjects), reprinted in Teng Shih 鄧實 (1865?–1948?) and Huang Pin-hung 黃賓虹 (1865–1955), comps., *Mei-shu ts'ung-shu* 美術叢書 (Anthology of Writings on Fine Art), *chi* 集 (part) 3, *chi* 輯 (division) 3 (Taipei: I-wen Bookstore, 1963–72), vol. 11, p. 187.

17  In breaking away from traditional painting styles, the Yangchou painters stressed spontaneity and new compositional arrangements. Their works, playful and direct, often bear lively inscriptions merged into the composition. These artists inscribed poems amid tree leaves, between tree trunks, and amid bamboo stalks. In some Yangchou paintings, the calligraphy almost functions as elements in the background. For example, see Li Shan's 李鱓 (1686–1760?) *Bamboo and Calligraphy*, in the former John Crawford, Jr. Collection, published in Wan-go Weng, *Chinese Painting and Calligraphy: A Pictorial Survey* (New York: Dover Publications, 1978), pl. 68, pp. 146–47. In this work, Li Shan's calligraphy is clearly more important than the bamboo.

18  For a definition of "green mountain," see *Han-yü ta-tz'u-tien* 漢語大詞典 (Chinese Terminology Dictionary), vol. 11, p. 516, s.v. "qingshan (ch'ing-shan) 青山" (green mountain).

19  "Green mountain" has always been a popular idiom in painters' inscriptions. For example, the famous painter T'ang Yin 唐寅 (1470–1523) once wrote, "Hsien-lai hsieh-teh ch'ing-shan mai, pu-shih jen-chien tso-nieh ch'ien 閑來寫幅青山賣, 不使人間作孽錢," or "I would rather sell a landscape of the green mountains that I painted at my leisure than spend the filthy lucre of this mundane world!" See He Liangjun (Ho Liang-chün) 何良俊 (1506–1573), *Siyouzhai congshuo (Ssu-yu chai ts'ung-shuo)* 四友齋叢說 (The Collected Notes at [Ho's] Four-Friend Studio), preface dated 1569, *juan (chüan)* 卷 (chapter) 29, reprinted in *Yuan Ming shiliao biji congkan (Yüan-Ming shi-liao pi-chi ts'ung-k'an)* 元明史料筆記叢刊 (A Series of Literary Sketches on Historical Materials of the Yüan and Ming Dynasties) (Beijing: Zhonghua Press, 1959) p. 133.

20  For the historical background on Shuang-chiu, see *Han-yü ta-tz'u-tien* 漢語大詞典 (Chinese Terminology Dictionary), vol. 2, p. 1552, s.v. "Shuangjiu (Shuang-chiu) 爽鳩," and in the same dictionary, p. 1655, s.v. "Shaogao (Shao-kao) 少皞."

21  For the meaning of ya-t'ou, see note 3.

22  See *Tz'u-hai* 辭海 (Sea of Terminology: Chinese Language Dictionary), vol. 2 (Taipei: Chung-hua Press, 1974), p. 2403, s.v. "Hsing-hua 興化 ."

23  For an example of Hsü Wei's work, see his long handscroll entitled *Twelve Plants and Twelve Calligraphies*, at the Honolulu Academy of Arts. It is reproduced in Suzuki Kei 鈴木敬, comp., *Comprehensive Illustrated Catalog of Chinese Paintings*, vol. 1 (Tokyo: University of Tokyo Press, 1982), no. A38-004, pp. 388–89. A section of this work is also reproduced in Fu Shen, C. Y. 傅申, *Traces of the Brush: Studies in Chinese Calligraphy* (New Haven: Yale University Art Gallery, 1977), no. 61, pp. 192–93. Interestingly, in Fu's book, under Hsü Wei's handscroll, there is another version of Cheng Hsieh's *Bamboo and*

**Cheng Hsieh** 鄭燮
**Bamboo and Orchids**
*continued*

128

*Orchids,* which is dated 1742. This work is currently at the Art Museum, Princeton University. Such an arrangement is possibly for the purpose of comparing Cheng Hsieh's and Hsü Wei's respective styles.

**41. Shih Ch'ü** 石渠
*active Chia-ch'ing* 嘉慶 *period*
*(1796–1820)*
*Ch'ing dynasty (1644–1911)*

**Portrait of Tseng Ching**
**(1564–1647)**

*Tseng P'o-ch'en hsien-sheng hsiang
(Portrait of Mr. Tseng P'o-ch'en [Tseng
Ching's* tzu *meaning "an emperor's
servitor on waves"])*

曾波臣先生像

1  P'o-ch'en 波臣 (an emperor's servitor on waves) is Tseng Ching's *tzu.*

2  Hsi-ku 西谷 is the *tzu* of Shih Ch'ü 石渠, the artist who copied this portrait of Tseng Ching.

3  For more information on P. S. Chiang of Seattle, see note 4 of entry 19 on Tseng Ching's *Portrait of P'an Ch'in-t'ai.*

4  Tsui-li 檇李 was the ancient name for Chia-hsing 嘉興 in Chekiang. Tsui-li literally means "drunken plum," indicating the well-known local fruit, juicy by nature and bearing a ruddy blush such as would characterize the complexion of a drunkard. See *Hanyu dacidian (Han-yü ta-tz'u-tien)* 漢語大詞典 (Chinese Terminology Dictionary), vol. 4 (Shanghai: Hanyu Dacidian Press, 1988), p. 1315, s.v. "Zuili (Tsui-li) 檇李."

5  For more information regarding Hsiang Tzu-ching, see note 10.

6  Three place names are included in this sentence. The first one, P'ing-chiang 平江, could refer to two different cities in ancient times. One is in Hunan 湖南 province, which bears no relation to Tseng Ching's creative career. The other is Wu-hsien 吳縣, or Suchou, where Tseng Ching often visited and executed many portraits of the local gentry. See entry 19 for Tseng Ching's portrait of P'an Ch'in-t'ai, and see *Tz'u-hai* 辭海 (Sea of Terminology: Chinese Language Dictionary), vol. 1 (Taipei:

Chung-hua Press, 1974), p. 1036, s.v. "P'ing-chiang 平江." The second place name mentioned in this sentence is Chih-shui 淛水, which is the ancient name of Chekiang 浙江, or the River of Che, from which Chekiang province is named. Thus, Chih-shui indicates the Chekiang area. See *Sea of Terminology,* p. 1733, s.v. "Chih-shui 淛水." The third place name mentioned is San-Wu 三吳, or the "Three Wu area." This name could indicate four different locations. See *Sea of Terminology,* p. 27, s.v. "San-Wu." The one most applicable to this inscription is the area that includes portions of the Kiangsu and Chekiang provinces.

7  Shen Tsung-ch'ien 沈宗騫 (active c. 1770–1817) was from Wu-ch'eng 烏程, Chekiang. His *tzu* was Hsi-yüan 熙遠 (prosperity and longevity) and his *hao,* Chieh-chou 芥舟 (small boat). A calligrapher, he also painted landscapes and figures. See Yu Jianhua 于劍華 et al., *Zhongguo Meishujia Renming Cidian (Chung-kuo mei-shu chia jen-ming tz'u-tien)* 中國美術家人名詞典 (Biographical Dictionary of Chinese Artists) (Shanghai: Renmin Meishu Chubanshe, 1981), p. 424. For examples of Shen's painting, see Group for the Authentication of Ancient Works of Chinese Painting and Calligraphy, ed., *Zhongguo gudai shuhua tumu (Chung-kuo ku-tai shu-hua t'u-mu)* 中國古代書畫圖目 (Illustrated Catalogue of Selected Works of Ancient Chinese Painting and Calligraphy), vol. 7 (Beijing: Wenwu Chubanshe, 1987), nos. 蘇 24-1028, 蘇 24-1029, 蘇 24-1030, p. 229.

8  Hsi-wu 西吳 is the ancient name of Wu-hsing 吳興, or present-day Hu-chou 湖州, located in northern Chekiang. For more on Fei Tan-hsü, see entry 46.

9  For more information on Tseng Ching and his work, see entry 19.

10  Hsiang Tzu-ching was the premier collector of Chinese painting and calligraphy during the early seventeenth century, before the Manchus invaded China in 1644. References to three of his great-grandsons are found in Chinese records. The most prominent was Hsiang Kuei 項奎 (active 18th century), a painter and contemporary of Hsin Chi-chang. It is quite possible that Hsiang Kuei was the one who owned the original Tseng Ching self-portrait in Hsin Chi-chang's time. See Cheng Shu-yin 鄭銀淑, *Hsiang Yüan-pien chih shu-hua shou-ts'ang yü i-shu* 項元汴之書畫收藏與藝術 (Hsiang Yüan-pien's Painting and Calligraphy Collection and His Art), in *I-shu ts'ung-k'an* 藝術叢刊 (Collection of Art Books Series) (Taipei: Wen-shih-che Press, 1984), p. 19. See also

## 42. Chang Ch'i 張琪
*(active 18th century)*
*Ch'ing dynasty (1644–1911)*

129

P'an Kuang-tan 潘光旦, *Ming-Ch'ing liang-tai Chia-hsing teh wang-tsu* 明清兩代嘉興的望族 (The Distinguished Families in Chia-hsing during the Ming and Ch'ing Dynasties) (Shanghai: Commercial Press, 1947), pp. 42–43, which indicates that Cheng Shu-yin drafted a family tree of Hsiang Tzu-ching and clearly designated Hsiang Kuei as the son of Hsiang Hui-mo 項徽謨, the grandson of Hsiang Tzu-ching. The well-known painter Hsiang Sheng-mo 項聖謨 (1597–1658) was Hsiang Kuei's uncle.

11 See entry 46, on Fei Tan-hsü.

12 Hsin Chi-chang and Fei Tan-hsü's father both studied under Shen Tsung-ch'ien 沈宗騫 (active c. 1770–1817). See note 7.

13 Hsin Chi-chang's given name was Hsin K'ai 莘開. See *Chung-kuo mei-shu chia jen-ming tz'u-tien* 中國美術家人名詞典 (Biographical Dictionary of Chinese Artists), p. 928.

14 See ibid., p. 928.

15 See ibid., p. 177. See also *Chung-kuo li-tai shu-hua chuan-k'e chia tzu-hao suo-yin* 中國歷代書畫篆刻家字號索引 (An Index of the Sobriquets of the Painters, Calligraphers, and Seal-Carvers of Past Dynasties), vol. 2 (Hong Kong: Chinese Painting Research Association, 1974), p. 120.

16 Shih Ch'ü's biography is found in "Shi Qu Wu Mi zhuan (Shih Chü Wu Mi chuan) 石渠吳芑傳" (Biographies of Shih Ch'ü and Wu Mi) in Yang Xian's (Yang Hsien) 楊峴 (1819–96), *Chihongxuan wenxu (Ch'ih-hung-hsüan wen-hsü* 遲鴻軒文續 (Sequel to the Writings from the Late Wild Goose Studio), preface dated 1893, reprinted in *Chihongxuan ji (Ch'ih-hung hsüan chi)* 遲鴻軒集 (Collected Writings at the Late Wild Goose Studio), vol. 3 (Beijing: Wenwu Chubanshe, 1992), p. 13 a & b. The entry reads: "Shih Ch'ü's *tzu* was Hsi-ku. He was from Kuei-an and was adept in painting religious figures. Consequently, people called him Shih-fo (Shih the Buddha). At the age of seventy, he still looked like a person in his forties or fifties. His contemporary Fei Tan-hsü, who was from Wu-ch'eng, was also a famous painter. I [Yang Hsien] acquired a painting by Fei entitled *A Beauty Taking a Break from Embroidering* and showed it to Shih. Shih commented that the seductive expressions on the face of the beauty in Fei's painting was similar to that found on the faces of women depicted in the erotic works by the Ming painter Ch'iu Ying (1502?–1552). [Shih continued that] before the Ming period, no artist ever executed this type of painting. However, people's hearts [morality] were not what they were in the old

days. [People] were fond of lewd and ugly [things]. [Thus] Fei's fame in the future would surely overshadow mine [Shih Ch'ü]. [Yang continues] this [regrettably] turned out to be true. Today, people know only of Fei Tan-hsü. Few have ever heard of Shih Ch'ü." (石渠, 字西谷. 歸安人. 善畫仙佛, 人呼曰: '石佛.' 年七十餘, 望之如四五十許人. 同時烏程費丹旭, 亦以畫名. 余得所畫' 美人倦繡圖' 示君. 君曰: '眉目間有春意. 明, 仇英 '秘戲圖' 耳. 明以前, 無此法. 然而人心不古, 好斜而醜. 正若必掩吾名矣. 已而果然. 至今知有丹旭, 不知有君也.)

17 See ibid., p. 13 a & b.

18 For more information on tables of the Ming dynasty, see Wang Shixiang 王世襄, *Classic Chinese Furniture: Ming and Early Qing Dynasties* (Beijing and Hong Kong: Joint Publishing Co., 1986), pp. 132–67.

19 This is recorded in an entry by Huang Tsung-hsi 黃宗羲 (1610–96), in his *Wu-hui chi* 吾悔集 (My Collected Lamentations), compiled in his *Nan-lei chi* 南雷集 (Collected Writings of Nan-lei), vol. 5, *chüan* 卷 (chapter) 2, pp. 2–3. During the seventeenth century in China, the spectacles would have been newly imported and a luxurious novelty. Their presence also suggests Tseng Ching's relative prosperity. See "T'i Chang Tzu-yu Chüan 題張子遊卷" (Colophon on Chang Tzu-yu's Handscroll) in Huang Tsung-hsi's 黃宗羲 (1610–95) *Wu-hui chi* 吾悔集 (My Collected Lamentations), included in *chüan* 卷 (chapter) 28, *Nan-lei chi* 南雷集 (Collected Writings of Nan-lei), reprinted in *chüan* 卷 (chapter) 2 in *Ssu-pu ts'ung-k'an* 四部叢刊 (Selected Volumes from the Ssu-pu Encyclopedia) (Shanghai: Shang-wu Press, 1937–38), reprinted, vol. 5 (Taipei: n.p., 1978), pp. 2–3.

20 See entry 19 on Tseng Ching.

21 During the Ming dynasty, red was a color traditionally reserved for official garments and would indicate an official position. Tseng Ching, as he had no such position, would likely not have applied red pigment on the robe of his own portrait. During the Ch'ing dynasty, color as a whole was more popular; consequently, red was rarely used to indicate official status.

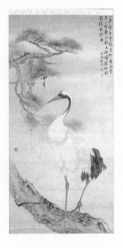

## Crane on a Pine Branch
*Sung-ho t'u*
*(Pine and Crane)*

松鶴圖

1 In April of 1930, representatives from the University of Michigan traveled to New York in order to attend the estate sale of Mrs. H. O. Havemeyer (1855–1929). Prior to this auction, the distinguished Havemeyer collection had been displayed at the Metropolitan Museum of Art, and this auction was a major event in the world of art and antiquities. The University of Michigan successfully acquired a number of fine works, including this painting by Chang Ch'i, which is published in the third volume of the sales catalogue, no. 1390, p. 230. All the objects acquired from this auction were stored at the College of Architecture and Design. In 1972, this painting, along with others from the Havemeyer collection, was transferred to the Museum of Art.

2 The "old man with [green] bristled beard" in this line apparently indicates the pine tree in the painting. Chinese painters often referred to pine trees in their works as old men.

3 The "gentleman" in this line refers to the crane in the painting. To the Chinese, this dignified bird, striding forward with its head up, represented an elegant gentleman with a lofty demeanor.

4 The term *hung-meng* 鴻濛 (sometimes written as 鴻蒙) in this line indicates the chaotic atmosphere before the universe was created. See *Hanyu dacidian (Han-yü ta-tz'u-tien)* 漢語大詞典 (Chinese Terminology Dictionary), vol. 12 (Shanghai: Hanyu Dacidian Press, 1988), p. 1100, s.v. "*hongmeng (hung-meng)* 鴻蒙."

**Chang Ch'i** 張琪
**Crane on a Pine Branch**
*continued*

*(1773–1828)*
*Ch'ing dynasty (1644–1911)*

130  5  Jun-chou is the ancient name for the city of Chinkiang 鎮江, the present-day capital of Kiangsu province.

6  The southern mountain in this line is derived from the famous verse, "Plucking chrysanthemums by the east wattle-fence, leisurely I paused and noticed the hills in the south," found in T'ao Ch'ien's 陶潛 (365–427) *Yin-chiu shih* 飲酒詩 (Wine-drinking Poems). For the complete poem, see entry 16 of Li Shih-ta.

7  For more information on Chang Ch'i, see *Hua-jen pu-i* 畫人補遺 (An Addendum of the Painters' Biographies), c. 18th century, reprinted in William Yeh Hung 洪業, ed., *Ch'ing hua-chuan chi-i san-chung fu yin-te* 清畫傳輯佚三種附引得 (Biographies of Ch'ing Dynasty Painters in Three Collections) in supplement no. 8, Harvard-Yenching Institute Sinological Index Series (Peking: Yenching University Library, 1934), p. 39b.

8  For more on Chang Ch'i's relationship with the other two local painters in his hometown, Chinkiang, see ibid. These two painters are also recorded in "*Ts'ao-ho lu-hsia* 草河錄下" (The Accounts of the Grass River), part 2, in Li Tou's 李斗 (active second half of 18th century) *Yang-chou hua-fang lu* 揚州畫舫錄 (The Accounts of the Gaily Painted Pleasure Boats in Yangchou), preface dated 1795, *chüan* 卷 (chapter) 2, reprint (Yangzhou: Jiangsu Guangling Guji Keyinshe, 1984), pp. 40–41. It seems that while Tsai Chia was famous for his flowers, birds, and figures, Chiang Chang was renowned for his large figure paintings executed with his fingers. Chiang's work must have been popular, as his reputation was said to be equal to that of Huang Shen 黃慎 (1687–1770?), the celebrated figure painter among the Eight Eccentrics of Yangchou. See entry 36 on Huang Shen.

9  People often mistakenly believe that the black plumage on a crane is located on its tail. As a matter of fact, the black plumage actually grows on the tips of the bird's two wings and can be seen when the bird is in flight. When cranes fold their wings, the black plumage rests on top of their tails, thus creating the false impression that the cranes have black feathers on their tails.

10  For more information on the "pine and crane" subject matter, see *Han-yü ta-tz'u-tien* 漢語大詞典 (Chinese Terminology Dictionary), vol. 4, p. 877, s.v. "*songhe* (*sung-ho*) 松鶴" (pine and crane). Sometimes, this title is further elaborated by the term *sung-hsing ho-ku* 松形鶴骨 (a person's appearance [is like] a pine tree [with] a crane's [elegant] frame).

11  See ibid., vol. 1, p. 1148, s.v. "*xianqin* (*hsien-ch'in*) 仙禽" (divine fowl) and p. 1152, s.v. "*xianhe* (*hsien-ho*) 仙鶴" (divine crane).

12  When cranes are used as immortals' vehicles, they are often referred to as *hsien-chia* 仙駕, or an "immortal's vehicle." See ibid., p. 1150, s.v. "*xianjia* (*hsien-chia*) 仙駕."

13  For a discussion of Tung Ch'i-ch'ang and his aesthetic philosophy, see "Tung Ch'i-ch'ang's Transcendence of History and Art," in Wai-kam Ho 何惠鑑, ed., *The Century of Tung Ch'i-ch'ang 1555–1636*, vol. 1 (Kansas City: Nelson-Atkins Museum of Art, 1992), pp. 3–41.

**Lady in Her Study with Attendants**
*Shen-kuei kuan-shu*
*(Reading Books at the Inner Chamber)*
深閨觀書

1  Kai Ch'i's birth and death dates are based on Hu Yi's 胡藝 article, "Dui *Zhongguo meishujia renming cidian* (Qingdai bufen) de buzheng (Tui *Chung-kuo mei-shu-chia jen-ming tz'u-tien* [Ch'ing-tai pu-fen] teh pu-cheng) 對中國美術家人名辭典 (清代部分) 的補正"(Revision of [the Ch'ing Dynasty Section of] *Biographical Dictionary of Chinese Artists*), in *Duoyun* (*To-yün*) 朵雲 (Cloud Art Journal) 4 (Shanghai: Shuhua Chubanshe, 1982), p. 235.

2  The first painting attributed to Kai Ch'i was purchased from Ms. Ann Shaftel of Cambridge, Massachusetts, in 1973. The second painting was acquired through Sotheby's, New York, in 1982. It is reproduced in Sotheby's sales catalogue, *Chinese Furniture and Decorations* (New York: Sotheby's, June 5, 1982), lot no. 86. The scroll attributed to Yü Chi was also purchased from an auction at Sotheby's, New York, in 1989. It is reproduced in Sotheby's sales catalogue, *Fine Chinese Paintings* (New York: Sotheby's, December 6, 1989), lot no. 138.

3  A brief biography of Kai Ch'i may be found in Yu Jianhua 于劍華 et al., *Zhongguo meishujia renming cidian* (*Chung-kuo mei-shu-chia jen-ming tz'u-tien*) 中國美術家人名詞典 (Biographical Dictionary of Chinese Artists) (Shanghai: Renmin Meishu Chubanshe, 1981), p. 335. This entry synthesizes information on Kai Ch'i from several books, which are listed at the end of the entry.

## 44. Kai Ch'i 改琦
(1773–1828), attributed to
Ch'ing dynasty (1644–1911)

## 45. Yü Chi 余集
(1738–1823), attributed to
Ch'ing dynasty (1644–1911)

**Presenting Lichee Fruit on a [Carved] Ice Platter**

*Ping-p'an chin-li*
*(Presenting Lichee Fruit on a [Carved] Ice Platter)*

冰盤進荔

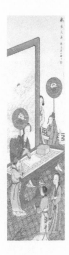

**Presenting Lichee Fruit on a [Carved] Ice Platter**

*Ping-p'an chin-li*
*(Presenting Lichee Fruit on a [Carved] Ice Platter)*

冰盤進荔

4  Wai-shih 外史 is an ancient official title assigned to people who were in charge of the collection of legends and narratives at the court. Later this title was adopted by literati to reflect their literary inclination. For purposes of identifying individuals, a specific word, such as the name of a place or some other elegant term, was often added in front of the title. For example, the artist Chang Yü 張雨 (1277–1348) of the Yüan dynasty called himself Chü-ch'ü wai-shih 句曲外史 (The Literary Official from Chü-ch'ü). The painter Yün Shou-p'ing 惲壽平 (1633–90) of the Ch'ing dynasty called himself Pai-yün-wai-shih 白雲外史 (The White Cloud Literary Official).

5  The term "western region" has two possible interpretations. In the past, most scholars accepted the notion that Kai Ch'i was from Chinese Turkistan, or Sinkiang province, as it was understood that *hsi-yü* referred to this region. Yet more recently, such as in the entry for Kai Ch'i in V. Contag and C. C. Wang's *Seals of Chinese Painters and Collectors of the Ming and Ch'ing Periods* (Shanghai: Commercial Press, 1940), no. 112, p. 138, *hsi-yü* is interpreted as the Yünnan 雲南 and Kuichou 貴州 provinces. Nevertheless, the Yünnan and Kuichou area is traditionally referred to as the *hsi-nan* 西南, or "southwest [region.]" It should not be confused with the *hsi-yü* region in the northwest.

6  Since the 14th century, when Genghis Khan (1167–1227) conquered *hsi-yü*, thousands of Muslims migrated east and set-

tled in China. By Kai Ch'i's time, during the late 18th and early 19th centuries, these Muslims had already been assimilated into the Chinese cultural tradition, although they continued to worship in mosques and refrained from eating pork. This is especially true of Kai Ch'i's home city in the *chiang-nan* 江南, or the lower Yangtze River delta region, an area resplendent with Chinese culture and custom. Kai Ch'i's official biographical record shows that his grandfather's name was Kuang-tsung 光宗, the regional commander of Shou-ch'un 壽春 in Anhui 安徽 province. As a reward for his service, Kuang-tsung was allowed to relocate to Sung-chiang, the fertile area historically referred to as *yü-mi chih-hsiang* 魚米之鄉, or "the land of fish and rice." See Kuo-shih kuan 國史館 (National Historical Bureau), ed., *Ch'ing-shih-kao chiao-chu* 清史稿校注 (The Collated Draft of the History of the Ch'ing Dynasty with Commentary), *chüan* 卷 (chapter) 510, biography 291, art 3, vol. 15 (Taipei: Kuo-shih-kuan, 1990), p. 11555. It says: "Kai Ch'i's *tzu* was Po-yün and his *hao*, Ch'i-hsiang. His ancestors were from the western region. He was the grandson of Kuang-tsung, the Regional Commander in Shou-ch'un [county, Anhui province.] Thus his family moved to the *chiang-nan* (south of bank of the lower Yangtze River delta) and settled down in the county of Hua-t'ing [in Kiangsu province.] Kai Ch'i was bright, quick, and versatile and was adept in poetry. After the Chia-ch'ing (r. 1796–1820) and Tao-kuang (r. 1821–50)

periods, Kai Ch'i was considered the best figure painter. [His style] was close to those [old masters such as] Li Kung-lin (c. 1041–1106), Chao Meng-fu (1254–1322), and T'ang Yin (1470–1524), as well as the style of late painter Ch'en Hung-shou (1598–1652). [Kai Ch'i's] floral painting, including his orchids and bamboo, is from beyond this dusty world. [Stylistically,] it is related to the work of Yün Ko (Yün Shou-p'ing 惲壽平, 1633–90)." (改琦 字伯蘊 號七薌. 先世為西域人 壽春鎮總兵光宗孫. 因家江南 居華亭. 琦通敏多能, 工詩詞. 嘉道後人物, 琦號最工. 出入李公麟, 趙孟頫, 唐寅 及近代陳洪綬諸家. 花草蘭竹小品, 迥出塵表 有惲格遺意.) According to Ch'ien Yung 錢泳 (1759–1844): "Kai Ch'i's *hao* was Ch'i-hsiang. His grandfather was (originally) from the Pei Chih-li region (present-day northern Hopei 河北 province), and served as a *yu-chi* (the former title for a military major) in Sung-kiang (present-day Shanghai), thus settling in Hua-t'ing (near present-day Shanghai). Kai Ch'i was deft in landscape and figure paintings. He was well known in an area between Suchou and Sung-chiang. His calligraphy in the regular script and in small size is also outstanding. It is unconstrained, elegant, and saturated [with ink]." (改琦, 號七薌. 其祖本北直隸人. 官松江遊擊, 遂占籍華亭. 工山水人物, 有聲蘇松間. 小楷亦精, 天然豐秀.) See Ch'ien Yung's *Lü-yüan hua-hsüeh* 履園畫學 (Studying Painting in the [Author's] Garden of Performance), reprinted in Yu Anlan 于安瀾, comp., *Huashi congshu* (*Hua-shih ts'ung-shu*) 畫史叢書 (Compendium of Painting History), vol. 9 (Shanghai: Renmin Meishu Chubanshe, 1962), p. 12. Nevertheless, this information is to some extent unreliable. It contradicts all other sources concerning Kai Ch'i's ancestor being originally from the western region. If Ch'ien Yung made a mistake in this respect, what he wrote about the background of Kai Ch'i's grandfather may also be questionable. In entry no. 71 of *Masterworks of Ming and Qing Painting from the Forbidden City* (Lansdale: International Arts Council, 1988), p. 202, Howard Rogers asserted that Kai Ch'i's grandfather, "a military man who served in the eastern portion of the empire, was granted the surname Gai by the emperor and registered in Songjiang." Since no source is given, it is difficult to determine the credibility of this assertion. Rogers may have relied on the information found in Yang Hsien's 楊峴 (1819–96) book, which asserts: "[The emperor] granted [Kai Ch'i's ancestor] an audience and bestowed upon him the family name, Kai [in recognition of his meritorious service]. [They] were originally natives of the western region [but] adopted Hua-t'ing in Kiangsu

Kai Ch'i 改琦
Lady in Her Study with Attendants
*continued*

132

province as [their] hometown." (以蒙召對,
賜姓"改." 本西域人, 隸江蘇, 華亭籍.) See
Yang's *Ch'ih-hung-hsüan suo-chien shu-
hua lu* 遲鴻軒所見書畫錄 (A Record of the
Painting and Calligraphy Viewed at the
Late Wild Goose Studio), preface dated
1879, reprint, vol. 3 (Suchou: Wen-hsüeh
Shan-fang Studio, 1921), p. 24.

7   See Sheng Dashi (Sheng Ta-shih) 盛大士
(1762–after 1850), *Xishan woyoulu* (*Hsi-
shan wo-yu lu*) 溪山臥遊錄 (A Record of
the Mountains and Rivers in the [Author's]
Mind: Documenting Contemporary
Painters and Essays on Painting), preface
dated 1822, reprinted in Yu Anlan 于安瀾,
comp., *Huashi congshu* (*Hua-shih ts'ung-
shu*) 畫史叢書 (Compendium of Painting
History), vol. 9, *juan* (*chüan*) 卷 (chapter) 3
(Shanghai: Renmin Meishu Chubanshe,
1962), p. 40.

8   This is based on Sheng Ta-shih's *Hsi-shan
wo-yu-lu* 溪山臥遊錄 (A Record of the
Mountains and Rivers in the [Author's]
Mind), p. 40. For Kai Ch'i's flower paint-
ings, see the set of his album leaves
entitled *Xiesheng huahui* (*Hsieh-sheng
hua-hui*) 寫生花卉 (Live Studies of Flow-
ers), illustrating a variety of flowers. The
album leaves are reproduced in Group for
the Authentication of Ancient Works of
Chinese Painting and Calligraphy, ed.,
*Zhongguo gudai shuhua tumu* (*Chung-
kuo ku-tai shu-hua t'u-mu*) 中國古代書畫
圖目 (Illustrated Catalogue of Selected
Works of Ancient Chinese Painting and
Calligraphy), vol. 12 (Beijing: Wenwu
Chubanshe, 1993), no. 滬 5-15, p. 28. It
belongs to the collection of the Shanghai
Renmin Chubanshe 上海人民出版社
(Shanghai People's Art Press).

9   Kai Ch'i's inscriptions often designated his
work as after T'ang Yin, Ch'en Hung-shou,
or the Yüan masters. For example, the
inscriptions on Kai Ch'i's second painting
at the University of Michigan indicate
that the painting was after T'ang Yin.
Although a later copy, the inscription
probably was transcribed from the original
work onto this painting. Inscriptions on
his painting at the Royal Ontario Museum
allude to Yüan masters, although the fig-
ures are actually in the style of Ch'en
Hung-shou. See Suzuki, Kei, comp., *Com-
prehensive Illustrated Catalog of Chinese
Paintings*, vol. 1 (Tokyo: University of
Tokyo Press, 1982), no. A9-008, p. 50. One
of his works, found in Sotheby's sales cata-
logue, *Fine Chinese Paintings* (New York:
Sotheby's, May 29, 1991), lot no. 63, has
an inscription dating the painting to 1800,
when he was only twenty-six years old. He
inscribed the painting seven years later as
"after Ch'en Hung-shou." The composi-
tion of this work is very close to that of a

section of a handscroll by Ch'en Hung-
shou now at the Museum Rietburg,
Zurich. See *Comprehensive Illustrated
Catalog of Chinese Paintings*, vol. 1, no.
E7-056, pp. 146–47. Another example after
Ch'en Hung-shou, dated 1827 and belong-
ing to the Shanghai Museum, is repro-
duced in the *Illustrated Catalogue of
Selected Works of Ancient Chinese Paint-
ing and Calligraphy*, vol. 5, no. 滬 1-4374,
p. 371. The Shanghai Museum owns the
best collection of Kai Ch'i's work, all illus-
trated in the same catalogue, pp. 370–71.

10  For T'ang Yin's paintings of beautiful
women, see his *Pan-chi t'uan-shan* 班姬團
扇 (Lady Pan with a Round Fan) and
*Ch'ang-o pen-yüeh* 嫦娥奔月 (Lady Ch'ang-
o Fleeing to the Moon), reproduced in *Ku-
kung shu-hua t'u-lu* 故宮書畫圖錄 (An
Illustrated Catalogue of Painting and Cal-
ligraphy at the Palace Museum), vol. 7
(Taipei: National Palace Museum, 1991), p.
19 and p. 21, respectively. For Ch'en Hung-
shou's historical figures, see his *T'ao Yüan-
ming ku-shih t'u-chüan* 陶淵明故事圖卷
(The Homecoming of T'ao Yüan-ming)
handscroll at the Honolulu Academy of
Arts, reproduced in Suzuki, Kei, comp.,
*Comprehensive Illustrated Catalog of
Chinese Paintings*, vol. 1 (Tokyo: Univer-
sity of Tokyo Press, 1982), no. A38-001,
pp. 386–88.

11  For more on this novel and its author, see
entry on Ts'ao Chan 曹霑 (d. 1763) in
Arthur W. Hummel, ed., *Eminent Chinese
of the Ch'ing Period (1644–1912)*, vol. 2
(Washington D.C.: United States Govern-
ment Printing Office, 1943–44), pp.
737–38. For a reproduction of one of Kai
Ch'i's female portraits based on *Dream of
the Red Chamber*, see *Zhongguo lidai
renwu huoxuan* (*Chong-kuo li-tai jen-wu
hua-hsüan*) 中國歷代人物畫選 (Selected
Chinese Figure Paintings from Successive
Dynasties) (Jiangsu: Jiangsu Meishu
Chubanshe, 1985), p. 194.

12  For information on Yü Chi, see Ch'ien
Yung's *Lü-yüan hua-hsüeh* 履園畫學
(Studying Painting in the [Author's] Gar-
den of Performance), p. 4. Ch'ien asserts:
"Yü Chi's *hao* was Ch'iu-shih (Autumn
chamber). He was from Jen-ho (present-day
Hangchou) and achieved his *chin-shih*
degree in the *ping-hsü* year (1766) during
the Ch'ien-lung reign (r. 1736–96). His
highest official position was imperial
expositor-in-waiting in the Hanlin
Academy. [Yü] was adept in calligraphy
and loved to paint. [His] figure painting fol-
lowed the style of Ch'en Lao-lien (Ch'en
Hung-shou, 1598–1652), and he was espe-
cially good at painting female beauties.
People in the capital [thus] dubbed him
'Yü, The [Painter of] Beauties.' At the age

of eighty, he could still execute calligraphy
in the regular script and in a size as small
as the head of a fly." (余集, 號秋室, 仁和人.
乾隆丙戌進士. 官至翰林侍讀學士. 工書而喜
畫, 人物宗陳老蓮, 畫美人尤妙. 京師人稱之
曰 "余美人." 年八十, 尚能作蠅頭小楷.) See
also Qin Zuyong (Ch'in Tsu-yung) 秦祖永
(1825–84), *Tongyin lunhua* (*T'ung-yin lun-
hua*) 桐陰論畫 (Discussing Paintings under
the *Wu-t'ung* Tree), preface dated 1864,
*pien* 編 (volume) 3, *chüan* 卷 (chapter) 1,
reprint (Shanghai: Sao-yeh Shan-fang
Press, 1936), p. 8a. Chin's book states: "Yü
Ch'iu-shih, [whose name was] Chi, was
accomplished in painting. [He] was espe-
cially good at painting female figures and
was called 'Yü, the [Painter of] Beauties.'"
At the end of the entry the author added
the following commentary: "Jung-shang
(Yü Chi's *tzu*) was from Ch'ien-t'ang. He
achieved his *chin-shih* degree in the 31st,
or the *ping-hsü* (1766) year, during the
Ch'ien-lung reign (1736–96). [Sixty years
later] In the next *ping-hsü* year (1826) dur-
ing the Chia-ch'ing reign (1795–1820),
when he served as imperial expositor-in-
waiting, he attended a banquet hosted by
the emperor to celebrate the sixtieth
anniversary of his degree, and his rank was
promoted to grade three. [Yü] was also deft
in executing orchids, bamboo, flowers, and
birds. [However,] he was best known for
his female figures. His calligraphy is also
classical and elegant, and his poems, care-
free and lofty, never contain ordinary
phrases. [People] admired the accomplish-
ments of his three consummate skills
(painting, calligraphy, and poetry). He was
a kind person who did not possess the air
of a high bureaucrat. He was born during
the Ch'ien-lung period and died in *kuei-
wei*, the third year of the Tao-kuang reign.
He lived until his eighties." (余秋室, 集, 繪
事精工, 尤擅長士女, 有余美人之目.) (蓉裳,
錢塘人. 乾隆三十一年丙戌進士, 嘉慶丙戌,
復以侍講學士, 重赴鹿鳴, 加三品卿銜. 兼長
蘭竹, 花卉, 禽鳥. 尤工士女. 詩,
神韻閑遠, 不屑作庸熟語. 有三絕之譽. 為人
和易, 無達官氣 生於乾隆, 卒於道光三年癸
未, 年八十餘.) The author made one error
in the above entry. The *ping-hsü* year
(1826) when Yü Chi attended the imperial
banquet was actually during the reign of
Tao-kuang (1821–50) and not Chia-ch'ing.
Yü Chi's biography is also found in Jiang
Baoling's (Chiang Pao-ling) 蔣寶齡
(1781–1840), *Molin jinhua* (*Mo-lin chin-
hua*) 墨林今話 (Commentary on Contem-
porary Painters), preface dated 1851, *juan*
(*chüan*) 卷 (chapter) 7, reprint (Hefei:
Huangshan Shushe, 1992), p. 1 (or p. 159),
or in the chapter "The Younger Genera-
tion: Hangzhou and Suzhou," in Ju-hsi
Chou and Claudia Brown, *The Elegant
Brush: Chinese Painting under the Qian-*

long Emperor, 1735–1795 (Phoenix: Phoenix Art Museum, 1985), pp. 249–50.

13 See translation in note 12.

14 Yü Chi's female figure painting depicting the *Goddess of the Lo River* is reproduced in *The Elegant Brush: Chinese Painting under the Qianlong Emperor*, no. 78, p. 250.

15 Chinese artists often do not assign titles to their works. Consequently, the Museum of Art based both the Chinese and English titles of the first painting on the apparent subject matter. Both the second and third paintings, however, have titles assigned by the artist.

16 The *p'u-t'ou* head wrap of the T'ang dynasty (618–905) was made of a square piece of black gauze or thin silk with cords attached to the two front corners. It was worn on the top of the head and covered the hair-knot at the back. The cords were wrapped around the knot and tied in the back.

17 For an earlier painting showing figures dressed in the T'ang style with *p'u-t'ou* head wraps, see Emperor Hui-tsung's 徽宗 (r. 1101–25) copy of an eighth-century painting by Chang Hsüan 張萱 (active 714–42), entitled *Guoguo furen youchuntu* (*Kuo-kuo fu-jen yu-ch'un t'u*) 虢國夫人遊春圖 (Lady Kuo-kuo's Spring Outing) at the Liaoning Provincial Museum, Shenyang 瀋陽. It is reproduced in Richard M. Barnhart et al., *Three Thousand Years of Chinese Painting* (New Haven: Yale University Press, 1997), pl. 72, p. 77. See also *Yang Kuei-fei Mounting a Horse*, attributed to Ch'ien Hsüan 錢選 (c. 1235–1301) at the Freer Gallery of Art, Washington, D.C., published in James Cahill, *Chinese Painting* (Geneva: Skira, 1960), p. 100.

18 See the female figures in a painting by Wu Wei 吳偉 (1459–1508), plates 47 and 48 in James Cahill, *Parting at the Shore: Chinese Painting of the Early and Middle Ming Dynasty, 1368–1580* (New York and Tokyo: Weatherhill, 1978), pp. 112–13.

19 Similar screens are often found behind scholars in Ming paintings. See *Sung-yin po-ku t'u* 松陰博古圖 (Examining Antiquities under the Shade of Pine Trees), by Yu Ch'iu 尤求 (active second half of 16th century) at the National Palace Museum, Taipei, reproduced in *Ku-kung shu-hua t'u-lu* 故宮書畫圖錄 (Illustrated Catalogue of Calligraphy and Painting at the Palace Museum) (Taipei: National Palace Museum, 1991), p. 261. For a photograph of Ch'ing dynasty furniture with highly ornamented curving, see the photo inside the great Western-style house in old China, which was a blend of Victorian and Chinese decor, in Burton F. Beers, *China* in *Old Photographs: 1860–1910* (Milton, Mass.: Museum of the American China Trade, 1978), no. 134, pp. 134–35.

20 See entry 34 on Yüan Chiang for a detailed description of this technique.

21 Although there was a traditional term, *nü-hsüeh* 女學 or "female learning," which indicated a special type of education suitable for women, it did not really include scholarly training. *Nü-hsüeh* refers to four specific areas that a woman should be educated in: 1) female ethics; 2) female speech; 3) female skills; and 4) female appearance. It was not until the late Ch'ing dynasty that this term implied any scholarly connotation. See *Hanyu dacidian* (*Han-yü ta-tz'u tien*) 漢語大詞典 (Chinese Terminology Dictionary), vol. 4 (Shanghai: Hanyu Dacidian Press, 1988), p. 265, s.v. "*nyuxue* (*nü-hsüeh*) 女學" (female learning). However, some gentry families did allow talented daughters to pursue scholarly studies. For example, Lee Ch'ing-chao 李清照 (1084–c. 1151) of the Sung dynasty (960–1279) was a prominent woman poet. For a detailed biography of her life and social background, see Chung Ling, "Lee Ch'ing-chao: The Molding of Her Spirit and Personality," in Anna Gerstlacher, Ruth King, Wolfgang Kubing, Margit Miosga, and Jenny Schon, eds., *Women and Literature in China* (Bochum: Studienverlag Brockmeyer, 1985), pp. 141–64. For more information on the education of women in China, see Dorothy Ko, *Teachers of the Inner Chamber: Women and Culture in Seventeenth-Century China* (Stanford: Stanford University Press, 1994). For more on Chinese women writers, see Hu Wen-kai 胡文楷, *Lidai funu zhuzuo kao* (*Li-tai fu-nü chu-tso k'ao*) 歷代婦女著作考 (A Research on Women Writers), reprint (Shanghai: Shanghai Kuji Chubanshe, 1985). For information on educated female artists, see Marsha Weidner et al., *Views from Jade Terrace: Chinese Women Artists, 1300–1912* (Indianapolis: Indianapolis Museum of Art, 1988).

22 Traditionally confined within the protective boundary of the home, Chinese women had their activities further restricted by the custom of foot-binding. This practice, developed around the tenth century, deforms the feet; consequently, it limits mobility. For more on foot-binding, see W. Scott Morton, *China: Its History and Culture* (New York: McGraw-Hill, 1995), pp. 270–71.

23 The perforated garden rocks represent a special kind of rock retrieved from Lake T'ai, located near Kai Ch'i's hometown. These rocks were used for decorating fine gardens.

24 This information can be found in the entry for *lichee* in the dictionary *Han-yü ta-tz'u tien* 漢語大詞典 (Chinese Terminology Dictionary), vol. 9, p. 397, s.v. "*lizhi* (*li-chih*) 荔支" (lichee). The entry is based on the biography of Emperor Ho 和帝記 (r. 89–105) in the *Hou-Han shu* 後漢書 (The Book of the Eastern Han Dynasty).

25 See *Han-yü ta-tz'u tien* 漢語大詞典 (Chinese Terminology Dictionary), vol. 9, p. 397, s.v. "*lizhixiang* (*li-chih hsiang*) 荔枝香" (the fragrance of lichee). This episode is recorded in chapter 12 of *Li-yüeh chih* 禮樂志 (The Annals of Ceremonial Music) in *Hsin-T'ang shu* 新唐書 (The New Book of the T'ang Dynasty).

26 Although this work clearly resembles a subject and composition associated with Kai Ch'i, there is little evidence suggesting Yü Chi copied Kai Ch'i's work and signed his own name. It would have been highly inappropriate for an older and established literati artist and high official like Yü Chi to copy the work of a younger professional painter. In all probability this work was copied by a later artist from an original or copy after Kai Ch'i. As Yü Chi was quite well known as an accomplished painter of female figures, his name was probably added by an early twentieth-century counterfeiter in order to increase the work's market value.

27 The conservation job is also flawed by the poor repainting of the artist's inscription. The fine strokes of the characters, although not seriously damaged, appear weak and languid.

28 *Hsüan-chih* is a type of superior-quality rice paper made from the bark of the *ch'u* 楮, or mulberry tree. Originally, this type of paper was made in Ching 涇 county in Anhui 安徽. Because the paper was shipped to the city of Hsüan 宣城 for distribution, people called it *Hsüan-chih*, or "Hsüan paper." It became popular among painters during the late nineteenth and early twentieth centuries. Rice paper has no relation to rice. People in the West so named it only because the paper is white and soft. See *Han-yü ta-tz'u tien* 漢語大詞典 (Chinese Terminology Dictionary), vol. 3, p. 1411, s.v. "*Xuanzhi* (*Hsüan-chih*) 宣紙" (Hsüan paper).

29 Due to the unsized surface of this paper, ink and color washes are quickly absorbed into the fibers of the paper, resulting in soft outlines and pastel tones. This characteristic can be witnessed in the third Michigan scroll as well.

30 See *Comprehensive Illustrated Catalog of Chinese Paintings*, vol. 3, no. JM26-010.

**Kai Ch'i** 改琦
**Lady in Her Study with Attendants**
*continued*

134  31  If the artist used neither the second Michigan scroll nor the fourth painting in Fukuoka as a model, he may have used another undiscovered or lost copy. Because of Kai Ch'i's popularity, he attracted many followers; chief among them was Huang Shan-shou 黃山壽 (1855–1919). Huang moved to Shanghai and spent the last fifteen years of his life as a professional painter. An example of his female figure painting in Kai Ch'i's style can be found in Robert Hatfield Elisworth, *Later Chinese Painting and Calligraphy, 1800–1950*, vol. 2 (New York: Random House, 1987), accession no. P053.01, p. 78. Another work by Huang Shan-shou, *Tung-shan ssu-chu* 東山絲竹 (Mr. Tung-shan in the Company of Female Musicians) is even more clearly in the style of Kai Ch'i. Two of the female figures in this painting, those in the lower front of the composition, are remarkably similar to those in the Michigan paintings. The perforated garden rock in the lower left corner of this painting also resembles that found in the second and third Michigan paintings. This work by Huang is reproduced in National Museum of History, *Wan-ch'ing min-chu shui-mo-hua chi* 晚清民初水墨畫集 (Collection of Late Ch'ing and Early Republic Chinese Painting, 1850–1950) (Taipei: National Museum of History, 1997), cat. no. 99, p. 265. It is interesting to note that even the style of Huang's calligraphy is similar to that of Kai Ch'i. For a brief biography of Huang Shan-shou, see *Zhongguo meishujia renming cidian* (Chung-kuo mei-shu-chia jen-ming tz'u-tien) 中國美術家人名詞典, p. 1136.

32  The University of Michigan Museum of Art is not the only institution plagued by Kai Ch'i attribution problems. The Los Angeles County Museum has a painting called *T'ien-nü t'u* 天女圖 (Picture of a Celestial Maiden) attributed to Kai Ch'i. There are at least four versions of this work, two of which belong to the Shanghai Museum. In 1989, the fourth was auctioned by Sotheby's, New York, at the same sale that the University of Michigan obtained its second painting attributed to Kai Ch'i. It is an amazing coincidence that a single auction involved two Kai Ch'i paintings, both of which exist in precisely the same number of problematic versions! Kai Ch'i's painting at the Los Angeles County Museum has never been published. One of the two scrolls attributed to Kai Ch'i at the Shanghai Museum is definitely a later copy by a little-known Shanghai painter, Yüan Hsün-fu 袁洵甫. The two paintings are reproduced in the *Illustrated Catalogue of Selected Works of Ancient Chinese Painting and Calligraphy*, vol

no. 滬 1-4372, p. 371 and no. 滬 1-4447, p. 383. See Sotheby's sales catalogue, *Chinese Furniture and Decorations* (New York: York Avenue Galleries, Saturday, June 5, 1982), lot number 90. This work was listed in the sales catalogue as executed in the "Style of T'ang Yin." Because of the high estimate of the auction house, it did not sell. Its present location is unknown.

## 46. Fei Tan-hsü 費丹旭
*(1802–50), attributed to*
*Ch'ing dynasty (1644–1911)*

## The Goddess of the Lo River
*Lo-shen fu*
*(Ode to the Goddess of the Lo River)*
洛神賦

1  Huang-ch'u 黃初 was the reign mark for Emperor Wen-ti 文帝 (r. 220–26) of the Wei 魏 dynasty (220–53). Emperor Wen-ti's name was Ts'ao P'i 曹丕 (187–227), the elder brother of Ts'ao Chih 曹植 (192–232), who was the author of this *Ode to the Goddess of the Lo River*. The capital mentioned in Ts'ao Chih's writing was the city of Lo-yang 洛陽 in Honan 河南.

2  The Lo River is a major tributary of the Yellow River. It flows from the southwestern region of the city of Lo-Yang and continues northeast into the Yellow River.

3  Princess Mi, or Mi-fei 宓妃, was said to be the beautiful daughter of the legendary prehistoric emperor Shen-nung 神農 (meaning "Agriculture God," also known as Fu-hsi 伏羲 and Mi-hsi 宓羲). According to Chinese mythology, the princess was drowned in the Lo River and later deified as a goddess. See *Hanyu dacidian* (Han-yü ta-tz'u-tien) 漢語大詞典 (Chinese Terminology Dictionary), vol. 3 (Shanghai: Hanyu Dacidian Press, 1988), p. 1404, s.v. "Mi-fei 宓妃."

4  The tale of *The Nymph of the Wu Gorge Meeting the King of Ch'u* is based on another famous ode, entitled *Kao-t'ang fu* 高唐賦 (Ode of the Kao-t'ang [Pavilion]), by the celebrated poet Sung Yü 宋玉 (290–222 B.C.). It narrates an encounter between the nymph and the king of the Ch'u State during the Warring States period (481–221 B.C.). According to the ode, it happened during one of the king's excursions when the king sojourned at the Kao-t'ang pavilion in the scenic Yün-meng 雲夢 marshes on the bank of the Yangtze River. This

pavilion is located in the southwestern region of the present day city of Wu-han 武漢 in Hupei 湖北. While there, in his dream, the king was greeted by a beautiful woman who offered herself amorously. When she left, she whispered to the king that she was the nymph of the Wu Gorge, and that she dwelled on the south slope of the Wu 巫 Mountain amid the perilous peaks. In the dawn she became the morning glow and at dusk, she transferred herself into the evening drizzle. Later, the king traveled to the Wu Mountain and witnessed these natural phenomena, exactly as she stated. In memory of this fantastic encounter, a shrine called Chao-yün 朝雲 or "Morning Clouds," was erected by the king. Sung Yü's ode is found in Chen Hongtian 陳宏天 et al., *Zhaoming wenxuan shizhu* (*Chao-ming wen-hsüan shih-chu*) 昭明文選釋注 (Selected Famous Writings by Prince Chao-ming [501–31, whose name was Hsiao T'ung 蕭統] with Modern Translation and Annotation) (Changchun: Jilin Wenshi Chubanshe, 1988), pp. 1037–50. Sung Yü also wrote another ode, entitled *Shen-nü fu* 神女賦 (Ode of the Nymph), which also centers around the nymph of the Wu Gorge. It is also found in ibid., pp. 1052–65.

5 I-ch'üeh Mountain is located south of Lo-yang. It is also called Lung-men 龍門 (Dragon Gate) where the famous Buddhist caves along the I River were later excavated. See *Tz'u-hai* 辭海 (Sea of Terminology: Chinese Language Dictionary), vol. 1 (Taipei: Chung-hua Press, 1974), p. 195, s.v. "*I-ch'üeh* 伊闕." The Huan-yüan pass, on the other hand, is the name of a dangerous and strategic mountain path at Mt. Sung 嵩. It is well-known in Chinese history for its treacherous condition. For more information of this mountain path, see ibid., vol. 2, p. 172.

6 The term *ch'eng-ch'üan* 承權 literally means "to contain power." The poem implies a double entendre in that her dimples are so deep that they could contain power, yet so charming that they would soften the heart of the empowered.

7 The family name of Chiao-fu is Cheng 鄭. The episode of how he was tricked by two young women is originally found in *Han-shih nei-chuan* 韓詩內傳 (The Anecdotes in Han Ying's Poetry), a book composed during the Han period (206 B.C.–A.D. 220) that has long been lost. According to an annotation, which does survive, by Li Shan 李善 (?–689) for Ts'ao Chih's ode, the account is as follows: "One day Cheng Chiao-fu met two young women under a famous terrace. He chatted with them and expressed his affection. The two women untied their jade pendants and gave them

to him as tokens of their pledged love. Cheng put the pendants next to his bosom under the lapel of his robe and bade the two women farewell. After taking only ten steps, the jade was gone. Turning his head back, he found the two women had also disappeared. See *Chao-ming wen-hsüan shih-chu* 昭明文選釋注, p. 1072, n. 64 for *Lo-shen fu*, s.v. "*jiaofu* (*chiao-fu*) 交甫."

8 The "two goddess queens of the Hsiang River" in the ode indicate the two beautiful imperial wives, O-huang 娥皇 and her sister, Nü-ying 女英, of the legendary Emperor Shun 舜. According to Chinese mythology, Shun took an inspection tour of the south and died in Ts'ang-wu 蒼梧 in Kwanghsi. His two devout queens committed suicide by drowning themselves in the Hsiang River. Due to their faithfulness, they were rewarded by Heaven and became the goddesses of the river. See *Tz'u-hai* 辭海 (Sea of Terminology: Chinese Language Dictionary), vol. 1, pp. 1759–60, s.v. "Hsiang-chün 湘君 (Lady Hsiang)."

9 The *yu-nü* 遊女, or "wandering women," in this line refers to the beautiful women gathered at the bank of Han River in ancient times. This term is derived from the Chinese classic, *Book of Songs*. See the poem entitled *Hanguang* (*Han-kuang*) 漢廣 (The Extensive Han River) found in the *Guofeng* (*Kuo-feng*) 國風 (Airs of the States [folk poems]) category, "Zhounan (Chounan) 周南 (South of the Chou State) chapter, in Jin Qihua 金啟華, ed., *Shijing quanyi* (*Shih-ching ch'üan-i*) 詩經全譯 (A Complete Translation of the Book of Songs) (Jiangsu: Jiangsu Guji Chubanshe, 1984), pp. 20–21. The text says, "There are beautiful women wandering by the bank of the Han River. [Sadly], I cannot go after them and court them." (漢有遊女, 不可求思.)

10 P'ao-kua is the name of a constellation comprising five stars. It is also known as the T'ien-chi 天雞 (heavenly rooster) constellation. As it exists alone in the sky, Chinese astrologers in ancient times did not assign any other constellation as its mate. See *Tz'u-hai* 辭海 (Sea of Terminology: Chinese Language Dictionary), vol. 1, p. 436, s.v. "*p'ao-kua* 匏瓜."

11 The Herdboy constellation is composed of six stars positioned on the south side of the Milky Way. It is one of the twenty-eight important constellations in Chinese astronomy. According to Chinese mythology, this constellation represents an unlucky herdboy who was allowed to meet his wife, a weaver who lived on the opposite side of the Milky Way, only once each year on the seventh night of the seventh moon. See ibid., p. 1871, s.v. "Niu-su 牛宿 (the Ox Constellation)."

12 P'ing-i is the name of a deity in ancient Chinese mythology who could represent different natural spirits including: 1) the Spirit of Clouds; 2) the Spirit of Rain; 3) the Spirit of Thunder; and 4) the Spirit of Wind. See *Han-yü ta-tz'u-tien* 漢語大詞典 (Chinese Terminology Dictionary), vol. 12, p. 41, s.v. "Pingyi (P'ing-i) 屏翳." Although this spirit has existed in Chinese mythology since ancient times, his exact role has always been ambiguous. Not only does he represent several different natural phenomena, but he also is known by several different names. For example, P'ing-i 屏翳 is also sometimes known as Ping-i 冰夷. Furthermore, the aqua deity, Feng-i 馮夷, found in the next sentence of this ode, although written in a different manner, probably shares the same origin. For a discussion of this deity, see item (e), "Certain Spirits and Spirits' Palaces" in definition (1) "Ssu-tu Shen 四瀆神" (The Spirits of the Four Watercourses) in the entry for "Shui-fu 水府" (The Palaces of Waters) in D. E. T. C. Werner's *A Dictionary of Chinese Mythology*, reprint (Taipei: Wen-hsing Press, 1961), p. 438.

13 For Feng-i 馮夷, see *A Dictionary of Chinese Mythology*, p. 126. Nü-wa was a female deity who was the younger sister of the legendary prehistoric emperor Fu-hsi 伏羲. Worshipped as the "goddess of the go-betweens," she was supposed to have made the original rules regarding purchase prices and presents at weddings, the marriage ceremony, and the prohibitions of premarital relations. See ibid., pp. 334–35.

14 For Fei Tan-hsü's hometown, see Yang Hsien's 楊峴 (1819–96) *Ch'ih-hung-hsüan suo-chien shu-hua lu* 遲鴻軒所見書畫錄 (A Record of the Painting and Calligraphy Viewed at the Late Wild Goose Studio), preface dated 1879, reprint, vol. 3 (Suchou: Wen-hsüeh Shan-fang Studio, 1921), p. 35. Prior to the establishment of the Republic (1912– ), Fei Tan-hsü's hometown was also known as Wu-ch'eng 烏程.

15 See Huang Yongquan's 黄湧泉 article, "Fei Tan-hsü 費丹旭," in Hu Peiheng 胡佩衡 et al., *Lidai huajia pingzhuan, Qing* (*Li-tai hua-chia p'ing-chuan, Ch'ing*) 歷代畫家評傳. 清 (Biographies of and Comments on Painters of the Past Dynasties: Ch'ing Period) (Hong Kong: Chung-hua Press, 1979), p. 1. The second character, *hsi* 溪, in Fei's *hao*, Huan-hsi sheng, is sometimes also known as *chu* 渚 (an islet). Thus, this name becomes Huan-chu sheng 環渚生. See Yu Jianhua 于劍華 et al., *Zhongguo meishujia renming cidian* (*Chung-kuo mei-shu-chia jen-ming tz'u-tien*) 中國美術家人名詞典 (A Biographical Dictionary of Chinese Artists) (Shanghai: Renmin Meishu Chubanshe, 1981), p. 1113, and

Fei Tan-hsü 費丹旭
The Goddess of the Lo River
*continued*

136    Victoria Contag and Wang Chi-ch'üan 王季
銓, *Seals of Chinese Painters and Collec-
tors of the Ming and Ch'ing Periods*,
reprint (Taipei: Shang-wu Press, 1965), p.
383. It is not known whether this is
indeed one way of writing the artist's *hao*,
or whether it is merely a supposition of
the authors of these books.

16    This particular sobriquet of Fei Tan-hsü is
found in *Seals of Chinese Painters and
Collectors of the Ming and Ch'ing Periods*,
p. 383 and seal no. 13 on p. 384. The artist
chose this name because in his hometown,
there used to be three steles of the Han
dynasty (206 B.C.–A.D. 220) recording the
history of two members of the Fei family.
See Huang Yongquan's 黃湧泉 article "Fei
Tan-hsü 費丹旭," p. 1, n. 1.

17    See Huang Yongquan's 黃湧泉 article "Fei
Tan-hsü 費丹旭," p. 4. In a colophon Fei
Tan-hsü inscribed on *Portrait of Tseng
Ching* by Shih Ch'ü 石渠 (active during
the Chia-ch'ing 嘉慶 period, 1796–1820) at
the University of Michigan Museum of
Art, he stated that his father studied paint-
ing under Shen Tsung-ch'ien. See entry 41
on Shih Ch'ü for Fei's inscription. For
Shen Tsung-ch'ien's brief biography, see
*Chung-kuo mei-shu-chia jen-ming tz'u-
tien* 中國美術家人名詞典 (Biographical Dic-
tionary of Chinese Artists), p. 424.

18    For a discussion of the idealized painting
of beautiful women, see entry 43 on Kai
Ch'i.

19    For more information on the painter Shih
Ch'ü, see entry 41.

20    Shih Ch'ü's comments on Fei's work are
found in "Shi Qu Wu Mi zhuan (Shih Ch'ü
Wu Mi chuan) 石渠吳墨傳" (Biographies of
Shih Chü and Wu Mi) in *Ch'ih-hung-
hsüan wen-hsü* 遲鴻軒文續 (Sequel to the
Writings from the Late Wild Goose Stu-
dio), preface dated 1893, reprinted in
*Ch'ih-hung-hsüan chi* 遲鴻軒集 (Collected
Writings of the Late Wild Goose Studio),
vol. 3, p. 13a & b. See note 16 in entry 41
on Shih Chü for the translation of this
episode.

21    For a discussion of the famous Shanghai
painter Kai Ch'i, see entry 43.

22    Fei Tan-hsü's patron, Wang Yüan-sun, was
from a prominent family in Fei's home-
town of Hu-chou. His grandfather estab-
lished the prestigious book collection
housed at the Chen-ch'i t'ang 振綺堂 (The
Inspiring Beauty Studio) in Hangchou. An
east wing of the Wang family's house,
known as Ching-chi tung-hsüan 靜寄東軒
(The East Hall of Tranquil Transmissions),
was noted for its beautiful environment. It
was a place for the elite of Hangchou to
gather and be entertained. For more infor-

mation on Wang Yüan-sun and his family,
see Arthur W. Hummel, ed. *Eminent Chi-
nese of the Ch'ing Period (1644–1912)*, vol.
2 (Washington, D.C.: United States Gov-
ernment Printing Office, 1943–44), pp.
821–22.

23    See Huang Yongquan's 黃湧泉 article "Fei
Tan-hsü 費丹旭," p. 7. Brief biographies of
the artists Chao Chih-ch'en and Ta-shou
can be found in *Chung-kuo mei-shu-chia
jen-ming tz'u-tien* 中國美術家人名詞典
(Bibliographical Dictionary of Chinese
Artists), pp. 1270–71 and p. 1241, respec-
tively.

24    For example, in the year of *jen-ch'en* 壬辰,
or 1832, Fei Tan-hsü executed a handscroll
entitled *Huayiguan jishitujuan (Hua-i-
kuan chi-shih-t'u-chüan)* 花宜館輯詩圖卷
(Editing Poetry at the Studio of Appropri-
ate Flowers), which depicts Wu Chen-yü 吳
振棫 (*chin-shih* degree in the Chia-ch'ing
嘉慶 reign, 1796–1820), a well-known
scholar-statesman, composing poems in an
elegant setting. The name of Wu's famous
studio was Yang-chi Chai 養吉齋 (The Stu-
dio of Cultivating Propitiousness). Fei's
painting is now at the Zhejiangsheng Wen-
wu Guanliju (Chekiang-sheng Wen-wu
Kuan-li-chü) 浙江省文物管理局 (Zhejiang
Provincial Relics Bureau). This scroll has
not been reproduced but is mentioned in
Huang Yongquan's 黃湧泉 article "Fei Tan-
hsü 費丹旭," pp. 7–8 and pp. 30–31. Fei
also executed another famous handscroll
in the same year. It is entitled *Dongxuan
yinshe tujuan (Tung-hsüan yin-she t'u-
chüan)* 東軒吟社圖卷 (A Handscroll of the
East-hall Poetry Guild). It is reproduced in
Yü I 余毅, ed., *Fei Hsiao-lou jen-wu hua-
chi* 費曉樓人物畫集 (Paintings of Fei Hsiao-
lou [Fei Tan-hsü]) (Taipei: Chong-hua shu-
hua Press, 1981), pp. 42–53. This long
handscroll contains almost forty figures,
many of them portraits of famous scholars
and poets in Hangchou. It is considered
one of Fei Tan-hsü's masterpieces. The
third work of this year was a set of four
portraits of famous scholars, all from
Hangchou, entitled *Mo Wulin sizhengjun
xiang (Mo Wu-lin ssu-cheng-chün hsiang)*
摹武林四徵君像 (Copy after the Portraits of
Four Gentlemen from Hangchou Who
Rejected Official Position). The four were:
1) Hang Shih-chün 杭世駿 (1696–1773); 2)
Chin Nung 金農 (1687–1763); 3) Li O 厲鶚
(1692–1752); and 4) Ting-Ching 丁敬
(1695–1765). Although these four portraits
were not created by Fei Tan-hsü, as he
merely copied the four done by earlier
artists, Fei's versions do reveal his painting
skill and carry his personal expression.
The set of four album leaves is reproduced
in Group for the Authentication of
Ancient Works of Chinese Painting and

Calligraphy, ed., *Zhongguo gudai shuhua
tumu (Chung-kuo ku-tai shu-hua t'u-mu)*
中國古代書畫圖目 (An Illustrated Cata-
logue of Selected Works of Ancient Chi-
nese Painting and Calligraphy), vol. 11
(Beijing: Wenwu Chubanshe, 1994), no. 浙
1-701, p. 145. Another version of these
four portraits by Fei Tan-hsü belongs to
the Palace Museum, Beijing. See ibid., vol.
1, no. 京 1-163, p. 33.

25    Chiang Kuang-hsü was from Hsia-shih 硤
石, a town in the district of Hai-ning 海寧
in Chekiang province. His famous paint-
ing collection is recorded in the *Pieh-hsia
chai shu-hua lu* 別下齋書畫錄 (The Paint-
ing and Calligraphy at the Pieh-hsia Studio
[The meaning of the name of Chiang's stu-
dio, *pieh-hsia* is unclear]). For information
on Chiang Kuang-hsü's life, see *Eminent
Chinese of the Ch'ing Period (1644–1912)*,
vol. 1, pp. 138–39.

26    The brief biographies of these artists can
all be found in *Chung-kuo mei-shu-chia
jen-ming tz'u-tien* 中國美術家人名詞典
(Biographical Dictionary of Chinese
Artists). The biography of Ch'ien Tu is
found on p. 1426; of Wen Ting on p. 38; of
Chu Ang-chih on p. 206; of Huang Chün
on p. 1143; of Weng Lo on p. 751; of Chang
T'ing-chi on p. 826; and of Chang Hsiung
on pp. 867–68. Among them, Ch'ien tu,
Chang T'ing-chi, and Chang Hsiung are
better known today.

27    See Huang Yongquan's 黃湧泉 article "Fei
Tan-hsü 費丹旭," pp. 8–9.

28    See ibid., pp. 8–9.

29    See ibid., p. 5.

30    For information on Fei's two sons, see
*Chung-kuo mei-shu-chia jen-ming tz'u-
tien* 中國美術家人名詞典 (Biographical Dic-
tionary of Chinese Artists), p. 1113.

31    See ibid., p.1114. The work and career of
Fei's grandson are little known today.

32    According to Huang Yongquan's 黃湧泉
article "Fei Tan-hsü 費丹旭," p. 10, after
the death of Fei Tan-hsü, Wang Shih 汪鋕
from Hangchou collected the artist's
manuscripts and provided a title for Fei's
anthology. In 1868, with financial support
from the family of Fei Tan-hsü's past host,
Wang Yüan-sun, the manuscripts were
published. Then, in 1930, one of Fei Tan-
hsü's descendants, Fei Yu-jung 費有容,
published the manuscripts for the second
time using modern printing facilities.

33    Traditionally in Chinese history, Mi-fei
(Princess Mi) was known as the goddess of
the Lo River. The origin of this myth
seems to have started in literature such as
the famous ode *Li-sao* 離騷 (Grievance of
Separation), by Ch'ü Yüan 屈原 (343–290

B.C.) written during the Warring States period (481–221 B.C.). See note 3 for a discussion of the origin of Mi-fei.

34  Ts'ao Chih's life is recorded in Ho Ching's 何經 (1223–75) *Hsü hou-Han-shu* 續後漢書 (Sequel to the Book of the Post-Han Period), preface dated 1272, reprint, mid. section, vol. 29 (Shanghai: Commercial Press, 1958), pp. 315–32.

35  Ts'ao P'i's biography is also found in ibid., vol. 26, pp. 297–98.

36  For Ts'ao Ts'ao's life, see ibid., vol. 25, pp. 245–95. Much of the Ts'ao family history was used for the popular novel *San-kuo yen-i* 三國演義 (The Romance of the Three Kingdoms). For fascinating information on the Ts'ao family and the Three Kingdoms in English, see Rafe De Crespigny, *Man from the Margin: Cao Cao and the Three Kingdoms* (Canberra: Australian National University, 1998).

37  The popular version of the background history of Ts'ao Chih's ode, *The Goddess of the Lo River*, probably originated with Li Shan's 李善 (?–689) annotation. See Morohashi Tetsuji 諸橋轍次, *Dai Kanwa Jiten* 大漢和詞典 (The Great Chinese-Japanese Dictionary), vol. 6 (Tokyo: Daishukan, 1976), p. 1094, s.v. "うくしん のつ 洛神賦."

38  It seems that later literature has further embellished the story into a more romantic affair. It is recorded that during the reign of Emperor Ming 明 (r. 227–40), a scholar named Hsiao Kuang 蕭曠 was traveling along the bank of the Lo River. He played his lute under the bright moon and a beautiful, but sad, woman appeared from the river. She claimed that she was the goddess of the Lo River. Her husband, Emperor Wen 文 (Ts'ao P'i), condemned her to death in a dungeon for having derived too much enjoyment from the lyric poetry of Ts'ao Chih, her secret lover and brother-in-law. Her soul, after separating from her body, met Ts'ao Chih on the river and inspired him to compose the well-known ode. See item (a) "The Lo 洛" in section (2) "Spirit of Various Bodies of Water," under the entry for "Shui Fu 水府" (water department) in *A Dictionary of Chinese Mythology*," p. 439.

39  While Ts'ao Chih was apparently too young to have a love affair, at that time the older brother, Ts'ao P'i, was eighteen years old, old enough to take a concubine. In her union with Ts'ao P'i, Lady Chen gave birth to one daughter and one son, who would later become Emperor Ming. When Ts'ao P'i usurped the throne from the Han emperor, he officially made Lady Chen his queen. But she was forced to commit suicide in 221 at age forty under the imperial decree of her husband.

40  Ts'ao Chih's two counselors executed by the emperor were the two Ting brothers, Ting I 丁儀 (?–220) and Ting I 丁廙 (?–220). See *Hsü hou-Han-shu* 續後漢書 (Sequel to the Book of the Post-Han Period), vol. 29, p. 317. Although the romanization and pronunciation of the two brothers' names are the same, they are indicated by different characters.

41  Ts'ao Chih's ode is closely related to the earlier *Li-sao* by Ch'ü Yüan. It fact, Ch'ü Yüan not only used his ode to vent his grievance caused by his poor relations with the king, he also mentioned the goddess of the Lo River in his writing. His ode says, "I asked the Thunder Spirit, Feng-lung, to ride the clouds so that he could search the location of the dwelling of Princess Mi (the goddess of the Lo River)." (吾令豐隆乘雲兮, 求宓妃之所在.) See *Han-yü ta-tz'u-tien* 漢語大詞典 (Chinese Terminology Dictionary), vol. 3, p. 1404, s.v. "Mi-fei 宓妃 (Princess Mi)."

42  In the early writings on Chinese painting, several works focusing on the *Goddess* (or *Nymph*) of the Lo River are attributed to Ku K'ai-chih. None of these survive today. Furthermore, whether or not Ku created the original scrolls is still questionable. As a matter of fact, few people realize that the earliest example of a painting depicting this subject matter does not bear Ku K'ai-chih's name. This work is recorded under Emperor Ming 明帝 (r. 323–25) in P'ei Hsiao-yüan's 裴孝源 (active c. mid-7th century) *Chen-kuan kung-ssu hua-shih* 貞觀公私畫史 (Public and Private Collections during the Cheng-kuan Period [627–49]). It was not until the twelfth century that Ku's name was associated with the Nymph of the Lo River motif. For a discussion of this problem, see Xu Bangda's 徐邦達, *Gushuhua wei e kaobian (Ku-shu-hua wei-o k'ao-pien)* 古書畫偽訛考辯 (Examinations and Verifications of Ancient Paintings and Calligraphy), Text, vol. 1 (Nanking: Jiangsu Guji Chubanshe, 1984), pp. 21–27 and plates, vol. 1, pp. 23–42. Yet two later copies attributed to Ku are extant. One belongs to the Freer Gallery of Art, Washington, D.C., and the other, to the Palace Museum, Beijing. The Freer scroll is reproduced in Suzuki Kei 鈴木敬, comp., *Comprehensive Illustrated Catalog of Chinese Paintings*, vol. 1 (Tokyo: University of Tokyo Press, 1982), no. A21-027, p. 195. The Palace Museum version, although more complete, has some of the scenes arranged incorrectly due to an ignorant mounter during a past conservation. It is reproduced in Palace Museum Editorial Committee, *Zhongguo lidai huihua (Chung-kuo li-tai hui-hua)* 中國歷代繪畫 (Paintings of the Past Dynasties) in the series *Gugong bowuyuan canghuaji (Ku-*

*kung po-wu-yüan ts'ang-hua chi)* 故宮博物院藏畫集 (Paintings in the Collection of the Palace Museum), vol. 1 (Beijing: Renmin Meishu Chubanshe), pp. 2–19.

43  For a reproduction of *The Goddess of the Lo River* currently at the Palace Museum, Beijing, see above note.

44  Wei Chiu-ting's hanging scroll, *The Goddess of the Lo River*, is reproduced in *Ku-kung shu-hua t'u-lu* 故宮書畫圖錄 (An Illustrated Catalogue of Calligraphy and Painting at the Palace Museum), vol. 5 (Taipei: National Palace Museum, 1993), p. 107. A work with the same title by Yü Chi is published in Ju-hsi Chou and Claudia Brown, *The Elegant Brush: Chinese Painting under the Qianlong Emperor, 1735–1795* (Phoenix: Phoenix Art Museum, 1985), p. 250. This work by Yü Chi is also reproduced in entry 43 on Kai Ch'i.

45  The other four hanging scrolls, entitled *The Goddess (Nymph) of the Lo River* and attributed to Fei, with identical figures, calligraphy, dates, seals, and signatures belong to: 1) the Allen Memorial Art Museum, Oberlin College (never published); 2) Kaikodo, Kamakura, Japan and New York (published in Howard Rogers, ed., *Kaikodo Journal: "Visions of Man in Chinese Art" with Selected Japanese Paintings* [Kamakura and New York: Kaikodo, Spring 1997], no. 20, pp. 96–97 and pp. 230–32); 3) Central Academy of Fine Arts in Beijing (reproduced in *New Interpretations of Ming & Qing Paintings* [Shanghai: n.p., 1994], cat. no. 57, p. 75); 4) Duoyun Xuan Yishupin Paimai Gongsi 朵雲軒藝術品拍賣公司 (Duoyun Xuan Art Auctioneer's Co.), Shanghai (reproduced in the sales catalogue *Ancient Calligraphy and Paintings* [Shanghai: Duoyun Xuan Art Auctioneer's, Spring 1997], lot no. 997. At the Guangzhou Municipal Museum 廣州市美術館, there is also a *Goddess of the Lo River* attributed to Fei Tan-hsü. It is a hanging scroll with ink and color on silk and is also dated 1847. This work is listed in *Chung-kuo ku-tai shu-hua t'u-mu* 中國古代書畫圖目 (An Illustrated Catalogue of Selected Works of Ancient Chinese Painting and Calligraphy), vol. 14, no. 粵 2-516, p. 296. Unfortunately, there is no reproduction of this work. There are also three other versions with some variations. They are: 1) A scroll showing the same figure and calligraphy, but attributed to Shen Tsung-ch'ien, the teacher of Fei Tan-hsü's father and grand-uncle. Dated 1768, the thirty-third year of the Ch'ien-lung 乾隆 (r. 1736–96) era, this work is of poor quality and is obviously forged by the hand of a twentieth-century artist. It is reproduced in Christie's sales

Fei Tan-hsü 費丹旭
The Goddess of the Lo River
*continued*

## 47. Wang Ying-hsiang 王應祥
*(active late 18th to early 19th century)*
*Ch'ing dynasty (1644–1911)*

138

catalogue, *Fine Chinese Paintings, Calligraphy, and Rubbings* (New York: Christie's, September 18, 1966), lot no. 185; 2) A painting belonging to the Walters Art Gallery and bearing Fei Tan-hsü's signature features the same composition but embodies a decidedly different figure along with the addition of waves. This suggests an artist keenly aware of earlier examples but concerned with adding a personal interpretation. It is reproduced in Howard Rogers, ed., *Kaikodo Journal: "Visions of Man in Chinese Art" with Selected Japanese Paintings*, Autumn 1997, p. 47; 3) The last work, a later copy, dated 1938, was executed by a painter named Li Feng-t'ing 李鳳廷 (1884–1967), with calligraphy by a calligrapher named Huang Wei-mao 黃維琚. The painter's name that appears on the painting, Feng-kung 鳳公, is Li Feng-t'ing's *tzu*. He not only added waves under the goddess but also switched the curve of the goddess's body from the left to the right. In spite of this innovation, the overall quality of the painting is inferior to the above-mentioned examples. This work is reproduced in *Lingnan mingren shuhua* (*Ling-nan ming-jen shu-hua*) 嶺南名人書畫 (Painting and Calligraphy of Famous Artists from Canton) (Guangzhou: Renmin Meishu Chubanshe, 1997), no. 515.

46  Fei Tan-hsü's album leaf entitled *The Goddess of the Lo River*, currently at the Palace Museum, Beijing, is reproduced in Shi Dafu 施達夫 et al., *Qingdai renwu huafeng* (*Ch'ing-tai jen-wu hua-feng*) 清代人物畫風 (The Styles of Figure Painting of the Ch'ing Dynasty) (Chongqing: Chongqing Chubanshe, 1995), pl. 134.

47  Fei Tan-hsü's *Beauty under the Willow Tree* is reproduced in *Chung-kuo ku-tai shu-hua t'u-mu* 中國古代書畫圖目 (An Illustrated Catalogue of Selected Works of Ancient Chinese Painting and Calligraphy), vol. 13, no. 粵 1-0959, p. 320.

48  This was what Mrs. J. Leonard Hyman told the Museum when she made the donation.

49  Among the five versions of this painting, the scroll at the Central Academy of Fine Arts in Beijing was not approved by the Group for the Authentication of Ancient Works of Chinese Painting and Calligraphy in 1986; consequently, it was excluded from *Chung-kuo ku-tai shu-hua t'u-mu* 中國古代書畫圖目 (An Illustrated Catalogue of Selected Works of Ancient Chinese Painting and Calligraphy), vol. 1, nos. 京 7-1 to 117, pp. 112–18. The Kokaido scroll was published as a genuine work. The Oberlin scroll was never questioned before the other versions surfaced.

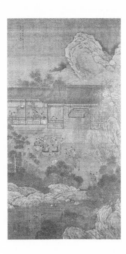

### The Three Abundant Blessings
*San-to t'u*
*(The Three Abundant Blessings)*
三多圖

1  The three abundant blessings include: 1) wealth or happiness; 2) longevity; and 3) the benefits of many sons and grandsons. See S. Howard Hansford, *A Glossary of Chinese Art and Archaeology* (London: The China Society, 1961), p. 76.

2  This type of subject matter is also known as *chia-ch'ing t'u* 家慶圖 (pictures of family celebration). For the source of this title, see Deng Chun (Teng Ch'un) 鄧椿 (active 12th century), *Huaji (Hua-chi)* 畫繼 (Treatise on Painters and Paintings of the Period between 1070–1160), preface dated 1167, *juan (chüan)* 卷 (chapter) 10, reprinted in Yu Anlan 于安瀾, comp., *Huashi congshu* (*Hua-shih ts'ung-shu*) 畫史叢書 (Compendium of Painting History), vol. 3 (Shanghai: Renmin Meishu Chubanshe, 1962), p. 76. Deng states: "When my late father served at the central government, [the emperor] bestowed him a residence by the Dragon-stream Bridge. [Since] my late father was the Vice-president, [who was in charge of] eunuchs, he sent eunuch officials from the palace to inspect the renovation of [this new house]. When they mounted paintings on the wall, they chose works by court painters, including flower-and-bird, bamboo, and family celebration pictures." (先大夫樞府日, 有旨賜第於龍津橋側. 先君侍郎, 作提舉官. 乃遣中使監修. 比背畫壁, 皆院人所作翎毛花竹, 及家慶圖之類.)

3  It is unclear why the first character of the inscription is missing. Nevertheless, this missing character should be *chia* 嘉, the first character of the reign mark, "Chia-ch'ing 嘉慶," of Emperor Jen-tsung 仁宗 (r. 1795–1820) of the Ch'ing dynasty. As the

second character, *ch'ing* 慶, is followed by the name of the year, *wu-yin* 戊寅, the first two characters in this inscription could only be the reign name of an emperor. Checking the dates of the artist, active during the late eighteenth to early nineteenth centuries, indicates that the year was 1818, the only *wu-yin* year during Emperor Chia-ch'ing's reign.

4  Wang Ying-hsiang's brief biography is attached to the entry of his elder brother, Wang Chao-hsiang, found in Wang Chün's 王鋆 (active 19th century) *Yang-chou hua-yüan lu* 揚州畫苑錄 (Painters of Yangchou), preface dated 1883, *chüan* 卷 (chapter) 2, pp. 22–23, in vol. 3 of *Yang-chou ts'ung-k'o* 揚州叢刻 (Miscellaneous Books on Yangchou), reprinted in *Chung-kuo fang-chih ts'ung-shu* 中國方誌叢書 (A Collection of Chinese Gazetteers), series 3 (Taipei: Cheng-wen Press, 1970), new page nos. 882–83.

5  See ibid.

6  See ibid.

7  See ibid. According to this source, a third brother, Wang Teng-hsiang 王登祥, the youngest of the three, was also a figure painter. The source states that Wang Teng-hsiang painted in his brother's style yet fails to specify which brother.

8  See Li Tou 李斗 (active second half of 18th century), *Yang-chou hua-fang-lu* 揚州畫舫錄 (The Gaily Painted Pleasure Boats in Yangchou), preface dated 1796, *chüan* 卷 (chapter) 2, reprint (Yangzhou: Jiangsu Gangling GUI Keyinshe, 1984), p. 39.

9  While Emperor K'ang-hsi 康熙 (r. 1662–1722) made six tours to the south, his grandson, Emperor Ch'ien-lung 乾隆 (r. 1736–96), also visited the south six times. For more information on these imperial tours, see Maxwell K. Hearn, "Document and Portrait: The Southern Tour Paintings of Kangxi and Qianlong," in Ju-hsi Chou and Claudia Brown, eds., *Chinese Painting under the Qianlong Emperor: The Symposium Papers in Two Volumes*, Phœbus: A Journal of Art History 6, no. 2 (Tempe: Arizona State University, 1991), pp. 91–131.

10  Almost all the early Ch'ing painters active in Yangchou painted in the realistic manner, including Hsiao Ch'en 蕭晨 (active second half of 17th century), Yü Chih-ting 禹之鼎 (1647–c.1716), Wang Yün 王雲 (1652–after 1735), Li Yin 李寅 (active late 17th century–early 18th century), and Yen I 顏嶧 (1666–after 1749). See also entry 34 on Yüan Chiang for more discussion of realism in Yangchou during this period.

11 For a discussion of the intellectual inclinations of the patrons in Yangchou, see F. W. Mote, "The Intellectual Climate in Eighteenth-Century China," in *Chinese Painting under the Qianlong Emperor: The Symposium Papers in Two Volumes*, pp. 17–55.

12 For a description of the decline of Yangchou, see Juan Yüan's 阮元 (1764–1849) prologue for *Yang-chou hua-fang-lu* 揚州畫舫錄 (The Gaily Painted Pleasure Boats in Yangchou), p. 7. Juan wrote two prologues for this book. The first one is dated 1834, and the second 1839. According to Juan, the decline of Yangchou started around 1808. By 1819, when he visited Yangchou for the second time, many of the old mansions had already fallen into disrepair.

13 See ibid.

14 Wang Ying-hsiang's host, Pao Chih-tao, is listed in *Yang-chou hua-fang-lu* 揚州畫舫錄 (The Gaily Painted Pleasure Boats in Yangchou), *chüan* 卷 (chapter) 6, p. 142. Originally, the Paos were from a small town, T'ang-yüeh 棠樾, located west of She 歙 county near Mt. Huang in Anhui 安徽 province. During the Ming and Ch'ing periods, many natives from this region, including Pao Chih-tao, engaged in business, became wealthy, and moved to Yangchou. In Yangchou, Pao's frugal lifestyle and his emphasis on the importance of children's education must have been extraordinary in contrast to the notoriously lavish manner of his peers. Interestingly, in the entry for Pao in *Yang-chou hua-fang-lu*, in order to stress Pao's virtue, the author described the many wild ways the rich salt merchants in Yangchou spent their money:

"At the beginning, the [wealthy] salt merchants in Yangchou vied with one another to be indulged in luxury. They would easily spend thousands of dollars on their weddings, funerals, houses, banquets, clothes, and horses. There was a certain family whose cooks at dinnertime would prepare more than ten banquets, each consisting of multiple courses. The host and hostess would sit at the table while the servants brought out the many courses of each banquet, including tea, noodles, meat, and vegetables. When the servants saw the host shake his head with disapproval, they would immediately take the dishes away and bring in the many courses of the next banquet. Other wealthy families liked fine horses and kept several hundred of the finest steeds in their stables. Each horse cost a great deal of money for its daily upkeep. In the morning the horses were herded out of the city, and in the evenings they returned to their stables. Like colorful

blossoms in spring, these beautiful horses would bewilder local residents who attempted to count them. Some wealthy families that liked orchids would inundate their estates, from the door all the way to their inner chambers, with expensive orchids. One salt merchant used wood to make a mannequin of a naked woman that was animated by machines. He would invite guests into a room where the mannequin was placed. When it became animate, it would greatly startle his guests who would subsequently run for the door. In the early days, An Ch'i (1683–?) was the most opulent. After An, the salt merchants became even crazier. One merchant tried to spend ten thousand ounces of gold in a second. A servitor in his entourage purchased thin gold foil and shipped it to the top of the Gold Hill Pagoda. When the wind began to blow, he released the foils and in a second, it dispersed in the winds. The foil, unretrievable, was caught by the grass and trees. Another merchant spent three thousand ounces of gold and purchased all the small roly-polys in Suchou. He placed them in the Yangtze River and blocked the passage of boats. One merchant liked handsome servants; consequently, all his servants, including janitors and maids who worked in the kitchen, were all young and beautiful. One merchant went to the opposite extreme, preferring ugly help. He would only hire those who were ugly. In order to get hired, people would scar their faces, rub brown-colored bean jam into the wound, and stand under the sun to destroy their appearance. Those who liked everything large would make huge brass chamber pots over five feet tall. In order to relieve themselves during the night, they would have to climb on top of the gigantic pot. It is impossible to record all the excesses of the Yangchou salt merchants. However, when Pao Chih-tao came to Yangchou, he emphasized frugality.... Although he amassed a huge fortune, his wife and children practiced restraint; they cooked meals and swept floors. The gate of his house was [so small and narrow] that the cart and horse could not pass through. He would not hire theatrical troupes to perform at his house, nor would he keep anyone who introduced lewd and novel ideas at his home."

(初, 揚州鹽務, 競尚奢麗. 一婚嫁喪葬, 堂室飲食, 衣服輿馬, 動輒費數十萬. 有某姓者, 每食庖人備席十數類. 臨食時, 夫婦並坐堂上, 侍者抬席于前. 自茶麵葷素等色, 凡不食者, 搖其頤. 侍者審色, 則更易其他類. 或好馬, 蓄馬數百, 每馬日費數十金. 朝自內出城, 暮自城外入. 五花燦著, 觀者目眩. 或好蘭, 自門以至于內室, 置蘭殆遍. 或以木作裸體婦人, 動以機關, 置諸齋閣. 往往座客為之驚避. 其先, 以安綠村為最盛. 其後起之家, 更有足異者. 有欲以

萬金 一時費去者. 門下客, 以金盡買金箔. 載至金山塔上, 向風颺之. 頃刻而散. 沿江草樹之間, 不可收復. 又有三千金盡買蘇州不倒翁. 流于水中, 波為之塞. 有喜美者, 自司閽以至灶婢, 皆選十數齡清秀之輩. 或反之而取. 盡用奇醜者. 自誠之, 以為不稱. 毀其面, 而以醬敷之, 暴于日中. 有好大者, 以銅為溺器, 高五六尺. 夜欲溺, 起就之. 一時爭奇鬥異. 不可勝記. 自誠一來揚. 以儉相戒 ... 誠一擁資巨萬然其妻婦子女尚勤中饋箕帚之事門不容車馬不演劇淫巧之客不留于宅.)

Thus if Wang Ying-hsiang worked for the Pao family, the subject matter of Kuo Tzu-i, known for his wealth and control, makes perfect sense.

15 For Kuo Tzu-i's biography, see Liu Hsü 劉煦 (887–946) et al., *Jiu Tangshu (Chiu T'ang-shu)* 舊唐書 (The Old Version of the Book of T'ang), *juan (chüan)* 卷 (chapter) 120, *Liezhuan (Lieh-chuan)* 列傳 (Biographies) section, no. 70, reprint, vol. 11 (Beijing: Zhonghua Shuju, 1977), pp. 3449–76. For information on Kuo's hometown, see *Tz'u-hai* 辭海 (Sea of Terminology: Chinese Language Dictionary), vol. 2 (Taipei: Chung-hua Press, 1974), p. 2465, s.v. "Hua-chou 華州."

16 The territory where Kuo Tzu-i was stationed was called *pei-ti* 北地, or "northern frontier." See ibid., vol. 1, p. 440, s.v. "*pei-ti* 北地."

17 In Chinese history, the insurrection of An Lu-shan and Shih Ssu-ming is referred to as *An-shih chih-luan* 安史之亂, or "The Mutiny of An and Shih." It occurred during the height of the T'ang period in the mid-eighth century. Although eventually subdued, the revolt led to a decline in national strength. Thus, this war has been considered by historians a turning point of the T'ang period. For a discussion of this event, see Keith Buchanan et al., *China* (New York: Crown Publishers, 1980), pp. 222–28. In order to avoid being captured by the enemy, the emperor fled to Szechwan. A well-known painting, *T'ang-jen Ming-huang hsing-shu t'u* 唐人明皇幸蜀圖 (Emperor Ming-huang Traveling to Shu [Szechwan] by a painter of the T'ang Dynasty) at the National Palace Museum, Taipei, provides a vivid depiction of the unfortunate imperial trip. This painting is reproduced in *Ku-kung shu-hua t'u-lu* 故宮書畫圖錄 (An Illustrated Catalogue of Calligraphy and Painting at the Palace Museum), vol. 1 (Taipei: National Palace Museum, 1993), p. 39.

18 The episode of how Kuo Tzu-i subdued the Uigurs and Turfans is recorded in the *Chiu T'ang-shu* 舊唐書 (The Old Version of the Book of T'ang), *chüan* 卷 (chapter) 120, *Lieh-chuan* 列傳 (Biographies) section, no.

Wang Ying-hsiang 王應祥
The Three Abundant Blessings
*continued*

140

70, p. 3462. This historical event is also the subject of a famous handscroll, *Mien-chou t'u* 免冑圖 (Restraining from Putting on Armor and Helmets), attributed to Li Kung-lin 李公麟 (c. 1041–1106) of the Northern Sung period (960–1127), now at the National Palace Museum, Taipei. The title of this scroll is also often translated as *General Kuo Tzu-i Meeting the Uigurs.* It is reproduced in *Ku-kung shu-hua t'u-lu* 故宮書畫圖錄 (An Illustrated Catalogue of Calligraphy and Painting at the Palace Museum), vol. 15, pp. 289–91. Although this scroll may not be a genuine work by Li Kung-lin, it is a good example of the artist's *pai-miao* 白描 (ink drawing) technique. Not only is the ink linear work of this scroll excellent, but the painting also provides a vivid depiction of the magnificent array of armies, horses, armors, and weapons. In this work, the subdued leaders of the invaders dismount and kneel down meekly in front of the gallant Chinese general.

19 Paintings depicting the three blessings must have been fairly popular among the wealthy salt merchants in Yangchou. Another example is a work by Yü Chih-ting 禹之鼎 (1647–c.1716), a famous figure painter from Yangchou in the seventeenth century. See Yü's *Fang Zhao Qianli sanduotu* (*Fang Chao Ch'ien-li san-to t'u*) 倣趙千里三多圖 ("The Three Abundant Blessings" in the Style of Chao Ch'ien-li [Chao Po-chü, active second half of 12th century]) published in Kao Mayching 高美慶, ed., *Qingdai Yangzhou huajia zuopin* (*Ch'ing-tai Yangchou hua-jia tso-pin*) 清代揚州畫家作品 (Paintings by Yangzhou Artists of the Ch'ing Dynasty from the Palace Museum) (Hong Kong: Art Gallery, Institute of Chinese Studies, Chinese University of Hong Kong), pl. 27, pp. 120–21.

20 For the origin of the three abundant blessings, see "T'ien-ti 天地 (Heaven and Earth) in Chuang Chou's 莊周 (369–? B.C.) *Chuang-tzu* 莊子 (The Works of Chuang Tsu), reprint with commentary by Chang Ti-kuang 張耿光, vol. 1 (Taipei: Ti-ch'iu Press, 1994), pp. 271–73.

21 One entry addressing this topic is found in Lin Shuzhong 林樹中, ed., *Meishu cilin: Zhongguo huihua juan* (*Mei-shu tz'u-lin: Chung-kuo hui-hua chüan*) 美術辭林, 中國繪畫卷 (Dictionary of Fine Art Terminology: Chinese Painting Section), vol. 1 (Xian: Renmin Meishushe, 1995), p. 237, s.v. "Huafeng sanzhutu (Hua-feng san-chu t'u) 華封三祝圖"(The Three Blessings at the Hua State).

22 For more information on this fruit, see *Tz'u-hai* 辭海 (Sea of Terminology: Chinese Language Dictionary), vol. 1, p. 212,

s.v. "*fo-shou-kan* 佛手柑" (the Buddha's hand citrus fruit).

23 For an explanation of "the Buddha's hand citrus fruit" in the representation of *The Three Abundant Blessings*, see Lin Shuzhong's 林樹中 *Mei-shu tz'u-lin* 美術辭林 (Dictionary of Terminology in Fine Art), p. 237, s.v. "Sanduotu (San-to t'u') 三多圖" (Paintings Depicting the Three Abundant Blessings).

24 See ibid. For the story of the everlasting peach tree in Taoism, see "*P'an-t'ao hui* 蟠桃會" (The Flat Peach Banquet), in E. T. C. Werner, *A Dictionary of Chinese Mythology*, reprint (Taipei: Wen-hsing Press, 1961), p. 356. See also entry of "*Hsi-wang-mu* 西王母" (The Western Royal Mother) in Werner's book on p. 164. The flat peach, originally from Chinese Turkistan, is a small sweet peach, which, as the name suggests, is flat instead of round. As this type of peach was rare in China, it was thought in ancient times to bestow special benefits to those who ate it. For more on the celestial flat peach banquet, see the legend of Emperor Han-wu 漢武 (r. 140–87 B.C.) entertained by the Western Royal Mother, found in Li Fang's 李昉 (925–96) *Taiping guangji* (*T'ai-p'ing kuang-chi*) 太平廣記 (Extensive Records of the Peaceful Years), preface dated 977, *juan* (*chüan*) 卷 (chapter) 22, reprint, vol. 1 (Shanghai: Shanghai GUI Chubanshe, 1990), p. 4 (or new page no. 1043-13). In this story, the goddess, at the end of a celestial dinner party, served the emperor seven flat peaches on a jade plate. The immortal told the emperor that the fruits were from a tree in her garden. When the emperor tried to save the pits to be planted later in his own imperial garden, he was told that the soil on earth was too infertile for growing the tree of heaven which blooms only once every three thousand years.

25 For information on the pomegranate symbolizing posterity, see Lin Shuzhong's *Mei-shu tz'u-lin* 美術辭林 (Dictionary of Fine Art Terminology), p. 237, s.v. "Sanduotu (San-to t'u) 三多圖"(Paintings Depicting the Three Abundant Blessings).

26 These hieroglyphs were found on oracle bones from the Shang dynasty (c. 1600–c. 1100 B.C.). For the origin and derivation of the two characters, *ch'üeh* 雀 (a sparrow) and *chüeh* 爵 (aristocratic titles), see Hsü Shen 許慎 (30–124), *Shuowen jiezi* (*Shuowen chieh-tzu*) 說文解字 (An Etymological Dictionary with Explanation of Characters), 1st ed. dated c. 100, with commentary by Duan Yucai (Tuan Yü-tsai) 段玉裁 (1735–1815), chapter 5, reprint (Shanghai: Shanghai GUI Chubanshe, 1981), p. 217.

27 There are many examples of sparrows in the works of the painters of the Che school, active during the Ming dynasty. One common variation of this motif is referred to as the *Pai-chüeh t'u* 百雀圖 (The Hundred Sparrows). This depiction usually features ninety-nine brown birds flocking around one single white bird. As the white feathers of this bird are supposed to resemble the white hairs of an aged gentleman, the white bird represents General Kuo Tzu-i, while the brown birds represent his many wives, sons, and grandsons. Thus the central idea of the three blessings is invoked by the birds, derived from the reference to this great general, who was in turn a direct reference to the three blessings. For the painters of the Ming dynasty, the hundred sparrows motif was quite popular. Today there are at least four versions of *The Hundred Sparrows* found in several collections. For example, one is at the National Palace Museum, Taipei, under the title *Yüan-jen sui-ch'ao pai-chüeh* 元人歲朝百爵 (One Hundred Sparrows Presenting New Year Greetings by a Painter of the Yüan Dynasty [1280–1368]). Although attributed to an anonymous artist of the Yüan period, this scroll is apparently a work of a Che school painter of the Ming period. This painting is reproduced in *Ku-kung shu-hua t'u-lu* 故宮書畫圖錄 (An Illustrated Catalogue of Calligraphy and Painting at the Palace Museum), vol. 5, p. 371. A second version is also at the National Palace Museum, Taipei. Executed by a Ming court painter, Pien Wen-chin 邊文進 (c. 1354–1428), it is entitled *Hua-niao* 花鳥 (Flower and Bird). It is also reproduced in *Ku-kung shu-hua t'u-lu* 故宮書畫圖錄 (An Illustrated Catalogue of Calligraphy and Painting at the Palace Museum), vol. 6, p. 77. The third version, a later copy, is attributed to Lü Chi 呂紀 (active c. 1475–c. 1530), who was also a Ming court painter. This work, entitled *Copy of Pien Wen-chin's One Hundred Sparrows*, currently at the San Diego Museum of Art, is published in Richard M. Barnhart, *Painters of the Great Ming: The Imperial Court and the Zhe School* (Dallas: Dallas Museum of Art, 1993), cat. no. 59, p. 213. All three versions show a flock of sparrows amid three stalks of bamboo, with one white sparrow on the rock near the lower left corner, surrounded by a small group of sparrows with brown feathers. In these works, through the allusion to the three abundant blessings, General Kuo is also referenced. The plum tree in the compositions of these three paintings indicates New Year celebrations. It is very likely that Pien Wen-chin was the artist who initially created such a composition, which was copied by later Ming painters. The fourth version belongs to the Cleveland

Museum of Art. Although this scroll is accepted as a work by Pien Wen-chin, its composition displays noticeable differences from the other versions. First, four magpies are present among the hundred sparrows. Furthermore, pine needles are added on the upper left corner of the painting. Thus the Cleveland version is entitled *The Hundred Birds and the Three Friends*. The original meaning of the three abundant blessings seems to have been somewhat altered. The Cleveland version is published both in Ho Wai-kam 何惠鑑 et al., *Eight Dynasties of Chinese Paintings: The Collections of the Nelson Gallery-Atkins Museum, Kansas City, and the Cleveland Museum of Art* (Cleveland: Cleveland Museum of Art, 1980), cat. no. 121, p. 146 and in *Painters of the Great Ming: The Imperial Court and the Zhe School*, cat. no. 19, p. 62.

28  For examples of the grander, more luxurious buildings in Chinese painting, see entry 34 on Yüan Chiang 袁江 (active c. 1690–c. 1730).

29  For more examples of this type of large fan, see the famous handscroll attributed to Yen Li-pen 閻立本 (?–673), *Li-tai ti-wang hsiang* 歷代帝王像 (Portraits of the Thirteen Emperors), reproduced in *Selected Masterpieces of Asian Art* (Boston: Museum of Fine Arts, 1992), cat. no. 133, p. 147.

30  For a brief history of the *ju-i* scepter, see Li Chu-tsing 李鑄晉 and James C. Y. Watt 夜志仁, eds., *The Chinese Scholar's Studio: Artistic Life in the Late Ming Period—An Exhibition from the Shanghai Museum* (New York: Asia Society Galleries, 1987), pl. 67 and entry no. 67, pp. 179–80. In this entry, James Watt does not mention its origin as a back-scratcher, but this information is included in Wen C. Fong and James C. Y. Watt, *Possessing the Past: Treasures from the National Palace Museum, Taipei* (New York: Metropolitan Museum of Art, and Taipei: National Palace Museum, 1996), p. 467. For information on *ju-i* in early Chinese sources, see Wu Tseng 吳曾 (active during the Shao-hsing 紹興 reign, 1127–62), "Shih-shih 事始" (The Original Sources) in *Neng-kai chai man-lu* 能改齋漫錄 (Random Notes at the [Author's] Reforming One's Errors Studio), *chüan* 卷 (chapter) 2, p. 16b, reprint, vol. 2 (Taipei: Kuang-wen Press, 1970). According to Wu: "Emperor Kao-tsu (r. 479–82) of the Ch'i dynasty (479–501) bestowed upon the hermit monk Shao a *ju-i* scepter made from bamboo root. Emperor Wu-ti (r. 502–49) of the Liang dynasty (502–56) bestowed upon Prince Chao-ming (501–31) a *ju-i* scepter made from the wood of a magnolia tree. Shih

Chi-lun (Shih Ch'ung 石崇, 249–300) and Wang Tun (266–324) both held *ju-i* scepters made of iron. Thus these three *ju-i* scepters were made of bamboo, wood, and iron. In fact, these were all claw-wands. Thus from its pronunciation and meaning, the term *ju-i* should be this claw-wand of ancient time. Bone, antler or horn, bamboo, and wood were often carved in the shape of human fingers and attached to a three-foot-long handle. When there was an itchy area on one's back that was unreachable, this object could scratch any area desired. This is the reason these scepters were called *ju-i* (meaning 'as desired' or 'as wished'). Monks [however] argued, 'since Bodhisattva Manjusri held this object, did this deity use it to scratch his back?' Customarily, abbots hold this scepter when preaching. They copy scriptures and eulogies on the handles of their scepters. Holding them in their hands, they can [easily] read the texts as they wish. This is the second reason why it is called *ju-i* or 'as you wish.'" (齊高祖, 賜隱士明僧紹竹根如意. 梁武帝, 賜昭明太子木犀如意. 石季倫, 王敦, 皆執鐵如意. 三者, 以竹, 木, 鐵, 為之. 蓋爪杖也. 故音意指歸. 云如意者, 古之爪杖也. 或用角竹木, 削作人手指爪, 柄可長三尺許. 或脊有癢, 手所不到, 用以搔抓, 如人之意. 然釋流以文殊亦執之, 豈欲搔癢耶? 蓋講僧尚執之, 私記節文祝辭于柄, 以備忽忘. 手執目對, 如人之意. 凡兩意耳.) There were typically three manifestations of these *ju-i* scepters. The end of the first was shaped like a hand, often complete with individual fingers, and was used to scratch or point. The second, with a flat end, was used primarily for ceremonial purposes. The end of the third was shaped to resemble clouds. Appearing sometime during the late Ming dynasty, this cloud pattern was a symbol of good luck.

31  For examples of narrative paintings of the Sung dynasty, see *Che-chien t'u* 折檻圖 (Breaking the Railing) and *Ch'üeh-tso t'u* 卻坐圖 (Protesting the Emperor's Consort Taking the Seat Reserved for the Empress), both at the National Palace Museum, Taipei. The first painting is about Chu Yün 朱雲 (1st century B.C.), a high official who, after failing to persuade the emperor, grabbed hold of a railing. When imperial guards tried to drag him away, he refused to let go, and the railing was subsequently broken. The second work depicts Yüan Ang 袁盎 (c. 2nd century B.C.), protesting the emperor's decision to allow his favorite concubine to sit in the seat reserved for the empress. Both works by anonymous painters of the Sung period are reproduced in *Ku-kung shu-hua t'u-lu* 故宮書畫圖錄 (An Illustrated Catalogue of Calligraphy and Painting at the Palace Museum), vol. 3, p. 81 and p. 82, respectively.

32  For paintings with heavy pigment executed in the manner of the T'ang dynasty, see *Chiang-fan lou-ko* 江帆樓閣 (Riverside Pavilions), attributed to Li Ssu-hsün 李思訓 (651–716) at the National Palace Museum, Taipei. It is reproduced in *Ku-kung shu-hua t'u-lu* 故宮書畫圖錄 (An Illustrated Catalogue of Calligraphy and Painting at the Palace Museum), vol. 1, p. 9. The use of heavy red, green, and blue can be witnessed in the many murals excavated from tombs of the T'ang dynasty. See Zhang Hongxiu 張鴻修, ed., *Tangmu bihua jijin* (*T'ang-mu pi-hua chi-chin*) 唐墓壁畫集錦 (Highlights of the T'ang Dynasty Tomb Frescoes) (Xian: Shaanxi Renmin Meishu Chubanshe, 1991).

33  At the National Palace Museum, Taipei, there are many large hanging scrolls painted in the manner of Wang Ying-hsiang. The exact date of these paintings is difficult to ascertain. Traditionally these scrolls were attributed to anonymous painters of the Sung dynasty, although some believe they were created later, during the Yüan and Ming dynasties. Few would have dated them to the nineteenth century, as most scholars believed the realist impulse in Yangchou declined much earlier. Yet it is more likely that these works were executed by later Ch'ing artists. Consequently, Wang Ying-hsiang's work at the University of Michigan aids us in reexamining these paintings and enables us to date them, as well as the realist impulse in Yangchou, more accurately. For examples of these paintings at the National Palace Museum, see *Ying-hsi t'u* 嬰戲圖 (Children at Play) attributed to Su Han-ch'en 蘇漢臣 (active c. 1120s–60s), reproduced in *Ku-kung shu-hua t'u-lu* 故宮書畫圖錄 (An Illustrated Catalogue of Calligraphy and Painting at the Palace Museum), vol. 2, p. 77, and *Sui-chao t'u* 歲朝圖 (The New Year Celebrations) attributed to Li Sung 李嵩 (active c. 1190–1230), also reproduced in *Ku-kung shu-hua t'u-lu*, vol. 2, p. 145. Of these, the latter was most likely executed by the hand of Wang Ying-hsiang.

## 48. Li Chi-shou 李吉壽
*(active second half of 19th century)*
*Ch'ing dynasty (1644–1911)*

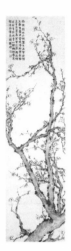

### Plum Blossoms after Chin Nung
(1687–1764)

*Fang Chin Nung mei-hua
(Plum Blossoms after Chin Nung)*

做金農梅花

1   Li Chi-shou adopted Tz'u-hsing (a lesser star) as his *tzu* so that he could show the lineage of his father, whose *tzu* was Hsingmen 星門, or "star gate."

2   While accomplished, Li Hsi-yüan's work is of little distinction. Currently at the Guangxi Zhuangzu zizhiqu bowuguan 廣西壯族自治區博物館 (Kwangsi Province Zhuang Minority Autonomous Region Museum), it is reproduced in Group for the Authentication of Ancient Works of Chinese Painting and Calligraphy, ed., *Zhongguo gudai shuhua tumu (Chung-kuo ku-tai shu-hua t'u-mu)* 中國古代書畫圖目 (Illustrated Catalogue of Selected Works of Ancient Chinese Painting and Calligraphy), vol. 14 (Beijing: Wenwu Chubanshe, 1996), no. 桂 1-185, p. 275.

3   See Hsüeh T'ien-pei 薛天沛, *I-chou shuhua lu hsü-pien* 益州書畫錄續編 (Sequel to Record of Painting and Calligraphy from the Szechwan Area) (Ch'eng-tu: Ch'ung-li T'ang, 1945), pp. 35b–36a. It says: "Li Chishou's *tzu* was Tz'u-hsing (a lesser star) and he was from Kweilin [in Kwangsi province.] He achieved the degree of *chüjen* (a commendable gentleman) and occupied the official position of prefect of P'ihsien [in Szechwan province.] [An honest official] he won a favorable reputation as an administrator. He was adept in both painting and calligraphy, especially in the genre of plum blossoms. In painting and calligraphy, he followed the personal style of Chin Tung-hsin (Chin Nung, 1687–1764). [His work is] luscious and purely elegant. Going beyond merely imi-

tating [Chin Nung's work, Li's work] is entirely separated from the dust [of this mundane world.] This is definitely something that could not be accomplished by an ordinary painter!" (李吉壽, 字次星, 桂林人. 舉人. 官郵縣知縣, 有政聲. 工書畫, 畫梅尤長. 書畫皆取法金冬心. 清潤淹雅, 不僅貌似. 迴絕塵氣, 斷非俗手所能及也!)

4   For more on Chin Nung, see entry 38.

5   See Yu Jianhua's 于劍華 et al., *Zhongguo meishujia renming cidian (Chung-kuo mei-shu-chia jen-ming tz'u-tien)* 中國美術家人名詞典 (Biographical Dictionary of Chinese Artists) (Shanghai: Renmin Meishu Chubanshe, 1981), p. 356.

6   Li died sometime during the late nineteenth century during the Kuang-hsü 光緒 period (1875–1908). Yet one source records that Li died during the Chia-ch'ing 嘉慶 period (1796–1821). Since his father's dates were 1780–1869 and one of his last works is dated 1890, Li could not have lived during the Chia-ch'ing period. For the source of the inaccurate date of Li Chi-shou's death, see Chinese Calligraphy and Painting Institute, comp., *Chung-kuo li-tai shu-hua chuan-k'e-chia tzu-hao suo-yin* 中國歷代書畫篆刻字號索引 (Index for Sobriquets of Chinese Artists in History), vol. 1 (Hong Kong: Pacific Book Company, 1974), p. 460. For a discussion of this issue, including his late work dated 1890, see *Chung-kuo mei-shu-chia jen-ming tz'u-tien* 中國美術家人名詞典 (Biographical Dictionary of Chinese Artists), p. 356.

7   The source comparing the noble characters of plum blossoms to jade and ice is Su Shih's 蘇軾 (1036–1101) poem, which says: "[The plum blossoms] in the Plum Blossom Villa under Mt. Fu-lo take snow-white jade for their bones and ice for their soul." (羅浮山下梅花村玉雪為骨冰為魂.) For the source of Su Shih's poem entitled "Sung-feng t'ing-hsia mei-hua sheng-k'ai 松風亭下梅花盛開" (The Fully-Blooming Plum Blossoms by the Pine Wind Pavilion), see Su Shih, *Shih-chu Su-shih* 施注蘇詩 (Su Shih's Poems with Shih Yüan-chih's [施元之, c. 13th century] Comments), reprint, preface dated 1883, *chüan* 卷 (chapter) 35, p. 14a, reprint, vol. 2 (Taipei: Kuang-wen Press, 1964), p. 439.

8   Numerous terms using the character plum are found in many different aspects of Chinese culture, including plum water, plum moon, plum hill, plum rain, plum immortal, the Three Strokes of Plum-blossoms (the name of a popular music piece), Plum Village, plum blossom deer. See *Hanyu dacidian (Han-yü ta-tz'u-tien)* 漢語大詞典 (Chinese Terminology Dictionary), vol. 4 (Shanghai: Hanyu Dacidian Press, 1988), pp. 1043–51.

9   Plum blossoms are held in such high esteem that when the Republic of China was founded in 1912, they were chosen as the national flower.

10   For the story of Mei-fei, see anonymous, "Mei-fei chuan 梅妃傳" (Biography of the Plum Blossom Consort) in Lu Chi-yeh 盧冀野, ed., *T'ang Sung ch'uan-ch'i hsüan* 唐宋傳奇選 (Selected Legends of the T'ang and Sung Dynasties) (Chang-sha: Commercial Press, 1937), pp. 128–32. For excerpts of this story in English, see Maggie Bickford et al., *Bone of Jade, Soul of Ice* (New Haven: Yale University Art Gallery, 1985), pp. 176–79.

11   For Lin Pu's biography, see the first section on "Yin-i 隱逸" (Hermits), no. 216 in "Lieh-chuan 列傳" (Biographies), in T'o T'o 脫脫 (1313–55) et al., *Sung-shih* 宋史 (History of the Sung Dynasty), reprint (Beijing: Zhonghua Shuju, 1977), p. 13432. For Lin's biography in English, see Schlepp Wayne, "Lin Pu," in Herbert Franke, ed., *Sung Biographies: Ostasiatische Studien*, Bd. 17 (Wiesbaden: F. Steiner, 1976), pp. 613–15. For the source of the term, "plum tree wife and crane sons," see section 2, "Jen-shih 人事" (Human Affairs), in Shen Kua 沈括 (1029–1093), *Meng-hsi pi-t'an* 夢溪筆談 (Brush Dialogue at Dream Creek [the author's notes on various subjects]), *chüan* 卷 (chapter) 10, reprint with collation by Hu Daojing 胡道靜, vol. 1 (Shanghai: Shanghai Chubanshe, 1956), p. 402.

12   For the source of Lin Pu's well-known poem including these two lines, see his first poem entitled "Shan-yüan hsiao-mei shih erh-shou 山園小梅詩二首" (Two Poems on the Tender Plum Blossoms at a Mountain Garden) in his *Lin Ho-ching hsien-sheng shih-chi* 林和靖先生詩集 (Anthology of Mr. Lin Ho-ching [Li Pu's posthumous title conferred by the emperor, meaning "harmonious and tranquil"]) *chüan* 卷 (chapter) 2, reprint (Shanghai: Commercial Press, 1935), p. 22a.

13   While Li Chi-shou's work *Plum Blossoms after Chin Nung (1687–1764)* is executed in a style resembling Chin Nung, it is even closer in style to a student of Chin Nung named Lo P'in 羅聘 (1733–99), one of the Eight Masters of Yangchou. For a discussion of Lo P'in and his work, see Juhsi Chou and Claudia Brown, *The Elegant Brush: Chinese Painting under the Qianlong Emperor, 1735–1795* (Phoenix: Phoenix Art Museum, 1985), pp. 201–10.

14   Li Chi-shou's work is less accomplished than one would expect from the generous praise Li's work received in early sources, much of which may have been motivated by Li's official position. For the source of this praise, see note 3.

## 49. Jen Hsiung 任熊
(1823–57)
*Ch'ing dynasty (1644–1911)*

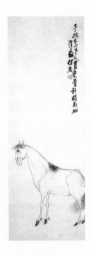

### Ferghana Horse after Chin Nung (1687–1764)
*Fang Tung-hsin Lao-jen hua ta-yüan-ma chou*
*(Ferghana Horse after Tung-hsin Lao-jen [hao of Chin Nung])*
做冬心老人畫大宛馬

1 Tung-hsin Lao-jen, meaning "old man with a wintry heart," was the *hao* of the eighteenth-century painter Chin Nung. For more information, see entry 38.

2 Jen's horse scroll was initially brought to the University of Michigan in the early 1980s by a dealer who went to China to acquire antiques. At that time, the Cultural Revolution had recently ended, and government repositories were brimming with confiscated art objects. Works by artists of the nineteenth and twentieth centuries failed to capture the attention of Chinese officials and were sold by the sackful. Jen's horse, which was nondescript and simple-looking, was among such package deals. When it was examined at the Museum of Art, its important relationship with Chin Nung's prototype was recognized. When the Museum expressed an interest in purchasing the work, however, the dealer quoted an astronomical price, which aborted the potential purchase. Three years later, in 1985, the painting surfaced at Sotheby's. The Museum again took initiative, pursued the opportunity, and acquired the scroll for a fraction of the original amount. See Sotheby's sales catalogue, *Fine Chinese Paintings* (New York: Sotheby's, June 3, 1985), lot no. 97.

3 In Cahill's article, Gong's name is printed as "Gong Yanxing 龔彥興." See James Cahill, "Ren Xiong (Jen Hsiung) and His Self-Portrait," *Ars Orientalis* 25 (Ann

Arbor: Department of the History of Art, University of Michigan, 1995), p. 119.

4 Zhang's article is also published in Gugong Bowuyuan Zijincheng Chubanshe, ed., *Gugong bowuyuan cangbaolu* (*Ku-kung po-wu-yüan ts'ang-pao-lu*) 故宮博物院藏寶錄 (A Catalogue of the Treasures at the Palace Museum) (Shanghai: Wenyi Chubanshe, 1986), p. 49, comments on pp. 181–83.

5 For more on Ch'ien-lung's life, see Arthur W. Hummel, ed., *Eminent Chinese of the Ch'ing Period (1644–1912)*, vol. 1 (Washington, D.C.: United States Government Printing Office, 1943–44), pp. 369–73.

6 For more on Ho-shen's life, see ibid., pp. 288–90.

7 Previously, there were as many as eight different dates given for Jen Hsiung's birth and death. Much of what is available on Jen Hsiung is predicated on the writings of Ch'en Tieh-yeh's 陳蝶野 (1896–1989, *tzu* Ting-shan 定山, meaning "steadfast mountain") *T'ung-yin fu-chih* 桐陰復志 (A Successive Account under Shades of the Paulownia Tree). Ch'en, a native of Shanghai, left China before the Communist Revolution and died in Taiwan. Unfortunately, his prose style is casual and often fictional; consequently, much of the content, including many of the dates, is inaccurate. The most conspicuous mistake Ch'en T'ieh-yeh made concerns the anecdote about Jen Hsiung's learning ancestral portraiture from a local teacher. Ch'en claims that this happened after the pacification of the T'ai-p'ing Rebellion in 1863. In reality, Jen died six years before in 1857. See Gong Chanxing 龔產興, "Ren Weichang shengping shilue kao (Jen Weich'ang sheng-p'ing shih-lue k'ao) 任渭長生平事略考" (Research on Jen Hsiung's Life and Activities), in *Meishu yanjiu* (*Mei-shu yen-chiu*) 美術研究 (The Research and Study of Fine Arts) 4 (Beijing: Central Art Academy, 1981), p. 87. The publication of Gong's short article in 1981 was a major breakthrough in research on Jen Hsiung. In the fall of 1980, Gong went to Jen Hsiung's hometown and discovered a rare manuscript at the county library, *Xiaoshan Renshi jiacheng* (*Hsiao-shan Jen-shih chia-ch'eng*) 蕭山任氏家乘 (A Historical Record of the Jen Family from Hsiaoshan), which documents at least 25 generations of the Jen clan. According to this genealogy, Jen Hsiung belonged to the twenty-second generation. The dates of his birth, 1823, and death, 1857, are clearly registered in the book. Thus, Gong's article clarified the widely divided opinions of the past. Gong located a sec-

ond book entitled *Fanhu caotang yigao* (*Fan-hu ts'ao-t'ang i-kao*) 范湖草堂遺稿 (The Unpublished Manuscripts at the Thatched Cottage of Lake Fan). The author, Chou Hsien 周閑 (1820–75), was Jen Hsiung's close friend. Although Gong did not specify where he discovered the book, he does mention that six volumes of Chou's manuscripts were published posthumously in 1893. In volume 1, there is an article, *Jen ch'u-shih chuan* 任處士傳 (Biography of Jen Hsiung, A Gentleman without Official Position), which provides a detailed description of Jen Hsiung, including his life, creative career, and friendships. Volumes 4 and 5 document Chou Hsien and Jen Hsiung's literary gatherings and travels. At present, Chou's writings are by far the most dependable material concerning Jen Hsiung's life yet to be discovered. Chou Hsien was from Hsiushui in northern Chekiang. His brief biography can be found in Yu Jianhua 于劍華 et al., *Zhongguo meishujia renming cidian* (*Chung-kuo mei-shu-chia jen-ming tz'u-tien*) 中國美術家人名詞典 (Biographical Dictionary of Chinese Artists) (Shanghai: Renmin Meishu Chubanshe, 1981), p. 493. Unable to achieve access to the above-mentioned books, scholars in the West have had to rely on Gong's article. Fortunately, he cites freely from Chou's writings; thus, those who read Chinese can still glimpse transcriptions of the original texts. In 1988, Gong Chanxing also published a chronological table of Jen Hsiung containing even more substantial and detailed information on the artist. See his "Jen Wei-ch'ang nien-piao 任渭長年表" (Chronological Table of Jen Hsiung) in *Meishushilun jikan* (*Mei-shu-shih-lun chik'an*) 美術史論季刊 (Quarterly Journal of History and Theory of Fine Arts) 25 (Beijing: Institute of Fine Arts, China Art Academy, Spring 1988), pp. 80–84.

8 Information on Jen Hsiung's father is found in Gong's article, "Jen Wei-ch'ang sheng-p'ing shih-lüeh k'ao 任渭長生平事略考" (Research on Jen Hsiung's Life and Activities), p. 86. Gong cited this information from *Hsiao-shan Jen-shih chia-ch'eng* 蕭山任氏家乘 (A Historical Record of the Jen Family from Hsiao-shan).

9 The original text by Chou Hsien concerning Jen Hsiung follows: "人短小精悍, 眉目間有英氣. 少失父, 事母能孝, 視弟妹能友愛. 與人交, 坦白和易, 能久而益敬... 家綦貧. 作畫得金, 以養母畜妻子... 傾資助喪... 能吟詩, 填詞... 詩寫靈性, 詞有逸趣... 諸子百家咸皆涉獵... 能馳馬能開弓霹靂射能為貫跤諸戲, 能刻畫金石, 能斲桐為琴, 鑄鐵成簫笛, 皆分劃合度. 能自制琴曲, 春秋佳日, 以之娛悅. 能飲酒, 不多亦不醉. 有盧同之癖. 然以味醺為美, 不暇辨精粗也."

Jen Hsiung 任熊
**Ferghana Horse after Chin Nung**
(1687–1764)
*continued*

10 This passage is found in Wang Ling's 王齡 preface for Jen Hsiung's woodblock print, *Gaoshizhuan tuxiang* (*Kao-shih chuan t'u-hsiang*) 高士傳圖像 (Biographies and Images of Ancient Lofty Scholars), pp. 1–2, 1st ed. dated 1857, reprint, *Ren Weichang huazhuan sizhong* (*Jen Wei-ch'ang hua-chuan ssu-chung*) 任渭長畫傳四種 (Jen Hsiung's Four Sets of Illustrated Biographies) (Beijing: China Bookstore, 1985). (渭長以高才畸行, 不偶世好, 與俗忤. 人怒其氣矯, 而喜其技炫, 心顏耐其剛.)

11 Information on Jen's early painting experiences is found in Fang Ruo's 方若 *Haishang hua-yü* 海上畫語 (Words about Painters and Painting in Shanghai), cited in Wang Jingxian's 王靖憲 *Ren Bonian zuopinji* (*Jen Po-nien tso-p'in-chi*) 任伯年作品集 (A Collection of Jen I's Works), vol. 1 (Shanghai: Renmin Meishu Chubanshe, 1987), p. 10. It states: "Young Jen liked to scribble on everything. He studied under Mr. Chang Ya-t'ang. [One day Chang] checked [his student's] satchel and found a stack of unfinished paintings. Later, in one of those war-ridden years [presumably in his late teens], he took refuge in a dilapidated temple in the mountains. [Since he could not find brush and paper] he gathered slack and drew lively illustrations on the ground of what he encountered." (自幼喜塗抹, 從張雅堂夫子讀. 偶撿其書包下, 皆畫稿耳. 亂戰作避難山中, 憩于古廟. 拾炭屑繪途中所見, 無不歷歷)

12 The original Chinese text concerning Jen's early training in ancestral portraiture is found in Ch'en T'ieh-yeh's 陳蝶野 *T'ung-yin fu-chih* 桐陰復志 (A Successive Account under Shades of the Paulownia Tree), which is cited in Zhang Anzhi's 張安治 article, "Ren Xiong he tade zihuaxiang (Jen Hsiung ho t'a-teh tzu-hua-hsiang) 任熊和他的自畫像 (Jen Hsiung and His Self-portrait), in Editorial Committee of the Palace Museum Bulletin, *Gugong bowuyuan yuankan* (*Ku-kung po-wu-yüan yüan-k'an*) 故宮博物院院刊 (Palace Museum Bulletin) 4 (Beijing: Palace Museum, Summer 1979), note 2, p. 13. This passage is also found in Gong Chanxing's "Jen Wei-ch'ang nien-piao 任渭長年表" (Chronological Table of Jen Hsiung), p. 80: "At that time, the T'ai-p'ing Rebellion had just been pacified. [People] lost all their belongings in the war and the neighborhood became quite desolate. As few of the ancestral images survived, [the villagers] missed their fathers and grandfathers. At the studio of this local painter [in order to replace these lost images] people had to select an ancestral painting among the existing model portraits. The images of old people with unsightly features could be used as portraits of grandfathers or

great-grandfathers. Those looking simple and honest could be used as portraits of fathers or uncles. People referred to this practice as 'buying an ancestor.' In general, a portrait of a father or grandfather cost about one hundred, while an image of a great-grandfather or an even older ancestor would cost in the thousands. This village professional painter had six to seven apprentices. They were provided model portraits of men and women, both young and old, and were required to first trace, then to fill in the colors accordingly. Jen Hsiung [who was talented and inventive] quickly grew bored with these activities and covertly altered the patterns. As a result, those who were attired in dignified official garments and wore hats decorated with peacock feathers lost their fanciful hats and were instead caricatured as bald. Those who sat on a chair in a stately fashion were depicted in a casual fashion, with one leg bent and resting on the opposite knee. Jen Hsiung also emphasized some of the figures' harelips and otherwise deformed mouths. All sorts of nonflattering and awkward features appeared in Jen Hsiung's portraits; consequently, the teacher angrily denounced him. After several severe reproaches, young Jen Hsiung persisted in his rebellious ways. The conservative preceptor boiled with rage and Jen Hsiung had to flee in fear." (時洪楊亂初定, 閭里蕭條, 百物盡失. 子孫念祖烈, 而真容已鮮. 則就村畫師儘所畫中選取. 若者老醜, 似其祖曾. 若者椎魯, 似其父叔. 乃從而論值謂之買太公. 大率父祖百, 高曾千也. 師授徒六七人, 授以藍本. 影描勾填, 畫男女老幼悉具. 渭長厭之, 乃竊變成法. 于是朝服翎頂者, 禿其顱矣! 端拱者, 翹一足矣! 缺嘴壞唇, 無怪不具. 師大怒. 悛責不改, 遂逃去.) The peacock-feather decoration worn on the hats of the Manchu officials mentioned in this passage was an important citation that was awarded for a person's meritorious service. Altering this would have been a serious insult and could have resulted in severe trouble for the village artist.

13 See "Jen Wei-ch'ang nien-piao 任渭長年表" (Chronological Table of Jen Hsiung), p. 80. Gong cited this information from *Hsiao-shan Jen-shih chia-ch'eng* 蕭山任氏家乘 (A Historical Record of the Jen Family from Hsiao-shan). It is a story told many years ago by a member of the Jen family.

14 For an example of Jen Ch'i's work, see his *Songzi dekuitu* (*Sung-tze te-k'uei t'u*) 送子得魁圖 (Escorting a Son to Achieve the Championship) at the Zhejiang Provincial Museum (浙江省博物館), published in Editorial Committee of the Complete Collection of Chinese Art, *Zhongguo meishu quanji* (*Chung-kuo mei-shu ch'üan-chi*) 中國美術全集 (A Complete Collection of

Chinese Art), vol. 11 (Shanghai: Renmin Meishu Chubanshe, 1988), no. 173, p. 166. An example of Jen Hsiung's work after Ch'en Hung-shou, *Yaogong qiushan tu* (*Yao-kung ch'iu-shan t'u*) 瑤宮秋扇圖 (The Autumn Fan at the Jade Palace), dated 1855 and currently at the Nanjing Museum, is reproduced in *A Complete Collection of Chinese Art*, vol. 11, no. 176, p. 170. The fact that both works are direct copies after Ch'en Hung-shou's paintings is clearly indicated in the artists' inscriptions.

15 This information is found in "Ren Bonian nianpu (Jen Po-nien nien-p'u) 任伯年年譜" (Chronological Table of Jen Po-nien), in Ding Xiyuan's 丁羲元 *Ren Bonian* (*Jen Po-nien*) 任伯年 (Jen Po-nien) (Shanghai: Shuhua Chubanshe, 1989), p. 5. The year of Jen Hsiung's trip to Ting-hai is not certain. This episode is originally found in Wu Heng's 吳恆 (1826–95) inscription on Jen Hsiung's hanging scroll, *Songyin tuzhou* (*Sung-yin t'u-chou*) 松隱圖軸 (An Ascetic amid Pine Trees), now at the Palace Museum, Beijing. See "Jen Wei-ch'ang nien-piao 任渭長年表" (Chronological Table of Jen Hsiung), entry for 1846, p. 80 and entry for 1849, p. 81.

16 *Arhat* is a name derived from the Sanskrit *arhan* or *arhat* and refers to an ascetic who has achieved enlightenment. In China, this is also referred to as *lohan* 羅漢. For more information on arhats, see E. T. C. Werner, *A Dictionary of Chinese Mythology*, reprint (Taipei: Wen-hsing Press, 1961), pp. 259–79. For a discussion of the sixteen *arhats*, see notes 16–18 of chapter 18 in Wen C. Fong and James C. Y. Watt, *Possessing the Past: Treasures from the National Palace Museum, Taipei* (New York: Metropolitan Museum of Art, and Taipei: National Palace Museum, 1996), p. 601. The Sheng-yin Temple used to be a well-known monastery near the West Lake in Hangchou. The photo of the steles on which Kuan Hsiu's sixteen *arhat* paintings are carved can be found in Ernst Boerschmann's (1873–1949) *Old China in Historic Photographs*, reprinted with a new introduction by Wan-go Weng (New York: Dover Publications, 1982), p. 115.

17 See "Jen Wei-ch'ang nien-piao 任渭長年表" (Chronological Table of Jen Hsiung), entry for 1846, p. 80 and entry for 1849, p. 81.

18 This set of sixteen leaves used to belong to a private collector in China and is reproduced in color in Gao Yun 高雲 and Huang Jun 黃峻, eds., *Zhongguo minjian micang huihua zhenpin* (*Chung-kuo min-chien mi-ts'ang hui-hua chen-p'in*) 中國民間秘藏繪畫珍品 (Precious Paintings from Private Collections in China) (Nanjing: Jiangsu Meishu Chubanshe, 1989), pp. 59–74.

19 For examples of Chou Hsien's paintings, see *Shanghai bowuguan cang haishang minghuajia jingpinji* (*Shanghai po-wu-kuan ts'ang hai-shang ming-hua-chia ching-p'in chi*) 上海博物館藏海上名畫家精品集 (Masterworks of Shanghai School Painters from the Shanghai Museum) (Hong Kong: Ta-ye Co., 1991), cat. nos. 8–9. Chou Hsien participated in the oppression of the Small Sword Society in Shanghai in 1853 and decapitated five hundred of the enemy. Thus, he was promoted to *lang-kuan* 郎官 (deputy commander) in the army and allowed to wear a blue pheasant feather on his hat. This is recorded in a preface written by Ting Wen-wei 丁文蔚 for Jen Hsiung's *Liexian jiupai* (*Lieh-hsien chiu-p'ai*) 列仙酒牌 (Drinking Cards Decorated with Immortals), p. 1. See Jen Hsiung's *Drinking Cards Decorated with Immortals*, 1st ed. dated 1854, reprinted in *Jen Wei-ch'ang hua-chuan ssu-chung* 任渭長畫傳四種 (Jen Hsiung's Four Sets of Illustrated Biographies). For more information on the Small Sword Society, see *Eminent Chinese of the Ch'ing Period (1644–1912)*, vol. 1, pp. 118–19 and 367.

20 Jen Hsiung's time at Yao's home between 1849 and 1850 is recorded in Yao Hsieh's postscript on Jen Hsiung's album leaves currently in the Ching Yüan Chai Collection, entitled *Enchanting Vignettes from the Past*. Jen Hsiung's album leaves are reproduced in Suzuki Kei 鈴木敬, comp., *Comprehensive Illustrated Catalog of Chinese Paintings*, vol. 1 (Tokyo: University of Tokyo Press, 1982), nos. A31-092, 1/12–12/12, p. 357. Yao Hsieh's postscript is not reproduced. Fortunately, the postscript is translated in Claudia Brown and Ju-hsi Chou, *Transcending Turmoil: Painting at the Close of China's Empire, 1769–1911* (Phoenix: Phoenix Art Museum, 1992), pl. 59, p. 165. The book says: "In the *jiyou* (1849) year of the Tao-kuang reign (1821–50), Jen Hsiung came to Ning-po from Hsiao-shan, carrying his zither and intending to sell his paintings. He stayed at my Great Plum Blossom Mountain Retreat by the Kan stream in the region for one year. . . . At the end of the late autumn of *gengxu* (1850), we parted as he was tired of being away from home." This episode is also recorded in *Hai-shang hua-yü* 海上畫語 (Words about Painters and Painting in Shanghai), cited in Wang Jingxian's 王靖憲 *Ren Bonian zuopingji* (*Jen Po-nien tso-p'in-chi*) 任伯年坐品集 (A Collection of Jen I's Works), vol. 1, p. 10. It says: "After the war ended, Jen Hsiung, seeking a livelihood, went to Shanghai to sell his painting. Few were interested in his works. At that time, Yao Hsieh, who was from Chen-hai, stayed at the You-sheng temple in Shanghai, recuperating from an illness. When Yao viewed Jen Hsiung's paintings, he admired them and invited Jen Hsiung to live and paint at his villa, The Great Plum Blossom Mountain Retreat." (亂後無可謀生, 鬻畫甬上. 鮮人過問. 鎮海姚梅伯燮, 適在甬養痾佑聖觀. 遇而嘆賞, 館于大梅山館.)

21 Jen Hsiung's one hundred twenty album leaves painted at Yao Hsieh's home now belong to the Palace Museum in Beijing. On the last leaf, there is a colophon by Jen Hsiung, dated 1851. This indicates the paintings were probably finished early, possibly in 1850. Jen's colophon says: "On the fifteenth day of the first moon in the first year of the Hsien-feng reign (1851–61), Jen Hsiung, [whose *hao* is] Wei-ch'ang, from Hsiao-shan, added this colophon on his own painting. . . . In my leisure time, Fu-chuang [*hao* of Yao Hsieh] would select verses and ask me [to use these poems as inspirations] for paintings. Under a lamp, [I] made drafts and applied color the [next] morning. After a little over two months, [we] produced one hundred twenty leaves." (咸豐紀元, 上元之日, 蕭山任熊渭長, 自跋... 暇時, 復莊自摘其句, 囑余為之圖. 燈下構稿, 晨起賦色. 閱二月餘, 得百有二十葉.) See Zhang's article "Jen Hsiung ho t'a-te tzu-hua-hsiang 任熊和他的自畫像" (Jen Hsiung and His Self-Portrait), p. 13, n. 3. Eighteen leaves from this set are reproduced in *Ren Xiong Yao Xie shiyi tuce* (*Jen Hsiung Yao Hsieh shih-i t'u-ts'e*) 任熊姚燮詩意圖冊 (Album Leaves Based on Poems by Jen Hsiung and Yao Hsieh) (Shanghai: Renmin Meishu Chubanshe, 1981). See also Hsi-pai's 希白 article, "Chi Jen Hsiung ta-mei shan-min shih-chung hua-ts'e 記任熊大梅山民詩中畫冊" (A Record of Jen Hsiung's Album Leaves Based on Poems by Yao Hsieh, Whose Sobriquet Was Dweller in the Great Plum Mountain) in *I-lin ts'ung-lu* 藝林叢錄 (A Collection of Art Related Articles), vol. 10 (Hong Kong: Commercial Bookstore, 1973), pp. 256–62.

22 For a discussion of the T'ai-p'ing Rebellion, see the entry on Hung Hsiu-ch'üan 洪秀全 (1813–64), leader of this insurrection, in *Eminent Chinese of the Ch'ing Period (1644–1912)*, vol. 1, pp. 361–66.

23 Ting Wen-wei was also a native from Jen Hsiung's hometown of Hsiao-shan. His brief biography is found in *Chung-kuo mei-shu-chia jen-ming tz'u-tien* 中國美術家人名詞典 (Biographical Dictionary of Chinese Artists), p. 2.

24 Zhang Anzhi 張安治 mentioned that Jen Hsiung painted a portrait for Chou Hsien in 1856 in his article "Jen Hsiung ho t'a-te tzu-hua-hsiang 任熊和他的自畫像" (Jen Hsiung and His Self-Portrait), p. 13, n. 4, and stated that this portrait belonged to the Palace Museum in Beijing. As a matter of fact, this work is at the Zhejiang Provincial Museum and is reproduced in Group for the Authentication of Ancient Works of Chinese Painting and Calligraphy, ed., *Zhongguo gudai shuhua tumu* (*Chung-kuo ku-tai shu-hua t'u-mu*) 中國古代書畫圖目 (Illustrated Catalogue of Selected Works of Ancient Chinese Painting and Calligraphy), vol. 11 (Beijing: Wenwu Chubanshe, 1994), no. 浙 1-720, p. 146.

25 According to Ting's biography in *Biographical Dictionary of Chinese Artists*, Ting first served as the prefect of a small county in Fukien. His military title, which is provided by Jen Hsiung on Ting's portrait, was *ts'an-chün* 參軍 (staff officer). For more on Chou Hsien's military accomplishments, see note 19.

26 Some sources indicate that while Jen Hsiung was in Suchou, he was hired by the general Hsiang Jung 向榮 (1801–56) as a cartographer. Although this is mentioned both in Zhang Anzhi's article and in an entry on Jen Hsiung in *Transcending Turmoil: Painting at the Close of China's Empire, 1769–1911*, p. 340, n. 231, its original source is found in *Xiaoshan xianzhi-gao* (*Hsiao-shan hsien-chih kao*) 蕭山縣志稿 (Manuscripts of the Gazetteer of Hsiao-shan), reprint of 1935 ed., *juan* (*chüan*) 卷 (chapter) 4, entry on Jen Hsiung (Shanghai: Shanghai Bookstore, 1993). The translation of the Chinese text says: "During the beginning years of the Hsien-feng reign (1851–61), through the recommendation of Mr. Chou Hsien, Jen Hsiung was hired by General Hsiang Jung as a cartographer. Jen stayed there for several years. Taking inspiration from the local scenery, he became more mature in his execution. Returning home, he sold his paintings to make a living in Suchou. . . . He died during the early years of the Kuang-hsü reign (1875–1908) in his 60s." (咸豐初年, 以嘉興 周陽荐入向武公榮金陵戎幕, 為繪地圖. 羈居積年. 得江山之助, 筆法逾健. 既歸, 鬻畫蘇州自給... 光緒初年年, 年六十許.) As the date of Jen Hsiung's death is wrong, the validity of this record is doubtful. Jen Hsiung may have met a few officials, presumably Chou Hsien's colleagues, and received warm hospitality when he traveled to Suchou with Chou. Nevertheless, there was no commission offered. Hsiang Jong was a well-known general in the Manchu army. See *Eminent Chinese of the Ch'ing Period (1644–1912)*, vol. 1, pp. 292–94. Neither Jen Hsiung nor his friends in the army could establish a relationship with the general due to their low status.

27 Jen Hsiung's affair is recorded in "Jen Wei-ch'ang nien-piao 任渭長年表" (Chronological

**Jen Hsiung** 任熊
**Ferghana Horse after Chin Nung**
 (1687–1764)
*continued*

146   Table of Jen Hsiung), entry for 1852,
p. 82.

28   Jen Hsiung's marriage and his intention to
enlist are recorded in Ting Wen-wei's pref-
ace for Jen's *Lieh-hsien chiu-p'ai* 列仙酒牌
(Drinking Cards Decorated with Immor-
tals), p. 1 in *Jen Wei-ch'ang hua-chuan
ssu-chung* 任渭長畫傳四種 (Jen Hsiung's
Four Sets of Illustrated Biographies).
Huang Chiü was from Suchou and his *tzu*
was Kung-shou 公壽. He was known for
his painting and seal-carving skills. It is
important to remember, however, that
there was a Shanghai painter, Hu Yüan 胡
遠 (1823–86), whose *tzu* was also Kung-
shou 公壽. Since the two artists were
active simultaneously in the same area,
people often could not tell them apart. See
Chinese Calligraphy and Painting Insti-
tute, *Chung-kuo li-tai shu-hua chuan-k'e-
chia tzu-hao suo-yin* 中國歷代書畫篆刻家字
號索引 (Index for Aliases of Chinese
Artists in History), vol. 1 (Hong Kong:
Pacific Book Company, 1974), 184. See
also *Chung-kuo mei-shu-chia jen-ming
tz'u-tien* 中國美術家人名辭典 (Biographical
Dictionary of Chinese Artists), p. 1168. Jen
Hsiung's wife, Liu, was born in 1834 and
was eleven years younger than her hus-
band. See "Jen Wei-ch'ang nien-piao 任渭
長年表" (Chronological Table of Jen Hsi-
ung), p. 80. Gong cited this information
from *Hsiao-shan Jen-shih chia-ch'eng* 蕭山
任氏家乘 (A Historical Record of the Jen
Family from Hsiao-shan), entry for 1834,
p. 80. Her name is recorded in Gong
Chanxing's article, "Haipai de zaoqi huajia
(Hai-p'ai te tsao-ch'i hua-chia) 海派的早期
畫家" (Early Painters in the Shanghai
School), found in *Meishushi lun* (*Mei-shu-
shih lun*) 美術史論 (Journal of History and
Theory of Fine Arts) 29, Spring 1989, p. 57.

29   Jen Hsiung's self-portrait is reproduced in
several books. For a color plate, see
Richard M. Barnhart et al., *Three Thou-
sand Years of Chinese Painting* (New
Haven: Yale University, 1997), pl. 279, p.
295. See also Zhang Anzhi 張安治, "Ren
Xiong he tade zihuaxiang (Jen Hsiung ho
t'a-teh tzu-hua-hsiang) 任熊和他的自畫像"
(Jen Hsiung and His Self-Portrait) in
Gugong Bowuyuan Zijincheng Chubanshe,
ed., *Gugong bowuyuan cangbaolu* (*Ku-
kung po-wu-yüan ts'ang-pao lu*) 故宮博物
院藏寶錄 (A Catalogue of the Treasures at
the Palace Museum) (Shanghai: Wenyi
Chubanshe, 1986), p. 182.

30   See Liang Shih-ch'iu 梁實秋, ed., *A New
Practical Chinese-English Dictionary*
(Taipei: Far East Book Co., 1972), p. 376,
s.v. "*o-wan* 扼腕." The explanation of this
term found in R. H. Mathews, *Mathews'
Chinese-English Dictionary*, rev. Ameri-
can ed. (Cambridge, Mass: Harvard Uni-

versity Press, 1963), p. 667, is incorrect. *O-
wan* does not mean "affection" or "unwill-
ingness to part."

31   The complete translation and text of Jen
Hsiung's inscription on his self-portrait
follows.

"[Within this] tumultuous and chaotic
heaven and earth, what kind of creatures
are these before my eyes? [I] turn sideways,
laugh, and take a moment [in order to] per-
ceive what it is that makes [people,] one
after another, strive for [worldly] connec-
tions and clamber [for promotion]. By no
means is this an easy [question]. Allow me
to contemplate power and wealth. What is
left today of the [glorious] Chin, Chang,
Hsü, and Shih families [of the Western
Han dynasty, 206–23 B.C.]? Is it not also
pathetic when a young woman [constantly]
changes mirrors [in order to find a better
image of herself], or applies dust on her
head [to] disguise [her] white hair. Rushing
around here and there will not solve any-
thing. What is even more foolish is to live
obsessed with achieving fame yet fail to
inspire even one recorded word. The young
gentleman [in Chang Heng's (78–139) *Ode
of Two Capitals*] is fictitious, and the
scholar [in the same book] is impossible to
find. It is difficult to find a close friend.
Rather let me sing loudly and dance. Those
who have authority over me, please do not
judge that [I am] dejected and dispirited.
Pretend that [I am] an adolescent who does
not really mean these things. I merely
wanted to offer examples from history.
[After all] who is foolish and who should
be regarded as a sage? I am entirely con-
fused. Yet in a flash, the twinkling of an
eye, [everything vanishes] in the boundless
[universe]! The above text is in the struc-
ture of the 'twelve-hour' [songlike poem],"
Jen Hsiung, [whose *tzu* is] Wei-ch'ang,
composed this accordingly."

(莽乾坤, 眼前何物? 翻笑側身長繫, 覺甚事, 紛
紛攀依? 此則談何容易! 試説豪華, 金, 張, 許,
史, 到如今能幾? 還可惜, 鏡換青娥, 塵掩白頭,
一樣奔馳無計. 更誤人, 可憐青史, 一字何曾
記? 公子憑虛, 先生希有, 總難為知己. 且放歌
起舞, 當途慢怪頹氣, 算少年, 原非是想, 聊寫
古來陳例. 誰為愚蒙? 誰為賢哲? 我也全無意.
但恍然一瞬, 茫茫淼淼 無涯矣! 右調 "十二時,"
渭長任熊依聲)

The term *ch'ang-hsi* 長繫 in Jen Hsiung's
inscription, literally meaning "to be tied
for a long period of time," usually indi-
cates a long prison term. In this context,
this term is an abbreviation of a four char-
acter phrase, *ch'ang-sheng chi-jih* 長繩繫
日, literally meaning "to use a long rope to
tie down the sun." The character "*hsi* 繫"
in this case is pronounced as "*chi*." The
phrase is used to show Jen's desire to halt

time in order to examine history. See
*Hanyu dacidian* (*Han-yü ta-tz'u-tien*) 漢語
大詞典 (Chinese Terminology Dictionary),
vol. 11 (Shanghai: Hanyu Dacidian Press,
1988), p. 608, s.v. "*changsheng jiri* (*ch'ang-
sheng chi-jih*) 長繩繫日." Jen Hsiung's use
of several prestigious families in Chinese
history illustrates the fleeting nature of
power and wealth. Chin Jih-ti 金日磾
(134–86 B.C.) was a Hun from the north-
ern desert. His father, a tribal king, was
killed by another king when the latter
decided to surrender to China. Chin was
brought to China as a slave. At that time,
he was in his teens and served as a groom
at the emperor's stable. Later, however, he
became a loyal high official under Emperor
Wu-ti 武帝 (r. 140–88 B.C.) and enjoyed
special imperial favor. For Chin's biogra-
phy, see Pan Ku's 班固 (32–92) *Han-shu* 漢
書 (The Book of the Han Dynasty), *juan*
(*chüan*) 卷 (chapter) 68, reprint, vol. 9 (Bei-
jing: Zhonghua Shuju, 1975), pp. 2959–62.
Chang in Jen Hsiung's inscription refers to
Chang An-shih 張安世 (?–62 B.C.). Chang's
father Chang T'ang 張湯 (?–115 B.C.) was a
well-known administrator and Chang
himself was the most influential high offi-
cial under Emperor Hsüan-ti 宣帝 (73–49
B.C.). Chang's biography is found in the
same book, *chüan* 卷 (chapter) 59, pp.
2647–49. Both Chin Jih-ti and Chang An-
shih enjoyed power and fame during their
lifetime. After they died, their descendants
also occupied high government positions
for seven generations. Hsü, the next fam-
ily in Jen Hsiung's inscription, must be
Hsü Kuang-han 許廣漢 (active 1st century
B.C.), who was the father of Emperor
Hsüan-ti's wife. His biography is also
listed in the same book, *chüan* 卷 (chapter)
97, reprinted vol. 12, p. 3961. The last
family name, Shih, alludes to Shih Kung
史恭 (active late 2nd to early 1st century
B.C.) and his son, Shih Kao 史高 (active 1st
century B.C.). Shih Kung was the elder
brother of Emperor Hsüan-ti's grand-
mother, Shih Liang-ti 史良娣 (active late
2nd to early 1st century B.C.). When the
emperor was young, he was raised by the
Shih family. By the time he ascended to
the throne, his granduncle Shih Kung was
dead already. But Shih Kao and his two
younger brothers, were all promoted to
high positions by Emperor Hsüan-ti. The
Shihs, for several successive generations
were politically influential. For the history
of the Shih family, see *chüan* 卷 (chapter)
82, reprinted vol. 10, pp. 3375–79 in the
same book. As all these families were
famous in history, they are used to repre-
sent transient power and wealth. For an
explanation of how these names came to
represent power and wealth, see *Han-yü
ta-tz'u-tien* 漢語大詞典 (Chinese Terminol-

ogy Dictionary), vol. 11, p. 1167, s.v. "Jin Zhang (Chin Chang) 金張" (The Chin and Chang families), "Jin Zhang Xu Shi (Chin Chang Hsü Shih) 金張許史" (The Chin, Chang, Hsü, and Shih families), and "Jin Zhang Guan (Chin Chang Kuan) 金張館" (The residential buildings of the Chin and Chang families). The two sentences in Jen Hsiung's inscription concerning "mirrors and young women" and "applying dust on white hair" might also refer to certain idioms or historical episodes. Based on the structure of the characters in the sentences, they could also be translated as "The same mirror has changed hands among numerous young women, and so many people with white hair were buried under dust. While time flashes by, there is no better way out." The young gentleman and the scholar refer to two characters in Chang Heng's famous *Ode of the Two Capitals*. Chang, an esteemed scholar and astronomer of the Han dynasty, created these two characters in order to explore certain arguments and philosophies. The young gentleman named P'ing-hsü 憑虛 (meaning "to lean against the void") argued for the west capital's position of emphasizing the accumulation of wealth. The scholar named An-ch'u 安處 (meaning "to manage things peacefully") argued instead for the east capital's position of emphasizing moral and ethical standards. Jen Hsiung uses these two figures to represent his confusion over having opposing priorities. For Chang Heng's *Erjingfu (Erh-ching fu)* 二京賦 (The Ode of Two Capitals), see Zhang Zaiyi et al., eds., *Zhang Heng wenxuanyi (Chang Heng wen-hsüan i)* 張衡文選譯 ([A Modern] Translation of Selected Writings by Chang Heng) (Chengdu: Bashu Shushe, 1990), pp. 1–100. For another translation of Jen Hsiung's inscription, see James Cahill, "Ren Xiong (Jen Hsiung) and His Self-Portrait" in *Ars Orientalis* 25 (Ann Arbor: Department of the History of Art, University of Michigan, 1995), p. 126.

32  Sha Ying, a native of Suchou, had a sobriquet of Chia-ying 家英. He and his elder brother Sha Fu 沙馥 (1831–1906) were both known for their figure and flower-and-bird paintings. The fact that Sha Ying learned painting from Jen Hsiung is recorded in his preface for Jen's woodblock prints, *Kao-shih chuan t'u-hsiang* 高士傳圖像 (Biographies and Images of Ancient Lofty Scholars), p. 2, in *Jen Wei-ch'ang hua-chuan ssu-chung* 任渭長畫傳四種 (Jen Hsiung's Four Sets of Illustrated Biographies). It says: "Between 1853–54, Mr. [Jen] came to Suchou. I [Sha Ying] was a beginner at painting and thus I studied with [Mr. Jen]. Later, I followed [Jen] to visit the Chin and Chiao mountains [near the Yangtze River]

in order to enjoy the beautiful views of mountains and rivers." (癸丑甲寅間, 先生來吳. 余方習六法, 因從受業. 繼又隨至金焦, 覽江山之勝.) For more information on the two Sha brothers, see *Transcending Turmoil: Painting at the Close of China's Empire, 1769–1911*, p. 214 and cat. no. 78 on p. 215. Brown and Chou claim that both brothers learned from Jen Hsiung. Nevertheless, in note 388 on p. 349, only the above information cited from Sha Ying's preface is given. There is no indication of any specific source indicating that Sha Fu also studied with Jen Hsiung. According to Yang I's 楊逸 (1864–1929) *Hai-shang mo-lin* 海上墨林 (The Ink Forest [Artistic Circles] in Shanghai), 3rd ed. dated 1929, (Shanghai: n.p., reprint, *chüan* 卷 (chapter) 3 (Taipei: Wen-shih-che Press, 1975), p. 14a, Sha Fu's teacher was Ma Ken-hsien 馬根仙. *Chung-kuo mei-shu-chia jen-ming tz'u-tien* 中國美術家人名詞典 (Biographical Dictionary of Chinese Artists), p. 415, Ma Ken-hsien is mistakenly printed as Ma Hsien-ken 馬仙根. See Ma's biography in *Biographical Dictionary of Chinese Artists*, p. 771.

33  This story about Jen Hsiung is found in Chou Hsien's *Jen ch'u-shih chuan* 任處士傳 (Biography of Jen Hsiung, A Gentleman without Official Position) cited in "Jen Wei-ch'ang nien-piao 任渭長年表" (Chronological Table of Jen Hsiung), entry for 1852, p. 82. (大商賈欲以千金交. 渭長不樂其清, 拒之而去.)

34  See "Jen Wei-ch'ang nien-piao 任渭長年表" (Chronological Table of Jen Hsiung), entry for 1853, p. 82.

35  Originally, Ts'ai Chao's name was Ts'ai Chao-ch'u 蔡照初 and his *tzu* was Jung-chuang 容莊. His brief biography can be found in *Chung-kuo mei-shu-chia jen-ming tz'u-tien* 中國美術家人名詞典 (Biographical Dictionary of Chinese Artists), p. 1372. The episode of Ts'ai Chao undertaking the project of carving the woodblocks for Jen Hsiung's drinking cards is recorded in Ting Wen-wei's preface for Jen Hsiung's *Lieh-hsien chiu-p'ai* 列仙酒牌 (Drinking Cards Decorated with Immortals), p. 1 in *Jen Wei-ch'ang hua-chuan ssu-chung* 任渭長畫傳四種 (Jen Hsiung's Four Sets of Illustrated Biographies). See also Wang Tzu-tou's 汪子豆 article, "Lieh-hsien chiu-p'ai chi-ch'i k'e-che Ts'ai Chao 列仙酒牌及其刻者蔡照" (*Drinking Cards Decorated with Immortals* and the Carver Ts'ai Chao Who Prepared the Woodblocks for Printing the Cards) in *I-lin ts'ung-lu* 藝林叢錄 (A Collection of Art Related Articles), vol. 9 (Hong Kong: Commercial Bookstore, 1973), pp. 429–34.

36  See Jen Ch'i's preface for Jen Hsiung's *Lieh-hsien chiu-p'ai* 列仙酒牌 (Drinking Cards

Decorated with Immortals), p. 1 in *Jen Wei-chang hua-chuan ssu-chung* 任渭長畫傳四種 (Jen Hsiung's Four Sets of Illustrated Biographies).

37  See "Jen Wei-ch'ang nien-piao 任渭長年表" (Chronological Table of Jen Hsiung), entry for 1855, p. 83.

38  See ibid., entry for 1857, p. 84.

39  Today Jen Hisung's *Thatched Cottage of Lake Fan* belongs to the Shanghai Museum and is published in *Transcending Turmoil: Painting at the Close of China's Empire, 1769–1911*, p. 168. A detail of the scroll is reproduced in the same book, cat. no. 61, pp. 168–69. The whole scroll is reproduced in *Shanghai po-wu-kuan ts'ang hai-shang ming-hua-chia ching-p'in chi* 上海博物館藏海上名畫家精品集 (Masterworks of Shanghai School Painters from the Shanghai Museum), cat. no. 14. One should bear in mind that there is another handscroll under the same title at the Shanghai Museum. It was painted by seven of Jen Hsiung's contemporaries, all friends of Chou Hsien. Although it is listed, there is no reproduction. See *Chung-kuo ku-tai shu-hua t'u-mu* 中國古代書畫圖目 (Illustrated Catalogue of Selected Works of Ancient Chinese Painting and Calligraphy), vol. 5, no. 滬 1-4485, p. 480.

40  The work jointly executed by Fei I-keng and Jen Hsiung belongs to the Jiaxing 嘉興 Municipal Museum in Zhejiang. It is reproduced in *Chung-kuo ku-tai shu-hua t'u-mu* 中國古代書畫圖目 (Illustrated Catalogue of Selected Works of Ancient Chinese Painting and Calligraphy), vol. 11, no. 浙 8-47, p. 235.

41  Jen's patron Wang Ling, a member of the gentry from Hsiao-shan, wrote a preface for each of Jen Hsiung's last three sets of woodblock prints. All three prefaces are dated winter 1857. By then Jen Hsiung had already died. The fact that Wang's prefaces are shown at the very beginning of each set of Jen Hsiung's prints clearly indicates that Wang was the one who sponsored the project. See Jen Hsiung's three sets of prints: 1) *Yuyue xianxian xiangzhuan zan (Yü-yüeh hsien-hsien hsiang-chuan tsan)* 於越先賢像傳贊 (Biographies of Noted Worthies of Chekiang with Images and Eulogies); 2) *Jianxia xiangzhuan (Chien-hsia hsiang-chuan)* 劍俠像傳 (Biographies and Images of Famous Knights Errant); and 3) *Gaoshizhuan tuxiang (Kao-shih chuan t'u-hsiang)* 高士傳圖像 (Biographies and Images of Ancient Lofty Scholars). All three are reproduced in *Jen Wei-ch'ang hua-chuan ssu-chung* 任渭長畫傳四種 (Jen Hsiung's Four Sets of Illustrated Biographies). This single book also includes Jen's *Lieh-hsien chiu-p'ai* 列仙酒牌 (Drinking

*The Orchid Pavilion Gathering*
Notes

Jen Hsiung 任熊
Ferghana Horse after Chin Nung
    (1687–1764)
*continued*

148

Cards Decorated with Immortals). See also note 35.

42  See preface of *Jen Wei-ch'ang hua-chuan ssu-chung* 任渭長畫傳四種 (Jen Hsiung's Four Sets of Illustrated Biographies).

43  This episode is recorded in Chou Hsien's *Jen ch'u-shih chuan* 任處士傳 (Biography of Jen Hsiung, A Gentleman without Official Position), which is cited in Gong's "Jen Wei-ch'ang sheng-p'ing shih-lüeh k'ao 任渭長生平事略考 (Research on Jen Hsiung's Life and Activities), p. 86. T'ien-t'ai is a famous scenic mountain in east Chekiang, about one hundred fifty kilometers southeast of Jen Hsiung's hometown. It is also a well-known religious site, where the *ch'an* Buddhism T'ien-t'ai Sect 天臺宗 originated.

44  For a comparison between Ch'en Hung-shou's and Jen Hsiung's linear works, see Ch'en's *Female Immortals*, cat. no. 33, p. 67, and Jen Hsiung's *Self-Portrait*, cat. no. 73, p. 106, in Howard Rogers and Sherman E. Lee, *Masterworks of Ming and Qing Paintings from the Forbidden City* (Lasdale: International Arts Council, 1988).

45  Jen Hsiung could have established contact with Chang when the latter served as a district police master in Hangchou between 1821 and 1850. See "Ren Xiong (1823–57)" in *Transcending Turmoil: Painting at the Close of China's Empire, 1769–1911*, p. 161. Chang Hsüeh-kuang's brief biography is found in *Chung-kuo mei-shu-chia jen-ming tz'u-tien* 中國美術家人名詞典 (Biographical Dictionary of Chinese Artists), p. 876. Today Chang Hsüeh-kuang 張學廣 (?–1861) is little known, even among Chinese scholars. His work is often reproduced under his *tzu* Chang Meng-kao 張夢皋. See his fan painting at the Hebei Provincial Museum 河北省博物館 reproduced in *Chung-kuo ku-tai shu-hua t'u-mu* 中國古代書畫圖目 (Illustrated Catalogue of Selected Works of Ancient Chinese Painting and Calligraphy), vol. 8 (Beijing: Wenwu Chubanshe, 1990), no. 冀 1-240, p. 70.

46  Chou Hsien's comments on Jen Hsiung's artistic development are found in Chou's *Biography of Jen Hsiung*, which is cited by Gong Chanxing in his article. See "Jen Wei-ch'ang sheng-p'ing shih-lüeh k'ao 任渭長生平事略考 (Research on Jen Hsiung's Life and Activities), pp. 86–88. The Chinese text follows: " 初宗陳洪綬, 後出入宋元諸大家... 變化神妙, 不名一法. 古人所能, 無不能, 亦無不工. 其布局運筆, 慘淡經營, 不期與古人和. 而間有古人所不能到. 設色精采, 復能勝于古人."

47  For an example of Jen Hisung's works copying early masters, see his *Guqintu (Ku-ch'in t'u)* 鼓琴圖 (Playing the Qin Zither) in *Shanghai po-wu-kuan ts'ang hai-shang ming-hua-chia ching-p'in chi* 上海博物館藏海上名畫家精品集 (Masterworks of Shanghai School Painters from the Shanghai Museum), cat. no. 12. This hanging scroll is almost a direct copy after the famous handscroll *T'iao-ch'in chui-ming t'u* 調琴啜茗圖 (Palace Ladies Listening to Music and Drinking Tea), attributed to Chou Fang 周昉 (active c. 780–810) and currently at the Nelson Gallery–Atkins Museum, Kansas City. This work is reproduced in Sherman Lee's *A History of Far Eastern Art* (New York: Harry N. Abrams, 1964), color pl. 26, p. 291. A hanging scroll with identical composition attributed to the Yüan dynasty (1280–1368) was sold at Sotheby's, New York, in 1995. See Sotheby's sales catalogue, *Fine Chinese Paintings* (New York: Sotheby's, March 21, 1995), lot no. 5. It is not clear whether Jen Hsiung copied from this scroll or this scroll is a fabricated painting after Jen Hsiung's work. Jen Hsiung also copied numerous works after Ch'en Hung-shou. See note 14.

48  Chin Nung's *Ferghana Horse*, belonging to a private collector in Taiwan, was auctioned at Christie's, New York, in 1994. See Christie's sales catalogue, *Fine Chinese Paintings* (New York: Christie's, June 1, 1994), lot no. 227, p. 129. In Chin Nung's inscription on his horse painting, he used "*Tung-ku-li* 東骨利" as the country from which the fine horses were imported. *Tung-ku-li* may have derived from the sound of *Tadjik* or *Tasi*, which in Persian means "Arabia." See R. H. Mathews, *Mathews' Chinese-English Dictionary*, rev. American ed. (Cambridge, Mass: Harvard University Press, 1963), p. 849, s.v. "Ta-shih 大食." Chin Nung could also be referring to the *Ku-li-kan* 骨利幹 tribe recorded in Chinese history. This nomad tribe used to reside in the northwestern region of China. See Morohashi Tetsuji 諸橋轍次, *Dai Kanwa Jiten* 大漢和詞典 (The Great Chinese-Japanese Dictionary), vol. 12 (Tokyo: Daishukan, 1976), p. 572 (new page no. 13168), s.v. "*Ku-li-kan* 骨利幹." Due to Chin Nung's limited knowledge of foreign countries, on the other hand, he could have simply used this name to represent the region from which these fine horses came. The real name of the country from which the Chinese imported their horses was, of course, Ferghana.

49  For more information on the Ferghana horse, see Morohashi Tetsuji's *The Great Chinese-Japanese Dictionary*, vol. 3, p. 374 (new page no. 2648), s.v. "Ta-wan 大宛" and 153, s.v. "Ta-wan chih-ma 大宛之馬." See also W. Scott Morton, *China: Its History and Culture*, 3rd ed. (New York: McGraw-Hill, 1995), pp. 55–56. In one of

Chin Nung's inscriptions he says, "I now engage in painting horses amid a cold and mournful atmosphere. Gazing at the horse in my picture, I seem to see myself and feel pity [for my toiling, wandering life.]"(今余畫馬, 蒼蒼涼涼. 有顧影酸嘶, 自憐之態.) See Chin Nung, *Tung-hsin hua-ma t'i-chi* 冬心畫馬題記 (A Collection of Chin Nung's Inscriptions on His Horse Paintings), reprinted in Teng Shih 鄧實 (1865?–1948?) and Huang Pin-hung 黄賓虹 (1865–1955), comps., *Mei-shu ts'ung-shu* 美術叢書 (Anthology of Books on Fine Art), *chi* 集 (part) 1, *chi* 輯 (division) 3 (Shanghai: n.p., 1912–36), reprint, vol. 2 (Taipei: I-wen Bookstore, 1963–72), p. 97.

50  For Chin Nung's bitterness at his lack of recognition, see Marshall P. S. Wu, "Chin Nung: An Artist with a Wintry Heart," Ph.D. diss., vol. 1 (Ann Arbor: University of Michigan, 1989), pp. 263–65. The symbolic connection between horses and unrecognized scholars is derived from a historical episode involving a horse expert of the Spring and Autumn period (770–481 B.C.) named Po-lo 伯樂 (active c. 650 B.C.). Po-lo's family name was Sun 孫 and his given name, Yang 陽. Po-lo was famous for his ability to pick out a fine horse. One day he saw a man beating a recalcitrant horse. The man, ignorant of the horse's quality, had hitched the horse to a heavy cart, which the horse refused to pull. Po-lo immediately released the horse from the cart, and the horse issued a long whinny expressing his appreciation. The horse turned out to be one of the fastest in all the land and was said to have been able to travel one thousand miles a day. Consequently, unrecognized scholars appropriated this story to express their frustration in being overlooked. As a result, Po-lo's name is frequently referred to in early manuscripts. For more on this story and metaphor, see Morohashi Tetsuji 諸橋轍次, *Dai Kanwa Jiten* 大漢和詞典 (The Great Chinese-Japanese Dictionary), vol. 1 (Tokyo: Daishukan, 1976), p. 677, s.v. "Po-lo 伯樂," or ibid., vol. 3, p. 869 (new page no. 3143), s.v. "Sun Yang 孫陽."

51  Jen Hsiung probably copied Chin Nung's horse because he both admired the latter's innovation and considered the Yangchou master a mentor. Yangchou, where Chin Nung was active, was the economic and cultural center of China during the eighteenth century. The city declined in the nineteenth century, and its exalted position was replaced by Shanghai, the new major international and commercial port. Because of the expeditiousness of this ascension, Shanghai patterned itself, in many ways, upon Yangchou. This trend influenced the painters in or near Shang-

## 50. Jen Hsün 任薰
*(1835–93)*
*Ch'ing dynasty (1644–1911)*

hai to use the earlier Yangchou painters as their primary role models. Chin Nung's horse painting bears a collecting seal of a modern painter, Chin Cheng 金城 (1878–1926), who was from Chin Nung's hometown of Hangchou. This seal indicates that the scroll remained in the Hangchou area during the nineteenth century. The close proximity of Hangchou and Jen's home in Hsiao-shan most assuredly accounts for Chin's access to this particular piece. For more information on Chin Cheng, see entry 57.

52 See note 12.

53 For examples of two of the Three Hsiung's works, see *Shanghai po-wu-kuan ts'ang hai-shang ming-hua-chia ching-p'in chi* 上海博物館藏海上名畫家精品集 (Masterworks of Shanghai School Painters from the Shanghai Museum), cat. nos. 1–10, pp. 4–6, and 11–15.

54 For more information on Jen Hsün and Jen I, see entries 50 and 51.

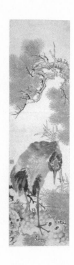

## Crane, Pine, and Bamboo
*Sung-ho yen-nien t'u*
*(Pine and Crane, [Emblems of] Longevity)*
松鶴延年圖

1 Dr. J. E. Val-Meijas reportedly purchased this hanging scroll in 1986 from an anonymous collector in Taipei.

2 See Shanghai Museum, *Zhongguo shuhuajia yinjian kuanshi (Chung-kuo shu-hua-chia yin-chien k'uan-shih)* 中國書畫家印鑒款識 (Signatures and Seals of Chinese Painters and Calligraphers), vol. 1 (Shanghai: Wenwu Chubanshe, 1987), no. 20, p. 311.

3 For more on Jen Hsiung, see entry 49.

4 See Chang Ming-k'o 張鳴珂 (1828–1908), *Han-sung-ko t'an-i so-lu* 寒松閣談藝瑣錄 (A Record of Discussions on Art at the Frigid Pine Pavilion), preface dated 1908, reprint, *chüan* 卷 (chapter) 2 (Shanghai: Wen-ming Bookstore, 1936), entry on Jen Hsiung, p. 8a.

5 Although the exact year their father died is unclear, credible sources suggest it happened when Jen Hsiung was merely sixteen years old. See Gong Chanxing's 龔產興 "Ren Weichang nianbiao (Jen Wei-ch'ang nien-piao) 任渭長年表" (Chronological Table of Jen Hsiung) in *Meishushilun jikan (Mei-shu-shih-lun chi-k'an)* 美術史論季刊 (Quarterly Journal of History and Theory of Fine Arts) 25 (Beijing: Institute of Fine Arts, China Art Academy, Spring 1988), entry on 1838, p. 80. If true, Jen Hsün would have been four. It is recorded that as an adult, Jen Hsün was extraordinarily sloppy. One source states that everything in Jen Hsün's bedroom was covered with dust and that his bed was swarming with bedbugs. See Chou T'ao 鄒弢 (active last quarter of 19th century), *San-chieh-lu chui-t'an* 三借盧贅談 (Prolixities at the Three-loan Studio), prefaces dated 1881 and 1885, reprint, *chüan* 卷 (chapter) 12 (Shanghai: Shen-pao Press, n.d.), p. 12b. This lack of hygiene may have been due to the early death of his father. In all probability, his elder brother, Jen Hsiung, could not afford to spend much time looking after his little brother.

6 Jen Hsün emulated not only Jen Hsiung's painting but also his calligraphic style. He also followed Jen Hsiung in settling at Suchou in order to market his paintings.

7 For more on Ch'en Hung-shou 陳洪綬 (1598–1652), see James Cahill, "Ch'en Hung-shou: Portraits of Real People and Others," in *The Compelling Image: Nature and Style in Seventeenth-Century Chinese Painting* (Cambridge, Mass.: Harvard University Press, 1982), pp. 106–45.

8 These patrons included Yao K'uei 姚夔 (active 19th–20th century), who was Yao Hsieh's 姚燮 (1805–64) son. Jen Hsiung stayed with the Yao family for one year, between 1850 and 1851. Another patron was Chou Hsien 周閑 (1820–75), Jen Hsiung's best friend.

9 This story is found in Xu Beihong's 徐悲鴻 (1895–1953) "Ren Bonian pingzhuan (Jen Po-nien p'ing-chuan) 任伯年評傳" (Comments and Biography of Jen Po-nien), reprinted in Gong Chanxing 龔產興, *Ren Bonian yanjiu (Jen Po-nien yen-chiu)* 任伯年研究 (Research on Jen Po-nien) (Tianjin: Renmin Meishu Chubanshe, 1982), p. 1. Another version of this story is based on a record of Chen Nian's 陳年 (1877–1970, whose *tzu* was Pan-ting 半丁, meaning "merely half of an insignificant adult") account at a seminar on Jen Po-nien's art. See "Ren Bonian he tade hua (Jen Po-nien ho t'a-te hua) 任伯年和他的畫" (Jen Po-nien and His Painting) in *Research on Jen Po-nien*, pp. 23–24. For more on this story, see entries on Jen I and Jen Hsiung.

10 For more on this story, see entry 51 on Jen I.

11 For information on Jen I selling his work in Ning-po 寧波, see "Ren Bonian nianpu (Jen Po-nien nien-p'u) 任伯年年譜" (A Chronicle of Jen I's Life) in Ding Xiyuan's 丁羲元 *Ren Bonian (Jen Po-nien)* 任伯年 (Shanghai: Shuhua Chubanshe, 1989), entries of 1865–68, pp. 18–21. For more on the two painters' return to Suchou, see Jen I's inscription on his *Dongjin huabie tu (Tung-chin hua-pieh t'u)* 東津話別圖 (Farewell at the East Ford), dated 1868. Jen I's inscription is transcribed in *Jen Po-nien* 任伯年, pp. 21–22.

Jen Hsün 任薰
**Crane, Pine, and Bamboo**
*continued*

12 Jen I's handscroll belongs to the Zhongguo Meishuguan 中國美術館 (China Gallery of Art) in Beijing. It is reproduced in Group for the Authentication of Ancient Works of Chinese Painting and Calligraphy, ed., *Zhongguo gudai shuhua tumu (Chung-kuo ku-tai shu-hua t'u-mu)* 中國古代書畫圖目 (Illustrated Catalogue of Selected Works of Ancient Chinese Painting and Calligraphy), vol. 1 (Beijing: Wenwu Chubanshe, 1986), no. 京 3-177, p. 62. A reproduction of this scroll in larger size is found in Gong Chanxing's *Jen Po-nien yen-chiu* 任伯年研究 (Research on Jen Po-nien), pp. 6–7.

13 In 1870, Ku Wen-pin 顧文彬 (1811–89) paid a high price and purchased Jen Hsiung's famous *Ta-mei shih-i t'u* 大梅詩意圖 (Paintings Based on Poems at the Great Plum Blossom Mountain Retreat), which was painted in Ning-po especially for his patron Yao Hsieh 姚爕 (1805–64). See Hsi-pai's 希白 "Chi Jen Hsiung ta-mei shan-min shih-chung hua-ts'e 記任熊大梅山民詩中畫冊" (A Record of Jen Hsiung's Album Leaves Based on Poems by a Dweller of the Great Plum Mountain [*hao* of Yao Hsieh])," in *I-lin ts'ung-lu* 藝林叢錄 (A Collection of Articles on Art), vol. 10 (Hong Kong: Commercial Bookstore, 1973), pp. 257. For more information on Jen Hsiung's *Ta-mei shih-i t'u* 大梅詩意圖 album leaves, see entry 49 on Jen Hsiung. For more on Ku and Jen Hsün, see Claudia Brown and Ju-hsi Chou, *Transcending Turmoil: Painting at the Close of China's Empire, 1769–1911* (Phoenix: Phoenix Art Museum, 1992), pp. 171, 342 n. 265. See also Ku Wen-pin 顧文彬 (1811–89) and Ku Lin-shih 顧麟士 (1865–1930), *Guoyunlou shuhuaji (Kuo-yün lou shu-hua-chi)* 過雲樓書畫記 (A Record of the Painting and Calligraphy Collection at the Pavilion of Passing Clouds), preface dated 1882, reprint (Nanjing: Jiangsu Xinhua Bookstore, 1990), no. 34 among the forty poems lamenting the death of Ku Wen-pin's third son, Ku Cheng 顧承, p. 175. The poem was composed when Ku Wen-pin was forty-nine (fifty *sui*) years old. It records a painting done jointly by Jen Hsün and another painter. Ku Wen-pin's brief biography is found in Yu Jianhua's 于劍華 et al., *Zhongguo meishujia renming cidian (Chung-kuo mei-shu-chia jen-ming tz'u-tien)* 中國美術家人名詞典 (Biographical Dictionary of Chinese Artists) (Shanghai: Renmin Meishu Chubanshe, 1981), p. 1533.

14 For Wu Kuan's biography, see L. Carrington Goodrich and Fang Chaoying, eds., *Dictionary of Ming Biography*, vol. 2 (New York and London: Columbia University Press, 1976), pp. 1487–89. For more information on Shen Chou, see entry 4.

15 See Yue Junjie 岳俊杰 et al., *Suzhou wenhua shouce (Suchou Wen-hua shou-ts'e)* 蘇州文化手冊 (A Handbook on the Culture of Suchou) (Shanghai: Renmin Chubanshe, 1993), pp. 46–47. It is also known that Ku Wen-pin's grandson, Ku Lin-shih, established a painting club in the garden during the Kuang-hsü 光緒 reign (1875–1908). The club played an important role in the artistic activities of that city. For a detailed description of the structure of the I Garden, see also Suzhou Park and Garden Bureau, *Suzhou yuanlin (Suchou ylüan-lin)* 蘇州園林 (Gardens in Suchou) (Shanghai: Tongji University, 1991), pp. 116–26.

16 See "Ren Bonian nianpu (Jen Po-nien nien-p'u) 任伯年年譜 (A Chronicle of Jen I's Life) in *Jen Po-nien* 任伯年, entry for 1868, p. 24.

17 Jen Hsün's portrait belongs to the Zhongguo Meishuguan 中國美術館 (China Gallery of Art) in Beijing. It is reproduced in *Chung-kuo ku-tai shu-hua t'u-mu* 中國古代書畫圖目 (Illustrated Catalogue of Selected Works of Ancient Chinese Painting and Calligraphy), vol. 1, no. 京 3-176, p. 62. Jen I's inscription says: "Fu-ch'ang, my second uncle, asked me to paint this portrait. I begged that he offer me his valuable comments. In the tenth moon, the winter of 1868, we were both travelers in Suchou. [Signed] I." (阜長二叔大人命畫, 即求正之. 戊辰冬十月, 同客蘇臺. 頤.) The portrait also bears a colophon, written in seal script, by Li Chia-fu 李嘉福 (1829–93). This colophon provides vital information on Jen Hsün's life. It reads:

> Hand holding a fly swatter made of palm fiber, he (Jen Hsün) has a cloth robe draped over his shoulders.
> Bare-headed and sitting in silence, his two eyes are half-closed.
> Seeming to be absorbed in contemplation of painting, solemnly and quietly, he is carefree and content.
> A pile of tree leaves serves as his mat and he remains uncontaminated, not soiled by even a speck of dust.
> When this portrait was completed, it was close to the last moon of the year.
> Now this portrait belongs to me and brightens the shabby wall on which it is hung.

In the mid-spring of the *ping-shen* year (1896), the twenty-second year of the Kuang-hsü reign (1875–1908), I obtained the portrait of Jen Hsün by Jen Po-nien, dated in the winter of the *wu-ch'en* year (1868). At that time, Jen Hsün was only thirty-four *sui* (thirty-three years old). Twenty years later, both of his two eyes

became blind. It was in the *kuei-ssu* year (1893), nineteenth year of the Kuang-hsü reign, that Jen Hsün fell ill and died on the first day of the seventh moon. His son, Yang-an, also died in the winter of that year. All his paintings and calligraphy were dispersed and lost. It was tremendously pathetic!

Eulogy by Li Chia-fu from Shih-men, whose *tzu* is Sheng-yü.

> 手揮棕拂, 肩披布衲.
> 科頭默坐, 雙目微合.
> 如參畫禪, 靜觀自得.
> 疊葉為茵, 一塵不染.
> 昔寫此圖, 時將迎臘.
> 像今歸我, 蓬壁生輝.

> 光緒二十二年丙申仲春, 得伯年戊辰冬為阜長寫照. 其年阜長三十四歲. 後二十年, 兩目先瞽. 至十九年癸巳七月朔病卒. 其子養庵, 是年冬亦亡. 所有書畫, 散失無存. 不勝可嘆!

> 石門笙魚李嘉福贊

18 For Jen Hsiung's portrait, see entry 49 on Jen Hsiung.

19 This story is based on Chen Nian's 陳年 account found in Gong Chanxing's *Jen Po-nien yen-chiu* 任伯年研究 (Research on Jen Po-nien), p. 24. The same account is also found in *Meishu* 美術 (Arts) 5 (Beijing: Renmin Meishu Chubanshe, May 1957), p. 42.

20 See *Chung-kuo ku-tai shu-hua t'u-mu* 中國古代書畫圖目 (Illustrated Catalogue of Selected Works of Ancient Chinese Painting and Calligraphy), vol. 6, nos. 蘇 1-487 to 蘇 1-497. Five of these paintings are reproduced on pp. 108–9.

21 See Li Chia-fu's colophon on Jen Hsün's portrait by Jen I in note 17.

22 For examples of Jen Hsün's painting with cinnabar tree leaves, see his works in Editorial Committee of the Complete Collection of Chinese Art, *Zhongguo meishu quanji (Chung-kuo mei-shu ch'üan-chi)* 中國美術全集 (A Complete Collection of Chinese Art), vol. 11 (Shanghai: Renmen Meishu Chubanshe, 1988), 3rd scroll of no. 193 and no. 195.

23 For examples of Jen Hsün's blue foliage, see his *Haitang caochong (Hai-t'ang ts'ao-ch'ung)* 海棠草蟲 (Insects and Crabapple Blossoms) in *Shanghai bowuguan cang haishang minghuajia jingpinji (Shanghai po-wu-kuan ts'ang hai-shang ming-hua-chia ching-p'in chi)* 上海博物館藏海上名畫家精品集 (Masterworks of Shanghai School Painters from the Shanghai Museum) (Hong Kong: Ta-ye Co., 1991), cat. no. 43, and his *Sunflower and Rooster* reproduced in Ho Kung-shang 何恭上, ed.,

# 51. Jen I 任頤

*(1840–96)*

*Ch'ing dynasty (1644–1911)*

*Hai-shang hua-p'ai* 海上畫派 (The Shanghai School) (Taipei: Art Bookstore, 1985), no. 27, p. 23.

24  For more information on "pine and crane" subject matter, see entry 42 on Chang Ch'i.

25  For example, this technique is found repeatedly in the work of Hsü Ku 虛谷 (1821–96). See his *Mudan shuanghe tu* (*Mu-tan shuang-ho t'u*) 牡丹雙鶴 (Two Cranes by Peony Bushes), reproduced in *Chung-kuo ku-tai shu-hua t'u-mu* 中國古代書畫圖目 (Illustrated Catalogue of Selected Works of Ancient Chinese Painting and Calligraphy), vol. 13, no. 粵 1-0984, p. 324. For comparison, see also Hsü Ku's *Songhe yannian tu* (*Sung-ho yen-nien t'u*) 松鶴延年圖 (Pine and Crane, [Emblems of] Longevity), reproduced in *Chung-kuo mei-shu chüan-ji* 中國美術全集 (A Complete Collection of Chinese Art), vol. 11, no. 179. This scroll depicts the same subject matter and has the same title as the Michigan scroll.

26  See Shanghai Museum, *Zhongguo shuhuajia yinjian kuanshi* (*Chung-kuo shu-hua-chia yin-chien k'uan-shih*) 中國書畫家印鑒款識 (Signatures and Seals of Chinese Painters and Calligraphers), vol. 1 (Shanghai: Wenwu Chubanshe, 1987), seal no. 13, p. 311.

27  According to *Chung-kuo shu-hua-chia yin-chien k'uan-shih* 中國書畫家印鑒款識 (Signatures and Seals of Chinese Painters and Calligraphers), this seal was originally stamped on Jen Hsün's painting entitled *Yingjizhou* (*Ying-chi chou*) 鷹雞軸 (The Eagle and Rooster Hanging Scroll), which is dated to the *i-ch'ou* year (1885).

28  Similar red bamboo and ink pine trees can be found in Jen Hsün's other works reproduced in *Chung-kuo mei-shu ch'üan-chi* 中國美術全集 (A Complete Collection of Chinese Art), vol. 11, nos. 194 and 195. See also Jen Hsün's similar hanging scroll dated 1886 and under the same title, *Sung-ho yen-nien t'u* 松鶴延年圖 (Pine and Crane, [Emblems of] Longevity). It also depicts the pine and crane subject matter, and it belongs to the government antique shop Boguzhai 博古齋 (Conversant with Antiquity Studio) in Shanghai. This work is reproduced in *Boguzhai cang shuhuaji* (*Po-ku-chai ts'ang shu-hua chi*) 博古齋藏書畫集 (Paintings and Calligraphy in the Collection of the Conversant with Antiquity Studio) (Shanghai: Xinhua Bookstore, 1994), no. 32.

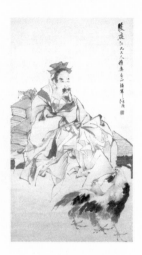

## Scholar with Roosters

*Kao-shih chin-chi*

*(Lofty Scholar with Brilliant Feathered Roosters)*

高士錦雞

1  The inscriber of this label is unidentified. He might have been a contemporary calligrapher working for the Antiquity Department under the Chinese Communist regime. Both the mounting and the label of the Michigan scroll are new, and the calligraphy on the label is rather casual. These factors indicate that the painting was possibly one of the thousands of scrolls preserved at a governmental Wenwu Shangdian 文物商店 (antique shop) before being sold after the Cultural Revolution in the early 1980s.

2  Hsiao-t'ing, the recipient of this scroll, was probably Wu Shu-sheng 吳樹聲 (1819–73). See Yu Jianhua 于劍華 et al., *Zhongguo meishujia renming cidian* (*Chung-kuo mei-shu-chia jen-ming tz'u-tien*) 中國美術家人名詞典 (Biographical Dictionary of Chinese Artists) (Shanghai: Renmin Meishu Chubanshe, 1981), p. 313.

3  This seal is also reproduced in Shanghai Museum, *Zhongguo shuhuajia yinjian kuanshi* (*Chung-kuo shu-hua-chia yin-chien k'uan-shih*) 中國書畫家印鑒款識 (Signatures and Seals of Chinese Painters and Calligraphers), vol. 1 (Shanghai: Wenwu Chubanshe, 1987), no. 34 on p. 306.

4  Chih-ch'ün Chai, or "The Studio of Gregarious Intentions," is unidentified. It is not known whether the studio belongs to the recipient of the painting or to a contemporary collector who once owned the scroll.

5  Based on recent publications, there are at least six hundred paintings and calli-

graphic works by Jen I that survive today. His creative career spanned his early twenties to his mid-fifties. Among the numerous publications of Jen I's works, the most comprehensive is Wang Jingxian's 王靖憲, *Ren Bonian zuopinji* (*Jen Po-nien tso-p'in chi*) 任伯年作品集 (A Collection of Jen I's Works), vols. 1 and 2 (Beijing: Renmin Meishu Chubanshe, 1992). Wang's book reproduces 512 works by Jen I.

6  For more information on the Opium War, see Keith Buchanan et al., *China: The Land and the People, the History, the Art and the Science* (New York: Crown Publishers, 1980), pp. 328 and 366. See also the biography of Lin Tse-hsü 林則徐 (1785–1850) in Arthur W. Hummel, ed., *Eminent Chinese of the Ch'ing Period (1644–1912)*, vol. 1 (Washington, D.C.: United States Government Printing Office, 1943–44), pp. 511–14.

7  For the history of the development of Shanghai, see George Lanning (1852–1920), *The History of Shanghai*, reprint (Taipei: Ch'eng-wen Publishing Co., 1973).

8  Shao-hsing was a well-known cultural city in Chinese history. During the Spring and Autumn period (722–481 B.C.), the city, known as K'uai-chi 會稽 served as the capital of the Chu State. In the Ch'in 秦 dynasty (221–201 B.C.), its name was changed to Shan-yin 山陰. During the T'ang dynasty (618–905), this city was divided into two prefectures: Shan-yin and K'uai-chi. It was under the reign of the first emperor, Kao-tsung (r. 1127–62) of the Southern Sung dynasty (1127–1279), that the two counties were unified and renamed as Shao-hsing. Although in ancient times there were several cities known by the name of Shan-yin, including one in Shansi province, the most famous was the one in Chekiang. For example, the great calligrapher Wang Hsi-chih 王羲之 (321–79) of the Tsin dynasty (265–419) used to live in the city and was often referred to as "Shan-yin." See *Hanyu dacidian* (*Han-yü ta-tz'u-tien*) 漢語大詞典 (Chinese Terminology Dictionary), vol. 3 (Shanghai: Hanyu Dacidian Press, 1988), p. 783, s.v. "Shanyin 山陰."

9  Jen I's family was evidently not a branch of the Jen clan in Hsiao-shan. When he was young, Jen I never met the other two Jen painters, Jen Hsiung or Jen Hsün. According to the *Xiaoshan Renshi jiacheng* (*Hsiao-shan Jen-shih chia-ch'eng*) 蕭山任氏家乘 (A Historical Record of the Jen Family from Hsiao-shan), the Jen family lived in Hsiao-shan for at least twenty-five generations. See *Gong Chanxing* 龔產興, "Ren Weichang shengping shilue kao

151

(Jen Wei-ch'ang sheng-p'ing shih-lüeh k'ao) 任渭長生平事略考 (Research on Jen Hsiung's Life and Activities) in *Meishu yanjiu* (*Mei-shu yen-chiu*) 美術研究 (Research and Study of Fine Arts) 4 (Beijing: Central Art Academy, 1981), p. 87.

10  For an example of Jen I's signature, "Shan-yin Jen I 山陰任頤," see his *Fang Gao Kegong yunshan tu* (*Fang Kao K'o-kung yün-shan t'u*) 仿高克恭雲山圖 (After Kao K'o-kung's [1248–1310] *Cloudy Mountain*), *Guanjiantu* (*Kuan-chien t'u*) 觀劍圖 (Examining the Sword), and *Zhongkui dushu tu* (*Chung-k'uei tu-shu t'u*) 鍾馗讀書圖 (Chung-k'uei, the Pacifier of Ghosts, Reading a Book), reproduced in *Shanghai bowuguan cang haishang minghuajia jingpinji* (*Shanghai po-wu-kuan ts'ang hai-shang ming-hua-chia ching-p'in-chi*) 上海博物館藏海上名畫家精品集 (Masterworks of Shanghai School Painters from the Shanghai Museum) (Hong Kong: Ta-ye Co., 1991), cat. nos. 57, 58, and 59.

11  See "Ren Bonian nianpu (Jen Po-nien nien-p'u) 任伯年年譜 (Chronological Table of Jen I) in Ding Xiyuan's 丁羲元, *Ren Bonian* (*Jen Po-nien*) 任伯年 (Shanghai: Shuhua Chubanshe, 1989), pp. 21–22. This is based on the signatures, "Shan-yin Jen Jun, Hsiao-lou 山陰任潤小樓" or "Shan-yin Jen Hsiao-lou, Jun 山陰任小樓潤," he inscribed on paintings executed in Ning-po 寧波 around 1865. According to Ding Xiyuan, these works now belong to the Palace Museum in Beijing. See ibid., p. 18. An example of Jen I's signature, Jen Hsiao-lou, and his seal bearing the same name can be found on the page displaying Jen I's signatures and seal in Ding's book (no page number).

12  See ibid., p. 1. See also entry 1889 in ibid. on p. 95. In that year, Jen I's student-friend, Wu Ch'ang-shuo 吳昌碩 (1844–1927), also pronounced as Wu Ch'ang-shih, carved a seal, Jen Ho-shang 任和尚 (Jen the monk), and presented it to Jen I. Wu also incised one side of the seal, indicating that when Jen I was young, his parents called him by this nickname.

13  See ibid., p. 18. One theory about why he called himself Po-nien proposes that both the form and the sound of the character *po* 伯 in his name and the character *pai* 百 (meaning "one hundred") are similar. Thus he borrowed the character *po* to imply the character *pai*, and his name really means *pai-nien* 百年, or "One Hundred Years," which suggests that his paintings will be extremely valuable in a hundred years. See Ch'en Ting-shan 陳定山 (1896–1989), *Ch'un-shen chiu-wen* 春申舊聞 (Old Stories in Shanghai), vol. 1 (Taipei: Ch'en-kuang Monthly Magazine Co., 1964), p. 103.

14  There are two sources concerning Jen I's father. One is Xu Beihong's 徐悲鴻 (1895–1953), "Ren Bonian pingzhuan (Jen Po-nien p'ing-chuan) 任伯年評傳" (Commentary and Biography of Jen Po-nien) reprinted in Gong Chanxing 龔產興, *Ren Bonian yanjiu* (*Jen Po-nien yen-chiu*) 任伯年研究 (Research on Jen Po-nien) (Tianjin: Renmin Meishu Chubanshe, 1982), p. 1, which says that "His (Jen I's) father, who could do portraiture, moved the family from Shan-yin to Hsiao-shan. The father was a rice merchant." (其父能畫像, 從山陰遷蕭山. 業米商.) The second source is based on a colophon written by Jen I's son, Jen Chin, on a portrait of his grandfather. The portrait was done posthumously by Jen I. The portrait and the grandson's inscription, *Ti Ren Yi hua Ren Songyun xiang* (*T'i Jen I hua Jen Sung-yün hsiang*) 題任頤畫任淞雲像 (Inscription on the Portrait of Jen Sung-yün by Jen I) now belong to the Palace Museum, Beijing. The passage concerning Jen I's father, transcribed in "Jen Po-nien nien-p'u 任伯年年譜" (Chronological Table of Jen I), p. 1, follows: "[Jen I's father] educated himself, yet not for the purpose of securing a position in the government. [Instead] he established a shop facing the street. While running his business, he continued his studies. He was adept in painting, especially in portraiture. [However] he was ashamed of displaying his skill, and therefore few knew [of his talent]." (讀書不苟仕宦. 設臨街肆, 且讀且賈. 善畫, 尤善寫真術. 恥以術炫, 故鮮知者.)

15  See "Jen Po-nien nien-p'u 任伯年年譜" (Chronological Table of Jen I), entry 1849, p. 6.

16  For a discussion of the T'ai-p'ing Rebellion, see *China: The Land and the People, the History, the Art, and the Science*, pp. 332, 336, and 339. See also the biography of Hung Hsiu-ch'üan 洪秀全 (1813–64) in *Eminent Chinese of the Ch'ing Period (1644–1912)*, vol. 1, pp. 361–66.

17  The colophon *Ti Ren Yi hua Ren Songyun xiang* (*T'i Jen I hua Jen Sung-yün hsiang*) 題任頤畫任淞雲像 (Colophon on the Portrait of Jen Sung-yün by Jen I) by Jen I's son Jen Chin 任堇 (1881–1936) states that Jen I found the corpse of his father after the war. For the transcription of Jen Chin's colophon, see entry 1861 in "Jen Po-nien nien-p'u 任伯年年譜" (Chronological Table of Jen I), pp. 13–14. Jen Sung-yün was the name of Jen I's father whose *hao* was Ho-sheng 鶴聲 His portrait was done posthumously by Jen I. It is reproduced in Ding's book *Jen Po-nien* 任伯年 (no catalogue nor page no.).

18  This colophon is reproduced at the end of Ding's book *Jen Po-nien* 任伯年. It is also transcribed by Ding in entry 1861 in ibid., pp. 13–14, "Ren Bonian sishijiu sui sheying (Jen Po-nien si-shih-chiu sui she-ying) 任伯年四十九歲攝影" ([Jen Chin's] Colophon on a Photo of Jen I Taken at the Age of forty-nine.] The Chinese text of Jen Chin's colophon follows: "先處士少值儉歲. 年十六陷洪楊軍, 大酋令掌軍旗. 旗以二丈縱衰連數端為之, 貫如兒臂之幹, 傅以風力, 數百斤物矣. 戰時麾之, 以為前驅. 既餒, 植幹於地, 度其風色何向, 乃反風跌坐, 隱以自障. 敵陣彈丸, 挾風嘶嘶, 汰旗掠鬢. 或沿幹墮, 墮處觸石, 猶能殺人. 嘗一彈猝至, 撼旁坐者額, 血濡縷, 立斃. 先處士顧無恙. 軍行或野次, 草塊枕藉, 露宿達晨. 贏糧尊食, 則群跐如蹲鴟, 此嶺表俗也. 年才逾立, 已種種有二毛, 嗜酒病肺. 捐館前五年, 用醫者言, 止酒不復飲. 而涉秋徂冬, 猶咳嗆嗆逆, 喘汗顙泚. 則陷賊軍時道塗霜露, 風瘴所淫且賊也. 此影蓋四十九歲所攝孤子堇敬題."

19  One error in the son's colophon is that he mistakenly states his father's age at the time of conscription as sixteen. In reality, the T'ai-p'ing army sacked Jen I's hometown in 1861, when Jen I was twenty-one. Another confusion that results from Jen I's conscription by the T'ai-p'ing army is his alleged involvement with *Hsiao-tao hui* 小刀會 (the Small Sword Society), an anti-Manchu movement that originated in Shanghai in 1853 during the early years of the T'ai-p'ing Rebellion and lasted until 1855. His participation in this movement is extremely dubious, since at this time he would have been only fourteen years old, not to mention that there is no record of Jen I in Shanghai until 1868. For a discussion of the Small Sword Society, see entry on Chi-erh-hang-a 吉爾杭阿 (?–1856) in *Eminent Chinese of the Ch'ing Period (1644–1912)*, vol. 1, pp. 118–19.

20  See entry 1865 in "Jen Po-nien nien-p'u 任伯年年譜" (Chronological Table of Jen I), p. 18.

21  See ibid. This story is based on a colophon by Ma Heng 馬衡 (active early 20th century) inscribed on one of the portraits Jen I did for a friend.

22  See ibid., entries 1866 and 1867. Chou and Yao were both friends with Jen Hsiung. Thus they not only provided companionship for Jen I but also made him more familiar with the work of Jen Hsiung, a major influence on Jen I's development as an artist.

23  For more information on Fei Tan-hsü, see entry 46. For more information on Jen I's adopted names, see "Ren Bonian yishulun (Jen Po-nien i-shu-lun) 任伯年藝術論" (A Discussion of the Art of Jen I) in Ding's *Jen Po-nien* 任伯年 (Shanghai: Shuhua Chubanshe, 1989), pp. 4, 125, 145 n. 3.

24 See ibid.

25 See Xu Beihong's 徐悲鴻 (1895–1953), "Ren Bonian pingzhuan (Jen Po-nien p'ing-chuan) 任伯年評傳" (Comments and Biography of Jen Po-nien), reprinted in *Jen Po-nien yen-chiu* 任伯年研究 (Research on Jen Po-nien), p. 1. For more on this story, see the entries on Jen Hsiung and Jen Hsün.

26 Much evidence indicates that Jen I met Jen Hsün during this period in Ning-po and followed him back to Suchou in order to study. This is recorded in Jen I's hand-scroll, *Tung-chin hua-pieh t'u* 東津話別圖 (Farewell at the East Ford). See entry 1868 in "Jen Po-nien nien-p'u 任伯年年譜" (Chronological Table of Jen I), pp. 21–22. See also entry 50 on Jen Hsün.

27 Jen I's handscroll belongs to the Zhongguo Meishuguan 中國美術館 (China Gallery of Art) in Beijing. It is reproduced in Group for the Authentication of Ancient Works of Chinese Painting and Calligraphy, ed., *Zhongguo gudai shuhua tumu (Chung-kuo ku-tai shu-hua t'u-mu)* 中國古代書畫圖目 (Illustrated Catalogue of Selected Works of Ancient Chinese Painting and Calligraphy), vol. 1 (Beijing: Wenwu Chubanshe, 1986), no. 京 3-177, p. 62. A larger reproduction of this scroll is found in *Jen Po-nien yen-chiu* 任伯年研究 (Research on Jen Po-nien), pp. 6–7.

28 In Suchou, Jen I was provided with a nurturing environment and given resources that enabled him to concentrate fully on painting. He was also introduced to many important artists and patrons who commented on his work and broadened his vision. It was also in Suchou that he met Hu Yüan 胡遠 (1823–86, *tzu* Kung-shou 公壽), a painter who later helped Jen establish himself in Shanghai. See entry 1868 in "Jen Po-nien nien-p'u 任伯年年譜" (Chronological Table of Jen I), p. 23.

29 See ibid.

30 Jen Hsün's portrait by Jen I belongs to the Zhongguo Meishuguan 中國美術館 (China Gallery of Art) in Beijing. It is reproduced in *Zhongguo gudai shuhua tumu (Chung-kuo ku-tai shu-hua t'u-mu)* 中國古代書畫圖目 (Illustrated Catalogue of Selected Works of Ancient Chinese Painting and Calligraphy), vol. 1, no. 京 3-176, p. 62. See entry 50 on Jen Hsün for more information on this important work.

31 See entry 1869 in "Jen Po-nien nien-p'u 任伯年年譜" (Chronological Table of Jen I), p. 25.

32 Jen I always remembered his early difficulties in Shanghai and his indebtedness to the fan shop where he was first employed. Years later, during the pinnacle of his suc-cess, he would return at the end of each year and paint for the shop. Now a great honor for the shop, these fans were sold at a large profit. See entry 1884 in "Jen Po-nien nien-p'u 任伯年年譜" (Chronological Table of Jen I), p. 65.

33 See ibid., p. 25.

34 For Jen I's paintings depicting goats, see his *Three Rams*, published in Claudia Brown and Ju-hsi Chou, *Transcending Turmoil: Painting at the Close of China's Empire, 1769–1911* (Phoenix: Phoenix Art Museum, 1992), pl. 68, pp. 185 and 187.

35 For the story relating Jen's observation of the cat fights, see "Ren Bonian yishulun (Jen Po-nien i-shu-lun) 任伯年藝術論" (A Discussion of the Art of Jen I) in Ding's *Jen Po-nien* 任伯年, pp. 131–32. For the source of the story involving chickens, see entry 1869 in "Jen Po-nien nien-p'u 任伯年年譜" (Chronological Table of Jen I), p. 25

36 See entry 1869 in "Jen Po-nien nien-p'u 任伯年年譜" (Chronological Table of Jen I), p. 25.

37 For an example of Jen I's depiction of a cat, see his *Furong baimao tu (Fu-jung pai-mao t'u)* 芙蓉白貓圖 (White Cat under Hibiscus), reproduced in *Shanghai po-wu-kuan ts'ang hai-shang ming-hua-chia ching-p'in chi* 上海博物館藏海上名畫家精品集 (Masterworks of Shanghai School Painters from the Shanghai Museum), cat. no. 54. There are numerous paintings by Jen I depicting chickens. In addition to the Michigan scroll, see also his *Ji zhu tu (Chi chu t'u)* 雞竹圖 ([Two] Chickens and Bamboo), reproduced in ibid., cat. no. 60.

38 See ibid.

39 See ibid., p. 26. More information on Jen Hsia's life and paintings can be found in Marsha Weidner et al., *Views from Jade Terrace: Chinese Women Artists, 1300–1912* (Indianapolis: Indianapolis Museum of Art, 1988), pp. 167–71.

40 For example, in 1870 when Jen I completed a portrait of his late father, he asked Hu Yüan to add the setting. See ibid., entry 1869, p. 26.

41 See ibid., entry 1870, p. 27. This is based on a statement of a contemporary painter, Zhang Yuguang 張聿光 (1885–1968).

42 This is based on Chen Nian's 陳年 (1877–1970) statement made at a colloquium on Jen I in Shanghai, 1957. The proceeding is originally published in *Meishu* 美術 (Arts) 5 (Beijing: Renmin Meishu Chubanshe, May 1957), p. 42.

43 For examples of Jen I's landscape paintings, see his *Fang Gao Kegong yunshan tu (Fang Kao K'o-kung yün-shan t'u)* 仿高克恭雲山圖 (After Kao K'o-kung's [1248–1310] *Cloudy Mountains*) at the Shanghai Museum. It is reproduced in *Shanghai po-wu-kuan ts'ang hai-shang ming-hua-chia ching-p'in chi* 上海博物館藏海上名畫家精品集 (Masterworks of Shanghai School Painters from the Shanghai Museum), cat. no. 57.

44 See entry 1877 in ibid., p. 38.

45 See "Ren Bonian yishulun (Jen Po-nien i-shu-lun) 任伯年藝術論" (A Discussion of the Art of Jen I), p. 129.

46 See ibid., p. 34. The author cited from two sources. One was from a book published in 1947 and the other was from an inscription by Jen I's son, Jen Chin, concerning the surviving clay portrait of Jen I's father.

47 This sculpture is reproduced in Ding Xiyuan's 丁羲元 *Ren Bonian (Jen Po-nien)* 任伯年 (Shanghai: Shuhua Chubanshe, 1989).

48 See note 46.

49 Many Chinese artists went to Japan to receive training in Western art. For example, Kao Lun 高侖 (1878–1951), also known by his *hao*, Chien-fu 劍父), the founder of the Ling-nan 嶺南 (Canton) school, graduated from the Tokyo Art Academy. See Yu Jianhua 于劍華 et al., *Zhongguo meishujia renming cidian (Chung-kuo mei-shu-chia jen-ming tz'u-tien)* 中國美術家人名詞典 (Biographical Dictionary of Chinese Artists) (Shanghai: Renmin Meishu Chubanshe, 1981), p. 784.

50 See "Jen Po-nien i-shu-lun 任伯年藝術論" (A Discussion of the Art of Jen I) in Ding's *Jen Po-nien* 任伯年, p. 141 and entry 1879 in "Jen Po-nien nien-p'u 任伯年年譜" (Chronological Table of Jen I), p. 46.

51 See ibid., p. 43. Little can be found about Liu Te-chai's life. As the Catholic Church Art Academy was a branch of the mission's orphanage, he could have had a humble origin. To provide asylum and education for the orphans in Shanghai, the priests opened several training institutes including academies of print, art, photography, carpentry, and machinery. Talented orphans were sent to Japan and Europe for further instruction. See Wang Wei-fang 王維芳, "Zhongguo shuicaihua de kaichuangzhe Xu Yongqing (Chung-kuo shui-ts'ai-hua te k'ai-ch'uang-che Hsü Yung-ch'ing) 中國水彩畫的開創者徐詠青" (Mr. Hsü Yung-ch'ing, the Pioneer of Chinese Watercolor Painting), in *Meishushilun jikan (Mei-shu-shih-lun chi-k'an)* 美術史論季刊 (Quarterly Journal of History and Theory of Fine Arts) 18 (Beijing: Institute of Fine Arts, China Art Academy, Summer 1986), p. 58.

Jen I 任頤
Scholar with Roosters
*continued*

52 Jen I was fascinated by the realism of Western art. Besides admiring more formalistic works, he also collected hundreds of reproductions of Western pictures, amassing a large collection of used Christmas cards, which he considered novel and ornate. See entry 1878 in "Jen Po-nien nien-p'u 任伯年年譜" (Chronological Table of Jen I), p. 44.

53 His friends, in addition to the above-mentioned Hu Yüan, included Chang Hsiung 張熊 (1803–86) and Hsü Ku 虛谷 (1823–96). These two painters were among the well-known flower-and-bird painters in Shanghai. For their biographies and works, see their entries in Claudia Brown and Ju-hsi Chou, *Transcending Turmoil: Painting at the Close of China's Empire, 1769–1911* (Phoenix: Phoenix Art Museum, 1992), pp. 138–39 and pp. 115–25, respectively. Two younger artists under his guidance and tutelage were Kao Yung 高邕 (1850–1921) and Wu Ch'ang-shuo. Kao and Wu were also important painters in Shanghai. Of the two, the latter was particularly influential. After Jen I died in 1896, his position in the artistic circle was filled by Wu Ch'ang-shuo. For his life and creative career, see the above book, pp. 272–75.

54 See note 5.

55 For information of Jen I's addiction to opium, see entry 1886 in "Jen Po-nien nien-p'u 任伯年年譜" (Chronological Table of Jen I), p. 79.

56 See ibid.

57 For stories of Jen I accepting payments for paintings that he had no intention of completing, see entry 1887 in "Jen Po-nien nien-p'u 任伯年年譜" (Chronological Table of Jen I), p. 88. The story cited here is found in ibid., entry of 1886, p. 79.

58 See ibid.

59 See entry 1891 in ibid., p. 103.

60 This is based on the colophon of Jen Chin, Jen I's son. See note 18.

61 See entry 1894 in "Jen Po-nien nien-p'u 任伯年年譜" (Chronological Table of Jen I), p. 109.

62 Jen I's daughter, Jen Hsia, learned painting from her father and could imitate his style quite proficiently. After Jen I died, she often forged his signature on her paintings and sold them in order to support her mother and younger brother. Dejected after a failed engagement, she attempted suicide. A later marriage to an elderly widower-scholar by the name of Wu Shao-ch'ing 吳少卿 ended after a year due to his unexpected death. She died in poverty soon after. See entry 1895 in ibid., pp.

111–14, as well as Cheng I-mei 鄭逸梅, *Hsiao-yang-ch'iu* 小陽秋 (Minor History) (Shanghai: Ji-hsin Press, 1947), pp. 1–2. Information from this book is reprinted in *Jen Po-nien yen-chiu* 任伯年研究 (Research on Jen Po-nien), p. 18. Jen I's young son, Jen Chin, although only twelve at the time of his father's death, had much potential. He scored high in his preliminary examination and was accepted at the government academy. Unfortunately, though, he failed the civil service examination. Later, he joined several administrations as a lower staff member and eventually became a distinguished scholar. Although a competent painter, he was better known for his calligraphy. Just as his career began to blossom, he fell victim to the same vices that plagued his father: drinking and opium. In 1936, he died of tuberculosis at the age of fifty-five. Jen Chin's daughter, due to a failed marriage, later committed suicide. Jen Chin's son followed Wu K'ai 吳揩, whose *tzu* was Chung-hsiung 仲熊, to the United States. Wu was the son of Jen Chin's late brother-in-law, Wu Shao-ch'ing. See "Kin hyakunen rai Chugoku gajin shiryo 近百年來中國畫人資料" (Information on Chinese Painters during the Last Hundred Years), in *Bijutsu Kenkyu* 美術研究 (The Journal of Art Studies) 294 (Tokyo: Tokyo Kokuritsu Bunkazai kenkyujo, Bijutsubu, 1973), p. 67.

63 The story of Sung Tsung is found in several old books. For example, Sung's name is listed in Li Han's 李瀚 (active 937–50) *Meng-ch'iu* 蒙求 (literally meaning "the request of uneducated children"), a book containing essays on famous historical events for the purpose of instructing children. Sung Tsung is also found in Lian Yung-hsien's 廖用賢 (active early 17th century) *Tseng-pu shang-yu lu* 增補尚友錄 (The Augmented Version of the Records of Friends, an informal biographical dictionary of famous men in Chinese history), preface dated 1617, *chüan* 卷 (chapter) 17 (no place nor date), p. 21. The entry says: "Sung Chu-tsung of the Tsin dynasty was from the Pei county (present-day northern Kiangsu province). He served as the governor of Kun-chou (present-day Shantung province). Sung obtained a rooster, which he took good care of and kept [in a cage] by the window. Later, the fowl talked liked a person and spoke on profound matters with Sung. As a result, Sung's knowledge of literature and writing were greatly improved." (宋處宗, 晉, 名宗 沛國人. 官兗州刺史. 得一長鳴雞, 愛養窗間 後作人語. 與宗談論極妙. 由是文學大進.)

64 See Ding Xiyuan's 丁義元, "Huashu changchun 畫樹長春 (Painting an Everlasting Tree)," in *Jen Po-nien* 任伯年, pp. 9–10.

65 The title of Jen I's scroll, with bamboo leaves as background, is *Cizhong tanji tu* (*Tz'u-chung t'an-chi t'u*) 次中談雞圖 (Mr. Tz'u-chung Conversing with Chickens). It is reproduced in *Jen Po-nien tso-p'in chi* 任伯年作品集 (A Collection of Jen I's Works), vol. 2, p. 389. This title, designated by Chinese scholars, is evidently incorrect. More likely, this work, like the Michigan work, also depicts the Tsin dynasty scholar Sung Tsung. The mistaken name in this title, "Tz'u-chung," sounds similar to Sung Tsung's *tzu*, "Ch'u-tsung," and probably explains the mistake. The author Ding Xiyuan also uses this incorrect title in his book *Jen Po-nien* 任伯年. See entry 1877 in "Jen Po-nien nien-p'u 任伯年年譜" (Chronological Table of Jen I), p. 39.

66 This work by Jen I is reproduced in *Jen Po-nien tso-p'in chi* 任伯年作品集 (A Collection of Jen I's Works), p. 410 and is listed as *Renwu (Jen-wu)* 人物 (Figure Painting).

67 The source of the rooster's five virtues is found in vol. 2 of Han Ying's 韓嬰 (c. 150 B.C.) *Han-shih wai-chuan* 韓詩外傳 (Han Ying's Comments on Poems in the Book of Odes). See Lai Yen-yüan 賴炎元, ed., *Han-shih wai-chuan chin-chu chin-i* 韓詩外傳今註今譯 (Modern Footnotes and Translation of Han Ying's Commentary on Poems in the Book of Odes), *chüan* 卷 (chapter) 2 (Taipei: Taiwan Commercial Press, 1972), p. 70. Han Ying comments: "Surely it doesn't mean that you, a distinguished gentleman, have ignored (the virtues of) a rooster. The cockscomb on its head signifies 'education.' The sharp talons on its legs represent its 'martial attitude.' Its pugnacious attitude, when being challenged by a rival, manifests its 'bravery.' When finding food, a rooster usually clucks, thus expressing its 'benevolence.' Its daily sunrise crow exemplifies its 'trustworthiness.' The rooster has these five virtues!" (君獨不見夫雞乎? 首戴冠者, 文也 足搏距者, 武也 敵在前敢鬥者, 勇也 得食相告, 仁也 守夜不失時, 信也 雞有此五德!)

68 Using a rooster to represent the above-mentioned moral or ethical criteria has a long tradition in Chinese painting. For example, one hanging scroll at the Palace Museum in Beijing, *Furong jinji (Fu-jung chin-chi)* 芙蓉錦雞 (A Pheasant on the Branch of a Blossoming Hibiscus), bears an inscribed poem attributed to Emperor Hui-tsung (r. 1102–25). This poem clearly praises the *wu-teh* of the bird. The Chinese consider roosters and pheasants as belonging to the same *chi* 雞 or "fowl" category. *A Pheasant on the Branch of a Blossoming Hibiscus* is reproduced in Osvald Sirén, *Chinese Painting: Leading Masters and Principles*, vol. 3 (New York and London: Ronald Press, 1956), pl. 230.

## 52. Jen Yü 任預
(1853.–1901)
*Ch'ing dynasty (1644–1911)*

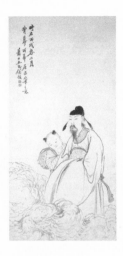

## God of Happiness and Attendant in the Clouds
*T'ien-kuan tz'u-fu*
*(The Heavenly Sovereign Bestowing Grace)*
天官賜福

1 Mr. Jung Ying Ts'ao is the owner of the Far East Fine Art Company, in San Francisco. He inherited an art collection from his grandfather, Ts'ao K'un 曹錕, who, in 1923, served as the fourth president of the Republic of China.

2 See Yang I's 楊逸 (1864–1929), *Hai-shang mo-lin* 海上墨林 (The Ink Forest [Artistic Circles] in Shanghai), 3rd ed. dated 1929, (Shanghai: n.p.), reprint, *chüan* 卷 (chapter) 3 (Taipei: Wen-shih-che Press, 1975), under entry no. 351 on Jen Hsiung, p. 9b.

3 Gong Chanxing 龔產興, "Ren Weichang nianbiao (Jen Wei-ch'ang nien-piao) 任渭長年表" (A Chronological Table of Jen Hsiung) in *Meishushilun jikan (Mei-shu-shih-lun chi-k'an)* 美術史論季刊 (Quarterly Journal of History and Theory of Fine Arts) 25 (Beijing: Institute of Fine Arts, China Art Academy, Spring 1988), p. 80.

4 See notes 35 and 41 of entry 49 on Jen Hsiung for more information on this set of forty-eight cards. A complete set of these cards is reprinted in *Ren Weichang huazhuan sizhong (Jen Wei-ch'ang hua-chuan ssu-chung)* 任渭長畫傳四種 (Jen Hsiung's Four Sets of Illustrated Biographies) (Beijing: China Bookstore, 1985).

5 See Jen Ch'i's 任淇 (?–after 1863) preface for Jen Hsiung's *Liexian jiupai (Lieh-hsien chiu-p'ai)* 列仙酒牌 (Drinking Cards Decorated with Immortals), p. 1 in *Ren Weichang huazhuan sizhong (Jen Wei-ch'ang hua-chuan ssu-chung)* 任渭長畫傳四種 (Jen Hsiung's Four Sets of Illustrated Biographies).

6 See entry 50 on Jen Hsün for more information on his life and activities.

7 Jen Hsün's father died when he was still a baby. Jen Hsiung, who was twelve years older, had to assume the responsibility of supporting Jen Hsün. See "Ren Weichang nianbiao (Jen Wei-ch'ang nien-piao) 任渭長年表" (A Chronological Table of Jen Hsiung), p. 80. In old Chinese society, such fraternal love was considered a grace, and the younger brother was supposed to reciprocate once mature. Thus, Jen Hsün was somewhat obligated to fulfill this expectation.

8 Jen Yü's life and artistic activities are well recorded. See Li Po-yüan 李伯元 (active late 19th to early 20th century), *Nan-t'ing pi-chi* 南亭筆記 (Notes Jotted Down at the South Pavilion), *chüan* 卷 (chapter) 9 (Shanghai: Tatong Bookstore, 1919), 5a, which states: "Even at a young age, when Jen Yü put his brush to paper, he could already [produce] outstanding works. Nevertheless, he was lazy, indifferent, and unrestrained. In comparison to the elder members of his family, his [behavior] was [far] worse. He conducted [himself] like floating clouds and flowing water, [constantly] drifting about without a definite course. At that age, he was unburdened by family responsibilities and roamed between Suchou and Hangchou. Although [people] heard of his fame and strove to invite him to [stay,] he was capricious and indulged [the whims of his] emotions. People desired to purchase his paintings yet could only do so when he was in a good mood; offering him a reward was useless. Usually, the more earnestly one requested, the more obstinate the artist would become. Throughout his life he was unwilling to demonstrate his painting skill on demand. When he did have money, he treated it indifferently, like dirt, never saving any for the next day. Other material goods had even less effect on him." ([任預] 年雖少，下筆已卓爾不群．然其疏懶落拓，較諸前輩，殆尤過之．其為人，如行雲流水，飄然靡定．少時，又無室家之累．隻身往來吳越間．聞其名，雖到處爭迎，然任情率意．人欲得其畫，可遇而不可求．大抵求之愈殷，則拒之愈甚．生平未嘗甘為人一獻其技．得錢則糞土視之．恆不為明日計．其餘百物，尤若無足以動之．)

9 See *Nan-t'ing pi-chi* 南亭筆記 (Notes Jotted Down at the South Pavilion), *chüan* 卷 (chapter) 9, p. 5b.

10 It seems a year was the longest Jen Yü ever stayed with a particular patron. Claudia Brown and Ju-hsi Chou point out that, according to *Wu-hsien chih* 吳縣誌 (The Suchou Gazetteer), a certain gentleman named Chang 張 living at Hsü-k'ou 胥口, a small town west of Suchou, was possibly Jen Yü's patron and that the artist stayed at his house for about a year. The name of this unidentified person's studio was Pi-yin hsüan 碧蔭軒 (the Jade Green Shadow Hall). Jen Yü painted at least a portrait and a handscroll for this collector. See Claudia Brown and Ju-hsi Chou, *Transcending Turmoil: Painting at the Close of China's Empire, 1769–1911* (Phoenix: Phoenix Art Museum, 1992), pp. 194–95 and note 328 on p. 146.

11 All these accounts of Jen Yü's unsanitary habits are found in Chou T'ao's 鄒弢 (active fourth quarter of 19th century) *San-chieh-lu chui-t'an* 三借盧贅談 (Prolixity at the Three-loan Studio), prefaces dated 1881 and 1885, reprint, *chüan* 卷 (chapter) 12 (Shanghai: Shen-pao Press, n.d.), p. 12b, which states: "[When] Li Fan (Jen Yü's *tzu*) put on new clothes, he [would] wear them [all the time] even when he went to bed. He would only disrobe when the garments finally became tattered or when the weather became too hot. When he had new clothes, he threw away the old ones. Nobody ever witnessed Jen Yü doing laundry. In Jen Yü's studio, which also served as his living quarters, money and household objects were piled up at random. New guests, who were afraid they might be accused of stealing, were usually loath to enter the room. As a painter, he received more than a thousand dollars each year, yet he never counted [his money]. Once a friend visited him and invited him to go out. [Before they left,] Jen Yü casually moved a large pile of papers and discovered several scores of foreign silver coins. He was overjoyed. Since the pockets on his clothes were all frayed, he sat down on his bed and took out his dirty and foul-smelling sock. Carrying the coins in the sock, he and his friend visited the home of a courtesan, had a wanton party, and spent all his money in one evening. When [his friend] asked him the next morning [about the money], he merely laughed and bid farewell." (立凡則一新衣上身，臥亦衣之．至敝或天暖，乃脫他日易新者，則舊者去之．從未聞其浣滌者．所居畫室，銀物遂意堆置．故生客避嫌，不敢入．所得畫資，歲及千金，已不能稽數．嘗有友人相訪，招立凡同出．立凡偶翻紙堆，得番餅數十枚，大喜．身無可藏，即以床頭，下破襪，實番餅於中．挈身畔，隨友醉倡家．一夕，銀盡揮去．明日問之，一笑而罷)

12 See ibid.

13 See ibid.

14 See ibid., p. 5a.

15 A photo of an opium den is reproduced in Burton F. Beers, *China in Old Photographs, 1860–1910* (Milton, Mass.: Museum of the American China Trade, 1978), no. 55, p. 72. A photo of a more ele-

Jen Yü 任預
**God of Happiness and Attendant in the Clouds**
*continued*

### 53. Wu Ch'ing-yün 吳慶雲
*(?–1916)*
*Ch'ing dynasty (1644–1911)*

156

gant den for the wealthy is reproduced in Keith Buchanan et al., *China: The Land and the People, the History, the Art, and the Science* (New York: Crown Publishers, 1980), p. 423.

16  See Li Po-yüan 李伯元 (active late 19th to early 20th century), *Nan-t'ing pi-chi* 南亭筆記 (Notes Jotted Down at the South Pavilion), *chüan* 卷 (chapter) 9, pp. 5 a & b. Li elucidates: "[Unfortunately, Jen Yü was] severely addicted to opium. When with knitted brow and in dire circumstances [craving opium], he would go to a dingy opium den. Lying down motionless on a broken-down bed covered with a tattered mat, his nose would run and his tears roll down. He would beg the owner for some "purple-mist paste" (opium) on credit so that he could satisfy his craving. The owner, of course, would refuse. [However,] people (dealers) already knew about this situation and schemed with the owners in advance. [The dealer] would tell the owner that he had several hundred dollars and would like to pay for Jen Yü [the next time Jen] arrived penniless at the opium shop. Although this person did not expect any reciprocation, [he suggested that] perhaps Jen could conveniently paint a fan or a hanging scroll for him. The owner agreed and passed on the request to Jen. At the time, Jen was extremely thankful and agreed immediately. After [Jen] inhaled [the opium], he borrowed brush and ink stone, put the paper on the bed, [and started] to paint. It would take only a short period of time for Jen to finish the painting. Examining it, [one found] it was truly an exceptional work. [When Jen's painting was sold] to a buyer, there was always a substantial profit. Thus, nine out of ten paintings [people] acquired from [Jen Yü] were those he executed at shabby opium dens." ( 惟阿芙蓉癖甚深. 值窘鄉, 則攢眉而入小煙室. 僵臥敗榻破席間, 涕淚橫流. 乞主人賒取紫霞膏, 以制癮. 主人不允. 於此有人焉, 先密商於主人. 俟其至, 當其窮蹙. 乃謂主人曰, 余有數百錢, 權為任先生作畫道, 并無他求. 扇一頁, 或紙一幀, 便願代請一揮何如? 主人曰諾. 第問先生可否. 於斯時也, 五中感激, 莫可言宣. 亦無不應之曰諾諾. 呼吸既畢, 即假筆硯, 就榻間攢簇渲染. 頃刻而成. 視之, 真佳搆也. 轉售於人, 立致重價. 故得其畫者, 什九從小煙室中來也.)

17  For examples of Jen Yü's more disciplined works, see his *Cuizhu baiyuan tuzhou* (*Ts'ui-chu pai-yüan t'u-chou*) 翠竹白猿圖軸 (A White Monkey among Green Bamboo Groove), published in Editorial Committee of the Complete Collection of Chinese Art, *Zhongguo meishu quanji* (*Chung-kuo mei-shu ch'üan-chi*) 中國美術全集 (A Complete Collection of Chinese Art), vol. 11 (Shanghai: Renmen Meishu Chubanshe,

1988), no. 207, p. 199. This work belongs to a set of four hanging scrolls, each of which has complex compositions. Dated 1881, these four paintings were executed by Jen Yü when he was only twenty-seven years old.

18  While Jen Yü's work is similar to that of Jen Hsiung, Jen Hsün, and Jen I, it does display more personal characteristics, perhaps because while all four Jen painters emulated Ch'en Hung-shou 陳洪綬 (1598–1652), Jen Yü did so to a lesser degree.

19  See E. T. C. Werner, *A Dictionary of Chinese Mythology*, reprint (Taipei: Wen-hsing Press, 1961), pp. 400–403.

20  See ibid., pp. 400–401.

21  See ibid.

22  See ibid., p. 143, s.v. "Fu-shen 福神." See also ibid., pp. 236–37, s.v. "Kuo Tzu-i 郭子儀." For more information on Kuo Tzu-i, see also entry 47 on Wang Ying-hsiang.

23  See ibid.

24  For examples of figure paintings on murals of the T'ang dynasty, see Editorial Committee of the Complete Collection of Chinese Art, *Chung-kuo mei-shu ch'üan-chi* 中國美術全集 (A Complete Collection of Chinese Art), vol. 2, album leaf 1, nos. 7 and 8, pp. 16–17, or Yin Shengping, ed., *The Cream of Original Frescoes from Tang Tombs* (Xian: Renmin Meishu Chubanshe, 1991), no. 47, p. 49.

25  For examples of Jen Yü's more elaborate paintings, see note 17.

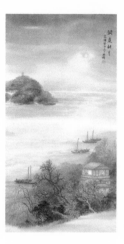

## Autumn Moon at Mt. Tung-t'ing

*Tung-t'ing ch'iu-yüeh*
*(Autumn Moon at [Mt.] Tung-t'ing)*
洞庭秋月

1  See Yang I 楊逸 (1864–1929), *Hai-shang mo-lin* 海上墨林 (The Ink Forest [Artistic Circles] in Shanghai), 3rd ed. dated 1929, (Shanghai: n.p.), reprint, *chüan* 卷 (chapter) 3 (Taipei: Wen-shih-che Press, 1975), p. 36a. Yang's book says: "Wu Shih-hsien is his (Wu Ch'ing-yün's) *tzu*, which he used as his given name. He was from Chin-ling (the old name of Nanking). He was skilled in landscape painting, which he executed with some European technique, a secret method that he alone mastered. The mountains and ravines [in his work] are remote and distinctive, appearing with a vast profoundness. In his depictions of summer mountains in rain, he applied the ink wash method [typically used for] clouds and mists. This was ingenious and effective. Wu's painting was in vogue and was especially appreciated by the populace of the Canton region. Five years after the *hsin-hai* year (1911) of the Hsüan-t'ung period (r. 1909–11), he died. ( 吳石僊, 以字行. 金陵人. 工山水, 略參西畫, 獨得秘法. 丘壑幽琦, 窅然深遠. 人物屋宇, 點綴如真. 畫夏山雨景, 渲染雲氣之法, 莫窺其妙. 畫甚投時, 粵人尤深喜之. 宣統辛亥後五年卒.)

2  This is based on the information found in Claudia Brown and Ju-hsi Chou, *Transcending Turmoil: Painting at the Close of China's Empire, 1769–1911* (Phoenix: Phoenix Art Museum, 1992), p. 224.

3  For a discussion of the T'ai-p'ing Rebellion, see Keith Buchanan et al., *China: The Land and the People, the History, the Art, and the Science* (New York: Crown Publishers, 1980), pp. 332, 336, and 339. See also the biography of Hung Hsiu-ch'üan 洪

秀全(1813–64) in Arthur W. Hummel, ed., *Eminent Chinese of the Ch'ing Period (1644–1912)*, vol. 1 (Washington, D.C.: United States Government Printing Office, 1943–44), pp. 361–66.

4  See Yu Jianhua's 于劍華 et al., *Zhongguo meishujia renming cidian (Chung-kuo mei-shu-chia jen-ming tz'u-tien)* 中國美術家人名詞典 (Biographical Dictionary of Chinese Artists) (Shanghai: Renmin Meishu Chubanshe, 1981), p. 310.

5  Wu Ch'ing-yün must have been popular in Shanghai artistic circles. Three of his landscapes, all dated fall of 1887, are included in the "Tseng-kuang ming-chia hua-p'u 增廣名家畫譜" (Additional Painting Models by Famous Painters) section in Chao Hsün's 巢勳 (1852–1917) *[Lin] Chieh-tzu-yüan hua-chuan* [臨] 芥子園畫傳 (A Copy of Mustard Seed Garden Manual of Painting), epilogue dated 1887, reprint, vol. 1 (Hong Kong: Chung-hua Press, 1972), pp. 373–76. During the late nineteenth century, Wang Kai's 王概 (active during the K'ang-hsi 康熙 reign, 1662–1722) *Mustard Seed Garden Manual of Painting*, which was originally published in the seventeenth century, grew to be in great demand. Therefore, Chao Hsün hand-copied the original version, added new examples by famous painters in Shanghai, and created the modern version.

6  The Tung-t'ing in Wu's painting should not be confused with the famous Lake Tung-t'ing, which is located in Hunan 湖南 province. The mountain in Lake Tung-t'ing is known as Chün Shan 君山 It is rather common for painters in the *chiang-nan*, or "south bank of the lower Yangtze River," region to depict Lake T'ai and Mt. Tung-t'ing as they lived near this lake. A hanging scroll depicting Mt. Tung-t'ing by the Yüan dynasty (1280–1368) master Chao Meng-fu 趙孟頫 (1254–1322) is currently at the Shanghai Museum. This work, entitled *Dongting dongshan tu (Tung-t'ing tung-shan t'u)* 洞庭東山圖 (East Tung-t'ing Mountain), is reproduced in Group for the Authentication of Ancient Works of Chinese Painting and Calligraphy, ed., *Zhongguo gudai shuhua tumu (Chung-kuo ku-tai shu-hua t'u-mu)* 中國古代書畫圖目 (Illustrated Catalogue of Selected Works of Ancient Chinese Painting and Calligraphy), vol. 2 (Beijing: Wenwu Chubanshe, 1987), no. 滬 1-0161, p. 79. For the geographical position of Mt. Tung-t'ing, see the map of Suchou in Richard Edwards, *The Art of Wen Cheng-ming (1470–1559)* (Ann Arbor: University of Michigan Museum of Art, 1976), p. 222.

7  The Chinese celebrate the Moon Festival on the fifteenth day of the eighth moon each year. Therefore, traditionally, fall is equated to a bright full moon. It is also a season that inspires painters and poets to create works related to cold weather, which establish desolate moods—for example, Shen Chou's 沈周 (1427–1509) famous handscroll entitled *Watching the Mid-Autumn Moon*, currently at the Museum of Fine Arts, Boston. For a reproduction of this work, see Richard Edwards, *The World around the Chinese Artist* (Ann Arbor: College of Literature, Science, and the Arts, 1987), fig. 2-11, p. 73.

## 54. Lu Hui 陸恢
*(1851–1920)*
*Ch'ing dynasty (1644–1911)*

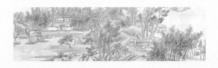

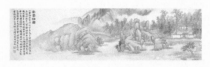

## The Small Cloud Dwelling
*Hsiao-yün-ch'i t'u*
*(A Picture of the Small Cloud Dwelling)*
小雲栖圖

1  The title of this handscroll is based on the inscription found in the *yin-shou* 引首, or the "introductory title block" at the beginning of the scroll. The fact that this title is derived from the name of the dwelling depicted in Lu Hui's painting is clearly stated in the artist's inscription as well as in several of the colophons attached to the end of the painting.

2  Mr. Kung Teyen, from whom the University of Michigan purchased this scroll, was the great-grandson of the younger brother of the famous Kung Tzu-chen 龔自珍 (*tzu* Ting-an 定庵, 1792–1841), a talented but controversial scholar, poet, and reformer. The University actually purchased this scroll from Mr. Kung's daughter in Ann Arbor, in 1981, when she came to the U.S. to attend Eastern Michigan University. According to Mr. Kung, his family owned this scroll for many years. Since originally this scroll was executed by Lu Hui for the Chang family, it is not clear how Mr. Kung's father or uncle acquired it. Possibly there was a relationship between the two families through marriage.

3  Hsiao-hsü is the given name of Cheng Hsiao-hsü 鄭孝胥 (1860–1938). He was a native of Fuchow 福州 in Fukien 福建 province. His *tzu* was T'ai-i 太夷 (the great peace) and his *hao*, Su-k'an 蘇戡 (easing suppression). He passed the national examination in 1882 with high marks and later became the administration commissioner in Hunan province. At the end of the Ch'ing dynasty (1644–1911), he was considered one of the most accomplished calligraphers in China, and his works were in great demand. During the earlier years of the Republic, he became a popular professional calligrapher in Shanghai. In 1930, however, when the last emperor Henry P'u I inaugurated the puppet Manchukuo government under the Japanese, Cheng Hsiao-hsü was appointed as the first prime minister. Cheng's reputation never recov-

**Lu Hui** 陸恢
**The Small Cloud Dwelling**
*continued*

158 ered from this political misstep. See Yu Jianhua 于劍華 et al., *Zhongguo meishujia renming cidian* (*Chung-kuo mei-shu-chia jen-ming tz'u-tien*) 中國美術家人名詞典 (Biographical Dictionary of Chinese Artists) (Shanghai: Renmin Meishu Chubanshe, 1981), pp. 1384–85.

4 Lu Hui's inscription calls the hometown of the recipient, "Hsün-hsi 潯谿" (The Hsün Stream). Hsün-hsi was the ancient name of the town of Nan-hsün 南潯 during Emperor Kao-tsung's (r. 1127–62) reign in the Southern Sung period (1127–1279). It is located south of Suchou, by the shore of Lake T'ai in Chekiang province. See *Tz'u-hai* 辭海 (Sea of Terminology: Chinese Language Dictionary), vol. 1 (Taipei: Chung-hua Press, 1974), p. 476, s.v. "Nan-hsün 南潯."

5 The name of this group of buildings in Lu Hui's painting, *The Small Cloud Dwelling*, is supposed to have been taken from the character *yün* 雲, or "clouds," in the name of the devout Buddhist Madame P'ang. Since "clouds" symbolize a purity that fluctuates and is transient, the character *yün* is commonly used for the names of Buddhist monks, nuns, and devotees.

6 Although these two seals indicate no specific owner, as they are stamped preceding this colophon, in all likelihood they belong to P'an Fei-sheng 潘飛聲 (1857–1934), the author of this colophon.

7 Se-jen 璱人 in this colophon was Kung Tzu-chen's *tzu*. The meaning of this verse is difficult to fathom. It is known that Mr. Kung Teyen, the former owner of this scroll, is a descendant of Kung Tzu-chen, a famous poet. But the Kung family got this scroll from the Chang family, the original recipient of Lu Hui's painting. Neither the mother, Madame P'ang, nor the son, Chang Pien-chün, was related to Kung Tzu-chen. It is not clear why a person should refrain from chanting Kung Tzu-chen's poem while lamenting the death of Madame P'ang. There seems to be some unknown significance or relationship regarding the members of the Chang family. The answer might also simply lie in the fact that an orphaned son should not chant Kung's poems as the poet's moving and sentimental verses would further increase his melancholy.

8 The *p'u-sa lien* 菩薩蓮 or "Bodhisattva's lotus" in the poem indicates the "lotus seats" specifically prepared for Bodhisattvas and their believers who have achieved enlightenment and have been reborn into the paradise found in the teaching of the Pure Land sect in Buddhism. To claim that the "Bodhisattva lotus" blooms over a large conglomeration

of "merciful clouds" in the poem, of course, implies that the deceased mother, who so piously worshipped Buddha in her lifetime, had successfully achieved enlightenment and was rewarded by being reborn onto the lotus pond of paradise. One should bear in mind that the mother's name was "clouds."

9 The original Chinese term, *lung-kang ch'ien* 瀧岡阡, in P'an Fei-sheng's essay indicates the famous green stele bearing the eulogy of scholar Ou-yang Hsün's 歐陽詢 (557–641) parents at Mount Lung-kang in Kiangsi 江西 province. See *Hanyu dacidian* (*Han-yü ta-tz'u-tien*) 漢語大詞典 (Chinese Terminology Dictionary), vol. 6 (Shanghai: Hanyu Dacidian Press, 1988), p. 209, s.v. "longgang (lung-kang) 瀧岡."

10 P'an Fei-sheng was a native of Canton, Kwangtung 廣東 province, but was active in Shanghai after 1900. As a man of letters, he was well-known for his calligraphy. Thus, he was often asked to inscribe fans and handscrolls. P'an could also paint, and he is especially known for his depiction of plum blossoms executed in his old age. See *Chung-kuo mei-shu-chia jen-ming tz'u-tien* 中國美術家人名詞典 (Biographical Dictionary of Chinese Artists), p. 1350.

11 Although Lan-shih literally means "orchid history," in this sense orchid is understood figuratively to mean "elegant." Thus P'an's *tzu* can be translated as "an elegant historian."

12 *Chang-shih* 丈室, or "a ten square-foot cubicle," indicates a small chamber. It appears in Buddhist sutras and has several meanings. For example, the small room in which Vimalakerti, a learned laymen and philosopher, debated with Manjushri, who represented the wisdom of Buddhism, was called a *chang-shih*. Later this term also referred to rooms where abbots lived. See *Han-yü ta-tz'u-tien* 漢語大詞典 (Chinese Terminology Dictionary), vol. 1, p. 335, s.v. "zhangshi (chang-shih) 丈室."

13 This line is based on the story found in the "Chi-shih 季氏" (chapter 16) of Confucius' (551–479 B.C.) *Lun-yü* 論語, or *The Analects*. The story presents a conversation between Confucius' son, Li 鯉 (carp) (532–483 B.C.), whose *tzu* was Po-yü 伯魚 (a noble fish), and a student of Confucius, Ch'en K'ang 陳亢 (511–?). Ch'en K'ang asked Li if he had recently heard anything remarkable from his father. Li replied that he had not, then elaborated further that once, when his father was alone, he happened to pass through the hall. Confucius stopped him and asked, "Have you ever studied poetry? If you have not, you will not be able to carry on a significant conversation." [The son continued that]

another time he passed through the hall, his father said to him, "If you have not studied the rites, you will not be able to establish yourself." After these two occurrences, Li told Ch'en K'ang that he concentrated on both poetry and the rites. Ch'en K'ang went away delighted and told his peers that he asked for one piece of advice and received three. In addition to the importance of learning poetry and the rites, he also found that a gentleman must keep his son at a certain distance. Thus, the phrase, "passing through the hall" became an expression indicating the relationship between a parent and a dutiful son. The original Chinese text follows: 陳亢問於伯魚曰: "子亦有異聞乎?" 對曰: "未也. 嘗獨立, 鯉趨而過庭. 曰: '學詩乎?' 對曰: '未也.' '不學詩, 無以言.' 鯉退而學詩. 他日, 又獨立. 鯉趨而過庭. 曰: '學禮乎?' 對曰: '未也.' '不學禮, 無以立.' 鯉退而後學禮. 聞斯二者." 陳亢退而喜曰: "問一得三. 聞詩, 聞禮, 又聞君子之遠其子也." See "Chi-shih 季氏," in Yang Bojun 楊伯峻, comp., *Lunyu yizhu* (*Lun-yü i-chu*) 論語譯注 (The Analects in Modern Chinese with Commentary), section 13, *juan* (*chüan*) 卷 (chapter) 16 (Beijing: Zhonghua Shuju, 1980), p. 178.

14 The character *k'o* 軻 in this verse indicates Mencius (372–289 B.C.), whose name was Meng K'o 孟軻. It is a well-known story in Chinese history that Mencius' mother took the trouble of moving her family three times in order to find the most appropriate environment to bring up her young son. The purpose of these moves was to keep her son from imitating the neighbor's improprieties. This line emphasizes the love and care of a wise, conscientious mother in bringing up her son. See *Sea of Terminology: Chinese Language Dictionary*, vol. 1, p. 36, s.v. "san-ch'ien 三遷 (moving the residence three times)." This story is originally recorded in Liu Hsiang's 劉向 (77–6 B.C.) *Lieh-nü chuan* 列女傳 (Biographies of Prominent Women). See "Tsou-Meng K'o-mu 鄒孟軻母," ([Madame] Tsou-Meng, K'o's Mother) in Wang Chao-yüan 王照圓, comp., *Lieh nü chuan p'u-chu* 列女傳補注 (Commentary on Biographies of Prominent Women), *chüan* 卷 (chapter) 1 (Taipei: Commercial Press, 1976), pp. 16–17. For a version of this story in English, see "The Mother of Mencius," in Ida Lee Mei, trans., *Chinese Womanhood* (Taipei: China Academy, 1982), pp. 2–23.

15 The "merciful and loving cloud" in this line refers to the mother Madame P'ang, as her name includes the character for clouds.

16 Wu Ch'ang-shuo is the *tzu* of Wu Chün-ch'ing 吳俊卿. He also had another *tzu*, Ts'ang-shih 倉石 (a rock in the granary). His *hao* was Fou-lu 缶廬 (pottery hut). He

was the leading artist in Shanghai around 1900. Both his expressive painting and powerful calligraphy, especially in the seal scripts, were in great demand by patrons. For his life and creative career, see Claudia Brown and Ju-hsi Chou, *Transcending Turmoil: Painting at the Close of China's Empire, 1769–1911* (Phoenix: Phoenix Art Museum, 1992), pp. 272–80.

17 Wu Chün 吳俊 was Wu Ch'ang-shuo's original name. Later, he changed his name to Wu Chün-ch'ing 吳俊卿. Wu Ch'ang-shuo was his *tzu*. In his later years, he was more known by his *tzu*. See Ch'ang-shuo, *Chung-kuo mei-shu-chia jen-ming tz'u-tien* 中國美術家人名詞典 (Biographical Dictionary of Chinese Artists), p. 290.

18 In this sentence, the Chinese text uses the term *yün-shui* 雲水, or "clouds and water." Originally the term indicated Taoists and Buddhist monks since these priests wandered about like scudding clouds and rushing waters. See *Han-yü ta-tz'u-tien* 漢語大詞典 (Chinese Terminology Dictionary), vol. 11, p. 635, s.v. "*yunshui* (*yün-shui*) 雲水." In the context of this colophon, it implies the deceased mother since she piously strove for Buddhism like a nun. Furthermore, the mother's name was *yün* 雲 or "clouds," and the pavilion was her living quarters for thirty years.

19 The elder son of Madame P'ang refers to Chang Jen-chieh 張人傑 (1877–1950), a renowned businessman and an influential official in the Republic government. His given name, Jen-chieh 人傑, meaning "a hero or distinguished person," has been cleverly worked into this line by indicating that Madame P'ang's son is of outstanding character. This line also implies the remarkable achievements of this son. Chang Jen-chieh is more known by his *tzu*, Chang Ching-chiang 張靜江. He provided early support to Dr. Sun Yet-sen (1866–1925), the founder of the Republic as well as a patron of Chiang Kai-shek (1886–1975), the Chinese generalissimo. Chang occupied many important governmental positions, including membership in the so-called four elder statesmen of the Kuomintang party, governor of Chekiang province, and director of the National Reconstruction Commission in Nanking. See Howard L. Boorman, ed., *Biographical Dictionary of Republican China*, vol. 1 (New York and London: Columbia University Press, 1967), pp. 73–77.

20 There are at least two reasons why the author of this poem chose to compare Lu Hui, the artist who executed this scroll, with Lu Chih. First, Lu Chih was a well-known painter from Suchou who was active during the sixteenth century. Sec-

ondly, Lu Chih and Lu Hui, although not directly related, share the same family name.

21 Little information is available on Shen K'un's life. It is possible that he is known under another name.

22 The most comprehensive data on Lu Hui's life and career are found in Yang I's 楊逸 (1864–1929) *Hai-shang mo-lin* 海上墨林 (The Ink Forest [Artistic Circles] in Shanghai), 3rd ed. dated 1929, (Shanghai: n.p.), reprint (Taipei: Wen-shih-che Press, 1975), entry no. 638. The entry asserts: "Lu Hui's *tzu* was Lien-fu and his *hao*, Chüan-an. He was a native of the Wu-chiang county. He excelled in landscape painting but was also proficient in flower painting. Minister Wu Ta-cheng (1835–1902), when he was appointed governor of Hunan, recognized Lu Hui's talent and invited him to join his staff. Later, Lu Hui also followed Wu on military expeditions to Manchuria. These appointments allowed Lu Hui the opportunity to experience the splendor of both the southern and northern landscapes. In 1896, when Chang Chih-tung (1833–1909) was the governor of Kiangsu and Chekiang, he commissioned a group of famous painters to illustrate the book *Ch'eng-hua shih-lueh* (Historical Materials for the Education of Princes), originally compiled by Wang Yün (1227–1304) of the Yüan dynasty (1280–1368). Lu Hui was commissioned as the chief artist for the completion of this project. The project required a great deal of research, and Lu Hui made sure the illustrations were detailed and accurate. The illustrations are classically elegant, without the triteness normally associated with commercial artisans, and the project received great acclaim from the court. Lu Hui later stayed with several patrons, including Mr. P'ang from Wu-hsing, Mr. Sheng from Wu-chin, and Mr. Ke from P'ing-hu. He helped them to authenticate many masterpieces of painting and calligraphy, and in turn he was able to study and copy these great works. This experience enhanced his artistic vocabulary and, as a result, greatly improved his painting. When he worked for Mr. P'ang in Shanghai, he sold many paintings. With the money he acquired, he purchased early calligraphic works as well as rubbings of antique bronze and stone inscriptions. He was also an accomplished calligrapher who excelled at executing the *li*, or "clerical script," of the Han dynasty (206 B.C.–A.D. 220). Lu Hui appropriated calligraphic elements of the Six Dynasties period (220–589) into his own calligraphy, producing powerful and expressive work full of the flavor of bronze and stone inscriptions. In his later years, Lu Hui returned to Suchou, where his work

remained in great demand. In 1920 he died around seventy years of age." (陸恢，字廉夫，號狷盦. 吳江人. 工山水，兼擅花卉. 為吳客齋尚書所稱賞. 嘗應吳聘入湘撫幕. 復從軍出關，飽覽南北山水之勝. 光緒丙申，張文襄任江督應詔集海內名畫家，補繪王元悌所進，承華事略. 以恢總其事. 圖中衣冠，彝器，悉準歷代制度. 古雅無匠氣. 廷諭褒稱. 其後，歷主吳興龐氏，武進盛氏，平湖葛氏. 為之審鑑書畫名蹟，心摹手追，所造愈臻神化. 寓滬時，館於龐. 得賣畫資，輒以易古碑拓. 書擅漢隸，旁參魏晉六朝. 遒勁有金石氣. 晚歲歸吳門. 索畫者郵遞不絕. 庚寅九月，卒年七十餘.)

23 See *Chung-kuo mei-shu-chia jen-ming tz'u-tien* 中國美術家人名詞典 (Biographical Dictionary of Chinese Artists), p. 973.

24 For Liu Te-liu's short biography, see *Chung-kuo mei-shu-chia jen-ming tz'u-tien* 中國美術家人名詞典 (Biographical Dictionary of Chinese Artists), p. 1330 and *Hai-shang mo-lin* 海上墨林 (The Ink Forest [Artistic Circles] in Shanghai), entry no. 381. For an example of Liu's painting, see his fan, *Sung-shu p'u-t'ao* 松鼠葡萄 (Squirrel and Grape), published in Robert Hatfield Ellsworth, *Later Chinese Painting and Calligraphy: 1800–1950* (New York: Random House, 1986), vol. 2, no. 21.

25 For T'ao T'ao's biography, see *Hai-shang mo-lin* 海上墨林 (The Ink Forest [Artistic Circles] in Shanghai), entry no. 497. For T'ao T'ao's work, see Hong Kong Museum of Art, *Fan Paintings by Late Ch'ing Shanghai Masters* (Hong Kong: Hong Kong Museum of Art, 1977), no. 109.

26 Yün Shou-p'ing was the most famous flower painter of the Ch'ing dynasty. For his short biography, see Arthur W. Hummel, ed., *Eminent Chinese of the Ch'ing Period (1644–1912)*, vol. 2 (Washington, D.C.: United States Government Printing Office, 1943–44), pp. 960–61.

27 For more information on Wang Yüan-chi, see entry 31.

28 For more information on the "Seven Friends of Suchou," see entry 55 on Ni T'ien. A fan by Chin Lan (whose *tzu* was Hsin-lan 心蘭) painted specifically for Lu Hui is reproduced in Robert Hatfield Ellsworth, *Later Chinese Painting and Calligraphy: 1800–1950* (New York: Random House, 1986), vol. 2, no. 73. See also a hanging scroll entitled *Ch'iu-chieh yen-hui t'u* 秋階艷卉圖 (Flowers on the Autumn Terrace), on which he collaborated with Lu Hui and another painter, Wu Ku-hsiang 吳穀祥 (1848–1903), reproduced in Editorial Committee of the National Museum of History, *Wan-ch'ing min-chu shui-mo-hua chi* 晚清民初水墨畫集 (Collection of Late Ch'ing and Early Republic Chinese Painting, 1850–1950) (Taipei: National Museum of History, 1997), no. 16.

Lu Hui 陸恢
The Small Cloud Dwelling
*continued*

29 For more information on Wu Ta-ch'eng, see *Eminent Chinese of the Ch'ing Period (1644–1912)*, vol. 2, pp. 880–82. One should also bear in mind that Wu Ta-ch'eng was the grandfather of the painter Wu Hu-fan 吳湖帆 (1894–1968). Wu Hu-fan was the teacher of the well-known New York based painting collector C. C. Wang.

30 Wu Ta-cheng's grandfather, Wu Ching-k'un 吳經坤 (?–1838), was a wealthy merchant. He was also well known for his interest in the arts. See ibid.

31 See ibid.

32 See ibid.

33 See ibid.

34 For Chang Chih-tung's biography, see ibid., pp. 26–31.

35 The term *ch'eng-hua* 承華 indicates the princes' palaces. See Morohashi Tetsuji 諸橋轍次, *Dai Kanwa Jiten* 大漢和詞典 (The Great Chinese-Japanese Dictionary) vol. 5 (Tokyo: Daishukan, 1976), p. 119, s.v. "*ch'eng-hua* 承華." The book *Ch'eng-hua shih-lüeh* 承華史略 (A Brief Text on Chinese History [for Tutoring Princes]) is recorded in Ding Fubao 丁福保 and Zhou Yunqing 周云青, *Sibu zonglu yishubian* (*Ssu-pu tzung-lu i-shu-pien*) 四部總錄藝術編 (The Art Section in the Summary of the Ssu-pu Encyclopedia) (Shanghai: Shangwu Yinshu Guan, 1957), p. 406. Nevertheless, as this book was designed for the education of the young princes of the imperial family, few people have had a chance to see it.

36 See Yang I 楊逸 (1864–1929), *Hai-shang mo-lin* 海上墨林 (The Ink Forest [Artistic Circles] in Shanghai), entry no. 638.

37 It seems that Wu Ta-ch'eng devoted all his free time to collecting and studying antiques. As a result, he compiled several major catalogues, including his *K'o-chai ts'ang-ch'i mu* 客齋藏器目 (A Catalogue of the Antique Objects in the Collection of Wu Ta-ch'eng), *Heng-hsüan so-chien so-ts'ang chi-chin lu* 恒軒所見所藏吉金錄 (The Bronzes Viewed and Collected by Wu Ta-ch'eng), *Ku-yü t'u-k'ao* 古玉圖考 (Research and Illustrations of Ancient Jades), and *K'o-chai chi-ku-lu* 客齋集古錄 (Collected Writings on Antiques in the Collection of Wu Ta-ch'eng). See *Eminent Chinese of the Ch'ing Period (1644–1912)*, vol. 2, p. 882. Wu's expertise in painting may not be as outstanding as his knowledge of bronze and jade. A handscroll in his collection, *Chang-kung tung* 張公洞 (Mr. Chang's Grotto), attributed to Shen Chou 沈周 (1427–1509), was auctioned at Sotheby's, New York, in 1986. See Sotheby's sales catalogue, *Fine Chinese Paintings* (New York: Sotheby's, June 3, 1986), lot no. 8. This scroll is accompanied by a copy of the painting by Wu Ta-ch'eng, mounted on paper and decorated with prunus design by Wu's grandson, Wu Hu-fan 吳湖帆 (1894–1968). It is important to point out that there is another version of Shen Chou's painting, perhaps of better quality, now owned by Wan-go Weng 翁萬戈, who inherited it from his grandfather Weng T'ung-ho (1830–1904). Wu Ta-ch'eng and Weng T'ung-ho were good friends in Suchou. Shen Chou's scroll in the Weng Collection is published in Richard Edwards, *The Field of Stones: A Study of the Art of Shen Chou (1427–1509)*, (Oriental Studies 5) (Washington, D.C.: Smithsonian Institution, Freer Gallery of Art, 1962), pls. 36 a & b. Furthermore, there is a third version of Shen Chou's scroll, in color but signed by Shih-t'ao 石濤 (1642–1707). It was originally owned by Chang Dai-chien 張大千 (1899–1983) and now belongs to the Art Museum, Princeton University. Although painted in Shih-t'ao's style, this version has brushwork similar to that associated with Chang Dai-chien.

38 Lu Hui's relationship with these three collectors is stated in *Hai-shang mo-lin* 海上墨林 (The Ink Forest [Artistic Circles] in Shanghai), entry no. 638. For biographical information on Sheng Hsüan-huai, see Ch'en San-li 陳三立 (1856–1937), *San-yüan ching-she wen-chi* 散原精舍文集 (The Collected Writings of Ch'en San-li's San-yüan Study), vol. 13 (Taipei: Chung-hua Press, 1961), pp. 281–84.

39 See ibid., p. 283.

40 Ko Chin-lang served as the *hu-pu lang-chung* 戶部郎中 (director of the Ministry of Revenue) under the Manchu court and accumulated great wealth, which he used to collect paintings and calligraphic works. The catalogue he composed contains detailed information on the artists' inscriptions, colophons, and seals.

41 Although Ko Chin-lang's catalogue was published by his son, Ko Ssu-t'ung, in 1910, the date of Ko Chin-lang's preface indicates that it was completed in 1881. Thus, the Ko collection must have been established before that date, i.e., before Lu Hui became an expert in appraisal.

42 The episode of Ko Ssu-t'ung inviting Lu Hui to view the Ko collection is recorded in Chang Ming-k'o's 張鳴珂 (1828–1908) *Han-sung-ko t'an-i so-lu* 寒松閣談藝瑣錄 (A Record of Discussions on Art at the Cold Pine Pavilion), preface dated 1908, reprint (Shanghai: Wen-ming Bookstore, 1936), pp. 5b–6a. The encounter of Ko Ssu-t'ung and Lu Hui could only have happened between Ko Ssu-t'ung's father's death in 1890 and the year 1908, when Chang Ming-k'o finished his book.

43 P'ang Yüan-chi's *tzu* was Lai-ch'en 萊臣 and his *hao*, Hsü-chai 虛齋. He was a native of Wu-hsing 吳興 in Chekiang province. His brief biographical information can be found in Xu Youchun 許友春, ed., *Minguo renwu dacidian* 民國人物大詞典 (Biographical Dictionary of the Personages during the Republic Period) (Shijiazhuang: Hebei Renmin Chubanshe, 1991), p. 1649, and *Chung-kuo mei-shu-chia jen-ming tz'u-tien* 中國美術家人名詞典 (Biographical Dictionary of Chinese Artists), p. 1515.

44 Lu Hui's inscription on his *Nanyue yunkai tu* (*Nan-yüeh yün-k'ai t'u*) 南嶽雲開 (The Clouds Dispersed at the South Mountains) at the Shanghai Municipal Museum asserts his great admiration for work of the Four Wangs. The painting is published in *Shanghai bowuguan cang haishang minghuajia jingpinji* (*Shanghai po-wu-kuan ts'ang hai-shang ming-hua-chia ching-p'in chi*) 上海博物館藏海上名畫家精品集 (Masterworks of Shanghai School Painters from the Shanghai Museum) (Hong Kong: Ta-ye Co., 1991), cat. no. 73. Lu Hui's inscription says, "When I was in my twenties, I began to learn how to paint landscapes. By the time I was in my thirties, I finally realized I needed to find access to the paintings of the Wangs, Wu Li, and Yün Shou-p'ing, who were all active during the early years of this dynasty. While these distinguished painters all based their works on the masters of the Sung and Yüan dynasties, they all developed an individual style. I became involved with their works (for many years) and have benefited. Nevertheless, now I find that my painting seems to be constrained by these early painters. My attempts at freeing myself were like a fish escaping from a net. How can this be an easy thing to accomplish?" (恢年二十餘, 知學山水. 三十餘, 知尋國初諸王氏, 及惲吳兩家門徑. 此數公者, 皆優나宋元之室, 而自具爐冶之人也. 游獵其中, 略有所得. 而法度規矩, 轉為束縛. 欲為透網鱗, 豈容易事矣?)

45 As a rule, brushes for writing calligraphy are made of goat hair, which is soft and absorbent. Painting brushes, on the other hand, are usually made from the bristles of mink or weasel. Few artists would prefer to use inappropriate brushes to execute their work. In this respect, Lu Hui was unique.

46 In sizing the surface of a piece of paper, the artist needs to apply a mixture of glue and alum. This seals the surface, holds the water, and prevents ink or color pigments from absorbing into the paper. It is easier

## 55. Ni T'ien 倪田
*(1855–1919)*
*Ch'ing dynasty (1644–1911)*

to control the ink on paper with a sized surface as it is less likely to streak and blot.

47  For more on Chang's career, see note 19.

48  See *Biographical Dictionary of Republican China*, vol. 1 (New York and London: Columbia University Press, 1967), pp. 73–74.

49  See ibid.

50  See ibid.

51  For more information on Dubosc, see note 3 in entry 10 on Ch'iu Ying's 仇英 (1502?–52) fan, *Peach Blossom Spring*, with Wen Cheng-ming's 文徵明 (1470–1559) calligraphy.

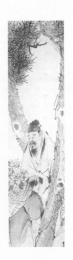

**T'ao Ch'ien (372–427)**
**Appreciating Chrysanthemums**
*T'ao Ch'ien shang-chü*
*(T'ao Ch'ien Appreciating Chrysanthemums)*
陶潛賞菊

1  See note 2 in entry 15 on Ch'en Kuan.

2  Pao-t'ien (meaning "a treasured field") was Ni T'ien's original name. See Yu Jianhua 于劍華 et al., *Zhongguo meishujia renming cidian (Chung-kuo mei-shu-chia jen-ming tz'u-tien)* 中國美術家人名詞典 (Biographical Dictionary of Chinese Artists) (Shanghai: Renmin Meishu Chubanshe, 1981), p. 652. Ni T'ien is also listed as Ni Pao-t'ien in Chang Ming-k'o 張鳴珂 (1828–1908), *Han-sung-ko t'an-i so-lu* 寒松閣談藝瑣錄 (A Record of Discussions on Art at the Cold Pine Pavilion), preface dated 1908, reprint, *chüan* 卷 (chapter) 6 (Shanghai: Wen-ming Bookstore, 1936), p. 5b.

3  See Yang I's 楊逸 (1864–1929) *Hai-shang mo-lin* 海上墨林 (The Ink Forest [Artistic Circles] in Shanghai), *chüan* 卷 (chapter) 3, reprint (Taipei: Wen-shih-che Press, 1975), entry no. 590 on p. 38b. Yang I states in his book that Ni T'ien was from Chiang-tu 江都, the ancient name for Yangchou.

4  Among Chinese families, especially those belonging to the lower class, the adjective *pao* 寶 or "treasure" was commonly added to a child's name in hopes of bringing future financial success.

5  See Shanghai Museum, *Zhongguo shuhua-jia yinjian kuanshi (Chung-kuo shu-hua-chia yin-chien k'uan-shih)* 中國書畫家印鑒款識 (Signatures and Seals of Chinese Painters and Calligraphers), vol. 1 (Shanghai: Wenwu Chubanshe, 1987), p. 745. Ni T'ien's sobriquets also include Mo-weng 墨翁 (Ink Old Man) and Mo Tao-jen 默道人 (a tacit, dignified, and cultivated person).

6  See *Hai-shang mo-lin* 海上墨林 (The Ink Forest [Artistic Circles] in Shanghai), *chüan* 卷 (chapter) 3, entry no. 590 on p. 38b.

7  See entry for 1889 in "Ren Bonian nianpu (Jen Po-nien nien-p'u) 任伯年年譜" (The Chronological Table of Jen I), in Ding Xiyuan 丁羲元, *Ren Bonian (Jen Po-nien)* 任伯年 (Shanghai: Shuhua Chubanshe, 1989), p. 97. The author cites the following passage from Ding Jianxing's 丁健行 *Molin yixiu lu* 墨林挹秀錄 (A Record of Selected Outstanding Figures in the Literary and Artistic Circle): "Ni T'ien (Mo-keng) was thirty-seven years old [in 1889]. He came to Shanghai around this time. Ni T'ien was originally an apprentice at Wang Su's studio in Yangchou. He was especially adept in depicting horses and often won his teacher's praises. Later, however, he was caught forging his teacher's painting entitled *Tou-p'eng hsien-hua t'u* 豆棚閒話圖 (Leisure Colloquy under the Arbor Covered with Climbing Peas) and was scolded by the latter. The teacher admonished him that one should never use counterfeit means to deceive people. Ni T'ien was disgraced and that day sailed across the Yangtze River and went to Shanghai. At first, he sold his paintings on the ground in front of the Ts'ui-hsiü T'ang Hall at the Yü Garden. It happened that Jen I saw him there and invited him to come home. Jen I introduced him to many patrons and praised his work. From that time on, Ni T'ien incorporated Jen I's style and technique. His ink bamboo and rocks as well as his colored flower paintings, all lush and lively, were outstanding works at that time. Ni T'ien was also adept in painting landscapes. He sold paintings in Shanghai for about thirty years. His paintings eventually commanded far greater sums than those of his early teacher Wang Su." (倪田 [墨耕] 三十七歲, 是年頃來滬. 倪墨耕原在揚州 為王小梅畫鋪之學徒, 尤善鞍馬, 深得小梅贊揚. 後因偽造小梅 "豆棚閒話圖," 被小梅歸責, 不當私作贗鼎 以欺世. 墨耕慚, 即日渡江走上海. 先在豫園萃秀堂前, 席地鬻藝, 適伯年過而見之, 遂招之至家, 為之引譽. 而墨耕受任畫影響, 參用其法, 水墨竹石, 設色花卉, 腴潤猷勁, 擅勝於時, 并工山水. 鬻畫於滬, 垂三十年. 其畫價值, 倍於小梅.) One version of Wang Su's *Leisure Colloquy under the Arbor Covered with Climbing Peas* now belongs to the Tokyo National Museum. See Tokyo National Museum, *Illustrated Catalogue of Tokyo National Museum: Chinese Paintings* (Tokyo: Benrido, 1979), no. 258, p. 159.

8  Since we know that Ni T'ien spent a period of about fifteen years in Suchou before he went to Shanghai, there are some

Ni T'ien 倪田
T'ao Ch'ien (372–427) Appreciating
Chrysanthemums
*continued*

162 complications regarding the accuracy of this story. Since Wang Su died in 1877, we can assume Ni T'ien arrived in Suchou a few years before this, probably around 1875. At that time, he would have been about twenty years old and would have been able to develop the skills he had already learned under Wang Su. Ni T'ien's activities in Shanghai began around 1890. According to Ding Xiyuan's account, Ni T'ien was already 36 years old when he arrived in Shanghai. See note 7.

9 For more information on Hua Yen 華嵒 (1682–1756), see Ju-hsi Chou and Claudia Brown, *The Elegant Brush: Chinese Painting under the Qianlong Emperor, 1735–1795* (Phoenix: Phoenix Art Museum, 1985), pp. 230–33 For more information on the Eight Eccentrics of Yangchou, see entry 38 on Chin Nung and entry 36 on Huang Shen.

10 Ni T'ien's fame in Suchou is noted in Wu Ta-ch'eng's poem, which says: "People vied with each other to collect Ni T'ien's paintings depicting Buddha. His work can be compared with those by Ch'en Hung-shou 陳洪綬 (1598–1652) and Hua Yen 華嵒 (1682–1756)." (墨耕畫佛人爭藏, 老蓮新羅相頡頏.) See note 8.

11 The term "the Seven Friends of Suchou" is found in Wu Ta-ch'eng's 吳大澂 (1835–1902) long poem *Ch'i-yu ko* 七友歌 (Song of the Seven Friends.) It is recorded in *Huashisheng (Hua-shih sheng)* 畫史繩 (History of Painting Recorded on a Knotted Rope) by the contemporary artist He Tianjian 賀天健 (1893–1974). See Lin Shuzhong 林樹中 et al., *Meishu cilin: chongguo huihua juan (Mei-shu tz'u-lin: Chung-kuo hui-hua chüan)* 美術辭林: 中國繪畫卷 (Dictionary of Terminology in Fine Art: Chinese Painting Section), vol. 1 (Xian: Renmin Meishushe, 1995), pp. 589–90, s.v. "Wu Dacheng qiyouge yu Gu Ying hege (Wu Ta-ch'eng ch'i-yu ko yü Ku Ying ho ko) 吳大澂七友歌與顧瀛和歌" (Wu Ta-ch'eng's *Song of the Seven Friends* and Song in Response by Ku Ying). In reality, Wu's song mentions eight artists: 1) Wu Ta-ch'eng; 2) Ku Yun 顧澐 (1835–96, *tzu* Jo-po 若波); 3) Ku Lu 顧潞 (active second half of 19th century, *tzu* Ch'a-ts'un 茶村); 4) Hsü Yüng 許鏞 (active second half of 19th century, *tzu* Tzu-chen 子振); 5) Lu Hui 陸恢 (1851–1920, *tzu* Lien-fu 廉夫); 6) Chin Lan 金東 (1841–?, *tzu* Hsin-lan 心蘭); 7) Ni T'ien; and 8) Ku Lin-shih 顧麟士 (1865–1930, *tzu* Ho-i 鶴逸). Ni T'ien is also included in another group of artists, known as "the Nine Friends of Suchou." See Claudia Brown and Ju-hsi Chou, *Transcending Turmoil: Painting at the Close of China's Empire, 1769–1911* (Phoenix:

Phoenix Art Museum, 1992), p. 202 and note 340.

12 For an example of Ni T'ien's work in Suchou painted in Wang Su's style, see his *Jingu yuan (Chin-ku yüan)* 金谷園 (The Chin-ku Garden), dated 1888, reproduced in *Shanghai bowuguan cang Haishang minghuajia jingpinji (Shanghai po-wu-kuan ts'ang Hai-shang ming-hua-chia ching-p'in chi)* 上海博物館藏海上名畫家精品集 (Masterworks of Shanghai School Painters from the Shanghai Museum) (Hong Kong: Ta-ye, 1991), cat. no. 81. For Ni T'ien's works painted in Hua Yen's style, see his *Fang Hua Yan Renwu shanshui ce (Fang Hua Yen Jen-wu shan-shui t'se)* 倣華嵒人物山水冊 (Figure and Landscape Album Leaves after Hua Yen), reproduced in the above publication, cat. nos. 82, 1–12.

13 For an example of Ni T'ien's painting after Jen I, see his *Ch'un-lu* 春鹿 (Deer in the Spring Time), reproduced in *Chung-kuo chin-tai ming-jia shu-hua chi* (A Collection of Painting and Calligraphy by Famous Modern Chinese Artists), vol. 1 in *Kuo-t'ai Mei-shu kuan hsüan-chi* 國泰美術館選集 (Selected Works from the Collection of the Kathay Art Museum) (Taipei: Kathay Art Museum, 1977), p. 9. For another example, see Ni T'ien's *T'ien-kuan ssu-fu* 天官賜福 (The Heavenly Sovereign Bestowing Grace) in Sotheby's sales catalogue (Hong Kong: Sotheby's, May 19, 1988), lot no. 97.

14 Another story states that during his time in Suchou, Ni T'ien possessed a large group of painting studies completed by the famous artist Jen Hsiung 任熊 (1823–57). Such studies are usually effective models for students to learn a master's technique and style. According to a popular account, Ni T'ien acquired these studies and refused to share them with Jen Yü 任預 (1853–1901), Jen Hsiung's young orphaned son. Upon close examination, however, this story seems highly unlikely. First, if Jen Hsiung did leave behind any studies, they would have most probably passed on to his younger brother, the painter Jen Hsün 任薰 (1835–93), who inherited the rest of his elder brother's belongings related to art and took responsibility for the orphaned Jen Yü. Second, Jen Yü was older than Ni T'ien! By the time the latter arrived in Suchou, Jen Yü would have been in his early twenties and would have already developed beyond the need for such rudimentary drawings. Finally, Jen Yü had access to his uncle Jen Hsün. These studies would have been of little use compared to the resource of the uncle's direct instruction. This story is more than likely one of the many hyperboles concerning the

hardships and hard luck experienced by the troubled painter Jen Yü. It is also possible that the studies that Ni T'ien possessed were actually collected in Shanghai, as opposed to Suchou, and that the studies were those by Jen I, as opposed to Jen Hsiung. This is more plausible because by the time Jen I died in Shanghai in 1896, Ni T'ien had already settled there and had begun to emulate Jen I's painting style. Since he was not able to study directly under Jen I, he would have needed access to studies such as these in order to reach such a high level of imitation. If Ni T'ien improperly acquired these studies from anybody, it was probably Jen I's son, Jen Chin 任董 (1881–1936), who was only in his early teens at the time of his father's death. These studies would have been valuable to the orphan, who was studying calligraphy and painting in preparation for an artistic career. Thus one can witness how the blending of dynamics and narratives resulted in the creation of this popular but illogical account. For more on Jen Yü's tragic life, see entry 52. For the source of the above story, see *Chung-kuo mei-shu-chia jen-ming tz'u-tien* 中國美術家人名詞典 (Biographical Dictionary of Chinese Artists), entry on Ren Yü, p. 185. For more on Jen Chin's life, see entry 51 on Jen I. If this episode actually occurred between Ni T'ien and Jen Chin, then the hard feelings did not last long. In 1894, Ni T'ien executed a painting depicting the famous historical figure Hsieh An 謝安 (320–85) of the Eastern Tsin dynasty (317–419), entertained by his troupe of female musicians. In that year, Jen Chin was only thirteen years old. Twenty-nine years later, in 1923, Jen Chin inscribed a colophon on the painting and pointed out that Ni T'ien, although never having studied with his father, was able to paint in a manner closely resembling his father's. In the son's words, Ni T'ien had gained the essence of his father's style. This hanging scroll with an almost square composition is reproduced in Sotheby's sales catalogue (Hong Kong: Sotheby's, May 19, 1988), lot no. 62. Jen Chin's inscription on Ni T'ien's painting states, "All of [Ni T'ien's] compositions and coloring were after my father [Jen I]. This was because [Ni T'ien] taught himself Jen I's painting style." (布局賦色, 處處規隨先處士. 蓋私淑先處士.)

15 For more on the tribulations in Jen I's life, see entry 51.

16 For a description of the *t'ang-tzu* brothels in Shanghai, see Ch'en Ting-shan 陳定山 (1896–1989), *Ch'un-shen chiu-wen* 春申舊聞 (Old Stories in Shanghai), vols. 1 and 2 (Taipei: Ch'en-kuang Monthly Magazine, 1964), especially entry nos. 39–48 in vol. 2, pp. 90–102.

17 One particularly intriguing story has him associating with the famous Madame Hsieh Ta-k'uai-t'ou 謝大塊頭, or "Hsieh the Imposing," who was described as voluptuous and of fair complexion. Ni T'ien went so far as to set up a studio in a room at her brothel. In the evenings, while he met with friends and painted, the madame would be busy running her business. It is reported that he had to get used to the sounds emanating from the occupied rooms and creaking beds. Ni T'ien taught his lover Hsieh the principles of painting and how to recognize and evaluate a work's merits and deficiencies. After Ni T'ien died in 1919, Hsieh inherited his collection of antiques and art works. Her *t'ang-tzu*, replete with the finest of paintings displayed on the walls, became the most elegantly decorated brothel in all of Shanghai. She reportedly knew many stories of the famous painters whose work enriched her environment and would spend hours elaborating on many of these to her customers. See ibid., vol. 1, pp. 19–20.

18 For T'ao Ch'ien's biography, see Fang Xuanling (Fang Hsüan-ling 房玄齡 (578–648) et al., *Jinshu* (*Tsin-shu*) 晉書 (The Book of Tsin), 1st ed. dated 648, "Biography of Hermits," *juan* (*chüan*) 卷 (chapter) 64, reprint, vol. 4 (Beijing: Zhonghua Shuju, 1974), pp. 2460–65. See also entry 16 on Li Shih-ta.

19 See *Tsin-shu* 晉書 (The Book of Tsin), p. 2461.

20 See ibid. The original Chinese text reads, "吾不能為五斗米折腰."

21 Discontented with the chaos of society and resenting the haughty attitude of his supervisor, he quit his position as a minor administrator and retired to his home to enjoy a rustic, simple life. His poems and prose are famous for exhorting the benefits of the pastoral experience. To express his lack of appetite for political ambition and to voice his preference for literary pursuits, he composed a famous essay, "Wu-liu hsien-sheng chuan 五柳先生傳," or "The Biography of Mr. Five Willow Trees." It is a story of a scholar whose estate was adorned with five beautiful willow trees and who preferred to spend his time drinking, reading, and studying as opposed to pursuing power and position. His quiet and reclusive nature prevented his neighbors from even knowing his name; consequently, he was referred to as "Mr. Five Willow Trees." As the protagonist possesses T'ao Ch'ien's general disposition, the scholar, "Mr. Five Willow Trees," is widely believed to be a thinly disguised portrait of the writer himself. T'ao Ch'ien's poem, "Let Me Return Home,"

is found in Gong Bin's 龔斌 *Tao Yuanming ji jiaojian* (*T'ao Yüan-ming chi chiao-chien*) 陶淵明集校箋 (T'ao Yüan-ming's Anthology with Collation by Gong Bin) (Shanghai: Shanghai Guji Chubanshe, 1996), vol. 5, pp. 390–401. T'ao Ch'ien's essay, "The Biography of Mr. Five Willow Trees," is found in the same book, vol. 6, pp. 420–24. The poem is translated in entry 16 on Li Shih-ta.

22 See T'ao Ch'ien's *Yin-chiu shih* 飲酒詩 (Wine-drinking Poems) in entry 16 on Li Shih-ta. The poem best reflects the close association between T'ao Ch'ien and chrysanthemums.

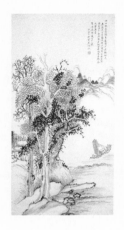

## Ink Landscape

*Mo-pi shan-shui*
*(Ink Landscape)*

墨筆山水

1 Since the calligrapher who inscribed this label did not sign his name, it is impossible to identify him. As the label states the painting was a gift, and the artist's inscription states that the recipient of the painting was Chiang Ju-tsao 蔣汝藻 (1877–1954), it is quite possible that this label was written by Chiang himself. Calligraphic examples by Chiang are uncommon, and this small label provides a rare sample of this collector's work. For more information of Chiang Ju-tsao, see note 4 in entry 19 on Tseng Ching.

2 The Museum purchased this painting in 1980 from Chiang Ju-tsao's daughter in Shanghai, who was represented by her brother, P. S. Chiang in Seattle.

3 Mi Fu 米芾 (1051–1107) was one of the most famous and talented painter-calligraphers in Chinese history. One old source says: "During the Ch'ung-ning reign (r. 1102–6), Mi Fu was in charge of the Official Transport Administration in the Kiangsu 江蘇 and Anhui 安徽 regions. [In order to enjoy art while sailing, he carried his painting and calligraphy collection on his official yacht.] A large sign reading 'The Painting and Calligraphy Yacht of the Mi Family' was installed on board his yacht." (崇寧間, 元章為江淮發運. 揭牌於行舸之上, 曰: "米家書畫船," 云). See *Hanyu dacidian* (*Han-yü ta-tz'u-tien*) 漢語大詞典 (Chinese Terminology Dictionary), vol. 5 (Shanghai: Hanyu Dacidian Press, 1988), pp. 724–25, s.v. "*shuhua ch'uan* (*shu-hua chuan*) 書畫船." The original source of this term was found in a poem composed for Mi Fu by his contemporary Huang T'ing-

Tseng Hsi 曾熙
Ink Landscape
*continued*

164  chien 黃庭堅 (1045–1105). Later, many literati-painters emulated Mi Fu's example and carried their art collections on yachts. As a result, the term *shu-hua ch'uan* has become an idiom referring to either the superior quality of an art collection or the lofty and elegant activity of a collector.

4  Heng-yang is located south of Chang-sha 長沙 city, along the bank of the famous Hsiang 湘 River. This area is considered the middle section of the Yangtze River. See also the entry on Tseng Hsi in Yu Jianhua 于劍華 et al., *Zhongguo meishujia renming cidian* (*Chung-kuo mei-shu-chia jen-ming tz'u-tien*) 中國美術家人名詞典 (Biographical Dictionary of Chinese Artists) (Shanghai: Renmin Meishu Chubanshe, 1981), p. 1080.

5  See chapter "Tseng-li erh-shih 曾李二師" (My Two Teachers, Mr. Tseng and Mr. Li) in Hsieh Hsiao-hua's 謝孝華 *Chang Dai-chien te shih-chieh* 張大千的世界 (The World of Chang Dai-chien) (Taipei: Chenghsin Press, 1968), p. 29. Chang writes: "[My teacher Mr.] Tseng was from a poor family. He was born on a cold day with heavy snow, which accumulated in the room through the broken roof. His mother, after giving birth, [was alone and] swallowed snow to quench her thirst. This story reveals how poor they were. Therefore, Tseng treated his mother with great filial piety. He was [actually] referred to as a 'filial son.' During a great flood, Tseng carried his mother on his back and waded through the water in order to reach safety." ( 曾老師出身貧寒. 曾師降生時, 適逢大雪寒天, 破屋積雪. 太師母產後, 抓吞生雪解焦渴, 其貧窘可知. 因此, 曾師事母至孝, 人稱曾孝子. 曾在水災泛濫中, 背負老母涉水逃難 .)

6  The Stone Drum Academy was located at the foot of the Stone Drum Mountain, north of Tseng Hsi's hometown in Hengyang. Founded during the Yüan-ho 元和 reign (r. 806–20) of the T'ang dynasty (618–905), this educational institute was reestablished in the Northern Sung period (960–1126) and became one of the four most distinguished academies of the Sung dynasty. Since then, this school has gained considerable fame among Chinese scholars. Even during Tseng's time, it was highly esteemed. See Morohashi Tetsuji 諸橋轍次, *Dai Kan Wa jiten* 大漢和詞典 (The Great Chinese-Japanese Dictionary), vol. 8 (Tokyo: Daishukan, 1976), p. 8447.

7  Li Jui-ch'ing 李瑞清 (1867–1920) was also a frustrated scholar who had to abandon his pursuit of a civil service career during the chaos of the late Ch'ing period. For more on this artist, see Fu Shen, *Chal-*

*lenging the Past: The Paintings of Chang Dai-chien* (Washington, D.C.: Arthur M. Sackler Gallery, Smithsonian Institution, 1991), pp. 23–25.

8  For more information on Shih-t'ao, see entry 29. For the source of Tseng's admiration of Shih-t'ao, see *Challenging the Past: The Paintings of Chang Dai-chien*, p. 65.

9  Tseng Hsi's statement *tso-hua shih wan-wu* 作畫師萬物, or "calling all the creatures of the universe (my) painting teacher" is based on the entry on Tseng Hsi found in *Chung-kuo mei-shu-chia jen-ming tz'u-tien* 中國美術家人名詞典 (Biographical Dictionary of Chinese Artists), p. 1080.

10  For more information of Chang Dai-chien, see entry 60.

11  See entry 60 on Chang Dai-chien.

12  See Fu Shen's *Challenging the Past: The Paintings of Chang Dai-chien*, pp. 65 and 162.

13  See Hsieh Hsiao-hua's *Chang Dai-chien te shih-chieh* 張大千的世界 (The World of Chang Dai-chien), p. 30.

14  See entry for 1931 in "*Chang Dai-chien nien-piao* 張大千年表" (Chronology of Chang Dai-chien) in Ba Tong's 巴東 *Chang Dai-chien yen-chiu* 張大千研究 (The Art of Chang Dai-chien) (Taipei: National Museum of History, 1998), p. 373.

15  See Hsieh Hsiao-hua's *Chang Dai-chien te shih-chieh* 張大千的世界 (The World of Chang Dai-chien), p. 30.

16  See ibid. The original text says: "真是忠厚長者仁義之風" ([Tseng] truly is a kind and generous elder with a humane demeanor).

17  For an example of Tseng Hsi's calligraphy executed with this type of brushwork, see his *Couple in Modified Clerical Script*, dated 1922 and reproduced in Fu Shen's *Challenging the Past: The Paintings of Chang Dai-chien*, fig. 6, p. 24.

18  The "flung-ink" technique associated with literati painters seems to have been started during the T'ang dynasty by an eccentric painter named Wang Hsia 王洽 (c. 8th–9th century), who was also known as Wang P'o-mo 王潑墨 (Wang the Ink-flinger). Wang preferred to paint while intoxicated. After untying the belt of his robe, dancing around, and uttering loud shouts, he would fling the ink on the surface of the silk or paper and then complete the painting using the irregular forms of the running ink. See Emperor Hui-tsung's 徽宗 (r. 1101–25) *Hsüan-ho hua-p'u* 宣和畫譜 (Catalogue of the Imperial Painting Collection during the Hsüan-ho Era), pref-

ace dated 1120, *chüan* 卷 (chapter) 10, reprint (Taipei: National Palace Museum, 1970), p. 6 a & b.

19  See note 3 for more information on Mi Fu's famous painting and calligraphy yacht.

## 57. Chin Ch'eng 金城
*(1878–1926)*
*Republic (1912– )*

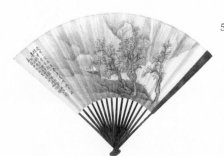

### Colored Landscape after Kung Hsien (c. 1618–89)

*Fang Kung Hsien she-se shan-shui (Colored Landscape after Kung Hsien)*

倣龔賢設色山水

1 Kung Hsien (c. 1618–89) was a famous landscape painter active in Nanking during the seventeenth century. He is considered the leader of the so-called Chin-ling pa-chia 金陵八家 (Eight Masters of Nanking). To create the textures on his rocks, Kung Hsien used a special type of *ts'un* brush-work known as "raindrop touches," which are similar to those found in the work of Fan K'uan 范寬 (active c. 990–1023). For more information on Kung Hsien see entry 28, as well as Howard Rogers and Sherman E. Lee, *Masterworks of Ming and Qing Paintings from the Forbidden City* (Lansdale: International Arts Council, 1988), cat. no. 46, p. 80 and pp. 169–71.

2 P. S. Chiang of Seattle was the second son of the Shanghai collector Chiang Ju-tsao 蔣汝藻 (1877–1954). The father was better known by the name of Chiang Meng-p'ing 蔣孟蘋. For more information on the Chiang family, see note 4 in entry 19 on Tseng Ching.

3 For information on using "white dragon" to represent water cascades, see *Hanyu dacidian (Han-yü ta-tz'u-tien)* 漢語大詞典 (Chinese Terminology Dictionary), vol. 8 (Shanghai: Hanyu Dacidian Press, 1988), p. 211, s.v. "*bailong (pai-lung)* 白龍" (white dragon).

4 It is unclear when the artist dropped the first character of his given name and started to use the present name Chin Ch'eng. Wu-hsing is located on the south bank of Lake T'ai and is also called Huchou 湖州. The local land is fertile, and the quality of silk from this area is considered the finest in all of China. For centuries, the city served as the center of brush-making. It was the hometown of Chao Meng-fu 趙孟頫 (1254–1322), one of the great masters of the Yüan dynasty (1280–1368), as well as of many other later painters.

5 See "Chin Kung-pei hsien-sheng shih-lüeh 金拱北先生事略" (A Brief Biography of Chin Kung-pei [*tzu of* Chin Ch'eng]), in *Hu-she yüeh-k'an* 湖社月刊 (Lake Club Monthly), 1st ed. 1927, 1–10, reprint, vol. 1 (Tianjin: Tianjin Guji Shudian, 1992), p. 2. Chin's biography asserts: "Chin Shao-ch'eng was also known as Chin Ch'eng. His *tzu* was Kung-po [editor's note: this name was written in an altered manner using different characters]. He had two *hao*, Pei-lou and Ou-hu. A native of Wu-hsing in Chekiang province, he was born with innate artistic ability. Fascinated by painting at a young age, he often produced unique works when not engaged in his studies. There were many local collectors [among his father's acquaintances]. When Chin Ch'eng copied works of early artists [from these collections], he could produce versions that were almost identical to the originals. Although he did not learn from a teacher, from the very beginning his paintings matched the works of classical painters. As for painting flowers and birds and landscapes, there was not one that he could not paint. In addition, he excelled in calligraphy and seal-carving. His knowledge of classical literature was also extensive." (金紹城, 又名城. 字鞏伯, 一字拱北. 號北樓, 一號藕湖. 浙江吳興人. 生有夙慧, 幼即嗜丹青. 課餘握管, 輒迴異常人. 其鄉里士紳, 富收藏. 偶假臨摹, 頗有亂真之概. 其作畫雖無師承, 而動筆即深得古人旨趣. 山水花鳥, 無一不能. 兼工篆隸, 鐫刻, 旁及古文辭.)

6 See ibid.

7 See Chin Ch'eng, "Pei-lou lun-hua 北樓論畫" (A Discussion on Painting by Pei-lou [*hao* of Chin Ch'eng]), in *Hu-she yüeh-k'an* 湖社月刊 (Lake Club Monthly), reprint, vol. 1, p. 16. Chin Ch'eng clearly states at the beginning of his article that although he had painted for almost thirty years, he did not learn from a teacher. (余從事畫學, 幾三十年, 無一師承.)

8 See "Chin Kung-pei hsien-sheng shih-lüeh 金拱北先生事略" (A Brief Biography of Chin Kung-pei [*tzu of* Chin Ch'eng]), in *Hu-she yüeh-k'an* 湖社月刊 (Lake Club Monthly), reprint, vol. 1, p. 2.

9 See ibid. One popular story concerning Chin Ch'eng's job in Shanghai involves his efforts to settle the dispute between the local Chinese and the administration of a certain foreign concession in the city. One Cantonese businessman arrived in Shanghai accompanied by several concubines and maids. A Western police investigator who did not understand the traditional practice of polygamy in China arrested this man and accused him of soliciting prostitutes. The local Chinese were furious, and the shopkeepers protested by carrying out a strike. It was through Chin Ch'eng's mediation that this Western investigator apologized and set the Cantonese businessman free.

10 By 1910, Shanghai was the most artistically oriented city in all of China. Thanks to their economic success, citizens of the city patronized many talented painters, including Jen I 任頤 (1840–96), Ni T'ien 倪田 (1855–1919), Wu Ch'ang-shuo 吳昌碩 (1844–1927), and Wang Chen 王震 (1867–1938). Shanghai also became a haven for collecting antiquities, as many of the old families in the *chiang-nan* region began to sell their ancestors' collections. For painters active during this period, see *Shanghai bowuguan cang Haishang minghuajia jingpinji (Shanghai po-wu-kuan ts'ang Hai-shang ming-hua-chia ching-p'in chi)* 上海博物館藏海上名畫家精品集 (Masterworks of Shanghai School Painters from the Shanghai Museum) (Hong Kong: Ta-ye, 1991), nos. 62–88.

11 See "Chin Kung-pei hsien-sheng shih-lueh 金拱北先生事略" (A Brief Biography of Chin Kung-pei [*tzu of* Chin Ch'eng]), in *Hu-she yüeh-k'an* 湖社月刊 (Lake Club Monthly), reprint, vol. 1, p. 2.

12 See ibid.

13 See ibid. The Palace Museum was established eleven years later on October 10, 1925, the anniversary of the founding of the Republic.

14 See Na Chih-liang 那志良, *Ku-kung ssu-shih-nien* 故宮四十年 (Forty Years at the Palace Museum [A Memoir]) (Taipei: Commercial Press, 1966), p. 18.

15 See "Chin Kung-pei hsien-sheng shih-lueh 金拱北先生事略" (A Brief Biography of Chin Kung-pei [*tzu of* Chin Ch'eng]), reprint, vol. 1, p. 3.

16 See ibid.

17 See ibid.

18 Among the many Japanese artists who visited China were Araki Kanpo 荒木寬畝 (1831–1915), Fukuda Heihachiro 福田平八郎 (1892–1974), Hashimoto Kansetsu 橋本關雪 (1883–1945), and others. For information on these Japanese painters, see Ellen P. Conant et al., *Nihonga, Transcending the Past: Japanese-Style Painting, 1868–1968* (St. Louis: Saint Louis Art Museum, 1995).

19 It is known that Chin Ch'eng went to Japan with Chou Chao-hsiang 周肇祥 (1880–1945), Chen Heng-k'o 陳衡恪 (1876–1923), and a group of Chinese artists.

20 All of Chin Ch'eng's followers adopted the character *hu* 湖, or "lake," as a part of their style names. His major followers include:

Chin Ch'eng 金城
Colored Landscape after Kung Hsien
   (c. 1618–89)
*continued*

166    Chin Ch'eng's son, Chin K'ai-fan 金開藩 (1895–1946, *hao* Yin-hu 蔭湖); his students, Ch'in Chung-wen 秦仲文 (1896–1974, *hao* Liu-hu 柳湖); Wu Ching-t'ing 吳鏡汀 (1904–72, *hao* Ching-hu 鏡湖); Hui Ch'ün 惠春 (1902–79, *hao* Tuo-hu 拓湖); Liu Tzu-chiu 劉子久 (1891–1975, *hao* Yin-hu 飲湖); Chao Meng-chu 趙夢朱 (1893–1985, *hao* Ming-hu 明湖); Li Shu-chih 李樹智 (active 1920–50?, *hao* Ch'ing-hu 晴湖); Ma Chin 馬晉 (1900–70, *hao* Yun-hu 雲湖), Kuan P'ing 管平 (active c. 1920–50, *hao* P'ing-hu 平湖); Li Shang-ta 李上達 (active c. 1920–50, *hao* Wu-hu 五湖); Chang Chin-fu 張晉福 (1874?–1932, *hao* Nan-hu 南湖); Ch'en Yün-chang 陳雲彰 (1907–54, *hao* Sheng-hu 昇湖); Ch'en Hsien-tung 陳咸棟 (active 1920–40?, *hao* Tung-hu 東湖); Li Jui-ling 李瑞齡 (1894–1966, *hao* Chen-hu 枕湖); Ch'en Hsü 陳煦 (1905–60?, *hao* Mei-hu 梅湖); Ch'en Lin-chai 陳林齋 (active c. 1920–50, *hao* Ch'i-hu 啟湖); Feng Shun 馮諄 (active c. 1920–50, *hao* Shun-hu 諄湖); Hsüeh Shen-wei 薛慎微 (active c. 1920–50, *hao* Shen-hu 慎湖); Wang Heng-kuei 王衡桂 (active c. 1920–50, *hao* Sheng-hu 聖湖); Sun Chü-sheng 孫菊生 (active c. 1920–50, *hao* Hsiao-hu 曉湖); and Chin Ch'eng's nephew, Chin Ch'in-po 金勤伯, whose original name was Chin K'ai-yeh 金開業. His *hao*, Chi-ou 繼藕, meaning "inherit the lotus-root," implies his ambition to extend his uncle's legacy.

21    Many early paintings reproduced in this journal later entered major museum collections. To name a few: Chü-jan's 巨然 (active c. 960–85) *Hsi-shan lan-jo* 谿山蘭若 (Buddhist Retreat by Stream and Mountain), which appeared in *Hu-she yüeh-k'an* 湖社月刊 (Lake Club Monthly), issue 92, p. 2; Hsü Tao-ning's 許道寧 (c. 970–1051 or 1052) *Yü-fu t'u* 漁夫圖 (Fishermen), appearing in issue 52, p. 17; and Wen Cheng-ming's 文徵明 (1470–1559), *Ku-po t'u* 古柏圖 (Old Cypress and Rock), found in issue 85, p. 6, all currently belonging to the Nelson Gallery-Atkins Museum, Kansas City. Others that now belong to the Museum of Fine Arts, Boston, include: *Li-tai ti-wang-hsiang* 歷代帝王像 (Portraits of the Emperors of the Successive Dynasties), a handscroll attributed to Yen Li-pen 閻立本 (?–673), reproduced in issues 11–20 and 33; Emperor Hui-tsung's 徽宗 (r. 1101–25) *Wu-se ying-wu* 五色鸚鵡 (The Five-Colored Parakeet), in issue 32, p. 1; and Chao Ling-jang's 趙令穰 (active 1070–1100) *Hu-chuang ch'ing-hsia* 湖莊清夏 (Summer Mist along the Lake Shore). Paintings now belonging to the Freer Gallery in Washington, D.C., include: Chao Meng-fu's 趙孟頫 (1254–1322) *Erh-yang t'u* 二羊圖 (Goat and Sheep), in issue 37, p. 3; Wu Chen's 吳鎮 (1280–1354) long handscroll entitled *Yü-fu*

*t'u* 漁夫圖 (Fishermen on the River), in issues 35–50; and Tsou Fu-lei's 鄒復雷 (active mid-14th century) *Chun-hsiao-hsi t'u* 春消息圖 (A Breath of Spring), in issue 61, p. 4. Two works are currently at the Metropolitan Museum of Art: a famous horse painting entitled *Chao-yeh pai* 照夜白 (Night-Shining White Horse), attributed to Han Kan 韓幹 (active c. 742–56), in issue 48, p. 1; and Kung Hsien's landscape album leaves, found in issues 35–41, 43, and 45–54 (see note 23). One work went to the Osaka Municipal Museum: a copy of a Chin 金 dynasty (1115–1234) painting, *Ming-fei ch'u-sai t'u* 明妃出塞圖 (Chao-chün on Her Way to Mongolia), which appeared in issues 45–46. The original version is attributed to a little-known female painter, Ku Su-han 宮素然, of the Northern Sung dynasty (960–1126) and is currently at the Shenyang Museum in China.

22    The reprinted magazines in three volumes were issued by the Tianjin Guji Shudian 天津古籍書店 (Ancient Books Bookstore in Tianjin) in 1992.

23    Kung Hsien's eighteen album leaves, including two leaves bearing a long inscription, were first reproduced in *Hu-she yüeh-k'an* 湖社月刊 (Lake Club Monthly), in issues 35–41, 43, and 45–54. They also appear in Suzuki Kei 鈴木敬, comp., *Comprehensive Illustrated Catalog of Chinese Paintings*, vol. 1 (Tokyo: University of Tokyo Press, 1982), nos. A1-128 1/18–18/18, pp. 25–27. The sequence of these leaves is arranged differently in these two publications. It is not known which sequence is accurate. Another copy of Kung Hsien's leaf was executed by a young student at the Lake Club whose name was Chang Lü-hsün 張閭珣. Chang was the younger son of General Chang Hsüeh-liang 張學良 who kidnapped Generalissimo Chiang Kai-shek 蔣介石 (1886–1975) in 1936. Chang's copy is found in *Hu-she yüeh-k'an* 湖社月刊 (Lake Club Monthly), issue 45, p. 15.

24    For more information on the raindrop textures, see note 47 in entry 28 on Kung Hsien.

25    It seems that Chiang's eldest son inherited the Sung and Yüan paintings in his father's collection. For example, the album leaf entitled *Mountain Freshet—Wind and Rain* at the University of Michigan was originally purchased from Chiang Ku-sun in Taipei by Professor Richard Edwards. See entry 2 on this work.

26    In 1980, the University of Michigan Museum of Art purchased a total of fourteen fans from Chiang's daughter in Shanghai.

27    Approximately forty objects in the collection of the University of Michigan Museum of Art were purchased from the old collection of Chiang Meng-p'ing.

## 58. Chin Chang 金章
*(1884–1939)*
*Republic (1912– )*

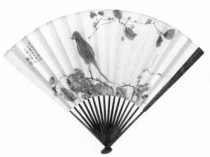

### Red Bird on a Tree Branch
*Chih-t'ou shou-tai*
*(Bird of Longevity Perched on a Tree Branch)*
枝頭綬帶

1  The dates of Chin Chang's birth and death are found in the epilogue written by her son, Wang Shixiang 王世襄, to her book *Hao-liang chih-le-chi* 濠梁知樂集 (Collected Writings of Sensing the Pleasure of the Fish in the Hao River), preface dated 1921, reprint (Beijing: Wenwu Chubanshe, 1985), p. 34.

2  For more information on P. S. Chiang, see note 4 in entry 19 on Tseng Ching.

3  The wealthy and prestigious Chin family had many members. It is not known whether Chin Ch'eng and Chin Chang were children of the same mother. In old Chinese society, children of wife and concubines were all considered legitimate siblings.

4  See Wang Shixiang's 王世襄 epilogue to *Hao-liang chih-le-chi* 濠梁知樂集 (Collected Writings of Sensing the Pleasure of the Fish in the Hao River), p. 34.

5  For an example of Chin Chang's fish painting, see the plates found at the beginning of her *Hao-liang chih-le-chi* 濠梁知樂集 (Collected Writings of Sensing the Pleasure of the Fish in the Hao River).

6  See Wang Shixiang's epilogue to ibid.

7  For more information on Chin Ch'eng's trip to the conference in Washington, D.C., see "Chin Kung-pei hsien-sheng shih-lüeh 金拱北先生事略" (A Brief Biography of Chin Kung-po [*tzu of* Chin Ch'eng]), in *Hu-she yüeh-k'an* 湖社月刊 (Lake Club Monthly), issues 1 to 10, 1927, reprint, vol. 1 (Tianjin: Tianjin Guji Shudian, 1992), p. 2. For more information on the reunion, see Chin Chang's *T'ao-t'ao nü-shih hua-ts'e* 陶陶女史畫冊 (A Set of Album Leaves by Lady T'ao-t'ao [*hao of* Chin Chang]), reproduced in *Hu-she yüeh-k'an* 湖社月刊 (Monthly Periodical of the Lake Painting Guild), issue 54, p. 10, reprint, vol. 2, p. 885. At the beginning of Chin Chang's album leaves, her brother inscribed a title page clearly stating that he inscribed it in Paris, 1910.

8  For information on Chin Chang's husband, Wang Chi-tseng, see Xu Youchun 許友春, ed., *Minguo renwu dacidian* (*Min-kuo jen-wu ta-tz'u-tien*) 民國人物大詞典 (Biographical Dictionary of the Personages during the Republic Period) (Shijiazhuang: Hebei Renmin Chubanshe, 1991), p. 111.

9  See Chin Chang's preface, dated 1921, for her *Hao-liang chih-le-chi* 濠梁知樂集 (Collected Writings of Sensing the Pleasure of the Fish in the Hao River), and also her brother Chin Ch'eng's preface in ibid., dated 1922. Both prefaces mention that Chin Chang taught classes in fish painting at her brother's painting institute.

10  According to Wang Shixiang's epilogue for his mother's *Hao-liang chih-le-chi* 濠梁知樂集 (Collected Writings of Sensing the Pleasure of the Fish in the Hao River), Chin Chang originally finished two manuscripts for her book. The one prepared for printing was destroyed at the beginning of the Sino-Japanese War around 1939 before it could be printed. In 1943, after her death, Wang published his mother's book based on the second manuscript in Sichuan. The text he used was a rough copy and lacked the original illustrations. Only one hundred copies were issued. The present edition of Chin Chang's book was reprinted in 1985 and illustrated with several of Chin Chang's fish paintings. This edition is more faithful to Chin Chang's original. As a matter of fact, Chin Chang's long fish scroll *Jinyu baiying tujuan* (*Chin-yü pai-ying t'u-chüan*) 金魚百影圖卷 (The One Hundred Goldfish Handscroll), belonging to the Palace Museum in Beijing and used in the latest edition, was the model used for the many illustrations in the original manuscript.

11  The story of the pleasures of the fish in the Hao River is found in the last section of chapter "Ch'iü-shui 秋水" (Autumn Water) in Chuang Chou's [commonly known in the West as Chuang Tzu] 莊周 (c. 300 B.C.) *Chuang-tzu* 莊子 (The Works of Chuang Chou). It says: "One day Chuang Chou and his friend, Hui-tzu, made an excursion to the Hao River. Promenading on a bridge over the water, Chuang Chou said to his friend that the slender white *t'iao* fish, swimming serenely in the water, seemed so happy. Hui-tzu confronted him by asking, 'You are no fish. How do you know whether the fish are happy?' Chuang Chou answered, 'But you are not me. How do you know that I could not sense the happiness of the fish?' Then Hui-tzu argued, 'It is true that I am not you. However, it is also true that you are not a fish! Therefore, clearly you could not have sensed the pleasure of the fish.' Chuang Chou concluded the conversation by asserting, 'Let us follow our argument logically. When you first asked me how did I know the fish were so happy, you had already admitted that I knew and only demanded an explanation as to how I sensed it. I happened upon their happiness on the bridge over the Hao River!' (莊子與惠子遊於濠梁之上. 莊子曰: "鰷魚出游從容, 是魚之樂也." 惠子曰: "子非魚, 安知魚之樂?" 莊子曰: "子非我, 安知我不知魚之樂?" 惠子曰: "我非子, 固不知子矣. 子固非魚也, 子之不知魚之樂全矣!" 莊子曰: "請循其本. 子曰 '汝安知魚樂' 云者, 既已知吾知之, 而問我. 我知之濠上也!) See Chuang Chou, *Chuang-tzu* 莊子, with comments by Chang Ti-kuang 張耿光, vol. 1 (Taipei: Ti-ch'iu Press, 1994), pp. 416–17.

12  Chin Chang's fish painting is reproduced in *Hu-she yüeh-k'an* 湖社月刊 (Lake Club Monthly), issues 1 to 10, reprint, vol. 1, p. 109. Her horse painting, with landscape by her brother, is reproduced in ibid., issue 27, p. 10, reprint, vol. 1, p. 436. Her flower-and-bird album leaves are found in ibid., issues 54 to 58.

13  See *Hu-she yüeh-k'an* 湖社月刊 (Lake Club Monthly), issue 51, p. 16, s.v. "hua-chieh so-wen 畫界瑣聞" (Scraps of Information in the Circles of Art). The journal reports that Chin Chang suffered from high blood pressure.

14  See entry 57 on Chin Ch'eng for more information of this fan by Kung Hsien.

15  See ibid.

16  For an example of Hua Yen's work in this style, see Claudia Brown and Ju-hsi Chou, *The Elegant Brush: Chinese Painting under the Qianlong Emperor, 1735–1795* (Phoenix: Phoenix Art Museum, 1985), pl. 75, pp. 232–33. See also Hua Yen's four album leaves in Shanghai Municipal Museum and Asahi News, *Yangzhou baguai zhan (Yang-chou pa-kuai chan)* 揚州八怪展 (The Eight Masters of Yangzhou Exhibition) (Tokyo: Asahi Shinbunsha, 1986), pl. 26.

17  Wang Shixiang's brief biography is attached to the end of his *Classic Chinese Furniture: Ming and Early Qing Dynasties* (Hong Kong: Joint Publishing Co., 1985). For more on his life, see also *Chung-kuo shih-pao chou-k'an* 中國時報周刊 (China Times Weekly), 5/6 (Taipei: China Times, February 15, 1992), pp. 90–97.

## 59. P'u Ju 溥儒
*(1896–1963)*
*Republic (1912– )*

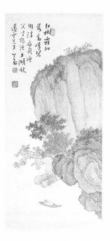

### Red Trees on a Blue Lofty Peak
*Pi-feng tan-shu*
*(Red Trees on a Blue Lofty Peak)*
碧峰丹樹

1 Marvin Felheim was a professor of English Literature at the University of Michigan. In the 1950s, he taught English at the Military Foreign Language School in Taipei and purchased this work directly from the artist.

2 Although Wu-hu 五湖 literally means "five lakes," it actually refers to Lake T'ai. See *Tz'u-hai* 辭海 (Sea of Terminology: Chinese Language Dictionary), vol. 1 (Taipei: Chung-hua Press, 1974), p. 145, s.v. "Wu-hu 五湖."

3 Mai-yün (meaning "to stroll in the clouds") was Professor Marvin Felheim's Chinese given name. He also adopted a Chinese family name, "Fei 費."

4 The second character in P'u Ju's name, *ju* 儒, means "a learned man or Confucianist." According to P'u, this name was assigned to him by Emperor Kuang-hsü on the third day after he was born. P'u Ju also stated that the emperor granted him an audience when he was three years old. On that occasion, the emperor exhorted him, saying that as his given name meant "learned man," he should grow up to become a "learned gentleman," not a "learned base person." See P'u Ju's reading notes, *Hua-lin yün-yeh* 華林雲葉 (Cloud and Foliage in a Splendid Forest), vol. 1 (Taipei: Kuang-wen Bookstore, 1963), p. 18.

5 In Chinese, Nurhaci is pronounced Nu-erh-ha-ch'i 努爾哈赤. For more information on Nurhaci, see Arthur W. Hummel, ed., *Eminent Chinese of the Ch'ing Period (1644–1912)*, vol. 1 (Washington, D.C.: United States Government Printing Office, 1943–44), pp. 594–99.

6 In Chinese, Aisin Gioro is Ai-hsin Chüeh-lo 愛新覺羅.

7 All the sons in the imperial family belonging to P'u Ju's generation shared the same first character, p'u, in their given names. After the establishment of the Republic of China in 1912, when the Manchus realized that they needed a family name, P'u Ju was the first one to adopt "P'u" as a family name. The other young men in the Manchu imperial family followed suit.

8 For more on P'u Ju's genealogy, see Shan Shiyuan 單士元, "Kung-wang-fu yen-ko k'ao-lüeh 恭王府沿革考略" (Research on the History of Prince Kung's Palace) in Chu Ch'uan-yü 朱傳譽, ed., *P'u Hsin-yü chuan-chi tzu-liao* 溥心畬傳記資料 (Materials on P'u Hsin-yü's [P'u Ju] Biography) (Taipei: T'ien-i Press, 1979), pp. 65–66. Shan's article was originally published in *Ta-ch'eng* 大成 magazine, no. 35, in Hong Kong.

9 For a brief biography of I-hsin, see *Eminent Chinese of the Ch'ing Period (1644–1912)*, vol. 1, pp. 381–84.

10 See ibid., p. 380.

11 For more on Lang Shih-ning's [Castiglione] life and art, see ibid., p. 381 and entry 35.

12 See ibid., p. 381. For Lord Elgin's biographical information, see William H. Harris and Judith S. Lefey, eds., *The New Columbia Encyclopedia* (New York and London: Columbia University Press, 1975), p. 855.

13 See I-hsin's biography in *Eminent Chinese of the Ch'ing Period (1644–1912)*, vol. 1, p. 381.

14 See ibid., pp. 381–82.

15 For more information on the Empress Dowager Tz'u-hsi, see *Eminent Chinese of the Ch'ing Period (1644–1912)*, vol. 1, under "Hsiao-ch'in Hsien Huang-hou 孝欽顯皇后" (The Eminent Empress Hsiao-ch'in), pp. 295–300. For information of Tsai-ch'un (Emperor Kuang-hsü), see ibid., vol. 2, pp. 729–31.

16 See ibid., vol. 1, p. 298.

17 See ibid., vol. 1, p. 383. I-hsin had four sons; the two youngest died before reaching maturity.

18 P'u Ju's mother, Hsiang, also gave birth to another son, P'u Hui 溥惠 (1906–?). It is not clear whether Hsiang, a native of Canton, was ethnically Chinese or Manchurian. Her father was a clerk at the Imperial hospital in Peking.

19 P'u Ju's father, Tsai-ying 載瀅 (1861–1909) had two titles. In 1868, he inherited the title of *beile* 貝勒, a prince of the third degree, from his uncle, who had no son. Then in 1889, Emperor Kuang-hsü designated him *chün-wang* 郡王, a prince of the second degree. Both titles were supposed to be handed down to his heir, which was P'u Ju. Unfortunately, Tsai-ying lost both titles after the Boxer Rebellion; as a result, P'u Ju became merely a member of the imperial family without designated residence or allowance.

20 See *Eminent Chinese of the Ch'ing Period*, vol. 1, p. 383.

21 See Tsai-t'ien's biography in ibid., vol. 2, pp. 731–33.

22 See ibid., p. 733.

23 The elementary education P'u Ju received is based on his own account. See "P'u Hsin-yü hsien-sheng tzu-shu 溥心畬先生自述" (An Account in Mr. P'u Hsin-yü's [P'u Ju] Own Words), recorded by Ch'en Chün-fu 陳儁甫, in Editorial Committee of the Lang-t'ao-sha Press, comp., *Chiu-wang-sun P'u Hsin-yü* 舊王孫溥心畬 (Taipei: Lang-t'ao-sha Press, 1974), p. 126. See also "P'u Hsin-yü hsien-sheng tzu-chuan 溥心畬先生自傳" (Mr. P'u Hsin-yü's [P'u Ju] Autobiography) in the same book, p. 33.

24 See ibid. Both of the above two sources, P'u's "P'u Hsin-yü hsien-sheng tzu-shu" and "P'u Hsin-yü hsien-sheng tzu-chuan," state that P'u Ju's first teacher was a local scholar, Ch'en Ying-jung 陳應榮. His two more advanced teachers were also scholars, Lung Tzu-shu 龍子恕 and Ou-yang Ching-hsi 歐陽鏡溪, from Kiangsi 江西 province. The five Chinese classics are the five canons of Confucius, which form the foundation of traditional education in China. These books are: 1) *I-ching* 易經 (The Book of Change); 2) *Shih-ching* 詩經 (The Book of Odes); 3) *Shu-ching* 書經 (The Book of History); 4) *Li-chi* 禮記 (The Book of Rites); and 5) *Ch'un-ch'iu* 春秋 (The Spring and Autumn Annals).

25 P'u Ju and his mother left Peking and took refuge at a Manchurian village in the Ch'ing-ho 清河 county because Yüan Shih-k'ai 袁世凱 (1858–1916), the haughty general who forced the Manchu emperor to abdicate, threatened to kill all the members of influential imperial families. P'u Ju recorded this incident in one of his unpublished writings, *Tz'u-hsün ts'uan-cheng* 慈訓纂證 (A Collection of the Admonitions of [the Author's] Mother with Commentary). See note 3 in Wu Yü-t'ing 吳語亭, "P'u Ju hsien-sheng chuan 溥儒先生傳" (A Biography of P'u Ju), in *Chuan-chi wen-hsüeh* 傳記文學 (Biographical Literature), no. 3, vol. 13, pp. 39–43. Wu's article is included in *P'u Hsin-yü chuan-chi tzu-liao* 溥心畬傳記資料 (Materials on P'u Hsin-yü's [P'u Ju] Biography), pp. 2–4.

26 Chieh-t'ai temple is also known as Chieh-t'an 戒壇 (altar for taking priestly vows) temple. Its name was derived from the temple's famous altar constructed during the Liao 遼 dynasty (916–1119). It is located in the Hsi-shan 西山, or West Mountains, west of Peking. For more information, see "Ming-chi lüeh-hsia 名蹟略下" (Brief Record of Relics, part 2) in T'ang Yung-pin 湯用彬, ed., *Chiu-tu wen-wu lüeh* 舊都文物略 (A Brief Record of the Relics in Peking) (Peking: Peking City Government, 1935), pls. 63–68, pp. 29–30.

27 P'u Ju's family collection consisted of a large number of paintings and calligraphic works; however, the collection was inherited by P'u Ju's elder brother. The few scrolls in the possession of P'u Ju were works he borrowed from his brother for the purpose of studying and copying. These works were supposed to be returned to the elder brother. It is quite possible that P'u Ju, a capable painter and calligrapher, could tell the quality and value of the scrolls better than his brother and that, as a result, P'u selected only the famous and valuable works to borrow. After the death of his elder brother, P'u Ju legally inherited the scrolls he had not returned. A few of the remarkable scrolls in P'u Ju's ownership included: *Chao-yeh pai* 照夜白 (Night-Shining White Horse) attributed to Han Kan 韓幹 (active c. 742–56); *Chü-yüan t'u* 聚猿圖 (A Group of Gibbons) attributed to I Yüan-chi 易元吉 (active c. 1060–70); and *Sung-jen wu-k'uan shan-shui* 宋人無款山水 (A Landscape Handscroll [in the style of Ma Yüan and Hsia Kuei]) attributed to an anonymous Sung dynasty painter. The calligraphic examples include: *P'ing-fu t'ieh* 平復帖 (A Passage on Recovering from Illness) attributed to Lu Chi 陸機 (261–303) and *K'u-sun t'ieh* 苦筍帖 (A Passage about Bitter Bamboo Shoots) attributed to T'ang dynasty calligrapher Huai-su 懷素 (725–85). Han Kan's horse painting was sold first to Sir Percival David, then to John M. Crawford, Jr., New York, and now belongs to the Metropolitan Museum, New York. The painting is published in Wen C. Fong, *Beyond Representation: Chinese Painting and Calligraphy 8th–14th Century* (New York: Metropolitan Museum of Art, 1992), pl. 1, pp. 16–17. I Yüan-chi's monkey scroll was sold to the Abe Collection at the Osaka Municipal Museum. It is reproduced in Osvald Sirén, *Chinese Painting: Leading Masters and Principles*, vol. 3 (New York and London: Ronald Press, 1956), pl. 217. The landscape handscroll by an anonymous painter in the Ma-Hsia style now belongs to the Nelson Gallery-Atkins Museum, Kansas City. This painting is published in Ho Wai-kam

何惠鑑, et al., *Eight Dynasties of Chinese Paintings: The Collections of the Nelson Gallery-Atkins Museum, Kansas City, and the Cleveland Museum of Art* (Cleveland: Cleveland Museum of Art, 1980), cat. no. 138, pp. 162–63. Although Laurence Sickman and Kwan-shut Wong point out in *Eight Dynasties* exhibition catalogue that a thirteenth-century date for this handscroll should not be ruled out, the date has been recently reassigned to the early Ming dynasty. Lu Chi's and Huai-su's calligraphic works are now at the Palace Museum, Beijing. Lu Chi's work is reproduced in Forbidden City Press of the Palace Museum, ed., *Gugong bowuyuan cangbaolu (Ku-kung po-wu-yüan ts'ang-pao-lu)* 故宮博物院藏寶錄 (A Catalogue of the Treasures at the Palace Museum) (Shanghai: Wenyi Chubanshe, 1986), p. 51.

28 Lo Shu-chia's 羅淑嘉 (1887–1947) *tzu* was Ch'ing-yüan 清媛. The exact year P'u Ju married Lo Shu-chia is unclear. According to P'u Ju, he married Lo in 1917. His relatives, however, state that P'u got married in 1913. It seems that P'u Ju married his wife hastily when he visited his elder brother, P'u Wei, in Tsingtao shortly after the Republic was established. This is quite possible since both P'u Wei and Sheng-yün, P'u Ju's father-in-law, were in Tsingtao during that period of time. It is also known that P'u Ju's mother was quite upset that P'u Ju's wedding was so informal. When her younger son, P'u Hui, was married, the wedding, sponsored by the abdicated emperor P'u I, took place in the Forbidden City. See Jan Chian-yu 詹前裕, *P'u Hsin-yü shu-hua i-shu chih yen-chiu* 溥心畬書畫藝術之研究 (Research on the Art of P'u Hsin-yü [P'u Ju]) (Taichung: Taiwan Museum of Art, 1992), p. 17.

29 See ibid.

30 P'u Ju and his wife had three children, including their daughter, T'ao-hua 韜華, and two sons, Yü-li 毓岦 and Yü-ts'en 毓岑. Later in Taiwan, Yü-li changed his name to P'u Hsiao-hua 溥孝華. See years 1924, 1925, and 1946 in "P'u Hsin-yü hsien-sheng nien-piao 溥心畬先生年表" (The Chronological Table of P'u Hsin-yü [P'u Ju]) in ibid., pp. 67–68. P'u Ju and his second wife, Li Mo-yün 李墨雲, also adopted a son, Yü-ch'i 毓岐, who was the son of the business manager of the P'u family in Peking.

31 This controversial issue concerning P'u Ju's two doctorates at the University of Berlin arose mainly due to his own assertions. P'u Ju's National Normal University curriculum vitae stated that he had a Ph.D. in literature from the University of Berlin. When a magazine published an

article introducing P'u Ju as a painter in 1954, it indicated that P'u Ju studied chemistry and astronomy at the University of Berlin and that the topic of his dissertation was Chinese Chemistry. After 1958, P'u Ju often claimed in public lectures that he earned two doctorates, one in biology and the other in astronomy.

32 See Jan Chian-yu 詹前裕, *P'u Hsin-yü hui-hua i-shu chih yen-chiu* 溥心畬書畫藝術之研究 (Research on the Art of P'u Hsin-yü [P'u Ju]), p. 15. P'u Ju claimed that he studied in Berlin after he settled down in Taiwan. In fact, as early as 1948, P'u's vitae was published in the *Chung-kuo mei-shu nien-chien* 中國美術年鑑 (Chinese Arts Almanac) and contains assertions that he graduated from the Political Science University in Peking, studied art and literature, and attended the German William Imperial Academy in Tsingtao where he studied the history of Western literature. (北平法政大學畢業後, 專心研究文學, 藝術. 再入青島德國威廉帝國研究院, 專攻西洋文學史.) In 1950, the second year after he arrived in Taipei, P'u Ju was invited to teach at the Taiwan Normal University. On his curriculum vitae, he put, "Ph.D. in literature from the Berlin University, Germany, 1914." (德國柏林大學文學系博士.) Four years later in 1954, P'u's educational background changed to: "In 1914, he went to Germany and studied at the Berlin University specializing in biology and astronomy. The topic of his Ph.D. dissertation was 'chemistry in China.'" (民國二年, 赴德國柏林大學留, 學專攻生物, 天文. 以 "中國的化學" 一論文, 獲得博士學位.) P'u composed a tract entitled *Hsin-yü hsüeh-li tzu-shu* 心畬學歷自述 (A Self-account of My Educational Background) in which he claimed, "[In 1913] at age seventeen. . . I visited [my mother and brother] in Tsingtao and studied German at a school called Li-hsien Hsüeh-yüan. Through the introduction of Prince Henry of Germany, I went to Berlin, passed the entrance examination, and attended the Berlin University." According to P'u Ju, this Prince Henry was the Minister of the Navy and the younger brother of King William II of Germany. P'u Ju also stated, "In the year of *chia-yin* (1914), I was eighteen years old. I graduated [from the University of Berlin] in three years. I then sailed back to Tsingtao and got married through the arrangement of my mother. In that year, I was twenty-one years old. In the fall, during the eighth moon, I again visited my mother in Tsingtao. [From there, I] sailed to Germany, and with my qualification as a graduate of the University of Berlin, entered the Berlin Research Institute. After three and a half years, I graduated and received my Ph.D. degree." (年十八 . . . 余因省親至青島, 遂在

P'u Ju 溥儒
**Red Trees on a Blue Lofty Peak**
*continued*

170　禮賢學院補習德文. 因德國亨利親王之介紹, 亨利親王為德皇威廉第二之弟, 時為海軍大臣, 遊歷德國. 考入伯林大學. 時余年十九, 為甲寅年. 三年畢業後, 回航至青島. 時余嫡母為余完婚. 余是年二十二歲. 秋八月, 再往青島省親. 乘輪至德國, 以柏林大學畢業生資格, 入柏林研究院. 在研究院三年半, 畢業得博士學位.) As this passage sounds fairly credible, it convinced many people. In December 1958, when P'u Ju delivered a public speech at the Hong Kong Hsin-ya College, he told the audience that when he was young, he studied Latin, Greek classics, and Egyptian literature, and at the age of twenty-six, when he returned to China, had earned Ph.D. degrees in astronomy and biology from Germany. (我研究過拉丁古代文學埃及文學二十七歲便帶了德國天文學博士及生物博士兩個博士學位回國.)

33　The author heard P'u's assertions that he studied astronomy in Berlin when he was in attendance at a painting class taught by P'u.

34　Tsingtao was occupied by the Germans from 1897 until World War I in 1914. Many of the buildings in the city were constructed by the Germans in German architectural styles. The Germans also started the beer-brewing industry in Tsingtao, which is even today the name of a popular beer. As so many Germans lived in Tsingtao in the early twentieth century, it was certainly the best place in China to learn the language.

35　In researching her dissertation, "The Life and Art of P'u Hsin-yü," at the University of Kansas, Lawrence, Jane Chuang Ju (Chu Jing-hua 朱靜華) wrote to Dr. Martin Gimm at Cologne University in 1989 and asked him about P'u Ju's degrees at the University of Berlin. Gimm is a specialist in the study of Manchuria and checked almost all the colleges and universities in Germany; he found no record showing that P'u Ju ever studied in Germany. Jane Ju also wrote to P'u Ju's cousin, P'u Jie 溥傑, in Beijing in order to solve this puzzle and was convinced that P'u Ju had never studied in Germany.

36　See note 33. In his tract documenting his educational background, P'u Ju asserted, "After three and half years at the research institute, I graduated and received my Ph.D. degree." (在研究院三年半畢業得博士學位.)

37　In addition to the numerous writers and scholars in Taiwan and Hong Kong who publicly defended P'u Ju on this issue, the two major museums in Taiwan, the National Palace Museum and the National Museum of History, also honored P'u Ju's claim. While many of these scholars were either P'u's students or friends, the two national museums perhaps accepted P'u's allegation because he was a well-known artist. Interestingly, among the scholars who sided with P'u, none had exposure to Western education. Unfortunately, Western scholars often trusted these sources. For example, the prestigious *Biographical Dictionary of Republican China* from Columbia University Press includes the information in the entry for P'u Ju that he studied at Berlin University and earned a Ph.D. degree.

38　Among the many scholars who studied P'u Ju's life, two did intensive research and both found P'u Ju's claims that he studied and earned two degrees in Berlin improbable. See *P'u Hsin-yü hui-hua i-shu chih yen-chiu* 溥心畬書畫藝術之研究 (Research on the Art of P'u Hsin-yü [P'u Ju]), pp. 15–17.

39　For a discussion of the famous Kung palace, see Shan Shiyuan 單士元, "Kung-wang-fu yen-ko k'ao-lüeh 恭王府沿革考略" (Research on the History of Prince Kung's Palace) in *P'u Hsin-yü chuan-chi tzu-liao* 溥心畬傳記資料 (Materials on P'u Hsin-yü's [P'u Ju] Biography), pp. 65–67; see also Lin Hsi 林熙, "Ts'ung Kung-wang-fu t'an-tao chiu-wang-sun 從恭王府談到舊王孫" (A Discussion Concerning the Prince Kung Palace and a Former Imperial Descendant) in Editorial Committee of the Lang-t'ao-sha Press, comp., *Chiu-wang-sun P'u Hsin-yü* 舊王孫溥心畬 (P'u Hsin-yü [P'u Ju]: A Descendant of the Former Imperial Family) (Taipei: Lang-t'ao-sha Press, 1974), pp. 2–3.

40　For a description of Ho-shen's career, see *Eminent Chinese of the Ch'ing Period (1644–1912)*, vol. 1, pp. 288–90.

41　See Lin Hsi's "Ts'ung Kung-wang-fu t'an-tao chiu-wang-sun 從恭王府談到舊王孫" (A Discussion Concerning the Prince Kung Palace and a Former Imperial Descendant), p. 5.

42　See ibid., p. 12.

43　See ibid., pp. 8–9.

44　See ibid., p. 8.

45　In P'u Ju's account, he was invited by Kyoto University as a guest lecturer. In reality, he was invited by a Japanese company, the Okura 大倉 Co., to promote Chinese culture and art. See *P'u Hsin-yü shu-hua i-shu chih yen-chiu* 溥心畬書畫藝術之研究 (Research on the Art of P'u Hsin-yü [P'u Ju]), p. 67.

46　See ibid., p. 19. Jan cited this information from an article, "Yu-kuan Hsi-shan I-shih erh-san shih 有關西山逸士二三事" (Several Anecdotes of P'u Hsin-yü [P'u Ju]) by T'ai Ching-nung 臺靜農. It is unclear where T'ai's article was originally published.

47　In the mid-1930s, P'u Ju's mother, Madame Hsiang, owned a young slave-maid, Wen-shu 文淑. P'u Ju and his younger brother both wanted to adopt this maid as a concubine. According to tradition, such behavior was customary. In order to settle the dispute between the two brothers, P'u Ju's wife, Madame Lo, let the younger brother have the maid and bought Ch'üeh-p'ing 雀屏 for her husband. After Ch'üeh-p'ing entered the P'u family, she soon took control of everything. See *P'u Hsin-yü shu-hua i-shu chih yen-chiu* 溥心畬書畫藝術之研究 (Research on the Art of P'u Hsin-yü [P'u Ju]), pp. 19–20.

48　Lu Chi (261–303) lived even earlier than the famous calligrapher Wang Hsi-chih 王羲之 (321–79). From the many collecting seals found on *P'ing-fu t'ieh*, one learns that it belonged to the most prestigious collections in Chinese history. For example, during the twelfth century, it was in Emperor Hui-tsung 徽宗 (r. 1101–25) and his son Emperor Kao-tsung's 高宗 (r. 1127–62) collections. During the seventeenth century, it belonged to Chang Ch'ou 張丑 (1577–1643), who was the author of the important catalogue *Ch'ing-ho shu-hua-fang* 清河書畫舫 (The Ch'ing-ho Boat Studio of Painting and Calligraphy [a catalogue of works known to the author]). Later, this work was owned by Liang Ch'ing-piao 梁清標 (1620–91) and An Ch'i 安歧 (1683–?). Under Emperor Ch'ien-lung (r. 1736–96), this precious calligraphy was in the hands of the Empress Dowager, Emperor Ch'ien-lung's mother. In 1777, after she died, her grandson, Prince Ch'eng (1752–1823), a well-known calligrapher, inherited it. Around 1880, P'u Ju's grandfather, I-hsin, was the most powerful figure at the court; consequently, Prince Ch'eng's descendant presented it to I-hsin. From I-hsin this work passed to P'u Ju's elder brother P'u Wei, who inherited I-hsin's title, estate, and collection. There is no doubt that P'u Ju received *P'ing-fu t'ieh* from his brother. For further discussion of *P'ing-fu t'ieh*, see Wang Shixiang 王世襄 (1914– ), "Xi Jin Lu Ji *Pingfutie* liuchuan kaolue" (Hsi-Tsin Lu Chi *P'ing-fu t'ieh* liu-ch'uan k'ao-lüeh) 西晉陸機平復帖流傳考略 (Research on the Provenance of Lu Chi's *P'ing-fu t'ieh* of the Western Tsin Dynasty) in *Ku-kung po-wu-yüan ts'ang-pao-lu* 故宮博物院藏寶錄 (A Catalogue of the Treasures at the Palace Museum), pp. 193–95. In 1937, when P'u Ju was selling *P'ing-fu t'ieh*, the Chinese collectors were concerned that Japanese or other foreign museums would acquire this important work of calligraphy. The scholar-collector Zhang Boju 張伯駒 (1898–1982) offered over 40,000 Chinese dollars to purchase it. After the establishment of the People's

Republic, Zhang, in 1956, donated this and a group of other important objects to the Palace Museum, Beijing.

49  See Fu Shen 傅申, *Challenging the Past: The Paintings of Chang Dai-chien* (Washington, D.C.: Arthur M. Sackler Gallery, Smithsonian Institution, 1991), p. 114.

50  See ibid., pp. 110–15.

51  It seems that this expression originated from an article published in 1935 entitled "The South Has Chang and the North Has P'u," by Yü Fei-an 于非厂 (1888–1959). Yü's article appeared originally in the May 22, 1935, newspaper *Peking Ch'en-pao* 北京晨報 (Peking Morning Paper). For a translation of this article, see *Challenging the Past*, pp. 110 and 114. Yü described Chang's work as "bold, free, and untrammeled," and P'u Ju's work as "polished and courtly." Yü was a close friend of Chang Dai-chien; it seems that the purpose of his article was to promote Chang's national reputation.

52  For a general summary on Manchukuo, see Keith Buchanan et al., *China: The Land and the People, the History, the Art and the Science* (New York: Crown Publishers, 1980), pp. 362–64.

53  See Li Hsiu-wen 李秀文, "Chi P'u Hsin-yü ta-shih tsai Chou-shan teh jih-tzu 記溥心畬大師在舟山的日子" (A Record of the Days When Master P'u Ju Stayed in the Choushan Islands) in *Chiu-wang-sun P'u Hsin-yü* 舊王孫溥心畬 (P'u Hsin-yü [P'u Ju]: A Descendant of the Former Imperial Family), pp. 82–88. There is speculation that P'u left mainland China for Taiwan because the Communist regime was attempting to enlist him for purposes of propaganda.

54  The year after P'u Ju arrived in Taipei, he moved into a small Japanese-style house at 8 Alley 17, Lane 69, Lin-i Street (臨沂街六十九巷十七弄八號) and stayed there until he passed away in 1963. It was a small building located on a narrow alley that cars could not drive through. His studio was also humble, with only a table and a few chairs. For a description of his residence in Taipei, see *P'u Hsin-yü shu-hua i-shu chih yen-chiu* 溥心畬書畫藝術之研究 (Research on the Art of P'u Hsin-yü [P'u Ju]), p. 24.

55  See ibid.

56  Once P'u Ju traveled to Japan and tried to send a letter to a friend at the Chinese embassy in Seoul, Korea. After he inscribed this person's name, Seoul, and Korea on the envelope, P'u asked a chef at the hotel to write "Republic of China Embassy" for him. See Sung Hsün-lun 宋訓倫 "Chiu-wang-sun P'u Hsin-yü 舊王孫溥心畬 (P'u Hsin-yü [P'u Ju]: A Descendant of the Former Imperial Family), p. 21.

57  See "Ming-shih-p'ai tang-chung t'uo-i 名士派當眾脱衣" (A Famous Unconventional Scholar Disrobing in Public) in Chu Sheng-chai's 朱省齋 "P'u Hsin-yü erh-san-shih 溥心畬二三事" (Several Anecdotes on P'u Hsin-yü [P'u Ju]), published in *Chiu-wang-sun P'u Hsin-yü* 舊王孫溥心畬 (P'u Hsin-yü [P'u Ju]: A Descendant of the Former Imperial Family), pp. 109–10. According to Chu, around 1953, one evening in Tokyo, he and P'u Ju went out to dinner at a lavish restaurant with dim lights, a singer, and piano player. When they sat down at a table under candlelight, P'u Ju kept complaining that the temperature was too high. While Chu was reading the menu, he suddenly heard two American women at the next table shrieking. He looked to find that P'u had taken off his heavy wool robe and was left with only his undershirt.

58  P'u Ju's fondness for freshwater crab was notorious. He could consume ten or more crabs at one meal and even took a trip from Taiwan to Hong Kong for the sole purpose of eating crabs. See Chia Na-fu's 賈納夫 article "P'u Hsin-yü tsai Hsiang-kang 溥心畬在香港" (P'u Hsin-yü's [P'u Ju] Visit to Hong Kong) in ibid., pp. 60–62.

59  See Chang Mu-han's 張目寒 article "P'u Hsin-yü chen-wen i-shih 溥心畬珍聞軼事" (Minor Anecdotes on P'u Hsin-yü [P'u Ju]) in ibid., p. 15. See also "Sheng-huo lo-ch'ü 生活樂趣" (Joys of Life) in Sung Hsün-lun's 宋訓倫 article "Chiu-wang-sun P'u Hsin-yü 舊王孫溥心畬" (P'u Hsin-yü [P'u Ju]: A Descendant of the Former Imperial Family), published in *Chiu-wang-sun P'u Hsin-yü* 舊王孫溥心畬 (P'u Hsin-yü [P'u Ju]: A Descendant of the Former Imperial Family), p. 41. Sung describes P'u Ju's table manners as "*chih-hsiang nan-k'an* 吃相難看" (When eating, his manner is disgusting). Not only did P'u spit out the bones and shells on the table, he also often placed his favorite dish in front of him and would not share with other guests. This was especially true when shark-fin soup was served. P'u could finish the whole tureen, which typically contained a portion for ten to twelve people.

60  Despite students and admirers offering him imported cigarettes, P'u was known for smoking Banana brand cigarettes, one of Taiwan's cheapest and lowest quality filterless brands.

61  The doctors in Taipei diagnosed P'u Ju's illness as malignant nose cancer, which spread to his throat. Before he died, he could neither talk nor swallow. See "Pi-ai o-hua, i-shih hua-ho 鼻癌惡化 逸士化鶴" (Deteriorating Due to Nose Cancer, the Recluse [Finally] Became a Crane [died]), in Tu Yün-chih's 杜雲之 article, "P'u Hsin-yü te wan-nien sheng-huo 溥心畬的晚年生活" (P'u Hsin-yü's [P'u Ju] Later Years), published in *Chiu-wang-sun P'u Hsin-yü* 舊王孫溥心畬 (P'u Hsin-yü [P'u Ju]: A Descendant of the Former Imperial Family), pp. 104–5.

62  See "Ting-chü Taipei, yü-hua shou-t'u" 定居台北, 鬻畫收徒 (Settling down in Taipei, Selling Paintings, and Receiving Students) in Tu Yün-chih's 杜雲之 "P'u Hsin-yü te wan-nien sheng-huo 溥心畬的晚年生活" (P'u Hsin-yü's [P'u Ju] Later Years), in *Chiu-wang-sun P'u Hsin-yü* 舊王孫溥心畬 (P'u Hsin-yü [P'u Ju]: A Descendant of the Former Imperial Family), p. 101.

63  See ibid., pp. 99–100.

64  Li Mo-yün's dominating personality and her affairs were open secrets among P'u Ju's friends and students. One of her lovers was a young tailor who eventually moved in and lived at the P'u's residence. Later he was evicted when Li found that he used the money received from her to support a younger woman. P'u Ju, unable to prevent her activities, could only play dumb. During those years, everyone was sympathetic to P'u Ju and helped him to cover up this embarrassing situation. P'u had three children from his first wife. His younger son died in 1939 at age fifteen. His daughter was married to a man named Liu 劉 and died in mainland China. His elder son, P'u Hsiao-hua 溥孝華, who was crippled, passed away in Taipei in 1991. Hsiao-hua's wife, Yao Chao-ming 姚兆明, was murdered in 1989 in front of her house. P'u Ju had no grandchildren. A few years after P'u Ju's death, his second wife, Li Mo-yün, remarried.

65  For P'u Ju's paintings collected by the National Palace Museum, see Editorial Committee of the National Palace Museum, ed., *P'u Hsin-yü shu-hua wen-wu t'u-lu* 溥心畬書畫文物圖錄 (A Catalogue of P'u Hsin-yü's [P'u J'u] Painting, Calligraphy, and Other Art Objects) (Taipei: National Palace Museum, 1993). For P'u's works at the National Museum of History, see Editorial Committee of the National Museum of History, ed., *Kuan-ts'ang P'u Hsin-yü shu-hua* 館藏溥心畬書畫 (The Painting and Calligraphy of P'u Hsing-yü [P'u Ju] from the Collection of the National Museum of History) (Taipei: National Museum of History, 1996).

66  Author Hsüeh Hui-shan 薛慧山 states in "P'u Hsin-yü hua pai-sung ch'ang-chüan 溥心畬畫百松長卷" (P'u Hsin-yü's [P'u Ju] Long Handscroll "One Hundred Pines"), published in *Chiu-wang-sun P'u Hsin-yü* 舊王孫溥心畬 (P'u Hsin-yü [P'u Ju]: A

P'u Ju 溥儒
*Red Trees on a Blue Lofty Peak*
*continued*

Descendant of the Former Imperial Family), p. 80, that in 1962, one year before P'u Ju's death, he visited Hong Kong and lectured at the Hong Kong Chinese University for three months. During that period of time, he was asked to demonstrate his technique constantly, and it is believed that he probably painted almost three hundred paintings. The last one he executed was an ink landscape with swift, spontaneous brushwork and wet washes. This work won much admiration. P'u Ju said to his friend that it was time for him to change his painting style. He indicated that it would be a drastic modification of his traditional style. Unfortunately, he soon became ill and died in the next year. He never carried out his vow.

67   It seems that P'u Ju studied assiduously when he was young and had an astonishing memory. According to Li Yü 李漁 in his "P'u Hsin-yü hsien-sheng Han-yü t'ang shih 溥心畬先生寒玉堂詩" (P'u Hsin-yü's [P'u Ju] Poems Composed at His Cold-jade Studio), published in *Chiu-wang-sun P'u Hsin-yü* 舊王孫溥心畬 (P'u Hsin-yü [P'u Ju]: A Descendant of the Former Imperial Family), p. 52, P'u Ju had read the 294 volumes of Szu-ma Kuang's 司馬光 (1019–86) *Tsu-chih t'ung-chien* 資治通鑑 (The "Chronicle"; a synopsis of history covering a period of 1,362 years, from the Chou dynasty [c. 1100–265 B.C.] to the Five Dynasties [907–60]) more than nineteen times. Hsüeh Hui-shan 薛慧山 stated in "P'u Hsin-yü hua pai-sung ch'ang-chüan 溥心畬畫百松長卷" (P'u Ju's Long Handscroll "One Hundred Pines"), published in the same book, p. 65, that P'u Ju memorized the names, characteristics, and lives of Confucius' seventy-two disciples, as well as thirty-seven types of ancient wine vessels, their dates, and related information.

68   In China, poetry has traditionally been considered an inherently intellectual and refined art. As literati painters sought to differentiate themselves from professional painters and artisans, it was quite common for a literati artist to consider himself primarily a poet rather than a painter.

69   See Chou Ch'i-tsu's 周棄子 "Chung-kuo wen-jen-hua tsui-hou i-pi 中國文人畫最後一筆" (The Last Brush Stroke of the Chinese Literati Painters), published in *Chiu-wang-sun P'u Hsin-yü* 舊王孫溥心畬 (P'u Hsin-yü [P'u Ju]: A Descendant of the Former Imperial Family), p. 118. See also "Fuku teh wen-jen hua-chia 復古的文人畫家" (A Literati Painter Who Returns to the Ancient Ideology), section 2, chapter 6, "P'u Hsin-yü tsai Chung-kuo mei-shu-shih shang-te ti-wei 溥心畬在中國美術史上的地位" (P'u Hsin-yü's [P'u Ju] Proper Position in Chinese Art History), in Jan Chian-

yu's 詹前裕 *P'u Hsin-yü shu-hua i-shu chih yen-chiu* 溥心畬書畫藝術之研究 (Research on the Art of P'u Hsin-yü [P'u Ju]), pp. 51–53.

70   For a discussion of the "axe-hewn" brushwork, see Wen C. Fong, *Beyond Representation: Chinese Painting and Calligraphy 8th–14th Century* (New York: Metropolitan Museum of Art, 1992), pp. 112, 114, 207, 269, 275, 277, 283, 402, 491, and 495.

71   Traditionally an artist painting in the Northern style is considered a "Northern" or "professional" painter. Yet in P'u's case, despite his Northern painting style, he has been unanimously recognized as a literati painter. For a discussion of the Northern and Southern painting styles as well as literati and professional painters, see Sherman E. Lee, "Literati and Professionals: Four Ming Painters," in *Bulletin of the Cleveland Museum of Art* 53 (Cleveland: Cleveland Museum of Art, January 1966), pp. 2–25. See also "Two Landscape Traditions: The Che and Wu Schools," in James Cahill, *Parting at the Shore: Chinese Painting of the Early and Middle Ming Dynasty, 1368–1580* (New York and Tokyo: Weatherhill, 1978), pp. 4–5.

72   Lake T'ai is located at the boundary of Kiangsu and Chekiang provinces. In ancient times, it was also called Chen-tse 震澤, Chi-ch'ü 具區, Wu-hu 五湖, and Li-tse 笠澤. The waters from the T'iao-hsi 笤溪 River and the Great Canal flow into this lake and continue to the Yangtze River via the Huang-p'u 黃浦 River. The third largest fresh water lake in China, it occupies 2,213 square kilometers. There are forty-eight islands in this large lake, including the famous misty East and West Mt. Tung-t'ing 洞庭, famous for their many scenic spots. (Mt. Tung-t'ing should not be confused with Lake Tung-t'ing, which is located in Hunan 湖南 province.) From ancient times, Lake T'ai has been a major topic in Chinese literature and art. Many painters from the twelfth to the nineteenth centuries are from cities near this lake. T'ai-hu rocks, a special type of perforated stone found on the bottom of this lake, have been used to decorate famous Chinese gardens. During the twelfth century, Emperor Hui-tsung assigned special envoys to collect such rocks and shipped them to the capital in the north to be placed in the imperial gardens. Lake T'ai has always been considered the ideal place for a recluse to retire. By choosing Lake T'ai as the subject matter for his poem and painting, P'u perhaps betrays his intense sentiment as a descendant of the Manchu imperial family.

## 60. Chang Dai-chien 張大千
*(1899–1983)*
*Republic (1912– )*

## Mountain Landscape after Hung-jen (1610–63)
*Fang Hung-jen shan-shui (Landscape after Hung-jen)*

倣弘仁山水

1   Dai-chien, meaning "the boundless," was the artist's Buddhist name and reflects his spiritual inclination.

2   Since the scribe of this label did not sign his name, it is difficult to identify him. From his seal, one learns that his family name is Cheng 鄭. I-an 逸庵 must be his *tzu* or *hao*.

3   The character Yüan 爰 in Chang Yüan, one of Chang Dai-chien's many names, literally means "gibbon." Chang's link to a gibbon is based on a story related by Chang himself. According to Chang, a few days before he was born, his mother dreamed that an old man handed her a large brass gong. In the center of this instrument, there was a small black gibbon. Soon Chang was born. Therefore, everyone in his family believed that he was the reincarnation of that black gibbon. Chang himself was very fond of painting gibbons, and he kept several in his gardens as pets. The large brass gong in his mother's dream was supposed to symbolize the moon. When Chang was young, he was afraid of the full moon; as a result, he never included a depiction of the moon in any of his paintings.

4   The character Shu 蜀 in this seal was the ancient name of Szechwan. Thus, this province is often referred to as Shu.

5   The term *hao-fa* 豪髮 in Chang's seal literally means "the soft hairs of the body and the hairs on the head." Chang is borrowing this expression from literature to indicate the refined nature of his work.

6  For a list of Chang Dai-chien's forgeries of early paintings, see Fu Shen, *Challenging the Past: The Paintings of Chang Dai-chien* (Washington, D.C.: Arthur M. Sackler Gallery, Smithsonian Institution, 1991), pp. 308–9.

7  Tseng Hsi gave Chang Dai-chien this unusual name based on the dream Chang's mother had of a gibbon before Chang was born. See note 3 for more information on the dream.

8  Few people understand why salt merchants would move from an area with access to the ocean, to the interior of China. The Changs did so because Nei-kiang is located near Tzu-kung 自貢, a city famous for its abundant supplies of well saltwater and natural gas, both essential ingredients in the production of salt. In fact, today Tzu-kung is home of the Salt Museum, which focuses on the history and production of salt. For the location of Nei-kiang, see *Zhongguo jiaotong luyu tuce* (*Chung-kuo chiao-t'ung lü-yu t'u-ts'e*) 中國交通旅遊圖冊 (Tourist Maps of China) (Beijing: Zhongguo Ditu Chubanshe, 1993), pp. 26 and 94.

9  See Hsieh Hsiao-hua 謝孝華, *Chang Dai-chien teh shih-chieh* 張大千的世界 (The World of Chang Dai-chien) (Taipei: Cheng-hsin Press, 1968), p. 2. According to Chang Dai-chien, his mother was very strict. If a child was naughty or made a mistake, she would make him kneel as punishment. Every morning and evening, the children had to greet their parents by offering tea. Her rules also demanded that when a younger member met a member of the older generation, the younger one had to kowtow. The family's great affluence, combined with the fact that Chang Dai-chien had ten brothers and one sister, suggests that his father may have had several concubines. In old Chinese society, all children regarded their father's legal wife as their mother, even if their birth mother was one of the father's concubines. The fact that Chang's second elder brother, Chang Shan-tzu 張善孖 (1882–1940), was seventeen years older and that Chang also had two younger brothers suggests that Chang Dai-chien's birth mother was more than likely one of the father's younger concubines. If Chang Dai-chien's father had only one wife, she would have given birth to eleven children until into her forties. It is possible but quite unlikely.

10  See ibid. The author witnessed Chang Dai-chien observing this rite in his old age. When the artist and his wife visited Taipei around 1960, they were introduced to the father-in-law of a close friend. In front of all the guests, Chang and his wife immediately knelt down on their knees and kowtowed to their friend's father-in-law.

11  While little is known about Chang Dai-chien's elder sister, Chang Ch'üng-chih, Chang's younger brother, Chang Chün-shou, was a talented painter who died young. According to Chang Dai-chien, he and his younger brother both learned calligraphy from Tseng Hsi in Shanghai around 1919. Unfortunately, due to problems in his marriage, his brother committed suicide at the age of eighteen by jumping into the ocean. Chang's elder brother, Chang Shan-tzu, was a famous painter who specialized in tiger painting. See Kao Yang 高陽, *Mei-ch'iu sheng-ssu mo-yeh meng* 梅丘生死摩耶夢 (A Dream at the Abode of Illusion and Life and Death at the Plum Blossom Bank) (Taipei: Lien-ching Press, 1984), pp. 127–44.

12  See Hsieh Hsiao-hua, *Chang Dai-chien teh shih-chieh* 張大千的世界 (The World of Chang Dai-chien), pp. 8–22.

13  According to Fu Shen, Chang Dai-chien directly benefited from his exposure to Japan and Japanese culture. For example, he gained considerable knowledge of pigments. This experience helped him to apply bold colors to his paintings. As some of the pigments he used for painting required exact methods of preparation similar to those of a textile dyer, the knowledge he gained in Japan about textiles was crucial as well. Furthermore, in Japan, he familiarized himself with Japanese tools and media which are often manufactured in the traditional Chinese manner. Based on this understanding, Chang utilized the appropriate brush to replicate the style of ancient brushwork, composition, and signature and figured out how to dye new paper and silk to make them look stained by exposure to light, smoke from incense, and dust. He used such aged silk and paper to produce convincing counterfeits. He also established a close relationship with famous Japanese mounters. As a result, most of his important works were mounted in Japan. See Fu Shen, *Challenging the Past: The Paintings of Chang Dai-chien*, p. 20.

14  Tseng Hsi was a famous scholar-calligrapher who also occasionally painted. For more information on this artist, see entry 56.

15  See Hsieh Hsiao-hua's *Chang Dai-chien teh shih-chieh* 張大千的世界 (The World of Chang Dai-chien), p. 27.

16  Chang's private life has always been controversial, and the chronology and exact details of many events are ambiguous. When exactly he became involved with Huang Ning-su is difficult to ascertain. See Kao Yang 高陽 *Mei-ch'iu sheng-ssu mo-yeh meng* 梅丘生死摩耶夢 (A Dream at the Abode of Illusion and Life and Death at the Plum Blossom Bank), p. 25. This is adapted from Appendix 1, "The Life of Chang Dai-chien" in Ba Tong's 巴東 *Chang Dai-chien yen-chiu* 張大千研究 (The Art of Chang Dai-chien) (Taipei: National Museum of History, 1998), p. 315. Ba Tong's book contradicts some of the facts regarding Chang's early marriages. On page 21 in *Challenging the Past: The Paintings of Chang Dai-chien*, Fu Shen states that Chang Dai-chien married Huang Ning-su in 1922, two years after he married his first wife Tseng Ch'ing-jung.

17  See "Tzu-hsiao ch'i-hsien t'ien-lun-le 子孝妻賢天倫樂" (Worthy Progeny, Virtuous Wives, and Family Happiness) in Hsieh Hsiao-hua's *Chang Dai-chien teh shih-chieh* 張大千的世界 (The World of Chang Dai-chien), pp. 80–82. This chapter addresses Chang's many wives. Chang also had a number of long-term relationships with several other women, in Japan, Korea, and possibly in India and Brazil. As he adopted a number of children, it is difficult to calculate exactly how many children he actually fathered. Chang seemed to be able to manage this polygamy successfully based on models from China's past. See also "Ming-shih feng-liu yen-wen-do 名士風流艷聞多" (The Many Romances of a Celebrated Artist) in ibid., pp. 83–85.

18  Li Jui-ch'ing was a famous scholar-educator who served as the Chief Educational Commissioner of the Kiangsu province. He specialized in calligraphy that followed ancient epigraphic inscriptions. For a discussion of Chang Dai-chien's education under his two teachers, see Fu Shen's *Challenging the Past: The Paintings of Chang Dai-chien*, pp. 23–24. See also the chapter entitled "Tseng-Li erh-shih 曾李二師" (Tseng and Li: Two Teachers) in Hsieh Hsiao-hua's *Chang Dai-chien teh shih-chieh* 張大千的世界 (The World of Chang Dai-chien), pp. 28–34.

19  See "Pai-sui ch'ien-ch'iu chin-shih-ch'ing 百歲千秋金石情" (Eternal Feelings as Solid as Gold and Rocks) in ibid., pp. 74–79.

20  The artists with whom Chang associated in Shanghai included poet Hsieh Chin-yü 謝覲虞 (1899–1935, also known as Hsieh Yü-ts'en 謝玉岑), who was the older brother of the famous artist Xie Zhiliu 謝稚柳 (1910–98); painter Wu Hu-fan 吳湖帆 (1894–1968); and the famous connoisseur Yeh Kung-ch'o 葉公綽 (1880–1968), who advised Chang Dai-chien to bypass the later Chinese painting styles of the Ming and Ch'ing dynasties and cultivate the taste of earlier paintings of the T'ang, Sung, and Yüan dynasties. It was probably Yeh who persuaded Chang to spend two

Chang Dai-chien 張大千

Mountain Landscape after Hung-jen
   (1610–63)

*continued*

174   and a half years at the ancient Buddhist caves in Tun-huang.

21   Furthermore, Chang Dai-chien and Chang Feng also shared the same family name. Therefore, Chang borrowed the style name of this accomplished artist for his studio. Chang Dai-chien was so fond of the name Ta-feng T'ang that he used it to sign his works, as well as to represent his collection of paintings by early masters. For the origin of Chang Dai-chien's Ta-feng T'ang studio and information on Chang Feng, see Fu Shen, *Challenging the Past: The Paintings of Chang Dai-chien,* p. 49 and cat. no. 5, *Scholar Admiring a Rock* on pp. 96–98.

22   For more on Jen I, see entry 51.

23   For information on how Chang Dai-chien received early recognition as a forger and used this notoriety to promote himself, as well as how Huang Pin-huang (1864–1955) mistook his forgery for an original, see "Through Ancient Eyes, Signed as Shitao," in Fu Shen's *Challenging the Past: The Paintings of Chang Dai-chien,* pp. 84–87.

24   See Ch'en Ting-shan 陳定山 (1896–1989), *Ch'un-shen chiu-wen* 春申舊聞 (Old Stories in Shanghai), vol. 1 (Taipei: Ch'en-kuang Monthly Magazine Co., 1964), entry no. 83, "Ti-p'i ta-wang Cheng Lin-sheng 地皮大王程霖生" (The Real Estate Tycoon Cheng Lin-sheng), pp. 164–65.

25   For more on Shih-t'ao, see entry 29.

26   It seems Chang never felt guilty about selling these forgeries. Even during his later years, he was proud of his many forgeries. In 1960, Chang Dai-chien attended a lecture on Chu Ta 朱耷 (1626–1705) in New York given by Aschwin Lippe, the former curator of Asian art at the Metropolitan Museum of Art. Chang Dai-chien pointed out candidly that a couple of the slides used in the presentation were actually his forgeries of Chu Ta. Again in 1968, at a symposium and exhibition of Shih-t'ao 石濤 (1642–1707) held at the University of Michigan in Ann Arbor, Chang admitted in front of numerous scholars that a number of the paintings displayed in the exhibition were his counterfeits.

27   For information on Chang Dai-chien as a shrewd collector, see the chapter entitled "Collecting Ancient Masterpieces" in Fu Shen's *Challenging the Past: The Paintings of Chang Dai-chien,* pp. 39–42. The first group of famous old paintings in Chang Dai-chien's collection are reproduced in Chang Dai-chien, ed., *Ta-feng T'ang ming-chi* 大風堂名蹟 (Illustrated Catalogue of the Masterpieces from Chang Dai-chien's Ta-feng T'ang Studio), 4 vols. (Kyoto: Benrido 便利堂, 1955–56).

28   This story was told at a luncheon by Yü Chün-chih 虞君質, who taught at the National Taiwan Normal University, Taipei, and the Chinese University, Hong Kong. The author was present at this luncheon.

29   T'ang Yin's painting, now belonging to the Metropolitan Museum of Art, New York, is reproduced in Wan-go Weng, *Chinese Painting and Calligraphy: A Pictorial Survey* (New York: Dover Publications, 1978), no. 35, pp. 74–75.

30   *Lu-t'ing hsi-chou* 蘆汀繫舟 (A Boat Moored by a Reed Bank) is reproduced in *Ku-kung shu-hua t'u-lu* 故宮書畫圖錄 (Illustrated Catalogue of Calligraphy and Painting at the Palace Museum), vol. 7 (Taipei: National Palace Museum, 1993), p. 27

31   For a discussion of P'u Ju and his art, see entry 59.

32   This episode was witnessed by the author, who was a student of P'u Ju in 1956 at the National Normal University, Taipei. The fact that Chang Dai-chien often asked P'u Ju to inscribe favorable comments for his collection is not a secret. It is mentioned by several others as well. See Chu Sheng-chai's 朱省齋 article, "P'u Hsin-yü er-san-shih 溥心畬二三事" (Several Anecdotes of P'u Ju), published in Editorial Committee of the Lang-t'ao-sha 浪淘沙 Press, comp., *Chiu-wang-sun P'u Hsin-yü* 舊王孫溥心畬 (P'u Hsin-yü [P'u Ju]: A Descendant of the Former Imperial Family) (Taipei: Lang-t'ao-sha Press, 1974), p. 111. Chu Sheng-chai frankly stated that Chang Dai-chien often took advantage of P'u Ju's good nature. P'u was repeatedly asked by Chang to inscribe favorable comments for the dubious old paintings in Chang's collection. Chang would not even show these scrolls to P'u Ju. According to Chu, after Chang Dai-chien settled down in Brazil, he even wrote to P'u Ju in Taipei urging P'u to inscribe eleven characters on a piece of paper, "*Tung Yüan wan-mu ch'i-feng t'u, wu-shang shen-p'in* 董源萬木奇峰圖無上神品" (The Supreme Masterpiece: "Thousand Trees on Marvelous Mountain Peaks Scroll" by Tung Yüan), to be mounted on top of a painting in Chang's collection. Chang also demanded that P'u Ju sign and stamp a seal under the signature. Later, people heard P'u complaining, "Who knows whether this scroll is genuine or a fake? However, it would be rude if I rejected Chang's request."

33   A precocious boy, Chang Dai-chien had the ambition to be a professional painter as early as in his teens. By his mid-twenties, in 1925, he held his first one-person show in Shanghai. He displayed one hundred paintings and within one month had sold them all. According to a price list of the paintings by Chang Dai-chien and his older brother, Chang Shan-tzu, published in 1929, their least expensive paintings commanded a price that could feed a Chinese family of five to six for two years! See "Price List," in Fu Shen, *Challenging the Past: The Paintings of Chang Dai-chien,* pp. 76–78.

34   The history of the Wang-shih garden can be traced to the twelfth century during the Southern Sung dynasty (1127–1279). It is one of the most elegant residential gardens in Suchou. Even today it still attracts numerous tourists. As the layout of this garden is among the finest, Chang Dai-chien used it as a model to design the several gardens he occupied later in his life. While living at Wang-shih garden, Chang Dai-chien and his brother did not rent the whole property. They shared the garden with Yeh Kung-ch'o, the famous scholar who encouraged Chang to paint figure paintings and *kung-pi hua* 工筆畫, or paintings that are very precisely executed, with meticulous attention to details and modeling, and usually associated with color. For the history of the Wang-shih garden, see Suzhou Park and Garden Bureau, *Suzhou yuanlin (Suchou Yüan-lin)* 蘇州園林 (Gardens in Suchou) (Shanghai: Tongji University, 1991), pp. 96–106.

35   See the chapter entitled "Erh-ko yü-hu 二哥與虎" (My Second Elder Brother and [His] Tiger), in Hsieh Hsiao-hua's *Chang Dai-chien teh shih-chieh* 張大千的世界 (The World of Chang Dai-chien), pp. 35–41. The tiger the two Chang brothers raised in the Wang-shih garden later died and was buried there. Today, the stone stele in front of the tiger's tomb is still a popular tourist destination.

36   For artists using Mt. Huang as subject matter, see James Cahill ed., *Shadows of Mt. Huang: Chinese Painting and Printing of the Anhui School* (Berkeley: University Art Museum, 1981).

37   In 1931, Chang Dai-chien served as delegate to a government-sponsored exhibition sent to Japan. This exhibition included art from the T'ang, Sung, Yüan, and Ming dynasties. In 1933, Chang Dai-chien participated in the Chinese painting exhibition at the Musée du Jeu-de-Paume in Paris. His work *Lotus* was purchased by that museum.

38   Chang Dai-chien's 1934 exhibition in Peking was his first held in the north. The success of this show served as the impetus for Chang to move to the north and settle in Peking.

39   See the chapters entitled "Hsien-jih ni-liu 陷日逆流" (Falling into an Adverse Envi-

ronment under Japanese Occupation) and "T'o-hsien kuei-Shu 脫險歸蜀" (Escaping from a Dangerous Environment and Arriving in Szechwan), in Hsieh Hsiao-hua's *Chang Dai-chien teh shih-chieh* 張大千的世界 (The World of Chang Dai-chien), pp. 49–60.

40  See "Tun-huang mien-pi 敦煌面壁" (Meditating at the Grottos in Tun-huang), in ibid., pp. 61–73.

41  See ibid., p. 72.

42  Before World War II, when the last emperor Henry P'u I inaugurated the puppet Manchukuo government, he brought numerous old scrolls to Manchuria. These were mostly paintings that he had smuggled out from the Forbidden City between the time he abdicated in 1911 and the time he was eventually exiled in 1924. After the war, when he was arrested by the Russian army, his collection was raided and many of the paintings surfaced in the antique markets in Peking. See chapter 11, "Hao-ch'ing 豪情" (Lofty Sentiments), in Chung Ko-hao's 鍾克豪 "I-t'an tsung-shih Chang Dai-chien" 藝壇宗師張大千 (The Great Master in the Realm of Art: Chang Dai-chien) found in Ch'in Hsiao-yi 秦孝儀 comp., *Chang Dai-chien hsien-sheng chi-nien ts'e* 張大千先生紀念冊 (Commemorative Writings of Mr. Chang Dai-chien) (Taipei: National Palace Museum, 1983), p. 433. The old paintings Chang Dai-chien bought in Peking after World War II included two masterpieces: 1) *Han Hsi-tsai yeh-yen t'u* 韓熙載夜宴圖 (The Night Revels of Han Hsi-tsai), attributed to Ku Hung-chung 顧閎中 (active 943–60), an exquisite figure painting from which Chang learned the skill of fine-line drawing and how to apply color; and 2) the magnificent landscape handscroll *Hsiao-hsiang t'u* 瀟湘圖 (The Hsiao and Hsiang Rivers), attributed to Tung Yüan 董源 (active ca. 943–58). These two paintings are reproduced in color in Palace Museum Editorial Committee, *Gugong bowuyuan canghuaji (Ku-kung po-wu-yüan ts'ang-hua chi)* 故宮博物院藏畫集 (Paintings in the Collection of the Palace Museum) in the series *Zhongguo lidai huihua (Chung-kuo li-tai hui-hua)* 中國歷代繪畫 (Paintings of Past Dynasties), vol. 1 (Beijing: Renmin Meishu Chubanshe), pp. 84–93 and 98–100, respectively.

43  According to Chuang Shang-yen 莊尚嚴, the former Deputy Director at the National Palace Museum, Taipei, Chang Dai-chien first brought his two masterpieces to Taiwan and tried to sell them to the Palace Museum. Unfortunately, the Taiwanese government could not afford the high price. He then brought the two paintings to Hong Kong and eventually sold them to the Palace Museum, Beijing. It is generally believed that Premier Zhou Enlai 周恩來 approved the transaction.

44  See Fu Shen's *Challenging the Past: The Paintings of Chang Dai-chien*, p. 27.

45  See "Bade (Pa-teh) Garden" in appendix 3, "Garden and Residences," in ibid., pp. 311–12.

46  Information on Chang Dai-chien's trip to Europe and his rendezvous with Picasso is found in Chang's own writing. See Chang Dai-chien's "Pi Chia-so wan-ch'i ch'uang-tso chan hsü-yen 畢加索晚期創作展序言" (A Preface for the Exhibition of Picasso's Later Works), in Lo Shu-jen 樂恕人, comp., *Chang Dai-chien shih-wen chi* 張大千詩文集 (Collected Writings and Poems of Chang Dai-chien) (Taipei: Li-ming Bookstore, 1984), pp. 127–28. Chang's preface says: "Picasso was the great master of modern art in the West. I had heard Picasso's name when I was a teenager. Then I was able to meet him in the summer of the *pin-shen* year (1956). This was the year I first displayed my copies of the Tung-huang murals at the Musée Cernuschi, Paris, as well as my recent works at the Louvre Museum. [Editor's note: it was actually at the Musée d'Art Moderne, Paris]. Before the exhibitions, I went to Rome and observed the many works, including murals and sculptures, of the three Renaissance masters: da Vinci (1452–1519), Raphael (1483–1520), and Michelangelo (1475–1564). Thereby I witnessed many of the masterpieces of Western art in situ. With this understanding, I feel profoundly that art is the mutual language of humanity. Although the expression and presentation varies, the artistic conception, effectiveness, and techniques [in the East and West] are the same." (畢加索為泰西現代繪畫大師, 予少年時已耳聞其名. 而把晤論交, 則在民國四十五年丙申之夏. 是年, 予先後分展個人近作與敦煌摹本於巴黎羅浮, 東方兩博物館. 事前, 迺赴羅馬, 觀摩文藝復興與三傑; 達文西, 拉斐爾, 米蓋朗基羅之壁畫, 雕刻. 於西方傳統藝術實地研考, 先作了解. 深感藝術為人類共通語言. 表現方式或殊, 而講求意境, 功力, 技巧則一.)

47  It is difficult to ascertain the exact year that Chang began his experimental landscapes that clearly possessed elements of Western-style abstraction. There are examples of splashed-ink landscapes, such as his *Latter Ode on the Red Cliff* from the *Album of Miscellaneous Images*, as early as 1956. See Fu Shen's *Challenging the Past: The Paintings of Chang Dai-chien*, fig 55, p. 73. By the mid-sixties, this ink and color technique became Chang's predominant mode. Some have attributed this shift to his weakened eyesight; however, no one can deny the impact of West-ern art on Chang, as well as his creativity and originality.

48  This extraordinary masterpiece remains in the Chang family collection. For a reproduction of *Lu-shan t'u* 廬山圖 (Mount Lu), see Fu Shen, *Challenging the Past: The Paintings of Chang Dai-chien*, cat. no. 87, pp. 298–99.

49  See Fu Shen's *Challenging the Past: The Paintings of Chang Dai-chien*, cat. nos. 8, 9, 13, and 16. These are all Chang's forgeries in the style of the Four Monks. Chang even faked the signatures. A fan executed by Chang but signed Hung-jen is reproduced on p. 105.

50  During the same period, around 1935, Chang executed a number of scrolls in the style of Hung-jen with tinted paper, suggesting that he was investigating the possibility of producing paintings that could be passed off as genuine Hung-jen works. Another hanging scroll in the style of Hung-jen and dated 1935, is entitled *Precipitous Cliffs* (currently in the collection of C. P. Lin, Hong Kong). It is reproduced in ibid., cat. no. 13, p. 121.

51  For more on the Mt. Huang school, see James Cahill, ed., *Shadows of Mt. Huang: Chinese Painting and Printing of the Anhui School* (Berkeley: University Art Museum, 1981). See also entry 26 on Sun I.

52  Chang was most impressed with Picasso's continuous creative energy and his relentless drive to innovate. Although Chang had, up to this point, mastered the techniques of the past, he seemed never to have made dramatic change a priority. Chang not only admired Picasso but also understood how Picasso borrowed from the traditions of other cultures, such as those of Africa. He especially acknowledged Picasso's paintings in the Cubist style. He said that his initial reason for visiting Picasso was simply to satisfy a curiosity to meet him, as well as to fulfill a traditional Chinese obligation of paying respects to an older artist. Some have suggested that self-promotion was the primary motivation for the visit. Regardless of the exact reason, Chang was profoundly impressed with the Western master's creativity, intelligence, and knowledge. This meeting was also the likely impetus for Chang's later experiments that created a unique new style by synthesizing elements of Western and Chinese traditions. See Chang Dai-chien's "Pi Chia-so wan-ch'i ch'uang-tso chan hsü-yen 畢加索晚期創作展序言" (A Preface for the Exhibition of Picasso's Later Works), in Lo Shu-jen 樂恕人, comp., *Chang Dai-chien shih-wen chi* 張大千詩文集 (Collected Writings and

**Chang Dai-chien** 張大千
**Mountain Landscape after Hung-jen**
   **(1610–63)**
*continued*

176    Poems of Chang Dai-chien) (Taipei: Li-
        ming Bookstore, 1984), pp. 127–28.

   53   It is also interesting that Chang never
        understood any language other than Chi-
        nese. Whatever understanding he acquired
        of Western art was attained visually rather
        than intellectually.

# Chronology of Dynasties

*(pinyin romanization)*

| | |
|---|---|
| NEOLITHIC PERIOD 新石器時代 | c. 7000–c. 2000 B.C. |
| Yang-shao (Yangshao) Culture 仰韶 | c. 5000–c. 2000 B.C. |
| Hung-shan (Hongshan) Culture 洪山 | c. 3600–c. 2000 B.C. |
| Liang-chu (Liangzhu) Culture 良渚 | c. 3600–c. 2000 B.C. |
| Lung-shan (Longshan) Culture 龍山 | c. 3000–c. 1700 B.C. |
| | |
| BRONZE AGE | |
| **Hisa (Xia) Dynasty** 夏 | c. 2100–c. 1600 B.C. |
| **Shang Dynasty** 商 | c. 1600–c. 1100 B.C. |
| **Chou (Zhou) Dynasty** 周 | c. 1100–256 B.C. |
| Western Chou (Zhou) 西周 | c.1100–771 B.C. |
| Eastern Chou (Zhou) 東周 | 770–256 B.C. |
| Spring and Autumn Period 春秋 | 770–476 B.C. |
| Warring States Period 戰國 | 475–221 B.C. |
| **Ch'in (Qin) Dynasty** 秦 | 221–207 B.C. |
| | |
| IRON AGE | |
| **Han Dynasty** 漢 | 206 B.C.–A.D.220 |
| Western Han 西漢 | 206 B.C.–A.D. 8 |
| Hsin (Xin) [Wang Mang usurpation] 新莽 | 9–23 |
| Eastern Han 東漢 | 25–220 |
| **Period of Disunity** | 220–589 |
| Three Kingdoms 三國 | 220–280 |
| Wei 魏 | 220–265 |
| Shu Han 蜀漢 | 221–263 |
| Wu 吳 | 222–280 |
| Western Tsin (Jin) 西晉 | 165–316 |
| Southern Dynasties [or Six Dynasties] 南朝 [六朝] | |
| Wu [extension of Three Kingdoms] ? 吳 | 222–280 |
| Eastern Tsin (Jin) 東晉 | 317–420 |
| Liu Sung (Song) 劉宋 | 420–479 |
| Southern Ch'i (Qi) 南齊 | 479–502 |
| Liang 梁 | 502–557 |
| Ch'en (Chen) 陳 | 557–589 |
| Northern Dynasties 北朝 | 304–589 |
| Sixteen Kingdoms 十六國 | 304–439 |
| Northern Wei 北魏 | 386–534 |
| Eastern Wei 東魏 | 524–550 |
| Western Wei 西魏 | 535–557 |
| Northern Ch'i (Qi) 北齊 | 550–557 |
| Northern Chou (Zhou) 北周 | 557–581 |
| **Sui Dynasty** 隋 | 581–618 |
| **T'ang (Tang) Dynasty** 唐 | 618–907 |
| **Five Dynasty** 五代 | 907–960 |
| **Liao Dynasty** 遼 | 907–1125 |
| **Western Hsia** (Xia) 西夏 | 1032 –1227 |
| **Sung (Song) Dynasty** 宋 | 960–1279 |
| Northern Sung (Song) 北宋 | 960–1126 |
| Southern Sung (Song) 南宋 | 1127–1279 |
| **Chin (Jin) Dynasty** 金 | 1115–1234 |
| **Yüan (Yuan) Dynasty** 元 (founded 1206) | 1280–1368 |
| **Ming Dynasty** 明 | 1368–1644 |
| **Ch'ing (Qing) Dynasty** 清 | 1644–1911 |
| **Republic of China** 中華民國 | 1912– |
| **Peoples' Republic of China** 中華人民共和國 | 1949– |

# Chronology of Emperors

*Sung, Yüan, Ming,*
*and Ch'ing Dynasties*

\* *Restored to throne*

( ) *Emperors, who had no posthumous temple titles, are represented by their personal names.*

| Emperor's posthumous Temple Title | Reign Mark | Reign Dates |
|---|---|---|
| **Northern Sung** | | |
| T'ai-tsu 太祖 | | 960–76 |
| T'ai-tsung 太宗 | | 976–97 |
| Chen-tsung 真宗 | | 998–1022 |
| Jen-tsung 仁宗 | | 1023–63 |
| Ying-tsung 英宗 | | 1064–67 |
| Shen-tsung 神宗 | | 1068–85 |
| Che-tsung 哲宗 | | 1086–1100 |
| Hui-tsung 徽宗 | | 1101–25 |
| Ch'in-tsung 欽宗 | | 1126–27 |
| **Southern Sung** | | |
| Kao-tsung 高宗 | | 1127–62 |
| Hsiao-tsung 孝宗 | | 1163–89 |
| Kuang-tsung 光宗 | | 1190–94 |
| Ning-tsung 寧宗 | | 1195–1224 |
| Li-tsung 理宗 | | 1225–64 |
| Tu-tsung 度宗 | | 1265–74 |
| Kung-t 恭帝 | | 1275–76 |
| Tuan-tsung 端宗 | | 1276–78 |
| (Ti Ping) (帝昺) | | 1278–79 |
| **Yüan** | | |
| Shih-tsu 世祖 | | 1260–94 |
| Ch'eng-tsung 成宗 | | 1295–1307 |
| Wu-tsung 武宗 | | 1308–11 |
| Jen-tsung 仁宗 | | 1312–20 |
| Ying-tsung 英宗 | | 1321–23 |
| Chin tsung 晉宗 (or T'ai-ting-ti 泰定帝) | | 1324–28 |
| Wen-tsung 文宗 | | 1328–29 |
| Ming-tsung 明宗 | | 1329 |
| Wen-tsung \* 文宗 | | 1330–32 |
| Ning-tsung 寧宗 | | 1332–33 |
| (Shun-ti) (順帝) | | 1333–68 |
| **Ming** | | |
| T'ai-tsu 太祖 | Hung-wu (Hongwu) 洪武 | 1368–1398 |
| (Hui-ti) 惠帝 | Chien-wen (Jianwen) 建文 | 1399–1402 |
| Ch'eng-tzu 成祖 | Yung-lo (Yongle) 永樂 | 1403–1424 |
| Jen-tsung 仁宗 | Hung-hsi (Hongxi) 洪熙 | 1425 |
| Hsüan-tsung 宣宗 | Hsüan-teh (Xuande) 宣德 | 1425–1435 |
| Ying-tsung 英宗 | Cheng-t'ung (Zhengtong) 正統 | 1436–1449 |
| Tai-tsung 代宗 | Ching-t'ai (Jingtai) 景泰 | 1450–1457 |
| Ying-tsung\* 英宗 | T'ien-shun (Tianshun) 天順 | 1458–1464 |
| Hsien-tsung 憲宗 | Cheng-hua (Chenghua) 成化 | 1465–1487 |
| Hsiao-tsung 孝宗 | Hung-chih (Hong-zhi) 弘治 | 1488–1505 |
| Wu-tsung 武宗 | Cheng-teh (Zhengde) 正德 | 1506–1521 |
| Shih-tsung 世宗 | Chia-ching (Jiajing) 嘉靖 | 1522–1566 |
| Mu-tsung 穆宗 | Lung-ch'ing (Longqing) 隆慶 | 1567–1572 |
| Shen-tsung 神宗 | Wan-li (Wanli) 萬曆 | 1573–1619 |
| Kuang-tsung 光宗 | T'ai-ch'ang (Taichang) 泰昌 | 1620 |
| Hsi-tsung 熹宗 | T'ien-ch'i (Tianqi) 天啟 | 1621–1627 |
| (Ssu-tsung) 思宗 | Chung-chen (Chongzhen) 崇禎 | 1628–1644 |
| **Ch'ing** | | |
| Shih-tsu 世祖 | Shun-chih (Shun-zhi) 順治 | 1644–1661 |
| Sheng-tsu 聖祖 | K'ang-hsi (Kangxi) 康熙 | 1662–1722 |
| Shih-tsung 世宗 | Yung-cheng (Yongzheng) 雍正 | 1723–1735 |
| Kao-tsung 高宗 | Ch'ien-lung (Qianlong) 乾隆 | 1736–1796 |
| Jen-tsung 仁宗 | Chia-ch'ing (Jiaqing) 嘉慶 | 1796–1820 |
| Hsüng-tsung 宣宗 | Tao-kuang (Dao-guang) 道光 | 1821–1850 |
| Wen-tsung 文宗 | Hsien-feng (Xianfeng) 咸豐 | 1851–1861 |
| Mu-tsung 穆宗 | T'ung-chih (Tongzhi) 同治 | 1862–1874 |
| Teh-tsung 德宗 | Kuang-hsü (Guangxu) 光緒 | 1875–1908 |
| (P'u-i) (溥儀) | Hsüan-t'ung (Xuan-tong) 宣統 | 1908–1911 |

# Bibliography

*Collectanea and periodical are abbreviated as follows:*

HSCS. *Huashi congshu (Hua-shih ts'ung-shu)* 畫史叢書 (Compendium of Painting History). 10 vols. Yu, Anlan 于安瀾, comp. Shanghai: Renmin Meishu Chubanshe, 1962.

HLCK. *Hualun congkan (Hua-lun ts'ung-k'an)* 畫論叢刊 (Compendium of Painting Theory), 1st edition 1937. Yu, Anlan 于安瀾 ed. Reprint. 2 vols. Beijing: Renmin Meishu Chubanshe, 1962.

HPCS. *Huapin congshu (Hua-p'in ts'ung-shu)* 畫品叢書 (A Collection of Books on Painting). Liu, Haisu 劉海粟, ed. Shanghai: Renmin Meishu Chubanshe, 1982.

ILMCTK. *I-lin ming-chu ts'ung-k'an* 藝林名著叢刊 (Collected Famous Writings on Art Serial). Shanghai: World Press, 1936.

ILTL. *I-lin ts'ung-lu* 藝林叢錄 (A Collection of Articles on Art). 10 vols. Hong Kong: Commercial Bookstore, 1961–.

MSTS. *Mei-shu ts'ung-shu* 美術叢書 (Anthology of Writings on Fine Art). Teng, Shih 鄧實 (1865? –1948) and Huang Pin-hung 黃賓虹 (1865–1955), comp. Shanghai: 1912–36. Reprinted. 25 vols. Taipei: I-wen Bookstore, 1963–1972).

MSYJ. *Meishu yanjiu (Mei-shu yen-chiu)* 美術研究 (The Research and Study of Fine Arts). Editorial Committee of Meishu Yanjiu Journal, ed. Beijing: Central Art Academy, 1979–.

MSSL. *Meishushilun (Mei-shu-shih lun)* 美術史論 (History and Theory of Fine Arts). Compiled by Zhongguo Yishu Yanjiuyuan Meishushilun bianjibu (Chung-kuo I-shu Yen-chiu-yüan Mei-shu shih-lun pien-chi pu) 中國藝術研究院。"美術史論" 編輯部 (The Editorial Committee of the *History and Theory of Fine Arts* at the Institute of Fine Art, the Chinese Art Research Academy). Beijing: Wenhua Yishu Chubanshe, 1981–.

MSTK. *Mei-shu ts'ung-k'an* 美術叢刊 (Collected Works on the Fine Arts). 4 vols. Yü, Chün-chih 虞君質, comp. Taipei: Chung-hua ts'ung-shu wei-yüan-hui, 1956–65).

YBYJZLCS. *Yangzhou baguai yanjiu ziliao congshu (Yang-chou pa-kuai yen-chiu tzu-liao ts'ung-shu)* 揚州八怪研究資料叢書 (The Books on the Eight Eccentrics of Yangzhou Serial). Jiangsu: Meishu Chubanshe, 1992–.

ZGSHQS. *Zhongguo shuhua quanshu (Chung-kuo shu-hua ch'üan-shu)* 中國書畫全書 (The Complete Collection of Books on Chinese Painting and Calligraphy). Lu, Fusheng 盧輔聖 et al., comp. 12 vols.Shanghai: Shanghai Shuhua Chubanshe, 1992.

An, Ch'i 安歧 (1683–?). *Mo-yüan hui-kuan* 墨緣彙觀 ("Ink-remains, Examined and Classified," catalogue of calligraphy and painting in the author's collection), preface 1742. Reprinted in *ZGSHQS.*, vol. 10, pp. 315–416.

*Zhongguo gudai shuhua jingpin lu (Chung-kuo ku-tai shu-hua ching-p'in lu)* 中國古代書畫精品錄 (Masterpieces of Ancient Chinese Calligraphy and Painting). Compiled by Ancient Chinese Calligraphy and Painting Authentication Group. Beijing: Wenwu Chubanshe, 1984.

Andrews, Julia F. "Zha Shibiao," In James Cahill, ed. *Shadows of Mt. Huang: Chinese Painting and Printing of the Anhui School.* Berkeley: University Art Museum, 1981, pp. 102–8.

Ba, Tong's 巴東 *Chang Dai-chien yen-chiu* 張大千研究 (Research on Chang Dai-chien). Taipei: National Museum of History, 1998.

Barnhart, Richard M. et al. *Painters of the Great Ming: The Imperial Court and the Zhe School.* Dallas: Dallas Museum of Art, 1993.

—— et al. *Three Thousand Years of Chinese Painting.* New Haven: Yale University Press, 1997.

——. *Peach Blossom Spring: Gardens and Flowers in Chinese Paintings.* Exhibition catalogue. New York: Metropolitan Museum of Art, 1983.

Barry, Till. *Art of the Middle Kingdom: China.* Victoria: Art Gallery of Greater Victoria, 1986.

Beurdeley, Cécile and Michel. *Giuseppe Castiglione: A Jesuit Painter at the Court of the Chinese Emperors.* Rutland, Vermont, and Tokyo: Charles E. Tuttle Co., 1971.

Bickford, Maggie et al. *Bone of Jade, Soul of Ice.* New Haven: Yale University Art Gallery, 1985.

*Boguzhai cang shuhua ji (Po-ku-chai ts'ang shu-hua chi)* 博古齋藏書畫集 (Paintings and Calligraphy in the Collection of the Conversant with Antiquity Studio). Shanghai: Xinhua Bookstore, 1994.

Boorman, Howard L., ed. *Biographical Dictionary of Republican China.* New York: Columbia University Press, 1967–1971.

Brinker, Helmut. *Zauber des chinesischen Fächers* (The Magic of Chinese Fans). Zürich: Museum Rietberg, 1979.

Brizendine, Curtis H. "Cloudy Mountains: Kao K'o-kung and the Mi Tradition." Ph.D. diss. Lawrence: University of Kansas, 1980.

Brown, Claudia and Ju-hsi Chou. *Transcending Turmoil, Painting at the Close of China's Empire 1796–1911.* Phoenix: Phoenix Art Museum, 1992.

Buchanan, Keith et al., *China, the Land and the People, the History, the Art and the Science.* New York: Crown Publishers, Inc., 1980.

Bunker, Emma C. et al. *"Animal Style" Art from East to West.* New York: The Asia Society Inc., 1970.

Bush, Susan. *The Chinese Literati on Painting: Su Shih (1037–1101) to Tung Ch'i-ch'ang (1555–1636).* Cambridge, Mass.: Harvard University Press, 1971.

Cahill, James, ed. *An Index of Early Chinese Painters and Paintings.* Berkeley: University of California Press, 1980.

——. *Fantastics and Eccentrics in Chinese Painting.* New York: Asia Society, 1967.

——. *Parting at the Shore: Chinese Painting of the Early and Middle Ming Dynasty,* 1368–1580. New York and Tokyo: Weatherhill, 1978.

——. "Ren Xiong (Jen Hsiung) and His Self-portrait." *Ars Orientalis.* 25. Ann Arbor: The Department of the History of Art, University of Michigan, 1995. Pp. 119–32.

——, ed. *Shadows of Mt. Huang: Chinese Painting and Printing of the Anhui School.* Berkeley: University Art Museum, 1981.

——. *The Compelling Image: Nature and Style in Seventeenth-Century Chinese Painting.* Cambridge: Harvard University Press, 1982.

——. *The Distant Mountains: Chinese Painting of the Late Ming Dynasty, 1560–1644.* New York and Tokyo: Weatherhill, 1982.

——. "The Early Styles of Kung Hsien." *Oriental Art* 16.1. London: Oriental Art Magazine, Ltd., Spring 1970, pp. 51–71.

——. *The Painters' Practice: How Artists lived and Worked in Traditional China.* New York: Columbia University Press, 1994.

——. "The Painting Style of Sakai Hyakusen," *Bijutsu-shi* 美術史 (Journal of the Japan Art History Society) 3–96. Tokyo: Bijutsushi Gakkai, 1976.

——, ed. *The Restless Landscape: Chinese Painting of the Late Ming Period.* Berkeley: University Art Museum, University of California, 1971.

——. "The Six Laws and How to Read Them," in *Ars Orientalis* 4. Ann Arbor: the Department of the History of Art, University of Michigan, 1966, pp. 372–381.

——. "Tung Ch'i-ch'ang's Southern and Northern Schools in the History and Theory of Painting: A Reconsideration," in *Sudden and Gradual: Approaches to Enlightenment in Chinese Thought*, edited by Peter N. Gregory. Honolulu: University of Hawaii Press, 1987, pp. 429–46.

——. "Yüan Chiang and His School." *Ars Orientalis* 5 & 6. Ann Arbor: The Department of the History of Art, University of Michigan, 1963, pp. 259–72 and 1966, pp. 191–212.

Chan, Ching-feng 詹景鳳 (active 1567–98). *Dongtu xuanlan (Tung-t'u hsüan-lan)* 東圖玄覽 (Tung-t'u's [the author's *hao*] Extensive View, notes on calligraphy and painting), preface 1591. Reprinted in *MSTS.*, vol. 21, *chi* 集 (part) 5, *chi* 輯 (division) 1, pp. 3–126.

Chang, Ch'ao 張潮 (active 17th century). *Yü Ch'u hsin-chih* 虞初新誌 (Yü Ch'u's Newly Collected Notes), preface 1683. Reprinted and collated by Shen Tzu-ying 沈子英 Shanghai: Liang-hsi Press, 1924.

Chang, Ch'ou 張丑 (1577–1643), see Zhang Chou.

Chang, Dai-chien 張大千 (1899–1983). "Pi Chia-so wan-ch'i ch'uang-tso chan hsü-yen 畢加索晚期創作展序 言" (A Preface for the Exhibition of Picasso's Later Works). In Lo Shu-jen 樂恕人, comp. *Chang Dai-chien shih-wen chi* 張大千詩文集 (Collected Writings and Poems of Chang Dai-chien). Taipei: Li-ming Bookstore, 1984, pp. 127–28.

——. *Ta-feng T'ang ming-chi* 大風堂名蹟 (Illustrated Catalogue of the Masterpieces from Chang's Hall of the Strong Wind Collection), 4 vols. Kyoto: Benrido, 1955–56.

Chang, Keng 張庚 (1685–1760), see Zhang, Geng.

Chang, Kuang-pin 張光賓. *Yüan ssu-ta-chia* 元四大家 (Four Great Masters of the Yüan Dynasty). Taipei: National Palace Museum, 1975.

Chang, Ming-k'o 張鳴珂 (1828–1908). *Han-sung-ko t'an-i so-lu* 寒松閣談藝瑣錄 (A Record of Discussions on Art at the Frigid Pine Pavilion), preface 1908. Reprint. Shanghai: Wen-ming Bookstore, 1936.

Chang, Tai 張岱 (1597–c. 1676). *T'ao-an meng-i* 陶庵夢憶 (Memoirs of T'ao-an). Reprinted in Yang Chia-lo 楊家駱, comp. *Chung-kuo pi-chi hsiao-shuo ming-chu* 中國筆記小説名著 (Famous Chinese Novels and Literary Sketches Serial). Taipei: World Press, 1959.

Chang, Yen-yüan 張彥遠 (active mid 9th century), see Zhang, Yanyuan.

Chang, Yu-hsin 張又新 (active first half of 9th century). *Chien-ch'a-shui chi* 煎茶水記 (Water for Brewing Tea). Reprinted in *Wu-ch'ao hsiao-shuo ta-kuan* 五朝小説大觀 (The Grand Spectacle of Notes and Novels of the Previous Five Dynasties). Shanghai: Sao-yeh Shan-fang, 1937.

*Chang Yüeh-chün hsien-sheng, Wang Hsüeh-t'ing hsien-sheng, Lo Chih-hsi fu-jen chüan-tseng shu-hua t'eh-chan mu-lu* 張岳軍先生、王雪艇先生、羅志希夫人 捐贈書畫特展目錄 (The Catalogue of the Special Exhibition of the Painting and Calligraphy Donated by Mr. Chang Ch'ün, Mr. Wang Shih-chieh, and Mrs. Lo Chia-lun). Compiled by the National Palace Museum. Taipei: National Palace Museum, 1978.

Chao, Chi 趙佶 (Emperor Sung Hui-tsung 宋徽宗, r. 1101–26). "Ta-kuan ch'a-lu 大觀茶錄" (A Record of Tea during the Ta-kuan Reign [1107–10]). Reprinted in T'ao Tsung-i's 陶宗儀 *Shuo-fu* 説郛 (A Collection of Summaries of History and Novels). Vol. 52, pp. 11–16 (new pp. 0822–24).

Chao, Erh-hsün 趙爾巽 (1844–1927), see Zhao Erxun.

Chen, Deyun 陳得芸. *Gujin renwu bieming suoyin* (*ku-chin jen-wu pieh-ming so-yin*) 古今人物別名索引 (An Index of Ancient and Modern Sobriquets). Canton: 1937. Reprint. Shanghai: Shanghai Shudian, 1984.

Chen, Hongtian 陳宏天 et al. *Zhaoming wenxuan shizhu* (*Chao-ming wen-hsüan shih-chu*) 昭明文選釋注 (Selected Famous Writings by Prince Chao-ming, [Hsiao T'ung 蕭統 501–31], with Modern Translation and Annotation). Changchun: Jilin Wenshi Chubanshe, 1988.

Chen, Naiqian 陳乃乾. *Shiming biehao suoyin* (*Shih-ming pieh-hao so-yin*) 室名別號索引 (An Index of Sobriquets). Beijing: Zhonghua Shuju, 1982.

Chen, Shih-hsiang and Harold Acton. *The Peach Blossom Fan*. Berkeley: University of California Press, 1976.

Chen, Xizhong 陳希仲, ed. *Gong Banqian shanshuihua ketu gao* (*Kung Pan-ch'ien shan-shui-hua k'o-t'u kao*) 龔半千山水畫課徒稿 (Kung Hsien's Landscape Painting Models for Tutoring Students). Chengdu: Sichuan Renmin Chubanshe, 1981.

Ch'en, Chi-ju 陳繼儒 (1558–1639). *Ni-ku lu* 妮古錄 (A Record of Being Close with Antiquity), first edition 1635. Reprinted in *MSTS.*, vol. 5, *chi* 集 (part) 1, *chi* 輯 (division) 10, pp. 201–308.

Ch'en, Fang-mei 陳芳妹. *Tai Chin yen-chiu* 戴進研究 (Research on Tai Chin). Taipei: The National Palace Museum, 1981.

Ch'en, Jen-t'ao 陳仁濤 (1906–68). *Chin-k'uei ts'ang-hua* 金匱藏畫 (Paintings from Ch'en Jen-t'ao's Gold Cabinet Collection). Kyoto: n.p., 1956.

——. *Chin-k'uei ts'ang-hua p'ing-shih* 金匱藏畫評釋 (Comments on Paintings in Ch'en Jen-t'ao's Gold Cabinet Collection). Hong Kong: Tung-ying Co., 1956.

Ch'en, Pao-chen 陳葆真. "The Goddess of the Lo River: A Study of Early Chinese Narrative Handscrolls." Ph.D. diss. 2 vols. Princeton: Princeton University, 1987.

Ch'en, Ting-shan 陳定山 (1896–1989). *Ch'un-shen chiu-wen* 春申舊聞 (Old Stories in Shanghai). 2 vols. Taipei: Ch'en-kuang Monthly Magazine Co., 1964.

Cheng, Hsieh 鄭燮 (1693–1765). *Cheng Pan-ch'iao ch'üan-chi* 鄭板橋全集 (The Complete Collection of Cheng Hsieh's Writing). Reprint. Taipei: T'ien-jen Press, 1968.

Cheng, I-mei 鄭逸梅. *Hsiao-yang-ch'iu* 小陽秋 (A Small Version of Confucius' *Spring and Autumn*, minor history). Shanghai: Ji-xin Press, 1947.

Cheng, Shu-yin 鄭銀淑. *Hsiang Yüan-pien chih shu-hua shou-ts'ang yü i-shu* 項元汴之書畫收藏與藝術 (Hsiang Yüan-pien's Painting and Calligraphy Collection and His Art). In *I-shu ts'ung-k'e* 藝術叢刻 (Collection of Art Books Series). Taipei: Wen-shih-che Press, 1984.

Chi, Yu-kung 計有功 (active 1121–61), see Ji, Yougong.

Ch'ien, Ch'ien-i 錢謙益 (1522–1644), see Qian, Qianyi.

Chiang, Pao-ling 蔣寶齡 (1781–1840), see Jiang, Baoling.

Chiang, Chao-shen 江兆申 (1925–1996). *Kuan-yü T'ang Yin teh yen-chiu* 關於唐寅的研究 (A Study of T'ang Yin). Taipei: National Palace Museum, 1976.

——. "Wang Yüan-ch'i: Notes on a Special Exhibition." *National Palace Museum Bulletin*. 2. 4. Taipei: National Palace Museum, Sept. 1967, pp. 10–16.

——. *Wen Cheng-ming hua hsi-nien* 文徵明畫系年 (Wen Cheng-ming's Paintings at the National Palace Museum in Chronological Order). 2 vols. Tokyo: Orijin Bookstore, 1976.

——. "Wen Cheng-ming nien-p'u" 文徵明年譜 (The Chronicle of Wen Cheng-ming's Life) in *Ku-kung chi-k'an* 故宮季刊 (National Palace Museum Quarterly). 5. Taipei: National Palace Museum, 1971, no. 4, pp. 39–88; 6, 1972, no. 1, pp. 31–80; no. 2, pp. 45–75; no. 3, pp. 49–80; and no. 4, pp. 67–109.

——. "*Wen Cheng-ming yü Suchou hua-t'an* 文徵明與蘇州畫壇 (Wen Cheng-ming and the Suchou School of painting). Taipei: National Palace Museum, 1977.

——. "Wang Yüan-ch'i: Notes on a Special Exhibition." *National Palace Museum Bulletin*. 2. 4. Taipei: National Palace Museum, Sept. 1967, pp. 10–15.

Chiang, Ch'un 江春. "Wang Shih-min yü Wang Hui teh kuan-hsi 王時敏與王翬的關系" (The Relationship between Wang Shih-min [1592–1680] and Wang Hui [1632–1717]) in *ILTL.*, vol. 2, pp. 312–13.

Chiang, Kuang-hsü 蔣光煦 (1813–60). *Pieh-hsia chai shu-hua lu* 下齋書畫錄 (The Painting and Calligraphy at the Pieh-hsia Studio). 4 vols. N.d., n.p.

Chiang, Shao-shu 姜紹書 (active 1635–1680), see Jiang, Shaoshu.

Ch'ien, Mu 錢穆 *Kuo-shih ta-kang* 國史大綱 (An Outline of Chinese History). Taipei: Shang-wu Press, 1950.

Ch'ien, Yung 錢泳 (1759–1844), see Qian, Yong.

Ch'ien, Ch'ien-i 錢謙益 (1522–1644), see Qian, Qianyi.

Chin, Chang 金章 (1884–1939). *Haoliang zhile ji* (*Hao-liang chih-lo chi*) 濠梁知樂集 (Collected Writings of Sensing the Pleasure of the Fish in the Hao River), preface 1921. Reprint. Beijing: Wenwu Chubanshe, 1985.

Chin, Ch'eng 金城 (1878–1926). "Beilou lun-hua (Pei-lou lun-hua) 北樓論畫" (A Discussion on Paintings by Pei-lou [*hao* of Chin Ch'eng]). *Hushe yuekan* (*Hu-she yüeh-k'an*) 湖社月刊 (Lake Club Monthly). 1st ed. 1927, 1–10. Reprint. Vol. 1. Tianjin, Tianjin Guji Shudian, 1992, p. 16.

"Jin Gongbo xiansheng shilue (Chin Kung-po hsien-sheng shih-lüeh) 金拱北先生事略" (A Brief Biography of Chin Kung-po [*tzu* of Chin Ch'eng]). *Hu-she yüeh-k'an* 湖社月刊 (Lake Club Monthly). Reprint. Vol. 1, pp. 2–3.

Chin, Nung 金農 (1687–1764). *Dongxinji* (*Tung-hsin chi*) 冬心集 (Chin Nung's Anthology), preface 1733. Reprint. Shanghai: Shanghai Guji Chubanshe, 1979.

——. *Tsa-hua t'i-chi* 雜畫題記 (Inscriptions on Paintings of Miscellaneous Subjects). Reprinted in *MSTS.*, vol. 11, *chi* 集 (part) 1, *chi* 輯 (division) 3, pp. 171–211.

——. *Tung-hsin hua-chu t'i-chi* 冬心畫竹題記 (A Collection of Chin Nung's Inscriptions on his Bamboo Paintings), preface 1750. Reprinted in *MSTS.*, vol. 2, *chi* 集 (part) 1, *chi* 輯 (division) 3, pp. 61–84.

——. *Tung-hsin hua-ma t'i-chi* 冬心畫馬題記 (A Collection of Chin Nung's Inscriptions on His Horse Paintings), manuscript completed 1762. Reprinted in *MSTS.*, vol. 2, *chi* 集 (part) 1, *chi* 輯 (division) 3, pp. 93–98.

——. *Tung-hsin hua-mei t'i-chi* 冬心畫梅題記 (A Collection of Chin Nung's Inscriptions on His Plum Blossom Paintings). Reprinted in *MSTS.*, vol. 2, *chi* 集 (part) 1, *chi* 輯 (division) 3, pp. 85–92.

——. *Tung-hsin hsien-sheng hsü-chi* 冬心先生續集 (Sequel to Chin Nung's [Poetry] Anthology), preface 1773. Ed. by Lo P'in 羅聘 (1733–99). Reprinted in *Hsi-ling wu-pu-i i-chu* 西泠五布衣遺著 (The Written Legacies of Five Deceased Scholars from Hangchou Who Never Occupied Any Official Positions). Hangchou: Hsi-ling Seal Guild, 1904.

——. *Tung-hsin hsien-sheng san-t'i-shih* 冬心先生三體詩 (Chin Nung's Poems in Three Different Styles), preface 1752, published in 1773. Reprinted in *Hsi-ling wu-pu-i i-chu* 西泠五布衣遺著 (The Written Legacies of Five Deceased Scholars from Hangchou Who Never Occupied any Official Positions)

Ch'in, Hsiao-yi 秦孝儀, comp. *Chang Dai-chien hsien-sheng chi-nien ts'e* 張大千先生紀念冊 (Commemorative Writings of Mr. Chang Dai-chien). Taipei: National Palace Museum, 1983.

Ch'in, Tsu-yung 秦祖永 (1825–1884), see Qin, Zuyong.

*Chinese Art Treasures* (exhibition catalogue of treasures from the National Palace Museum). Taipei. Washington, D.C., Geneva: Skira, 1961.

*Chinese Paintings of the Ming and Qing Dynasties, 14th–20th Centuries*. Exhibition catalogue. International Cultural Corporation of Australia, Ltd., n. p., 1981.

*Ch'ing Kao-tsung yü-chih shih-wen ch'üan-chi* 清高宗御製詩文全集 (The Complete Anthology of Emperor Ch'ien-lung [1711–1799]). 10 vols. Reprint. Taipei: National Palace Museum, 1976.

*Ch'ing-shih-kao chiao-chu* 清史稿校注 (The Collated Draft of the History of the Ch'ing Dynasty with Commentary). Compiled by the National Historical Bureau. Taipei: Kuo-shih-kuan, 1986–.

*Ch'ing-shih lieh-chuan* 清史列傳 (Biographies of the Ch'ing Dynasty). 80 vols. Compiled by the National Historical Bureau. Shanghai: Chung-hua Press, 1928.

*Chiu-wang-sun P'u Hsin-yü* 舊王孫溥心畬 (P'u Hsin-yü [P'u Ju], a Descendant of the Former Imperial Family). Compiled by Editorial Committee of the Lang-t'ao-sha Press. Taipei: Lang-t'ao-sha Press, 1974.

Chou, Ch'i-Tzu 周棄子. "Chung-kuo wen-jen-hua tsui-hou i-pi 中國文人畫最後一筆" (The Last Brush Stroke of the Chinese Literati Painters). In *Chiu-wang-sun P'u Hsin-yü* 舊王孫溥心畬 (P'u Hsin-yü [P'u Ju]: A Descendant of the Former Imperial Family), p. 118–121 .

Chou, Hui 周暉 (active early 17th century), see Zhou, Hui.

Chou, Ju-hsi, trans. "The *Hua-yü-lu* and Tao Chi's Theory of Painting" *Occasional Paper*. 9. Tempe: Arizona State University, 1977.

Chou, Ju-hsi and Claudia Brown. *The Elegant Brush, Chinese Painting Under the Qianlong Emperor 1735–1795*. Phoenix: Phoenix Art Museum, 1985.

Chou, Liang-kung 周亮工 (1612–1672). *Shu-hua tse-lu* 書影擇錄 (Selected Notes from the Shadows of Books). Reprinted in *MSTS*. Vol. 2, *chi* 集 (part) 1, *chi* 輯 (division) 4, pp. 207–8.

——. see also Zhou, Lianggong.

Chu, Ch'uan-yü 朱傳譽, ed. *P'u Hsin-yü chuan-chi tzu-liao* 溥心畬傳記資料 (Materials on P'u Hsin-yü's [P'u Ju] Biography). Taipei: T'ien-i Press, 1979.

Chu, Doris C. J. *T'ang Yin (1470–1524): The Man and His Art*. New York: Highlight International, 1986.

Chu, I-tsun 朱彝尊 (1629–1709). *P'u-shu-t'ing shu-hua pa* 曝書亭書畫跋 (Colophons for Paintings and Calligraphy Composed at [Chu's] Airing-books Pavilion). Reprinted in *MSTS.*, vol. 5, *chi* 集 (part) 1, *chi* 輯 (division) 9, pp. 153–185.

Chu, Jing-hua 朱靜華, see Ju, Jane Chuang.

Chu, Sheng-chai 朱省齋. "P'u Hsin-yü erh-san shih 溥心畬二三事" (Several Anecdotes of P'u Hsin-yü [P'u Ju]). In *Chiu-wang-sun P'u Hsin-yü* 舊王孫溥心畬 (P'u Ju, A Descendant of the Former Imperial Family). Compiled by Lang-t'ao-sha Press. Taipei: Lang-t'ao-sha Press, 1974.

Chu Chih-ch'ih 朱之赤 (active mid-17th c.). *Chu Wo-an ts'ang shu-hua mu* 朱臥庵藏書畫目 (A Catalogue of Painting and Calligraphy in Chu's Sleeping-hut Collection). Reprinted in *MSTS.*, vol. 8, *chi* 集 (part) 2, *chi* 輯 (division) 6, pp. 65–126.

Chuang, Chou 莊周 (c. 300 BC). *Chuang-tzu* 莊子 (The Work of Chuang Chou, with comments by Chang Ti-kuang 張耿光). Taipei: Ti-ch'iu Press, 1994.

*Chugoku no kaiga: Min, Shin, kindai* 中國の繪畫明, 清, 近代 (The Chinese Painting from the Hashimoto 橋本 Collection]: Ming, Ch'ing, and Modern). Nara: The Museum Yamato Bunkakan, 1980.

Chung, Ko-hao 鍾克豪. "I-t'an tsung-shih Chang Dai-chien" 藝壇宗師張大千 (The Great Master in the Realm of Art: Chang Dai-chien). In Ch'in Hsiao-yi 秦孝儀

comp. *Chang Dai-chien hsien-sheng chi-nien ts'e* 張大千先生紀念冊 (Commemorative Writings of Mr. Chang Dai-chien). Taipei: National Palace Museum, 1983, pp. 418–436.

*Chung-kuo chin-tai ming-chia shu-hua chi* 中國近代名家書畫集 (Collected Works of Famous Modern Chinese Painters and Calligraphers). In *Kuo-t'ai Mei-shu kuan hsüan-chi* 國泰美術館選集 (Selected Works from the Collection of the Kathay Art Museum Serial). Vol. 1. Taipei: Kathay Art Museum, 1977.

*Chung-kuo li-tai shu-hua chuan-k'o-chia tzu-hao so-yin* 中國歷代書畫篆刻家字號索引 (Index to Alternate Names of Chinese Calligraphers, Painters, and Seal Carvers). Hong Kong: Chung-kuo shu-hua yen-chiu hui, 1978.

Clapp, Anne De Coursey. *Wen Cheng-ming: The Ming Artist and Antiquity*. Artibus Asiae Supplementum 34. New York: New York University, 1975.

——. *The Painting of T'ang Yin*. Chicago and London: University of Chicago Press, 1991.

Clark, John, ed. *Modernity in Asian Art*. Honolulu: University of Hawaii Press, 1993.

K'ung Ch'iu 孔丘 (Confucius) (551–478 B.C.). *Lun-yü* 論語 (The Analects). Translated by D. C. Lau. New York: Penguin Books, 1979.

Contag, Victoria and Wang Chi-ch'üan 王季銓. *Maler-und Sammler-Stempel aus der Ming-und Ch'ing-Zeit* (Seals of Chinese Painters and Collectors of the Ming and Ch'ing Periods), first edition Shanghai: 1939, Reprint. Taipei: Shang-wu Press, 1965.

De Bary, W. Theodore. *Self and Society in Ming Thought*. New York: Columbia University Press, 1970.

Deng, Chun (Teng, Ch'un) 鄧椿 (active 12th century). *Huaji (Hua-chi)* 畫繼 (Painting Continuation, treatise on painters and paintings of the period between 1070–1160), preface 1167. 10 *juan (chüan)* 卷 (chapter). Reprinted in *HSCS*. Vol. 3.

Ding, Xiyuan's 丁羲元. *Ren Bonian (Jen Po-nien)* 任伯年. Shanghai: Shuhua Chubanshe, 1989.

*Dongnan wenhua (Tung-nan wen-hua)* 東南文化 (The Southeast Civilization Periodical), special issue on Kung Hsien. 5. Nanjing: Jiangsu Guji Chubanshe, 1990.

Dong, Qichang (Tung, Ch'i-ch'ang) 董其昌 (1555–1636). *Huachanshi suibi (Hua-ch'an-shih sui-pi)* 畫禪室隨筆 (Casual Notes at the Author's Painting-Ch'an Studio), preface 1720. Reprinted in *YLMZCK*.

Dong, You (Tung, Yu) 董逌 (active 1st quarter of 12th century). *Guangchuan huaba (Kuang-ch'uan hua-pa)* 廣川畫跋 (Painting Colophons of Tung Yu). 6 *juan (chüan)* 卷 (chapter). Reprinted in *HPCS*.

Dubosc, Jean-Pierre (1903–88). "A Letter and fan Painting by Ch'iu Ying." *Archives of Asian Art*. 28. New York: Asia Society, 1974–75, pp. 108–12.

Ecke, Gustuf. *Chinese Painting in Hawaii*. Honolulu: Honolulu Academy of Arts, 1965.

Ecke, Tseng Yu-ho 曾幼荷. *Chinese Calligraphy*. Philadelphia: Philadelphia Museum of Art, 1971.

——. *Poetry on the Wind: The Art of Chinese Folding Fans from the Ming and Ch'ing Dynasties*. Honolulu: Honolulu Academy of Arts, 1982.

Edwards, Richard. *The Field of Stones: A Study of the Art of Shen Chou (1427–1509)*. Washington, D.C.: Smithsonian Institution, Freer Gallery of Art, 1962.

——. "Pine, Hibiscus and Examination Failure," *University of Michigan Museum of Art Bulletin*. Ann Arbor: University of Michigan Museum of Art, 1965–66.

——. *The Art of Wen Cheng-ming (1470–1559)*. Ann Arbor: University of Michigan Museum of Art, 1976.

——. *The Painting of Tao-chi*. Ann Arbor: University of Michigan Museum of Art, 1967.

——. *The World Around the Chinese Artist*. Ann Arbor: University of Michigan, 1987.

*Eighty Works in the Collection of the University of Michigan Museum of Art: A Handbook*. Ann Arbor: The University of Michigan Museum of Art.

Ellsworth, Robert Hatfield. *Later Chinese Painting and Calligraphy: 1800–1950*. New York: Random House, 1986.

Endo, Koichi 遠藤孝一, trans. *Sekito Gagoroku* 石濤話語錄 (Shih-t'ao's Notes on Paintings). Tokyo: Nihon Bijutsu Shinho Sha, 1977.

*Exhibition of Paintings of the Ming and Ch'ing Periods*. Exhibition catalogue. Hong Kong: City Museum and Art Gallery, 1970.

Fan Ye (Fan, Yeh) 范曄 (398–445). *HouHan shu (Hou-Han shu)* 後漢書 (The Book of the Later Han Dynasty). Reprint. Beijing: Zhonghua Shuju, 1973.

Fang, Xuanling (Fang, Hsüan-ling) 房玄齡 (578–648) et al. *Jinshu (Tsin-shu)* 晉書 (The Book of Tsin), 1st ed. 648. Reprint. Beijing: Zhonghua Shuju, 1974.

Feng, Jinbo (Feng, Chin-po) 馮金伯 (active second half of 18th century). *Guochao huashi (Kuo-ch'ao hua-shih)* 國朝畫識 (Identification of Painters of the Ch'ing Dynasty), first edition 1797. 27 *juan (chüan)* 卷 (chapter). Reprinted in *ZGSHQS.*, vol. 10, pp. 571–684.

Feng, Kuei-fen 馮桂芬 and Li Ming-huan 李銘皖 *Su-chou-fu chih* 蘇州府誌 (Gazetteer of Suchou Prefecture), first edition 1883. Reprint. Taipei: Ch'eng-wen Press, 1970.

Feng, Zhaoping 馮兆平 and Hu Cao 胡操. *Lushan lidai shixuan (Lu-shan li-tai shih-hsüan)* 廬山歷代詩選 (Selected Poems on Mount Lu by Poets of Past Dynasties). Nanchang: Jiangxi Renmin Chubanshe, 1980.

Fong, Wen C. *Beyond Representation: Chinese Painting and Calligraphy 8th–14th century*. New York: The Metropolitan Museum of Art, 1992.

——. "Wang Hui: The Great Synthesis." *Ku-kung chi-k'an* 故宮季刊 (National Palace Museum Quarterly) 3. 2. Taipei: National Palace Museum, 1968, pp. 5–10.

——. "Orthodoxy and Change in Early-Ch'ing Landscape Painting." *Oriental Art*. 16. 1. London: Oriental Art Magazine, Ltd., Autumn, 1983, pp. 38–44.

——. and James C. Y. Watt. *Possessing the Past: Treasures from the National Palace Museum, Taipei*. New York: The Metropolitan Museum of Art and Taipei: National Palace Museum, 1996.

—— et al. *Images of the Mind, Selections from the Edward L. Elliott Family and John B. Elliott Collections of Chinese Calligraphy and Painting at the Art Museum, Princeton University*. Princeton: The Art Museum, Princeton University, 1984.

Foucade, François. *Art Treasures of the Peking Museum*. New York: Abrams, n.d.

Fu, K'ai-sen (Ferguson, John C.) 福開森 (1866–1945), comp. *Li-tai chu-lu hua-mu mu-lu* 歷代著錄畫目目錄 (Index of Recorded Chinese Paintings in All Periods). First edition, Nanking: 1934. Reprinted. Taipei: Chun-hua Press, 1968.

Fu, Shen C. Y. 傅申. "An Aspect of Mid-Seventeenth Century Chinese Painting: The 'Dry Linear' Style and the Early Work of Taochi," in *Journal of the Institute of Chinese Studies of the Chinese University of Hong Kong*. 8. Hong Kong: Chinese University of Hong Kong, December 1976.

——. *Chang Dai-chien teh shih-chieh* 張大千的世界 (The World of Chang Dai-chien). Taipei: I-chih T'ang Wen-hua Ch'u-pan Shih-yeh Co., 1998.

——. "Foruier cang Wang Hui Fuchun juan de xiangguan wenti (Fo-jui-erh ts'ang Wang Hui Fu-ch'ün chüan teh hsiang-kuan wen-t'i) 佛瑞爾藏王翬富春卷的相關問題"(Related Issues Concerning Wang Hui's *Fu-ch'un* Scroll at the Freer Gallery). in *Qingchu siWang huapai yanjiu* 清初四王畫派研究 (Research on the Paintings of the Four Wangs of the Early Ch'ing Dynasty), pp. 629–53.

——. *Traces of the Brush: Studies in Chinese Calligraphy*. New Haven, Yale University Press, 1977.

—— et al. *Challenging the Past: The Paintings of Chang Dai-chien*. Washington D. C.: Arthur M. Sackler Gallery, Smithsonian Institution, 1991.

Fu, Marilyn Wong, and Shen C. Y. Fu. *Studies in Connoisseurship: Chinese Paintings from the Arthur M. Sackler Collection in New York and Princeton*. Princeton: Princeton University Press, 1973.

Gao, Shihqi (Kao, Shih-ch'i) 高士奇 (1645–1704). *Jiangcun shuhua mu* (*Chiang-ts'un shu-hua mu* 江村書畫目 (A List of Painting and Calligraphy in Kao's Collection). Reprinted in *ZGSHQS.*, vol. 7, pp. 988–1040.

——. *Jiangcun xiaoxia lu* (*Chiang-ts'un hsiao-hsia lu*) 江村消夏錄 (Chiang-ts'un's [*hao* of Kao Shih-ch'i] Catalogue for Whiling away the Hot Summer Days: Paintings and Calligraphy Seen and Owned by Kao between 1690 an 1693). Reprinted in *ZGSHQS.*, vol. 7, pp. 1068–78.

Gao, Yun 高雲 and Huang Jun 黃峻, eds. *Zhongguo minjian bicang huihua zhenpin* (*Chung-kuo min-chien pi-ts'ang hui-hua chen-p'in*) 中國民間秘藏繪畫珍品 (Precious Paintings from Private Collections in China). Nanjing: Jiangsu Meishu Chubanshe, 1989.

Giacalone, Vito and Ginger Cheng-chi Hsü. *The Eccentric Painters of Yangzhou*. New York: China Institute in America, 1990.

Giles, Herbert A. *A Chinese Biographical Dictionary*. London and Shanghai: B. Quaritch, 1898.

Gong, Bin 龔斌. *Tao Yuanming ji jiaojian* (*T'ao Yüan-ming chi chiao-chien*) 陶淵明集校箋 (T'ao Yüan-ming's Anthology with Collation by Gong Bin). Shanghai: Shanghai Guji Chubanshe, 1996.

Gong, Chanxing 龔產興. "Ren Weichang shengping shilue kao (Jen Wei-ch'ang sheng-p'ing shih-lüeh k'ao) 任渭長生平事略考" (A Research on Jen Hsiung's Life Story), in *MSYJ.*, 4. 1981, pp. 86–88.

——. *Ren Bonian yanju* (*Jen Po-nien yan-chiu*) 任伯年研究 (A Study of Jen Po-nien). Tianjin: Renmin Meishu Chubanshe, 1982.

——. "Ren Weichang nianbiao (Jen Wei-ch'ang nien-piao) 任渭長年表" (Chronological Table of Jen Hsiung). *MSSL.*, 25. 1988, pp. 80–4.

Gong, Xian (Kung, Hsien) 龔賢 (c. 1618–89). *Caoxiangtang ji* (*Ts'ao-hsiang t'ang chi*) 草香堂集 (The Grass-fragrance Hall Anthology), first edition c. 1660. Reprinted in Liu, Haisu 劉海粟, ed. *Kung Hsien yen-chiu chi*) 龔賢研究集 (Collected Research Materials on Kung Hsien), vol. 1, pp. 9–125.

Goodrich, L. Carrington and Fang Chaoying, eds. *Dictionary of Ming Biography, 1368–1644*. New York and London: Columbia University Press, 1976.

*Zhongguo gudai shuhua tumu* (*Chung-kuo ku-tai shu-hua t'u-mu*) 中國古代書畫圖目 (Illustrated Catalogue of Selected Works of Ancient Chinese Painting and Calligraphy). Compiled by Group for the Authentication of Ancient Works of Chinese Painting and Calligraphy. 24 vols. Beijing: Wenwu Chubanshe, 1986– .

Gu, Linwen 顧麟文, *Yangzhou bajia shiliao* (*Yang-chou pa-chia shih-liao*) 揚州八家史料 (Historical Material of the Eight Masters in Yangchou). Shanghai: Renmin Meishu Chubanshe, 1962.

Gu, Qiyuan (Ku, Ch'i-yüan) 顧起元 (1565–1628). *Kezuo zhuiyu* (*K'o-tso chui-yü*) 客座贅語 (Notes on Miscellaneous Subjects from the Conversations of My Guests), postscript dated 1618, 4 *juan* (*chüan*) 卷 (chapter). Reprint. Beijing: Zhonghua Shuju Chubanshe, 1991.

*Guangzhou Meishuguan cang MingQing huihua* (*Kwang-chou Po-wu-kuan ts'ang Ming-Ch'ing hui-hua*) 廣州美術館藏明清繪畫 (Paintings of the Ming and Qing Dynasties from the Guangzhou Art Gallery). Hong Kong: The Chinese University of Hong Kong, 1986.

*Gugong bowuyuan canghuaji* (*Ku-kung po-wu-yüan ts'ang-hua chi*) 故宮博物院藏畫集 (Paintings in the Collection of the Palace Museum). Compiled by Palace Museum Editorial Committee. 8 vols. Beijing: Renmin Meishu Chubanshe, 1986.

*Gugong bowuyuan cangbao lu* (*Ku-kung po-wu-yüan ts'ang-pao lu*) 故宮博物院藏寶錄 (A Catalog of the Treasures at the Palace Museum). Compiled by Gugong Bowuyuan Zijincheng Chubanshe. Shanghai: Wenyi Chubanshe, 1986.

*Gugong bowuyuan cang MingQing shanmian shuhua ji* (*Ku-kung po-wu-yüan ts'ang Ming-Ch'ing shan-mien shu-hua chi*) 故宮博物院藏明清扇面書畫集(Ming and Ch'ing Fan Album Leaves at the Palace Museum). Compiled by the Palace Museum. Beijing: Renmin Meishu Chubanshe, 1985.

*Gugong bowuyuan yuankan* (*Ku-kung po-wu-yüan yüan-k'an*) 故宮博物院院刊 (Palace Museum Bulletin). Compiled by The Editorial Committee of the Palace Museum Bulletin. Beijing: Palace Museum, 1958– .

Guo, Ruoxu (Kuo, Jo-hsü) 郭若虛 (fl. 1070–75). *Tuhua jianwen zhi* (*T'u-hua chien-wen chih*) 圖畫見聞誌 (A Record of Experiences in Painting), completed c. 1075. 6 *chüan* 卷 (chapter). Reprinted in *HSCS.* Vol. 1.

Guo, Weiqu 郭味蕖, ed. *SongYuan MingQing shuhuajia nianbiao* (*Sung-Yüan Ming-Ch'ing shu-hua-chia nien-piao*) 宋元明清書畫家年表 (A Chronological Table of Painters and Calligraphers of the Sung, Yüan, Ming, and Ch'ing Dynasties ). Beijing: Renmin Meishu Chubanshe, 1958.

Hajek, Lubor. "A Landscape Album by Gong Xian (Kung Hsien) Dated 1637." *Orientations* 22.8. Hong Kong: Orientations Magazine Ltd., August 1991, pp. 43–49.

Hansford, S. Howard. *A Glossary of Chinese Art and Archaeology*. London: The China Society, 1961

Hay, Jonathan Scott. "Shitao's Late Work (1697–1707)." Ph.D. diss. Vols. 1–3. New Haven: Yale University, 1989.

Hay, Jonathan. "The Suspension of Dynastic Time." In John Hay, ed. *Boundaries in China*. London: Reaktion Books Ltd., 1994, pp. 171–97.

He, Liangjun (Ho, Liang-chün) 何良俊 (1506–1573). *Siyouzhai congshuo* (*Ssu-yu chai ts'ung-shuo*) 四友齋叢説 (Collected Notes at Ho's Four-Friend Studio), preface 1569. Reprint. Beijing: Zhonghua Press, 1959.

Ho, Cheng-kuang 何政廣, ed. *Shih-t'ao teh shih-chieh* 石濤的世界 (The World of Shih-t'ao). Taipei: Hsiung-shih mei-shu yüeh-k'an she, 1973.

Ho, Ch'iao-yüan 何喬遠 (active 1st half of 17th century), comp. *Ming-shan ts'ang* 名山藏 (Treasures in a Famous Mountain). 20 *juan* (*chüan*) 卷 (chapter). Reprint. Taipei: Ch'eng-wen Press, Ltd., 1971.

Ho, Liang-chün 何良俊 (1506–1573), see He, Liangjun.

Ho, Ping-ti 何秉棣. *The Ladder of Success in Imperial China: Aspects of Social Mobility, 1368–1911*. Science Editions, Studies of the East Asian Institute Serial. New York: The East Asian Institute, 1964.

——. "The Salt Merchants of Yangchou: A Study of Commercial Capitalism in Eighteenth Century China." *Harvard Journal of Asiatic Studies*. 17. Cambridge: Harvard University, June 1954, pp. 130–68.

Ho, Wai-kam 何惠鑑 et al. *Eight Dynasties of Chinese Paintings: The Collections of the Nelson Gallery-Atkins Museum, Kansas City, and the Cleveland Museum of Art*. Cleveland: Cleveland Museum of Art, 1980.

——, ed. *The Century of Tung Ch'i-ch'ang 1555–1636*. Kansas: The Nelson-Atkins Museum of Art, 1992.

Hsi-pai 希白. "Chi Jen Hsiung ta-mei shan-min shih-chung hua-ts'e 記任熊大梅山民詩中畫冊" (A Record of Jen Hsiung's Album Leaves Based on Poems by Yao Hsieh, [Whose Sobriquet Was] a Dweller in the Great-plum Mountain). In *ILTL*, vol. 10, pp. 256–62.

Hsia, Wen-yen 夏文彥 (active mid-14th c.), see Xia, Wenyan.

Hsiao, Chi-tsung 蕭繼宗. *Meng Hao-jan shih-shuo* 孟浩然詩説 (An Explanation of Meng Hao-jan's Poetry). Reprint. Taipei: Commercial Press, 1985.

Hsiao, Yün-ts'ung 蕭雲從 (1596–1674). *T'ai-p'ing shan-shui shih-hua ts'e* 太平山水詩畫冊(Landscapes of and Poems of the T'ai-p'ing Area), 1st ed. c. 1650. Reprinted, 2 vols. Osaka: n.p., 1931.

Hsieh, Hsiao-hua 謝孝華. *Chang Dai-chien teh shih-chieh* 張大千的世界 (The World of Chang Dai-chien). Taipei: Cheng-hsin Press, 1968.

*Hsin-yü hsüeh-li tzu-shu* 心畬學歷自述 (A Self-account of My [P'u Ju's] Educational Background). In *Chiu-wang-sun P'u Hsin-yü* 舊王孫溥心畬 (P'u Hsin-yü [P'u Ju], a Descendent of the Former Imperial Family). Pp. 122–25. (The manuscript is reproduced as a front leaf in the book.)

Hsu, Cheng-chi (Ginger). "Chü Chieh: A Problematic Painter in the 16th Century." *National Palace Museum Bulletin*. 19. 6. Part 1. Taipei: National Palace Museum, January-February, 1985; 20. 1. Part 2. March-April, 1986.

———. "Patronage and the Economic Life of the Artist in Eighteenth Century Yangchou Painting." Ph.D. diss. Berkeley: University of California Berkeley, 1987.

Hsü, Wei 徐渭 (1521–93). *Hsü Wen-ch'ang ch'üan-chi* 徐文長全集 (The Complete Collected Writings of Hsü Wei). Hong Kong: Kuang-chih Press, 1956.

*Hsüan-ho hua-p'u* 宣和畫譜 (Catalogue of the Imperial Painting Collection During the Hsüan-ho Era [1119–25]), preface 1120. Facsimile reprint. Taipei: National Palace Museum, 1771.

Hsüeh, T'ien-pei 薛天沛. *I-chou shu-hua lu hsü-pien* 益州書畫錄續編 (Sequel to Record of Painting and Calligraphy from Szechwan Area). Ch'eng-tu: Ch'ung-li T'ang, 1945.

Hu, Peiheng 胡佩衡. *Wang Shigu* 王石谷 (Wang Hui). In *Zhongguo huajia congshu* (*Chung-kuo hua-chia ts'ung-shu*) 中國畫家叢書 (Chinese Painters Series). Shanghai: Renmin Meishu Chubanshe, 1963.

*Hu-she yüeh-k'an* 湖社月刊 (Lake Club Monthly), originally published between 1927 and 1936. 100 issues. Reprint. 3 vols. Tianjin: Tianjin Guji Shudian, 1992.

Hu, Yi 胡藝 "Dui *Zhongguo meishujia renming cidian*—Qingdai bufen—de buzheng (Tui *Chung-kuo mei-shu-chia jen-ming tz'u-tien*—Ch'ing-tai pu-fen—teh pu-cheng) 對中國美術家人名辭典清代部分) 的補正" (A Revision of the—Ch'ing Dynasty Section—in the *Biographical Dictionary of Chinese Artists*), in *Duoyun* (*To-yün*) 朵雲 (A Cloud Art Journal), no. 4. Shanghai: Shuhua Chubanshe, 1982, p. 235.

———. "Yu Zhiding nianbiao (Yü Chih-ting nien-piao)" 禹之鼎年表 (Chronological Table of Yü Chih-ting). *Duoyun* (*To-yün*) 朵雲 (A Cloud Art Journal). 3. Shanghai: Shanghai Shuhua Chubanshe, September 1982, pp. 207–15.

Hua, Derong 華德榮. *Gong Xian yanjiu* (*Kung Hsien yen-chiu*) 龔賢研究 (A Study on Kung Hsien). Shanghai: Renmin Meishu Chubanshe, 1988.

*Hua-jen pu-i* 畫人補遺 (An Addendum of the Painters' Biography), 18th c. Reprinted in William Yeh Hung 洪業 ed., *Ch'ing hua-chuan chi-i san-chung fu yin-teh* 清畫傳輯佚三種附引得 (Biographies of Ch'ing Dynasty Painters in Three Collections, with index) in Supplement no. 8, *Harvard-Yenching Institute Sinological Index Serial*. Peiping: Offices in Yenching University Library, 1934.

*Huang-ming i-min chuan* 皇明遺民傳 (Biographies of Remnants of The Emperor's Ming Dynasty). Compiled by an anonymous Korean writer. Reprint. Nanking: Jiangsu Guangling Guji Keyinshe, 1991.

Huang, Shucheng 黃淑成 "Zheng Xie diuguan kao (Cheng Hsieh tiu-kuan k'ao) 鄭燮丟官考" (An Investigation into Cheng Hsieh's Loss of Official Position). In Xue Yongnian 薛永年, ed. *Yang-chou pa-kuai k'ao-pien chi* 揚州八怪考辨集 (A Collection of Essays Examining the Writings on the Eight Eccentrics of Yangzhou), pp. 387–92.

Huang, Tsung-hsi 黃宗羲 (1610–95). *Nan-lei chi* 南雷集 (Collected Writings of Nan-lei). Reprinted in *Ssu-pu ts'ung-k'an* 四部叢刊

(Selected Books from the Imperial Encyclopedia), 3025 vols. Shanghai: Commercial Press, 1937–38.

Huang, Ximing 黃希明 and Tian Guisheng 田貴生, "Tantan 'Yangshi Lei' tangyang (T'an-t'an 'Yang-shih Lei' t'ang-yang) '樣式雷'燙樣" (General Discussion on the Small Models by Lei, the Model-designer). *Gugong bowuyuan yuankan* (*Ku-kung po-wu-yüan yüan-k'an*) 故宮博物院院刊 (Palace Museum Bulletin). 26. Beijing: Palace Museum, Winter, 1984, pp. 91–94.

Huang, Yung-ch'uan. 黃永川. "Min-ch'u hui-hua tsai Chung-kuo mei-shu-shih teh ti-wei 民初繪畫在中國美術史的地位" (Significance of 1910's–1930's Paintings in Chinese Art History). In *Proceedings of the International Symposium on Chinese Art History*. Part 1: Painting and Calligraphy. Taipei: National Palace Museum, 1991, pp. 529–43.

Huang, Yongquan 黃湧泉. "Fei Tan-hsü 費丹旭." In Hu Peiheng 胡佩衡 et al. *Lidai huajia pingzhuan, Qing* (*Li-tai hua-chia p'ing-chuan, Ch'ing*) 歷代畫家評傳·清 (Biographies and Commentaries on Painters of the Past Dynasties, Ch'ing Period). Hong Kong: Chung-hua Press, Hong Kong Branch, 1979.

Hummel, Arthur W., ed. *Eminent Chinese of the Ch'ing Period (1644–1912)*. Washington D.C.: United States Government Printing Office, 1943–44.

Hyland, Alice R. M. *The Literati Vision: Sixteenth Century Wu School Painting and Calligraphy*. Memphis: Memphis Brooks Museum of Art, 1984.

———. *Deities, Emperors, Ladies and Literati: Figure Painting of the Ming and Ch'ing Dynasties*. Birmingham: Birmingham Museum of Art, 1987.

Ishida, Mikinosuke Ishida 石田幹之助. "Rosenei ten no kanryaku 郎世寧傳の考略" (A Biographical Study of Giuseppe Castiglione), A Jesuit Painter in the Court of Peking under the Ch'ing Dynasty." *Toyo Bunka Kenkyujo kiyo* 東洋文化所記要 (The Memoirs of the Institute of Oriental Culture). 19. Tokyo: The Institute of Oriental Culture, Tokyo University, 1960.

Jan, Ch'ien-yü 詹前裕. *P'u Hsin-yü hui-hua i-shu chih yen-chiu* 溥心畬書畫藝術之研究 (Research on the Art of P'u Hsin-yü [P'u Ju]). Taichung: Taiwan Museum of Art, 1992.

Jang, Scarlett Ju-yu. "Ox-herding Painting in the Sung Dynasty," *Artibus Asiae*. 52, 2. New York: Institute of Fine Arts, New York University, 1992, pp. 54–93.

Jao, Tsung-i 饒宗頤. "Qingchu Guangdong zhi-huajia Wu Wei yu Tieling Gaoshi (Ch'ing-ch'u Kuang-tung chih-hua-chia Wu Wei yü T'ieh-ling Kao-shih) 清初廣東指畫家吳韋與鐵嶺高氏" (The Relationship between the Early Ch'ing Finger Painter Wu Wei of Canton and Mr. Kao from T'ieh-ling). *MSSL*. 14. Beijing: Wenhua Yishu Chubanshe, Summer 1985, pp. 70–74.

———. "Painting and the Literati in the Late Ming." *Renditions*. 6. Hong Kong: Centre for Translation Projects, Chinese University of Hong Kong, Spring 1976, pp. 138–143.

Jen, Hsiung 任熊 (1823–57), see Ren Xiong.

Ji, Yougong (Chi, Yu-kung) 計有功 (active 1121–61). *T'ang-shih chi-shih* 唐詩記事 (Episodes Recorded in T'ang Dynasty Poems), first edition 1224. Reprint. Shanghai: Zhonghua Shuju, 1965.

Jiang, Bao-ling (Chiang, Pao-ling) 蔣寶齡 (1781–1840). *Molin jinhua* (*Mo-lin chin-hua*) 墨林今話 (Comments on Contemporary Painters), preface 1851. Reprint. Hefei: Huangshan Shushe, 1992.

Jiang, Shaoshu (Chiang, Shao-shu) 姜紹書 (active 1635–1680). *Wusheng shishi* (*Wu-sheng-shih shih*) 無聲詩史 (A History of Voiceless Poems), preface 1720. Reprinted in *MSCS.*, vol. 4.

Jiao, Hong (Chiao, Hung) 焦竑 (1541–1620), comp. *Guochao xianzhenglu* (*Kuo-ch'ao hsien-cheng-lu*) 國朝獻徵錄 (Biographies of Famous Individuals of the Ming Dynasty). Reprint. Shanghai: Shanghai Shudian, 1987.

Jin, Qihua 金啟華, trans. *Shijing quanyi* (*Shih-ching ch'üan-i*) 詩經全譯 (The Complete [Modern Chinese] Translation of *The Book of Odes*). Jiangsu: Jiangsu Guji Chubanshe, 1984.

*Jilinsheng Bowuguan suocang Zhongguo MingQing huihuazhan tulu* (*Chi-lin-sheng Po-wu-kuan so-ts'ang Chung-kuo Ming-Ch'ing hui-hua-chan t'u-lu*) 吉林省博物館所藏中國明清繪畫展圖錄 (A Pictorial Exhibition Catalogue of Chinese Paintings of the Ming and Ch'ing Periods from the Chi-lin Provincial Museum). Chi-lin: Jilin Provincial Museum, 1987.

Ju, Jane Chuang (Chu, Ching-hua 朱靜華). "The Life and Art of P'u Hsin-yü." Ph.D. diss. Lawrence: University of Kansas, 1989.

"Kangxi jianchu an (K'ang-hsi chien-ch'u an) 康熙建儲案" (The Case of the Petitioning of Emperor K'ang-hsi to Designate an Heir). In *Wen-hsien ts'ung-pien* 文獻叢編 (A Collection of Historical Documents). No. 4. Taipei: Kuo-feng Press, 1964, pp. 106–9.

*Kangxi qiju zhu (K'ang-hsi ch'i-chü chu)* 康熙起居注 (A Record of Emperor K'ang-hsi's Life and Activities). Beijing: Zhonghua Bookstore, 1984.

Kao, Mayching 高美慶, ed. *Mingdai huihua (Ming-tai hui-hua)* 明代繪畫 (Paintings of the Ming Dynasty). Hongkong: The Chinese University of Hong Kong, 1988.

—— et al. *Paintings of the Ming and Qing Dynasties from the Guangzhou Art Gallery*. Hong Kong: The Chinese University of Hong Kong, 1986.

———, ed. *Qingdai Yangzhou huajia zuopin* (*Ch'ing-tai Yangchou hua-jia tso-pin*) 清代揚州畫家作品 (Paintings by Yangzhou Artists of the Ch'ing Dynasty from the Palace Museum). Hong Kong: The Chinese University of Hong Kong, 1984.

———. "Sheng Maoye yanjiu (Sheng Mao-yeh yen-chiu) 盛茂燁研究" (Research on Sheng Mao-yeh), in Yang, Xin 楊新, ed. *Wumen huapai yanjiu* (*Wu-men hua-p'ai yen-chiu*) 吳門畫派研究 (Research on Paintings of the Wu School). Beijing: Palace Museum, 1993, pp. 204–18.

Kao, Ping 高秉 (active second half of 18th century). *Chih-t'ou hua-shuo* 指頭畫說 (Treatise on Finger Painting), first edition c. 1771. Reprinted in *MSCS.*, chi 集 (part) 1, chi 輯 (division) 8, vol. 4, pp. 37–64.

Kao Shih-ch'i 高士奇 (1645–1704), see also Gao, Shiqi.

Kao, Yang 高陽. *Mei-ch'iu sheng-ssu mo-yeh meng* 梅丘生死摩耶夢 (A Dream at the Abode of Illusion and Life and Death at the Plum Blossom Bank). Taipei: Lien-ching Press, 1984.

Kim, Hongnam. "Chou Liang-kung and His *Tu-hua-lu* Painters." In Chu-tsing Li 李鑄晉,

183

184

ed. *Artists and Patrons: Some Social and Economic Aspects of Chinese Painting.* Lawrence: Kress Foundation Department of Art History, University of Kansas, 1989, pp. 189–201.

*Kiangsu-sheng ch'ung-hsiu Hsing-hua hsien-chih* 江蘇省重修興化縣誌 (The Revised District Gazette of Hsing-hua, Kiangsu Province). Reprint of 1852 edition. Taipei: Cheng-wen Press, 1970.

Ko, Chin-lang 葛金俍 (1837–1890). *Ai-jih-yin lu shu-hua lu* 愛日吟廬書畫錄 (The Painting and Calligraphy at Ko's Enjoying Daily Poetry Chanting Hut), preface 1881, and Ko Ssu-t'ung 葛嗣彤 (c. 1860–1930). *Pu-lu* 補錄 (part 2), preface 1912; *hsü-lu* 續錄 (part 3), preface 1913. Reprint. Taipei: Wen-shih-che Press, 1977.

Ku, Ch'i-yüan 顧起元 (1565–1628), see Gu, Qiyuan.

Ku, Fu 顧復 (active second half of 17th century). *P'ing-sheng chung-kuan* 平生壯觀 (The Great Paintings and Calligraphic Works Viewed in Ku Fu's Life), preface 1692. Reprint. Taipei: Han-hua Wen-hua Shi-yeh Co. Ltd., 1971.

*Ku-kung ming-hua san-pai-chung* 故宮名畫三百種 (Three Hundred Masterpieces of Chinese Painting in the Palace Museum). Compiled by the Editorial Committee of the Joint Board of Directors of the National Palace Museum and the National Central Museum. Taichung: National Palace Museum and National Central Museum, 1959.

*Ku-kung shu-hua t'u-lu* 故宮書畫圖錄 (Illustrated Catalogue of Calligraphy and Painting at the Palace Museum). Compiled by National Palace Museum Editorial Committee. 19 vols. Taipei: National Palace Museum, 1989–.

*Ku-kung shu-hua lu* 故宮書畫錄 (Catalogue of Calligraphy and Painting at the Palace Museum). 4 vols. Taipei: National Palace Museum, 1965.

*Ku-kung wen-wu yüeh-k'an* 故宮文物月刊 (The National Palace Museum Monthly of Chinese Art). Taipei: National Palace Museum, 1983–.

Ku, Wen-pin 顧文彬 (1811–89) and Ku, Lin-shih 顧麟士 (1865–1930). *Guoyunlou shuhua ji (Kuo-yün lou shu-hua chi)* 過雲樓書畫記 (A Record of the Painting and Calligraphy Collection at the Passing-clouds Pavilion), preface 1882. Reprint. Nanjing: Jiangsu Xinhua Bookstore, 1990.

*Kuan-ts'ang P'u Hsin-yü shu-hua* 館藏溥心畬書畫 (The Painting and Calligraphy of P'u Hsin-yü [P'u Ju] from the Collection of the National Museum of History). Taipei: National Museum of History, 1996.

K'ung, Shang-jen 孔尚任 (1648–1708). *Hu-hai chi* 湖海集 (The Lake and Sea of the Author's Collected Writings). Taipei: The World Press, 1964.

Kuo, Chi-sheng (Jason) 郭繼生. "Huichou Merchants as Art Patrons in the Late Sixteenth and Early Seventeenth Centuries." In Chu-tsing Li 李鑄晉, ed. *Artists and Patrons: Some Social and Economic Aspects of Chinese Painting.* Lawrence: Kress Foundation Department of Art History, University of Kansas, 1989, pp. 177–88.

—— (under pseudonym of Li Ta-kung 李大空). "MingQing zhiji zanzhu yishu de Huizhou shangren (Ming-Ch'ing chih-chi tsan-chu i-shu teh Hui-chou shang-jen) 明清之際贊助藝術的徽州商人" (Merchants in the Hui-chou Area Who Patronized Art during the Ming and Ch'ing Periods). In *Lun Huang-*

shan zhu huapai wenji (Lun Huang-shan chu-hua-p'ai wen-chi) 論黃山諸畫派文集 (Collected Essays on the Huang-shan Painting Schools). Shanghai: Renmin Meishu Chubanshe, 1987, pp. 334–50.

——. "Ming-tai Wu-men hui-hua tui Hsin-an hua-p'ai te ying-hsiang, che-yao 明代吳門繪畫對新安畫派的影響 摘要"(A Summary of the Influences Received by the Hsin-an Painting School from the Works of the Wu School during the Ming Dynasty). In Yang Xin 楊新, ed. *Wumen huapai yan-jiu (Wu-men hua-p'ai yen-chiu)* 吳門畫派研究 (Research on Paintings of the Wu School). Beijing: Palace Museum, 1993, pp. 360–63.

——. *Wang Yüan-ch'i teh shan-shui-hua i-shu* 王原祁的山水畫藝術 (The Art of Wang Yüan-ch'i's Landscape Painting). Taipei: National Palace Museum, 1981.

——. *The Austere Landscape: The Paintings of Hung-jen.* Taipei and New York: SMC Publishing Inc., 1990.

Kuo, Hsi 郭熙 (active second half of 11th century). *Lin-ch'üan kao-chih* 林泉高致 (Lofty Ambition in Forests and Streams). Compiled by Kuo's son, Kuo Ssu 郭思 (*chin-shih* degree in 1082), preface 1117. Reprinted in *HLCK.*, vol. 1, pp. 16–32.

Kuo, Jo-hsü 郭若虛 (fl. 1070–75), see Guo, Ruoxu.

Kuo, Moruo 郭沫若 (1891–1978). "You WangXie muzhi de chutu lundao *Lant-ingxu* de zhenwei (Yu Wang-Hsieh mu-chih teh ch'u-t'u lun-tao *Lan-t'ing hsü* teh chen-wei) 由王謝墓誌的出土論到蘭亭序的真偽" (The Authenticity of the *Lan-t'ing hsü* in Light of the Epitaphs of Wang Hsing-chih and Hsieh K'un), in *Wen Wu* 文物 (Cultural Relics journal). 6. Beijing: Wenwu Chubanshe, 1965, pp. 1–25.

Laing, Ellen J. *Chinese Paintings in Chinese Publications, 1956–1968: An Annotated Bibliography and an Index to the Paintings.* Ann Arbor: University of Michigan Center for Chinese Studies, 1969.

——. "Ch'iu Ying's Three Patrons." *Ming Studies.* 3. Minneapolis: University of Minnesota, History Dept., Spring 1977

——. "*Riverside* by Liu Yüan-ch'i and *The Waterfall on Mt. K'uan-lu* by Shao Mi." *University of Michigan Museum of Art Bulletin.* 5. Ann Arbor: University of Michigan Museum, 1970–71, pp. 1–16.

Lan, Ying 藍英 (1585–?), and Xie Bin (Hsieh, Pin) 謝彬 (1602-after 1680). *Tuhui baojian xucuan (T'u-hui pao-chien hsü-ts'uan)* 圖繪寶鑑續纂 (Sequel to Precious Mirror of Painting, Painters of the Ming and Ch'ing dynasties). Reprinted in *HSCS.*, vol. 3.

Lang, Ying 郎英 (1487–after 1566). *Qixiu leigao (Ch'i-hsü lei-kao)* 七修類稿 (Notes on Seven Categories of Miscellaneous Topics), first edition c. second quarter of 16th century. Reprinted. Shanghai: Zhonghua Press, 1959 and 1961.

Lawton, Mary S. *Hsieh Shih-ch'en: A Ming Dynasty Painter Reinterprets the Past.* Chicago: David and Alfred Smart Gallery, University of Chicago, 1978.

Lawton, Thomas. "An Eighteenth Century Catalogue of Calligraphy and Painting." Ph.D. diss. Cambridge: Harvard University, 1970.

——. *Chinese Figure Painting.* Washington D. C., Smithsonian Institution, Freer Gallery of Art, 1973.

Lee, E. Rose. "The Life and Work of Chiang Sung." Master's thesis. Ann Arbor: University of Michigan, 1983.

Lee, Sherman E. *A History of Far Eastern Art.* New York: Harry N. Abrams, Inc., 1964.

——. *China, 5,000 Years: Innovation and Transformation in the Arts.* New York: Guggenheim Museum, 1998.

—— and Wai-kam Ho. *Chinese Art Under the Mongols: The Yüan Dynasty (1279–1368).* Cleveland: Cleveland Museum of Art, 1968.

Lee, Stella Yu. "Art Patronage of Shanghai in the Nineteenth century." In Chu-tsing Li 李鑄晉, ed. *Artists and Patrons: Some Social and Economic Aspects of Chinese Painting.* Lawrence: Kress Foundation Department of Art History, University of Kansas, 1989, pp. 223–29.

Lei, Zhengmin 雷正民 et al., comp. *Zhongguo xiandai meishujia renming dacidian (Chung-kuo hsien-tai mei-shu-chia jen-ming ta-tz'u-tien)* 中國現代美術家人名大詞典 (A Great Biographic Dictionary of Modern Chinese Artists). Xian: Shaanxi Renmin Meishu Chubanshe, 1989.

Li, Chu-tsing 李鑄晉, ed. *Artists and Patrons: Some Social and Economic Aspects of Chinese Painting.* Lawrence: Kress Foundation Department of Art History, University of Kansas, 1989.

——. "A Thousand Peaks and Myriad Ravines: Chinese Paintings in the Charles A. Drenowartz Collection." *Artibus Asiae Supplementum* 30. New York: Institute of Fine Arts, New York University, 1974.

—— and James C. Y. Watt 屈志仁, eds. *The Chinese Scholar's Studio: Artistic Life in the Late Ming Period—an Exhibition from the Shanghai Museum.* New York: The Asia Society Galleries, 1987.

*Li-tai ming-jen nien-li pei-chuan tsung-piao* 歷代名人年里碑傳總表 (Chronological Index to Biographical Records of Famous Men). Taipei: Shang-wu Press, 1962.

Li, Fang 李昉 (925–96). *Taiping guangji (T'ai-p'ing kuang-chi)* 太平廣記 (Records of the Peaceful Years), preface 977. Reprint. 4 vols. Shanghai: Shanghai Guji Chubanshe, 1990.

Li, Huan 李桓 (1827–91), comp. *Kuo-ch'ao ch'i-hsien lei-cheng ch'u-pien* 國朝耆獻類徵初編 (A Preliminary Compilation of Biographies of the Eminent Individuals of the Ch'ing Dynasty), 1884. Reprint. Taipei: Wen-hai Press, 1966.

Li, Po-yüan 李伯元 (active late 19th to early 20th c.). *Nan-t'ing pi-chi* 南亭筆記 (Notes Jotted down at the South Pavilion). Shanghai: Ta-tung Bookstore, 1919.

*Li Shan huahuice (Li Shan hua-hui ts'e)* 李鱓花卉冊 (A Set of Flower Album Leaves by Li Shan). Shanghai: Renmin Meishu Chubanshe, 1984.

Li, Ta-k'ung 李大空, pseudonym of Kuo, Jason Chi-sheng 郭繼生.

Li, Tou 李斗 (active second half of the 18th century). *Yang-chou hua-fang lu* 揚州畫舫錄 (The Accounts of the Gaily-painted Pleasure-boats in Yangchou), preface 1795. Reprint. Yangzhou: Jiangsu Guangling Guji Keyinshe, 1984.

Li, Tso-hsien 李佐賢 (1807–1876). *Shu-hua chien-ying* 書畫鑑影 (Reflections on Calligraphy and Painting), first edition 1871. n. p.

Li, Yü-fen 李玉棻 (active 2nd half of the 19th c). *Ou-po-lo-shih shu-hua kuo-mu k'ao* 甌鉢羅室書畫過目考 (A Study of the Painting and Calligraphy Viewed at the Ou-po-lo Studio), preface 1873. 4 *juan (chüan)* 卷 (chapter). Reprinted in *MSTS.* Vol. 25, *chi*

集 (division) 5, *chi* 輯 (collection) 9, pp. 29–336.

Liang, Chang-chü 梁章鉅 (1775–1849), see Liang, Zhangju.

Liang, Zhangju (Liang, Chang-chü) 梁章鉅 (1775–1849). *Tuian suocang jinshi shuhua bawei* (*T'ui-an so-ts'ang chin-shih shu-hua pa-wei*) 退庵所藏金石書畫跋尾 (Colophons for the Bronze Vessels, Stone Steles, Paintings and Calligraphy in the Collection at [Liang's] Reticence Hut Studio], preface dated 1845. 20 *juan* (*chüan*) 卷 (chapter). Reprint in *ZGSHQS*., vol. 9, pp. 991–1115.

Liao, Yung-hsien 廖用賢 (active early 17th century) *Tseng-pu shang-yu lu* 增補尚友錄 (The Augmented Version of the Records of Friends [an informal biographical dictionary of famous men in Chinese history]), preface 1617. N. p, n. d.

Lai, Yen-yüan 賴炎元, ed., *Han-shih wai-chuan chin-chu chin-i* 韓詩外傳今註今譯 (Modern Footnotes and Translation of Han Ying's [韓嬰, c. 150 B. C.] Commentary on Poems in the *Book of Odes*). Taipei: Taiwan Commercial Press, Ltd., 1972.

Lin, Lü 林綠 et al. *P'u Hsin-yü shu-hua ch'üan-chi* 溥心畬書畫全集 (The Complete Collection of Paintings and Calligraphy of P'u Hsin-yü [P'u Ju]). Taipei: National Book Company, 1978.

Lin, Pu 林逋 (967–1028). *Lin Ho-ching hsien-sheng shih-chi* 林和靖先生詩集 (Anthology of Mr. Lin Ho-ching [Lin Pu]). Reprint. Shanghai: Commercial Press, 1935.

Lin, Shuzhong 林樹中 et al., ed. *Meishu cilin: Zhongguo huihua juan* (*Mei-shu tz'u-lin: Chung-kuo hui-hua chüan*) 美術辭林.中國繪畫卷 (Dictionary of Fine Art Terminology: Chinese Painting Section). Xian: Renmin Meishushe, 1995.

Lin, Yü-t'ang 林語堂 (1895–1976). *The Gay Genius: The Life and Times of Su Tung-p'o*. New York: J. Day Co., 1947.

*Lingnan mingren shuhua* (*Ling-nan ming-jen shu-hua*) 嶺南名人書畫 (Painting and Calligraphy of Famous Artists from Canton). Guangzhou: Renmin Meishu Chubanshe, 1997.

Little, Steve. "Qiu Ying he Wen Zhengming de guanxi (Ch'iu Ying ho Wen Cheng-ming teh kuan-hsi) 仇英和文徵明的關係" (The Relationship between Ch'iu Ying and Wen Cheng-ming). In Yang Xin 楊新, ed. *Wumen huapai yanjiu* (*Wu-men hua-p'ai yen-chiu*) 吳門畫派研究 (Research on Paintings of the Wu School), pp. 132–39

Liu, Changjiu 劉長久, ed., *Dazu shike yanjiu* 大足石刻研究 (Collected Works of Research on Dazu Stone Carvings). Szechwan: Social Science Academy Press, 1985.

Liu, Daoguang 劉道廣. "Zeng Jing de xiaoxianghua jifa fenxi (Tseng Ching teh hsiao-hsiang hua chi-fa fen-hsi) 曾鯨的肖像畫技法分析" (An Analysis of Technique in Tseng Ching's Portrait Painting). *Duoyun* (*To-yün*) 朵雲 (A Cloud Art Journal). 5. Shanghai: Shanghai Shuhua Chubanshe, Nov. 1983, pp. 56–59.

Liu, Gangji 劉綱紀. *Huang Yingpiao renwuce* (*Huang Ying-p'iao jen-wu-ts'e*) 黃癭瓢人物冊 (A Set of Album Leaves of Huang Shen's Figure Painting). Shanghai: Shuhua Chubanshe, 1982.

———. *Gong Xian* (*Kung Hsien*) 龔賢. In *Zhongguo huajia congshu* (*Chung-kuo hua-chia ts'ung-shu*) 中國畫家叢書 (The Series of Chinese Painters). Shanghai: Renmin Meishu Chubanshe, 1981.

Liu, Haisu 劉海粟, ed. *Gong Xian yanjiuji* (*Kung Hsien yen-chiu chi*) 龔賢研究集 (Collected Research Materials on Kung Hsien). Nanjing: Jiangsu Meishu Chubanshe, 1988.

Liu, Hsü 劉煦 (887–946), see Liu, Xu.

Liu, Xu (Liu, Hsü) 劉煦 (887–946) et al. *Jiu Tangshu* (*Chiu T'ang-shu*) 舊唐書 (The Old Version of the *Book of T'ang*). 102 *juan* (*chüan*) 卷 (chapter). Reprint. Beijing: Zhonghua Shuju, 1977.

Liu Yujia's 劉宇甲. "Gong Xian de shengping (Kung Hsien teh sheng-p'ing) 龔賢的生平" (The Life of Kung Hsien). In Liu Haisu 劉海粟 ed. *Gong Xian yanjiuji* (*Kung Hsien yen-chiu chi*) 龔賢研究集 (Collected Research Materials on Kung Hsien). Pp. 2–22.

Liu, Zhengcheng 劉正成 et al., ed. *Zhongguo shufa jianshang dacidian* (*Chung-kuo shu-fa chien-shang ta-tz'u-tien*) 中國書法鑒賞大辭典 (The Great Dictionary of Chinese Calligraphy for Appreciation and Authentication), 2 vols. Beijing: Dadi Chubanshe, 1989.

Lo, Shu-jen 樂恕人 comp. *Chang Dai-chien shih-wen chi* 張大千詩文集 (Collected Writings and Poems of Chang Dai-chien). Taipei: Li-ming Bookstore, 1984.

Luo, Zhufeng 羅竹風 et al., ed. *Hanyu dacidian* (*Han-yü ta-tz'u-tien*) 漢語大詞典 (Chinese Terminology Dictionary). Shanghai: Hanyu Dacidian Press, 1988.

Lovell, Hin-cheung. *An Annotated Bibliography of Chinese Painting Catalogues and Related Texts*. Ann Arbor: University of Michigan Center for Chinese Studies, 1973.

Lu, Chi-yeh 盧冀野, ed. *T'ang Sung chuan-ch'i hsüan* 唐宋傳奇選 (Selected Legends of the T'ang and Sung Dynasties). Chang-sha: Commercial Press, 1937.

Lu, I-t'ien 陸以湉 (1801–65), see Lu, Yitian.

Lu, Jung 陸容 (1436–94), see Lu Rong.

Lu Rong (Lu, Jung) 陸容 (1436–94). *Shuyuan zaji* (*Shu-yüan tsa-chi*) 菽園雜記 (Miscellaneous Notes at the *Bean Garden*). 15 *juan* (*chüan*) 卷 (chapter). Reprint. Beijing: Zhonghua Press, 1985.

Lu, Suh-fen (Sophia) 盧素芬. "A Study on Tseng Ching's Portraits." Master's thesis. Ann Arbor: University of Michigan, 1986.

Lu, Yitian (Lu I-t'ien) 陸以湉 (1801–65). *Lenglu zashi* (*Leng-lu tsa-shih*) 冷盧雜識 (Miscellaneous Records at Lu's Cold-hut Studio), preface 1856. Reprint. Beijing: Zhonghua Shuju, 1984.

Lu, Yü 陸羽 (?– 804). *Ch'a-ching* 茶經 (The Book of Tea). Reprinted in *Wu-ch'ao hsiao-shuo ta-kuan* 五朝小説大觀 (Collected Historical Notes and Novels), in the serial *Hsiao-shuo ts'ung-shu chih-erh* 小説叢書之二 (Second Serial of the Collection of Novels), vol. 17. Shanghai: Sao-yeh Shanfang, 1937, pp. 265–76.

Lu, Hsin-yüan 陸心源 (1834–1894). *Jang-li-kuan kuo-yen lu* 穰梨館過眼錄 (Paintings Viewed at Lu's Sharing-Pear Studio), preface 1891. Wu-hsing: n.p., 1891.

———. *Jang-li-kuan kuo-yen lu hsü-chi* 穰梨館過眼錄續集 (Sequel to Paintings Viewed at Lu's Sharing-Pear Studio). Wu-hsing: n.p., 1891.

Lü, Liu-liang 呂留良 (1629–83) et al., ed. *Sung shih-ch'ao* 宋詩鈔 (A Complete Record of Sung Dynasty Poetry). Reprinted in Yang

Chia-lo 楊家駱, chief ed. *Li-tai shih-wen* 歷代詩文 (Poetry of the Past Dynasties). Vol. 9. Taipei: The World Bookstore, 1962.

Lu, Shihua (Lu, Shih-hua) 陸時化 (1714–79). *Wuyue suojian shuhualu* (*Wu-yüeh so-chien shu-hua lu*) 吳越所見書畫錄 (Paintings and Calligraphy Viewed in the Wu and Yüeh Regions). 4 *juan* (*chüan*) 卷 (chapter). Reprinted in *ZGSHQ*., vol. 8, pp. 1137.

Maeda, Robert J. "*Chieh-hua*: Ruled-line Painting in China." *Ars Orientalis*. 10. Ann Arbor: The Department of the History of Art, University of Michigan, 1975, pp. 123–41.

March, Benjamin. *Some Technical Terms of Chinese Painting*. Baltimore: Waverly Press, Inc., 1935.

*Masterpieces of Chinese Album Painting in the National Palace Museum*. Compiled by The National Palace Museum. Taipei: National Palace Museum, 1971.

*Masterpieces of Chinese Calligraphy in the National Palace Museum*. Compiled by The National Palace Museum. Taipei: National Palace Museum, 1970.

*Masterpieces of Chinese Figure Painting in the National Palace Museum*. Compiled by The National Palace Museum. Taipei: National Palace Museum, 1973,

Mathews, R. H. *Mathews' Chinese-English Dictionary*. Revised American edition. Cambridge: Harvard University Press, 1963.

Mei, Ida Lee, trans. *Chinese Womanhood*. Taipei: China Academy, 1982.

Meyden, Hans van der. "The Life and Works of Ren Bonian (1840–96)." *Oriental Art*. 38. 1. London: Oriental Art Magazine, Ltd., Spring, 1992, pp. 27–40.

*Mingdai wumen huihua* (*Ming-tai Wu-men hui-hua*) 明代吳門繪畫 (The Wumen Paintings of the Ming Dynasty). Compiled by Palace Museum. Beijing: Palace Museum, 1990.

"*Min-shih* 明史" (History of the Ming Dynasty), in *Erh-shih wu-shih* 二十五史 (The Twenty-five History Books). Reprint. Shanghai: K'ai-ming Book Company, 1935, pp. 293–295.

*MinShin no kaiga* 明清の繪畫 (Paintings of the Ming and Ch'ing Dynasties). Compiled by the Tokyo National Museum. Tokyo: Benrido 便利堂, 1964.

Morohashi, Tetsuji 諸橋轍次 et al., eds. *Dai Kanwa Jiten* 大漢和詞典 (The Great Chinese-Japanese Dictionary). Tokyo: Daishukan Publ., 1976.

Morton, W. Scott. *China, Its History and Culture*. 3rd ed. New York: McGraw-Hill, Inc., 1995.

Moss, Paul. *Old Leaves Turning: Fans*. London: Sydney L. Moss Ltd., 1995

Mu, Yiqin 穆益勤. *Mingdai gongting yu Zhepai huihua xuanji* (*Ming-tai kung-t'ing yü Che-p'ai hui-hua hsüan-chi*) 明代宮廷與浙派繪畫選集 (A Selection of Ming Dynasty Court Paintings and Che School Paintings). Beijing: Palace Museum, 1983.

———. *Mingdai yuanti Zhepai shiliao* (*Ming-tai yüan-t'i Che-p'ai shih-liao*) 明代院體浙派史料 (Historical Material on the Imperial Court Style and the Zhe School of the Ming Dynasty). Shanghai: Renmin Chubanshe, 1985.

Munakata, Kiyohiko 宗方清彦. *Sacred Mountains in Chinese Art*. Urbana and Chicago: University of Illinois Press, 1991.

185

186

Murck, Alfreda. "Yuan Jiang: Image Maker." In Ju-hsi Chou and Claudia Brown, eds. *Chinese Painting under the Qianlong Emperor: The Symposium Papers in Two Volumes.* Phœbus 6, 2. Phoenix: Arizona State University, 1991, pp. 228–49.

Murck, Christian F., ed. *Artists and Traditions: Uses of the Past in Chinese Culture.* Princeton: Princeton University Press, 1976.

Myokyo-ni (Irmgard Schloegl). *Gentling the Bull: The Ten Bull Pictures, A Spiritual Journey.* London: Zen Center, 1988.

Na, Chih-liang 那志良. *Ku-kung ssu-shih-nien* 故宮四十年 (Forty Years at the Palace Museum [A Memoir]). Taipei: Commercial Press, 1966.

Nakata, Yujiro 中田勇次郎, ed. *Shodo geijutsu* 書道藝術 (Calligraphic Art). Vol. 9. Tokyo: Heibonsha, 1976.

—— and Fu Shen 傅申. *Masterpieces of Chinese Calligraphy in American and European Collections.* Tokyo: Chuokoron-sha, Inc., 1983.

Nie, Chongzheng 聶崇正. "Xiyanghua dui Qing gongting huihua de yingxiang (Hsi-yang-hua tui Ch'ing kung-t'ing hui-hua teh ying-hsiang) 西洋畫對清宮廷繪畫的影響" (The Influence of Western Painting on the Court Paintings of the Ch'ing Dynasty). *Duoyun (To-yün)* 朵雲 (A Cloud Art Journal). 5. Shanghai: Shanghai Shuhua Chubanshe, May 1983, pp. 193–97 and 237.

———. *Lang Shihning* 郎世寧 (Giuseppe Castiglione). Beijing: Renmin Meishu Chubanshe, 1984.

———. *Yuan Jiang yu Yuan Yao (Yüan Chiang yü Yüan Yao)* 袁江與袁耀 (Yüan Chiang and Yüan Yao). Shanghai: Renmin Meishu Chubanshe, 1982.

———. "Yuan Yao youguan Yangzhou de liangjian zuopin (Yüan Yao yu-kuan Yang-chou teh liang-chien tso-p'in) 袁耀有關揚州的兩件作品" (Two Works by Yüan Yao Related to Yangchou). *Wenwu* 文物 (Cultural Relics Journal). 4. Beijing: Wenwu Chubanshe, 1979, pp. 46–48.

Nishigami, Minoru. 西上實. *Obaku no bijutsu* 黃檗の美術 (The Art of Obaku). Kyoto: Kyoto National Museum, 1993.

Niu, Hsiu 紐琇 (active late 17th to early 18th centuries). *Hui-t'u ku-sheng cheng-hsü-pien* 繪圖觚賸正續編 (Illustrated Random Notes Left in a *Ku* Cup, and its Sequel [Anecdotes of the Late Ming to Early Ch'ing Period]), preface 1702. Reprint. Taipei: Kuang-wen Press, 1969.

*Ogi-e* 扇繪 (Fan Paintings). Compiled by Kuboso Kinen Hokubutsukan 久保惣紀念博物館 (Kuboso Memorial Museum). Waizumi-shi, Japan: Kuboso Kinen Hokubutsukan, 1990.

Owyoung, Steven D. "The *Lan-t'ing hsiu-hsi t'u* by Sheng Mao-yeh: The Artist, the Painting and the Lan-t'ing Painting Tradition." M.A. thesis. Ann Arbor: University of Michigan, 1977.

P'an, Kuang-tan 潘光旦. *Ming-Ch'ing liang-tai Chia-hsing teh wang-tsu* 明清兩代嘉興的望族 (The Eminent Families in the Chia-hsing Area during the Ming and Ch'ing Dynasties). Shanghai: Commercial Press, 1936).

Pang, Mae Anna Quan 潘美恩. "Wang Yüan-ch'i (1641–1715) and Formal Construction in Chinese Landscape Painting." Ph.D. diss. Berkeley: University of California, 1967.

P'ang, Yüan-chi 龐元濟 (1864–1949). *Hsü-chai ming-hua lu* 虛齋名畫錄 (A Catalogue of Paintings in the Collection of Pang's Studio of Humility). 20 *juan (chüan)* 卷 (chapter). Shanghai: n.p., 1909.

———. *Hsü-chai ming-hua lu pu-i* 虛齋名畫錄補遺 (A Catalogue of Paintings in the Collection of the Author, supplement). Shanghai: n.p. 1924 and addendum, 1925.

Pien, Yüng-yü 卞永譽 (1645–1712). *Shih-ku t'ang shu-hua hui-k'ao* 式古堂書畫彙考 (A Corpus of Studies on Painting and Calligraphy at Pien Yüng-yü's Conforming-antiquity Studio), preface 1682. Facsimile reprint. 4 vols. Taipei: Cheng-chung Press, 1958.

Pohl, Karl-Heinz. *Cheng Pan-ch'iao: Poet, Painter and Calligrapher.* Nettetal: Steyler, 1990.

*Proceedings of the International Colloquium on Chinese Art History.* Part 1: Painting and Calligraphy. Taipei: National Palace Museum, 1991.

*P'u Hsin-yü shu-hua wen-wu t'u-lu* 溥心畬書畫文物圖錄 (A Catalogue of P'u Hsin-yü's [P'u Ju] Painting, Calligraphy, and Other Art Objects). Compiled by The Editorial Committee of the National Palace Museum. Taipei: National Palace Museum, 1993.

"P'u Hsin-yü hsien-sheng tzu-shu 溥心畬先生自述" (An Account in Mr. P'u Hsin-yü's [P'u Ju] Own Words). Recorded by Ch'en Chün-fu 陳雋甫. In *Chiu-wang-sun P'u Hsin-yü* 舊王孫溥心畬. Compiled by Editorial Committee of the Lang-t'ao-sha Press. Taipei: Lang-t'ao-sha Press, 1974, pp. 126–30.

P'u, Ju' 溥儒 (1896–1963). *Hua-lin yün-yeh* 華林雲葉 (Cloud and Foliage in a Splendid Forest). Taipei: Kuang-wen Bookstore, 1963.

Qian, Qianyi (Ch'ien, Ch'ien-i) 錢謙益 (1522–1644), *Liechao shiji xiaozhuan (Lieh-ch'ao shih-chi hsiao-chuan)* 列朝詩集小傳 (Poetry Anthologies of the Past Dynasties). Reprint. Shanghai: Gudian-wenxue Chubanshe, 1957.

Qian, Shifu 錢實甫. *Qingdai zhiguan nianbiao (Ch'ing-tai chih-kuan nien-piao)* 清代職官年表 (A Chronological Table of the Officials and Officers of the Ch'ing Dynasty). 4 vols. Beijing: Zhonghua Shuju, 1980.

Qian, Yong (Ch'ien, Yung) 錢泳 (1759–1844). *Luyuan huaxue (Lü-yüan hua-hsüeh)* 履園畫學 (The Knowledge of Painting at the Garden of Fulfillment), preface 1822. Reprinted in *HSCS,* vol. 9.

Qin, Zuyong (Ch'in, Tsu-yung) 秦祖永 (1825–84). *Tongyin lunhua (T'ung-yin lun-hua)* 桐陰論畫 (Discussing Paintings under the *Wu-t'ung* Tree), preface 1864., Reprinted in *YLMZCK.*

*Qingbai leichao xuan (Ch'ing-pai lei-ch'ao hsüan)* 清稗類鈔選 (Selected Anecdotes of the Ch'ing Dynasty Grouped into Categories). Beijing: Shumu Wenxian Chubanshe, 1983–84.

Qiu, Youxuan 丘幼宣. "Huang Shen fengmu gui Min niandai kaobian (Huang Shen feng-mu kuei-Min nien-tai k'ao-pien) 黃慎奉母歸閩年代考辨" (Inquiry into the Date of Huang Shen Returning with his Mother Back to their Hometown in Fukien). In Xue Yongnian 薛永年, ed., *Yangzhou baguai kaobian ji (Yangchou pa-kuai k'ao-pien chi)* 揚州八怪考辨集 (A Collection of Essays Investigating the Materials of the Eight Eccentrics of Yangchou). pp. 220–23.

———. "Huang Shen nianpu (Huang Shen nien-p'u) 黃慎年譜" (A Chronicle of Huang Shen's Life). In Qiu Youxuan, ed. *Yangzhou baguai nianpu (Yangchou pa-kuai nien-p'u)* 揚州八怪年譜 (Chronicles of the Yangchou Eight Eccentrics' Lives), pp. 69–185.

———. "Huang Shen zihao yanbian kao (Huang Shen tzu-hao yen-pien k'ao) 黃慎字號演變考" (Research on Huang Shen's Name Change). In *Yangchou pa-kuai k'ao-pien-chi* 揚州八怪考辨集 (A Collection of Essays Examining the Writings on the Eight Eccentrics of Yangzhou), pp. 205–10.

———, ed. *Yangzhou baguai nianpu (Yangchou pa-kuai nien-p'u)* 揚州八怪年譜 (Chronicles of the Yangchou Eight Eccentrics' Lives). In *YBYJZLCS.* Jiangsu: Meishu Chubanshe, 1992.

*Qingchu siWang huapai yanjiu (Ch'ing-ch'u ssu-Wang hua-p'ai yen-chiu)* 清初四王畫派研究 (Research on the Paintings of the Four Wangs of the Early Ch'ing Dynasty). Compiled by Editorial Department of the Douyun Press. Shanghai: Shuhua Chubanshe, 1993.

Ren, Xiong (Jen, Hsiung) 任熊 (1823–57). *Gaoshizhuan tuxiang (Kao-shih chuan t'u-hsiang)* 高士傳圖像 (Biographies and Images of Ancient Lofty Scholars). Reprinted in *Ren Weizhang huazhuan sizhong (Jen Wei-Ch'ang hua-chuan ssu-chung)* 任渭長畫傳四種 (Jen Hsiung's Four Sets of Illustrated Biographies). Beijing: China Bookstore, 1985.

———. *Liexian Jiupai (Lieh-hsien chiu-p'ai)* 列仙酒牌 (Immortal Wine Cards), 1st edition 1854. Reprinted in *Ren Weizhang huazhuan sizhong (Jen Wei-ch'ang hua-chuan ssu-chung)* 任渭長畫傳四種 (Jen Hsiung's Four Sets of Illustrated Biographies). Beijing: China Bookstore, 1985.

Robinson, James. "Postscript of an Exhibition: A Discovery of a Collective Work." *Ars Orientalis.* 25. Ann Arbor: University of Michigan, 1995, pp. 143–48.

Rogers, Howard. "For Love of God: Castiglione at the Court of Qianlong." In Ju-hsi Chou and Claudia Brown, eds. *Chinese Painting under the Qianlong Emperor: The Symposium Papers.* Vol. 1. *Phœbus: A Journal of Art History.* 6. 1. Tempe: Arizona State University, 1991, pp. 141–160.

———, ed. *Kaikodo* 懷古堂 (The Cherishing the Past Studio Journal). Kamakura, New York: Kaikodo, 1996–.

———. "Fei Tan-hsü." *Kaikodo Journal: Visions of Man in Chinese Art with Selected Japanese Paintings.* Kamakura and New York: Kaikodo, Spring 1997, no. 20, p. 96 and pp. 230–32, Autumn 1997, pp. 46–7 and pp. 61–2.

———. "Ren Xiong, *Self-Portrait.*" In Rogers, Howard and Lee, Sherman E. *Masterworks of Ming and Qing Painting from the Forbidden City.* Entry no. 73, p. 203.

———. "Yü Chih-ting." In *Masterworks of Ming and Qing Paintings from the Forbidden City.* Entry no. 53, pp. 180–81.

———. and Sherman E Lee. *Masterworks of Ming and Qing Paintings from the Forbidden City.* Lasdale: International Arts Council, 1988.

Ruitenbeek, Klaas. "Gao Qipei and the Art of Finger Painting." In *Proceedings of International Colloquium on Chinese Art History: Part 1: Painting and Calligraphy.* Taipei: National Palace Museum, 1991, pp. 453–67.

Sakamoto, Mitsuru 坂本滿編. *Nanban bijutsu to yofuga* 南蠻美術と 洋風畫 (The Southern Barbarian [European] Art and Paintings with Western Influences), in *Genshoku-Nihon no bijutsu* 原色日本の 美術 (Japanese Art in Polychrome) serial. Vol. 25. Tokyo: Shogakukan, 1970.

Shan, Guoqiang 單國強. "Dai Jin shengping kao (Tai Chin sheng-p'ing k'ao) 戴進生平 考" (Research on Tai Chin's Life). *Duoyun* (*To-yün*) 朵雲 (A Cloud Art Journal). 4. Shanghai: Shuhua Chubanshe, 1982, pp. 161–66.

Shan, Guo-lin 單國霖. "Qiu Ying shengping huodong kao (Ch'iu Ying sheng-p'ing huo-tung k'ao) 仇英生平活動考" (A Study of Ch'iu Ying's Life and Activities). In Yang Xin 楊新, ed., *Wumen huapai yanjiu* (*Wu-men hua-p'ai yen-chiu*) 吳門畫派研究 (Research on Paintings of the Wu School), pp. 219–27.

Shan, Shiyuan 單士元 "Kung-wang-fu yen-ko k'ao-lüeh 恭王府沿革考略" (Research on the History of Prince Kung's Palace). In Chu Ch'uan-yü 朱傳譽, ed. *P'u Hsin-yü chuan-chi tzu-liao* 溥心畬傳記資料 (Materials on P'u Hsin-yü's [P'u Ju] Biography). Taipei: T'ien-i Press, 1979, pp. 65–66. (Shan's article was originally published in *Ta-ch'eng* 大成 magazine, no. 35, Hong Kong.)

Shang, Chengzuo 商承祚 and Huang Hua 黃 華, eds. *Zhongguo lidai shuhua zhuanke-jia zihao suoyin* (*Chung-kuo li-tai shu-hua chuan-k'o-chia tzu-hao so-yin*) 中國歷代 書畫篆刻家字號索引 (Index for Aliases of Chinese Artists in History). Reprint. Hong Kong: Pacific Book Company, 1974.

*Shanghai bowuguan cang haishang minghua-jia jingpin ji* (*Shang-hai Po-wu-kuan ts'ang hai-shang ming-hua-chia ching-p'in chi*) 上海博物館藏海上名畫家精品集 (Masterworks of Famous Shanghai School Painters). Compiled by the Shanghai Municipal Museum. Hong Kong: Ta-ye Co., 1991.

*Shandongsheng Bowuguan shuhuaxuan* (*Shan-tung-sheng Po-wu-kuan shu-hua-hsüan*) 山 東省博物館書畫選 (Selected Calligraphy and Paintings from the Collection of the Shandong Provincial Museum). Shanghai: Renmin Meishu Chubanshe, n.d.

She, Cheng 佘城 *Chung-kuo shu-hua* 中國書 畫 (Chinese Painting and Calligraphy). Vol. 1. Figure Painting. Taipei: Kuang-fu Press, 1981.

Shen, Ch'i 沈起 (active 1660–76), see Shen, Qi.

Shen, Chou 沈周 (1427–1509). *Shih-t'ien hsien-sheng chi* 石田先生集 (Shen Chou's Anthology), first edition 1615. Facsimile reprint. Taipei: The National Central Library, 1968.

*Shen-chou kuo-kuang chi* 神州國光集 (The National Glory of the Sacred Continent [selected works of Chinese painting and calligraphy]). 21 vols. Shanghai: Shen-chou Kuo-kuang She, 1908–12.

*Shen-chou ta-kuan* 神州大觀 (The Great View of the Sacred Continent [selected works of Chinese painting and calligraphy]), 1912–22, and *Hsü-pien* 續編 (Sequel), 1928–31. Shanghai: Shen-chou Kuo-kuang She, 1912–31.

Shen, Defu (Shen, Teh-fu) 沈德符 (1578–1642). *Wanli yehuo bian* (*Wan-li yeh-huo pien*) 萬 曆野獲編 (A Collection of Notes from Unofficial Sources), preface 1606. Reprint. Beijing: Zhonghua Shuju, 1959.

Shen, Hao 沈顥 (1586–after 1661). *Huachen* (*Hua-ch'en*) 畫塵 (Dusts of Painting). Reprinted in *ZGSHQS.*, vol. 4, pp. 814–16.

Shen, Gua (Shen, Kua) 沈括 (1029–93). *Mengxi bitan jiaozheng* (*Meng-hsi pi-t'an chiao-cheng*) 夢溪筆談校正 (Brush Dialogue at Dream Creek [the author's notes on various subjects], with collation by Hu Daojing 胡道靜. 2 vols. Shanghai: Shanghai Chubanshe, 1956.

Shen, Qi (Shen, Ch'i) 沈起 (active 1660–76). *Zha Dongshan xiansheng nianpu* (*Cha Tung-shan hsien-sheng nien-p'u*) 查東山先 生 年譜 (The Chronological Biography of Cha Tung-shan [Cha Chi-tso]). Reprint. Beijing: Zhonghua Press, 1992.

Shen, Teh-fu 沈德符 (1578–1642), see Shen, Defu.

Sheng, Dashi (Sheng, Ta-shih) 盛大士 (1762–after 1850). *Xishan woyou lu* (*Hsi-shan wo-yu lu*) 溪山臥遊錄 (A Record of the Mountains and Rivers in the Author's Mind [documenting contemporary painters and essays on painting]), preface 1822. Reprinted in *HSCS.*, vol. 9.

Sheng, Ta-shih 盛大士 (1762–after 1850), see Sheng, Dashi.

Shi, Dafu 施達夫 et al. *Qingdai renwu huafeng* (*Ch'ing-tai jen-wu hua-feng*) 清代人物畫 風 (The Styles of Figure Painting of the Ch'ing Dynasty). Chongqing: Chongqing Chubanshe, 1995.

Shi, Xingbang 石興邦, ed. *Famensi digong zhenbao* (*Fa-men-ssu ti-kung chen-pao*) 法 門寺地宮珍寶(Precious Cultural Relics in the Crypt of Famen Temple). Xian: Shaanxi People's Fine Arts Publishing House, 1989.

*Shih-ch'ü pao-chi* 石渠寶笈 (Precious Books in a Box at a Rocky Stream [catalogue of painting and calligraphy in Emperor Ch'ien-lung's collection]), 1st edition 1745. Compiled by Chang, Chao 張照 (1691–1745) et al. Facsimile reprint. Taipei: National Palace Museum, 1971.

*Shih-chü pao-chi hsü-pien* 石渠寶笈續編 (Sequel to Precious Books in a Box at a Rocky Stream [catalogue of painting and calligraphy in Emperor Ch'ien-lung's collection]), preface 1739. Compiled by Wang Chieh 王杰 (1725–1805) et al. Facsimile reprint. Taipei: National Palace Museum, 1971

*Shih-ch'ü pao-chi san pien* 石渠寶笈三編 (The Third Sequel to Precious Books in a Box at a Rocky Stream [catalogue of painting and calligraphy in the imperial collection]), completed 1816. Compiled by Hu Ching 胡敬 (1769–1845) et al. Facsimile reprint. Taipei: National Palace Museum, 1969.

*Shibaizhai shuhua lu* (*Shih-pai chai shu-hua lu*) 十百齋書畫錄 (A Record of the Painting and Calligraphy at the Ten-hundred Studio), first edition c. early 19th century. 22 juan (chüan) 卷 (chapter). Reprinted in *ZGSHQS.*, vol. 7, pp. 520–744.

Shih, Shou-ch'ien 石守謙. "A Study on an Orchid-Bamboo Scroll Collaborated by Shih-t'ao and Wang Yüan-ch'i." *Proceedings of the International Colloquium on Chinese Art History*. Part 1: Painting and Calligraphy. Taipei, National Palace Museum, 1991, pp. 491–511.

——. "The Landscape Painting of the Frustrated Literati: The Wen Cheng-ming Style in the Sixteenth Century." In *The Power of Culture*. Willard Peterson, ed. Hong Kong: Chinese University Press, 1994.

Shih-t'ao 石濤 (1642–1707). *Hua-yü-lu* 畫語錄 (Notes on Painting). Reprinted in *MSTS*.

Vol. 1, chi 集 (part) 1, chi 輯 (division) 1, pp. 41–59.

Shimada Hidemasa 島田英誠. "Sho So no san-suiga wa tsuite 蔣嵩の 山水畫について " (On the Landscape Paintings by Chiang Sung). In *Toyo Bunka Kenkyujo kiyo* 東洋 文化所記要 (The Memoirs of the Institute of Oriental Culture). 78. Tokyo: The Institute of Oriental Culture, Tokyo University, March 1979, pp. 1–53.

Shimada, Shujiro 島田修次郎. "Shu Shin hitsu Shosen nicha to 周臣筆松泉煮茶圖" (Brewing Tea under Pines by a Spring by Chou Ch'en). *Kokka* 國華 (The National Splendor Art Journal). 782. Tokyo: Asahi Shinbin Press, May 1957, pp. 154–59.

*Shina nanga taisei* 支那南畫大成 (Compendium of Chinese Painting of the Southern School). 22 vols. Tokyo: Kobunsha, 1935–37.

*Sibu zonglu yishubian* (*Ssu-pu tsung-lu i-shu-pien*) 四部總錄藝術編 (Annotated Bibliography of Literature on the Fine Arts). Compiled by Ding Fubao 丁福保 and Zhou Yunqing 周雲青. Shanghai: Shangwu Tushuguan, 1957.

Siggstedt, Mette. *Zhou Chen.* Reprinted as a monograph from *Bulletin.* 54. Stockholm: The Museum of Far Eastern Antiquities, 1982.

Silbergeld, Jerome. "Political Symbolism in the Landscape Painting and Poetry of Kung Hsien (c. 1620–89)." Ph.D. diss. Stanford: Stanford University, 1974.

——. "The Political Landscapes of Kung Hsien" (Proceedings of the Symposium on Paintings and Calligraphy by Ming *I-min* Held at the Chinese University of Hong Kong). *Journal of the Institute of Chinese Studies of the Chinese University of Hong Kong*, 8. 2. Hong Kong: Chinese University, Dec. 1976, pp. 561–74.

Sima, Qian (Ssu-ma Ch'ien) 司馬遷 (145–86 B.C.). *Shiji* (*Shih-chi*) 史記 (The Historical Records). Reprint with punctuation by Li Quanhua 李全華. Shanghai: Yuelu Shushe, 1990.

Sirén, Osvald. *Chinese Painting: Leading Masters and Principles.* New York and London: The Ronald Press, 1956.

Sorensen, Henrik H. "A Study of the 'Ox-Herding Theme' as Sculptures at Mount Baoding in Dazu County, Sichuan." *Artibus Asiae.* 51,3⁄4. New York: New York University, 1991, pp. 207–33.

Spence, Jonathan D. *The Memory Palace of Matteo Ricci.* New York: Viking Penguin Inc., 1984.

Strassberg, Richard E., trans. *Enlightening Remarks on Painting by Shih-t'ao.* Pacific Asia Museum Monographs, no. 1. Pasadena: Pacific Asia Museum, 1989.

——. *The Abode of Illusions: The Garden of Chang Dai-chien.* Photographs by Hu Chung-hsien. Pasadena: Pacific Asia Museum, 1983.

——. *The World of K'ung Shang-jen.* New York: Columbia University Press, 1983.

Ssu-ma, Ch'ien 司馬遷 (145–86 B.C.), see Sima, Qian.

Su, Shih 蘇軾 (1037–1101). *Su-wen-chung-kung shih-pien-chu chi-ch'eng* 蘇文忠公詩 編注集成 (The Complete Compilation of Su Shih's Poetry with Commentary and Explanation). 1st ed. 1819. Reprint. 4 vols. Taipei: Student Press, 1967.

187

*Suiboku bijutsu taikei* 水墨美術大系 (An Outline of Ink Painting Serial). Tokyo: Kotansha Press, 1974.

Sun, Ch'eng-tse 孫承澤 (1592–1676). *Ch'unming meng-yü-lu* 春明夢餘錄 (A Record of Dreams in Spring Time). Reprint. Hong Kong: Lung-men Bookstore, 1965.

——. *Ken-tzu hsiao-hsia chi* 庚子銷夏記 (A Record [of Calligraphy and Painting] Compiled in the Summer of 1660), preface 1755 and 1761. N.p, n.d.

Sung, Lo 宋犖 (1634–1713). *Hsi-p'i lei-kao* 西陂類稿 (Sung Lo's Collected Writings), 1st edition 1711. Reprint. Taipei: Taiwan Student Press, 1973.

——. *Man-t'ang shu-hua pa* 漫堂書畫跋 (Colophons for Paintings and Calligraphy [Composed] at [Sung's] Hall of Boundlessness), manuscript completed in 1711. Reprinted in *MSCS.*, *chi* 集 (part) 1, *chi* 輯 (division) 5, vol. 3, pp. 67–90.

*Suzhou yuanlin (Suchou yüan-lin)* 蘇州園林 (Gardens in Suchou). Compiled by Suzhou Park and Garden Bureau. Shanghai: Tongji University, 1991.

Suzuki, Kei 鈴木敬. *Mindai Kaigashi no kenkyu: Seppa* 明代繪畫史の研究:浙派 (A Study of the Painting History of the Ming Dynasty: The Che School). Tokyo: n. p., 1968.

——. "Hsia Kuei and the Academic Style in Southern Sung." In *Proceedings of the International Sympositum on Chinese Painting. Taipei: National Palace Museum*, 1972, pp. 417–60.

——, comp. *Comprehensive Illustrated Catalog of Chinese Paintings.* 5 vols. Tokyo: University of Tokyo Press, 1982.

*Suzuki Kei sensei kanreki kinen: Chugoku kaigashi ronko* 鈴木敬先生還曆記念:中國繪畫史論集 (In Memory of Professor Suzuki Kei's Retirement: Collected Thesises on Chinese History of Art. Tokyo: Kikkawa Kobunkan, 1981.

"Tai Wen-chin chuan 戴文進傳" (Biography of Tai Chin). In Chang Ch'ao 張潮 (active 17th century). *Yü Ch'u hsin-chih* 虞初新誌 (Yü Ch'u's Newly Collected Notes ), pp. 150–51.

T'ang, Tai 唐岱 (1673–after 1752). *Hui-shih fawei* 繪事發微 (Revealing the Abstruse Aspects of Painting), prefaces 1717 and 1718. Reprinted in *ZGSHQS.*, vol. 8, pp. 886–94.

T'ang, Yung-pin 湯用彬, ed. *Chiu-tu wen-wu lüeh* 舊都文物略 (A Brief Record of the Relics in Peking). Peking: The City Government, 1935.

T'ao, Ch'ien 陶潛 (372–427). "T'ao-hua yüanchi 桃花源記" (The Account of the Peach Blossom Spring). In Tao's *T'ao Yüan-ming chi* 陶淵明集 (T'ao Ch'ien's Anthology), vol. 6. Reprinted and collated with commentary by Gong Bin 龔斌 *Tao Yuanminji jiaojian* (*T'ao Yüan-ming chi chiao-chien*) 陶淵明集校箋 (Collated Version of T'ao Yüan-ming's Collected Writings). Shanghai: Shanghai Guji Chubanshe, 1996, pp. 402–8.

T'ao, Tsung-i 陶宗儀 (active second half of 14th century), comp. *Shuo-fu* 説郛 (A Collection of Summaries of History and Novels). Reprint. Taipei: Hsin-hsing Press, 1963.

——. *Ch'o-k'eng lu* 輟耕錄 (Notes after Ceasing Farm Labors). Shanghai: Shang-wu Press, 1936.

Tao, Yuanzao (T'ao, Yüan-tsao) 陶元藻 (1716–1801). *Yuehua jianwen* (*Yüeh-hua chien-wen*) 越畫見聞 (Painters from the Yüeh Region), preface 1795. Reprinted in *ZGSHQS.* vol. 10 under the title of *Yuehua jiwen* (*Yüeh-hua chi-wen*) 越畫記聞, pp. 762–82.

T'ao, Yüan-tsao 陶元藻 (1716–1801), see Tao Yuanzao.

*Tessai O Sakuhin shu* 鐵齋翁作品集 (Collected Works by Tessai O [1836–1924]), preface 1947. N.p., n.d.

*The Selected Painting and Calligraphy of Shiht'ao.* Hong Kong: Cafa Company, 1970.

*To So Gen Min meiga taikan* 唐宋元明名畫大觀 (A Conspectus of Famous Paintings of the T'ang, Sung, Yüan, and Ming Dynasties). 2 vols. Tokyo: Otsuka kogeisha, 1929.

T'o T'o 脱脱 (1313–55), see Tuo Tuo.

Toda, Teisuke 戸田禎佑 and Hiromitsu Ogawa 小川裕充 comp. *Comprehensive Illustrated Catalog of Chinese Paintings: Second Serial.* Tokyo: University of Tokyo Press, 1982.

Toshinari, Nakamura 吉田宏志 and Kohara Hironobu 古原宏伸. *Chanoyu kaiga shiryo shusei* 茶の湯繪畫資料集成 (Tea Ceremony History Through Pictorial Art). Tokyo: Heibonsha Publishing Company, 1992.

Tsang, Li-ho 臧勵龢 et. al. *Chung-kuo jenming ta-tz'u-tien* 中國人名大詞典 (Encyclopedia of Chinese Biographies). Shanghai: Commercial Press, 1924.

Tsao, Yün-yüan 曹允源 and Wu Hsiu-chih 吳秀之. *Wu-hsieh chih* 吳縣誌 (Gazetteer of Wu County), first edition 1933. Reprint. Taipei: Ch'eng-wen Press, 1970.

Tseng, Shao-chieh 曾紹杰 (active c. 1955–1980.). *Hsiang-hsiang Tseng Shaochieh yin-ts'un* 湘鄉曾紹杰印存 (Collected Seals of Tseng Shao-chieh from Hunan). Taipei: n.p., 1956.

Tseng, Yü 曾堉. "Huang-ho teh shui na-li-lai? 黃河的水那裡來?" (From Where Did The Water of the Yellow River Come?). *Kukung yüeh-k'an* 故宮月刊 (The National Palace Museum Monthly of Chinese Art). 1. 2. Taipei: National Palace Museum, May 1983, pp. 90–3.

——. "Tsai-t'an Chu Pi-shan yin-ch'a yü tiaok'o teh chien-ting" 再談朱碧山銀槎與雕刻的鑒定" (An Additional Discussion of Chu Pi-shan's Silver Tree Raft [Shaped] Cup and the Authentication of Sculptures) in *Ku-kung yüeh-k'an* 故宮月刊 (The National Palace Museum Monthly of Chinese Art). 3. 3. June 1985, pp. 128–33.

*Tsin-T'ang i-lai shu-hua-chia chien-ts'ang-chia k'uan-yin p'u* 晉唐以來書畫家鑒藏家款印譜 (Signatures and Seals on Painting and Calligraphy: The Signatures and Seals of Artists, Connoisseurs, and Collectors on Painting and Calligraphy since Tsin Dynasty). Compiled by The Joint Board of Directors of the National Palace Museum and The National Central Museum. 6 vols. Kowloon: Cafa Co., Ltd., 1964.

Tsou, T'ao 鄒弢 (active 4th quarter of the 19th c.). *San-chieh-lu chui-t'an* 三借盧贅談 (Prolixities at the Three-loan Studio), prefaces 1881 and 1885. Reprint. Shanghai: Shen-pao Press, n.d.

Tsuruta, Takeyoshi 鶴田武洞 "Kin hyakunen rai Chugoku gajin shiryo 近百年來中國畫人資料 (Information of Chinese Painters during the Last Hundred Years)." *Bijutsu kenkyu* 美術研究 (The Journal of Art Studies). Vol. 293, pp. 27–38; vol. 294, pp. 29–34; vol. 303, pp. 22–37; and vol. 307, pp. 21–36. Tokyo: Tokyo Kokuritsu Bunkazai kenkyujo, Bijutsubu, 1973–.

Tung, Ch'i-ch'ang 董其昌 (1555–1636), see also Dong Qichang

Tung, Ch'i-ch'ang 董其昌 (1555–1636). *Jungt'ai chi* 容臺集 (Collected Writings from [T'ung's] Capacity of a Terrace Studio), preface by Ch'en Chi-ju 陳繼儒 (1558–1639) dated 1630. Facsimile reprint. Taipei: National Central Library, 1968.

Tung, Yu 董逌 (active 1st quarter of 12th century), see Dong You.

Tuo Tuo (T'o T'o) 脱脱 (1313–55) et al. *Sung shih* 宋史 (History of the Sung Dynasty). Reprint. Beijing: Zhonghua Shuju, 1977.

*Tz'u-hai* 辭海 (Sea of Terminology [Chinese language dictionary]). Taipei: Chung-hua Press, 1974.

Vinograd, Richard. *Boundaries of the Self: Chinese Portraits, A.D. 1600–1900.* Cambridge; New York: Cambridge University Press, 1992.

——. "Private Art and Public Knowledge in Later Chinese Painting." In Susanne Kuchler and Walter Melion, eds. *Images of Memory: On Remembering and Representation.* Washington D. C.: Smithsonian Institution Press, 1991, pp. 176–202, 242–246.

——. "Reminiscences of Ch'in-huai: Tao-chi and the Nanking School." *Archives of Asian Art.* 31. New York: Asia Society, 1977–78, pp. 6–31.

*Wan-ch'ing min-ch'u shui-mo-hua chi* 晚清民初水墨畫集 (Collection of Late Ch'ing and Early Republic Chinese Painting, 1850–1950). Compiled by Editorial Committee of the National Museum of History. Taipei: The National Museum of History, 1997.

*Wan-Ming pien-hsing chu-i hua-chia tso-p'in chan* 晚明變形主義畫家作品展 (Style Transformed: A Special Exhibition of Works by Five Late Ming Artists). Compiled by the National Palace Museum. Taipei: National Palace Museum, 1977.

Wang, Chao-yüan 王照圓, comp. *Lieh nü chuan pu-chu* 列女傳補注 (Commentary on Biographies of Prominent Women). Taipei: Commercial Press, 1976.

Wang, Chen (Wang, Ch'en) 王宸 (1720(97). *Huilin facai (Hui-lin fa-ts'ai)* 繪林伐材 (The Talented Artists in the Painting Circles), preface 1780. Reprinted in *ZGSHQS.*, vol. 9, pp. 871–990.

Wang, Ch'ih-teng 王穉登 (1545–1612). *Wuchün tan-ch'ing chih* 吳郡丹青誌 (A Record of Painters in Wu County). Reprinted in *MSTS.*, vol. 6, *chi* 集 (division) 2, *chi* 輯 (collection) 2, pp. 129–40.

Wang, Chih 王直 (1379–1462). *I-an wen houchi* 抑庵文後集 (A Sequel to the Collected Writings at Wang's Study of Restraint), first edition 1568. Facsimile reprint of the Wen-yüan ko 文淵閣 copy. Taipei: Shangwu Press, 1978.

Wang, Chün 汪鋆 (active second half of 18th century). *Yang-chou hua-yüan lu* 揚州畫苑錄 (Painters of Yangchou), preface 1883. 4 *juan* (*chüan*) 卷 (chapter). Reprinted in *Yang-chou ts'ung-k'o* 揚州叢刻 (Miscellaneous Books on Yangchou). *Chung-kuo fang-chih ts'ung-shu* 中國方誌叢書 (Chinese Gazetteers Serial). Vol. 3. Taipei:

Ch'eng-wen Press, 1967, (modern) pp. 741–1010.

Wang, Hui 王翬 (1632–1717), comp. *Ch'ing-hui tseng-yen* 清暉贈言 (Words Presented to Ch'ing-hui [Wang Hui]). Reprint. Shanghai: Fen-yü lou Studio, 1911.

*Wang Hui hua-lu* 王翬畫錄 (Catalogue of Wang Hui's Painting in the Collection of the National Palace Museum). Compiled by The National Palace Museum. Taipei: National Palace Museum, 1970.

Wang, Jingxian 王靖憲. *Ren Bonian zuoping ji* (*Jen Po-nien tso-p'in chi*) 任伯年作品集 (A Collection of Jen I's Works). 2 vols. Shanghai: Renmin Meishu Chubanshe, 1987.

Wang, I 王繹 (active c. mid 14th century), see Wang, Yi.

Wang, Luyu 王魯豫. "Li Shan nianpu (Li Shan nien-p'u) 李鱓年譜 (A Chronicle of Li Shan's Life). In Qiu Youxuan 丘幼宣, ed. *Yangzhou baguai nianpu* (Yang-chou pa-kuai nien-p'u) 揚州八怪年譜 (Chronicles of the Eight Eccentrics of Yangchou). Jiangsu: Meishu Chubanshe, 1992, pp. 11–62.

Wang, Mao-lin 汪懋麟 (1640–88). *Baichi wutong ge gao ji ji yigao* (*Pai-chih wu-t'ung-ko kao chi chi i-kao*) 百尺梧桐閣稿集及遺稿 (Wang's Collected Writings and Posthumously Collected Writings at His Hall of the One-Hundred-Foot-Tall Wu-t'ung Tree). 8 *juan* (*chüan*) 卷 (chapter). Shanghai: Shanghai Guji Chubanshe, 1980.

Wang, Ming-ch'ing 王明清 (1127–after 1197), see Wang, Mingqing.

Wang, Mingqing (Wang Ming-ch'ing) 王明清 (1127–after 1197). *Huichenlu* (*Hui-ch'en-lu*) 揮塵錄 (A Record of the Author's Notes While Gesturing with a Fly-whisk), preface 1166, and *Huichen houlu yuhua* (*Hui-ch'en hou-lu yü-hua*) 後錄餘話 (A Second Record and Additional Words), preface 1194. Reprint. Shanghai: Zhonghua Bookstore, 1964.

Wang, Shih-chen 汪士慎 (1634–1711). *Yü-yang ching-hua lu* 漁洋精華錄 (The Essence of Wang Shih-chen's Poems). Reprint. Taipei: The World Press, 1960.

Wang, Shih-chen 汪士慎 (1634–1711), see also Wang Shizhen.

Wang, Shih-min 王時敏 (1592–1680). *Hsi-lu hua-pa* 西廬畫跋 (Colophons on Painting by Hsi-lu [Wang Shih-min]). In Ch'in Tzu-yung 秦祖永 (1825–84). *Hua-hsüeh hsin-yin* 畫學心印 (The Study of Paintings Impressed on the Heart), *chüan* 卷 (chapter) 3. Shanghai: Sao-yeh Shan-fan Press, 1936, pp. 13a–17b.

Wang, Shiqing 汪世清. "Gong Xian de *Caoxiangtang ji* (Kung Hsien teh *Tsao-hsiang-t'ang chi*) 龔賢的草香堂集 (Kung Hsien's Anthology Entitled *Grass-fragrance Hall*). *Wenwu* 文物 (Cultural Relics Journal). Beijing: Wenwu Chubanshe, May 1978, pp. 45–49.

——. "'Qiufeng wenji' zhong youguan Shitao de shiwen ('Ch'iu-feng wen-chi' chung yu-kuan Shih-t'ao teh shih-wen) 虯蜂文集中有關石濤的詩文"(Poems and Articles Related to Shih-t'ao Found in the Collected Writings of Li Lin [李驎, 1634–c. 1707]). *Wenwu* 文物 (Cultural Relics Journal). 12. Beijing: Wenwu Chubanshe, 1979, pp. 43–48.

——. "Tung Ch'i-ch'ang teh chiao-yu 董其昌的交遊" (Tung Ch'i-ch'ang's Circle). In Wai-kam Ho 何惠鑑, ed. *The Century of Tung Ch'i-ch'ang, 1555–1636*. Vol. 1. Kansas: The Nelson-Atkins Museum of Art, 1992, pp. 459–83.

Wang, Shilun 王士倫. "NanSong gugong yizhi kao (Nan-Sung ku-kung i-chih k'ao) 南宋故宮遺址考"(An Investigation of the Site of Southern Song Palaces), in Zhou Xun 周勛, ed., *NanSong Jingcheng Hangzhou* (*Nan-Sung ching-ch'eng Hang-chou*) 南宋京城杭州 (Hangzhou: The Capital of Southern Sung). Hangzhou: Zhengxie Hangzhoushi Weiyuanhui Bangongshi, 1985.

Wang, Shizhen (Wang Shih-chen) 汪士禛 (1634–1711). *Chibei outan* (*Ch'ih-pei ou-t'an*) 池北偶談 (Casual Conversations at the North of the Pond), preface 1691. Reprint. Beijing: Zhonghua Shuju, 1984.

Wang, Shixiang 王世襄. *Classic Chinese Furniture: Ming and Early Qing Dynasties*. Beijing and Hong Kong: Joint Publishing Co., 1986.

Wang, Sizhi 王思治 et al. *Qingdai renwu zhuangao* (*Ch'ing-tai jen-wu chuan-kao*) 清代人物傳稿 (Biographical Manuscripts of the Personages of the Ch'ing Dynasty). Beijing: Zhonghua Bookstore, 1988.

Wang, Ssu-jen 王思任 (1575–1646). *Wang Chi-chung tsa-chu* 王季重雜著 (Miscellaneous Writings by Wang Chi-chung [Wang Ssy-jen]). Reprint. Taipei: Wen-wen Tu-shu Press, 1977.

Wang, Teh-i 王德毅. *Ch'ing-jen pieh-ming tzu-hao so-yin* 清人別名字號索引 (An Index of Sobriquets of the Ch'ing Dynasty). Taipei: by the author, 1985.

Wang, Tzu-tou 汪子豆. "Lieh-hsien chiu-p'ai chi-ch'i k'o-che Ts'ai Chao 列仙酒牌及其刻者蔡照" (The Immortal Wine Cards and Carver Ts'ai Chao [Who Prepared the Woodblocks for Printing the Cards]). In *ILTL.*, vol. 9, pp. 429–34.

Wang, Wei-fang 王維芳. "Zhongguo shuicaihua de kaichuangzhe Xu Yongqing (Chung-kuo shui-ts'ai-hua teh k'ai-ch'uang-che Hsü Yung-ch'ing) 中國水彩畫的開創者徐詠青" (Mr. Hsü Yung-ch'ing, the Pioneer of Chinese Watercolor Painting). *MSSL.*, 18. 2. 1986, pp. 58–61.

Wang, Yao-t'ing 王耀庭. *Chieh-hua t'eh-chan mu-lu* 界畫特展目錄 (A Catalogue of the Special Exhibition of Ruled-line Painting). Taipei: National Palace Museum, 1986.

——. "*The Land of Peach Blossoms* and *A Recluse Angling on a Flowering Stream*." In *Proceedings of the International Colloquium on Chinese Art History*, 1991. Part 1: Painting and Calligraphy. Taipei: National Palace Museum, 1991, pp. 279–97.

Wang, Yi (Wang, I) 王繹 (active c. mid 14th century). *Hsieh-hsiang mi-chüeh* 寫像秘訣 (Secret Methods for Executing Portraits), originally included in T'ao Tsung-i's 陶宗儀 (active second half of 14th century) *Ch'o-k'eng lu* 輟耕錄 (Notes after Ceasing Farm Labors). Reprinted in *HLCK.*, vol. 2, pp. 852–55.

Wang, Yikun 王以坤. *Shuhua zhuanghuang yange kao* (*Shu-hua chuang-huang yen-ke k'ao*) 書畫裝潢沿革考 (An Investigation into the History of the Mounting and Decorating of Painting and Calligraphy). Beijing: Forbidden City Press, 1993.

Wang, Yuanqi (Wang, Yüan-ch'i) 王原祁 (1642–1715). *Lutai tihua gao* (*Lu-t'ai t'i-hua kao*) 麓臺題畫稿 (Manuscripts of Wang Yüan-ch'i's Painting Inscriptions). Reprinted in *HLCK.*, vol. 1, pp. 210–33.

——. *Yuchuang manbi* (*Yü-ch'uang man-pi*) 雨窗漫筆 (Casual Notes by a Window on a Rainy Day). Reprinted in *HLCK.*, vol. 1, pp. 206–09.

Wang, Yüan-ch'i 王原祁 (1642–1715), see Wang, Yuanqi.

Wang, Zhaoyong 汪兆鏞. *Lingnan huazheng lu* (*Ling-nan hua-cheng lu*) 嶺南畫徵錄 (A Record of Painters from Canton). Guangdong: Guangdong Renmin Chubanshe, 1988.

Watt, J. C. Y. "The *Qin* and the Chinese Literati." *Orientations*. 12. 11. Hong Kong: Orientations Magazine Ltd., November 1981, pp. 38–49.

Weidner, Marsha et al. *Views from Jade Terrace: Chinese Women Artists, 1300–1912*. Indianapolis: the Indianapolis Museum of Art, 1988.

Wen, Chen-heng 文震亨 (1585–1645), *Ch'ang-wu chih* 長物誌 (A Record of Fine Objects), first edition 1637, reprinted in *MSTS.*, vol. 15, *chi* 集 (part) 3, *chi* 輯 (division) 9, pp. 165–268.

Wen, Cheng-ming 文徵明 (1470–1559). *Fu-t'ien chi* 甫田集 (The Collected Writings of Wen Cheng-ming). 36 *juan* (*chüan*) 卷 (chapter). , c. 1574. Facsimile reprint. Taipei: National Central Library, 1968.

——. "Shen hsien-sheng hsing-chuang" 沈先生行狀 (A Document of Mister Shen Chou's Life), in Wen's *Fu-t'ien chi* 甫田集 (Wen Cheng-ming's Anthology), *chüan* 卷 (chapter) 25, pp. 10–13 (new page nos. 584–89).

Wen, Chia 文嘉 (1501–83). "Hsien-chün hsing-lüeh" 先君行略 (The Life Story of My Late Father), in the *Fu-lu* 附錄 (Appendix) in Wen Cheng-ming's *Fu-t'ien chi* 甫田集 (The Collected Writings of Wen Cheng-ming), *chüan* 卷 (chapter) 36, p. 1a and 1b (new page nos., 893–94).

——. *Ch'ien-shan-t'ang shu-hua chi* 鈐山堂書畫記 (The Painting and Calligraphy Collection of the Hall of Mount Chien [Yen Sung's 嚴嵩, 1480–1569, studio]), preface 1568. Reprinted in *MSTS.* Vol. 8, *chi* 集 (part) 2 and *chi* 輯 (division) 6, pp. 39–64.

Weng, Kuang-p'ing 翁廣平 (1760–1842). "Shu Huzhou Zhuangshi shiyu (Shu Hu-chou Chuang-shih shih-yü) 書湖州莊氏史獄" (The History of the Legal Case against Mr. Chuang from Hu-chou). In Shen Ch'i's 沈起 *Cha Tung-shan hsien-sheng nien-p'u* 查東山先生年譜 (The Chronological Biography of Cha Chi-tso), pp. 152–58.

Weng, Wan-go 翁萬戈. *Chinese Painting and Calligraphy: A Pictorial Survey*. New York: Dover Publications, Inc., 1978.

Werner, E. T. C. *A Dictionary of Chinese Mythology*. Reprint. Taipei: Wen-hsing Press, 1961.

Whitfield, Roderick. *In Pursuit of Antiquity*. Princeton: The Art Museum, Princeton University, 1969.

Wicks, Ann. "Wang Shimin's Orthodoxy: Theory and Practice in Early Qing Painting." *Oriental Art*. 29. 3. London: Oriental Art Magazine, Ltd., Autumn, 1983, pp. 265–274.

Wilson, Marc. "Kung Hsien: Theorist and Technician in Painting." *Nelson Gallery and Atkins Museum Bulletin* 4. Kansas City: Nelson Gallery and Atkins Museum, 1969.

—— and Kwan S. Wang 黃光實. *Friends of Wen Cheng-ming: A View from the Crawford Collection*. New York: China House Gallery, 1974.

Wu, Ching-tzu 吳敬梓 (1701–54). *The Scholars* (*Ju-lin wai-shih* 儒林外史). New York: Columbia University Press, 1992.

190

Wu, Ch'i-chen 吳其貞 (1605-after 1677). *Shu-hua-chi* 書畫記 (A Record of Paintings and Calligraphy), c. 1677. Facsimile reprint. Taipei: Wen-shih-che Press, 1971.

Wu, Huan 吳歡. "Chung-kuo ti-i wan-chia 中國第一玩家 (The Foremost Hobbyist in China). In *Chung-kuo shih-pao chou-k'an* 中國時報周刊 (China Times Weekly). ⁵⁄₆. Taipei: China Times Inc., Feb. 15, 1992), pp. 90–97.

Wu, Lai 吳萊 (1297–1340). *Yüan-ying chi* 淵穎集 (A Collection of Versatile and Extensive Writings [Wu Lai's anthology]), preface 1354. Reprint. Ch'ang-sha: Shang-wu Press, 1937.

Wu, Marshall P. S. "Chin Nung: An Artist with a Wintry Heart." Ph.D. diss. 4 vols. Ann Arbor: University of Michigan, 1989.

——. "History Hidden in a Chinese Scroll." In Richard M. Barnhart, ed. *The Jade Studio: Masterpieces of Ming and Qing Painting and Calligraphy from the Wong Nan-p'ing Collection.* New Haven: Yale University Art Gallery, 1994, pp. 43–50.

——. "Black-glazed Jian Ware and Tea Drinking in the Song Dynasty." *Orientations,* 29, 4. Hong Kong: Orientations Magazine Ltd., April 1998, pp. 22–31.

——. "Wang Hui kejingshi qijian zhi jiaowang yu huihua huodong (Wang Hui k'o-ching-shih ch'i-chien chih chiao-wang yü hui-hua huo-tung)' 王翬客京師期間之交往與繪畫活動 (Wang Hui's Painting Activities and Social Life in Beijing). In *Qingchu siWang huapai yanjiu (Ch'ing-ch'u ssu-Wang hua-p'ai yen-chiu)* 清初四王畫派研究 (Research of the Paintings of the Four Wangs of the Early Ch'ing Dynasty). Shanghai: Shuhua Chubanshe, 1993, pp. 607–27.

*Wu-pai hua chiu-shih nien* 吳派畫九十年 (Ninety Years of Wu School Painting). Taipei: National Palace Museum, 1975.

Wu, Sheng 吳升 (active K'ang-hsi period, 1662–1722). *Ta-kuan lu* 大觀錄 (An Extensive Record of Wonderful Sights [record of calligraphy and painting]), preface 1712. Reprint. Taipei: Hanhua Press, 1971.

Wu, Tseng 吳曾 (active during the Shao-hsing reign, 1127–62). *Neng-kai chai man-lu* 能改齋漫錄 (Random Notes at the [Author's] Reforming One's Errors Studio). 2 vols. Reprint. Taipei: Kuang-wen Press, 1970.

Wu, Wei-yeh 吳偉業 (1609–71). *Wu Mei-ts'un shih-chi chien-chu* 吳梅村詩集箋注 (Wu Wei-yeh's Poetry Anthology), preface 1814. Collated by Wu I-feng 吳翌鳳. Shanghai: Kuo-hsüeh Cheng-li-she, 1936.

——. *Meicunji (Mei-ts'un chi)* 梅村集 (Collection of Mei-ts'un [Wu Wei-yeh]). Reprint. Shanghai: Guji Chubanshe, 1990.

Wu, William. "Kung Hsien's Style and His Sketchbooks." *Oriental Art.* 16.1. London: Oriental Art Magazine,Ltd., Spring 1970, pp. 72–80.

Xia, Wenyan (Hsia, Wen-yen) 夏文彥 (active mid-14th c.). *Tuhui baojian (T'u-hui pao-chien)* 圖繪寶鑑 (Precious Mirror of Painting), preface 1365. Reprinted in *HSCS.*, vol. 3.

Xiao, Ping 蕭平 and Liu Yujia 劉宇甲. *Gong Xian (Kung Hsien)* 龔賢. In *MingQing Zhongguohua dashi yanjiu congshu (Ming-Ch'ing Chung-kuo-hua ta-shih yen-chiu ts'ung-shu)* 明清中國畫大師研究叢書 (Series of Studies on Chinese Painting Masters of the Ming and Ch'ing Dynasties). Jilin: Jilin Meishu Chubanshe, 1996.

Xie, Congrong 謝從榮 and Qiu Youxuan 丘幼宣, eds. *Yingpiao shanren Huang Shen shuhua ce (Ying-p'iao Shan-jen Huang Shen shu-hua ts'e)* 癭瓢山人黃慎書畫冊 (A Set of Painting and Calligraphy Album Leaves by Huang Shen, Whose *Hao* is Ying-p'iao Shan-jen). Fuzhou: Fujian Meishu Chubanshe, 1988.

Xu, Bangda 徐邦達 *Gushuhua weie kaobian (Ku-shu-hua wei-o k'ao-pien)* 古書畫偽訛考辯 (Examinations and Verifications of Ancient Paintings and Calligraphy). 3 vols. Nanking: Jiangsu Guji Chubanshe, 1984.

——. *Lidai shuhuajia zhuanji kaobian (Li-tai shu-hua-chia chuan-chi k'ao-pien)* 歷代書畫家傳記考辯 (Verification of Biographies of Past Calligraphers and Painters). Shanghai: Renmin Meishu Chubanshe, 1984.

——. *Zhongguo huihuashi tulu (Chung-kuo hui-hua-shih t'u-lu)* 中國繪畫史圖錄 (An Illustrated History of Chinese Painting). 2 vols. Shanghai: Renmin Meishu Chubanshe, 1984.

Xu, Beihong 徐悲鴻 (1895–1953). "Ren Bonian pingzhuan (Jen Po-nien p'ing-chuan)' 任伯年評傳" (Comments and Biography of Jen Po-nien). Reprinted in Gong, Chanxing 龔產興 *Ren Bonian yanjiu (Jen Po-nien yen-chiu)* 任伯年研究 (A Study of Jen Po-nien). Tianjin: Renmin Meishu Chubanshe, 1982.

Xu, Qin (Hsü Ch'in) 徐沁 (active first half of 17th century). *Minghua lu (Ming-hua lu)* 明畫錄 (Painters of the Ming Dynasty). Reprinted in *HSCS.*, vol. 5.

Xu, Youchun 徐友春, ed. *Minguo renwu dacidian (Min-kuo jen-wu ta-tz'u-tien)* 民國人物大詞典 (Biographical Dictionary of the Personages during the Republic Period). Shijiazhuang: Hebei Renmin Chubanshe, 1991.

Xue, Feng 薛峰 and Zhang Yuming 張郁明, eds. "Qingdai Yangzhou huapai yanjiu zongshu (Ch'ing-tai Yang-chou hua-p'ai yen-chiu tsung-shu)' 清代揚州畫派研究綜述" (A General Survey of Researches on the Yangzhou Painting School)." *MSYJ.*, 1984, no. 4, pp. 79–83.

Xue, Yongnian 薛永年. *Shuhuashi lun conggao (Shu-hua-shih lun ts'ung-kao)* 書畫史論叢稿 (A Collection of Papers on the History of Chinese Painting and Calligraphy). Chengdu: Sichuan Educational Press, 1992, pp. 222–37.

——, ed. *Yangzhou baguai kaobian ji (Yang-chou pa-kuai k'ao-pien chi)* 揚州八怪考辨集 (A Collection of Essays Examining the Materials of the Eight Eccentrics in Yangzhou). In *YZPGZLCS.*, Jiangsu: Meishu Chubanshe, 1992.

Yang, Boda 楊伯達. "Lang Shining zai Qing neiting de chuangzuo huodong ji qi yishu chengjiu (Lang Shih-ning tsai Ch'ing nei-t'ing teh ch'uang-tso huo-tung chi-ch'i i-shu ch'eng-chiu) 郎世寧在清內廷的創作活動及其藝術成就" (Castiglione's Creative Activities and His Achievements at the Inner Imperial Court during the Ch'ing Dynasty). *Gugong bowuyuan yuankan (Ku-kung po-wu-yüan yüan-k'an)* 故宮博物院院刊 (Palace Museum Bulletin). 2. Beijing: Palace Museum, 1988, pp. 6–7.

Yang, Chia-lo 楊家駱 et al., comps. *Li-tai jen-wu nien-li t'ung-p'u* 歷代人物年里通譜 (A Register of the Dates of Birth, Death, and Birthplaces of Famous Figures in Chinese History). Taipei: World Bookstore Press, 1974.

Yang, Hsien 楊峴 (1819–96), see also Yang, Xian.

Yang, I 楊逸 (1864–1929). *Hai-shang mo-lin* 海上墨林 (The Artistic Circles in Shanghai), first edition 1929. Reprint. Taipei: The Wen-shih-che Press, 1975.

Yang, Renkai 楊仁愷. *Muyulou shuhua lungao (Mu-yü-lou shu-hua lun-kao)* 沐雨樓書畫論稿 (The Collected Research Papers on Painting and Calligraphy at [Yang's] Immersed in Rain Pavilion). Shanghai: Renmin Meishu Chubanshe, 1988, pp. 186–99.

Yang, Shih-ch'i 楊士奇 (1365–1444). *Tung-li ch'üan-chi* 東里全集 (The Collected Writings of Yang Shih-ch'i). Reprinted in *Ssu-k'u ch'üan-shu chen-pen* 四庫全書珍本 (Condensed Version of the Imperial Ch'ien-lung Encyclopedia). Taipei: Shang-wu Press, 1977.

Yang, Xian (Yang Hsien) 楊峴 (1819–96). *Chih-hongxuan ji (Ch'ih-hung hsüan chi)* 遲鴻軒集 (Collected Writings at Yang's Late Wild-Goose Studio). 3 vols., and *Chihongxuan wenxu (Ch'ih-hung-hsüan wen-hsü)* 遲鴻軒文續 (A Sequel to the Writings from the Late Wild Goose Studio), preface 1893. Reprint. Beijing: Wenwu Chubanshe, 1992.

——. *Ch'ih-hung-hsüan so-chien shu-hua lu* 遲鴻軒所見書畫錄 (A Record of the Painting and Calligraphy Viewed at the Late Wild Goose Studio), preface 1879. Suchou: Wen-hsüeh Shan-fang Studio, 1921.

Yang, Xin 楊新 ed. *Wumen huapai yanjiu (Wu-men hua-p'ai yen-chiu)* 吳門畫派研究 (Research on Paintings of the Wu School). Beijing: Palace Museum, 1993.

——. *Yang Xin meishu lunwenji (Yang Hsin mei-shu lun-wen chi)* 楊新美術論文集 (The Collected Theses on Art by Yang Xin) (Beijing: Zijincheng Chubanshe, 1994)

*Yangzhou baguai zhan (Yang-chou pa-kuai chan)* 揚州八怪展 (The Eight Masters of Yangzhou Exhibition). Compiled by Shanghai Municipal Museum and Asahi News. Tokyo: Asahi Shinbunsha, 1986.

*Yangzhou bajia huaxuan (Yangchou pa-chia hua-hsüan)* 揚州八家畫選 (Selected Works by the Eight Masters of Yangchou). Compiled by Tianjin Art Museum. Tianjin: Renmin Meishu Chubanshe, 1983.

Yeh, Kung-cho 葉公綽 (1880–1968). *Ch'ing-tai hüeh-che hsiang-chuan* 清代學者像傳 (Biographies and Portraits of Ch'ing Dynasty Scholars). Reprint. Taipei: Wen-hai Press, 1969.

Yeh, Tu-I 葉篤義, trans. *Ying-shih yeh-chien Ch'ien-lung chi-shih* 英使謁見乾隆記實 (An Authentic Account of an Embassy from the King of Great Britain to Ch'ien-lung Emperor). Hong Kong: San-lien Bookstore, 1994.

Yen, I-p'ing 嚴一萍, comp. *Hua-ching ts'ung-shu* 華菁叢書 (A Serial of Excellent Books). Taipei: I-wen Press, 1972.

*Yiyuan duoying (I-yüan to-ying)* 藝苑掇英 (Selected Excellent Works in the Realm of Art). Shanghai: Renmin Meishu Chubanshe, 1978–.

Yu, Jianhua 于劍華 et al., *Zhongguo meishujia renming cidian (Chung-kuo mei-shu-chia jen-ming tz'u-tien)* 中國美術家人名詞典 (Biographical Dictionary of Chinese

Artists). Shanghai: Renmin Meishu Chubanshe, 1981.

Yü, Shao-sung 余紹宋 (1882–1949). *Shu-hua shu-lu Chieh-t'i* 書畫錄解題 (Comments on Old Books of Painting and Calligraphy), first edition 1938. Reprint. Taipei: Chung-hua Press, 1968.

——. *Hua-fa yao-lu* 畫法要錄 (A Compilation of Painting Methods), preface 1926. 2 vols. Taipei: Chung-hua Press, 1967.

Yün, Shou-p'ing 惲壽平 (1633–90). "Ou-hsiang kuan hua-pa 甌香館畫跋" (Colophons on Paintings by Yün's Fragrance from a Small Cup Studio). 2 vols. In Ch'in Tzu-yung 秦祖永 (1825–84). *Hua-hsüeh hsin-yin* 畫學心印 (The Study of Paintings Impressed on the Heart). *Chüan* 卷 (chapter) 5 and 6. Reprint. Shanghai: Sao-yeh Shan-fan Press, 1936.

Zeng, Yan (Tseng, Yen) 曾衍 (1750–1825). *Xiao-toupeng xuan (Hsiao-tou-p'eng hsüan)* 小豆棚選 (Selected Anecdotes Told under a Small Bean Trellis). Reprint, selected and edited by Xu Zhenglun 徐正倫 and Chen Ming 陳銘. Hangzhou: Zhejiang Guji Chubanshe, 1986.

Zhang, Anzhi 張安治. "Ren Xiong he tade zihuaxiang (Jen Hsiung ho t'a-teh tzu-hua-hsiang) 任熊和他的自畫像," (Jen Hsiung and His Self-portrait). *Gugong bowuyuan yuankan (Ku-kung po-wu-yüan yüan-k'an)* 故宮博物院院刊 (Palace Museum Bulletin). 4. Beijing: Palace Museum, Summer, 1979, pp. 14–18.

Zhang, Chou (Chang, Ch'ou) 張丑 (1577–1643). *Qinghe shuhua fang (Ch'ing-ho shu-hua fang)* 清河書畫舫 (Ch'ing-ho's [the author's *hao*] Calligraphy and Painting Yacht), preface 1616. Reprinted in *CGSHQS.*, vol. 4, pp. 127–384.

——. *Zhenji rilu (Chen-chi jih-lu)* 真蹟日錄 (Daily Record of Genuine Works Seen by the Author), first edition c. 1620. 3 vols. Reprinted in *ZGSHQS.*, vol. 4, p. 431

Zhang, Geng (Chang, Keng) 張庚 (1685–1760). *Guochao huazhenglu (Kuo-ch'ao hua-cheng lu)* 國朝畫徵錄 (Biographical Sketches of the Artists of the Ch'ing Dynasty), preface 1739. Reprinted in *HSCS.*, vol. 5.

Zhang, Hongxiu 張鴻修, ed. *Tangmu bihua jijin (T'ang-mu pi-hua chi-chin)* 唐墓壁畫集錦 (Highlights of the T'ang Dynasty Tomb Frescoes). Xian: Shaanxi Renmin Meishu Chubanshe, 1991.

Zhang, Yanyuan (Chang, Yen-yüan) 張彥遠 (active mid 9th century). *Lidai minghuaji (Li-tai ming-hua chi)* 歷代名畫記 (Record of Famous Paintings in Successive Dynasties), completed 847. Reprinted *HSCS.*, vol. 1.

Zhang, Yuanqi 張園齊, ed. *Baihua yijing (Pai-hua i-ching)* 白話易經 (*I-Ch'ing* in Colloquial Chinese). Beijing: Gongming Daily News Chubanshe, 1989.

Zhao, Erxun (Chao, Erh-hsün) 趙爾巽 (1844–1927) et al., comps. *Qingshigao (Ch'ing-shih-kao)* 清史稿 (Historical Manuscripts of the Ch'ing Dynasty). Reprint. Beijing: Zhonghua Shuju Chubanshe, 1977.

Zheng, Minzhong 鄭岷中. "Zhu Bishan longcha ji (Chu Pi-shan lung-ch'a chi) 朱碧山龍槎記" (A Record of Chu Pi-shan's Dragon Tree Raft [Shaped] Cups). *Gugong bowuyuan yuan-kan (Ku-kung po-wu-yüan yüan-k'an)* 故宮博物院院刊 (Palace

Museum Bulletin). 2. Beijing: Palace Museum, 1960, pp. 165–69.

——. "Guanyu Zhu Bishan yincha de bianwei wenti: yu Taiwan wenwu gongzuozhe Tseng Yü shangque (Kuan-yü Chu Pi-shan yin-ch'a te pien-wei wen-t'i: yü Taiwan wen-wu kung-tso-che Tseng Yü shang-ch'üeh) 關於朱碧山銀槎的辨偽問題: 與台灣文物工作者曾埆商榷" (Concerning the Questions of the Authenticity of the Silver Tree Raft [Shaped] Cup Made by Zhu Bishan: A Discussion with Tseng Yü, a Taiwanese Cultural Relics Professional). *Ku-kung po-wu-yüan yüan-k'an* 故宮博物院院刊 (Palace Museum Bulletin). 3. 1984, pp. 52–57.

Zheng, Wei 鄭威. "Shao Mi de mingzi ji shengzu nian kao (Shao Mi teh ming-tzu chi sheng-tsu nien k'ao) 邵彌的名字及生卒年考" (A Study of Shao Mi's Names, Birth and Death Dates). *Duoyun (To-yün)* 朵雲 (A Cloud Art Journal). 8. Shanghai: Meishu Chubanshe, Dec. 1985, pp. 175–76.

*Zhongguo diming cidian (Chung-kuo ti-ming tz'u-tien)* 中國地名詞典 (A Dictionary of Names of Places in China). Shanghai: Shanghai Cishu Chubanshe, 1990.

*Zhongguo gudai shuhua jingpin lu (Chung-kuo ku-tai ching-p'in lu)* 中國古代書畫精品錄 (Selected Painting and Calligraphy of the Past Dynasties). Beijing: Wenwu Chubanshe, 1984.

*Zhongguo lidai renwu huaxuan (Chung-kuo li-tai jen-wu hua-hsüan)* 中國歷代人物畫選 (Selected Figure Paintings from the Past Dynasties). Nanjing: Jiangsu Meishu Chubanshe, 1985.

*Zhongguo meishu quanji (Chung-kuo mei-shu ch'üan-chi)* 中國美術全集 (A Complete Collection of Chinese Art). Vols. 6–11. Shanghai: Renmin Meishu Chubanshe, 1988.

*Zhongguo shuhuajia yinjian kuanshi (Chung-kuo shu-hua-chia yin-chien k'uan-shih)* 中國書畫家印鑒款識 (Signatures and Seals of Chinese Painters and Calligraphers). Compiled by the Shanghai Municipal Museum. Shanghai: Wenwu Chubenshe, 1987.

*Zhonghua wenhua mingrenlu (Chung-hua wen-hua ming-jen-lu)* 中華文化名人錄 (A Biographical Dictionary of Famous Individuals in the Cultural Circle). Beijing: Zhongguo Qingnian Chubanshe, 1993.

Zhou, Daozhen 周道振, ed. *Wen Zhengming quanji (Wen Cheng-ming ch'üan-chi)* 文徵明全集 (Wen Zhengming's Complete Anthology). Shanghai: Guji Chubanshe, 1987.

Zhou, Hui (Chou, Hui) 周暉 (active early 17th century). *Jinling suoshi (Chin-ling so-shih)* 金陵瑣事 (Trivial Notes of Nanking), preface 1610. Facsimile reprint. Beijing: Wenxue Guoji Kanxingshe, 1955.

Zhou, Jiyin 周積寅. *Zeng Jing de xiaoxiang hua (Tseng Ching teh hsiao-hsiang hua)* 曾鯨的肖像畫. Beijing: Wenwu Chubanshe, 1983.

Zhou, Lianggong (Chou Liang-kung) 周亮工 (1612–1672). *Duhua lu (Tu-hua lu)* 讀畫錄 (A Record of Examined Paintings), preface 1673. 4 *juan* (*chüan*) 卷 (chapter). Reprinted in *HSCS.*, vol. 9, pp. 1–62.

Zhu, Baojiong 朱保炯 and Xie Peilin 謝沛霖. *MingQing jinshi timingbei lu suoyin (Ming-Ch'ing chin-shih t'i-ming-pei lu so-yin)* 明清進士題名碑錄索引 (An Index of

the Stele Bearing the Names of the Holders of the *chin-shih* Degree during the Ming and Ch'ing Dynasties). Shanghai: Guji Chubanshe, 1980.

Zhu, Jinfu 朱金甫. "Lun Kangxi shidai de Nan-shufang (Lun K'ang-hsi shi-tai teh Nan-shu-fang) 論康熙時代的南書房" (The Nan-shu-fang Study during the Reign of Emperor K'ang-hsi). In *Qingdai gongshi tanwei (Ch'ing-tai kung-shih t'an-wei)* 清代宮史探微 (Preliminary Research on the History of the Palace of the Ch'ing Dynasty). Beijing: Forbidden City Press, 1991.

Zhu, Chuanrong 朱傳榮, ed. *Dijing Jiuying (Ti-ching chiu-ying)* 帝京舊影 (As Dusk Fell on the Imperial City). Beijing: Forbidden City Publishing House of the Palace Museum, 1994.

Zhu, Mouyin (Chu Mou-yin) 朱謀堊 (active early 17th c.). *Huashi huiyao (Hua-shih hui-yao)* 畫史會要 (The Assemblage of Distinguishing Figures in Painting History), preface 1631. Reprinted in *ZGSHQS.*, 4 *juan* (*chüan*) 卷 (chapter), pp. 495–459.

# List of Figures